Blogs, Wikipedia,
Second Life, *and* Beyond

Steve Jones
General Editor

Vol. 45

PETER LANG
New York • Washington, D.C./Baltimore • Bern
Frankfurt am Main • Berlin • Brussels • Vienna • Oxford

Axel Bruns

Blogs, Wikipedia, Second Life, *and* Beyond

From Production to Produsage

PETER LANG
New York • Washington, D.C./Baltimore • Bern
Frankfurt am Main • Berlin • Brussels • Vienna • Oxford

Library of Congress Cataloging-in-Publication Data

Bruns, Axel.
Blogs, Wikipedia, Second Life, and beyond: from production to produsage /
Axel Bruns.
p. cm. — (Digital formations; v. 45)
Includes bibliographical references.
1. User-generated content. 2. Social media. 3. Blogs. 4. Wikipedia.
5. Second Life (Game) I. Title.
ZA4482B78 006.7—dc22 2007046097
ISBN-13: 978-0-8204-8867-7 (hardcover)
ISBN-13: 978-0-8204-8866-0 (paperback)
ISSN 1526-3169

Bibliographic information published by **Die Deutsche Bibliothek**.
Die Deutsche Bibliothek lists this publication in the "Deutsche
Nationalbibliografie"; detailed bibliographic data is available
on the Internet at http://dnb.ddb.de/.

Cover image: "Externalised 2" (2006), by Ann McLean (www.amcleanart.com)

The paper in this book meets the guidelines for permanence and durability
of the Committee on Production Guidelines for Book Longevity
of the Council of Library Resources.

© 2008 Peter Lang Publishing, Inc., New York
29 Broadway, 18th floor, New York, NY 10006
www.peterlang.com

Printed in the United States of America

FOR ANN

Contents

Acknowledgments

This book ties together a wide range of ideas developed in conversation with many colleagues in Brisbane and abroad, and it builds on a number of collaborative research, teaching, and publishing projects. It was developed in good part during my sabbatical at the University of Leeds and Massachusetts Institute of Technology, and so I would especially like to thank my hosts and colleagues at both universities, including Stephen Coleman and Chris Paterson; Henry Jenkins, William Uricchio, Joshua Green, and Generoso Fierro; as well as my colleagues at QUT for making this sabbatical possible. I wrote almost the entire first draft of the book at MIT's Steam Café, in fact—so, many thanks to the Steam staff as well.

My sincere thanks also go to the many friends and colleagues who have supported my work on this book: in Brisbane, especially John Hartley, Stuart Cunningham, Terry Flew, Jude Smith, Jean Burgess, Liz Ferrier, Jo Tacchi, Chris Spurgeon, Greg Hearn, Stephen Towers, Suzi Vaughan, Rachel Cobcroft, Debra Adams, Sal Humphreys, Joanne Jacobs, Mel Gregg, John Banks, Jason Wilson, and Barry Saunders; and further afield, Michel Bauwens, Steve Jones, Fay Sudweeks, Matthew Allen, Nancy Baym, Charles Ess, Trebor Scholz, P. David Marshall, Guy Redden, and the many colleagues whose feedback on talks and papers presenting the concepts of produsage has helped shape the structure and contents of this book. I'm also very grateful to Julien Beauséjour, who contributed the wonderful 'gentle slope' graphic for Chapter 10. As always, many thanks to the M/C—Media and Culture team (http://www.media-culture.org.au/), and particular gratitude also to my family and friends for their support.

Finally and foremost, though, my love and thanks go to Ann McLean for giving so much of her own time and energy to sustain me through what was at times a very lonely and exhausting effort. I hope the result is worth the sacrifice.

Axel Bruns
Brisbane, December 2007

http://produsage.org/
http://snurb.info/

Introduction

This book begins with a simple, yet fundamental proposition: the proposition that to describe the creative, collaborative, and *ad hoc* engagement with content for which user-led spaces such as the *Wikipedia* act as examples, the term 'production' is no longer accurate. This, I argue, is true even where we re-imagine the concept of production as 'user-led production,' 'commons-based peer production,' or more prosaicly as the production of 'customer-made' products: not the adjectives and qualifiers which we may attach to the term 'production' are the problem, but the very noun itself.

Users who participate in the development of open source software, in the collaborative extension and editing of the *Wikipedia*, in the communal world-building of *Second Life*, or processes of massively parallelized and decentralized creativity and innovation in myriads of enthusiast communities do no longer produce content, ideas, and knowledge in a way that resembles traditional, industrial modes of production; the outcomes of their work similarly retain only few of the features of conventional products, even though frequently they are able to substitute for the outputs of commercial production processes. User-led content 'production' is instead built on iterative, evolutionary development models in which often very large communities of participants make a number of usually very small, incremental changes to the established knowledge base, thereby enabling a gradual improvement in quality which—under the right conditions—can nonetheless outpace the speed of product development in the conventional, industrial model.

Such modes of content creation—involving large communities of users, who act without an all-controlling, coordinating hierarchy—operate along lines which are fluid, flexible, heterarchical, and organized *ad hoc* as required by the ongoing process of development; they are more closely aligned with the emergent organizational principles in social communities than with the predetermined, supposedly optimized rigid structures of governance in the corporate sphere. User-led content creation in this new model harnesses the collected, collective intelligence of all participants, and manages—though in some cases better than in others—to direct their contributions to where they are best able to make a positive impact.

This style of content creation must be examined, then, without the baggage of 'common sense' assumptions and understandings about industrial processes of content production which we have developed over the past century. Industrial modes of production, from this point of view, provide only one possible paradigm for the development of products, and 'products' themselves are only one possible configuration of information, knowledge, and creative work—and not necessarily the most appropriate such configuration in the emerging context of the information age.

Terminology itself, then, is part of the problem: the very term 'product' necessarily implies a specific form of outcome, a process of reaching that outcome, and a set of likely consumer interactions with that outcome. Microsoft Windows, to pick just one example, is clearly a product (if at its core an informational one), has been developed following an industrial process of production, and is offered to the consumer to use, but not to extend and contribute to; it is less clear, on the other hand, whether the same can truthfully be said about open source software such as the Linux operating system or the Firefox Web browser, even though they can be used as substitutes for comparable closed-source products.

To overcome the terminological dilemma which faces us as we attempt to examine processes of user-led content creation, we must introduce new terms into the debate. The concept of *produsage* is such a term: it highlights that within the communities which engage in the collaborative creation and extension of information and knowledge that we examine in this book, the role of 'consumer' and even that of 'end user' have long disappeared, and the distinctions between producers and users of content have faded into comparative insignificance. In many of the spaces we encounter here, users are always already necessarily also producers of the shared knowledge base, regardless of whether they are aware of this role—they have become a new, hybrid, *produser*.

Produsage in Context

Produsage exists within a wider context of new and emerging concepts for describing the social, technological, and economic environment of user-led content creation. In particular, two terms have been used widely (and sometimes all too liberally) to describe the technological and technosocial frameworks for produsage communities: Web 2.0, and social software.

Coates provides a useful definition of social software:

> Social software is a particular sub-class of software-prosthesis that concerns itself with the augmentation of human, social and / or collaborative abilities through structured mediation (this mediation may be distributed or centralised, top-down or bottom-up/emergent).[1]

Many of the collaborative spaces provided by social software have become environments for produsage, as we see throughout this book; social software alone—understood, in line with Coates, as a prosthesis for human collaboration—cannot in itself guarantee the rise of produsage as an alternative to production, however. What it does offer, then, is a toolkit to support the produsage processes and principles which we encounter in greater detail in the following chapters:

- it removes "the real-world limitations placed on social and / or collaborative behaviour by factors such as language, geography, background, financial status, etc." by providing the tools for widespread, equitable collaboration across large communities of users;
- it compensates "for human inadequacies in processing, maintaining or developing social and / or collaborative mechanisms," especially also as they relate to the limitations imposed by geography, by providing tools and mechanisms for the development and maintenance of collaborative networks which can be organized and reconfigured *ad hoc* as required by the task at hand;
- it creates "environments or distributed tool-sets that pull useful end results out of human social and / or collaborative behaviour" by providing the means of filtering and evaluating collaborative processes and outputs and thereby harnessing and harvesting the most successful teams and content contributions.[2]

These affordances of social software speak directly to the core principles of produsage as we outline them in the following chapter; indeed, the technological characteristics of social software have emerged in parallel to and under mutual feedback with the social, organizational, and intellectual characteristics of produsage as we will soon encounter them.

Closely aligned to this understanding of social software as the technology to support and enable sociality and collaboration is the concept of Web 2.0, which highlights specifically the implications of such socially based content creation for the economic world. The term Web 2.0—which, it should be noted, has also been frequently criticized for its implication of a revolutionary new stage in Internet development, rather than portraying it as a gradual shift as may be more accurate—was introduced by Tim O'Reilly, who provides a useful definition:

> Web 2.0 is the business revolution in the computer industry caused by the move to the internet as platform, and an attempt to understand the rules for success on that new platform.[3]

Among these rules are the following:

1. Don't treat software as an artifact, but as a process of engagement with your users. ("The perpetual beta")
2. Open your data and services for re-use by others, and re-use the data and services of others whenever possible. ("Small pieces loosely joined")
3. Don't think of applications that reside on either client or server, but build applications that reside in the space between devices. ("Software above the level of a single device")[4]

Although there has been significant debate about the concept of Web 2.0 and the many other derivative '2.0' concepts it has spawned, focusing largely on the fact that many such terms can be seen as a blatant attempt by incumbent corporate players to cash in on the rise of collaborative content creation without embracing the core principles outlined by O'Reilly and others, the buzzword status of Web 2.0 and similar terms also indicates the significant commercial and industrial attention now paid to the new models of community and content development now emerging from the realm of social software. As we see throughout this book, the environments of what we will describe as produsage now often offer credible alternatives to and sustained competition for established industries and their products. For many corporate players who have found it impossible to contain the rise of such alternatives, the question has now shifted from containment to engagement—what models are available for them to harvest the content created by these communities, and to harness the communities themselves for their own purposes; what new business opportunities lie in helping rather than hindering the creation and distribution of content created within such communities? We return to examine such questions throughout this book.

In addition to the technological and commercial recognition of produsage as a major driver of change in these contexts, recent years have also seen an increasing popular attention on produsage environments—especially, perhaps, on some of its most visible proponents, such as blogs, *Wikipedia*, and *YouTube*. *Time Magazine*, for example, broke with tradition to make 'you'—that is, all of us who participate in collaborative content creation environments—its 'Person of the Year' in 2006, while in the same year, *Advertising Age* also named the consumer as 'Advertising Agency of the Year,' recognizing the impact of user-led knowledge sharing on consumption patterns.

In a similar vein, *Trendwatching* (a key observer of new trends in corporate/user engagement) even suggests that an entire new 'Generation C' has emerged, creating "an avalanche of consumer generated 'content' that is building on the Web, adding tera-peta bytes of new text, images, audio and video on an ongoing basis."[5] Generation C should not be misunderstood as a strictly generationally bounded grouping, of course—it is defined by attitude and aptitude, that is, by the interest and ability to participate in the online communities of produsage, more than by the age or background of participants: *Trendwatching* suggests that "anyone with even a tiny amount of creative talent can (and probably will) be part of this not-so-exclusive trend."[6]

For *Trendwatching*, the 'C' in Generation C stands for 'content' only in the first place; additional themes include "Creativity, Casual Collapse, Control, and Celebrity."[7] This returns us to wider economic and legal questions which the emergence of produsage as an alternative model to production raises: does the user-led, collaborative, and at least initially often non-profit model of produsage spell the 'casual collapse' of traditional content and copyright industries, as well as of other entities traditionally charged with the accumulation and dissemination of information, knowledge, and creative works (including journalism, educational institutions, and the mass media)? Who owns and controls the vast communal information and knowledge resources which have already been created by produser communities, and are further extended in a continuous process; how do such content repositories relate to the realm of copyrighted content, and how reliant are they on appropriating, incorporating, remixing, and mashing up materials which they have no permission to use? Who are the leaders and emerging celebrities of these new communities, and what opportunity is there for them to build sustainable careers from their participation in produsage, either within the realm of produsage itself, or by transitioning into the more conventional production industries? Is there, indeed, the space for a stance of seasoned produsers as bridges between produsage and production, perhaps along the lines outlined by Leadbeater and Miller: they suggest that "in the last two decades a new breed of amateur has emerged: the Pro-Am, amateurs who work to professional standards. ... The Pro-Ams are knowledgeable, educated, committed and networked, by new technology."[8] We highlight and explore such questions throughout the book.

The concept of produsage is intended as a means of connecting such developments in the cultural, social, commercial, intellectual, economic, and societal realms. The task at hand is to synthesize the various available approaches to examining what happens in commons-based peer production, social software, Web 2.0, and related environments, to move beyond the commonplace assumptions associated with traditional concepts of producers, products, and production, and to develop a systematic understanding of the processes, principles, and participants of produsage.

This book will necessarily serve only as a first contribution to that task. Produsage itself continues to evolve, both on the level of specific produsage projects and environments and on the broader level of harnessing community collaboration in the service of new aims and goals, and it is likely that some of the specific projects discussed here will have been superseded by new developments even six or twelve months from now. But whether we are still speaking of *MySpace*, *YouTube*, or *OurMedia* at that point, or whether they have been replaced by ever more intricately designed, outlandishly named successors, the phenomenon of produsage itself as abstracted beyond its specific sites is likely to continue and develop, and we have much to learn both from success and from failure. The principles of produsage as we outline them in Chapter 2 are likely to remain prevalent for the foreseeable future, and a key task of research in

this area is to investigate how best to build on these principles in order to create strong and sustainable produsage communities and projects.

It also remains possible, of course, that the continuing tendency towards harvesting the outputs of produsage communities for commercial gain, or towards hijacking the communities themselves by locking them into corporate-controlled environments, combined with stronger enforcement of commercial copyrights, will serve to fundamentally undermine participant enthusiasm for taking place in produsage projects. Recent experience in related fields suggests that ostensibly anti-community efforts tend not to have the intended effect, however, but instead simply serve to drive communities further out of the reach of corporate intervention; this, certainly, is the lesson now grudgingly learnt by the music industry, and slowly dawning on the movie and television industries. By contrast, a more benign corporate embrace may produce benefits to both industry and community, as the contrasting community reactions to the closure of Napster and the establishment of iTunes indicate. Positive commercial take-up of produsage ideas and principles will similarly help to accelerate trends while maintaining industry sustainability; negative efforts to undermine produsage, on the other hand, may also accelerate the prevailing trend towards produsage, but for very different reasons.

At any rate, the rapid speed of change in online information, knowledge, and creative work which is described by produsage serves to indicate the magnitude of the continuing paradigm shift which we are currently experiencing. Written in the midst of this paradigm shift, not all the observations made in this book may be agreeable to all readers, and not all the projects highlighted here as key examples for produsage may ultimately prove to be successful and influential, despite their ability to generate significant early enthusiasm. However, as Alvin Toffler noted at the dawn of the Information Age, in writing his 1970 book *Future Shock*: "in dealing with the future, at least for the purposes at hand, it is more important to be imaginative and insightful than to be one hundred percent 'right.' Theories do not have to be 'right' to be enormously useful."[9]

The concept and theory of produsage which is introduced in this book, I hope, will prove a useful tool to understand and describe the present shift away from industrial modes of production and towards collaborative, user-led content creation. In keeping with the core principles of produsage itself, where knowledge remains always in the process of development, and where information remains always unfinished, extensible, and evolving, this book is intended as the starting point, not the closing statement, in a conversation about produsage and its implications; it should not be read as providing a final definition of produsage and its processes that must remain fixed in stone (or at least in ink on paper) forever.

That said, I realize the irony of offering this opening statement of an ongoing conversation about produsage in a form which epitomizes the very model of traditional, industrial production which produsage so thoroughly departs from—in the

form of a printed book. The book format is also a useful indication, however, that, for all the enthusiasm about produsage and related forms of user-led content creation, the process of establishing produsage as a credible and reliable alternative for industrial production has only just begun; the final balance between production and produsage (none is likely to replace the other entirely, of course) remains yet to be determined. Although this book emerges from traditional industrial models of research and publishing, I would very much like to invite interested readers to continue the conversation about produsage through the means of produsage itself—both in direct engagement with me, for example through my Website and research blog at snurb.info, and on a wider scale through the appropriate environments of collaborative knowledge management: see, for example, if there's a *Wikipedia* entry on "produsage" in your language yet...

NOTES

1. Tom Coates, "My Working Definition of Social Software...," *Plasticbag.org*, 8 May 2003, http://www.plasticbag.org/archives/2003/05/my_working_definition_of_social_software / (accessed 25 Feb. 2007), n.p.

2. Coates, n.p.

3. Tim O'Reilly, "Web 2.0 Compact Definition: Trying Again," *O'Reilly Radar*, 10 Dec. 2006, http://radar.oreilly.com/archives/2006/12/web_20_compact.html (accessed 12 July 2007), n.p.

4. O'Reilly, n.p.

5. *Trendwatching.com*, "Generation C," 2005, http://www.trendwatching.com/trends/ GENERATION_C.htm (accessed 18 Feb. 2007), n.p.

6. *Trendwatching.com*, n.p.

7. *Trendwatching.com*, n.p.

8. Charles Leadbeater and Paul Miller, "The Pro-Am Revolution: How Enthusiasts Are Changing Our Economy and Society," *Demos* 2004, http://www.demos.co.uk/publications /proameconomy/ (accessed 25 Jan. 2007), p. 12.

9. Alvin Toffler, *Future Shock* (New York: Random House, 1970), p. 7.

The Key Characteristics of Produsage

Produsage, as a concept, stands in direct contrast to traditional modes of industrial production, and so it is useful to begin our examination of produsage by highlighting the key assumptions inherent in traditional industrial production. 'Traditional' is a conflicted term in this context: the traditions of industrial production date back little further than to the start of the industrial revolution itself, and examinations of pre-industrial societies would be likely to show the existence of very different, and often very communally organized, modes of creating both physical 'products' and intellectual 'content'. Although this book is not the appropriate place for a detailed examination of that argument, it is certainly possible to suggest that when viewed from a wider historical perspective, industrial production as it has dominated global life over the past few centuries could be seen as aberration rather than norm.

For better or for worse, at any rate, the industrial model of production emerged as a necessary corollary to the emergence of industrial-scale means of production. The need to build, operate, and maintain the means of production of physical goods, and the need to distribute these increasingly mass-produced goods effectively to their target markets, led to an ever wider separation of producers, distributors, and consumers as separate entities in the industrial production value chain. Especially at the dawn of the industrial age, such a separation was an appropriate and effective organizational model, dividing participation in industrial society into three clearly defined tasks.

producer ➜ distributor ➜ consumer

Figure 2.1: The Industrial Production Value Chain

This division of tasks also enabled all segments in the value chain to develop their own expertise, of course, thereby also establishing a source of power over their component of the chain; for the end point of that chain, however, the consumer, this initially had very little impact, as consumption was already reliant on the exercise of production and distribution power, and—in the context of limited product options—consuming was regarded as a matter of necessity rather than one of choice. Any sense

of feedback into the production and distribution process was (initially) absent: "even the conventional term for an individual end user, 'consumer,' implicitly suggests that users are not active in product and service development."[1]

However, this model tells only part of the real story: in practice, consumers even in monopoly markets have the choice at least to withhold consumption and thereby influence development, manufacturing, and pricing options of producers and distributors; in competitive markets, they are able to exercise a choice between different products and different producers and/or distributors. Nonetheless, especially in the early stages of the industrial age, power structures in the production value chain were very strongly slanted in favor of producers and (to some extent) distributors rather than consumers; building on Fordist and Taylorist models for organizing their production lines, corporations focused on maximizing production efficiency and worker productivity rather than consumer satisfaction. The famous adage used to describe the product choices available for customers of the Ford Motor Company, "you can have any color you like, as long as it's black," aptly describes the options generally made available to customers.

Product development in such environments was organized along highly hierarchical lines, and took place in a context of fierce competition with other manufacturers. Development offices were highly secretive environments, and product ideas were controlled through the enforcement of copyrights and patents to lock down competitors' ability to develop comparable products. User involvement in development, or the showcasing of prototypes for user feedback, was impossible in this context. Von Hippel describes this as

> the traditional model, in which products and services are developed by manufacturers in a closed way, the manufacturers using patents, copyrights, and other protections to prevent imitators from free riding on their innovation investments. In this traditional model, a user's only role is to have needs, which manufacturers then identify and fill by designing and producing new products.[2]

Gradually, of course, this model was adjusted to enable producers to better anticipate and respond to the needs, wants, and preferences expressed by consumers. General market research tracking consumer purchasing behaviors, and specific research using customer focus groups and other instruments, were developed and improved over time, providing ever more detailed and accurate information about what products were likely to be successful. More recently, moves towards e-commerce have added further tools to the arsenal of market researchers by enabling increasingly intricate data mining (while also raising significant concerns about customer privacy).

Such extended tools for customer research may help close the feedback loop from consumer back to producer, but do little to address the overall imbalance of power inherent in the traditional production value chain. As Shirky puts it, "the consumers' appointed role in this system gives them ... no way to communicate anything about

themselves except their preference between Coke and Pepsi, Bounty and Brawny, Trix and Chex."[3] This limitation to research into consumer preferences in the context of a continuing absence of direct consumer involvement in the production process itself is perhaps most strongly felt in the context of media products, in which under the traditional model, such products—though themselves inherently tools for communication— are simply consumed by their audiences without an ability for those audiences to become active communicators themselves (at least immediately, within the medium at hand). Thus, "the historic role of the consumer has been nothing more than a giant maw at the end of the mass media's long conveyor belt, the all-absorbing Yin to mass media's all-producing Yang."[4] (Of course the consumers of mass media are never purely passive, as media and cultural studies has documented; however, organized along industrial models of production, mass media provide no more than a highly limited space within themselves for audiences to become active communicators, thus maintaining a strong producer/distributor/consumer trichotomy.)

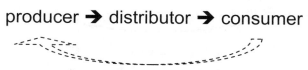

producer ➜ distributor ➜ consumer

Figure 2.2: Limited Feedback in the Value Chain

A further extension of the incorporation of customer feedback into the conventional production value chain arises with the emergence of smarter and more flexible production techniques, which enable producers to call upon consumers more directly to personalize and customize the products they purchase. Here, the consumer is no longer merely an end user of fixed products, but gains the ability (usually in a strictly limited, prescribed fashion) to alter the products purchased, according to the user's own preferences. This model is described by Alvin Toffler in his concept of prosumption, and is recently sometimes misapplied to describe the participants in what we will soon examine as produsage. Toffler's own description of the prosumer is somewhat unclear and shifts over time; overall, what prosumption appears to envision is not a shifting of the balance between producers and consumers, but merely the development of even more advanced consumption skills by consumers (the very term 'prosumer' itself also hints at the emergence of a professional consumer, of course). This is evident for example in the area of high-end home theater equipment, where customers are frequently described as 'prosumers' by the industry, and where marketing actively contributes to the establishment of a hierarchy of consumption in which many 'average' consumers are encouraged to aspire to achieving a status as 'prosumers'. In this context, turning 'pro' is seen to be possible for consumers if they commit to following relevant industry magazines, frequenting quality stores, attending consumer electronics exhibitions, and otherwise investing considerable time and effort into researching their consumption choices; in the process, the emerging trends in this high-end 'pro-

sumer' segment of the market also provide useful market intelligence for the wider industry.

Prosumption, if understood in this way, therefore describes merely the perfection of the feedback loop from consumer to producer; it sketches a capitalist paradise in which "the willing seduction of the consumer into production"[5] is complete, but where production and distribution remain driven very much by corporate interests:

> the long-range dream of the world's network builders is a single integrated loop, running from the customer (who will electronically tell business what goods or services to make) ... to the producer ... through what remains of distribution intermediary firms ... to the retailer or the electronic home shopping service ... to the ATM or the credit card payment system ... and ultimately back into the home of the consumer.[6]

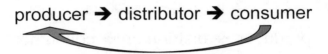

producer → distributor → consumer

Figure 2.3: The Prosumption Value Chain

Clearly, this integrated loop continues to operate under the conditions and limitations set by corporate producers; consumers' role as the 'giant maw' described by Shirky essentially remains the same, even if they are now placed in a position of having somewhat more influence over the nature of what they consume. Ultimately, corporate producers remain in the position of harnessing consumer preferences and harvesting consumer suggestions for their own gain:

> producer and consumer, divorced by the industrial revolution, are reunited in the cycle of wealth creation, with the customer contributing not just the money but market and design information vital for the production process. Buyer and supplier share data, information, and knowledge. Someday, customers may also push buttons that activate remote production processes. Consumer and producer fuse into a "prosumer."[7]

This prosumer, however, is merely a composite, even schizophrenic figure: although perhaps reunited in a continuous cycle of wealth creation, prosumers remain clearly divided into dominant and subordinate personalities. As consumers, they may *contribute* to wealth creation, but only as producers and distributors are they able to *profit* from this process—and there appears to be little provision in the prosumption model for consumers to share in this profit.

From Industry to Internet, from Consumption to Usage

Like all such models, the prosumer is a child of its time. For theoretical models emerging in the 1980s and the early 1990s, it was necessarily impossible to foresee the coming popularization of networked media and communication forms which we now know to have had a profound impact on the possibilities for content creation and distribution networks to emerge outside of the corporate, industrial realm. Toffler's "network builders" are the designers of credit card and ATM systems, of mail-order distribution models, and of home shopping channels, not the developers of the Internet, the Web, and its many media and communication forms and formats. The network described as the basis for prosumption consists of a loop of controlled unidirectional connections from producer to distributor to consumer and back to producer, rather than of the *ad hoc*, many-to-many, bidirectional exchanges we are familiar with today.

That said, Toffler's vision *does* remain highly relevant for industries which deal predominantly in physical products: here, it does provide a further step towards improving the consumer-producer feedback loop whose inherent inefficiencies von Hippel has highlighted, and which are unlikely to be able to be resolved completely. As we narrow our focus from production in general to the production of predominantly informational goods and services, however, it becomes increasingly evident that the prosumption model as well as other models based on a continuing and inherent distinction between producers, distributors, and consumers are no longer viable. (In time, though, it will also become clear that new modes of informational production and produsage do have the ability to affect even strongly physically based industries.)

The rise of the Internet as a mass medium—and as a mass medium which is significantly different from previous mass media—introduces a number of important challenges to the traditional, industrial model of information production and distribution:

- access to information sources takes place on an information-pull basis rather than the product-push model of the traditional broadcast and print mass media: this means that the relationship between producers and consumers is no longer organized in the form of an asymmetrical feedback loop which sees products distributed by way of dominant media channels controlled by producers, and feedback gathered through the subordinate means of communication accessible to consumers;
- access to the means of producing and distributing information is widely available, rather than limited to a small number of operators, and does not inherently favor specific participants for commercial, organizational, or political reasons: this means that consumers themselves can now become active

producers and distributors of information, which is widely available to all users of the network;

- the same technology which makes possible many-to-many communication and distribution of content also enables peer-to-peer modes of organizing the collaborative engagement of communities in shared projects: this means that users can now communicate and engage directly with one another on a global scale, entirely bypassing traditional producers and distributors of information;

- in its digital form, content (whether representing information, knowledge, or creative work) is easily and rapidly shareable, and can be modified, extended, recombined, "unless regulatory policy makes [it] purposefully expensive in order to sustain the proprietary business models"[8]: this means that the term 'consumption' in its conventional sense no longer applies, as digital information is a non-rival good which is not consumed (used *up*) as it is used.

As the core organizing principle of this communicative environment, the network therefore poses a significant challenge to the traditional, hierarchically organized structure of individual entities within the economy, as well as to the structure of that economy in itself. Under the mass-mediated model, consumers "have no way to respond to the things they see on television or hear on the radio, and they have no access to any media on their own—media is something that is done to them, and consuming is how they register their response."[9] Under the new network paradigm, by contrast, producers and users of media content are both simply nodes in a neutral network and communicate with one another on an equal level.

This is particularly empowering for users, who now have access to a greater range of tools to network and build communities among themselves, away from the top-down mediated spaces of the traditional mediaspheres. Whether focusing in the main on peer-to-peer communication, or directed specifically at the collaborative creation of content, their interactions are now predominantly commons-based, as Benkler has pointed out; thus, having already moved from an industrial to an informational economy during the latter part of the twentieth century, a further shift towards a "networked information economy" is now taking place:

> what characterizes the networked information economy is that decentralized individual action—specifically, new and important cooperative and coordinate action carried out through radically distributed, nonmarket mechanisms that do not depend on proprietary strategies—plays a much greater role than it did, or could have, in the industrial information economy.[10]

In fact, to be a 'user,' in the first place, already implies a more active role than that of the consumer, even if—based on the evidence presented by cultural studies—we accept that the consumer of mass media already was at least an active interpreter of

mass media content, and not merely a passive recipient. Using the Internet and its communications technologies—chiefly perhaps the Web—implies no longer simply active but silent interpretation, however: it implies also the active expression and communication of views, values, beliefs, ideas, knowledge, and creativity. In its simplest form, even mere interaction with otherwise static Websites already constitutes the expression of choice, of course; as measured and operationalized by Google, Alexa, and other network traffic analyzers, as well as by the Websites themselves, such choices also often come to affect other users' experience of the Net.

From Usage to Produsage

For consumers turned users, the media are no longer "something that is done to them," as Shirky had described it for the traditional model[11]; instead, they become much more actively involved in shaping their own media and network usage. Provided suitable tools and frameworks, then (including effective means for private and public ephemeral conversation, and for the publication of a more permanent record of the community's interactions and exchanges and of the information and knowledge contained in such engagement), what the network model makes possible is the existence of a distributed but coordinated community, organized not according to the directions of a central authority to which all other nodes in the network are subordinate, but by the community's own protocols of interaction. This is what J.C. Herz has described as the 'hive mind',[12] playing on imagery of collectivist species in popular science fiction stories as much as on the studies of real-life hives in the world of insects which may have inspired such fiction.[13] Though existing without a central authority as preordained by the technological structures which support them, such networked hive minds can frequently be seen nonetheless to develop functioning and effective patterns and protocols of communal coordination, as well as shared information and knowledge resources which codify these protocols and other knowledge that is of interest and of value to the community. These hive minds form what von Hippel describes as "information communities": "communities or networks of individuals and/or organizations that rendezvous around an information commons, a collection of information that is open to all on equal terms."[14]

The interplay between the technologies supporting such information communities on the one hand, and the communities and their social protocols on the other, is what has been examined in detail by researchers in the field of computer supported cooperative work (CSCW); emerging in the mid-1980s, research in this field focused initially especially on cooperation in more conventional workplace environments, but has gradually expanded to also explore more diverse forms of collaboration in non-work contexts (leading variously to calls to substitute 'collaborative' for 'cooperative' in the CSCW acronym, or to drop the 'W' altogether and redefine the field as focusing

on computer-supported collaboration more broadly).[15] CSCW research is important especially in relation to the development and study of the technologies supporting many of the collaborative communities we will encounter in this book, and its findings are invaluable to the further development of produsage-based content creation as a credible alternative to conventional content production. Our focus here is less on the technological and more on the social, however: although the technological frameworks for information communities will necessarily continue to change and evolve, the social and collaborative processes driving the hive mind of any one successful community are now exhibiting increasingly stable characteristics which must be highlighted in their own right.

Fundamentally, then, this book is about a variety of such hive minds, such information communities, and their patterns and protocols of interaction and collaboration, or what the inventor of the World Wide Web, Tim Berners-Lee, has described as *intercreativity*.[16] Intercreativity constitutes a significant step beyond mere interactivity—a step made possible by the use of non-hierarchical, many-to-many media: in intercreative environments, users collaborate (often in large communities) on the development and extension of shared informational resources of common interest, rather than merely interacting with the material already available; they are taking into their own hands the tools to create content. As a result, such users are engaged in the development of a more participatory culture, as Jenkins points out. He similarly highlights

> a distinction between interactivity and participation, words that are often used interchangeably but which ... assume rather different meanings. ... Participation ... is shaped by the cultural and social protocols. ... Participation is more open-ended, less under the control of media producers and more under the control of media consumers[17]

—and, of course, consumers themselves are now no longer just that, but active users and participants in the creation as well as the usage of media and culture.

This is set to have profound implications for our present-day cultural and societal systems, as well as—more prosaically—for the industrial and institutional structures which support them. Networked community intercreativity, participatory culture, and what we will describe more systematically here as the collaborative produsage of information and knowledge by 'hive mind' communities, may have the potential to bring about the development, from the myriads of small contributions by individual participants in the 'hive mind,' of a networked, distributed, decentralized *collective intelligence*, as Pierre Lévy has suggested in his equally visionary and utopian book of the same title. In the first place, however, we can already see them as drivers of a new renaissance in the creation, distribution, and sharing of information, knowledge, and creative work,[18] and we examine the key spaces for such renaissance in the following chapters; like many other profound changes, however, this move from industrial con-

tent production towards community-based intercreativity also holds the potential for severe and controversial disruptions to the established *status quo*, of course.

The most fundamental disruption brought about by the networked model, indeed, is that it shifts the boundaries to participation. Under an industrial model of content production, such boundaries were clear-cut, as we have already seen: only industrial producers and, to a more limited extent, distributors were directly involved in production processes, while audiences were cast simply in the role of consumers. Under a networked model of the form we have described here, this is necessarily no longer true; barriers to participation now are determined by questions of the individual's access to the network itself, and their capacity for understanding and adopting the prevailing protocols for effective contribution to 'hive mind' communities. For many in developed as well as developing nations, such barriers are no less crippling than the barriers of access to the industrial process, of course, but at the same time, these boundaries of participatory culture, of participation *in* networked culture, are already significantly more inclusive of a wider range of participants, and are able to be extended to encompass wider sections of the global population more quickly, than were the barriers of participation in industrial processes. Access can be improved, and capacities can be built, in ways which allow many more consumers to make the move to user and beyond.

> The networked environment makes possible a new modality of organizing production: radically decentralized, collaborative, and nonproprietary; based on sharing resources and outputs among widely distributed, loosely connected individuals who cooperate with each other without relying on either market signals or managerial commands.[19]

In light of such developments, as early as 1999, Shirky made the somewhat triumphant assertion that "in place of the giant maw are millions of mouths who can all talk back. ... We are all producers now."[20] Proclaimed so boldly, the 'death of the consumer' remains an overstatement, perhaps; where participation is strong, however, and where the community is knowledgeable and creative, the outcomes of the user-driven, hive mind, collective intelligence process of content creation can nonetheless achieve high quality, as we see in this book.

But what, exactly, is it that we see taking place, taking shape here: are we seeing simply the emergence of another form of production—a peer-to-peer form of production, as Bauwens describes it,[21] or what Benkler has called 'commons-based peer production'?[22] On the one hand, such descriptions appear to be accurate: the community processes of the 'hive mind' clearly do produce a variety of information, knowledge, art, and other content which often can stand in and substitute very successfully for the products of traditional industrial processes, as open source software has demonstrated, and which can be captured and packaged at specific points in the process to be sold as stable 'products'. At the same time, to focus on the informational products of collabo-

rative content creation in this way clearly ignores a great deal of the specific circumstances of the creation process itself: a packaging and distribution of 'hive mind' products disconnects this content from its context in the participatory community; it extracts the content from the norms, protocols, and structures of the community which created it, and shuts down the potential for a further continuing collaborative development and extension of the content in and by the community. Although continuing to use the term 'production' in his concept of 'commons-based peer production,' Benkler also points to the fact that something more than simply a reconfiguration of the balance of power between producer and consumer is taking place. He notes that

> we are seeing the emergence of the user as a new category of relationship to information production and exchange. Users are individuals who are sometimes consumers and sometimes producers. They are substantially more engaged participants, both in defining the terms of their productive activity and in defining what they consume and how they consume it.[23]

However, this still appears to suggest that those forms of usage which are not inherently and overtly 'productive' are simply a form of (better informed and better targeted, but nonetheless largely conventional) consumption. The reality of user-led content creation communities is substantially more complex—rather than falling neatly into an either/or dichotomy of "these two great domains of life—production and consumption, work and play,"[24] participation in these social spaces spans a *continuum* stretching evenly from active content creation by lead users through various levels of more or less constructive and productive engagement with existing content by other contributors, and on to the mere use of content by users who perhaps do not even consider themselves as members of the community. Users are able to move smoothly across this continuum, without so much as noticing (or concerning themselves with) the fact that their participation has contributed to the overall, communal, collaborative process of content creation.

To fully understand how hive mind communities of content creators differ from the industrial producers of the traditional model, then, it is not enough to focus only on the level of the community as such, and to note that its collective, collaborative processes of content creation can act as a workable substitute for the hierarchical, directed model of content production as it exists in the conventional industry; while valuable in its own right—especially also in highlighting that the industrial model's prevalence during the twentieth century was determined by circumstance, and not by some kind of higher law of nature inherently privileging industrial over all other models of organization for productive processes—this macro-level examination necessarily misses a great deal of the principles of collaborative content creation in networked communities as they exist at an individual level.

At that level, contributors can no more be seen as the producers of the collective resource than a single worker on the 1920s assembly lines of the Ford Motor Company could be seen as the producer of a car. Just as the company itself is the producer of its cars, so the community of content creators can be seen as the producer of the content contained in its information commons; just as the individual worker on the production line is just that—a worker, whose work is determined by an overall plan, who is directed through hierarchical processes of command and control, and whose products are owned by the employer—, so the individual contributor to a collaborative process of content creation in a hive mind community participates according to the underlying design and logic of that community.

Where the two models diverge, however, is exactly in that design and logic, developed and determined through collaborative processes by the community itself, in its continuing exploration of the affordances of the networked technosocial environment within which it exists. The collective and networked approach is able to draw on four such key affordances, each of which profoundly affects and shapes the model of collective content creation which we will describe as produsage:

1. **Probabilistic, not directed problem-solving:**
 "Whereas participants in hierarchical systems are subject to the panoptism of the select few who control the vast majority, in P2P systems, participants have access to holoptism, the ability for any participant to see the whole."[25] This enables the identification of solutions to current problems through probabilistic rather than predetermined approaches: where in a top-down panoptic model, only project leaders have a full overview, and must therefore specifically direct staff to take on required tasks, in the bottom-up holoptic model participants can self-nominate as contributors to specific problem-solving activities as their interest is triggered; the more participants do so, and the more such activities run in parallel at the same time, the more likely it is that a solution is found. The probabilistic approach is thus a direct result of the redrawn boundaries to participation in the networked model as it builds on the greater range of individuals able to participate, and the improved ease of access for such users to the community and its existing content.

2. **Equipotentiality, not hierarchy:**
 Collective project communities assume that each participant has a constructive contribution to make—they operate under a principle of equipotentiality which "means that there is no prior formal filtering for participation, but rather that it is the immediate practice of cooperation which determines the expertise and level of participation. It does not deny 'authority,' but only fixed forced hierarchy, and therefore accepts authority based on expertise, initiation of the project, etc."[26] A hierarchical model of organization, on the other hand, attempts to identify and assess exactly the set of skills held by an

employee, and to deploy each employee at that place in the hierarchy which appears best-suited to their personal attributes. This limits their participation to their specific divisions in the hierarchy, and undermines the potential for random or chance contributions elsewhere.

3. **Granular, not composite tasks:**
 "The number of people who can, in principle, participate in a project is ... inversely related to the size of the smallest-scale contribution necessary to produce a usable module."[27] As Benkler points out, communal projects crucially rely on the granularity of available tasks: if the project can be divided into individual modules, and if the modules further break down into distinct tasks requiring a limited set of skills and a limited degree of user investment, this boosts both the potential for the development of solutions through probabilistic approaches (as trial-and-error experiments become less costly for participants) and the equipotentiality of contributors (as it becomes easier for all community members to participate). If it is impossible to carry out specific tasks without a thorough and systematic knowledge of the whole project, on the other hand, this would lead the project to continue to require significant administrative overhead and direction.

4. **Shared, not owned content:**
 The sharing of content, contributions, and tasks throughout the networked community is clearly fundamental to the process of collaboration. Such sharing utilizes available network means of distribution to facilitate equal access to information, and thereby provides the basis for a granular breakdown of development tasks, the equipotentiality of participation, and the probabilistic approach to the development of solutions. An industrial model of production which relies on ownership and secrecy, and distributes information through the corporate hierarchy only on a need-to-know, top-down, panoptic model is therefore unable to operate effectively in this way.

Operating under the conditions as determined by these technosocial affordances of the network (at least as they exist in many of the networked spaces of the Internet and the Web—not all networks are structured in similar fashion), then, users are able to involve themselves flexibly and fluidly in the tasks confronting the collaborative, 'hive' community; they collaborate not by performing only the monotonous, repetitive, predetermined tasks of the production line, or by contributing fully formed new ideas to the information commons, but instead engage in an ongoing, perpetually unfinished, iterative, and evolutionary process of gradual development of the informational resources shared by the community. Such "communality is powerful: It effectively eliminates the need to predict in advance who may benefit from one's knowledge; it provides information and expertise gained by others, thus eliminating

the need to experience phenomena firsthand; and it highlights the advantages of aggregated information resources, whose value can greatly exceed the sum of the parts."[28]

Thus, the production value chain is transformed to the point of being entirely unrecognizable—in the absence of producers, distributors, *or* consumers, and the presence of a seemingly endless string of users acting incrementally as content producers by gradually extending and improving the information present in the information commons, the value chain begins and ends (but only temporarily, ready for further development) with content. Whether in this chain participants act more as users (utilizing existing resources) or more as producers (adding new information) varies over time and across tasks; overall, they take on a hybrid user/producer role which inextricably interweaves both forms of participation, and thereby become *produsers*.

(as producer)

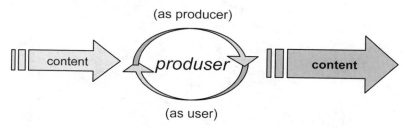

(as user)

Figure 2.4: The Produser

We must strive, then, to develop an even more systematic understanding of the processes of communal and collaborative development of content which take place here, and to develop the terminology required to describe them fully. In collaborative 'communities the creation of shared content takes place in a networked, participatory environment which breaks down the boundaries between producers and consumers and instead enables all participants to be users as well as producers of information and knowledge—frequently in a hybrid role of produser where usage is necessarily also productive. Produsers engage not in a traditional form of content production, but are instead involved in *produsage*—the collaborative and continuous building and extending of existing content in pursuit of further improvement. Participants in such activities are not producers in a conventional, industrial sense, as that term implies a distinction between producers and consumers which no longer exists; the artefacts of their work are not products existing as discrete, complete packages, as we will see; and their activities are not a form of production because they proceed based on a set of preconditions and principles that are markedly at odds with the conventional industrial model.

The produsage process itself is fundamentally built on the affordances of the technosocial framework of the networked environment, then, and here especially on the harnessing of user communities that is made possible by their networking through many-to-many communications media—"three basic functions are requisite to all collective action: (a) a means of identifying people with relevant, potential interests in the

public good; (b) a means of communicating messages commonly perceivable among them; and (c) a means of coordinating, integrating, or synchronizing their contributions."[29] By providing such functionality, network technologies have substantially extended the boundaries for the community of participants able to contribute to the produsage project. Indeed, even those members of the networked population who choose for the moment to remain users, simply utilizing the 'products' of the produsage process as substitutes for industrial products, are always already potential produsers themselves—and recent developments have made it ever more easy, and in some cases even inevitable, for such users to become produsers (for example as their very patterns of *usage* become direct inputs to the continuing processes of produsage).

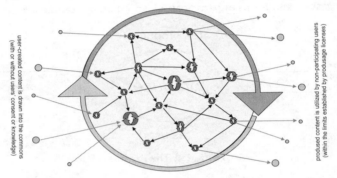

user-created content is drawn into the commons
(with or without users' consent or knowledge)

prodused content is utilized by non-participating users
(within the limits established by produsage licenses)

Figure 2.5: The Information Commons of Produsage

While produsage processes *produce* real outcomes, and while we could therefore describe produsage as a (commons-based, peer-to-peer) form of production, to understand the collaborative processes involved in produsage, and to examine their influence on the form and content of the information, knowledge, and creative work produced in the process, our focus must turn elsewhere. An important consequence of this shift of focus, then, is also that we must revise our understanding of the outcomes of produsage process, distinguishing them from the products of the industrial model. Although produsage outcomes *can* substitute for conventional products, this dressing-up of the temporary outcomes of a continuing process as 'products' in their own right should not be misunderstood to indicate that these artefacts are anything but temporary, that they *are* anything other than artefacts. A physical product—and by extension, an informational product produced and distributed through conventional industrial models which are ultimately rooted in physical production paradigms—is defined by its boundedness; it is 'the complete package,' a self-contained, unified, finished entity. By contrast, the 'products' of the collaborative content creation efforts which we examine throughout this book are the polar opposites of such products: they are inherently incomplete, always evolving, modular, networked, and never finished. Their process of 'production' is a process of perpetual, ceaseless, continuous update, extension, and

revision which operates not according to a predetermined blueprint or design, but is driven by the vagaries of user-producer interest in and enthusiasm for fixing specific problems or extending particular aspects of the project. Its outcomes are artefacts, not products.

The social, collaborative basis of the content creation communities engaged in produsage also indicates this; in produsage projects, the object of the communal effort is almost always as much the development of social structures to support and sustain the shared project as it is the development of that project itself. As von Hippel's term indicates, the object of such produsage is not simply information, but an information *commons*; in its full form, the information (knowledge, creative work) prodused by the community therefore exists not in abstraction from the social contexts of its development, as a stand-alone product, but exists only as directly embedded in such contexts, as a temporary artefact of continuing social processes of developing, extending, negotiating, and evaluating this shared content.[30] Just as we do not speak of 'producing' our social networks (we build, extend, maintain, improve them), in collaborative content creation much the same observation applies: here, too, content creation is an act of maintenance and construction (of both content and the social relationships among participants) at least as much as it is one of production. Most participants in content creation communities will therefore see themselves exactly as that: as participants, not as producers. Although their behavior in these communities may be 'productive' as their acts of participation accumulate, for some participants this may be only a corollary to their social use of the communal spaces, and to their engagement in the community.

The Key Principles of Produsage

What emerges is that in the online, networked, information economy, participants are not simply passive consumers, but active users, with some of them participating more strongly with a focus only on their own personal use, some of them participating more strongly in ways which are inherently constructive and productive of social networks and communal content. These latter users occupy a hybrid position of being both users and what in traditional terms would have to be described loosely as producers: they are productive users, or *produsers*, engaged in the act of *produsage*. In addition, we also see an increasing trend to make productive (overtly or covertly) even those forms of participation which we may traditionally have considered to be strictly private 'consumptive' uses: the very acts of using *Google* to search for information, of traversing the *Amazon* online catalog, or indeed of browsing the Web itself, now create data trails which when analyzed and fed back into the algorithms of search engines and content directories contribute to subtly alter the browsing experience of the next user. Not only are we all users, then—the more such tools for all of us to affect one another's ex-

perience of the shared online knowledge space become commonplace, the more do we all become producers of that knowledge space itself (whether we know it or not).

What we will describe and examine here as produsage covers all of these environments, therefore, though of course some collaborative content creation spaces and communities will better embody the key principles of produsage than others. Based on the preceding discussion and an observation of the dominant spaces for produsage in existence today it is now possible for us to identify the key principles of produsage, principles which apply across all of these environments regardless of the specific object of their produsage efforts. These principles have emerged from some of the earliest environments of produsage in the online world, and especially the open source software development community, and therefore embody what Stalder and Hirsh have described as 'Open Source Intelligence' or OS-INT[31]; in addition, however, they also trace their roots to the peer-based research and innovation communities which inspired open source itself, and have evolved to cover more than collaborative software— or more broadly, knowledge—development and today also apply to practices as diverse as citizen journalism and multi-user online gaming.

The four principles of produsage, which can be seen in action in the produsage sites and models which we will study throughout this book, build directly on the four preconditions for produsage which we have already encountered: in much the same way that the industrial model addressed the material and intellectual conditions of the time of its emergence by developing the production system most likely to succeed under such conditions, so is the produsage model which adheres to the four principles best able to operate under the conditions of probabilistic and equipotential contribution, and granular and shared content, as they were outlined earlier.

Open Participation, Communal Evaluation

A produsage approach assumes that quality control and improvement are probabilistic rather than linear: the assumption within the produsage community is that the more participants are able to examine, evaluate, and add to the contributions of their predecessors, the more likely an outcome of strong and increasing quality will be (an extension of open source's motto "given enough eyeballs, all bugs are shallow"). Such contributions may be major or minor, substantial or insubstantial, take the form of useful content or the form of social engagement in or administrative services to the community, but they are nonetheless all valuable to the overall project. Participation in produsage, therefore, must be invited from as wide a range of potential contributors as possible, and produsage environments are generally open to all comers. Produsage, in other words, is based on a principle of inclusivity, not exclusivity, and this also applies to the participation of producers in multiple produsage projects—indeed, as Miller and Stuart note,

it is in a group's interest for its members to engage with other organizations, to get involved in other issues, because it helps each group extend the impact of its message and actions. The network-centric approach encourages members to access their social networks.[32]

Produsage therefore draws on as broad a range of available knowledge, skills, talents, and ideas as is available, and encourages its participants to apply these diverse capacities to the project at hand. The applicability, relevance, and quality of their contributions is in turn evaluated by other participants as they make their own contributions to the shared effort: those contributions deemed useful and relevant will be further improved upon, while those leading to dead ends of development or introducing irrelevant ideas, concepts, and suggestions to the shared project will remain unused. Participants who consistently make such unusable contributions will also themselves drift to the outside of the community, although those found to be usually worthy contributors gradually rise to greater prominence among their peers. The organizational structure of produsage communities, therefore, is non-hierarchical and network-centric, extending even beyond the core community itself: "network-centric groups encourage leadership among their members. Power is distributed vertically and horizontally across the organization, and the sharing of resources often includes peer organizations, even potential rivals."[33]

This holoptic model of communal evaluation in produsage, in which each contributor is able to see and evaluate everyone else's contributions, also acts as a driver for a continuing process of socialization of participants into the community ethos: being able to view all of their peers' contributions provides individual members with a clear understanding of the forms and formats their own contributions may take, and the quality and quantity of input required of them if they wish to become a more central member of the community; being subject to evaluation by potentially any one of their fellow participants encourages them to be particularly careful and diligent in their contributions if they wish to retain their status in the community. This process of socialization does not militate against honest mistakes, prevent community disputes, or address the problem of pathological disruptors (also known as 'trolls'), but it does help to maintain community cohesion and content consistency, and over time is even likely to improve the odds of the probabilistic content development approach.

Fluid Heterarchy, *Ad Hoc* Meritocracy

Produsage necessarily proceeds from a principle of what Michel Bauwens describes as equipotentiality[34]: the assumption that while the skills and abilities of all participants in the produsage project are not equal, they have an equal ability to make a worthy contribution to the project. This approach, which allows project leaders to emerge from the community based on the quality of their contributions, necessarily departs from traditional, hierarchical organizational models. Further, basing the standing of

contributors in the community on the quality of their contributions also implies that such standing can decline again as their contributions diminish (for example once a specific problem encountered in the produsage process has been solved to general satisfaction); the structure of the produsage community is therefore not only organized along networked, non-hierarchical lines, but also remains in constant flux. Finally, in line with the granularity of problems on which produsage depends, the community's ability to organize its content creation and problem-solving activities along such fluid, flexible lines also relies on its ability to make progress working as individuals or in small teams of produsers, rather than requiring whole-of-community decisions at every step of the process.

Where this condition is met, produsage communities organize their processes through *ad hoc* forms of governance: as Toffler predicted in the 1970s, in these communities

> we are witnessing not the triumph, but the breakdown of bureaucracy. We are, in fact, witnessing the arrival of a new organizational system that will increasingly challenge, and ultimately supplant bureaucracy. This is the organization of the future. I call it 'Ad-hocracy.'[35]

Such produsage adhocracies are no anarchies, however: they do have their leaders both for the overall project and for specific aspects of it, but the power of those leaders is much diminished. Rather than forming a strict hierarchy of command and control, they operate in a much looser heterarchy which even allows for the existence of multiple teams of participants working simultaneously in a variety of possibly opposing directions. Leadership is determined through the continuous communal evaluation of participants and their ideas, and through the degree of community merit they are able to build in the process; in this sense, then, produsage heterarchies constitute not simply adhocracies, but *ad hoc* meritocracies.

As Jenkins puts it,

> new forms of community are emerging ... : these new communities are defined through voluntary, temporary, and tactical affiliations, reaffirmed through common intellectual enterprises and emotional investments. Members may shift from one group to another as their interests and needs change, and they may belong to more than one community at the same time. These communities, however, are held together through the mutual production and reciprocal exchange of knowledge.[36]

What directions of development will ultimately be accepted as the overarching project aims, then, depends once again on their take-up by the communal and ongoing processes of evaluation within the community itself—and where multiple frontrunners emerge, the temporary or permanent division of communities into separate groups is also possible.

Unfinished Artefacts, Continuing Process

As content development embraces a probabilistic model, as participant involvement becomes equipotential and fluid, as projects are deconstructed to form granular, modular tasks inviting and harnessing even small contributions from casual members of the produsage community, and as the collaboratively produced content is shared in an openly accessible information commons, the process of produsage must necessarily remain continually unfinished, and infinitely continuing. As we have already noted, produsage does not work towards the completion of products (for distribution to end users or consumers); instead, it is engaged in an iterative, evolutionary process aimed at the gradual improvement of the community's shared content. Such gradual, probabilistic processes do not ensure against temporary reductions in quality as poor-quality contributions are made by individual produsers, but over time the shared community resource is expected to improve in quality as long as such negative contributions are outweighed by the impact of a larger number of positive contributions.

To ensure that this overall positive development does indeed take place, and that negative contributions are identified and neutralized, produsage communities rely on a combination of community- and technology-based processes. On the one hand, the principle of community evaluation means that there is a good likelihood for negative contributions to be discovered speedily; a further implication of the fluid, heterarchical, *ad hoc* meritocracy structure of produsage communities is that contributors found to have made such contributions will diminish in social status within the community, thus both ensuring that their future contributions will be regarded more critically by the community from the outset, and providing an incentive for users to improve the quality of their future contributions in order to avoid further marginalization.

Finally, the technologies of coordinating produsage processes now also frequently offer advanced tools for examining the development history of specific content elements within the overall information commons, and the contribution history of individual participants, as well as means of rolling back development to a point preceding negative contributions. Combined with the communicative tools used to manage the process of produsage, this turns the collaboratively produced texts which are at the heart of produsage projects into communal property not unlike the medieval palimpsest: such projects take the form of texts authored collaboratively both by conducting a continuing discussion through comments and annotations 'in the margins,' and by the repeated overwriting of existing passages in a shared effort to arrive at a better representation of communally held values and ideas.

Such outcomes, produced through social processes, take on some of the aspects of those processes themselves; they resemble cultural artefacts more than commercial products. Artist Brian Eno suggests that we

> think of cultural products, or art works, or the people who use them even, as being unfinished. Permanently unfinished. We come from a cultural heritage that says

things have a "nature," and that this nature is fixed and describable. We find more and more that this idea is insupportable—the "nature" of something is not by any means singular, and depends on where and when you find it, and what you want it for.[37]

A description of produsage outcomes as 'artefacts' rather than products is therefore highly appropriate: as the process of content development within the produsage community is always necessarily incomplete, the content to be found in the information commons within which the produsage community exists always represents only a temporary artefact of the ongoing process, a snapshot in time which is likely to be different again the next minute, the next hour, or the next day. Any attempt to describe such content as a product once again overlooks the fact that produsage is not production, that users acting as produsers are not producers, and that the community does not operate under hierarchical, corporate frameworks aimed at generating a saleable product to consumers. However, by extending Eno's category of 'cultural products' to include a wider range of information products we might also ask whether much of the information sold as product today—from *Windows* to *Britannica* and beyond—is not similarly, necessarily, permanently unfinished, and whether the sale of such information as product does not claim a completeness which such 'products' cannot possibly provide. That such information is sold in the (physical) form of products has more to do with the legacy of information distribution models from the industrial, pre-network age than it has with the inherent qualities of those 'products'. If—owing to its changing and changeable nature—information is ill-suited for packaging as a product, however, then it is important to ask whether the conventional production model is appropriate for the creation of such informational 'products' at all; informational produsage may well represent a more suitable model.

Common Property, Individual Rewards

The communal produsage of content in an information commons necessarily builds on the assumption that content created in this process will continue to be available to all future participants just as it was available to those participants who have already made contributions. As Quiggin notes, although on a smaller scale such collaborative content produsage had long been possible within individual enthusiast and specialist communities, only the advent of network technologies enabled larger projects, while simultaneously also further reducing the possibility of providing direct rewards for contributors:

> the internet reversed the increase in scale that had long characterized research and innovation. Suddenly it became possible to undertake large projects on the basis of many small contributions. ... It is, in general, impractical to pay participants in these projects, and monetary payments tend to crowd out altruistic and other motivations.[38]

Instead, then, participation in produsage projects is generally motivated mainly by the ability of produsers to contribute to a shared, communal purpose. This purpose is embodied in the first place in the content gathered in the information commons itself, and the ability of produsage projects to generate such motivation in their participants therefore relies also on the project's ability to ensure that the commons is managed and protected effectively from abuse or exploitation, and remains openly accessible. Any attempt by individuals within or beyond the community, by community leaders, or by commercial entities outside of the community to capitalize on the content of the information commons beyond what is seen to be legitimate under the rules of the community must therefore be avoided; such rules (as enshrined in a variety of moral and legal documents including the GNU General Public License and Free Documentation License, the Open Source License, and the Creative Commons license framework) commonly stipulate, for example, that community-held content must remain freely available, that modifications of such content must be made available once again under similar conditions, and that the contributions of individual produsers to the shared project must be recognized and (where appropriate) rewarded.

Although content is held communally, therefore, produsers are able to gain personal merit from their individual contributions, and such individual rewards finally are a further strong motivation for participation in produsage communities and projects. Such personal merit (whether gained through contributions at the level of content development, community coordination, or administrative service) rewards the individual by adding to their social capital within and—in some cases—beyond the community; increasingly, where emerging from prominent produsage communities, it has also proven able to be converted into tangible rewards including professional accreditation and employment outcomes for produsers with a proven positive track record within their communities.

Produsers recognized in this way closely resemble the Pro-Ams described by Leadbeater and Miller: "innovative, committed and networked amateurs working to professional standards. This emerging group, the Pro-Ams, could have a huge influence on the shape of society in the next two decades."[39] Pro-Ams are not a modern-day reincarnation of Toffler's prosumers, however: they are not professional consumers able to provide simply particularly useful feedback to the commercial producers, but indeed become actively, creatively, innovatively involved in the process itself, with or without the permission of commercial operators.

> Pro-Ams are a new social hybrid. Their activities are not adequately captured by the traditional definitions of work and leisure, professional and amateur, consumption and production. We use a variety of terms—many derogatory, none satisfactory—to describe what people do with their serious leisure time: nerds, geeks, anoraks, enthusiasts, hackers, men in their sheds.[40]

Pro-Ams, then, form the very core of the wider produsage communities: those committed, long-term participants in produsage who rise to the higher levels of the produsage heterarchies, who coordinate the collaborative effort, maintain and steward the information commons, and represent the community to itself and to the wider society around it. They lead by example, not by coercion, by merit, not by power inherited from a position in the hierarchy, by consensus, not by decree.

Impacts and Implications of Produsage

Enthusiast and specialist communities which had been poorly served by the established information production industries were among the first to embrace produsage processes, but by now they are no longer the only heartland of produsage. As Benkler notes, the central role which information—and information production—now plays in developed nations also means that produsage processes and related practices find themselves at the very centre of their economies:

> new patterns of production—nonmarket and radically decentralized—will emerge, if permitted, at the core, rather than the periphery of the most advanced economies. It promises to enable social production and exchange to play a much larger role, alongside property- and market-based production, than they ever have in modern democracies.[41]

The more central to economy and society such processes become, however, the more their impact will extend beyond these projects and their economic impact themselves. Produsage has already extended from its early successes in open source software development to related areas of collaborative knowledge management, as evidenced for example in the unprecedented success of the *Wikipedia* as a collaboratively produced encyclopedia, but as it extends further into a widening range of information, knowledge, and creative work, it comes to affect culture itself, and heralds the age of what Jenkins describes as a participatory, convergence culture: "this is what happens when consumers take media into their own hands. ... Within convergence culture, everyone's a participant—although participants may have different degrees of status and influence."[42]

Such convergence processes are unlikely to take place without impacting on the incumbent cultural institutions, of course—chiefly, perhaps, those media organizations which have served as the producers and distributors of cultural content throughout the mass media age. Cultural convergence, convergence culture, robs them of their position at the privileged end of the production value chain, and reduces them to the level of all other participants in the network: this is, as Jenkins puts it, "where old and new media collide, where grassroots and corporate media intersect, where the power of the media producer and the power of the media consumer interact in unpredictable ways."[43] At the same time, as the rise of *Amazon* and *Google* already indicates, there is

also the potential for dominant new corporations (built on convergent models) to emerge; these will be feeder businesses which

> create a win-win situation: they make it easier for consumers and businesses to use a key service that, thanks to its popularity, reach and depth, has become so sophisticated that getting the most out of the service requires help from specialists.[44]

Overall, then, cultural convergence, driven in good part by the rise of produsage, is likely to bring about what the analysts at *Trendwatching* describe as the casual collapse at least of those of the established media powers which are unable to change their game fast enough to keep up with the new forms of content creation now found to be viable, as well as enabling the rapid rise of new players.[45]

But the media are likely to be only one of the fields affected by the rise of collaborative content creation. Content is information, information can be converted into knowledge, and knowledge is power—if, as *Trendwatching* predicts, "creativity is about to be unleashed full force" through the processes of produsage, then, across all areas of society this is likely to lead to "the ongoing demise of many beliefs, rituals, formal requirements and laws modern societies have held dear, which continue to 'collapse' without causing the apocalyptic aftermath often predicted by conservative minds."[46] We will explore the extent of such tendencies towards casual collapse, as well as the shape of new social, societal, and political formations which may emerge in their wake, in later chapters in this book.

Attempts to fend off such decline are already evident in the increasing emergence of what have been described as 'crowdsourcing' models, in which organizations release 'public beta' versions of their (informational or physical) products to select groups of knowledgeable users to gather in-depth feedback. In such approaches, the organizational thought process seeks to engage with the collective intelligence, the hive mind, of produsage communities. Crowdsourcing is only one possible approach to the commercial embrace of produsage communities and of the content they create, however. Overall, such approaches can be broadly divided into the following models:[47]

- **Feeding the hive:** an extension of the crowdsourcing model which describes all contributions of content into the produsage environment. Commercial operators may make such contributions in recognition of the beneficial outcomes which can result directly or indirectly from the community's produsage-based processing of the content, even though the specific material fed to the hive will now be governed by commons-based license and is therefore lost to direct commercial exploitation.
- **Helping the hive:** reversing the 'harvesting' model, here commercial or noncommercial operators provide services aimed at the produsage community itself. Such services may be directed at communities to help them coordinate their produsage processes, or at individuals to help them overcome obstacles

to effective participation. The emergence of 'drop shops' for items to be auctioned off on eBay, or production services for the print publication of collaboratively prodused texts, are examples here.

- **Harboring the hive:** another form of helping the hive, this model points to the provision of hosting services to the produsage community—for example community hosting as it is offered by *SourceForge* for open source projects, by *Wikia* for wiki-based knowledge management communities, or by *Flickr* for photo enthusiasts. Again, such practices are mostly benign unless a community lock-in to the harboring service is exploited by the service provider (and such threats may exist in the context of the increasing reliance of users on *Flickr* for photosharing or *YouTube* for videosharing, for example).

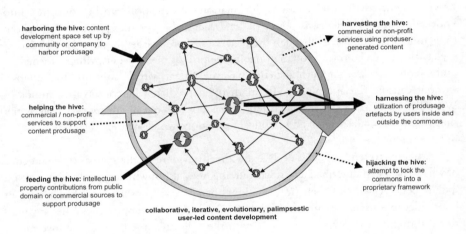

Figure 2.6: The Information Commons of Produsage in Context

- **Harnessing the hive:** adapted from Herz,[48] this model describes the non-commercial or commercial utilization of produsage artefacts by organizations inside and outside the produsage community, while respecting applicable content licenses and cooperating with the community. It describes for example the aggregation services in the blogosphere, which identify and collect the most-cited blog posts or tags and make them easily accessible to all participants.
- **Harvesting the hive:** this model describes the provision of value-added services, aimed mainly at non-participants, using artefacts developed by the produsage community—for example, the development of ready-to-install open source software distribution packages by companies like Red Hat. Such prac-

tices are mostly benign unless applicable content licenses are ignored by the harvester.

- **Hijacking the hive:** combining the worst aspects of harvesting and harboring, this practice deliberately aims to achieve lock-in of produsage communities for financial gain. Recent debates for example over the heavy-handed enforcement of end-user license agreements (EULAs) in massively multi-user online games like *EverQuest*, where game operator Sony attempted to bar its users from selling their hard-earned game characters and artefacts on eBay, can be seen as highlighting instances of this practice.[49]

We will encounter a variety of examples for each of these commercial approaches to produsage throughout this book.

While the commercial lock-in and exploitation of produsage communities may turn out to be highly profitable in the short term, and while large, well-established produsage communities may appear to be very lucrative prospects for such exploitation, commercial operators should be well aware that approaches which overtly aim to contain and lock in community participants must ultimately generate as much bad publicity and negative community response as they might offer positive outcomes in the short term. A more enlightened and sustainable strategy will be to seek open and equitable collaboration with the produsage community itself.

As we have noted, produsage models tap into the principle of collective intelligence as Lévy has outlined it:

> a form of *universally distributed intelligence*, constantly enhanced, coordinated in real time, and resulting in the effective mobilization of skills. ... The basis and goal of collaborative intelligence is the mutual recognition and enrichment of individuals rather than the cult of fetishized or hypostatized communities.[50]

This cannot but appear as a threat to those considered to be experts under traditional models of accreditation and recognition, and relations between such traditionally recognized experts and the non-expert, but often Pro-Am participants in produsage communities are frequently fraught. At the same time, such conflicts also raise very important questions of what, in today's environment of participatory, convergence culture with its shifting and unstable informational environments, is and should be considered to be established knowledge, and how that knowledge—reflecting our understanding of the world—should be structured and presented. Produsage communities, by developing their own, alternative organization for established and emerging knowledge, perform an important service in reopening such questions. Ultimately, however, such development efforts also require the broad-based establishment of a new range of digital literacies and capabilities across the wider citizenry—that is, the development of a more comprehensive understanding of communal produsage practices by the communities of (current and potential) produsers themselves.

Inherent in this move out of established knowledge structures into new, more malleable environments, and in the move of participants in the networked information economy from reader to writer, from consumer to user, from user to produser, then, is the potential for profound changes to our fundamental social institutions themselves—a potential for renaissance, as Rushkoff describes it:

> our renaissance's answer to the printing press is the computer and its ability to network. Just as the printing press gave everyone access to readership, the computer and internet give everyone access to authorship. The first Renaissance took us from the position of passive recipient to active interpreter. Our current renaissance brings us from the role of interpreter to the role of author. We are the creators.[51]

What results from this could be not simply a new range of open source software to challenge the commercial software industry; a new citizen journalism to act as a corrective to industrial journalism; or a *Wikipedia*, providing a compendium of our collected understandings of the world that traces different knowledge structures from the encyclopedias of old. What may result from this renaissance of information, knowledge, and creative work, collaboratively developed, compiled, and shared under a produsage model, may be a fundamental reconfiguration of our cultural and intellectual life, and thus of society and democracy itself.

Notes

1. Eric von Hippel, *Democratizing Innovation* (Cambridge, Mass.: MIT Press, 2005), p. 19.
2. Von Hippel, p. 2.
3. Clay Shirky, "RIP the Consumer, 1900–1999," *Clay Shirky's Writings about the Internet: Economics & Culture, Media & Community, Open Source,* 1999, http://www.shirky.com/writings/consumer.html (accessed 24 Feb. 2007), n.p.
4. Shirky, n.p.
5. Alvin Toffler, *The Third Wave* (New York: Random House, 1970), p. 275.
6. Alvin Toffler, *Powershift: Knowledge, Wealth, and Violence at the Edge of the 21st Century* (New York: Bantam, 1990), p. 126.
7. Toffler, *Powershift*, p. 239.
8. Yochai Benkler, *The Wealth of Networks: How Social Production Transforms Markets and Freedom* (New Haven, Conn.: Yale University Press, 2006), p. 105.
9. Shirky, n.p.
10. Benkler, p. 3.
11. Shirky, n.p.
12. JC Herz, "Harnessing the Hive," in John Hartley (ed.), *Creative Industries* (Malden, Mass.: Blackwell, 2005), pp. 327–341.

13. See, e.g., Stephen Johnson, *Emergence* (London: Penguin, 2001).

14. Von Hippel, p. 165.

15. For a concise overview of the first decade of CSCW studies, see Jonathan Grudin, "Computer-Supported Cooperative Work: History and Focus," *Computer* 27.5 (May 1994), pp. 19–26, http://research.microsoft.com/research/coet/grudin/papers/ieeecomputer1994.pdf (accessed 21 Sep. 2007).

16. Tim Berners-Lee, *Weaving the Web* (London: Orion Business Books, 1999).

17. Henry Jenkins, *Convergence Culture: Where Old and New Media Collide* (New York: NYU Press, 2006), p. 133.

18. See especially Douglas Rushkoff, *Open Source Democracy: How Online Communication Is Changing Offline Politics* (London: Demos, 2003), http://www.demos.co.uk/publications/opensourcedemocracy2 (accessed 12 July 2007).

19. Benkler, p. 60.

20. Shirky, n.p.

21. Michel Bauwens, "Peer to Peer and Human Evolution," *Integral Visioning*, 15 June 2005, http://integralvisioning.org/article.php?story=p2ptheory1 (accessed 1 Mar. 2007).

22. Benkler, *The Wealth of Networks*.

23. Benkler, p. 138.

24. Benkler, p. 138b.

25. Bauwens, p. 1.

26. Bauwens, p. 1.

27. Benkler, p. 101.

28. Bruce Bimber, Andrew J. Flanagin, and Cynthia Stohl, "Reconceptualizing Collective Action in the Contemporary Media Environment," *Communication Theory* 15.4 (2005), p. 371.

29. Bimber et al., p. 374.

30. Strictly speaking, this is true of some conventional products as well: the content of *Encyclopædia Britannica* is determined by the social context of its production—the make-up of its staff of editors and contributors—as much as the content of *Wikipedia* is determined by its community and the participatory protocols of that community. However, the distancing of production, distribution, and consumption as three distinct phases in the conventional value chain tends to obscure this significantly, enabling *Britannica* and other products to assume an aura of objectivity which neither applies to nor is pursued by most produsage communities and their artefacts.

31. Felix Stalder and Jesse Hirsh, "Open Source Intelligence," *First Monday* 7.6 (June 2002), http://www.firstmonday.org/issues/issue7_6/stalder/ (accessed 22 Apr. 2004).

32. Jed Miller and Rob Stuart, "Network-Centric Thinking: The Internet's Challenge to Ego-Centric Institutions," *PlaNetwork Journal: Source Code for Global Citizenship*, n.d., http://journal.planetwork.net/article.php?lab=miller0704 (accessed 14 Mar. 2007), p. 2.

33. Miller & Stuart, p. 2.

34. Bauwens, "Peer to Peer and Human Evolution."

35. Alvin Toffler, *Future Shock* (New York: Random House, 1970), p. 113.

36. Jenkins, p. 27.

37. Qtd. in Kevin Kelly, "Gossip Is Philosophy," interview with Brian Eno, *Wired* 3.05 (May 1995), http://www.wired.com/wired/archive/3.05/eno.html (accessed 12 July 2007), n.p.

38. John Quiggin, "Blogs, Wikis, and Creative Innovation," *International Journal of Cultural Studies* 9.4 (2006), pp. 492–493.

39. Charles Leadbeater and Paul Miller, "The Pro-Am Revolution: How Enthusiasts Are Changing Our Economy and Society," *Demos* 2004, http://www.demos.co.uk/publications/proameconomy/ (accessed 25 Jan. 2007), p. 9.

40. Leadbeater & Miller, p. 20.

41. Benkler, p. 3.

42. Jenkins, p. 132.

43. Jenkins, p. 2.

44. *Trendwatching.com*, "Feeder Businesses: An Emerging Consumer Trend and Related New Business Ideas," 2006, http://www.trendwatching.com/trends/FEEDER_BUSINESSES.htm (accessed 20 Feb. 2007), n.p.

45. *Trendwatching.com*, "Generation C," 2005, http://www.trendwatching.com/trends/GENERATION_C.htm (accessed 18 Feb. 2007), n.p.

46. *Trendwatching.com*, "Generation C," n.p.

47. Extended from Axel Bruns, "Produsage: Towards a Broader Framework for User-Led Content Creation," presented at Creativity & Cognition conference, Washington D.C., USA, 13–15 June 2007, http://snurb.info/files/Produsage%20(Creativity%20and%20Cognition%202007).pdf (accessed 12 July 2007).

48. JC Herz, "Harnessing the Hive."

49. Greg Sandoval, "Sony to Ban Sale of Online Characters from Its Popular Gaming Sites," *CNet News* 10 Apr. 2000, http://news.com.com/2100-1017_3-239052.html (accessed 12 July 2007).

50. Pierre Lévy, *Collective Intelligence: Mankind's Emerging World in Cyberspace*, trans. Robert Bononno (Cambridge, Mass.: Perseus, 1997), p. 13.

51. Rushkoff, p. 37.

Open Source Software Development: Probabilistic Eyeballs

Open source software development provides one of the earliest present-day examples for produsage in action. However, it is important to recognize that open source itself only reconnects with much older trends towards the free revealing of innovation which existed at the very start of the industrial age, as von Hippel notes in his book *Democratizing Innovation*.[1] In addition, of course, scientific research has a perhaps even longer history of freely revealing and sharing new ideas and innovations within the wider peer network.

The existence of such open sharing networks depends on the existence of a number of factors. One is the presence of a strong community and network of knowledgeable peers who are able to provide insightful feedback and criticism on new developments; this is represented in the academic community for example by the community of authors and readers of scholarly journals. Common protocols for participating in such journals (as author, reviewer, and editor) and for working with the material presented by them (such as the requirement to cite) are also crucial in this context. Further, open sharing requires the presence of stronger incentives towards free revealing than there are towards secrecy: the benefits gained from the open publication of research results must outweigh the potential benefits from keeping such results private (to develop commercial applications, for example).

At the same time, however, competitive pressures can also provide a strong incentive in favor of freely revealing innovation. This is the case especially in hypercompetitive markets where new innovations are unlikely to be protected from competitor adoption for long. (Research in the mobile devices industry provides a key example here.) Here, competitive advantage comes not from holding on to one's innovations, but from ensuring that they are as widely adopted as possible, even by competitors; again it is the reputation which flows from this wide adoption (and the tangible commercial benefits from being thus seen as an industry leader) which outweighs any benefits from strict patent enforcement. This is especially the case for smaller innovative players in competitive markets:

innovators often freely reveal because it is often the best or the only practical option available to them. Hiding an innovation as a trade secret is unlikely to be successful for long: too many generally know similar things, and some holders of the "secret" information stand to lose little or nothing by freely revealing what they know.[2]

Early Internet history represents a typical example of a time when—for a variety of reasons—the free revealing and sharing of innovations was common practice. Internet development arose from what was then a niche area of computer science, and largely in the absence of immediate commercial considerations (while the emergence of the Net from military and academic environments has become something of a cliché, it is nonetheless true that major commercial organizations were initially only mildly interested in the innovations emerging from Internet development). In addition, and this has held true to some extent until today, there was also a sometimes intense competition between developers to have their innovations for key aspects of the Internet's technological protocols accepted by the wider peer community; the reputational benefits which resulted from such adoption far outweighed any commercial opportunities to be derived from refusing to share freely. (Such tendencies remain in place at least to some degree even today—new protocols and content formats for sharing information online have generally proven to be most widely adopted when their underlying technologies were revealed freely. Even the marketing might of Microsoft, for example, was not able to establish its Windows Media format against the freely revealed MP3 as the preferred format for audio files.)

The open source software development community has emerged from such origins, but is now engaged in the development of software well beyond the purposes of Internet technology itself. Although initially itself operating perhaps mainly within small, niche areas poorly served by the commercial software producers, it is today also engaged in many much larger projects which directly challenge the commercial incumbents; indeed, today it is possible to see the strengths of the open source model especially in the coordination of large-scale development efforts involving a wide community of programmers, designers, documentation authors, beta testers, users, administrators, and other participants. It is in managing such diverse communities that the heterarchical, meritocratic model of community organization turns out to deliver particularly strong advantages over the traditional, hierarchical model typically found in the commercial software industry. As Shirky puts it,

> any commercial developer has a "resource horizon"—some upper boundary of money or programmer time which limits how much can be done on any given project. Projects which lie over this horizon either can't be accomplished ..., or, once started, can't be completed because of their size or scope.[3]

Open source's horizon is not determined by the limits of commercial resources, by contrast: its success depends simply on the ability of projects to attract participants of sufficient expertise and enthusiasm—and some of the larger projects (in terms of scope

and ambition) have turned out to be best able to attract the required community of contributors.

Scratching the Itch

Few users of computer software, few users of the Web are likely to be even remotely aware of the extent to which their experience of computer-mediated communication is made possible by open source software technologies. Today, as Leadbeater and Miller point out,

> half the websites on the internet depend on Pro-Am, open source Apache software. Most email uses sendmail, a program created by Pro-Ams. Usenet newsgroups are supported by the hacker-created INN program and the internet's plain language address system, eg *www.demos.co.uk*, depends on the Pro-Am-created BIND program.[4]

Open source development, in other words, has played a crucial role in ensuring and protecting the unity of the Internet as a global network by providing both the standard protocols of content transmission and reception and the software which enacts these standards; indeed, as many commercial developers have found, their attempts to add proprietary protocols and elements to these open standards (for example in the form of extensions to Hypertext Markup Language or proprietary media formats) have often met with concern and rejection by Internet users who found themselves confronted with notices that specific Web pages or media files would require them to download and install proprietary plugins.

But beyond such successes for open source software on the server side of the Internet (best exemplified perhaps by the market leadership of the open source Apache Web server even in the face of competition from Microsoft and other major commercial operators), open source software development has also produced highly successful software for advanced as well as amateur 'end users'. Such software includes for example the Firefox Web browser, which now commands a small but significant portion of its market (at present, it holds upwards of 15% of the browser market, making a notable impression on the formerly overwhelming market dominance of Microsoft's Internet Explorer), but continues to be best exemplified by the Linux operating system.

> Linux, the computer operating system, started life in September 1991, when Linus Torvalds, then a pasty-looking computer student at Helsinki University in Finland, posted the source code for his new operating system on the internet and asked his fellow software enthusiasts to make criticisms, propose improvements, take it away and tamper with it.[5]

Torvalds did so in part because at the time, there were no foreseeable commercial benefits to be gained from protecting his intellectual property from being revealed; most importantly, the embryonic state of his first attempts to build the kernel for his operating system prevented any serious use of the software. Torvalds knew that only broader involvement from a wider variety of skilled programmers would propel the project towards commercial quality.

As the Linux community grew, development of the Linux kernel gathered pace. Remarkably, however, its effectiveness proved not to follow patterns commonly observed in commercial software development processes. Raymond notes that

> the fundamental problem that traditional software-development organization addresses is Brooks's Law: "Adding more programmers to a late project makes it later." More generally, Brooks's Law predicts that the complexity and communication costs of a project rise with the square of the number of developers, while work done only rises linearly.[6]

As the open source community has found, however, this law is true only under a conventional model of corporate organization. Open source software development projects overcome such problems by building a non-hierarchical structure of organization and governance.

Torvalds's ability to attract and involve skilled and enthusiastic programmers in the shared effort of developing the Linux kernel proved a key ingredient towards the success and sustainability of the Linux project, and this is true to a similar extent for virtually all other open source projects. Although the personal interest of the project originator is therefore crucial in providing the initial impetus for an open source project—or as Eric Raymond's famous adage goes, "every good work of software starts by scratching a developer's personal itch"—it is just as important that the personal investment of the initial developer does not preclude the involvement of others, and the harnessing of their contributions to the project. This already points to the heterarchical tendencies inherent in open source communities: while the project originator, by virtue of that role, necessarily is an initial leader of the project, they also need to be able to step away from that role enough to enable others to provide leadership in areas of project development where their skills are most effectively utilized: "the next best thing to having good ideas is recognizing good ideas from your users. Sometimes the latter is better."[7]

This stance is founded on the principle of what Bauwens describes as equipotentiality. Equipotentiality proposes that although contributors' skills are necessarily varied, all participants do have the potential to make a unique contribution, and must be invited through the design and structure of the shared project to do so where this is most appropriate. Similarly, equipotentiality also suggests that all contributors have their weaknesses, their blind spots; for project leaders as well as for all other contributors to a shared project, therefore, it is also important to trust in the abilities of other

participants to move forward development processes in areas where their own expertise is limited. This is not a matter of blind trust, however, as all contributions to an open source (or indeed, produsage) project are evaluated by the community at large—such communal evaluation will highlight those elements which should be included in the overall development project, and will point out those elements to be excluded as not meeting sufficient standards. An equipotential model also leads to a probabilistic approach to open source software development, therefore: if all contributors are assumed to have the potential to make a worthy contribution to the project, then such potential is best harnessed by developing mechanisms which allow a wide range of contributions to be made, and which filter from these contributions those elements which are most likely to lead to the development of new innovations likely to be successful.

Together, then, equipotential and probabilistic approaches form a necessary precondition for the first of the principles of produsage as we have outlined them in the previous chapter, and which open source demonstrates: **open participation, communal evaluation**. Equipotentiality "believes that expertise cannot be located beforehand, and thus general and open participation is the rule. But selection immediately sets in as well, since the equipotency is immediately verified by the work on the project."[8] This applies to contributions as well as to contributors, and where effective and efficient processes for this communal evaluation are in place, it is therefore beneficial for produsage projects to take as inclusive an approach to participation as is feasible: the project has more to gain from allowing wide participation (and thereby possibly uncovering useful contributions and contributors previously unknown) than it does from cutting off access to participation for new users.

It should be noted that this *does* depend crucially on the efficiency of evaluation processes themselves, though: if such processes are overly time- or resource-consuming for the produsage community, the negative effect of their occupying the time of community members will outbalance the positive effect of distributing the produsage effort across a wider range of participants. In this, the efficiency of evaluation processes is determined both by community structures themselves and by the availability of support tools to manage the process—indeed, it relies on the third precondition for produsage as we have encountered it in the previous chapter: not only must contributions to the project itself be granular, that is, be able to be made in small increments which enable even casual, non-committed users to become produsers, but contributions to the evaluation process must similarly be granular for that process to be successful, efficient, and effective.

In the first place, then, Torvalds's approach in developing Linux was to "release early and often, delegate everything you can, be open to the point of promiscuity," as Raymond notes. In the process, the Linux development community was extended well beyond the development teams common in conventional software projects, to the point even of including non-programmer users of the emerging Linux kernel and op-

erating system as co-developers. By releasing software in a steady stream of incomplete, prepublication versions, open source software development enables the wider public to act as quality testers of its work; this release of 'public beta' versions massively extends the number of uses and misuses likely to be made of the software, and this treating of "users as co-developers is your least-hassle route to rapid code improvement and effective debugging,"[9] as open source developers have found.

The logic behind such open participation quality control approaches is a probabilistic one, then: it works by increasing the likelihood both that remaining problems or bugs within the current revision of the open source software project are going to be identified by one of the vastly increased number of beta testers in the wider community surrounding the project, and that a solution to any one such problem is going to be identified by one of the similarly larger number of active software developers contributing to the project. Such probability is further increased if a large number of the beta testers do themselves have rudimentary programming skills which enable them at least to identify clearly, if not fix, the source of the problem. As Raymond puts it, an increase in the number and diversity of the open source software development community corresponds most importantly to an increase in the diversity of skills and knowledges, or 'toolkits,' which participants bring to the project, and this is directly beneficial to quality improvement: "adding more beta-testers may not reduce the complexity of the current 'deepest' bug from the *developer's* point of view, but it increases the probability that someone's toolkit will be matched to the problem in such a way that the bug is shallow *to that person.*"[10]

This, then, corresponds to a parallelization of the development and quality improvement effort for open source software (and 'software' should be understood in this context to mean not only the software code itself, but also program documentation and other ancillary yet crucial information). Through such parallelization, "the principle behind Brooks's Law is not repealed, but given a large developer population and cheap communications its effects can be swamped by competing nonlinearities that are not otherwise visible."[11] In open source projects, non-programmer users are able to work directly with programmer-developers to identify and eradicate bugs as well as formulate and develop desired new project features; further, this can operate on a number of parallel tracks and even in competing teams seeking to develop the most effective or attractive solution to any given problem. Again given a suitably large and effective community of participants, the effects of openness and parallelization can vastly outweigh the affordances of traditional organizational approaches to software development, as open source's success across a number of areas has shown. Thus, the basic law of open source is that

> "debugging is parallelizable". Although debugging requires debuggers to communicate with some coordinating developer, it doesn't require significant coordination between debuggers. Thus it doesn't fall prey to the same quadratic complexity and management costs that make adding developers problematic.[12]

In pursuing maximum openness to participation, open source harnesses what Anderson has described as "long tail" phenomena[13]: it relies not simply on a core set of participants with clearly defined roles and skills, but instead includes a much wider range of professional, pro-am, and amateur contributors whose roles, skills, interests, and investment in the project vary widely. Eric Raymond's most famous aphorism, "given enough eyeballs, all bugs are shallow," is one example for this: the larger the contributor base to open source projects, the more likely are uses of the software which diverge some way from its intended purpose. However, one consequence of such divergent uses is that they may uncover errors which had gone unnoticed by beta testers using the software only in more conventional, intended, predetermined ways. Similarly, a larger and more diverse community of developers will also bring a broader range of potential solutions to any given problem. By contrast, in traditional, commercial, closed-source development projects the identification of problems and solutions is limited to the core project group's ability to 'break' the program and find solutions to its shortcomings—by introducing boundaries to participation, such development cuts off the long tail of potential uses, bugs and fixes outside of conventional wisdom, in other words.

Even the best-funded commercial software development projects have been shown to suffer from long tail phenomena. Microsoft's Windows operating system, for example, has frequently been derided as an unofficial 'public beta' whenever new versions are released; especially given the large number and wide diversity of users of Windows, even the considerable development budget of an industry leader like Microsoft cannot possibly sustain developer teams large enough to identify the many semi-obscure bugs which will be uncovered by its users. The regular and frequent release of 'hotfixes' and 'security updates' documents the many bugs necessarily left undiscovered in a complex software project produced under a closed source model, and the introduction of crash reporting features into more recent versions of Windows in fact constitutes a clear attempt to formally harness users as beta testers at least indirectly. Open source projects are not inherently immune from problems with bugs and other errors, of course; here, however, the quality of the software depends not on the vagaries of development budgets, but directly on the project's ability to attract a large and committed group of contributors (and users-as-produsers). As a result, a project's popularity and the quality of its software output can enter into a virtuous cycle: the better the software, the more popular it will be; the more popular it is, the larger the community of contributors able to identify remaining problems and suggest further avenues for improvement; the more active the community, the better the software.

Such observations, and the probabilistic logic on which they depend, do not account for the statistical anomaly of individual participants exerting a massively disruptive influence on the project (whether through ignorance or through malice); nor do they fully take into account the deleterious effects of an entire section of the community pulling in a different direction from the stated intentions of the overall produsage

community. Nonetheless, even such disruptions may be understood through a probabilistic approach, as Krowne has suggested[14]; they will be cancelled out (and, more importantly, overcome by the community) when on average, positive contributions outweigh negative contributions by a significant factor (this factor will need to be significant, as Krowne suggests, because participants "will be annoyed and demotivated by a smaller quantity of adversity than is actually insurmountable"[15]).

By extension, therefore, the open source, produsage model is not applicable to all problem-solving situations in software or other intellectual environments: it will generally require the existence of a unified sense of purpose which is communally held by the majority of project contributors; it cannot operate effectively if significant factions of the community are advocating differing, divergent directions for further development. (In such cases, a division or 'forking' of the community is an option, as we see in the following section.) Similarly, produsage models of content development depend crucially on the presence of a sufficiently large core community to kick-start their processes, and on the existence of a certain amount of seed content on which the community can base its improvement efforts.

A Community of Equ(ipotenti)als

Where such conditions are met, however, produsage can deliver better results more quickly than can traditional, closed-source models (and the level of speed and quality for its efforts are likely to be directly dependent on the size and diversity of its contributing communities). As such, produsage provides an alternative to traditional models of development; "it turns the old model on its head. There is no *a priori* selection, only 'after the fact'. ... Not select, then publish; but publish, then select."[16]

This also raises the question of how such selection takes place in practice. In the first place, the open evaluation of contributed content remains simply a matter of enabling other peers to make public their assessment of any one contribution (or contributor), but beyond this, the community also needs to establish protocols for aggregating and acting on these collected opinions. This is all the more problematic in open source communities as the very openness of its processes makes it difficult to define 'membership' of the community in any meaningful sense of the term.

Open source communities are therefore always evolving, and thereby exemplify the second core principle of produsage: **fluid heterarchy, *ad hoc* meritocracy**. Decisions are made *ad hoc*, in the moment, by a loose collection of those affected by these decisions, and remain largely non-binding: the open-access nature of open source communities and their development projects, and the assumption of participant equipotentiality on which they are built, also means that decisions gain effect largely only through practice, not through law. The decision to employ a specific programming approach to solve a given development problem, for example, will have a lasting effect

on the overall project only if decision makers follow up on that judgment by creating a new software module employing that approach; if a different group in the community develops an alternative module delivering better functionality using a different programming strategy, their solution is likely to be accepted by the wider community. As Bauwens describes it, thus,

> within the project, a hierarchy is ... immediately created depending on expertise, engagement, and the capacity to generate trust. But ... the hierarchies are fluid, not fixed, and always depend on concrete context, the precise task at hand. It's the model of the improvising jazz band, where everyone can in turn be the solo-ist or the trend-setter. Reputation is generated, but constantly on the move.[17]

This applies even to the originator of the open source project. Though immediately placed in a position of leader and gaining a strong reputation from their necessarily significant initial seeding of the project, this role, and the influence on the further development of the project which flows from it, is not guaranteed to last beyond the early stages. In addition, it is reputation which is founded just as much on the project originator's social skills as it is on their programming abilities: "charismatic leadership can ... play an important role in network-centric groups."[18] After all, the initial role of the project originator is not only in developing a seed idea from which the wider produsage project can grow; just as—or perhaps more—importantly, the project originator must also work to attract a project community large enough to sustain further development beyond the stage achievable by relying only on the originator's own skills.

This is reflected also in Raymond's description of open source project leaders as 'benevolent dictators'. While much commentary on this idea has tended to focus on the choice of the term 'dictator,' Stalder and Hirsh suggest that 'benevolent' is the operative term in this context: such project leaders

> are not benevolent because [they] are somehow better, but because their leadership is based almost exclusively on their ability to convince others to follow. Thus the means of coercion are very limited. Hence, a dictator who is no longer benevolent, i.e. who alienates his or her followers, loses the ability to dictate.[19]

The very need to be inclusive and collaborative—to build a community based on open participation and communal evaluation—therefore severely limits any project leader's ability to truly 'dictate' the direction of the project. Any such overt direction would inherently serve to limit inclusiveness and interfere with the community's own processes of evaluating contributions and contributors.

The coordinator of open source, produsage processes, therefore, is able only to exert their (nonetheless often considerable) influence on communal decision-making processes in order to guide such processes in directions which (through their long-term participation in the project) they believe to be beneficial to the overall develop-

ment process; in this context, Raymond notes, "it is not critical that the coordinator be able to originate designs of exceptional brilliance, but it is absolutely critical that the coordinator be able to *recognize good design ideas from others*."[20] Where such recognition fails, or where the coordinator's own limited abilities lead them to suggest development directions which diverge significantly from communal opinion, it becomes unlikely that their suggestions will be adopted by the overall community, and this may indeed even serve to diminish the project leader's standing in the community they helped kick-start.

This significant limitation on outright leadership in produsage communities already distances their coordination model from the hierarchical structures traditionally employed in conventional development efforts. Instead, produsage communities, including open source software development groups, are organized along more multiply led, heterarchical lines. This also addresses problems inherent in coordinating very large groups of participants. As Shirky notes, the coherence of groups degrades as their size increases; for example, "any mailing list or weblog with 10,000 readers will be very sparsely connected, no matter how it is organized"[21]; the same is true for software development collectives or any other large team. Corporate structures have traditionally attempted to address this problem through strictly hierarchical chains of command, but this has been found to generate only limited benefits; the larger the hierarchy, the more limited the buy-in of common workers into the overall goals expressed by hierarchical leaders, and the more complex the processes of coordination and communication both horizontally across the different divisions in the hierarchy, and vertically between its various strata.

For any larger group, of course, "sparse organization of the larger group can ... encompass smaller, more densely clustered communities," and it is on this principle that the heterarchical organization of open source communities builds. If "increasing the number of people in a group weakens communal connection," a solution is to enable the formation of smaller, densely connected clusters within the larger group, while also ensuring that the clusters within the group continue to communicate effectively with one another. Indeed, Shirky notes,

> one of the design challenges for social software is in allowing groups to grow past the limitations of a single, densely interconnected community while preserving some possibility of shared purpose or participation, even though most members of that group will never actually interact with one another.[22]

It is important to note in this respect that the development of open source software by large, diverse, and loosely structured communities of participants—and the processes of produsage overall, regardless of what domain they take place in—must therefore be considered to be social as much as they are productive processes; open source is community as much as it is project. In other words, through open source, "software became something you could join, either as a beta tester or as a coder on an

open source project."[23] Consequentially, open source projects are thus organized not through top-down direction by project leaders, but through the discursive determination of product directions.

> Discussion plays a key role in the negotiation of emergent, shared understandings— this is, perhaps, the essence of face-to-face collaboration. Discussion acts as a point of mediation between the individual collaborators and the creative outcome which may or may not eventuate.[24]

Open source and produsage communities always also operate through shared discursive, communicative spaces within which processes resembling a face-to-face negotiation of shared understandings and goals may take place. Over time, discussion also enables the community to identify its most insightful participants, building their reputation and thus awarding them a more central role in the process; in effect, where operating effectively, such discussion ensures the establishment of best fit between participant skills and project directions by discursively clarifying both the communal sense of project direction and establishing the specific range of skills present in the community.

In addition, discussion activates and taps into the enthusiasm present in the community, thereby ensuring that the most active and engaged contributors are also those who are the most enthusiastic. Indeed, discursive involvement offers the potential of developing a feedback loop between expertise, engagement, and enthusiasm: the ability for knowledgeable community members to exert a direct influence on the future direction of developments in and by the community also increases their buy-in and enthusiasm for the project, thus making them even more likely to contribute their expertise. Miller and Stuart describe this as a significant new approach to defining the structures of power and influence within the development community:

> New Power allows decision-making authority to spread to the edges of an organization, to membership, which not only generates excitement among supporters, but also opens up a deep well of creativity and expertise. The Old Power approach keeps this extraordinary knowledge resource untapped.[25]

Harnessing its diverse contributor communities in this way, produsage must be by necessity heterarchical, "characterized by relations of minimal hierarchy and by organizational heterogeneity. ... Heterarchies exist through permitting and even fostering a diversity of organizational logics and minimizing conformity."[26] However, in this context, it is important to note that even heterarchies still do involve structures of power: they are not anarchies. Their crucial distinction from traditional hierarchies, however, is the absence of structural permanence: heterarchies in produsage remain constantly in flux as contributions and contributors arrive into the community and are evaluated by it. Within a heterarchy, in other words, contributors participate as and when it appears appropriate for them to do so. In the first place, the choice to participate or to

abstain is their own; in addition, of course, the communal evaluation of their contributions (and of the skills these contributions demonstrate, thus ultimately of their standing as a community member) also provides further feedback from the community on whether the choice to participate was seen to be a prudent one, and is likely to affect participants' further behavior within the community; such communal evaluation therefore turns out to have a socializing effect on participants.

At the same time, the openness of produsage communities to potential participants, and their belief in the inherent equipotentiality of all contributors, also serve to mitigate some of the deleterious effects of such socialisation—even despite the high standards usually required to make substantial contributions to an open source project, for example, the project does remain continually open for new participants to provide at least a limited degree of input at first, and build gradually to greater involvement as their reputation as a respected community member grows: "the hurdle to participating in a project is extremely low. Valuable contributions can be as small as a single, one-time effort—a bug report, a penetrating comment in a discussion."[27] Newcomers who hope to make a significant impact with their first contribution to a project are likely to be disappointed (perhaps to the point of not returning to contribute again), but potential participants who *are* willing to be socialized into the community by those who are already active members within it—to learn the ropes, as it were—can rise to more prominent positions over time.

Indeed, the fact that larger produsage projects are usually structured into a number of smaller community clusters focusing on specific aspects of the common project also aids this socialization of new participants: newcomers in such environments need not come to terms with the community as a whole, but only need to become familiar with those members of the community whose engagement directly affects their own. This even enables vastly different social and organizational structures to exist within different clusters in the same project. Heterarchy also relies on the granularity of tasks, in other words. This impermanent networked organization, then, is best described as an adhocracy:

> the polar opposite of a bureaucracy, an adhocracy is an organisation characterised by a lack of hierarchy. In it, each person contributes to confronting a particular problem as needed based on his or her knowledge and abilities, and leadership roles shift as tasks change. An adhocracy, thus, is a knowledge culture that turns information into action.[28]

Indeed, Jenkins's description once again serves to highlight that within an open source, produsage environment, a contribution to the project does not need to consist necessarily of an addition or change to the shared source code itself. As Elliott notes (for wiki-based produsage projects, but the same is also applicable to open source development), "it is possible to contribute ... without discussing what you are contributing to or creating. Conversely, it is also possible to take part in discussion without

editing" the content of the project[29]; both forms of contribution are equally valid, and both drive forward the overall development process: contributions to the shared code base hope to fix bugs or introduce new functionality, while contributions to the shared discussion surrounding the code base contribute to determining future development directions or help evaluate the outcomes of development efforts to date.

Importantly, such discursive engagement helps further to bridge the gaps between differently skilled participants in the open source project, from programmers to designers, documentation developers, beta testers, and 'end users'—a gap commonly limiting the effectiveness of traditional closed-source approaches which involve only a subset of these actors: "open-source development breaks this bind, making it far easier for tester and developer to develop a shared representation grounded in the actual source code and to communicate effectively about it."[30] Collaboration on the basis of that shared text, made up of the source code itself, its documentation, and additional forms of communication surrounding it, helps shift the focus from a command-and-control structure involving individuals responsible for reporting problems and solutions up and down the hierarchy to a flatter, more open, broader engagement of the overall community in the shared effort of software development; this again demonstrates the move from ego-centric to network-centric structures of collaborative work. The networked community effectively trains itself through an ongoing process of socialization and communal evaluation. In this process, "power still gathers at the center, but the process of leadership decision-making is more inclusive, and reaches deep into the group's staff and membership."[31]

As Bauwens points out, however,

> power, in the form of reputation that generates influence, is given by the community, is time-bound to the participation of the individual (when he [sic] no longer participates, influence declines again), and can thus be taken back by the participating individuals.[32]

Power dissipates almost as quickly as it accumulates, in other words, always in accordance with the recent track record of the individual participant *as* participant; this constantly shifting distribution of power throughout the community ensures the continued fluidity of its heterarchical structures. This heterarchical, network-centric approach which limits the permanent accumulation of power by individual leaders may indeed help to make large projects more sustainable (and therefore potentially more successful) by being able to accommodate a wider range of divergent views under the same community umbrella—a community structured into a number of semi-autonomous clusters may not as acutely experience differences in direction as a challenge to its continued existence as would a more hierarchically structured, unified development project. This is not to say that such differences are never able to come to the fore, however, and that they do not hold the potential to severely undermine the continued existence of produsage communities.

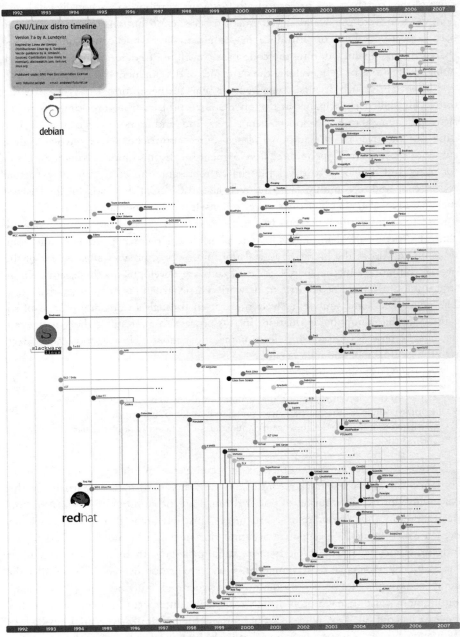

Figure 3.1: Family History and Timeline of Linux Revisions[33]

Open source projects—and many produsage projects alongside them—have developed the concept of forking as a relatively benign *ultima ratio* for addressing such fundamental community disagreement; forking allows for a temporary or permanent split in the development of the shared project even while enabling community members to continue to participate across a number of the emerging forked projects at the same time. Indeed, it is possible for forked projects to continue to share some of the same code base (and contribute to its continuing development) even while pursuing radically different development paths in other aspects of the project; this is the case for example for the Linux community which we discussed at the beginning of the chapter. Linux today exists in a wide variety of interrelated flavors which continue to incorporate some amount of shared code while configuring that code in a variety of different ways (for example for use in different contexts from desktops to laptops to mobile and embedded devices) and adding a number of further elements as required for their specific purposes.

This potential for forking also serves to keep the heterarchs of open source communities focused on serving their constituents rather than pursuing mainly personal goals;

> abandoning the leader and developing the project in a different direction ... is relatively easy and always a threat to the established players. The free sharing of the products produced by the collaboration among all collaborators—both in their intermediary and final forms—ensures that that there are no 'monopolies of knowledge' that would increase the possibility of coercion.[34]

At the same time, excessive forking also limits the contributor base for any one fork within the overall open source development community, however; forking therefore must remain only a last resort to overcome deep divisions within the community, and should not be attempted lightly. The presence of a number of 'dead ends' in our Linux development timeline (and the existence of a number of other attempts at creating new Linux flavors which never gained sufficient numbers of contributors and therefore are not represented here) serves as a clear warning in this regard.

At the same time, where conducted under the right circumstances (which include the presence of a large and diverse community of participants), the open source model can lead to a much faster process of innovation than is common in closed-source models: as Raymond notes, for example, Linux's open source approach of "Release early. Release often. And listen to your customers," when facilitated through Internet-based means of software distribution and community communication, was able to speed up software development "to a level of intensity that matched the complexity of what [Torvalds] was developing. ... Because he cultivated his base of co-developers and leveraged the Internet for collaboration harder than anyone else, this worked."[35] Much the same is true for other open source projects which have managed to attract a sizeable community of contributors. Long tail effects associated with the wider and diverse

base of developers, beta testers, and 'average' users for open source software also tend to make the software more reliable more quickly; more bugs are discovered, and by relying on a large number of contributors, projects are able to squash those bugs more speedily. This also applies for software features, which in effect simply constitute another form of error (an error of omission in the currently available revision of the software); open source software is therefore also able to respond more quickly and directly to user wants and needs than is software produced under traditional development models.

This tendency is further amplified by the lack of commercially determined bottlenecks in the open source software development process: the introduction of major new features into established software products normally presents an opportunity for software corporations to release a major new version of their software package, to be released to users not as a free update, but as a costly upgrade. Similarly, commercial developers may be told to focus on supporting in-house standards and formats supported only by the software of a specific manufacturer, rather than open standards which are accessible also to competing products, in order to maximize consumer lock-in to proprietary systems. In the absence of such commercial considerations, on the other hand, open source software communities can both roll out software improvements and new software gradually, as they become available in stable versions, and in the process gather further user feedback for their ongoing development processes, and they can freely support open standards and thereby ensure that the content produced and handled using open source packages remains readable even by software products in the more distant future. This is a significant shift, and one which we have already encountered under the key principle **unfinished artefacts, continuing process** in the previous chapter. It demonstrates once again that produsage outcomes are not products in a traditional sense: open source software exists not in distinct versions, as commercial software does, but simply in a series of continuous revisions emerging often very rapidly.

Indeed, through its open development processes, open source is even able to lead the commercial as well as non-commercial field in developing open standards accessible to all: "an innovation that is freely revealed and adopted by others can become an informal standard that may preempt the development and/or commercialization of other versions of the innovation."[36] Overall, in fact, as a non-commercial effort, open source software development takes a generally collaborative rather than competitive approach to other software available within its own market; the motivation of open source projects by other considerations than commercial profit means that tendencies towards the protection of trade secrets or competitive advantages have no place in its processes. At the same time, however, the absence of commercial incentives for participation in open source software development may also be seen as a limiting factor: a lack of remuneration for participants clearly means that there is no core group of developers who will remain with the development project even if the majority of the vol-

untary community moves on. But while this may be true in general, it must also be recognized that the long-term continuation of commercial software development is similarly uncertain (as it depends on the continued existence of a lucrative target market for the software product, as well as on factors external to the software product itself, such as the financial health parent development company); in addition, several non-commercial factors also serve to reduce the risk of a sudden decline in participation in open source software development communities.

From Plausible Promise to Tangible Outcomes

As we have already seen, open source software development projects tend to begin with the personal interests of an individual or a small group of programmers. To broaden out into larger community efforts, the 'personal itch' which such projects scratch must be relevant to a larger number of contributors, and the approach to scratching that itch must point to feasible solutions:

> when you start community-building, what you need to be able to present is a *plausible promise*. Your program doesn't have to work particularly well. It can be crude, buggy, incomplete, and poorly documented. What it must not fail to do is (a) run, and (b) convince potential co-developers that it can be evolved into something really neat in the foreseeable future.[37]

In this process, social factors within the emergent community—what Raymond describes as "the personality of the project"—are just as, if not more, important as the technical quality of the material already available to the community: potential contributors must be attracted to the social space for contribution as much as to the code itself.

As Shirky notes, then, this also provides one of the key limitations for the feasibility of applying open source approaches to development problems: "What if you have a problem that *doesn't* scratch some core developer's personal itch?" If a project is unable to attract contributors (or at least, to attract them in numbers sufficient to sustain the initial development and in turn attract a growing community), the project is likely to fail. In other words, "Open Source developers make software for the love of the thing, so love becomes the limiting factor as well. Unloved software can't be built using Open Source methods."[38] This limitation constitutes what Shirky describes as the 'interest horizon' of open source, in analogy to the resource horizon of conventional software development: where commercial projects are restricted in their ambition and scope by the amount of resources the parent company is able to commit to any one project, open source projects are limited by the amount of involvement time individual contributors are willing to commit, which is in turn determined by their level of interest in participating in the shared development effort.

At the same time, then, the existence of this interest horizon also points to the question of what does motivate participation in open source software development. Bauwens notes that such "motivation can be polyvalent, but will generally be anything but monetary"; for contributors it is found not in the "exchange value [of] the eventually resulting commodity, but [in] the increase in use value, their own learning and reputation."[39] In the first place, motivation can result from the sense of being involved in a process of innovation, that is, from the application of one's own skills to the communal identification and development of solutions to any given problem; open source development is therefore also a playful enterprise, a game of skill. As Leadbeater and Miller note, this contest has attracted even the participation of contributors who already "program software for a living but became involved in Linux in their spare time because the spirit of collaborative problem-solving appealed so strongly."[40] In part, motivation here also stems from the sense of making a contribution to the greater good, of course; this sense is further intensified also by the very quick turnaround times of open source software development: while participation in traditional, commercial software projects moves at a speed set by marketing schedules and organizational objectives and therefore provides no instant gratification for the developers of innovative solutions to complex problems, in the Linux development community, "Linus was keeping his hacker/users constantly stimulated and rewarded—stimulated by the prospect of having an ego-satisfying piece of the action, rewarded by the sight of constant (even *daily*) improvement in their work."[41]

At this point, personal gratification also turns into communal acclaim, of course—and this acclaim becomes another key motivator for participation. Thus, "the 'utility function' Linux hackers are maximizing is not classically economic, but is the intangible of their own ego satisfaction and reputation among other hackers."[42] Especially in a large and (in parts) highly skilled community, making significant contributions to the collaborative project offers a significant boost in prestige to the contributor. This applies to active programmers as well as to other participants in the community, in fact: users who see 'their' bugs fixed, and participants who see their suggestions for new features implemented (and are recognized as having contributed the original idea), will also derive a sense of personal satisfaction as well as rise in communal esteem from their direct participation in the development process (possibly even doubly so as they were able to take part in software development without being software developers in their own right).

As Bauwens points out, then, it would be simplistic to describe open source, and produsage more generally, simply as a form of gift economy in which each participant makes a contribution in the expectation that they will gain value at least equal to their contribution from the produsage project as it matures: he notes that such communal development methods

are not a gift economy based on equal sharing, but a form of communal shareholding based on participation. In a gift economy if you give something, the receiving party has to return if not the gift, then something of at least comparable value In a participative system ... , organized around a common resource, anyone can use or contribute according to his [sic] need and inclinations.[43]

Participation in open source and produsage projects, then, takes place "for the use value, for the learning involved, for reputational benefits perhaps, but only indirectly."

Perhaps this underestimates the role of an increase in community reputation as a motivating factor for participation in the collaboration, however; in addition to personal merit as a quasi-currency within produsage communities, in the case of some advanced produsage environments it is now also possible to identify opportunities for produsers to convert their community reputation into tangible, material outcomes. In the first place, however, merit (whether implicit in the social structures which emerge within produsage communities, or made explicit through the quantitative tracking of the number of contributions made by an individual user, and their level of adoption into the 'core text' of the shared project) *has* become a currency of many produsage environments, and through this process has begun to provide a structuring influence for the heterarchies of produsage projects: "by properly rewarding the egos of many other hackers, a strong developer/coordinator can use the Internet to capture the benefits of having lots of co-developers without having a project collapse into a chaotic mess." Raymond describes this as the emergence of "an efficient market in 'egoboo'— to connect the selfishness of individual hackers as firmly as possible to difficult ends that can only be achieved by sustained cooperation."[44] This market can be seen as providing a resolution, then, to what Miller describes as "a simmering tension between ego-centric thinking and network-centric thinking": it harnesses the ego-centric tendencies of the individual by using them to fuel the "transactional power" of the network "members' myriad interactions."[45]

Ultimately, then, 'egoboo'—or in other words, the social status of contributors within their community—may also be converted into status of another kind: it is now commonplace for commercial software development companies to seek out the key contributors in open source communities as potential employees. Open source communities (and the communities of produsage more generally) therefore provide a means of professional accreditation alternative to traditional educational institutions (a growing problem for traditional education which we examine further in Chapter 13), and the hope of such tangible economic outcomes of voluntary participation in social environments for software development can serve as a further motivation for open source contributors. Indeed, Shirky suggests that such (however faint) promise of employment may also serve as a means of overcoming the open source 'interest horizon': "one way to get people to do things they wouldn't do for love is to pay them"[46]— and the hope of financial rewards in the foreseeable future may encourage participants today to contribute to the solution even of what are perceived to be tedious problems.

Although the motivation of participants within produsage processes is an important factor in determining their success or failure, the presence of technological means of facilitating community interaction also should not be underestimated. As von Hippel notes, "innovation communities are often stocked with useful tools and infrastructure that increase the speed and effectiveness with which users can develop and test and diffuse their innovations"[47]; open source software development in particular depends crucially on a number of key enabling technologies. In the first place, of course, use of the Internet as such is an important factor—Raymond comments that

> I don't think it's a coincidence that the gestation period of Linux coincided with the birth of the World Wide Web, and that Linux left its infancy during the same period in 1993–1994 that saw the takeoff of the ISP industry and the explosion of mainstream interest in the Internet. Linus was the first person who learned how to play by the new rules that pervasive Internet access made possible.[48]

Indeed, Raymond suggests, the impact of such advanced communications technologies provides a final defense against Brooks's Law: in a massively networked environment, "many heads are inevitably better than one," as the use of user-driven many-to-many communications tools which facilitate coordination through heterarchical models can effectively mitigate the negative effects of having to manage a growing group of contributors.

This manifests, then, not only in the structure of the development community itself, but also in the process approaches it adopts. The clustering of communities into project groups which we have already encountered is one example for this, but even within these developer clusters, development problems are further deconstructed into their specific tasks which can be addressed by individuals or small teams of contributors collaborating in fluid teams. Thus,

> in the open-source community organizational form and function match on many levels. The network is everything and everywhere: not just the Internet, but the people doing the work form a distributed, loosely coupled, peer-to-peer network that provides multiple redundancy and degrades very gracefully. In both networks, each node is important only to the extent that other nodes want to cooperate with it.[49]

As we have already seen, this crucially depends on the ability for problems to be broken down in this manner—that is, on the granularity of development tasks. Benkler notes that the number of contributors likely to be able to work on any one problem is inversely related to the size of the tasks it consists of:

> if the finest-grained contributions are relatively large and would require a large investment of time and effort, the universe of potential contributors decreases. A successful large-scale peer-production project must therefore have a predominate portion of its modules be relatively finegrained.[50]

Raymond describes a similar ideal size of contributor tasks in open source software development:

> human beings generally take pleasure in a task when it falls in a sort of optimal-challenge zone; not so easy as to be boring, not too hard to achieve. A happy programmer is one who is neither underutilized nor weighed down with ill-formulated goals and stressful process friction. *Enjoyment predicts efficiency.*[51]

This breakdown of problems into granular, enjoyable tasks, and the reconstitution of new project innovations from solutions to individual programming tasks, is coordinated within the realm of open source software development especially through the use of concurrent versioning systems. These systems, usually hosted on publicly accessible Websites, enable the automatic tracking of widely distributed development efforts within the community. They contain the code for all modules and elements of the overall software project, and enable users to examine the changes between different revisions of these elements to identify the contributions made by individual developers; they also allow for the tracking of a number of simultaneous, parallel developments at the same time which may all vie for acceptance as the 'core' version. Indeed, the ability for the management of multiple development branches of the same code could even be used to house a number of project forks originating from the same code base within the same versioning system.

Such versioning systems reduce technological as well as social barriers to contribution. In particular, the version management functionality allows for the speedy rollout (and, where it becomes necessary, the rollback) of 'test' versions trialing new development ideas; this may encourage developers not yet confident in their abilities to contribute to make changes and suggestions for change nonetheless, as there is little likelihood that their changes can derail the overall communal development process. Further, versioning systems also provide a common environment for the management of development contributions which does not need to be strongly governed by human intervention: as Elliott notes, in many cases where specific community members do act as gatekeepers of the development process, such

> social mediation can provide a barrier to the rapid and seamless integration of contributions that characterises projects such as *Wikipedia.org* and the Open Source software movement. It may be that there is simply so much complex information to be negotiated when people communicate directly that the negotiations of the many collapse under their own weight without the mediation of an administrative/stigmergic system.[52]

In open source, by contrast, contributors communicate in the first place through the communal text of the shared, annotated source code itself.

In addition, at the same time one of the key affordances of versioning systems is also that they allow for the institution of a number of parallel versions of the collabo-

rative project which are managed under different principles. Many open source projects, for example, provide both a 'safe' and a 'bleeding edge' version of their software; here, the more radical version is a compilation of all the most recent contributions but may not have been fully tested for stability yet (as such versions are often automatically compiled overnight from the current versions of available components, they are commonly known in the community as 'nightly builds,' and participants are advised to use such versions at their own risk). By contrast, the 'stable' version of the software may be some time behind the current development process (sometimes by days or even weeks), but is generally considered to have been rid of all major bugs. The existence of such stable builds also helps to further increase the range of potential participants in the collaborative produsage process for open source software development, of course, as users too concerned with the stability of their software can use the stable version with some confidence, but may still (occasionally) be able to uncover an obscure error, as well as (more frequently) contribute ideas for further features and improvements.

Compared to the processes of commercial software development, concurrent versioning systems provide an insight 'behind the curtain' for developers and users alike, into the processes of software development itself. In the process, they point out that the always unfinished, constantly evolving nature of produced content is in fact also the nature of commercial informational products, but that for reasons which have nothing to do with the processes of production, and everything to do with the requirements of the commercial marketing, distribution, and sales process, commercial software operators will at regular intervals package up their current 'stable build' and sell it to end users as a new version. The produsage insight into the formerly black box of the production process shows instead that ultimately, software (and many if not most other information products) does not exist in versions, but only in incrementally improving revisions which change and evolve over time. The sale of software versions does in fact constitute a throwback to a pre-Internet commercial environment where software still had to be sold in physical formats (disks, CD-ROMs, DVD-ROMs) shipped to stores; in a networked context, however, a model which provides users constantly with software updates to ensure that they are operating the latest stable build of their software—where such software is commercial, perhaps under a paid subscription model—is therefore far more appropriate. (Microsoft's current model of selling its software in packaged versions, and then providing regular hotfixes and other updates for download, is a hybrid model which goes some way towards realizing such a subscription system in anything but name; its continuing practice of versioned releases requiring users to upgrade their software altogether seems driven mainly by commercial motives, however.)

Within the open source community, *SourceForge.net* is the most widely used free platform for concurrent versioning systems and other project management tools. *SourceForge* provides a standardized environment for the open source development, and is popular for that reason; developers moving from one project to another are

faced with the same system features and tools. *SourceForge* acts both as a repository for open source code, as a bridge between developers, and as a bridge between developers and the wider community of non-developer contributors; it offers tools for the submission, assignment, and tracking of bug reports, feature requests, and other content submissions related to the project, and a shared environment for community members to store, manage, comment upon, and retrieve information. It provides, in other words, a space to contain the innovation commons within which the open source produsage community exists, and as von Hippel notes, "the practical value of the 'freely revealed innovation commons' these users collectively offer will be increased if their information is somehow made conveniently accessible. This is one of the important functions of 'innovation communities'"[53]; *SourceForge* fills that role, enabling the community to collaboratively facilitate its development processes by relying on a set of standardized tools.

This crucial process of sharing information is managed within the open source community also through the introduction of a set of legal 'technologies'; indeed, these technologies serve to make possible the collaborative development of communal resources without fear of individual or commercial exploitation in the first place. Open source communities (and many, though not all, other produsage communities following in their wake) have developed a range of content licenses stipulating in legally binding detail the range of uses which may or may not be made of the shared resources in their information commons, including the GNU General Public License (GPL), a large number of other licenses approved by the Open Source Initiative as acceptable open source licenses, and more recently also the Creative Commons licenses. Such licenses typically forbid the direct commercial exploitation of open source software (that is, the incorporation of open source code into software for commercial sale), require the acknowledgment of community members who have contributed code into the software, and require that derivations of the code must be made available openly once again; however, lesser combinations of such requirements, and additional requirements (for example prohibiting the use of open source software in military contexts) are also known.

Open source communities are not only interested in using their licensing restrictions to avoid exploitation by organizations external to the community itself, however; they also closely police their own code for contributors' violations against other applicable license and copyright codes. "Contributors of code to open source software projects are very concerned with enforcing such restrictions in order to ensure that their code remains accessible to all"[54]; in fact, license breaches found in open source code may have a significant immediate impact on the community, but may affect it even more profoundly if such breaches have continued unnoticed for some time (in which case entire aspects of the overall software may have been built upon such rogue code, requiring a major retroengineering effort to remove the offending code). Thus, "as with markets, commons do not mean that anything goes."[55]

Open Source Effects

As noted at the beginning of this chapter, open source has found considerable success both in the server-side market and with 'end users'. In this, of course, it has been particularly the large projects such as Linux and Firefox which have captured public attention, supporting von Hippel's argument that "users will find it cheaper to innovate when manufacturers' economies of scale with respect to product development are more than offset by the greater scope of innovation assets held by the collectivity of individual users"[56]; however, at the same time the great majority of medium- and smaller-scale open source development communities have also managed to create a variety of highly successful, stable, and innovative software applications.

Such success has also generated a certain amount of negative responses from the incumbent software industry, of course. As Bauwens notes for what he describes as P2P production,

> its opponents will not fail to point out the so-called parasitical nature of P2P. P2P creates massive use-value, but no automatic exchange value, and thus, it cannot fund itself. It exists on the basis of the vast material wealth created by the presently existing system. Peer to peer practitioners generally thrive in the interstices of the system: programmers in between jobs, workers in bureaucratic organizations with time on their hand; students and recipients of social aid; private sector professionals during paid for sabbaticals, academics who integrate it into their research projects.[57]

Similarly, the development model of open source itself has also been roundly criticized for the apparent randomness of its probabilistic logic:

> traditionally-minded software-development managers often object that the casualness with which project groups form and change and dissolve in the open-source world negates a significant part of the apparent advantage of numbers that the open-source community has over any single closed-source developer. They would observe that in software development it is really sustained effort over time and the degree to which customers can expect continuing investment in the product that matters, not just how many people have thrown a bone in the pot and left it to simmer.[58]

Such objections are by now well-refuted both in practice and in theory. We have already spent considerable time exploring the benefits of a heterarchical, fluidly organized development model which is able to continually attract new participants and thereby increase the likelihood that new innovations will be made and identified by this community, while providing a system of communal merit designed to ensure that existing participants are recognized for their service to the community for as long as they choose to continue to participate. It is also worth noting that some of the leading lights of the open source community, from Linus Torvalds to much less well-known contributors, have held such leading positions for a considerable amount of time already; this indicates that participant churn is not necessarily a common feature of

open source communities, and is perhaps particularly rare among the most committed developers regardless of their life circumstances outside of the open source environment. "In fact, there have been open-source projects that maintained a coherent direction and an effective maintainer community over quite long periods of time without the kinds of incentive structures or institutional controls that conventional management finds essential."[59]

The question of sustaining open source development by operating parasitically from within the interstices of the established commercial system cannot be refuted as easily; many participants have indeed contributed to open source from such positions. However, with the growing public acceptance of open source as a viable model of software development which produces free resources of considerable value, we have also seen a change of attitude in commercial and public institutions, which increasingly allow and encourage their members and employees to contribute to open source projects. Parasites are not necessarily always harmful—and participation in open source is now seen by many employers in the computing industry as a useful way of maintaining employee skills; by public and educational institutions as contributing to the public good; and by other employers as generating publicly available tools which (like Linux or Firefox) may well benefit their own organization as well, whatever field it may operate in.

Nonetheless, some corporations in the software industry continue to wage what has become known in open source circles as FUD campaigns, promoting

> "Fear, Uncertainty, and Doubt." It is a term ... used to describe the use of lies and deceptive rhetoric, aimed chiefly at free software projects. It is an accurate term. In brief, the goal of FUD is to make money when the free software competition cannot be defeated fairly in the marketplace. This can be done by scaring consumers through wild propaganda, or more recently, confusing courts through more subtle arguments.[60]

Such campaigns are more than neutralized, however, by open source's growing ability to point to an impressive range of 'clients' using their 'products,' especially also for environments where software reliability and security is mission-critical: here, the ability to directly inspect the source code rather than being forced to implicitly trust the processes of a commercial developer has turned out to be a significant competitive advantage. Aerospace operators, for example, cannot afford to blindly rely on commercial mission control software if its failure would mean the loss of a virtually irreplaceable craft; governments and other organizations needing to protect sensitive information cannot afford to leave open any possibility for hacker intrusion through the exploitation of obscure bugs or maintenance backdoors in a commercial product. Indeed, the competition from open source—and the distrust for commercial operators—has been such that in its negotiations for major software contracts with the Chinese government, Microsoft was forced to open part of its Windows source code to Chinese inspection to demonstrate that it did not contain any loopholes through

which the company would have been able to access secret government information.[61] Even such unprecedented openness has not served to prevent the growth in open source use especially by government organizations, however, in China or elsewhere.

In part, some such developments are driven by political considerations; a sense of national pride or national security in avoiding a dependency on U.S. firms may also play a significant role. However, from an economic point of view, the use of open source also makes good sense both for individuals and for organizations: while for established users of commercial software, the transition costs to a new software option may be considerable, they are neutralized at least in part by the free availability of open source software; in addition, while commercial software requires the purchase and installation of updated versions at more or less regular intervals, open source software is freely available now and will continue to be so. Finally, organizations wishing to do so are also better able to customize software installations to their specific needs than is possible with commercial software—even to the point of developing their own in-house derivation of the open source software package. The same is true also for governments which are interested in developing a national operating system of their own in order to break their dependence on foreign suppliers. Building on an existing open-source operating system such as Linux, that aim can be achieved with high-quality results within a fraction of the time it would take to do so from scratch, while also providing the means of fostering the development of a local software industry in the country.

It is important to note, then, that the rise of open source software as a viable alternative to commercial products has also led to the establishment of a growing software industry built around open source software. On the one hand, this may appear paradoxical as open source software is necessarily always already available for free from its development communities; however, this does not preclude the development of commercial value-added service offerings. On the other hand, the past decades have seen the emergence of a variety of small and large commercial operators offering open source consultancy, installation, and maintenance services for organizations and individuals interested to move towards open source use. Many such companies were started by and employ active open source developers, in fact, demonstrating the potential for community volunteers to leverage their established reputation as a means of moving into paid employment in the open source field.

In addition, companies such as Red Hat have built businesses around the direct sale of open source products: they offer ready-to-install versions of the Linux operating system combined with a number of useful other software packages and further tools, for example. Such practices are not in breach of applicable open source licenses, in fact: Red Hat does not preclude its customers from further distributing the software packages included in its products, and charges them not for the software contained there as such, but instead for the service it provides in collating the various open source software programs into one unified package. By analogy, this is not unlike the sale of compressed air: while air as a basic resource is of course free, what customers

pay for in such a transaction is the service of compressing it into a convenient product. Similarly, then, open source software

> can eventually be sold, but such sale is usually only a credible alternative (since it can most often be downloaded for free), if it is associated with a service model. It is in fact mostly around such services that commercial open source companies found their model.[62]

In addition to the emergence of such new players, some of the more established corporations in the information technology industry have also gradually begun to embrace open source models. As Benkler notes, this must necessarily have a profound impact on their corporate structures:

> as the companies that adopt this strategic reorientation become more integrated into the peer-production process itself, the boundary of the firm becomes more porous. Participation in the discussions and governance of open source development projects creates new ambiguity as to where, in relation to what is "inside" and "outside" of the firm boundary, the social process is. In some cases, a firm may begin to provide utilities or platforms for the users whose outputs it then uses in its own products. ... In these cases, the notion that there are discrete "suppliers" and "consumers," and that each of these is clearly demarcated from the other and outside of the set of stable relations that form the inside of the firm becomes somewhat attenuated.[63]

In an industry generally dominated by a very small number of near-monopolists, however, such softening of corporate boundaries may still remain preferable to a direct confrontation with the market leader; for a number of technology companies, siding with the open source community provides an opportunity to tap into the strength in numbers which in commercial isolation was unavailable to them.

It is important to point out in this context that much open source software produsage itself builds at least on initial material *produced* in a traditional mode: the original Linux kernel, for example, was at its start the sole product of Linux Torvalds, working much like any conventional developer would have done; the initial codebase for the Firefox Web browser emerged from the Netscape Communications Corporation as it developed Mozilla as a replacement to its older Netscape Communicator Web browser. Indeed, strictly speaking any contribution of code as a starting point for open source software development—what we may describe as 'seeding the hive'—necessarily proceeds in this form; it is only the contribution of the original seed code (or, in some cases, seed ideas for coding projects) which kick-starts the community produsage process. At later points in the produsage project, too, further commercial 'feeding' of the community hive (for example through the open release of previously corporate-owned code to address specific development problems) may help drive on the produsage effort. Like individual contributors, software companies may well derive in-kind or financial corporate profits from such acts of sharing: on the one hand, the community of produsers may develop their code to a higher level of sophistication

than would have been possible for the limited team of developers available in the company itself; in addition, the resulting open source package may also be of direct practical value to the company (this has proved true for example in the case of the Firefox project). On the other hand, the company's role as the originator of specific projects or code contributions also adds to its own prestige as an information technology innovator, and is likely to place it well to offer commercial services around the emerging open source project, both to members of the produsage community and to outsiders intending to utilize the open source software.

The rise of Firefox and the adoption of Linux especially also in developing nations as a low-cost, high-quality alternative to Windows, both point to the significant growth potential for the open source 'market'. Like other forms of produsage, open source is unlikely to entirely wipe out the incumbent industry in its field, however; indeed, the balance between produsage and production in the software development field may never fully stabilize—instead, for the foreseeable future we are likely to see a continuous shifting which will sometimes have open source communities, sometimes commercial developers in the ascendancy. Whatever the current balance, however, the relationship between heterarchical communities of produsers and corporate hierarchies of producers is likely to remain fraught unless both sides begin to understand very clearly what advantages the other has to offer.

For all the conflict inherent in the relationship between software produsage and software production, however, and for all the further complications yet to arise as the relationship between the two continues to evolve and new technologies arrive to further alter the playing field, a significant change has already occurred. Open source emerged from the niches, in an effort to create solutions for problems which the commercial software industry had not even begun to identify, much less address, and from such humble beginnings has risen to provide a significant challenge to the *status quo*. Today, open source no longer fills in the gaps, responding to industry shortcomings; today, open source communities are frequently leaders in industry-wide research, innovation, and development. Thus,

> we are at a convergent moment, when a philosophy, a strategy, and a technology have aligned to unleash great innovation. Open source is powerful because it's an alternative to the status quo, another way to produce things or solve problems. And in many cases, it's a better way. Better because current methods are not fast enough, not ambitious enough, or don't take advantage of our collective creative potential.[64]

Open source, by contrast, does harness the hive of its communities of produsers, and it provides compelling proof for the transformative potential inherent in the produsage model of user-led, collaborative content creation.

NOTES

1. Eric von Hippel, *Democratizing Innovation* (Cambridge, Mass.: MIT Press, 2005), pp. 9–10.

2. Von Hippel, p. 10.

3. Clay Shirky, "The Interest Horizons and the Limits of Software Love," *Clay Shirky's Writings about the Internet: Economics & Culture, Media & Community, Open Source*, Feb. 1999, http://www.shirky.com/writings/interest.html (accessed 24 Feb. 2007), n.p.

4. Charles Leadbeater and Paul Miller, "The Pro-Am Revolution: How Enthusiasts Are Changing Our Economy and Society," *Demos* 2004, http://www.demos.co.uk/publications /proameconomy/ (accessed 25 Jan. 2007), p. 10.

5. Leadbeater & Miller, p. 10.

6. Raymond, "The Cathedral and the Bazaar," 2000, http://www.catb.org/~esr/writings /cathedral-bazaar/cathedral-bazaar/index.html (accessed 16 Mar. 2007), n.p.

7. Raymond, n.p.

8. Michel Bauwens, "Peer to Peer and Human Evolution," *Integral Visioning*, 15 June 2005, http://integralvisioning.org/article.php?story=p2ptheory1 (accessed 1 Mar. 2007), p. 3.

9. Raymond, n.p.

10. Raymond, n.p.

11. Raymond, n.p.

12. Raymond, n.p.

13. See Chris Anderson, "The Long Tail," *Wired* 12.10 (Oct. 2004), http://www.wired.com/ wired/archive/12.10/tail.html (accessed 20 Feb. 2007); Chris Anderson, *The Long Tail: Why the Future of Business Is Selling Less of More* (New York: Hyperion 2006).

14. Aaron Krowne, "The FUD-based Encyclopedia: Dismantling Fear, Uncertainty, and Doubt, Aimed at Wikipedia and Other Free Knowledge Resources," *Free Software Magazine* 2 (28 Mar. 2005), http://www.freesoftwaremagazine.com/articles/fud_based_encyclope- dia/ (accessed 2 Mar. 2007).

15. Krowne, p. 3.

16. Michel Bauwens interviewed in Richard Poynder, "P2P: A Blueprint for the Future?" *Open and Shut?* 3 Sep. 2006, http://poynder.blogspot.com/2006/09/p2p-blueprint-for-future .html (accessed 1 Mar. 2007), pt. 1.

17. Bauwens, p. 3.

18. Jed Miller and Rob Stuart, "Network-Centric Thinking: The Internet's Challenge to Ego- Centric Institutions," *PlaNetwork Journal: Source Code for Global Citizenship*, n.d., http://journal.planetwork.net/article.php?lab=miller0704 (accessed 14 Mar. 2007), p. 1.

19. Felix Stalder and Jesse Hirsh, "Open Source Intelligence," *First Monday* 7.6 (June 2002), http://www.firstmonday.org/issues/issue7_6/stalder/ (accessed 22 Apr. 2004), n.p.

20. Raymond, n.p.

21. Clay Shirky, "Communities, Audiences, and Scale," *Clay Shirky's Writings about the Internet: Economics & Culture, Media & Community, Open Source*, 6 Apr. 2002, http://shirky.com/ writings/community_scale.html (accessed 24 Feb 2007), n.p.

22. Shirky, "Communities, Audiences, and Scale," n.p.

23. Kevin Kelly, "We Are the Web," *Wired* 13.8 (Aug. 2005), http://www.wired.com/wired/archive/13.08/tech.html (accessed 24 Feb. 2007), p. 3.

24. Mark Elliott, "Stigmergic Collaboration: The Evolution of Group Work," *M/C Journal* 9.2 (May 2006), http://journal.media-culture.org.au/0605/03-elliott.php (accessed 27 Feb. 2007), b. 10.

25. Miller & Stuart, p. 2.

26. Anita J. Chan, "Collaborative News Networks: Distributed Editing, Collective Action, and the Construction of Online News on Slashdot.org," MSc thesis, MIT, 2002, http://web.mit.edu/anita1/www/thesis/Index.html (accessed 6 Feb. 2003), ch. 3.

27. Stalder & Hirsh, n.p.

28. Henry Jenkins, *Convergence Culture: Where Old and New Media Collide* (New York: NYU Press, 2006), p. 251.

29. Elliott, b. 12.

30. Raymond, n.p.

31. Miller & Stuart, p. 2.

32. Bauwens, p. 3.

33. Non Plus X, "Linux Distro Timeline," *Wikimedia Commons*, 8 May 2007, http://en.wikipedia.org/wiki/Image:LinuxDistroTimeline.png (accessed 12 July 2007).

34. Stalder & Hirsh, n.p.

35. Raymond, n.p.

36. Von Hippel, p. 86.

37. Raymond, n.p.

38. Shirky, "The Interest Horizon," n.p.

39. Bauwens, p. 2.

40. Leadbeater & Miller, p. 10.

41. Raymond, n.p.

42. Raymond, n.p.

43. Bauwens, p. 2.

44. Raymond, n.p.

45. Miller & Stuart, p. 1.

46. Shirky, "The Interest Horizon," n.p.

47. Von Hippel, p. 93.

48. Raymond, n.p.

49. Raymond, n.p.

50. Yochai Benkler, *The Wealth of Networks: How Social Production Transforms Markets and Freedom* (New Haven, Conn.: Yale University Press, 2006), p. 101.

51. Raymond, n.p.

52. Elliott, b. 11.

53. Von Hippel, pp. 95–96.

54. Benkler, p. 98.

55. Benkler, p. 144.

56. Von Hippel, p. 95.

57. Bauwens, p. 3.

58. Raymond, n.p.

59. Raymond, n.p.

60. Krowne, p. 1.

61. See, e.g., Ken Gao, "China to View Windows Code," *CNET News.com*, 28 Feb. 2003, http://news.com.com/China+to+view+Windows+code/2100-1007_3-990526.html (accessed 25 Aug. 2007).

62. Bauwens, p. 2.

63. Benkler, p. 125.

64. Thomas Goetz, "Open Source Everywhere," *Wired* 11.11 (Nov. 2003), http://www.wired.com/wired/archive/11.11/opensource_pr.html (accessed 1 Oct. 2004), n.p.

News Blogs and Citizen Journalism: Perpetual Collaboration in Evaluating the News

Open source software emerged to a significant extent in response to the short-comings in commercial software development, addressing fields of innovation and forms of software which for various reasons had not been covered sufficiently by the industrial process. Citizen journalism in all its forms, as it has emerged and developed during the first decade of the twenty-first century, is driven by similar motivations: it, too, acts as a corrective and a supplement to the output of commercial, industrial journalism. Like open source, too, it has recently begun to challenge the role of its corporate counterpart as opinion (and innovation) leader.

Indeed, citizen journalism and open source software development are directly re-lated, and the open, community-based, heterarchical, and meritocratic ethos of open source (and of produsage overall) is shared in full by citizen journalism. This close re-lationship dates back at least to what could be considered the founding moment of the citizen journalism movement proper: the coverage of protests surrounding the November 1999 World Trade Organization (WTO) meeting in Seattle.

> Concerned that the major news organisations would fail to cover the WTO protests adequately, if at all, a group of Seattle media activists planned a proactive approach. Months prior to the WTO meeting, they formed the Independent Media Center (or Indymedia). They gathered donations, organised volunteers, registered a Web site, www.indymedia.org, and set up a newsroom with computers, Internet lines, digital editing systems and streaming audio and video.[1]

The information technology tools for providing this bottom-up coverage of the WTO protests, including the Website software used to run the *Indymedia* online presence, were themselves largely developments of the open source community; open source approaches and ideas as well as developers were therefore inherently embedded deeply within the nascent citizen journalism movement. Indeed, the open and free availabil-

ity of ever more powerful, industry-quality Web publishing technologies in the form of open source (from the Apache Webserver to the many content management and blogging systems in existence today) continues to provide a significant boost to citizen journalism's feasibility and sustainability.

Much like the concurrent versioning systems of open source software development, such technologies also provide the tools for ensuring and maintaining community cohesion even despite a vastly diverse, distributed group of contributors to citizen journalism communities. As Meikle notes, the Independent Media Centers or "IMCs place the emphasis on the *production*, rather than the *consumption*, of media texts. And they stress the conversational dimension of the Net as the creation of DIY media, rather than just as a means of debating the writings of others"[2]; this, however, can be a challenge as much as an opportunity, as unchecked production of content does not guarantee (and can indeed undermine) the development of a consistent coverage and evaluation of news events. Against this tendency to fragment and degrade community cohesion, Shirky suggests, "the core group needs to defend itself so that it can stay on its sophisticated goals and away from its basic instincts."[3]

Citizen journalism and its allied forms of open news coverage (including news-related blogs) have developed a sophisticated array of processes, tools, and technologies for doing so, which are in place in different configurations across the many Web-sites of the movement. Some sites have deployed these tools more effectively than others, it should be noted; *Indymedia* itself, for example, has recently struggled to reconcile its principle of maximum openness with the need to police against overt disruptions and poor quality of content, and is no longer a catalyst and trailblazer for developments in the citizen journalism field. Other sites have erred so much on the side of caution and control that their collaborative processes now resemble more and more the modes of content production established in the mainstream news industry. Such choices between what must ultimately be seen as editorial models are choices between various possible options for the communal evaluation of content and the heterarchical organization of community, of course, and already familiar to us from our examination of the open source community in the previous chapter. In addition to embracing and embodying these first two key principles of produsage, however, citizen journalism also provides a particularly good example for the latter two aspects of that model, and it is on these two principles—unfinished artefacts, continuing process, and common property, individual rewards—which we focus in this chapter.

Beyond Gatekeeping

Rushkoff notes that "as the mainstream mediaspace, particularly in the United States, becomes increasingly centralized and profit-driven, its ability to offer a multiplicity of perspectives on affairs of global importance is diminished."[4] This dearth of alternative

perspectives in the mainstream media (snidely abbreviated as 'MSM' by many citizen journalists and news bloggers) has become one of the major motivating factors for the establishment of prodused alternatives to industrial modes of news production. Much of that dearth is attributable to the very modes of industrial news production itself: for a variety of reasons (many of them commercial and some of them still rooted in the economic principles of print and broadcast news distribution which no longer apply in the same form in online news), industrial news production must necessarily impose a strict model of gatekeeping on its processes.

Gatekeeping selects the stories to be covered in the products of mainstream journalism from the totality of all news currently available in the world; as Gans describes it, such "story selection is essentially composed of two processes: one determines the availability of news and relates journalists to sources; the other determines the suitability of news, which ties journalists to audiences."[5] Gatekeeping therefore polices both what can be called the input gates of the journalistic process—determining what stories becoming known to journalists are worth investigating and covering in any detail—and the output gates—examining which of the stories produced by journalists are fit to be included in the final news product, that is, the newspaper, broadcast bulletin, or online news publication. (A third stage exists after publication of the initial news story, where editors select from any audience responses those which may be published in a 'Letters to the Editor' page or its broadcast and online equivalents.)

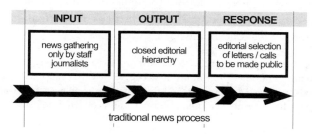

Figure 4.1: The Three Stages of Conventional News Production[6]

Such story selection clearly depends crucially on a judgment of content relevance by journalists and—perhaps more importantly—their editors: a function "of mapping" this (news) information "on a knowledge map," as Benkler puts it.[7] The selection of stories in this model is motivated in the first place by commercial and practical considerations, of course: the limited column space available for news in newspapers, and the limited broadcast time of radio and television news bulletins, necessitate a strict selection of news according to what is deemed to be the most important for audiences to know, and/or what is most likely to attract the largest market share for the news product. Especially in markets which are characterized by a limited number of competitors, or have a small group of clearly dominant news outlets, journalism also derives from its mode of operating a claim to fulfill a public function: as the core source

of news for the majority of the population, such news outlets play an important role in determining the shared public agenda and leading public opinion; they become the Fourth Estate of society.

However, in a massively multichannel, networked, many-to-many, information-pull, online environment, such claims can no longer hold:

> the tools of communication in the hands of a communication-savvy public have al-tered our dated concept of communication. It has changed from sender-focussed se-lection and transmission of messages, controlled by traditional mass media, including newspapers, to a liberating, spontaneous, interactive, public-oriented, and public-coauthored network of nearly limitless news and information venues.[8]

The gates of news organizations and other sources of information, in other words, have multiplied beyond all control; gatekeeping in its traditional sense no longer helps channel the continuing flow of information into manageable portions for the audi-ence, but instead comes to be seen as making only one of a large number of possible selections from the newsflow. As news and information sources have gone online, as news and information consumers have become more accustomed to directly seeking out the source of information rather than relying on journalists' digested version of events, journalism faces a crisis not unlike that experienced by commercial software production and many other fields impacted upon by produsage: audiences have be-come active users who, where they sense the omissions and contractions of informa-tion necessitated by the conventional, gatekept news production process, want to directly access the 'source code' of the news.

> Journalists see themselves as professionals working for a predominantly lay clientele; and like members of other professions, they believe that they must give the audience what it needs, not what it wants. In addition, they are convinced that the audience cannot know what it wants because it is not at the scene when journalists cover the news.[9]

Today, the users of news usually still are not 'at the scene' as events occur—but they now have a much better access to a variety of first-hand accounts of the scene, which undermines journalism's ability to capture their undivided attention with what (after undergoing the industrial production procedures of mainstream journalism) have nec-essarily become second-hand summaries of events. (This trend, incidentally, also pro-vides an explanation of the continuing shift of broadcast news towards an ever-stronger focus on live crosses which provide a sense of immediacy to the audience.)

Gatekeeping, as a process of correlating news events with the existing knowledge maps of news workers in the industry in order to determine the relevance and impor-tance of stories, crucially relies on the 'news judgment' of journalistic staff in the in-dustry, of course. Even assuming the best intentions on behalf of journalists and editors, this unavoidably introduces a certain sense of bias towards what common

sense in the industry considers to be 'important' news to readers, listeners, and viewers (groups often understood only very vaguely); in addition, best intentions are at times negated by the commercial or political imperatives set by the proprietors of commercial news organizations, intentionally introducing a systemic institutional bias. Whether overt or covert, intentional or accidental, such biases make gatekeeping processes highly problematic:

> even if journalism does not openly "act for" anyone as political institutions do, it still participates in the production and reproduction of power relations in several ways. Power resides in language in general and in the selection of news topics, frames, and sources.[10]

Ultimately, then, gatekeeping provides a model and process for news production which is far from ideal, and driven by corporate considerations of paring down the totality of news events to a manageable selection able to be packaged in commercially viable products as much as it is by a genuine desire on behalf of journalists to filter from the newsflow those stories which they believe to be of most relevance to their audiences. Therefore, it is important to note that "the existence of an editor means that there is less information for an individual to process. It does not mean that the values according to which the information was pared down are those that the user would have chosen."[11] As audiences turn into active users and produsers of content, then, especially in networked online environments, "it is proper to ask who should be responsible for story selection and production. The news may be too important to leave to the journalists alone."[12] Citizen journalism offers a multitude of alternative, produsage-based models for the user-led selection, coverage, and discussion of news stories, and its successes in attracting not just passive audiences, but active participants clearly indicate the acutely felt need for such opportunities among many of "the people formerly known as the audience," as Jay Rosen has memorably described them.[13]

Towards Gatewatching

Chief among the tools of this movement towards citizen journalism (whether found in centralized, dedicated sites or in decentralized forms across the news-related sectors of the overall blogosphere) is the process of gatewatching.[14] In contrast to gatekeeping, gatewatching does not concern itself with making a comprehensive news selection from all available information in the newsflow; it does not claim to present 'all the news that's fit to print,' thereby also avoiding the somewhat patronizing stance of industrial journalism which overtly or covertly accepts that audiences are too distanced from the newsflow to make intelligent judgments for themselves about what is of interest, importance, and relevance to them.

Gatewatching, instead, relies exactly on that ability of users to decide for themselves what they find interesting and worth noting and sharing with their peers; it harnesses the tendency of members of interest communities to pass on to their peers those news items which they have found interesting. Gatewatching describes the continuous, communal observation of the output gates of conventional news organizations, as well as of the primary sources of news and information, for information which is seen to be of interest to the gatewatcher's own community. Gatewatchers will then frame such information more or less elaborately, possibly also combining it with further, other reports from a variety of alternative sources as well as informative background information relating to the story, and submit it to the citizen journalism site or news blog of their choice (which will often cater to a specific interest community). This is a process of highlighting news, of publicizing rather than publishing information.

Like open source software development, such citizen journalism 'open news' story development therefore starts with users having an itch to scratch (coming across news or information which interests them, and which they think will also interest their peers), and doing some initial, limited development of the story for submission to the wider community. Having invited such open participation, the community will then engage in its communal evaluation (which as always in produsage will also affect at least in small increments the social standing of the initial story submitter, of course), and through a continuing discussion of the story will add further information, multiple points of view, and background detail to extend the initial coverage—often to the point that the quality of detail and discussion of the story well outstrips what is possible in industrial journalism's limited coverage of the same news item.

Much as in open source, such open news produsage therefore reverses the conventional industrial production process. Industrial software production operates on a principle of 'develop to marketable quality, then release,' whereas open source often releases its projects in no more than embryonic versions, divides the production process into granular produsage tasks, and then engages in the open and communally organized development of software to what we continue to refer to as 'commercial quality'. In communally based citizen journalism, a similar reversal applies, as Shirky has famously remarked:

> the order of things in broadcast is "filter, then publish." The order in communities is "publish, then filter." ... Writers submit their stories in advance, to be edited or rejected before the public ever sees them. Participants in a community, by contrast, say what they have to say, and the good is sorted from the mediocre after the fact.[15]

Communities themselves therefore act, communally and continuously, as filters of information on citizen journalism sites—but they do so generally not through the either/or choices of conventional editors, who ultimately exercise choice through the simple decision of whether or not to publish a story, but instead through the granular,

collaborative process of highlighting and subsequently building up those stories and threads of discussion which are seen to be of most interest to the community, and leaving relatively undeveloped those news items and discussion tangents which are less relevant to their interests.

Indeed, many of the processes of citizen journalism beyond the initial story submission by gatewatchers are fundamentally based in discussion, debate, and deliberation in the community. Although the initial stories may consist of barely more than pointers to new information and news items available elsewhere on the Web, citizen journalism extends them by enabling its communities to comment on such stories and thereby build up a more detailed, communal understanding of their background, context, and impact, as well as evaluating the information contained in the initial reports and combining or contrasting it with other available information. For Bardoel and Deuze, this constitutes a redefinition of journalism:

> with the explosive increase of information on a worldwide scale, the necessity of offering information about information has become a crucial addition to journalism's skills and tasks This redefines the journalist's role as an annotational or orientational one, a shift from the watchdog to the 'guidedog'.[16]

Citizen journalism produser communities therefore act in a guiding role for themselves as well as for any casual users of their sites. Although few of the contributors to citizen journalism sites may wish to compare themselves to 'professional' journalists or news producers, in collaboration their communities nonetheless exactly fulfill the roles of enhancing public understanding, shaping public agendas, and leading public opinion which we have attributed to the Fourth Estate—in the first place, for the realm of the citizen journalism community itself, but increasingly also beyond its bounds.

Much as open source processes can be described as a form of probabilistic software development which relies on the overall drive towards quality that is likely if positive contributions well outweigh negatives ones, citizen journalism therefore can be seen as a probabilistic form of news coverage. It assumes that given a sufficiently engaged and diverse group of contributors, and given the presence of more constructive than destructive contributions, the community's coverage of any one news story (and thus its overall understanding of the news) will improve over time—and indeed often quite rapidly as enthusiastic contributors make a large number of comments and additions in a short time.

Somewhat more prosaically, Rusty Foster, operator of the citizen journalism site *Kuro5hin*, translates such probabilistic quality assurance to a reliance on discussion and argument:

> collaborative media relies [sic] on the simple fact that people like to argue. I don't care how many people CNN runs any given report by, we run it by more. More people, in most cases, equals more accountability, equals better quality.[17]

But whatever the terms we use to describe it, such probabilistic, debate-driven story development does offer significant advantages over closed-shop, commercial models. Its open processes avoid the impact of personal or institutional bias on behalf of individual journalists and editors; misrepresentations in the initial gatewatcher story, for example, are usually corrected almost immediately as other community members exercise their evaluative role and comment on the story. As such comments are added, stories necessarily begin to involve a wider range of perspectives on the implications of the news story than is possible (even with the best intentions) under the limitations of conventional, industrial journalism. Further, the technological features of many citizen journalism sites, which enable the communal rating of individual comments (and therefore indirectly also of commentators) in accumulation enable the emergence from the wider discussion of the most insightful contributions and most respected community members (as adjudged by the community itself). Gatewatching, in other words, represents a translation of the overall produsage principle of **open participation, communal evaluation** to the coverage of news.

> An increasing need for orientation by citizens who are faced with information abundance and selection problems in a time- and information-driven society, combined with the possibilities set off by the combination of network technology and active monitorial citizenship, suggest the role of mediation will increase, albeit in different forms. Citizens have become more direct and active information seekers on familiar subjects, while they will continue to favour assistance in less familiar fields.[18]

Today, then, such assistance is provided by the 'hive mind' of citizen journalism sites as well as by the more conventional institutions of the journalism industry. In such sites, mediation is provided not by a select group of journalists and editors, but through collaborative processes by the community itself; not only does citizen journalism enable the rise of monitorial citizenship, therefore, but it is itself a key example of it. This is a crucial development in the struggle to maintain some degree of social and societal cohesion under present circumstances, as Jenkins points out:

> the ideal of the informed citizen is breaking down because there is simply too much for any individual to know. The ideal of monitorial citizenship depends on developing new skills in collaboration and a new ethic of knowledge sharing that will allow us to deliberate together.[19]

Gatewatcher Community Heterarchies

Much like open source communities, citizen journalism also relies on its means of evaluating content and contributors and extracting from the overall mass of information and participants those most likely to have an interesting, useful, constructive con-

tribution to make. In citizen journalism, we see the formalization of the 'market in egoboo' which we encountered in the previous chapter: its sites

> owe a big part of their usefulness to the large-scale use of reputation: to schemes for emphasizing what is perceived to be better, as measured by the explicit and implicit contributions of millions of users. If a reputation system is honest and well-designed, information filtering using a huge pool of individuals can be more stable, reliable, and insightful than the opinions of a small group of gatekeepers or pundits.[20]

Shirky adds that in the first place, such systems work simply from enabling participants to be recognized more permanently as continuing contributors, for example through personal user names: "if you give users a way of remembering one another, reputation will happen, and that requires nothing more than simple and somewhat persistent handles."[21] This introduction of online personas relating directly to human contributors is a crucial precondition for the emergence of a community heterarchy, however fluid it may be; heterarchy or any other form of non-anarchic organization and governance of the community cannot take place in an anonymous environment. (At the same time, requirements for all contributors to be identified *a priori* through fixed user names may also deter newcomers, and it may therefore be best to allow for at least some interaction with the community without requiring user registration; the very act of registering a user name is also a form of actively becoming part of the community, of moving from casual user to permanent community member and news produser, and should be recognized as such.)

Overall, then, the coverage of news by gatewatcher communities is clearly a collaborative effort involving both registered and unregistered community members (with community membership also expressed through the very act of collaborating in the citizen journalism process). As *Kuro5hin*'s Rusty Foster puts it, "the site, as a 'product' ... is the result of the cooperative efforts of many different people"[22]—and Foster's apparent unease at the term 'product' to describe the site itself, or the individual stories it carries, provides us with further indication that what happens in citizen journalism is described only poorly as industrial-style content production, and should be regarded more appropriately as produsage.

It is important to note, however, that the actual forms and processes of collaboration, and the technologies used to facilitate them, differ markedly across different citizen journalism sites, and the wider news blogosphere.[23] To a large extent, such differences are seen in the sites' approaches to the communal evaluation of gatewatcher stories: while some, like *Indymedia*, publish all submitted content immediately (thus leaving the community to evaluate the veracity and relevance of stories entirely after publication); some, like *Kuro5hin*, include a quasi-democratic open editorial stage in their processes, allowing registered community members to preview, comment upon, and vote on submitted stories before they are made visible to all users of the site; some, like *Slashdot*, retain a loose editorial process which sees a small group of site

operators filter out the least desirable stories before publication; and yet others, like *OhmyNews*, have introduced Pro-Am elements by combining gatewatcher story submissions with oversight by professional editors. News blogs, on the other hand, generally involve their operators in a role of sole gatewatcher, journalist, *and* editor, but through the operation of linking and commenting across blogs also severely undermine the power of that role.

Such models can already be seen as supporting a heterarchical approach to the management of community structures. Even within the limited collective of *Slashdot*'s editors, for example, Chan notes that

> editorial decision making occurs ... through a consideration of a wide diversity of voices from distinct constituencies, attempting to accommodate rather than assimilate them. ... By affording users a large role in influencing and shaping the site's news agenda, and fostering a diverse range of individual editorial approaches to it, the submissions bin immediately reveals itself as a key feature through which a heterarchical model manifests.[24]

Although acting as editors in a semi-traditional sense, then, the *Slashdot* operators show their awareness of heterarchical structures within their wider constituent community by attempting to accommodate that heterarchical community's diverse interests during story selection. Further "extending the Slashdot model in a different direction, Kuro5hin.org passed on editorial oversight to its members," to the point that "the audience acts as editor before and after publishing"[25]; here, a conventional organizational hierarchy is no longer in place any more at all, and decision making is both democratic in the sense that a vote determines the fate of the story submission, and adhocratic in the sense that the subset of the community voting on each story submission is self-selected *ad hoc* rather than determined *a priori*. (In passing, it is also worth noting that the development of *Kuro5hin* as a response and alternative option to the *Slashdot* model can be seen as a form of forking as we have encountered it in the open source community in the previous chapter. This provides a further indication of the heterarchical nature of the wider citizen journalism community.)

Virtually all such citizen journalism models include a significant role for the response stage after publication of the initial story, and in keeping with the 'publish, then filter' approach of citizen journalism it is at this stage—usually open to all participants, or at least to registered community members—that the bulk of story development takes place. Whatever editorial systems are in place in policing initial story submissions to citizen journalism sites, then, they do not constitute a significant retreat from the open participation principle of the produsage model, but are similar simply to the question of which community members are granted access to the main branch of software development within concurrent versioning systems; even those community members excluded from such access are still able to make their submis-

sions and thereby have their ideas aired by contributing to the discussion which surrounds the shared, core texts of the project.

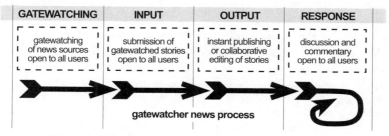

Figure 4.2: The Citizen Journalism News Produsage Process

In addition, beyond individual citizen journalism sites, it is also important to see the field of citizen journalism from a wider perspective which includes the many news-related blogs existing in the overall blogosphere. Together, these sites form a decentralized, loosely interconnected network of Websites concerned with the coverage, discussion, and deliberation of news and current events, and make any traditional editorial (in other words, hierarchical) approaches to news coverage entirely impossible; what may be prevented from being expressed on one site is ultimately virtually assured to find an airing on another site, or at least on the author's personal blog. This network of sites necessarily forms a heterarchical structure in which the power to attract attention and influence opinion is constantly and rapidly in flux, always based on the communal evaluation of recent performance. Of course, many commentators, especially those focusing specifically on the blogosphere, have observed the emergence of an 'A-list' of influential bloggers, but even these bloggers' position at the head of their field remains tenuous and always dependent on continuing performance as bloggers; reputation within the community cannot be taken for granted, and will degrade over time.

Within individual citizen journalism sites, much the same processes also take place—within many sites, reputation (and thus, social status in the community) can be accumulated through positive participation over time, and in sites which allow their participants to explicitly rate the contributions of their peers, personal merit is even able to be quantified through numerical 'karma' scores. At the same time, however, such karma is also easily reduced again through contributions rated as negative by the community, or may reduce over time through in-built depreciation mechanisms. In such systems, as well as in other communities which do not rely on quantifiable karma scores but nonetheless informally recognize the accumulation of esteem and reputation by participants, the community governs itself through a constant process of mutual evaluation through peer commentary and criticism, meted out *ad hoc* as the communicative context requires it. Citizen journalism therefore provides a clear example for the **fluid heterarchy,** *ad hoc* **meritocracy** principle of produsage; just as the

individual contributions of participants in this process of news coverage have been described as "random acts of journalism,"[26] in their engagement with one another, contributors to the collaborative processes of citizen journalism also perform random, *ad hoc* acts of community governance.

The benefits of the broader basis of information, knowledge, and opinion which such an 'open-sourcing' of journalism processes can harness have gradually also begun to be realized at least by some innovators in the journalism industry itself. As blogger-journalist Dan Gillmor has described it,

> my readers know more than I do. This has become almost a mantra in my work. It is by definition the reality for every journalist, no matter what his or her beat. And it's a great opportunity, not a threat, because when we ask our readers for their help and knowledge, they are willing to share it—and we can all benefit. If modern American journalism has been a lecture, it's evolving into something that incorporates a conversation and seminar.[27]

He also notes that this is a process of decentralization,[28] not unlike the decentralizing and parallelizing tendencies we have already observed for software development. This shift is beginning to have a profound impact on the processes of conventional journalism, in fact: citizen journalists may not have the resources to do much investigative journalism by themselves, but their strength lies in combining, evaluating, and drawing conclusions from a vast network of individual items of news and information, allowing key elements of stories to rise to the focus of popular attention through the communal processes of evaluation which take place in the journalism produsage environment. Much like open source, such processes crucially harness the enthusiasm and passion of their constituents:

> online participatory journalism is fuelled by people who fanatically follow and passionately discuss their favourite subjects. Their weblogs and online communities, while perhaps not as professionally produced, are chock full of style, voice and attitude. Passion makes the experience not only compelling and memorable but also credible.[29]

Unfinished Artefacts, Continuing Process

This decentralization and parallelization of journalistic processes through produsage also necessarily affects the nature of the content created through citizen journalism. In the process, it significantly challenges traditional journalism's conception of news as individual, self-contained news stories that can be printed or broadcast in separate installments. This perhaps more than any other aspects of its operation is likely to have a profound impact on our overall understanding of and engagement with the news, re-

gardless of whether we are active participants in citizen journalism communities or not.

As Rusty Foster points out, on *Kuro5hin* (as well as in most other citizen journalism sites)

> the story itself is not the final product, it's just the starting point, because ultimately the goal of every story is to start discussion, to start a lot of other people saying what they think about it. ... And eventually, after a while, you have sort of a complete view of an issue because many people are talking about it.[30]

Even that emerging view of the issues is never *entirely* complete, of course; other contributors may still add further comments or submit new, related stories to a site to begin further discussion.

This is fundamentally different from the traditional story form of journalism, which was designed to contain all the relevant facts readers needed to understand at least the core issues at hand, and which in many journalistic traditions continues to adhere to what is called an 'inverted pyramid' structure, providing all key information in the first paragraph or two and adding progressively less important material in subsequent paragraphs. Such stories present news as a standardized product, able to be distributed as a self-contained unit (and where necessary, condensed into fewer paragraphs, or ultimately, only a headline, to suit the space and time limitations of different formats of distribution); they disregard the context of the story and the interconnections between it and related news items in order to maximize the story's suitability for the industrial processes of its transmission. "News media are geared to own a story. They shape it, package it and sell it."[31] Conventional news stories, in other words, are designed to maximize their use and exchange value for the producers and distributors of news, not necessarily for its users.

By contrast, Bardoel and Deuze point out, in the new, user-led environment,

> a shift in the relationship between supplier and user to the advantage of the latter changes the old, paternalistic relationship into a new, more pragmatic arrangement and a new emancipation of the information user Traditional journalism is, more than perhaps the profession realises or is willing to admit, a product of industrial society with its centralised, hierarchical, and paternalistic characteristics.[32]

This is clearly visible in the changes to the format of news stories in citizen journalism environments. Here, Foster notes,

> the story is a process, ... instead of a product, like the news industry has taught us to think. It's never done, and the story is always evolving. Collaborative media gives [sic] us the power to contribute to that evolution, to all be part of the reporting of news, just like we're all part of the making of it.[33]

Such collaborative approaches to news coverage highlight the fact that any one participant's understanding of the news is necessarily always fragmentary and incomplete, regardless of whether they are a conventional or citizen journalist or simply a 'normal' member of the audience for news reports. Conventional journalists on average may be better trained and informed than the 'regular citizen' (although even this is questionable at a time of increasing commercial pressure on the journalism industry, resulting in significant staff reductions), but the citizen journalism community makes up for such deficits through its significantly larger size and diversity; collectively, echoing Dan Gillmor, they will know much more than journalists do. The application of that knowledge, however, must necessarily remain an ongoing process of discussion, debate, and evaluation of news reports and other information; news therefore never arrives at a final stage of complete containment and resolution. In citizen journalism communities, "what ensues is a community effort to uncover the truth. Sometimes journalists enter the fray in an effort to uncover the truth in traditional media."[34]

For these reasons, it is no longer appropriate to uphold the mirage of news as product; instead, news is a process, never finished, always continuing, and (given favorable conditions of participation in which constructive contributions outweigh disruption) gradually evolving towards a better understanding of 'the truth,' or at least towards the development of a widely shared consensus on what the facts of the matter at hand may be. News stories summarizing these facts, as well as the developing consensus which they represent, are at any stage only temporary artefacts of that ongoing process: they are subject to further change again as soon as new information comes to hand or as soon as the synthesis of existing information produces new knowledge within the community. The operation of time as a core structuring principle in most citizen journalism sites and news blogs, which commonly present their stories in reverse chronological order, succeeding one another often at a rapid pace, also clearly points to the constantly continuing, eternally unfinished nature of this process. Though not specifically referring to news, Richardson describes such textual produsage processes as a new genre of 'connective writing': "this ... genre actually continues post publication. That's because of the ability of readers to interact with the post, another example of the connective aspect of it. This is a crucial distinction that necessarily changes the purpose of the writing."[35]

Such incompleteness necessarily requires a turning away from the conventional news story formats of industrial journalism, which are implicated as premature attempts to define and contain 'all the news that's fit to print' without leaving sufficient space for communal discussion and evaluation in pursuit of a broader, deeper understanding of the full consequences of the news. Many commentators have noted that conventional news stories frequently reduce all differences of opinion and interpretation to simplistic dyads of 'left vs. right' and 'us vs. them' which are entirely unsuitable for the accurate portrayal of complex societal problems. Thus, "one challenge for

Internet activists ... is to develop ways of telling stories which are issues-focussed, without replicating the conflict-based narrative structures of the established media."[36]

Alternative forms of representing the news must necessarily offer a broader range of perspectives—they must, as Gans has described it, pursue the ideal of multiperspectival journalism[37]—and enable the open engagement rather than the staged conflict between such perspectives (which are not necessarily *oppositional* to one another, but simply represent more or less different approaches to the same issue). This form of journalism would be dialogic, and even deliberative, as Heikkilä and Kunelius note.

> Journalism must openly encourage different readings (and search for new modes of stories that do so) and it must commit itself to [the] task of making these different readings and interpretations public. The challenge is to make the accents and articulations heard, to give them the power and position they need to argue on particular problems and to make them the objects and starting points for new emerging public situations and conversations.[38]

Journalists themselves (whether 'professionals' or 'citizens') thus become simply another group of participants in this ongoing dialogue and deliberation. As pundit-blogger Glenn Reynolds has pithily described it, "the term 'correspondent' is reverting to its original meaning of 'one who corresponds,' rather than the more recent one of 'well-paid microphone-holder with good hair'"[39]—and at least at present, citizen journalists and news bloggers are substantially more positively predisposed towards engaging in a distributed process of correspondence aimed towards the continuing evaluation of news than are their industrial counterparts.

Overall, this clearly indicates the operation of the produsage principle of **unfinished artefacts, continuing process** as we have described it earlier. Operating under this logic, the object of journalistic processes of produsage is subtly but importantly different from that of conventional journalism: where the journalism industry aims to produce clearly delineated products which define and present the news as an objective matter of fact, the object of news produsage is the compilation of a range of plausible, multiperspectival interpretations of available news reports in context. Industrial journalism produces news *as resulting from* a process of journalistic evaluation; citizen journalism produses news *as material for* a continuing process of community exploration, interpretation, discussion, evaluation, and deliberation.

Individual Rewards from News Produsage

Finally, citizen journalism also serves to demonstrate the fourth and final key principle of produsage approaches: the ability for meritorious community leaders of the produsage process to derive individual rewards even despite the communally held ownership in all resources developed through produsage. The gradual reversion of journalism

from lecture to conversation, and of journalists from producers and editors to corre-spondents in the true sense of the term, is itself a sign of this phenomenon: status in the overall field of journalism is now no longer guaranteed by the intrinsic positions held by participants in the professional hierarchies of the journalism industry, but is determined increasingly by the reputation and merit gained and lost through con-structive or disruptive contribution to the communal project of citizen journalism.

In this new project of communal journalism produsage rather than industrial production, professional expertise or standing no longer has any special role. Indeed, expertise is accredited and standing conferred through communal evaluation, as we have seen:

> the sharing of information confers benefit both on the individual offering up the in-formation and the community which receives the information. Individuals identified as experts in a particular area gain in social standing within their communities; this is a form of wealth in itself, and though less tangible than cash, should never be dis-counted. This social calculus serves as the foundation for many communities, and it is both delicate and constantly in flux: members in every social network are constantly jockeying for position by sharing, aggregating, or critiquing the information.[40]

Perhaps paradoxically for adherents to traditional models of intellectual property, then, where ownership and the ability to control one's property was a key determinant of power, in produsage environments such as citizen journalism the ability to build one's own merit crucially depends on the sharing (or in von Hippel's terms, free re-vealing) of personal ideas and knowledge. This connection of sharing and merit also serves to contribute crucially to the sustainability of produsage as a social, communal project, of course, as it encourages the constant development and extension of com-munal resources. Far from being diametrically opposed to one another, contribution to communal resources builds individual status—the produsage principle of **common property, individual rewards**.

In the context of citizen journalism, such common property consists both of the actual news stories and commentary compiled by contributors to news produsage, and of the shared consensual interpretation and understanding of news and current events which they serve to indicate—in Lévy's terms, for the collective intelligence they repre-sent. This does not mean that a completely uniform shared understanding of or con-sensus about the interpretation of news exists in even the most monocultural of citizen journalism communities, much less in the wider network of citizen journalism sites and news blogs overall. Views will continue to differ between different partici-pants, even if some communities occasionally engage in 'groupthink' (or more appro-priately, the group *expression* of shared beliefs to the exclusion of all other interpretations). The consensual understanding of news which citizen journalism in specific sites and overall develops is not a uniform interpretation of the news itself, but a shared realization of the major streams of thought on any one issue, and a con-

sensus on how to continue to conduct the ongoing engagement between alternative points of view through discussion, debate, and deliberation across and within the sites of citizen journalism.

Like the common property compiled by other produsage projects, such consensus is necessarily always incomplete, and can be subject to deep rifts, leading to a forking of projects and communities; especially in the context of journalistic content, however, such divisions are not necessarily negative or problematic, as they serve to further increase the range of perspectives and interpretational paradigms available to users interested in news and information. In the context of the gradual contraction and amalgamation of the commercial news industry, this may be seen to be a thoroughly positive development.

For individuals contributing their own intellectual property into this communal pool of knowledge, then, the benefits from doing so clearly outweigh any detriment. Bowman and Willis outline a number of possible reasons for produser participation: "'to gain status or build reputation in a given community', 'to create connections with others who have similar interests, online and off', 'sense-making and understanding', 'to inform and be informed', 'to entertain and be entertained', 'to create'."[41] Produsers, in other words, are attracted largely by the social, communal, network features of the produsage environment, and realize that they are able to gain social status within the community (whether implicitly, or as made explicit through karma scores and similar systems) by contributing constructively over time.

This focus on individual opportunities serves to demonstrate that produsage projects—even those as decentralized and distributed as the blogosphere itself—are not organized simply in entirely flat operational structures; instead, as Benkler notes,

> these projects are based on a hierarchy of meritocratic respect, on social norms, and, to a great extent, on the mutual recognition by most players in this game that it is to everybody's advantage to have someone overlay a peer review system with some leadership.[42]

(The qualifier 'some leadership' also points to the fact that this meritocracy ultimately is a heterarchy rather than a hierarchy, however.)

Ultimately, such schemes for the recognition of individual merit do not exist purely for personal gratification, of course. Instead, merit has an immediate effect on the contributor's standing in their community, and frequently also opens up the potential to assume new roles within the community heterarchy; on *Slashdot*, for example, only contributors of some standing may be involved in the communal moderation and metamoderation system which both bestows karma points themselves *and* provides further peer review for those making such karma ratings. Karma points and similar ratings may also be taken into account by some systems as initial gatewatcher story submissions are evaluated, or as further comments on stories are displayed in discussion threads. Beyond these citizen journalism sites themselves, however, some highly

regarded contributors have also found themselves becoming involved in more main-stream forms of journalistic practice; some 'A-list' citizen journalists and news bloggers have become regular commentators in print, radio, and television news, for example.

This cooption of leading citizen journalists into the journalism industry, and the overall competition for social standing in the community which may result especially from very overt karma ratings systems, does not undermine the community of citizen journalists itself, however—in part also because, as we have seen, reputation remains constantly in flux and prominent members of the community are (because of their visibility) under particularly hard scrutiny at any point. Instead, the gradual incorporation of citizen journalists and their views into mainstream news media should be seen as proof for the success of the news produsage model itself. In engaging with the journalism industry, most citizen journalists generally do not 'sell out,' but instead inject citizen-journalistic elements into the mainstream; in effect, they act as ambassadors for citizen journalism.

New Spaces for Journalism

Citizen journalism's process of news produsage

> creates a new space to which news value may be assigned, expanding understandings of what crucial news documents are to include not just news articles, but the discussion forums that are associated with them, where users say news can be reported, assessed and interpreted.[43]

This new space has emerged in the first place as an alternative to the commercial spaces of the journalism industry, but over time the boundaries between both sides have begun to blur.

Initially, citizen journalism emerged very much in response and in opposition to the perceived shortcomings of the mainstream news media; in doing so, it filled the role of a second-tier of journalism as Gans had called for it, where the existing

> central (or first-tier) media would be complemented by a second tier of pre-existing and new national media, each reporting on news to specific, fairly homogeneous audiences. ... Their news organisations would have to be small [for reasons of cost]. They would devote themselves primarily to reanalysing and reinterpreting news gathered by the central media—and the wire services—for their audiences, adding their own commentary and backing these up with as much original reporting, ... as would be financially feasible.[44]

Such media outlets, he suggested, "would also function as monitors and critics of the central media, indicating where and how, by their standards, the central media have been insufficiently multiperspectival."[45] They would therefore largely feed on the products of mainstream journalism, opening them up for community contribution,

extension, correction, and refutation, and their processes would be largely triggered by reporting in the mainstream media, for whom they would operate as watchdogs and correctives.

Predictably, the adoption of such a role by citizen journalism has been regarded as a challenge by the incumbent journalism industry, which regards itself as a watchdog for other societal institutions, of course. Some journalists have been openly dismissive of the idea that collaboratively produed journalism could replace the hierarchically, professionally organized journalistic industry in this watchdog role; as we have seen in the realm of software development already, this is a response familiar from other industries threatened by the potential of a casual collapse of their standing at the hands of a new range of community-based, socially organized produsage alternatives. However, as Benkler notes,

> the argument about the commercial media's role as watchdog turns out to be a familiar argument—it is the same argument that was made about software and supercomputers, encyclopedias and immersive entertainment scripts. The answer, too, is by now familiar. Just as the World Wide Web can offer a platform for the emergence of an enormous and effective almanac, just as free software can produce excellent software and peer production can produce a good encyclopedia, so too can peer production produce the public watchdog function.[46]

In addition, however, although it is certainly possible to point to citizen journalism in its various forms as fulfilling that role today, we can also see the beginnings of a move beyond this two-tiered structure. Citizen journalism has become increasingly powerful in its own right, and has begun to pursue its own stories independent of the coverage of the mainstream news outlets (though, obviously, not independent of news events themselves as they take place). Perhaps the best example of this move beyond a stratified, two-tier structure is provided by the Korean Pro-Am citizen news publication *OhmyNews* (which recently also launched subsidiaries in English and Japanese): through its combination of citizen reporting and conventional professional assistance in editing processes, it has managed to enter an intermediary realm between the conventional journalism industry in Korea and its new citizen journalism counterparts. As a sign of its success,

> OhmyNews reporters are given access to government ministries and public institutions, putting them on level footing with professional reporters. Top officials increasingly give OhmyNews journalists exclusive interviews, a precedent set by President Roh, who gave his first postelection interview to OhmyNews—a startling snub of the country's established media.[47]

In addition to such hybrid approaches between the tiers,[48] citizen journalism has also been successful in inserting its own coverage of newsworthy events into the mainstream media where (for various reasons) the mainstream had initially shown little interest or ability to cover specific stories. Most prominently, this was the case for

example in the events leading to the resignation of U.S. senator Trent Lott from the post of House Minority Leader when news bloggers and citizen journalists discovered and led discussion of Lott's controversial remarks on racial segregation until the mainstream media began to cover the topic, and in the coverage of the return of Iraq War casualties to the United States, which began only after blogger Russ Kick filed a Freedom of Information request to have photos of the arrival of the soldiers' remains released to the public; since these highly publicized initial cases, a large number of other events have also emerged in which bloggers and citizen journalists played instrumental roles in perpetuating the coverage of events ignored by the media, often to the point of mainstream journalism gradually changing its routine storylines. In addition, citizen journalism has also been found to be of particular importance in covering major emerging events from the Christmas 2004 tsunami in the Indian Ocean to the 7 July 2005 bombings in London, to elections, cultural and sporting events, and to other events where for one reason or another industrial journalists were unable to provide immediate or comprehensive coverage.

Increasingly, both the mainstream media themselves and a new range of intermediaries have begun to harness and harvest the efforts of citizen journalists in order to incorporate them into their own products; conversely, the harnessing of the outputs of traditional journalism as catalysts for citizen journalism coverage has also become more sophisticated. Websites such as the largely French operation *Scooplive*, the British-based *Scoopt* (now owned by global photo agency Getty Images), or Yahoo!'s *YouWitness News* (building on the company's acquisition of photo sharing site *Flickr*), for example, enable the conduct of citizen journalism (focusing specifically on photo and video journalism) with a prospect of subsequently selling sought-after content to the mainstream media. At the same time, the citizen journalism site *NowPublic* provides advanced tools to gatewatchers which make it easier for them to directly appropriate, cite, and comment on the contents of mainstream online news outlets and thereby incorporate them into citizen journalism processes. *BBC News Online* and a number of other online journalism sites are beginning to experiment with approaches towards the encouragement and cultivation of citizen journalist communities on their own sites, thus harnessing the community for the further discussion, fact-checking, and extension of their stories.

NewAssignment, meanwhile, has begun to explore emerging Pro-Am journalism opportunities by setting up the frameworks for what it describes as the 'open-sourcing' of journalism; here,

> pros and amateurs cooperate to produce work that neither could manage alone. The site uses open source methods to develop good assignments and help bring them to completion. It pays professional journalists to carry the project home and set high standards; they work closely with users who have something to contribute. The betting is that (some) people will donate to stories they can see are going to be great because the open methods allow for that glimpse ahead.[49]

Such projects not only fundamentally undermine any hard and fast distinctions between 'professional' and 'amateur' journalists, between producers and produsers, but they also point to the growing entanglement between production and produsage which we encounter in examples from diverse industries throughout this book (and which we have also already seen in the changing structures of parts of the traditional software industries in the wake of open source's success).

They must necessarily also raise questions of what remains of 'professionalism' in journalism, of course. It must be noted that such questions are necessarily felt more acutely on the side of the journalism industry, which stands to lose the most from a weakening of perceptions of professional standards in news production; for the participants in citizen journalism processes, by comparison, the question of whether what they do is comparable to professional journalism tends to be irrelevant as long as the quality of the content generated in the process compares well with the outputs of the journalism industry. Indeed, citizen journalists tend to feel that the very absence of the need for professional accreditation as a precondition to participation serves to improve the quality of the content prodused in their communities: so, for example, "Slashdot's own users often say that it is precisely the incorporation of a broad body of users as potential critics of news that fosters a greater sense of trust in the site."[50]

Many users and produsers of news are in fact, if not professional, then nonetheless expert users of information, and through their engagement with citizen journalists at least some of the professional journalism classes are gradually beginning to realize this fact. This requires a significant shift of perspective from professionals in an industry which has customarily sought to minimize audience involvement in its production processes, however, and has instead taken a relatively distant stance towards readers, listeners, and viewers whom it saw as audiences needing to be informed through ready-made, predigested news packages rather than users able to process complex information for themselves: "after years of working their way up the professional ladder, some reporters will undoubtedly need to discover a newfound respect for their readers. Arrogance and aloofness are deadly qualities in a collaborative environment."[51]

Ultimately, disputes between news production and news produsage "rather crucially centre on questions of how users themselves, through social practices enabled by new technologies, are re-shaping the definition of news, newsmaking, and expertise."[52] Such changes as they are currently in the process of taking place must be followed closely, and both citizen journalists and professional newsmakers need to begin to speak to one another as equals more regularly to ensure that both sides of the journalism equation (neither of which is likely to be removed any time soon) are able to enter into a mutually beneficial arrangement. In this sense,

> those who choose to compose and disseminate alternative value systems may be working against the current and increasingly concretised mythologies of market, church and state, but they ultimately hold the keys to the rebirth of all three institutions in an entirely new context.[53]

From Casual Collapse to Renaissance

Rushkoff's work clearly points to the expectation that such changes are going to take the form of a renaissance, a rebuilding of societal institutions, not a revolution which does away with the old in favor of the new altogether. This is also in line with the 'casual collapse' of older forms as predicted by *Trendwatching*: a casual collapse allows for the gradual transformation of older models, the retaining of useful aspects of the older ways of working, and their incorporation with new ideas and innovations. We are now beginning to see this process at work in the changing landscape of journalism, industrial or otherwise.

What may be necessary, then, is a new form of arrangement between traditional and new forms of journalism. Traditional, industrial journalism must arrest its slide towards punditry, and redirect its efforts towards the production of quality raw materials for journalistic coverage (by both industrial and citizen journalists): clear, balanced, and factual investigative reporting which drills deeply into issues but avoids a focus on the interpretation of the facts it uncovers. Citizen journalism will then be able to focus on its strengths: collating and connecting factoids emerging from such stories which in combination and in synthesis provide a better understanding of wider societal issues, exploring and explaining the implications of the issues so uncovered, discussing and deliberating on potential approaches (political or otherwise) to addressing these implications. "'This is tomorrow's journalism,' says blogger and journalist Dan Gillmor, 'a partnership of sorts between professionals and the legions of gifted amateurs out there who can help us—all of us—figure things out. It's a positive development, and we're still figuring out how it works.'"[54] Such a model would also constitute a partnership between production and produsage not unlike those beginning to be explored in the field of software production, perhaps—where the initial kernel of an innovation is produced in traditional ways by individual developers such as Linus Torvalds or corporations such as Mozilla, but is then open-sourced to harness the benefits of wide community engagement in its produsage *and* to build the reputation of the initial contributor both within and beyond the produsage community. A professional journalism of this form would build its operational model around seeding, feeding, helping the 'hive mind' of the citizen journalism community.

Conversely, the produsage model of citizen journalism seems significantly better suited to the open exploration and evaluation of societal issues and events, to discussion, debate, and deliberation on their implications, than is the corporate journalistic model: the latter must necessarily always exist under the threat and the suspicion of outside influences exerting their pressure on the journalistic process for commercial or political reasons. (This is true, of course, also for publicly funded media under government mandate even where the charter of such media institutions appears directly to rule out the exertion of political pressure by the government of the day, as recent controversies about bias in the British Broadcasting Corporation or the Australian

Broadcasting Corporation have shown: as long as such media rely directly or indirectly on funding from government sources, pressure points to nudge them towards self-censorship or preferential reporting on sensitive topics do exist.) By contrast, Benkler notes,

> the networked public sphere, as it is currently developing, suggests that it will have no obvious points of control or exertion of influence—either by fiat or by purchase. ... It promises to offer a platform for engaged citizens to cooperate and provide observations and opinions, and to serve as a watchdog over society on a peer-production model.[55]

This is not to claim that individual communities of produsers within the realm of citizen journalism will not be biased, of course—but such biases represent personal or community opinion and stand in competition to many other, differently biased, sites of citizen journalism which in combination present a rich, varied, multiperspectival, and in-depth engagement with complex issues.

"Instead of being primarily journalist-centered, the news online appears increasingly to be also user-centered,"[56] therefore; this necessarily shifts the balance of participation in news from experts (to the extent that journalists *are* indeed experts in the fields they cover) to non-experts. More precisely, however, although the news produsage model may constitute a shift from expert to non-expert *journalists*, it also holds the potential for a simultaneous shift from journalists who are not experts in the topics they cover to *subject matter* experts themselves who are acting in a journalistic role—this may degrade to some extent the quality of writing, but is nonetheless likely to improve the quality of factual coverage for any one topic. Although the shift away from professional journalists, which is also a shift to a broader base of variously qualified contributors and commentators, necessarily diffuses the messages of news, the detrimental effects of such diffusion are well made up for by the benefits from a wider societal involvement in discussing, debating, and deliberating on the implications of events in the news. Indeed, it is important to keep in mind that news itself is inherently social, and therefore requires broad societal participation, which (largely because of technological features of mass media as one-to-many communications technologies) has been missing from public involvement in the news debate for some time.

Such shifts also affect our political system and society itself, of course (and we will return to the impact of produsage on democracy in more detail in Chapter 14):

> it affects the ways in which positions are crystallized and synthesized, sometimes still by being amplified to the point that the mass media take them as inputs and convert them into political positions, but occasionally by direct organization of opinion and action to the point of reaching a salience that drives the political process directly.[57]

What is crucial in this context is that despite the widely decentralized, parallelized, diffused nature of news produsage in the realm of citizen journalism, the system

nonetheless also contains the features which allow key topics and issues to rise to widespread public prominence even where the traditional news media have yet to thematize them. Such features are built directly on the heterarchical structures of evaluative produsage processes themselves. It is only this heterarchical structure without overt points of political or commercial influence on the conduct of wide-ranging discussions which supports a fully and equipotentially deliberative engagement with the news, by a range of produsers that is wide enough to instil the hope that it may become representative of society as such. If such moves towards a deliberative journalism succeed, this form of journalism would be substantially different from its industrial predecessors:

> deliberative journalism would underscore the variety of ways to frame an issue. It would assume that opinions—not to mention majorities and minorities—do not precede public deliberation, that thoughts and opinions do not precede their articulation in public, but that they start to emerge when the frames are publicly shared.[58]

Although, in sharp contrast to such visions of a more deliberative engagement with the news, Habermas suggests that the decline of traditional political journalism in this new environment of news produsage "would rob us of the centerpiece of deliberative politics,"[59] he offers few convincing arguments that this should be so. Indeed, we might argue instead that the very limited forms of political deliberation which are played out for—but generally in the absence of direct communicatory involvement by—audiences in the commercial (and even in publicly funded) journalistic media are entirely insufficient to support the functioning of complex modern societies and democracies (however instrumental such mass media were in fostering relatively cohesive national communities after World War II). What produsage journalism, and the overall move from broadcast one-to-many to networked many-to-many media of which it is a part, indicates is that there is a strong desire by citizens to engage significantly more actively in politics and society, and that the more passive role bestowed on audiences by the mass media was never a conscious choice of wide sections of the citizenry, but instead simply a by-product of the predominant media technologies of the day.

Through this new, non-mass-mediated, direct-engagement form of deliberative news and politics, then, "what is emerging is a new media ecosystem ..., where online communities discuss and extend the stories created by mainstream media."[60] Both sides of the journalism divide remain necessary for a functioning deliberative politics, a successful democratic society; indeed, both sides must actively bridge the apparent divide between them and work towards mutually beneficial arrangements and cooperation between them. As blogger-journalist Dan Gillmor notes of this new relationship, "I hope it's more symbiotic than parasitic. And over time, ... we have to find a balance and we have to find a way to support the traditional kinds of journalism where people spend a lot of money doing investigative journalism."[61] Or, as Jenkins puts it,

the power of the grassroots media is that it [sic] diversifies; the power of broadcast media is that it amplifies. That's why we should be concerned with the flow between the two: expanding the potentials for participation represents the greatest opportunity for cultural diversity. Throw away the powers of broadcasting and one has only cultural fragmentation. The power of participation comes not from destroying commercial culture but from writing over it, modding it, amending it, expanding it, adding greater diversity of perspective, and then recirculating it, feeding it back into the mainstream media.[62]

What needs to happen in the realm of journalism, therefore, is simply the closing of the feedback loop, no longer between producers and audiences, between producers and prosumers, or between producers and users of the news, but between producers and produsers, both of whom actively contribute to the development of society's shared understanding of news and current events, its common store of information and knowledge on how to identify, evaluate, and act upon newsworthy developments; what must happen for the new media ecosystem to be sustainable is the attraction to and involvement in processes of political deliberation of the greatest possible number of all members of democratic society.

Towards the Inevitable

"James Carey ... has put it this way in his own writing: Perhaps in the end journalism simply means carrying on and amplifying the conversation of people themselves."[63] If Carey is correct, then the change and transformation of traditional journalism towards a greater embrace of and partnership with produsage-based citizen journalism must surely be seen as inevitable. Nonetheless, such shifts will continue to face a number of obstacles along the way, not least also relating to questions of the enforcement of content ownership and the protection of corporate brands and reputations.

It is evident even from only a casual glance at the sites and blogs of citizen journalists that in many cases the produsers involved treat the products of the industrial journalism process as raw material for their own work; journalistic content is repurposed, reappropriated, and remixed as is required for its use as a catalyst for citizen journalism, and traditional news content is therefore introduced into the open news pool with little regard for questions of copyright or 'fair use'; this is the case, of course, especially with industrial journalism content which is already available in digital format through commercial online news Websites, and is therefore inherently particularly malleable, but even news in less immediately accessible formats (television, radio, print) is increasingly introduced into the realm of online citizen journalism through advanced digital technologies and relevant technological supports (such as, for example, videosharing sites like *YouTube*).

This is necessarily problematic from a copyright point of view, and Bowman and Willis suggest that "eventually, licensing and copyright policies will need to be reexamined to come into harmony with a collaborative audience model."[64] At the moment, the output of traditional journalistic production is in essence open-sourced against its producers' will by the common practices of blogging and citizen journalism; such open-sourcing does not necessarily produce only negative effects for the journalists and journalistic organizations involved: although ultimately it does put pressure on the news industry to confront its citizen journalism counterparts in general as well as in the specific context of the stories which are being picked up by them, to do so also raises the profile of journalists and news organizations whose work is highlighted through the citizen journalism practice of gatewatching, and may put them in the position to assume a new role of trusted guide to news users, in place of the gatekeeping role of mass media journalism which is now disappearing.[65] Some journalists and journalistic organizations have begun to understand and accept this change: for example, journalist Steve Yelvington asserts that "we are not gatekeepers anymore, the city walls are down, we don't own customers, we don't control information."[66] At the same time, of course, a consistently critical, negative treatment of journalists and journalistic organizations by citizen journalists is also likely to reduce their reputation with users; this further demonstrates citizen journalists' role as a watchdog for corporate journalism.

It appears virtually impossible to militate against the repurposing of industrial news products by citizen journalists, however (or at least to do so without severe negative effects on the news organization once again). For example, "news sites that sit behind registration firewalls, or whose content is quickly moved into paid archives, display the characteristics of a cul-de-sac rather than a connected node on a network"[67]; further, legal action by commercial news sites against citizen journalists creates substantial negative publicity for commercial journalism operators. In addition, the still-common refusal of mainstream journalism Websites to link substantially to material outside of their own sites (motivated by worries that such sites may contain content which could negatively impact on one's own reputation) is increasingly seen as similarly counterproductive; indeed, as Deuze points out, "if a site only refers to documents within a particular site [that is, only links internally], it actually tells the end-user that the World Wide Web does not exist, that only the local documents on that site can and should be interconnected."[68]

Ultimately, then, smarter players in the journalism industry are beginning to realize that they are part of "an emerging new media ecosystem—a network of ideas."[69] They have begun to link to outside sites offering further information on the stories they cover (gradually also including citizen journalism Websites), and many sites now also actively court take-up of their stories by news bloggers and citizen journalists, seeing such use as increasing the distribution of their products. As such developments gather pace, they are likely to become a self-reinforcing trend: "when some media out-

lets start making participatory media work effectively, media companies that dig in their heels and resist such changes may be seen as not only old-fashioned but out of touch."[70]

In attempting to embrace the benefits of harnessing their users as produsers of the news, journalistic organizations crucially must ensure that their approach to the community is seen as genuine, and that the parameters of the online spaces they deploy are in keeping with the basic principles of produsage. As Shirky warns,

> media outlets that try to set minimum standards of quality in community writing often end up squeezing the life out of the discussion, because they are so accustomed to filtering before publishing that they can't imagine that filtering after the fact can be effective.[71]

Instead, to generate the potential for mutually beneficial news produsage by the users of conventional news Websites it is necessary for news organizations to abide by the four principles of produsage: they must enable open participation in and communal evaluation of content contribution; they must allow for the emergence of fluid heterarchies and an *ad hoc* meritocratic governance in and by the communities which emerge from this process; they must allow for content and process to remain unfinished and continuing; and (perhaps most importantly) they must avoid the perception that content created in the process is intended to fall under the ownership of the news organization, providing rewards only for the corporation rather than also for individual participants.

Where such principles *are* met, on the other hand—whether in citizen journalism spaces developed by conventional operators in the news industry, or by newly emerged citizen journalism Websites and news blogs—they allow the rise of a new and substantially different form of news produsage which is set to have profound effects not simply on the journalism industry, but also on the political engagement and deliberation which it is the role of that industry, and of (professional and non-professional) journalism more generally, to support. Such produsage journalism will necessarily involve a broader cross-section of society, and a different constituency of participants than does industrial journalism; it will enable the creation of a more multiperspectival form of news, creating important new effects as Gans has outlined them:

> multiperspectival news is not designed to gain supporters for any specific political cause. Rather, it will enable people to obtain news relevant to their own perspectives, and therefore to their own interests and political goals, if they have any. In the process, the symbolic arena would become more democratic, for the symbolic power of now dominant sources and perspectives would be reduced.[72]

Such developments are outcomes of an overall shift from production to produsage in a post-industrial, networked society, and (as Rushkoff has pointed out) hold the potential for its rebirth, its renaissance; as we see in Chapter 14, along with produ-

sage overall, they are set to have profound effects on wider political, societal, and democratic processes. Although possibly contributing to the casual collapse at least of those traditional journalistic institutions which are unable or unwilling to adapt to such changes, such collapse where it occurs should not be seen as a negative development; indeed, it is a necessary change:

> democracy requires open access to public institutions and resources for knowledge. This holds for journalism, too, for it is a public institution regardless of its ownership. Therefore, access to journalism should be open to all citizens The variety of voices in journalism is thus the measure of its 'publicness'.[73]

Produsage-based citizen journalism is the first step towards restoring access to the public institution of journalism for a wide range of citizens-turned-produsers, breaking open the commercial (and political) lock on the journalistic industry as it has been established during the late stages of industrial capitalism.

NOTES

1. Gene Hyde, "Independent Media Centers: Cyber-Subversion and the Alternative Press," *First Monday* 7.4 (April 2002), http://firstmonday.org/issues/issue7_4/hyde/index.html (accessed 12 July 2007), n.p.

2. Graham Meikle, *Future Active: Media Activism and the Internet* (New York: Routledge, 2002), p. 87.

3. Clay Shirky, "A Group Is Its Own Worst Enemy," *Clay Shirky's Writings about the Internet: Economics & Culture, Media & Community, Open Source*, 1 July 2003, http://shirky.com/writings/group_enemy.html (accessed 24 Feb. 2007), n.p.

4. Douglas Rushkoff, *Open Source Democracy: How Online Communication Is Changing Offline Politics* (London: Demos, 2003), http://www.demos.co.uk/publications/opensourcedemocracy2 (accessed 12 July 2007), p. 17.

5. Herbert J. Gans, *Deciding What's News: A Study of* CBS Evening News, NBC Nightly News, Newsweek, *and* Time (New York: Vintage, 1980), p. 81.

6. From Axel Bruns, *Gatewatching: Collaborative Online News Production* (New York: Peter Lang, 2005).

7. Yochai Benkler, *The Wealth of Networks: How Social Production Transforms Markets and Freedom* (New Haven, Conn.: Yale University Press, 2006), p. 68.

8. Rob Anderson, Robert Dardenne, and George M. Killenberg, "The American Newspaper as the Public Conversational Commons." In Jay Black (ed.), *Mixed News: The Public/Civic/Communitarian Journalism Debate* (Mahwah, N.J.: Lawrence Erlbaum, 1997), p. 103.

9. Gans, pp. 234–5.

10. Heikki Heikkilä and Risto Kunelius, "Access, Dialogue, Deliberation: Experimenting with Three Concepts of Journalism Criticism," *International Media and Democracy Project*, 17 July

2002, http://www.imdp.org/artman/publish/article_27.shtml (accessed 12 July 2007), n.p.

11. Benkler, p. 171.

12. Gans, p. 322.

13. Jay Rosen, "The People Formerly Known as the Audience," *PressThink: Ghost of Democracy in the Media Machine*, 27 June 2006, http://journalism.nyu.edu/pubzone/weblogs/pressthink/2006/06/27/ppl_frmr.html (accessed 12 July 2007).

14. See Bruns, *Gatewatching*.

15. Clay Shirky, "Broadcast Institutions, Community Values," *Clay Shirky's Writings about the Internet: Economics & Culture, Media & Community, Open Source*, 9 Sep. 2002, http://shirky.com/writings/broadcast_and_community.html (accessed 24 Feb. 2007), n.p.

16. Jo Bardoel and Mark Deuze, "'Network Journalism': Converging Competencies of Old and New Media Professionals," *Australian Journalism Review* 23.3 (Dec. 2001), p. 94.

17. Rusty Foster, "The Utter Failure of Weblogs as Journalism," *Kuro5hin* (11 Oct. 2001), http://www.kuro5hin.org/story/2001/10/11/232538/32 (accessed 27 Sep. 2004), n.p.

18. Bardoel & Deuze, pp. 98-9.

19. Henry Jenkins, *Convergence Culture: Where Old and New Media Collide* (New York: NYU Press, 2006), p. 259.

20. Hassan Masum and Yi-Cheng Zhang, "Manifesto for the Reputation Society," *First Monday* 9.7 (July 2004), http://firstmonday.org/issues/issue9_7/masum/ (accessed 27 Feb. 2007), n.p.

21. Shirky, "A Group Is Its Own Worst Enemy," n.p.

22. Foster, n.p.

23. Also see Bruns, *Gatewatching*.

24. Anita J. Chan, "Collaborative News Networks: Distributed Editing, Collective Action, and the Construction of Online News on Slashdot.org," MSc thesis, MIT, 2002, http://web.mit.edu/anita1/www/thesis/Index.html (accessed 12 July 2003), ch. 3.

25. Shane Bowman and Chris Willis, *We Media: How Audiences Are Shaping the Future of News and Information* (Reston, Va.: The Media Center at the American Press Institute, 2003), http://www.hypergene.net/wemedia/download/we_media.pdf (accessed 21 May 2004), p. 28.

26. J.D. Lasica, "Blogs and Journalism Need Each Other," *Nieman Reports* (Fall 2003), http://www.nieman.harvard.edu/reports/03-3NRfall/V57N3.pdf (accessed 4 June 2004), p. 71.

27. Dan Gillmor, "Foreword," in Bowman & Willis, p. vi.

28. Dan Gillmor, "Moving toward Participatory Journalism," *Nieman Reports* (Fall 2003), p. 79.

29. Bowman & Willis, p. 44.

30. Qtd. in Bowman & Willis, p. 60.

31. Bowman & Willis, p. 60.

32. Bardoel & Deuze, p. 97.

33. Foster, n.p.

34. Bowman & Willis, p. 33.

35. Will Richardson, *Blogs, Wikis, Podcasts, and Other Powerful Web Tools for Classrooms* (Thousand Oaks, Calif.: Corwin Press, 2006), p. 31.

36. Meikle, p. 99.

37. Gans, pp. 313ff.

38. Heikkilä & Kunelius, n.p.

39. Glenn Harlan Reynolds, "Weblogs and Journalism: Back to the Future?" *Nieman Reports* (Fall 2003), p. 82.

40. Mark Pesce, "Qui Bono? [sic]". *Hyperpeople: What Happens after We're All Connected?* 11 Nov. 2006, http://blog.futurestreetconsulting.com/?p=24 (accessed 20 Feb. 2007), n.p.

41. Bowman & Willis, pp. 38–41.

42. Benkler, p. 105.

43. Chan, ch. 5.

44. Gans, p. 318.

45. Gans, p. 322.

46. Benkler, p. 264.

47. Leander Kahney, "Citizen Reporters Make the News," *Wired News*, 17 May 2003, http://www.wired.com/news/culture/0,1284,58856,00.html (accessed 12 July 2007), n.p.

48. Also see Mark Deuze, Axel Bruns, and Christoph Neuberger, "Preparing for an Age of Participatory News," *Journalism Practice* 1.3 (2007), pp. 322–338.

49. Jay Rosen, "Welcome to NewAssignment.Net," *New Assignment*, 19 Aug. 2006, http://newassignment.net/blog/jay_rosen/welcome_to_newassignment_net (accessed 12 July 2007), n.p.

50. Chan, ch. 2.

51. Bowman & Willis, p. 50.

52. Chan, ch. 1.

53. Rushkoff, p. 18.

54. Qtd. in Bowman & Willis, p. 33.

55. Benkler, p. 177.

56. Pablo J. Boczkowski, "Redefining the News Online," *Online Journalism Review*, http://ojr.org/ojr/workplace/1075928349.php (accessed 24 Feb. 2004), n.p.

57. Benkler, p. 213.

58. Heikkilä & Kunelius, n.p.

59. Jürgen Habermas, "Political Communication in Media Society: Does Democracy Still Enjoy an Epistemic Dimension? The Impact of Normative Theory on Empirical Research," *Communication Theory* 16.4 (2006), p. 423.

60. Bowman & Willis, p. 13.

61. Qtd. in "New Forms of Journalism," n.p.

62. Jenkins, p. 257.

63. Bill Kovach and Tom Rosenstiel, *The Elements of Journalism: What Newspeople Should Know and the Public Should Expect* (New York: Crown, 2001), p. 18.

64. Bowman & Willis, p. 49.

65. The growing popularity in the United States of U.K.-based news sources *Guardian Unlimited* and *BBC News Online* may be able to be explained this way—as domestic news organizations have largely abdicated their role as a Fourth Estate, news bloggers and citizen journalists in the United States have popularized such alternative mainstream sources through their gatewatching efforts.

66. Qtd. in Chris Nuttall, "Net Users Take over News," *BBC Online News* (2 July 1999), http://news.bbc.co.uk/1/hi/sci/tech/383587.stm (accessed 3 June 2004), n.p.

67. Bowman & Willis, p. 56.

68. Mark Deuze, "The Internet and Its Journalisms," *Online Journalism Review*, 27 Jan. 2003, http://www.ojr.org/ojr/future/1026407729.php (accessed 11 Dec. 2003), n.p.

69. Lasica, p. 71.

70. Bowman & Willis, p. 50.

71. Shirky, "Broadcast Institutions, Community Values," n.p.

72. Gans, p. 332.

73. Heikkilä & Kunelius, n.p.

Wikipedia:
Representations of Knowledge

At the conclusion of the previous chapter, we noted the fact that citizen journalism holds one of the keys to restoring access to public participation in one of the core institutions of modern society: journalism. Further, such public access makes possible a more profound transformation of journalism, enabling a greater focus on public deliberation in and through its coverage. In this, citizen journalism is not alone among produsage-based approaches to information and knowledge management—indeed, it is accurate to say that the collaborative creation and management of knowledge, whatever form that knowledge may take, should be seen as the very heartland of produsage.

In enabling new forms of knowledge creation, produsage ties into wider trends towards the positioning of information and knowledge at the very center not only of postindustrial economies, but also of human endeavor in the twenty-first century itself. Knowledge, or the emerging 'knowledge space' which we, and it, inhabit, is what Lévy refers to as a "new horizon" for civilization.

> There are at least three aspects to this newness: the rate of evolution of knowledge, the number of people who will be asked to learn and produce new forms of knowledge, and finally, the appearance of new tools (cyberspatial tools) capable of bringing forth, within the cloud of information around us, unknown and distinct landscapes, singular identities characteristic of this space, new sociohistoric figures.[1]

Over the following chapters, we will encounter and explore a number of such new cyberspatial tools, but—in keeping with an approach that is founded not in a sense of technological determinism, foregrounding those tools, but in a focus on the intellectual, social, and cultural principles of produsage which made them possible and continue to drive them—we examine the application of open, collaborative, produsage methodologies to the creation, collation, and combination of information and knowledge across various technological platforms now leading Web 2.0 phenomena.

The development and deployment of working and sustainable produsage projects and processes across these various fields of information and knowledge creation and management is necessarily dependent on a combination of social structures, intellectual drivers, community culture, *and* technological supports; as we will see, this confirms Lévy's assertion that

> new communications systems should provide members of a community with the means to coordinate their interactions within the same virtual universe of knowledge. This is not simply a matter of modeling the conventional physical environment, but of enabling members of delocalized communities to interact within a mobile landscape of signification. Events, decisions, actions, and individuals would be situated along dynamic maps of shared context and continuously transform the virtual universe in which they assume meaning. In this sense cyberspace would become the shifting space of interaction among knowledge and knowers in deterritorialized intelligent communities.[2]

In Chapters 7 and 8, we examine spaces which appear to fully mobilize and deterritorialize this shifting space of signification and knowledge (only to find that new central hubs and nodes, and new authorities for knowledge creation and verification, appear from within this knowledge space). For now, however, we turn our attention to what must surely be seen as the first major institution of the emerging knowledge space, "the poster child for the collaborative construction of knowledge and truth that the new, interactive Web facilitates"[3]: the collaboratively created and edited online encyclopedia *Wikipedia*.

Wikipedia is by no means the first encyclopedia to take to cyberspace, and indeed its story of development provides some useful reminders for those who consider the translation of offline, production ventures into an online, produsage world. By now it has become, however, by far the most successful online encyclopedia both in terms of its userbase and the breadth of its coverage. Beyond this, it is also the quintessential example for the use of wiki technology in an open access, open participation context.

Wikis themselves are, alongside blogs, perceived to be one of the key drivers of the wider Web 2.0, social software phenomenon. Indeed, they provide a useful complement for blogs and similar content management tools as we have encountered them in our discussion of citizen journalism: where blogs are founded in the first place on a temporal organization and classification of their contents (customarily listing the most recently created articles in the most prominent position), and therefore proceed from a time-based logic, wikis instead implement a space-based structure. Wikis enable their users to create a network of knowledge that is structured *ad hoc* through multiple interlinkages between individual pieces of information in the knowledge base; they represent, in short, a rapidly changeable microcosm of the structures of the wider Web beyond their own technological boundaries.

They add to this Web-like structure by introducing functionality not commonly found in the World Wide Web itself (though a frequent feature in the design sketches

for hypertext systems other than the Web): content in wikis is inherently designed to be easily editable by all users of the wiki system. Indeed, *Wikipedia* takes this editability further than many other wiki implementations, some of which restrict the right to edit only to a small group of registered, authorized users: in *Wikipedia*, as its iconic slogan puts it, "anyone can edit." This, of course, is anathema to the traditional processes of encyclopedic production, and has caused a great deal of controversy and confusion, as we will see.

In addition to the inherent (cyber)spatial features of wikis in general, and of *Wikipedia* in particular, wikis do also offer some degree of a secondary temporal structuration for their contents, however: individual pages within the wiki exist not only in their presently visible form, but also include both a page history (enabling users to see and compare previous edits of a page to thereby examine the genesis of its present contents), and a discussion function (providing a space for a more or less strictly temporally structured conversation about the page development process and related issues). Both such features, as we will see, play a crucial role in facilitating the process of knowledge construction in any wiki, and in *Wikipedia* especially.

Creating *Wikipedia*

The core object of produsage processes in the *Wikipedia* as a collaborative online encyclopedia, then, are *representations of knowledge*. This is a small but significant departure from traditionally produced, standard encyclopedias, in fact, which aim not to present representations of knowledge, but to encapsulate the current state of accepted knowledge itself; it is a departure, indeed, which fundamentally makes possible the project of encyclopedic produsage under the massively multi-user, collaborative model of the *Wikipedia*. Even with this slightly altered aim, however, the creation of an encyclopedia through collaborative produsage processes may appear to be an unlikely project at first—stereotypical conceptions of encyclopedia creation do not lend themselves obviously well to attracting large masses of users.

However, that view overlooks the fact that within the communities of the (online) world, a great deal of knowledge is inherent already, and had already been compiled at least in part through a variety of more or less produsage-based, communal processes for several decades before the emergence of *Wikipedia* to public attention. Online enthusiast communities covering topics as broad-ranging as quantum physics, *Star Trek*, and post-structuralism had been active in the discussion fora of mailing-lists and Usenet, and their interactions had gradually given rise to the compilation of Frequently Asked Questions (FAQ) lists by core community members.[4] Some such FAQs provide simply brief guides to the house rules of specific online communities; others, however, offer clear and in-depth introductions to the key objects of enthusiasm of their communities. Intentionally or accidentally, *Wikipedia* directly connects into such processes:

beyond community members' homepages or separate Websites and wikis set up to accommodate the community's core knowledge, it provides a central, accessible, and easily editable space for the compilation and maintenance of such communal knowledge, and an effective means for the aggregation of multiple and diverse such community knowledge bases into a unified, single project devoted to the compilation, synthesis, and extension of representations of human knowledge about the world.

But of course *Wikipedia* does not stop with the aggregation of existing knowledge communities and their accumulated information into a larger whole. In addition, it also provides the means for the compilation of knowledge beyond what had already been compiled by enthusiast groups; here, as recent events have shown, *Wikipedia* has also proven particularly effective in its coverage of current, unfolding events. In this process, it builds on the fundamental practices of gatewatching as we have encountered them in the previous chapter, but employs them towards its own ends: not to the highlighting and analysis of reports on current events in the pursuit of public debate and deliberation (although such interaction is certainly also present especially on *Wikipedia*'s discussion pages), but to the chronicling of history as it happens, and the gradual transformation of such chronicles into ever more solid representations of human knowledge about the history of the present, and of the recent past. Thus,

> like journalism, *Wikipedia* offers a first draft of history, but unlike journalism's draft, that history is subject to continuous revision. *Wikipedia*'s ease of revision not only makes it more up-to-date than a traditional encyclopedia, it also gives it (like the Web itself) a self-healing quality since defects that are criticized can be quickly remedied and alternative perspectives can be instantly added.[5]

Though today a success on many levels, it is important to note that *Wikipedia*'s immediate predecessor project, the *Nupedia*, had been an abject failure. Originated in March 2000 by Internet entrepreneur Jimmy Wales and editor-in-chief Larry Sanger, Nupedia operated on a traditional production model: Sanger

> assembled a roster of academics to write articles. (Participants even had to fax in their degrees as proof of their expertise.) And he established a seven-stage process of editing, fact-checking, and peer review. "After 18+ months and $250,000," Wales says, "we had 12 articles."[6]

Indeed, the core difference between *Nupedia* and *Wikipedia* is the former's dependence on established experts and a traditional, editor-based content review process: as Sanger describes it, *Nupedia*'s expert contributors "were editors and peer reviewers; the general public was able to propose and write articles on subjects about which they had some knowledge,"[7] but such articles remained subject to the editorial process before being posted to the site.

This arduous review process, especially as it was carried out by a highly limited number of dedicated paid and volunteer staff acting as editors for the project, must be

seen as the fundamental reason for *Nupedia*'s failure, even though it may have been perfectly well suited to the production of a commercial (online *or* offline) encyclopedia in the traditional model. It becomes clear that the *Nupedia* process not only did not harness the potential of produsage to its own ends, but indeed specifically denied the affordances of the preconditions for produsage as we have outlined them in Chapter 2 (trust in the equipotentiality of the contributor base, pursuit of a probabilistic approach to content creation processes, establishment of granular content creation practices, embrace of a shared ownership of outcomes):

- *Nupedia*'s closed or at least semi-closed approach to public participation clearly refused to entertain the possibility that available contributors in the wider community held an equal potential to contribute useful content;
- its editorial governance structure severely restricted the extent to which a parallelization of processes in pursuit of probabilistic effects was feasible, due to the necessarily limited number of editors acting as gatekeepers on the project;
- its production processes limited the level of granularity by focusing mainly on the development of full, self-standing new articles rather than also enabling cosmetic and minor edits of existing content (partly because the limited amount of editor staff-hours had to be directed towards assisting the creation of new articles rather than overseeing the incremental improvement of existing content);
- editorial oversight and approval processes distanced contributors from the final product, thereby reducing the sense of shared ownership in the site and limiting the individual rewards able to be derived from participation in the project.

A closer observation of knowledge creation in online spaces reveals that each of these preconditions is indeed potentially present and accessible for the creation of an online encyclopedia, however: the vast majority of Web users will be in a position to contribute *some* useful knowledge or skills to the collaborative project; an encyclopedia which divides its content into a large number of self-contained entries on specific topics does offer the basis for massively parallelized content development processes generating probabilistic effects; a process of development which enables users to participate by contributing anything from minor cosmetic edits to major new collections of knowledge does provide for a high level of granularity in editorial processes; and the sharing of outcomes not only does not undermine, but may indeed boost the sustainability of the project.

Nupedia's failure to recognize this potential for a wider involvement of the general public as co-creators of its content results from an approach strongly founded in the physical tradition of industrial production, of course. Here, several practical reasons

serve to constrain the feasibility of widespread collaborative approaches involving a diverse group of contributors:

> in the industrial economy in general, and the industrial information economy as well, most opportunities to make things that were valuable and important to many people were constrained by the physical capital requirements of making them. ... The practical individual freedom to cooperate with others in making things of value was limited by the extent of the capital requirements of production.[8]

Traditional encyclopedias are produced in the way they are not only because they inherently place trust only in the contributions of accredited experts; they also operate in this way because the traditional physical model of encyclopedia production allowed no openings for the participation of the wider public. With a move towards an online environment, this is no longer the case; there is no reason why traditional-model online encyclopedias from *Britannica* to *Encarta* should not at least allow their users to contribute by highlighting and/or correcting errors of expression and grammar, for example—thus open-sourcing at least part of the editorial process—or by adding their own contributions in areas not commonly covered (at least in detail) by mainstream encyclopedias: for example, at its most basic this could involve the contribution of detailed biographies and content analyses in fields of knowledge in which professional, accredited experts are outnumbered and outperformed by amateur, enthusiast experts.

A move to wiki-based approaches offered a model for *Nupedia* to harness the knowledge of the wider Net userbase in this form, but met with significant reluctance from *Nupedia*'s core participants, as Sanger writes: "a clear majority of the Nupedia Advisory Board wanted to have nothing to do with a wiki. Again, their commitment was to rigor and reliability, a concern I shared with them and continue to have."[9] (We will see this question of rigor and reliability, and more broadly the question of how to accommodate contributions both from externally accredited experts and from enthusiast contributors gaining merit in the community through their participation in produsage, reappear throughout the following chapters; indeed, it provides one of the core hurdles to a mainstreaming of produsage processes in partial replacement of traditional production models. Former *Nupedia* editor turned *Wikipedia* critic Sanger is a particularly vocal proponent of such critiques.) Ultimately, however, the continuing failure of *Nupedia* to produce content left little alternative than to explore the open participation, wiki-based collaboration model of creation encyclopedic content:

> in 2001, ... Wales and his team eliminated most of Nupedia's barriers to participation and invented Wikipedia. ... A grassroots encyclopedia, Wikipedia ... [uses] strict open source principles: Anybody can write an article, and anybody else can improve it. Revisions are posted on a Recent Changes page where suggestions are pored over by a dedicated group of Wikipedians. "There's a simple way to tell if it's any good," says Wales. "Find an entry on something you know something about. Odds are it'll hold up pretty well—you'll probably even learn something new."[10]

We will examine claims and counterclaims related to *Wikipedia*'s quality and accuracy later in this chapter; for now, at any rate, the fundamental statistics about this new online encyclopedia indicate at least the significant popular success of the produsage-based model: at the time of writing, the front-running English version of *Wikipedia* alone contains some two million articles, with another thirteen *Wikipedia* versions in a variety of languages from German to Japanese also well above the 100,000 article mark, and a total of some 200 *Wikipedia* versions containing at least 100 articles in their respective languages from Māori through Latin to Esperanto. The English version also boasts some 4.5 million registered users (due to the lack of registration requirements for editing the *Wikipedia*, not to be misunderstood as an accurate count of its active, productive participants), with the top ten *Wikipedias* all well above the 100,000 user mark.

Wikipedia as Produsage

What has made *Wikipedia* such a popular project is its clear embrace of produsage principles as we have encountered them in our investigation of open source and citizen journalism already. *Nupedia* was based on closed participation, a fixed hierarchy of experts, a focus on creating complete encyclopedia entries (importantly determined also by its limited contributor numbers, which meant that *Nupedia* could not allow itself the luxury of interminably fine-tuning its content entries once a passable version was available, but instead had to move on to the next topic to be covered), and—while freely available—did not make its contents communal property to be developed by the community. *Wikipedia*, on the other hand, embraces what Sanger has described as

> radical collaboration, in which (in principle) anyone can edit any part of anyone else's work, ... one of the great innovations of the open source software movement. On Wikipedia, radical collaboration made it possible for work to move forward on all fronts at the same time, to avoid the big bottleneck that is the individual author, and to burnish articles on popular topics to a fine luster.[11]

In other words, then, *Wikipedia* embraces the produsage principle of **open participation, communal evaluation** in the first place by implementing its 'anyone can edit' approach. By default, all *Wikipedia* pages are directly editable by all users, and users are also able to start new topic pages as required; indeed, there is no need even for prior registration of a user account to begin editing the *Wikipedia*. In addition, like most other wikis the site offers the means of examining and comparing previous edits of the same page for later users to evaluate the quality of work of their predecessors, and discussion features attached to each article to engage with fellow producers in this process of communal evaluation. *Wikipedia* editing processes are facilitated through a two-fold communicative engagement, then: they combine communication through

changes to the content of encyclopedia entry pages themselves, and communication through the discussion features attached through such pages. The fact that communication can take place directly through content changes, bypassing a preceding stage of negotiating collaborative involvement through community discussion, therefore marks *Wikipedia* content creation work as a form of stigmergic collaboration as Elliott describes it, and contributes to *Wikipedia*'s rapid development speeds:

> the use of stigmergic communication to sidestep social negotiation effectively fast-tracks the creative gestation period, removes social boundaries and as a consequence lowers the 'costs' of contribution by eliminating the need to become acquainted with and maintain relationships with fellow contributors. This is not to say that developing and maintaining relationships with co-authors isn't a valuable thing to do, or that it isn't possible during a stigmergic collaboration, but rather that it isn't a fundamental part of this collaborative process, whereas it is in traditional co-authorship.[12]

However, on many *Wikipedia* pages, *ad hoc* groups of topic enthusiasts engaged in the continuing discussion of the editing processes of 'their' pages *have* emerged. Such groups hold no inherent control over the content of the pages they focus on, however; both existing and new users remain able to make whatever changes they deem appropriate (but established groups of users on these pages do check back regularly and revert changes or make further edits if they feel that the previously existing community consensus on the content of a specific page has been violated).

This, then, also points us to the fact that *Wikipedia* adheres to the second core principle of produsage: the presence of **fluid heterarchies organized through *ad hoc* meritocratic governance**. As Jenkins notes, "the Wikipedia community, at its best, functions as a self-correcting adhocracy. Any knowledge that gets posted can and most likely will be revised and corrected by other readers."[13] Indeed, the continued *ad hoc* processes of the *Wikipedia* contribute directly to the emergence of its heterarchy: those users most active in editing content and engaging with the edits of others necessarily rise to greater visibility in their communities, and have the potential to become community leaders (but also community outcasts, if their participation is seen to be consistently in conflict with the contributions of the majority of other participants). This is a phenomenon well-known from many other forms of communal participation in computer-mediated communications environments: visibility in such environments, through sustained constructive participation, generally tends to lead to participant centrality in the community.

Overall, then, heterarchical structures will gradually emerge in the multiple spaces of the *Wikipedia*:

> multiple contributions to stigmergic collaborations naturally form clusters representing the contributors' interests. ... These 'contributor groups' form networks that may operate either implicitly or explicitly, with groups actively working together or (and perhaps more frequently) remaining largely unknown to each other.[14]

This should not be misunderstood as necessarily leading to the gradual rise of more permanent structures of administration and governance, however, as the fundamental openness to (anonymous) participation within the environment of the site also militates against permanence; again, the *Wikipedia* does not force its contributors to become part of the enthusiast communities which form around its topics. By avoiding such requirements it retains a largely decentralized, distributed structure for its community, maintaining what Bauwens describes as a peer-to-peer dynamic: "whereas hierarchical systems are based on creating homogeneity amongst [their] 'dependent' members, distributed networks using the P2P dynamic regulate the 'interdependent' participants preserving heterogeneity. It is the 'object of cooperation' itself which creates the temporary unity"[15]—and a very temporary unity at that.

Beyond the level of individual content areas, however, the gradual emergence of a somewhat more permanent structure of *Wikipedia* administrators can also be observed. This is not necessarily a threat to the overall heterarchical structure of the project, however: we have seen similar tendencies towards the emergence of 'benevolent dictators' and other key community leaders from within the community, based on their merit as project originators and participants, in the fields of open source and citizen journalism. (We examine the question of leadership within the *Wikipedia* in more detail in the next chapter, however.) There as much as here, community leaders and administrators are only tenable as long as they continue to respect the fundamentally heterarchical rather than hierarchical power structures of the produsage project, at any rate—as *Wikipedia*'s own documents outline, "respected editors [must] also respect the anarchic 'accept all comers' approach to this collaborative endeavor. Newcomers are a valued resource."[16] Failure to do so would not only serve to alienate new participants, thus possibly leading to a gradual reduction in the influx of new users to *Wikipedia*'s produsage processes, but would also lead to significant fissures within *Wikipedia*'s established community, most likely forcing the retreat of overly autocratic leaders. Like *Wikipedia* itself, therefore, its power structures and participant relationships remain under constant development.

Ultimately, then, *Wikipedia*'s content development processes are determined through the two key communicatory processes of direct content creation in the wiki environment, and community discussion *about* the content creation process (which also takes place in the wiki environment itself, and contributes to the development of content as well as of community structures). Despite the very open invitation to participate which *Wikipedia* offers to all comers, and of the highly fluid heterarchical structures of community organization especially at the coalface level of content creation within the individual wiki entries, content and community development are thus tightly bound together within the overall produsage process in the *Wikipedia*; as Doctorow describes it, "Wikipedia *entries* are nothing but the emergent effect of all the angry thrashing going on below the surface."[17]

Content creation within the *Wikipedia*, therefore, must necessarily remain an always incomplete, continuing process relying on the continued constructive participation of the *Wikipedia* community; quite apart from the more fundamental philosophical question of whether it could ever be possible to arrive at a full and complete definition of any one topic within an encyclopedia, the artefacts of the process remain as incomplete as the community's involvement is indefinite and subject to a continuing process of stigmergic negotiation—*Wikipedia* exhibits the core produsage principle of working with **unfinished artefacts in a continuing process**.

However, such processes guarantee neither quality nor accuracy, nor do they mean that the quality of content in the *Wikipedia* will necessarily improve over time. This is similar again to aspects of the open source and citizen journalism environments we have already encountered, in which a gradual appreciation in quality is reliant on probabilistic approaches which assume the net dominance of constructive contributions over disruptive edits. *Wikipedia* similarly embraces probabilistic calculations, and (writing in his former capacity as *Wikipedia*'s 'chief enthusiast') Sanger suggests that

> Wikipedia's self-correction process (Wikipedia co-founder Jimmy Wales calls it 'self-healing') is very robust. There is considerable value created by the public review process that is continually ongoing on Wikipedia—value that is very easy to underestimate, for those who have not experienced it adequately.[18]

Indeed, many of *Wikipedia*'s own contributors frequently hold the site's content to professional standards in their processes of communal evaluation, and this is a tendency prevalent especially in topical fields where a strong community of participants has by now gathered around a set of entries. Similar to what can be observed in other fields of produsage, the sense of community and belonging which exists in such environments may be seen as a key factor towards shifting the balance between positive and negative contributions towards a ratio which enables a gradual improvement in content quality; heterarchical communities of contributors which employ adhocratic, meritocratic forms of governance to police disruptions and encourage constructive collaboration are therefore a core ingredient of successful produsage projects.

At the same time, this may also explain why *Wikipedia* administrators themselves are surprisingly dismissive of the "'collective intelligence' or 'collective wisdom' argument: That given enough authors, the quality of an article will generally improve."[19] German *Wikipedia* administrator Elisabeth Bauer notes, for example, that "the best articles are typically written by a single or a few authors with expertise in the topic. In this respect, Wikipedia is not different from classical encyclopedias," and her Japanese counterpart Kizu Naoko adds that "most of the short articles remain short and of rather poor content"[20]—however, these statements should not be seen as an outright dismissal of 'collective intelligence' as articulated by Lévy: rather, they indicate that

collective intelligence in its full form only emerges where at least a semi-organized *collective* has been established.

Indeed, as we have already seen both in open source where individual programmers seed community through 'scratching an itch,' and in citizen journalism where the gatewatched summaries of mainstream media coverage of news events serve to kick-start a wider, deeper, more multiperspectival community discussion and deliberation, the development of such collective, community structures is frequently begun through the contribution of a first kernel of quality content by individual participants acting as produsage catalysts. In this sense, then, Kizu Naoko's statement that 'most short articles remain short' is perfectly in keeping with what we have come to expect, and Elisabeth Bauer's observation of a small core community of contributors around any one article—far from undermining the 'collective intelligence' idea—confirms it by showing that collective intelligence grows outwards from the actions of a small number of key participants who through the quality of their work and an open invitation to other contributors to further improve that quality are able to gradually attract a growing community of enthusiasts for the topic. Produsage phenomena, it appears, only set in once a minimal critical mass (in terms of both seed content and seed community) has been reached.

To be able to grow, then, necessarily also depends on the community's and the individual's adherence to the fourth key principle of produsage: the treatment of collaboratively created *Wikipedia* content as **common property**, from which **individual rewards** may nonetheless be derived for each constructive contributor. Although the latter aspect is at present not highlighted formally by the processes and systems of *Wikipedia* produsage, the need to place *Wikipedia* content in communal hands has been long recognized for both practical and intellectual reasons, and indeed serves as a founding principle of the encyclopedia. As Sanger notes, from a legal point of view,

> an open content, or free content, license is intended to guarantee that all of the content stays free forever. If we were simply to declare that the contents are in the public domain, then anyone could come along, make some slight changes to the text, and then copyright that, preventing others from using their slightly-changed version. We want to prevent that from happening.[21]

Indeed, as we have seen in previous chapters already, for practical reasons it seems virtually unavoidable that produsage projects use open content licenses in their various forms: although standard copyright is able to accommodate collaborative ventures and shared ownership of the resulting content, it does so only in the presence of a network of reciprocal usage and development permissions for individually held intellectual property that becomes exponentially more complex as more contributors join the collaborative effort; a further, similarly problematic alternative would be the general assignation of all intellectual property to a single administrator or to a jointly held

organization. Especially in the radically open participatory context of the *Wikipedia*, such approaches are clearly not feasible.

In addition, as Sanger also points out, the very direct sense of contributing their knowledge to the common good (the communal project of the *Wikipedia*) may provide an important motivating factor for participants:

> Wikipedia's contributors—called Wikipedians—understand that their efforts will be freely distributable forever. That is, I think, one of the main incentives they have to participate. If the organizers of the project were instead to claim the content for themselves, and not release it freely, the participants would have the sense that they were merely working for someone else's gain.[22]

(In fact, while the content of *Nupedia* was also freely available to all users of the site, it is possible to suggest that the sense of disconnection and distance between contributors and 'their' content, which the traditional-style editorial process necessarily introduced, turned out to be a crucial and crippling obstacle to the site's ability to generate a greater amount of participant enthusiasm.)

Motivations for participation in *Wikipedia* are therefore clearly determined not by content ownership considerations (including any sense of a possible commercial exploitation of one's intellectual property), but by the communal aspects of the site (both in the sense of contributing to the common good, and in the sense of participating in a knowledge community of enthusiast contributors). As Sanger describes it, "the focus on the encyclopedia provided the task and the open content license provided a natural motivation: people work hard if they believe they are teaching the world stuff,"[23] but this does not quite approach the core element of many participants' motivations to contribute to *Wikipedia*, perhaps: it is the sense of 'teaching the world stuff' *which they are enthusiastic about* which fundamentally drives *Wikipedia* contributors—the sense of working with fellow knowledge-holders (whether in fields of professional expertise or popular culture) and thus being a part of, or (more importantly) through participation being able to become a more central part of, a strong community of like-minded peers, and the sense of displaying that community knowledge, through the leading online knowledge base currently known, for the rest of the world to see.

This, then, also already points to the existence at least of an informal, individually experienced merit system offering personal rewards within *Wikipedia*; it is common for participants especially in the discussion fora attached to *Wikipedia* entries and topical areas to experience the presence of a clear (if heterarchical) delineation of participant merit, and thus of community centrality. As it does in other produsage environments, this informal merit system has the two-fold consequence of making it more difficult for newcomers to the community to assume key roles without a sometimes lengthy process of socialization (but *Wikipedia*'s open participation approach mitigates any deleterious effects of this tendency), as well as acting as a factor shifting the balance between constructive and negative contributions in favor of a net positive—at least in

the sense of 'positive' as defined by the wider community. As such, then, it is possible to argue that establishing contributor merit more formally would be a useful step in the further development of *Wikipedia* (and we will return to this question in the following chapter).

Controlling *Wikipedia*

As Reagle notes, "one of the most interesting features of the Wikipedia is the community itself. ... Yet, ... having thousands of participants editing a Web site so as to produce a coherent product and congenial community is a significant challenge."[24] *Wikipedia*, though built through open participation, fluid heterarchical community structures, and *ad hoc* governance, is therefore not a rules-free zone; instead, it has developed a set of increasingly specific and complex policies for content creation and community collaboration. Like *Wikipedia*, and its content and communities, these rules necessarily continue to be in a constant state of flux; at the same time, however, a small number of fundamental policies act as the foundational law of the *Wikipedia* project. Their existence should not be misunderstood as an anachronism amid the open and flexible environment of produsage itself—indeed, the core principles of *Wikipedia* crucially serve to define the fundamental purpose of the project itself, and ensure its continued feasibility. In addition to the requirement that all content produced through the *Wikipedia* process be governed by an open content license, which we have already encountered as a necessity of produsage itself, then, *Wikipedia*'s three core rules in essence simply stipulate that *Wikipedia* be, and remain, an encyclopedia, and that its content adhere to that fact. In practice, this is governed through the principles of 'Neutral Point of View' (NPOV), 'Verifiability,' and 'No Original Research'.

As *Wikipedia* itself describes it,

> neutral point of view is a fundamental Wikipedia principle. According to Jimmy Wales, NPOV is "absolute and non-negotiable."
> All Wikipedia articles and other encyclopedic content must be written **from a neutral point of view (NPOV)**, representing fairly and without bias all **significant** views (that have been published by reliable sources).[25]

In its content development practices, *Wikipedia* therefore departs somewhat from the editorial principles of traditional encyclopedias, which are closer to comparable practices in conventional journalism by providing an evaluative synthesis of a variety of views as determined in the eyes of the individual or small group of authors for any one entry. *Wikipedia*, by contrast, is closer to the multiperspectival approach of citizen journalism, and allows its users to add further perspectives on the topic at hand as long as these perspectives are supported by available sources, and summarized in a neutral rather than clearly sympathetic or oppositional voice. Contrary to conven-

tional encyclopedias, therefore, *Wikipedia* does not inherently judge the validity of any one view on the topic, but rather presents such views side by side, for its users to evaluate; it does, however, limit the presentation of such competing views to 'significant' representations of knowledge only. This is an important distinction, and means that—by contrast with traditional encyclopedias, which seek to present the current state of knowledge about the world—*Wikipedia* presents the currently prevalent *representations of knowledge about the world*. (This shift is both an innovation and a problem in the *Wikipedia* model, as we discuss below.)

NPOV is further aided by the associated principles of 'Verifiability' and 'No Original Research,' which were introduced also in direct response to criticism that *Wikipedia* "lacks the necessary research and precision"[26]: to improve quality standards and ensure that the various points of view on any one topic are accurately and neutrally presented, *Wikipedia* has introduced ever-stricter requirements to cite the sources for claims made in its entries.

> "Verifiable" in this context means that any reader should be able to check that material added to Wikipedia has already been published by a reliable source. Editors should provide a reliable source for quotations and for any material that is challenged or is likely to be challenged, or it may be removed.[27]

In a further effort to avoid that Verifiability can be claimed for self-published research which has not undergone some degree of review by relevant authorities, the 'No Original Research' policy outlaws self-published or 'original' research:

> **Original research (OR)** is a term used in Wikipedia to refer to unpublished facts, arguments, concepts, statements, or theories. The term also applies to any unpublished analysis or synthesis of published material that appears to advance a position—or, in the words of Wikipedia's co-founder Jimmy Wales, would amount to a "novel narrative or historical interpretation."[28]

Such policies are far from unproblematic, of course—especially when viewed through the eyes of the traditional encyclopedic paradigm, aiming to present knowledge itself rather than just to present the currently predominant representations of it. Indeed, *Wikipedia* itself makes plain that "the threshold for inclusion in Wikipedia is **verifiability, not truth,**"[29] surely a difficult statement to accept for the editors and contributors of conventional encyclopedias. However, this shift can be seen as immediately paralleling the approach of citizen journalism in its engagement with news stories: here, too, the immediate focus is on the representation of a wide variety of perspectives on the news, with the ultimate aim of thus enabling the formation of a wider consensus about their interpretation; *Wikipedia*, as we will see, can be regarded as providing the space for similar consensus formation through its necessarily non-conclusive, NPOV-driven, multiperspectival approach to the representation of knowledge.

Finally, an additional component of the *Wikipedia* policy core is the principle of 'WikiLove'. WikiLove can be seen as both a necessary aspect of an open participation produsage site hoping to continue to attract new contributors even as its more established communities begin to form more elaborate heterarchical structures of governance, and a fundamental enabler of the broad coverage of representations of knowledge through the NPOV approach:

> WikiLove is a term that refers to a general spirit of collegiality and mutual understanding. ... Because people coming from radically different perspectives work on Wikipedia together—religious fundamentalists and secular humanists, conservatives and socialists, etc.—it is easy for discussions to degenerate into flamewars. But we are all here for one reason: we love accumulating, ordering, structuring, and making freely available what knowledge we have in the form of an encyclopedia of unprecedented size. Wikipedia is not just another discussion forum—it is a project to describe and collect what we know.[30]

In practice, then, such principles are enforced through a number of governance tools relating both to the management of content, and to the governance of contributors. Through these tools, "Wikipedia, which began as an experiment in unfettered democracy, has sprouted policies and procedures."[31]

In the realm of content, an ever-growing array of content tags and page templates has enabled the gradual imposition of a growing structural consistency on the previously rather unruly spaces of the *Wikipedia*. On the one hand, this is a process of defining an increasingly complex set of genres and subgenres for the content of the *Wikipedia*; so, for example, many biographical pages in the site now share a set of common features, while subsets of that group (for example, the pages covering the lives of catholic popes, Australian prime ministers, or tennis grand slam winners) have further, more specific features which enable users to explore such groups more effectively. At the same time, content tags also allow users to highlight and trace in a more consistent way both the positives and negatives about extant pages in the *Wikipedia*: tags enable users to suggest particularly well-developed entries as candidates to be featured for a day on the *Wikipedia* front page, as well as to highlight their own or other contributors' work as incomplete, limited in scope, poorly edited, lacking sources, or otherwise defective (indeed, tags also allow users to suggest that a page be deleted altogether, for a variety of reasons). The wiki system itself provides tools for the easy aggregation and listing of all pages highlighted using particular content tags, too; this also helps to direct the efforts of willing produsers specifically to those pages which are currently considered to need the most work.

Further tools for content policing include so-called revert bots, which scan the *Wikipedia* database for unusual contribution patterns (including the insertion of obscene or otherwise unacceptable content) and automatically revert affected pages to their previous state, and a variety of similar automated tools. In addition, also to avoid

some of the more obvious forms of content vandalism, some likely target pages for vandalism (often including entries on the current U.S. President, or on controversial topics ranging from Israel to abortion) may be protected from editing by specific groups of users. Although this limits the open participation approach of the *Wikipedia*, it has become necessary in response to some persistent disruptions; it is important to note in this context that the restrictions to fully open editing remain relatively limited, however: so, for example,

> pages that are **semi-protected** cannot be edited by unregistered users or accounts less than four days old. A page can be semi-protected by an administrator in response to vandalism from multiple anonymous or newly-created accounts, where blocking them individually is not a solution. It can also be used to stop banned or blocked users who are using multiple IPs or accounts from editing an article. Semi-protection is usually a temporary measure, and lifted once the problem is likely to have passed.[32]

Indeed, as this description indicates, it is also possible for persistent offenders to be banned (by name, or by banning the IP address of their computer) from participation in the *Wikipedia* altogether—but such bans do not protect the site from users who register new usernames or begin accessing the site from another machine.

A development necessarily associated with the deployment of such content tracking and protection tools has been the emergence of a new class of users entitled to control such functionality, as well as facilitating the continuing development of the overall site. As long-time *Wikipedia* administrator Angela Beesley describes it for the English-language site, today

> there are readers, editors, administrators, recent changes patrollers (reverting vandalism), policy makers, subject area experts (WikiProjects offers a place for people who want to focus on one topic to have a focused community within the larger Wikipedia community), content maintainers, software developers, system operators and many more. There are also all sorts of informal groups within the project. For example, the welcoming committee is a self-selected group of people who say they will help with welcoming new users. A more formally selected group is the Arbitration Committee.[33]

This is a clear indication of heterarchical tendencies in progress, but like all heterarchies it also carries within it the threat of its own destruction if heterarchical structures were to solidify into a more permanent, impermeable hierarchy; an overtly and strongly hierarchically controlled *Wikipedia* would constitute a fundamentally different environment from the heterarchical fluidity which characterizes the present-day *Wikipedia*. As Japanese *Wikipedia* administrator Kizu Naoko describes it, like-minded enthusiasts "sometimes ... build a small community around their topic, so they build a portal for it. Such a portal tends to maintain a list of new articles (on that topic) and invites editors to work on those new entries."[34] This emergence of topic portals constitutes the emergence of a topical heterarchy from the initially flat network structure of the wiki in parallel with the emergence of a contributor heterarchy from open partici-

pation; it is evidence of the beginning of a (in the context of a wiki necessarily loose) canonization of what the community considers to be 'core' knowledge relevant to its interests, but holds significantly less power than the topical canon structures presented in traditional encyclopedias as the wiki environment always allows for the simultaneous presence of a variety of alternative canonical structures (and indeed, through the principle of NPOV, affords each such canon equal status).

We must also keep in mind that the interest communities which develop such portals as the bases for their collaborative content development work are very unlikely to work in complete isolation from one another; instead, they and their content frequently overlap with the communities and knowledge resources developed in related topical areas. In this way, both topical communities and their content form a loose and fluid patchwork of what we may be able to describe as issue publics, and together constitute the overall *Wikipedia* community and its shared information commons itself. *Wikipedia*'s distributed, heterarchical structure as a community of communities (rather than simply as one unified overall community) represents what can be described as a second-order form of communality, therefore, and "a crucial difference with second-order communality is that the communal information good now results from largely *uncoordinated* efforts, even though the collective action remains widespread and dependent on individual contributions."[35]

The continuing development of these shared spaces and structures is frequently referred to as a form of 'wiki gardening,' and as Kizu Naoko points out,

> some prefer to call maintainers janitors or gardeners. ... While in principle everyone can initiate a new policy creation process, it is usually just a small number of people who actually do this and draft new policies. I think we are still determining some of these 'legislative' roles. Some ... are formally defined, many of them are informal.[36]

The gardening metaphor is a productive one, and can be usefully extended to encompass the processes of landscaping more generally. The metaphor combines both Lévy's frequent references to our engagement in collective intelligence as a form of wandering in the newly deterritorialized knowledge spaces of humanity, and Elliott's highlighting of stigmergy as the reshaping of our collective environments through collaborative communicative engagement. Merholz notes real-life landscapes in which

> foot-worn paths ... appear in a landscape over time. Called "desire lines," these trails demonstrate how a landscape's users choose to move, which is often not on the paved paths. A smart landscape designer will let wanderers create paths through use, and then pave the emerging walkways, ensuring optimal utility.[37]

Transferred to the contexts of *Wikipedia* in particular, and of produsage more generally, this observation points to the need not to predetermine users' movements through and engagement with collaborative spaces, but to enable them to develop their own connections with, productive uses for, and transformational contributions

to such spaces and the informational objects they contain. This is an approach we have already seen employed in the communities of open source as they have allowed their social structures and development processes to emerge gradually from their own practices, and in the environments of citizen journalism as approaches to identifying quality content and rewarding productive contributions have matured over time. For *Wikipedia* and other more recent produsage projects, it points to a need to similarly allow the community to develop its own processes of content development and participant governance over time, rather than rush to conclusions about what should be implemented as the ideal structure for the communal process—a point to which we will return at various times throughout this and the following chapters. To follow this *in situ* and *ad hoc* rather than *ab exteriori* and *a priori* approach does not guarantee success, of course, and the application of foresight as well as hindsight by community leaders also remains important; it does appear to offer the best possible *chance* of success (in attracting contributors, developing content, and building an enthusiastic and committed community) for the produsage project, however.

From this perspective, then, it is also acceptable that the processes for dispute resolution and other consensus-building in the *Wikipedia* community remain inconsistent and provisional at this point. Indeed, the *Wikipedia* documentation itself shows signs of this lack of clarity in its description of how to put in train a decision-making process:

> virtually all existing voting methods have been tried and used, and no standard has been agreed upon yet. ... Basically, whenever you feel like it, you can try to start a vote on a talk page, but people will probably not participate in it if they think discussion has not yet been exhausted as a way to resolve conflicts of opinion. In general Wikipedia follows a deliberative democracy model, where nothing is in a hurry... it could evolve towards consensus democracy if the will is there.[38]

This lack of standards should not be confused for a lack of consensus-building mechanisms, then: rather, it indicates that within the individual issue publics that make up the *Wikipedia* (down to the level of any one encyclopedia entry and its associated 'talk' or discussion page), a variety of different yet nonetheless effective consensus models are in place. Over time, these may condense and standardize to form a set of generally accepted models, but that time has not yet arrived. For the moment, the *Wikipedia* community remains engaged in a process of multiple parallel evolution of its decision-making processes.

Criticizing *Wikipedia*

Both the considerable variations in content quality within the *Wikipedia* and the continuing lack of clarity about administrative structures within its community of users

have generated a significant amount of criticism of the site and its model of content produsage. In addition, the very rapid rise of *Wikipedia* to public recognition (though not necessarily deeper understanding), and the considerable challenge it offers to traditionally produced encyclopedias both online and offline, have served to further amplify both justified and more spurious critiques. Some such critiques have now been addressed at least in part by the *Wikipedia* community's increasing focus on enforcing its NPOV policy and related requirements to cite sources and avoid unverified original research, but a number of key criticisms remain common.

In particular, the site's policy of requiring a Neutral Point of View is itself the focus of many critics. Such criticism comes even though, as Rosenzweig has pointed out, "despite *Wikipedia*'s unconventionality in the production and distribution of knowledge, its epistemological approach—exemplified by the NPOV policy—is highly conventional, even old-fashioned."[39] Indeed, for a number of critics, the NPOV policy appears to indicate an altogether *too conventional* approach: it prevents Wikipedians from clearly taking sides on an issue, and instead leads to the creation of what some see as a rather weak and indecisive consensus position attempting to satisfy even diametrically opposed perspectives.

Perhaps such criticism misses the full implications of NPOV, however. It is true that some *Wikipedia* entries and topical areas devote a great deal of space to the presentation of what are generally considered to be 'fringe' theories lacking substantial supporting evidence, thereby creating the impression that such theories are as accepted in the expert community as are more mainstream views. While, for example, *Wikipedia* contains a detailed and (through some 200 citations) thoroughly referenced entry on the Darwinian theory of evolution, as well as a variety of additional subpages covering further detail, it also hosts similarly detailed and referenced pages on pseudoscientific concepts such as 'Creation Science' and 'Intelligent Design'. The coverage of such topics within the overall encyclopedia need not be regarded as one of its shortcomings, however; indeed, as Sanger points out, "a firm neutrality policy made it possible for people of widely divergent opinions to work together, without constantly fighting. It's a way to keep the peace."[40] Again it is important in this context to keep in mind the fact that *Wikipedia* departs from traditional encyclopedias by not presenting knowledge as such, but the divergent representations of knowledge currently in wider circulation; it describes (interpretations of) reality rather than itself making judgments of what is real.

Further, the very act of compiling and presenting such fringe views for a wide and diverse audience also enables their critique and refutation, both through the discussion pages and other social spaces of *Wikipedia* themselves and through a broader public discourse beyond it. This can be seen as a key contribution by *Wikipedia* to the wider processes of collective intelligence of which it forms a part, as Lévy defines them:

collective intelligence is less concerned with the self-control of human communities than with a fundamental *letting-go* that is capable of altering our very notion of identity and the mechanisms of domination and conflict, lifting restrictions on heretofore banned communications, and effecting the mutual liberation of isolated thoughts.[41]

Similarly, it is also important to understand the fundamental operation of NPOV in full detail: contrary to the synthesis commonly required for the coverage of topics in conventional encyclopedias, NPOV does not require the establishment of a universally accepted consensus description of the topic at hand—a kind of graveyard peace between opposing factions, achieved through arrival at a compromise which satisfies no one and omits any controversial points not acceptable to one of the participants. Instead, as Reagle points out, "the NPOV policy ... recognizes the multitude of viewpoints and provides an epistemic stance in which they all can be recognized as instances of human knowledge—right or wrong." Thus, he notes, "it may act rather as a heat shield: reducing conflict and otherwise channeling outstanding arguments in the productive context of the primary goal of developing an encyclopedia that is representative of many viewpoints."[42] Conflict over the correct representation of a topic, therefore, is redirected through the operation of the NPOV policy ideally towards all sides of the argument engaging productively to ensure that *their* preferred interpretation is presented most convincingly—a recasting of otherwise often bitter argument as a competition for discursive leadership without resorting to destructive means. (That said, destructive means of gaining the upper hand in disputed topical areas are sometimes utilized in the *Wikipedia*—'revert wars' between opposing factions which in turn remove one another's page edits, and the deliberate defacement of oppositional pages, do occur. These tend to be swiftly dealt with both through automated bots and the intervention of *Wikipedia* administrators, and usually do more damage to the causes they are designed to support than to those they oppose.)

Ultimately, then, the competitive contest between opposing views which the NPOV policy encourages can even be considered to have significant positive consequences: it enables the uncovering of a wide range of alternative perspectives on any given topic, and allows those perspectives to enter into a fair argumentative engagement with more established representations of knowledge. Building on the principle of equipotentiality, this is a key affordance of peer-to-peer, collaborative, communal modes of content creation, as Bauwens describes them:

> the individual has a single set of perspectives on things reflecting his [sic] own history and limitations. Truth can therefore only be apprehended collectively by combining a multiplicity of other perspectives, ... other unique points of integration, which are put in 'common'. It is this profound change in epistemologies which P2P-based knowledge exchange reflects.[43]

Again, however, it is also important to point out that *Wikipedia*'s fundamental project is not best characterized by an aim to collectively arrive at a universally agreed-upon

'truth'; more accurately, it merely presents representations of knowledge which may support individual participants in developing their own interpretations of 'reality' which are more or less closely aligned to current majority and minority consensus views.

Indeed, some common criticisms of *Wikipedia*'s NPOV principle and its multiple, divergent representations of knowledge may simply be considered to be part of a wider lament that any sense of the existence of a universal 'truth' has been thoroughly undermined in a postindustrial, postmodern context:

> we have again become nomads. ... Movement no longer means traveling from point to point on the surface of the globe, but crossing universes of problems, lived worlds, landscapes of meaning. These wanderings among the textures of humanity may intersect the well-delineated paths of the circuits of communication and transport, but the oblique and heterogeneous navigations of the new nomads will investigate a different space. We have become immigrants of subjectivity.[44]

Many of those who choose to attack *Wikipedia* for its lack of commitment to 'truth' are really engaged in a much larger, losing battle defending objectivity; *Wikipedia* provides merely an iconic target which can be used to rally their troops.

At the same time, however, somewhat paradoxically the spaces of the *Wikipedia* also sometimes serve as the last vestiges of established 'truths': as Rosenzweig points out, "*Wikipedia* can act as a megaphone, amplifying the (sometimes incorrect) conventional wisdom."[45] This over-reliance on an interpretation of available information through the lens of common sense is a common trait of everyday human communication, of course, and therefore difficult to overcome; the requirement for the verifiability of information and the outlawing of original, unreviewed research as we have seen them enshrined as universal principles of *Wikipedia* are clearly designed to militate against such tendencies, but will require constant and consistent enforcing in order to be effective.

Such principles also do not address the problem of provenance, as Schiff describes it: here, the question is not simply *whether* articles in *Wikipedia* cite their sources, but—even when they do—whether those sources constitute a sufficiently diverse and authoritative cross-section of available human knowledge on a specific topic.

> The bulk of Wikipedia's content originates not in the stacks but on the Web, which offers up everything from breaking news, spin, and gossip to proof that the moon landings never took place. Glaring errors jostle quiet omissions. Wales, in his public speeches, cites the Google test: "If it isn't on Google, it doesn't exist." This position poses another difficulty: on Wikipedia, the present takes precedent over the past. The (generally good) entry on St. Augustine is shorter than the one on Britney Spears.[46]

Provenance is likely to fade as a core problem for *Wikipedia* as the general trend for both old and new information on virtually all aspects of human knowledge to move

online continues; however, in the short term, it remains a problem especially for less digitally active areas of intellectual endeavor.

Comparisons such as that made by Schiff, between the entries for St. Augustine and for Britney Spears, are generally somewhat misleading, however, as outside the question of competing theories as we have discussed it earlier there is no obvious competition between the entries on any two randomly chosen topics within the encyclopedia. It is important to keep in mind in this context the produsage-based, parallelized mode of development of the *Wikipedia*, as opposed to production-based approaches to updating encyclopedias such as *Britannica* and *Encarta*: whereas a production model involving a strictly limited number of paid writing and editorial staff requires decisions about the allocation of effort across different topics to be made almost constantly, a produsage model harnessing the interests of an indefinite number of volunteer contributors does not operate under comparable conditions of scarcity. For *Britannica*, a staff hour spent on compiling the "Britney Spears" entry is an hour lost from "St. Augustine" or any other entry in the encyclopedia; for *Wikipedia*, that calculation does not hold.

Conversely, the content creation capacity of an open participation system such as *Wikipedia* advances beyond the closed production model precisely because it can harness the enthusiasm of participants with deep knowledge in topical areas whose inclusion in a conventional encyclopedia might be considered frivolous (indeed, it can even provide the means of developing encyclopedias in entirely fictional languages such as Klingon, without such work necessarily reducing the labor pool available for the development of the English or other real-world *Wikipedias*). As a community made up of a large variety of individual issue publics focusing on specific topical areas, *Wikipedia* can aspire to provide a coverage of the mythology of Tolkien's Middle Earth which is as detailed and accurate as that of historical Anglo-Saxon England; there is no automatism by which the fate of the two, or that of any other two topical fields covered by the community, is inversely linked.

In the process, indeed, *Wikipedia* rescues areas commonly excluded from conventional encyclopedias from their oblivion, and counteracts the institutionalized value judgments which have led to such exclusion. The omission of large swathes of popular cultural topics from traditional encyclopedias, indeed, is thereby revealed to be driven by operational reasons inherited from the age of print-based encyclopedias (where, similar to the production of newspapers, the need to keep the physical size of products manageable necessarily required a limitation to what were considered to be core fields of human knowledge); by contrast, *Wikipedia* is able to cover such topical areas in great detail and thereby affirms their importance to the everyday lives of its users—it has no selection criteria other than that a sufficient number of its participants found the topic important enough to develop an entry for it, and that independently verified material is available on which the encyclopedia entry can be based.

> Wikipedia is something new; it's not just a dry directory of facts, like its nearest com-
> petitor, Encyclopedia Britannica. Because it has been created by all of us, for all of us,
> its interests range as broadly as our own; Wikipedia has become the Codex of Cul-
> ture, the place where all things of interest to humanity—sacred, secular, vital and triv-
> ial—have been gathered together.[47]

A beneficial side effect of this broader role (in comparison with conventional encyclo-
pedias) may also be that initial participation of users in areas which they are most en-
thusiastic about may also socialize them to become constructive contributors on topics
to which they are able to make only smaller incremental contributions. This educative
role of users' participation in the creation of content related to popular culture has
also been highlighted in similar fashion for the participation of fans in other media
contexts.[48] If, then, as Rosenzweig notes, "'this is the encyclopedia that Slashdot built'
[is] a familiar complaint that alludes to the early promotion of Wikipedia by the Web
site that bills itself as the home of 'news for nerds,'"[49] it is a complaint which ulti-
mately may prove thoroughly misplaced: although *Wikipedia* may have been skewed
towards 'nerdy' topics in the early stages of its development, once the quality of arti-
cles in that field has reached a level no longer requiring in-depth involvement by large
numbers of users, those users can be expected to move on to other fields in which they
hold some knowledge they can usefully contribute. Playing on the other half of *Slash-
dot's* tag line "News for Nerds, and Stuff that Matters," the range of content covered in
detail in the *Wikipedia* must indeed be understood as a direct indication of the topical
information and knowledge—the stuff—that matters to its users; persistent attacks over
Wikipedia's apparent bias towards such topics may therefore well be accused of cultural
elitism.

Overall, then, Schiff must be said to be only partly correct in her assessment that
"Wikipedia is an online community devoted not to last night's party or to next sea-
son's iPod but to a higher good"[50]—for Wikipedians, these choices are no longer mu-
tually exclusive. Instead, *Wikipedia* can be seen as an important contributor to the
democratization of knowledge creation and representation, undermining the role of
traditional encyclopedic and similar publications in determining the canon of high
culture and accepted knowledge. *Wikipedia* makes no such *a priori*, conservative judg-
ments about what is or is not fit for an encyclopedia to contain; it offers a space for all
forms and fields of knowledge, and for its users as produsers of the representations of
that knowledge. "All of us have the right to be acknowledged as a knowledge identity"
(that is, as a source of knowledge), as Lévy asserts, and in thus acknowledging its con-
tributors, *Wikipedia* operates directly in keeping with the principles Lévy has outlined
for the emerging knowledge space:

> the knowledge space is brought to life whenever we initiate human relations based on
> ethical principles. These include individual improvement through skills acquisition,
> the efficient transformation of difference into collective wealth, the integration of the
> exchange of knowledge within a dynamic social process in which each of us is recog-

nized as a unique individual and is not prevented from learning by programs, prereq-uisites, *a priori* classifications, or prejudices about what is and is not worthwhile knowledge.[51]

Disrupting *Wikipedia*

Further strong criticism aimed at *Wikipedia* has been voiced over what are perceived as inaccuracies and mistakes in its content, especially also in the context of errors delib-erately introduced by malicious contributors. A number of such cases have been iden-tified by contributors and users of the *Wikipedia*, and indeed,

> it is … no more immune to human nature than any other utopian project. Pettiness, idiocy, and vulgarity are regular features of the site. Nothing about high-minded col-laboration guarantees accuracy, and open editing invites abuse. Senators and con-gressmen have been caught tampering with their entries; the entire House of Representatives has been banned from Wikipedia several times. (It is not subtle to change Senator Robert Byrd's age from eighty-eight to a hundred and eighty. It is sub-tler to sanitize one's voting record in order to distance oneself from an unpopular President, or to delete broken campaign promises.)[52]

Where such attempts to subvert the *Wikipedia* development process have been identi-fied, Wikipedians have usually responded swiftly; they have corrected or reverted the changes made, put in place automatic watch-bots to block further changes of similar nature, or—as Schiff notes—temporarily blocked entire groups of repeat offenders from editing the site. Such actions show that where the community is vigilant, a disruption response coordinated by a wide range of individual producers focusing on their spe-cific areas of personal expertise is not necessarily any less effective than the efforts of a dedicated, professional team of quality controllers. (Indeed, as some Wikipedians have developed a specialty in detecting and policing deliberate content disruptions, it can be suggested that *Wikipedia* now draws on both forms of disruption response.)

Coverage of such temporary disruptions in the mainstream media has frequently tended to portray them as highlighting fundamental weaknesses of the *Wikipedia* prod-usage model, however, and it is important to explore the validity of such attacks. The case of the widely reported falsification of the *Wikipedia* biography for journalist John Seigenthaler Sr. demands particular attention in this context: Seigenthaler's vandal-ized biography (claiming that he had been implicated in the assassinations of both John F. Kennedy and Robert F. Kennedy) had remained on the site unchanged for several months before Seigenthaler was informed of the falsification, at which time the misinformation was removed. Seigenthaler went on to use his status in the journalism industry to publicly question the *Wikipedia* model of content creation through an arti-cle in *USA Today* and appearances on CNN and U.S. National Public Radio.

Seigenthaler's case is not necessarily unique: other individuals who had found inaccuracies or felt misrepresented in their *Wikipedia* biographies, or who had identified other errors in *Wikipedia* content, have used this as the point of departure for a general attack on the *Wikipedia* model. A common response by Wikipedians is summarized by Roush's reaction to the Seigenthaler case:

> rather than railing at Wikipedia in general, why didn't Seigenthaler simply revise the objectionable entry and leave it at that? Indeed, the whole point of Wikipedia is that *anyone can publish* and *anyone can edit*. If you find an error, fix it. If you think you can write a better article, pull out your pen.[53]

However, while appropriate especially in cases in which what is at stake is simply the accurate portrayal of the current state of knowledge about a specific issue, this response does not fully address the legitimate concerns of Seigenthaler as a public figure of some standing whose personal reputation may be damaged by the misinformation contained in the *Wikipedia* article. Roush goes on to note that

> we're accustomed to thinking of public pronouncements, whether in print or on radio or television, as permanent and irretrievable. Once something libelous, defamatory, or scurrilous has been said or written, it cannot be unsaid or unwritten, and the only remedy is to sue for damages. But with Wiki-based media, this isn't the case. With a few mouse clicks, the victim of a false or offensive statement on Wikipedia can erase that statement, instantly and everywhere.[54]

Conventional mass media, however, also provide mechanisms for achieving public redress through corrections which must be published or broadcast in the same context as the original statement, and can therefore hope to reach much the same audience as the original offending statement (such mechanisms are themselves flawed, of course, but go at least some way towards undoing the damage which has been done). The interactive, 'pull' nature of Web content makes the deployment of similar mechanisms within *Wikipedia* and similar environments substantially more difficult: even if, as the Seigenthaler entry on *Wikipedia* now does, the error itself is highlighted and counteracted on the previously offending page, this does not reach those users (presumably the majority) who were simply one-off visitors to the Seigenthaler page during the time it carried the falsified biography, and—under the assumption that they have accessed correct information—are unlikely to return to the page any time soon.

However, at the same time, Seigenthaler's own response—consisting of a general condemnation of *Wikipedia* contributors and even what amounts to a thinly veiled argument in favor of withdrawing applicable free press or free speech protections from *Wikipedia* and comparable publications, is similarly insufficient:

> we live in a universe of new media with phenomenal opportunities for worldwide communications and research—but populated by volunteer vandals with poison-pen intellects. Congress has enabled them and protects them.[55]

Understandable though this reaction may be for someone personally affected by such instances of vandalism, it is important not to generalize from the work of an individual vandal to the majority of constructive contributors in *Wikipedia*, nor to claim without proof that applicable laws are not able to deal sufficiently with the offender in this case. (The question of exactly which national legislation may apply for the international project of building a collaborative online *Wikipedia* must also be raised here, however.) Indeed, even despite cases such as Seigenthaler's, the balance of individual benefit and public good must be considered in any potential legal ruling on the *Wikipedia* phenomenon, or in internal changes to *Wikipedia* procedures: on the one hand, the unprecedented level of socially diverse public participation in the collaborative project of building a comprehensive encyclopedia has a significant positive effect for society through its development of a free information commons containing a vast variety of public knowledge; on the other hand, it also serves an important educative function for each individual contributor, both in relation to the specific knowledge fields they participate in, and more generally as it builds their collaborative and social skills and capacities in shared online environments. Seigenthaler's rights to redress must be balanced with the need to keep this collaborative project feasible, therefore. "The community-editing model gives us a newfound power to create wrongs—but also to reverse wrongs. Let's not start restricting this power before we even understand it."[56]

Beyond any one individual case, at any rate, few feasible solutions appear immediately available. On the one hand, here as well as elsewhere in produsage environments it may be said that 'the price of freedom (here, freedom of participation as well as freedom of content) is eternal vigilance,' and any content defacement therefore must serve only to renew the community's attention to policing its information commons against vandals. Already, as German *Wikipedia* administrator Elisabeth Bauer notes, dealing with vandalism "works mostly by drawing community attention to the affected article. Once such a manipulator is known, there are usually a lot of people watching the corresponding articles and reverting manipulation attempts."[57] In addition, specifically in response to the particularly sensitive case of vandalism directed against the biographies of living persons, *Wikipedia* has further hardened its policy against unsubstantiated content for such entries:

> unsourced or poorly sourced contentious material—whether negative, positive, or just questionable—about living persons should be **removed immediately and without discussion** from Wikipedia articles, talk pages, user pages, and project space. ...
> This policy applies equally to biographies of living persons and to biographical material about living persons in other articles. The burden of evidence for any edit on Wikipedia, but especially for edits about living persons, rests firmly on the shoulders of the person who adds or restores the material.[58]

Even such policies do not effectively mitigate the potential viral nature of content seen on *Wikipedia* pages, even if it had been visible only for a short period of time. Be-

yond such policy-based approaches to ensuring the quality of Wikipedia content, however, further solutions to the prevention of negative impacts from poor quality Wikipedia pages are likely to lie more in the education of users (enabling them to identify poor content for themselves, and in that case to become active produsers of Wikipedia by taking action to highlight such poor quality to other users or to address it immediately through editing) than in limiting Wikipedia's editability or topical coverage. (It remains important to recognize in this context also that it is ultimately impossible to completely contain misinformation and negate its effects—and that conventional mass media are commonly required to make no more intensive efforts to redress the consequences of misinformation than including a brief correction statement, either. Wikipedia should perhaps not be held to a standard higher than this.)

Beyond such cases highlighting the shortcomings of high-profile individual entries in the Wikipedia, more general criticisms of its content, and its model of creating such content through massively distributed, probabilistic, collaborative efforts, have also been mounted. The fiercest of such attacks have emerged, perhaps unsurprisingly in the context of our observations of similar backlashes against produsage approaches in software production and journalism, from the encyclopedic industry itself. Indeed, Robert McHenry, "a former editor at the venerable Encyclopædia Britannica ... likened the site to a public rest room: You never know who used it last."[59] McHenry's argument is worthy of some attention, if only to explore some of the fundamental fallacies and misunderstandings of the produsage model inherent therein.

In the first place, McHenry takes aim at the probabilistic content development model of produsage, as we have seen it also in use by open source software communities. This approach, he suggests, "allows Wikipedia to approach the truth asymptotically. The basis for the assertion that this is advantageous vis-à-vis the traditional method of editing an encyclopedia remains, however, unclear."[60] However, this ignores the fact that the traditional model of producing an encyclopedia is itself highly questionable: McHenry's own description of an asymptotical approach to the truth betrays an assumption that a 'true,' irrefutable representation of human knowledge exists, beyond the most basic of facts; indeed, much of the core argument of McHenry's critique of Wikipedia is based on his discovery of a simple error in the correct birth date for Alexander Hamilton—an error also repeated in a number of other, conventional, encyclopedias. Beyond such basic data, however, for the most part knowledge is necessarily only ever an incomplete representation of truth; it is for this reason, of course, that Wikipedia's emphasis (through the NPOV principle) is on the coverage of the key prevalent representations of knowledge, rather than on presenting a universally accepted synthesis of human knowledge. Encyclopedias, on the other hand, "aspire to be infallible," as Pink notes. "But Wikipedia requires that the perfect never be the enemy of the good. Citizen editors don't need to make an entry flawless. They just need to make it better."[61]

Overall, in fact, McHenry's description of the *Wikipedia* model as he understands it resembles a caricature of the produsage approach we have encountered earlier in this chapter:

> To put the Wikipedia method in its simplest terms:
> 1. Anyone, irrespective of expertise in or even familiarity with the topic, can submit an article and it will be published.
> 2. Anyone, irrespective of expertise in or even familiarity with the topic, can edit that article, and the modifications will stand until further modified.
> Then comes the crucial and entirely faith-based step:
> 3. Some unspecified quasi-Darwinian process will assure that those writings and editings by contributors of greatest expertise will survive; articles will eventually reach a steady state that corresponds to the highest degree of accuracy.
> Does someone actually believe this? Evidently so. Why? It's very hard to say.[62]

However, our exploration of the *Wikipedia* process clearly points to the missing ingredient in McHenry's description: the presence of community processes in produsage which mitigate the randomness of the editing process as he describes it. Content in *Wikipedia* evolves under the influence of policing and development not by individual actors operating in inherent isolation from one another, but by communities organized through emerging and increasingly complex yet fluid heterarchical structures; far from being unspecified, a great number of implicit and explicit conventions, rules, and norms, which are themselves founded on the core conditions for and key principles of produsage, govern—on an *ad hoc* basis—this continuing communal process. The process, if conducted under supportive conditions, is self-reinforcing as community standards are developed and provide increasingly efficient social as well as technological barriers against disruptions and disruptors; it shifts the balance of probability towards a gradual if non-linear improvement in quality.

However, it is not surprising that such heterarchical, *ad hoc* community processes are unfamiliar to McHenry and similar detractors; they are unlikely to emerge with any significant force in closed, commercial enterprises drawing necessarily on a limited group of contributors, especially as the hierarchical organization of conventional production models necessarily undermines the emergence of strong community self-policing tendencies. By contrast, then, "Wikipedia represents a belief in the supremacy of reason and the goodness of others"[63]—but this is no blind faith in the inherent positive direction of Darwinian evolution as translated into content development, but a belief that such evolution can be explicitly directed towards the positive by a majority of constructively contributing participants. Indeed, the evolutionary metaphor holds, but only if in the context of the evolution of species as well as in the context of the evolution of encyclopedia content we understand the role played by environmental factors as selecting for goodness of fit: there, the accidental role of the natural environment in enabling the survival of some evolutionary modifications, and the decline of others, and here, the intentional role of the intellectual, social, and cultural envi-

ronment as shaped by active contributors to *Wikipedia* in encouraging some content modifications and discouraging others. Thus, Pink suggests,

> it turns out that Wikipedia has an innate capacity to heal itself. As a result, woefully outnumbered vandals often give up and leave. (To paraphrase Linus Torvalds [or actually Eric Raymond], given enough eyeballs, all thugs are callow.) What's more, making changes is so simple that who prevails often comes down to who cares more. And hardcore Wikipedians care. A lot.[64]

In addition, we may also turn the tables and ask whether the audiences for *Britannica* and other encyclopedias are any less asked to have faith in their processes of content production than the participants of *Wikipedia* are required to have in content produsage. Indeed, in the latter case, the evolutionary pathways for the content presented to users are conveniently available for them to explore: they can examine the edit histories and discussion processes which have led to the present state of any one encyclopedia entry. Short of going to the trouble of comparing the printed issues of *Britannica* through the centuries, the same is clearly not true of the conventional encyclopedia, nor are the editorial decision-making processes leading to determining the boundaries of its coverage or the structure of its content made accessible to anyone but editorial staff themselves; *Britannica* and its competitors continue to adhere to a closed-source, 'black box' model of content production which affords no transparency about the process to its consumer.

Indeed, from this perspective, as Krowne points out with some glee, "Wikipedia's revision history feature ... , which is a hallmark of open content production systems, makes it precisely *the opposite* of a public restroom. You *can* in fact see everything that 'came before you' with Wikipedia."[65] By contrast, the audiences of traditional encyclopedias, having virtually no insight into their production processes, are in a situation much more immediately comparable to that of using public amenities—it is they who are asked to have faith that the editors and contributors to such resources are professional in their janitorial work:

> an important underlying theme of McHenry's piece is his repeated harping on the fact that you "never really know" if a Wikipedia article is true, and his jeering at the Wikipedia community for honestly admitting this. Simultaneously, he utterly ignores the fact that *this is also the case for traditional encyclopedias.*[66]

Ultimately, at any rate, beyond random cases such as the inaccuracy regarding Alexander Hamilton's birth date that served as the trigger for McHenry's attack (now long corrected by *Wikipedia* contributors, of course—a course of action McHenry himself could have taken), which in isolation are unrepresentative of wider *Wikipedia* content overall, more systematic comparisons of *Wikipedia* content with that of its competitors have yet to find evidence of a substantially and inherently lower standard of quality in the prodused resource. A *Nature* study conducting "an expert-led investi-

gation ... to use peer review to compare Wikipedia and Britannica's coverage of science" found little difference in accuracy between both sources; it concluded that at least in this area of content, any high-profile examples of errors in *Wikipedia* cited in the mainstream media "are the exception rather than the rule."[67] Perhaps unsurprisingly, *Britannica* attacked *Nature* over its choice of evaluative methodology, an attack which *Nature* refuted in turn; such events should be seen in the first place simply as pointing to a need to conduct further independent studies comparing the accuracy of *Wikipedia* and competing resources on a variety of topics.

More generally, however, they may be seen also as an indication of a sense of crisis in the encyclopedic industry, foreshadowing perhaps the potential of the 'casual collapse' of the traditional production model at the hands of collaborative produsage unless steps can be taken to distinguish the traditional encyclopedic product from its new rivals. Indeed, this sense of crisis would also well serve to explain the equally vocal and misguided attack we have seen from Robert McHenry: those who have observed the backlash from incumbent corporations in software production and commercial journalism have drawn comparisons to McHenry's disparagement of *Wikipedia*, and identified his attack as part of a similar "Fear, Uncertainty and Doubt (FUD) campaign" against *Wikipedia*, describing McHenry's points as "contradictory and incoherent" and his rhetoric as "selective, dishonest and misleading."[68] Indeed, an objective and dispassionate reading of McHenry's argument suggests that this assessment is not entirely unwarranted.

Educating *Wikipedia* Users

In fact, it may be appropriate to observe that many of the early critiques of *Wikipedia* highlight not so much inherent shortcomings of its model of content produsage, but instead point to the as yet limited public understanding of that model's underlying principles. *Wikipedia* is criticized, disliked, even feared by some of the incumbent controllers of knowledge and its representations largely out of a misunderstanding which sees it as a competing organization: a new gatekeeper of knowledge set to replace the current leaders. Although there is some potential for *Wikipedia* to undermine a number of incumbent organizations, however, its collaborative, community-based produsage model makes it unlikely that *Wikipedia* could come to replace them entirely, however. Beyond the encyclopedia production industry itself, boyd notes, for example, that "many librarians, teachers and academics *fear* Wikipedia (not dislike it) because it is not properly understood, not simply because it challenges their privilege, just as most new systems and media are feared by traditionalists of all sorts."[69]

This, then, points to a wider need to educate both active contributors to *Wikipedia* and more casual users of its contents about questions of quality and accuracy in the resource, and about the available tools to examine that quality (such as, for exam-

ple, the edit history functions or the discussion pages attached to each entry). More broadly, however, this question is not limited to *Wikipedia* or any one collaboratively created knowledge resource online or offline; it is a wider matter of information and knowledge literacy and the capacity of users to work with such prodused resources (and we further discuss the need for new educational approaches in the face of a move from production to produsage in Chapter 13).

Indeed, the question is limited not even only to user engagement with prodused knowledge resources, but also extends to their assessment of the quality and authority of comparable conventional information and knowledge products: produsage serves merely to throw into contrast the question of how any one knowledge resource in current circulation has arrived at its present contents (as well as offering an answer to that question for its own practices, through its transparent features). As Shirky notes,

> the authority of Britannica ... is the authority of a commercial brand. Their sales are intimately tied into their reputation for quality, so we trust them to maintain those standards, in order to preserve an income stream. This is like trusting Levis or McDonald's—you don't know the individuals who made your jeans or your french fries, but the commercial incentive the company has in preserving its brand makes the level of quality predictable and stable.[70]

Wikipedia, by contrast, does not provide a similar claim to authority: it is not (and because of its base in open participation and communal property, can never be) a commercial brand, and therefore has neither a need to attract customers nor the subsequent need to maintain a level of quality sufficient to keep its audience. It does, however, nonetheless operate within "a kind of market, where the investment is time and effort rather than dollars and cents"[71]: it depends crucially on its continued ability to attract constructive contributors to police and extend its content. Here, however, the feedback loop between userbase and quality is considerably more immediate than it is in traditional content production approaches, as we have already seen in Chapter 2: *Britannica* and other commercial operators must necessarily balance the cost of further improving their content quality with the additional revenue obtainable through such content improvement; incremental increases in quality above a set level are unlikely to result in a substantial increase in revenue, however, and the overall quality of *Britannica* is thus necessarily limited by commercial considerations. In the case of *Wikipedia*, on the other hand, any increase in the quality of the overall resource is likely to attract more users, and (given the principle of equipotentiality) many of these users are similarly likely to further increase the quality of *Wikipedia* by contributing in those areas where they are particularly knowledgeable; *Wikipedia*'s processes of content produsage therefore have the potential to enter into a self-reinforcing cycle of quality improvement at least in those areas where a substantially diverse critical mass of knowledgeable contributors exists. This does not mean that *Wikipedia*'s quality will increase uniformly across the entire knowledge base, of course—and it is in the less ac-

tive areas where it is especially important to highlight the site's shortcomings as well as the achievements it has produced elsewhere.

It is a very far step from this realization to the suggestion made by Seigenthaler that "Wikipedia is a flawed and irresponsible research tool,"[72] however. *Wikipedia* content itself may well be flawed in specific cases, but the problem with using it in research contexts clearly lies not with the resource, but with the user. A ban on the use of *Wikipedia* as a reference, as it is practiced in some academic institutions, is not only misguided, but indeed must be considered as positively medieval in its approach; the 'problem' of *Wikipedia* in an academic context is not going to be made to disappear by shunning it. Indeed, as Rosenzweig notes,

> teachers have little more to fear from students' starting with *Wikipedia* than from their starting with most other basic reference sources. They have a lot to fear if students stop there. To state the obvious: *Wikipedia* is an encyclopedia, and encyclopedias have intrinsic limits.[73]

More to the point, then, it is incumbent on teachers and academics to make their students familiar with the inherent shortcomings of any of the research tools and sources they may be tempted to utilize. "Spend more time teaching about the limitations of all information sources, including *Wikipedia*, and emphasizing the skills of critical analysis of primary and secondary sources."[74] Alternatives to *Wikipedia* are hardly without their own institutionalized interpretative paradigms, after all—as Doctorow has put it, "*Britannica* tells you what dead white men agreed upon, Wikipedia tells you what live Internet users are fighting over."[75]

An understanding of *Wikipedia*, then, requires an understanding of its underlying paradigms of knowledge interpretation and content produsage. It requires users to realize that by contrast with traditional encyclopedias, which present an edited synthesis of available knowledge on any one topic and attempt from this to distill a presentation of 'the truth,' *Wikipedia* instead operates under a Neutral Point of View principle which merely aims to offer for the user's own evaluation the various representations of knowledge currently in wider circulation, without an attempt to distill from these an objective presentation of knowledge in its own right. Further, an understanding of *Wikipedia* also requires an understanding of the principles of produsage themselves: of the influence of open participation and communal evaluation of contributions on the range and quality of content represented in the resource; of the impact of heterarchical and *ad hoc* meritocratic governance on the continuing processes of content evolution; of the resulting always unfinished state of content artefacts presented through the site, and their gradual and potentially unsteady process of continuing development; and of the communal ownership of content which nonetheless allows contributors to derive individual rewards from their participation (and which therefore may influence their approach to collaboration on the site).

Such principles can be understood as contributing to the collective personality of the *Wikipedia* as a resource, even though, as Lanier points out, *Wikipedia*'s produsage processes do not allow for the emergence of *individual* personality in the texts presented through the site (individual voices *are* amply represented on its 'talk' or discussion pages, however, and produsage-literate users should therefore have little trouble seeking them out). Lanier voices the complaint that

> when you see the context in which something was written and you know who the author was beyond just a name, you learn so much more than when you find the same text placed in the anonymous, faux-authoritative, anti-contextual brew of the Wikipedia. ... Even Britannica has an editorial voice, which some people have criticized as being vaguely too "Dead White Men."[76]

What *Wikipedia* offers instead is the voice of a collective: not of the collective entirety of its millions of users, but of the hive mind composed of the many individual, fluid, and constantly evolving communities gathered around any one of its entries. Though composite, it is no less a voice which exhibits its own personal traits—and it is important that users of the site begin to understand the differences between the voices of individual collectives existing around specific pages in *Wikipedia*, and thereby learn to distinguish the credible, authoritative voices of fully formed issue communities from the vague, uncertain voices haunting the as yet less developed areas in the project.

NOTES

1. Pierre Lévy, *Collective Intelligence: Mankind's Emerging World in Cyberspace*, trans. Robert Bononno (Cambridge, Mass.: Perseus, 1997), p. 5.

2. Lévy, pp. 14–15.

3. Will Richardson, *Blogs, Wikis, Podcasts, and Other Powerful Web Tools for Classrooms* (Thousand Oaks, Calif.: Corwin Press, 2006), pp. 61–62.

4. See e.g. Nancy K. Baym, *Tune In, Log On* (Thousand Oaks, Calif.: Sage, 2000); Axel Bruns, "'Every Home Is Wired': The Use of Internet Discussion Fora by a Subcultural Community," 1998, http://snurb.info/files/honours/everyhome.html (accessed 12 July 2007).

5. Roy Rosenzweig, "Can History Be Open Source? Wikipedia and the Future of the Past," *Center for History and New Media: Essays*, 2006, http://chnm.gmu.edu/resources/essays/d/42 (accessed 28 Feb. 2007), n.p.

6. Daniel H. Pink, "The Book Stops Here," *Wired* 13.3 (Mar. 2005), http://www.wired.com/wired/archive/13.03/wiki.html (accessed 26 Feb. 2007), n.p.

7. Lawrence M. Sanger, "The Early History of Nupedia and Wikipedia: A Memoir (Pt. 1)," *Slashdot: News for Nerds, Stuff That Matters*, 18 Apr. 2005, http://features.slashdot.org/article.pl?sid=05/04/18/164213 (accessed 27 Feb. 2007), n.p.

8. Yochai Benkler, *The Wealth of Networks: How Social Production Transforms Markets and Freedom* (New Haven, Conn.: Yale University Press, 2006), p. 6.

9. Sanger, "The Early History of Nupedia and Wikipedia: A Memoir (Pt. 1)," n.p.

10. Thomas Goetz, "Open Source Everywhere," *Wired* 11.11 (Nov. 2003), http://www.wired.com/wired/archive/11.11/opensource_pr.html (accessed 1 Oct. 2004), n.p.

11. Lawrence M. Sanger, "The Early History of Nupedia and Wikipedia: A Memoir (Pt. 2)," *Slashdot: News for Nerds, Stuff That Matters*, 19 Apr. 2005, http://features.slashdot.org/article.pl?sid=05/04/19/1746205 (accessed 27 Feb. 2007), n.p.

12. Mark Elliott, "Stigmergic Collaboration: The Evolution of Group Work," *M/C Journal* 9.2 (May 2006), http://journal.media-culture.org.au/0605/03-elliott.php (accessed 27 Feb. 2007), b. 13.

13. Henry Jenkins, *Convergence Culture: Where Old and New Media Collide* (New York: NYU Press, 2006), p. 255.

14. Elliott, b. 14.

15. Michel Bauwens, "Peer to Peer and Human Evolution," *Integral Visioning*, 15 June 2005, http://integralvisioning.org/article.php?story=p2ptheory1 (accessed 1 Mar. 2007), p. 2.

16. Wikimedia, "Power Structure," *Wikimedia: Meta-Wiki*, 11 Dec. 2006, http://meta.wikimedia.org/wiki/Power_structure (accessed 28 Feb. 2007), n.p. The term 'anarchic' is somewhat misplaced here, of course, but chosen most likely as in popular parlance it is the most commonly used descriptor for the absence of traditional hierarchy. Notably, the same document also describes *Wikipedia*'s power structure as "a mix of anarchic, despotic, democratic, republican, meritocratic, plutocratic, and technocratic elements."

17. Cory Doctorow, "On 'Digital Maoism: The Hazards of the New Online Collectivism' by Jaron Lanier," *Edge: The Reality Club*, 2006, http://www.edge.org/discourse/digital_maoism.html (accessed 28 Feb. 2007), n.p.

18. Lawrence M. Sanger. "Wikipedia Is Wide Open: Why Is It Growing So Fast? Why Isn't It Full of Nonsense?" *Kuro5hin: Technology and Culture, from the Trenches*, 24 Sep. 2001, http://www.kuro5hin.org/story/2001/9/24/43858/2479 (accessed 27 Feb. 2007), n.p.

19. Qtd. in Dirk Riehle, "How and Why Wikipedia Works: An Interview with Angela Beesley, Elisabeth Bauer, and Kizu Naoko," in *Proceedings of the International Symposium on Wikis (WikiSym)*, 21–23 Aug. 2006, Odense, Denmark, http://www.riehle.org/computer-science/research/2006/wikisym-2006-interview.pdf (accessed 12 July 2007), p. 6.

20. Qtd. in Riehle, p. 6.

21. Lawrence M. Sanger, "Wikipedia and Why It Matters," *Wikimedia: Meta-Wiki*, 16 Jan. 2002, http://meta.wikimedia.org/wiki/Wikipedia_and_why_it_matters (accessed 27 Feb. 2007), n.p.

22. Sanger, "Wikipedia and Why It Matters," n.p.

23. Sanger, "The Early History of Nupedia and Wikipedia: A Memoir (Pt. 2)," n.p.

24. Joseph M. Reagle Jr., "A Case of Mutual Aid: Wikipedia, Politeness, and Perspective Taking," *Reagle.org*, 2004, http://reagle.org/joseph/2004/agree/wikip-agree.html (accessed 25 Feb. 2007), n.p.

25. *Wikipedia*, "Wikipedia: Neutral Point of View," *Wikipedia: The Free Encyclopedia*, 11 July 2007, http://en.wikipedia.org/wiki/Wikipedia:Neutral_point_of_view (accessed 12 July 2007), n.p.

26. danah boyd, "Academia and Wikipedia," *Many 2 Many: A Group Weblog on Social Software*, 4 Jan. 2005, http://many.corante.com/archives/2005/01/04/academia_and_wikipedia.php (accessed 25 Feb. 2007), n.p.

27. *Wikipedia*, "Wikipedia: Verifiability," *Wikipedia: The Free Encyclopedia*, 9 July 2007, http://en.wikipedia.org/wiki/Wikipedia:Verifiability (accessed 12 July 2007), n.p.

28. *Wikipedia*, "Wikipedia: No Original Research," *Wikipedia: The Free Encyclopedia*, 11 July 2007, http://en.wikipedia.org/wiki/Wikipedia:No_original_research (accessed 12 July 2007), n.p.

29. *Wikipedia*, "Wikipedia: Verifiability," n.p.

30. *Wikipedia*, "WikiLove," *Wikipedia: The Free Encyclopedia*, 18 Feb. 2007, http://en.wikipedia.org/wiki/Wikipedia:WikiLove (accessed 27 Feb. 2007), n.p.

31. Stacy Schiff, "Know It All: Can Wikipedia Conquer Expertise?" *New Yorker*, 31 July 2006, http://www.newyorker.com/archive/2006/07/31/060731fa_fact (accessed 13 Mar. 2007), p. 1.

32. *Wikipedia*, "Wikipedia: Semi-Protection Policy," *Wikipedia: The Free Encyclopedia*, 21 Feb. 2007, http://en.wikipedia.org/wiki/Wikipedia:Semi-protection_policy (accessed 26 Feb. 2007), n.p.

33. Qtd. in Riehle, p. 4.

34. Qtd. in Riehle, p. 6.

35. Bruce Bimber, Andrew J. Flanagin, and Cynthia Stohl, "Reconceptualizing Collective Action in the Contemporary Media Environment," *Communication Theory* 15.4 (2005), p. 372.

36. Qtd. in Riehle, p. 4.

37. Peter Merholz, "Metadata for the Masses," *Adaptive Path*, 19 Oct. 2004, http://www.adaptivepath.com/publications/essays/archives/000361.php (accessed 1 Mar. 2007), n.p.

38. Wikimedia, n.p.

39. Rosenzweig, n.p.

40. Sanger, "The Early History of Nupedia and Wikipedia: A Memoir (Pt. 2)," n.p.

41. Lévy, p. xxvii.

42. Reagle, n.p.

43. Bauwens, p. 2.

44. Lévy, pp. xxii-xxiii.

45. Rosenzweig, n.p.

46. Schiff, p. 5.

47. Mark Pesce, "Hyperintelligence," *Hyperpeople: What Happens after We're All Connected?* 2 June 2006, http://blog.futurestreetconsulting.com/?p=17 (accessed 23 Feb. 2007), n.p.

48. See, e.g., Henry Jenkins, *Fans, Bloggers, and Gamers: Exploring Participatory Culture* (New York: NYU Press, 2006); John Hartley, *Uses of Television* (London: Routledge, 1999).

49. Rosenzweig, n.p.

50. Schiff, p. 1.

51. Lévy, p. 13.

52. Schiff, p. 1.

53. Wade Roush, "Wikipedia: Teapot Tempest," *Technology Review*, 7 Dec. 2005, http://www.technologyreview.com/blog/editors/15974/ (accessed 28 Feb. 2007), n.p.

54. Roush, n.p.

55. John Seigenthaler, "A False Wikipedia 'Biography'," *USA Today*, 29 Nov. 2005, http://www.usatoday.com/news/opinion/editorials/2005-11-29-wikipedia-edit_x.htm (accessed 28 Feb. 2007), n.p.

56. Roush, n.p.

57. Qtd. in Riehle, p. 6.

58. *Wikipedia*, "Wikipedia: Biographies of Living Persons," *Wikipedia: The Free Encyclopedia*, 12 July 2007, http://en.wikipedia.org/wiki/Wikipedia:Biographies_of_living_persons (accessed 12 July 2007), n.p.

59. Pink, n.p.

60. Robert McHenry, "The Faith-Based Encyclopedia," *TCSDaily: Technology, Commerce, Society*, 15 Nov. 2004, http://www.tcsdaily.com/article.aspx?id=111504A (24 Feb. 2007), n.p.

61. Pink, n.p.

62. McHenry, n.p.

63. Pink, n.p.

64. Pink, n.p.

65. Aaron Krowne, "The FUD-based Encyclopedia: Dismantling Fear, Uncertainty, and Doubt, Aimed at Wikipedia and Other Free Knowledge Resources," *Free Software Magazine* 2, 28 Mar. 2005, http://www.freesoftwaremagazine.com/articles/fud_based_encyclopedia/ (accessed 2 Mar. 2007), p. 2.

66. Krowne, p. 3.

67. Jim Giles, "Internet Encyclopaedias Go Head to Head," *Nature* 438.900-901 (15 Dec. 2005), http://www.nature.com/nature/journal/v438/n7070/full/438900a.html (accessed 25 Jan. 2007).

68. Krowne, p. 3.

69. boyd, "Academia and Wikipedia," n.p.

70. Clay Shirky, "Wikipedia: The Nature of Authority, and a LazyWeb Request..." *Many 2 Many: A Group Weblog on Social Software*, 6 Jan. 2005, http://many.corante.com/archives/2005/01/06/wikipedia_the_nature_of_authority_and_a_lazyweb_request.php (accessed 25 Feb. 2007), n.p.

71. Shirky, n.p.

72. Seigenthaler, n.p.

73. Rosenzweig, n.p.

74. Rosenzweig, n.p.

75. Doctorow, n.p.

76. Jaron Lanier, "Digital Maoism: The Hazards of the New Online Collectivism," *Edge: The Third Culture* 183, 30 May 2006, http://www.edge.org/documents/archive/edge183.html (accessed 27 Feb. 2007), n.p.

The Palimpsest of Human Knowledge: *Wikipedia* and Beyond

The authorial voice which arises from the collective, collaborative produsage environment of the *Wikipedia* is necessarily a conflicting, heterogeneous one—both because of *Wikipedia*'s content creation processes and because of the NPOV-driven focus on multiperspectival representations of knowledge rather than the synthesis of a unified position of, and on, knowledge or 'truth' itself. As we have already seen in our examination of citizen journalism, that shift towards an embrace of multiperspectivality at the expense of presenting the 'complete story' may well be a necessary and inevitable outcome of produsage processes themselves, and of the shift to a fully digital, Internet-based model of content creation to which they contribute. *Wikipedia*'s competitors have yet to make that shift, as Pink points out:

> today, Britannica and World Book still sell some 130-pound, $1,100, multivolume sets, but they earn most of their money from Internet subscriptions. Yet while the medium has shifted from atoms to bits, the production model—and therefore the product itself—has remained the same.[1]

By contrast, the shift from production to produsage necessitates a different approach to engaging with content, and with those who participate in creating, developing, extending, evaluating, and policing that content. As we have already seen, content itself changes fundamentally, and indeed, continues to change on a constant basis without being able to be channeled into fixed, stable versions resembling the products of the traditional industrial production model (notwithstanding open source's 'stable' builds, which are always necessarily a compromise and must frequently limit the software's full functionality to reach a position of stability). A 'fixing' of *Wikipedia* content—removing editability from *Wikipedia* pages deemed to be of suitably high quality already, or collecting such pages into a 'stable' sister product to *Wikipedia*'s own site, and perhaps even removing edit histories and discussion pages, for example—would produce an online encyclopedia, but it would no longer be *Wikipedia*; it would lack some of the most crucial features of the core site, including the sense of the presence

of an active community of collaborative developers engaged in the further evaluation and extension of current *Wikipedia* content. (Indeed, in the absence of its most distinguishing features that site would resemble far more closely the non-transparent 'public restroom' described by McHenry than does the *Wikipedia* proper.)

Wikipedia is not that site—it relies crucially on its transparency, editability, and community involvement in the ongoing produsage of its contents.

> Instead of clearly delineated lines of authority, Wikipedia depends on radical decentralization and self-organization—open source in its purest form. Most encyclopedias start to fossilize the moment they're printed on a page. But add Wiki software and some helping hands and you get something self-repairing and almost alive. A different production model creates a product that's fluid, fast, fixable, and free.[2]

Indeed, as we have already seen, the term 'product' itself is no longer particularly appropriate for the outcomes of the *Wikipedia* or of any other produsage process: *Wikipedia*'s content almost never resembles the complete, 'finished,' packaged products of traditional content production processes. Instead, its pages are necessarily always unfinished, and rapidly changing—the *Wikipedia* entry seen by any one visitor at a given point in time is liable to change the next day, the next hour, even the next minute.

It is therefore much more appropriate to describe the currently visible content of the *Wikipedia* as nothing more than a temporary, quasi-ephemeral artefact of the ongoing, unfolding produsage process within the site, much as a single frame of a television broadcast may contain valuable information in its own right, but forms only part of a larger, moving picture. That said, individual, temporary *Wikipedia* artefacts do of course contain substantially more independently usable information than do television frames; in addition, the edit history functionality also serves to limit their ephemerality at least for users who have the information literacy skills sufficient to know to seek out such information. But nonetheless, the *Wikipedia* entries currently visible to a user remain artefacts of a continuing process, and *Wikipedia* overall makes no guarantees that such current content meets any applicable quality standards; it does operate from a belief (on available evidence, generally justified) that over time its pages will generally improve in quality, however.

As Shirky describes it,

> Wikipedia is not a product, it is a system. The collection of mass intelligence ... unfolds over time, necessarily. Like democracy, it is messier than planned systems at any given point in time, but it is not just self-healing, it is self-improving. Any given version of Britannica gets worse over time, as it gets stale. The Wikipedia, by contrast, whose version is always the Wiki Now, gets better over time as it gets refreshed. This improvement is not monotonic, but it is steady.[3]

In preference to the term 'system' (which highlights the underlying technological and social structures in place for *Wikipedia*), however, it may be more appropriate to describe the site as a process: that term encompasses not only the rules and regulations

put in place through *Wikipedia*'s system, but also the continuing interpretation and enactment by the *Wikipedia* community of participants.

This understanding of *Wikipedia* as process rather than product also again highlights the need for its users to approach the site and its content as such—it points to the fact that to use the site as product is ultimately to misunderstand both its strengths and its weaknesses. Again, this also indicates the important distinction between traditional encyclopedias' focus on synthesizing information into unified presentation of knowledge, and *Wikipedia*'s mission to fairly document a variety of representations of knowledge on any one topic. As Doctorow points out,

> if you want to really navigate the truth via Wikipedia, you have to dig into those "history" and "discuss" pages hanging off of every entry. That's where the real action is, the tidily organized palimpsest of the flamewar that lurks beneath any definition of "truth."[4]

Although perhaps overly dramatic (only a limited number of the discussion pages on *Wikipedia* resemble tense flamewars), this portrayal is nonetheless accurate in describing *Wikipedia*'s content (here properly understood to include both entry content, edit histories, and discussion pages). *Wikipedia* indeed resembles the historical palimpsest: a repeatedly overwritten document which on closer analysis still shows the traces of this temporally and spatially distributed process of content creation and collaboration; in addition, indeed, the pages of discussion about content and quality which are attached to its entries also serve as the modern-day reinvention of another medieval practice: the conduct of interpretative discussion and commentary on specific passages of core texts through a form of peer-to-peer annotation in the margins of those texts.

Through its reintroduction of such practices (or at least, through its provision of standardized spaces and functionality for the collective conduct of such practices which in the more recent past had taken place mainly in isolated collaborative and interpretive communities at a distance from the texts themselves), *Wikipedia* thus fundamentally changes the relationship between the text, its creators, and its users. This is a process both of deterritorialization, as it blends previously separated textual creation efforts and their outcomes into a continuous, ongoing, unfinished process, and of reterritorialization, as it provides a new knowledge space for the conduct of such new practices:

> the territory attempts to maintain borders, hierarchies, and structures. The knowledge space on the other hand is always in an emergent state. It issues from the individual acts and histories that animate the collective intellect. It is never structured *a priori*, but expresses, maps, makes visible the strands of subjective and necessarily unforeseeable durations.[5]

This new knowledge space is fundamentally different from previous territories of knowledge, therefore, as it must necessarily always remain fluid and changeable; it

does not allow for the development of fixed positions and canons of knowledge: "within the knowledge space knowledge no longer objectivizes but subjectivizes, on the basis of a subjectivity that is plural, open, and nomadic."[6] This further highlights the need for the development of new literacies and capacities by users engaging with this space; those who—like the adherents of traditional encyclopedia production—are accustomed to engaging with a knowledge environment characterized by relatively fixity, order, and predictability will find themselves ill-prepared and ill at ease in the knowledge space of produsage. (Or, as *Wikipedia* founder Jimmy Wales has put it, "Wikipedia is to Britannica as rock and roll is to easy listening. ... It may not be as smooth, but it scares the parents and is a lot smarter in the end."[7])

Governing *Wikipedia*

The problem of coming to terms with the fluid and changeable environment of this new knowledge space and its palimpsestic content structures also confronts those who have helped build it, however. Indeed, the question of *Wikipedia* administration and community governance is today perhaps one of the most controversial issues confronting *Wikipedia* and its participants.

As we have already seen, Wikipedians themselves describe their project as governed by "a mix of anarchic, despotic, democratic, republican, meritocratic, plutocratic, and technocratic elements."[8] This indicates little more than an existing lack of clarity about governance structures, of course, as well as the continuing experimentation with approaches to community self-regulation which is currently taking place in a variety of spaces on the site. This observation does not necessarily undermine *Wikipedia* and its produsage model itself, however: the key measure of the effectiveness of even such heterogeneous, heterarchical models of governance and control is ultimately to be found in the quality of the overall *Wikipedia* content, and here, *Wikipedia* has already been relatively successful overall.

Such success has also generated further problems for the site, however; the more popular and publicly recognized *Wikipedia* has become, the more has it necessarily attracted its share of disruptors and miscreants. At times, Wikipedians have found that their existing collective powers of content evaluation and participant policing were no match for committed vandals:

> even committed citizens sometimes aren't muscular enough to fend off determined bad guys. As Wikipedia has grown, Wales has been forced to impose some more centralized, policelike measures—to guard against "edit warriors," "point-of-view warriors," "revert warriors," and all those who have difficulty playing well with others. "We try to be as open as we can," Wales says, "but some of these people are just impossible."[9]

In keeping with the overall adhocracy, many such measures have themselves been introduced on the fly, but their development has also been accompanied by substantial discussion about their appropriateness within the *Wikipedia* community itself; this mirrors similar discussions about community structures and policies which have emerged at various times in the produsage communities of open source and citizen journalism, for example.

Crucial in such debates, and in the development of administrative structures which they highlight, is that the fundamental principles of produsage (and here especially the principles of open participation, heterarchical governance, and the recognition of individual contributors' merit, remain in place. It is possible to see such principles threatened within the *Wikipedia* if current trends towards the development of more permanent administrative structures continue, in fact: already, as Pink notes, a *Wikipedia* 'power pyramid' has emerged:

> at the bottom are anonymous contributors, people who make a few edits and are identified only by their IP addresses. On the next level stand Wikipedia's myriad registered users around the globe, people ... who have chosen a screen name ... and make edits under that byline. Some of the most dedicated users try to reach the next level—administrator. Wikipedia's 400 administrators ... can delete articles, protect pages, and block IP addresses. Above this group are bureaucrats, who can crown administrators. The most privileged bureaucrats are stewards. And above stewards are developers, 57 superelites who can make direct changes to the Wikipedia software and database. There's also an arbitration committee that hears disputes and can ban bad users.[10]

At the very top of this pyramid, of course, remains Jimmy Wales himself, described by some Wikipedians as the site's 'god-king'.

The importance of this structure should not be overstated, however: on the one hand, while it outlines a hierarchy of administrative personnel on the site, it does not describe the structural features of the content development communities existing around specific topics within *Wikipedia*. These communities continue to be organized on a much more *ad hoc*, fluid, and heterarchical basis which determines the centrality of participants to their community, and their resultant 'power' or influence within that community, very directly based on their continued performance as content contributors. On the other hand, the existence of a quasi-permanent structure of administrative roles within *Wikipedia* does not itself necessarily undermine the produsage model for as long as participant access to this structure remains possible—in other words, as long as the equipotentiality of participants is respected and users have the ability to join the ranks of *Wikipedia* administrators themselves. By all accounts, this continues to be the case, even though the preconditions for becoming an administrator appear to have become more demanding: as *Wikipedia* administrator Angela Beesley reports,

on the English Wikipedia, there is a 'requests for adminship' page where users are nominated, or (more rarely now) self-nominate. Everyone can vote on whether that person should be an administrator. 80% support means they will be, less than 75% means they won't, and 75-80 is at the bureaucrat's discretion. The same procedure is used for selecting bureaucrats, but with higher expectations, and a higher percentage needed for the promotion to happen. ... It's common for people to be rejected for having fewer than 3000 edits, having been involved for less than three months, or for any sort of dispute in their editing history.[11]

Beesley notes that these preconditions have become more taxing over past years. Such gradual changes should be seen not as an increased ossification of *Wikipedia* governance structures, however, but rather as a sign of the rising standards of expertise and commitment the *Wikipedia* community demands of its leaders.

By contrast, however, the very permeability of *Wikipedia* communities and administrative structures has also generated its share of criticism, not least from *Wikipedia* cofounder and erstwhile *Nupedia* editor Larry Sanger. Having departed from the project, he particularly laments the introduction of the 'WikiLove' principle which, as we have seen, extends a warm welcome to all newcomers and exhorts more established *Wikipedia* participants to treat them with care and respect:

the new policy of "WikiLove" handed trolls and other difficult users a very effective weapon for purposes of combatting those who attempted to enforce rules. After all, any forthright declaration that a user is doing something that is clearly against established conventions—posting screeds, falsehoods, nonsense, personal opinion, etc.—is nearly always going to appear disrespectful, because such a declaration involves a *moral* accusation.[12]

Described in such terms, Sanger's protest may be an exaggeration of the truth; nothing within the WikiLove doctrine appears to explicitly disallow the highlighting of shortcomings in the contributions of newcomers and more established participants alike, although it does encourage users to conduct their process of communal evaluation of contributed content with care and grace, and to voice their criticism in a way that socializes participants into constructive practices of participation rather than alienates them from the community altogether and thereby makes their continued participation less likely.

However, Sanger's criticism usefully highlights the ongoing process of finding a balance between outright administrative policing and implicit community socialization, and between emergent heterarchical structures of community self-determination and imposed hierarchies of *Wikipedia* governance. In part, this process is driven by the site's internal dynamics as it further develops its specific implementation of the produsage principles; in part, it also represents a necessary response to external factors such as the increasing incidence of content vandalism which appears a natural result of *Wikipedia*'s growing popular recognition, and the necessity to respect the legal frameworks within which the site operates (for example, requirements to deal swiftly with

cases of defamation or copyright violation). In other words, "this isn't happening because the Wikipedia model is a failure, it is happening because it is a success"[13]: *Wikipedia*'s engagement—and sometimes struggle—with such processes forms part of the ongoing growing pains which are to be expected for a large, diverse, volunteer-based, and rapidly expanding project such as this.

It is a problem, too, for which no *a priori* solutions are readily available—and this is an important lesson *Wikipedia* may have learnt from previous produsage-based projects such as those in open source and citizen journalism we have already discussed. As Sanger notes with some sense of surprise, "perhaps the root cause of the governance problem was that we did not realize well enough that a *community* would form, nor did we think carefully about what this entailed"[14]—but even any amount of however well-intentioned 'careful thinking' could not have foreseen, and continues to be unable to foresee at present, the exact shape and structure of the content development communities which are continuously forming, evolving, and occasionally dissolving around the pages of the *Wikipedia*. In the context of produsage, *ad hoc* emphatically means *ad hoc*—the gradual emergence of structures to sustain and manage the heterarchical adhocracies of produsage communities cannot be directed *a priori* towards predetermined outcomes without turning the project into something other than itself, and thus potentially fundamentally undermining the principles of produsage itself. Such prestructured community-based projects may still be highly successful, of course; however, they soon begin to resemble again the more traditional, hierarchically organized processes of content production, not the heterarchies of content produsage.

If Sanger notes that "what we did not have worked out in advance was how the community should be organized, and (not surprisingly) that turned out to be the thorniest problem,"[15] we should take issue with this characterization of the absence of *a priori* concepts for community organization as a 'problem'; more accurately, it represents instead a challenge and an opportunity for the community to determine for itself the appropriate structures of organization and governance which best enable *Wikipedia*'s collaborative project of encyclopedic content development both on the level of the project overall, and on the level of individual topical sections and environments within the *Wikipedia*, down even to the scale of each individual entry. From this perspective, indeed, *Wikipedia* might count itself lucky that Sanger was not able to impose his own will on the *Wikipedia* community: based on his experiences in the development of *Wikipedia*, he suggests that

> a collaborative community would do well to think of itself as a *polity* with everything that that entails: a representative legislative, a competent and fair judiciary, and an effective executive, all defined in advance by a charter.[16]

Such an *a priori*, legalistic approach cannot help but prove to be counterproductive for the establishment of an open and heterarchical community of participants in produsage, however. It assumes that the community of produsers arrives somehow

fully formed at the site of the project, and comes with an already established sense of itself, and remains internally stable if not static; in practice, however, such conditions are almost never met. Instead, as we have seen (and as is evident from *Wikipedia*'s own history, of course), the communities of produsage grow and evolve gradually: under beneficial conditions, productive participation is able to enter into a self-correcting, self-perpetuating cycle which over time attracts further contributors; their arrival must necessarily alter the make-up and ethos of the overall community, however. Any charter agreed upon by the founders of a project is therefore likely to be outdated and irrelevant by the time a more substantial community has established itself (and Sanger's own departure from *Wikipedia* and his subsequent criticism of its model of content produsage clearly indicates the disconnect between his intentions for the site and the community's developing understanding of its own processes and practices, of course); at worst, a strongly enforced founding charter for a 'produsage' project may in fact simply have the negative effect of inherently discouraging potential participants from contributing in the first place.

Of course, this is not to claim that produsage projects cannot be built on a set of founding principles; as we have seen in the previous chapter, for example, *Wikipedia* is clearly built on the three core principles of Neutral Point of View, Verifiability, and No Original Research (but we might note that their definition, interpretation, and enforcement by the *Wikipedia* community *has* evolved over time). Indeed, any deliberately initiated produsage project is most likely to start at least from a declaration of its overall mission. However, the originators of such projects must take care not to overdetermine the organizational structures and operational processes of the produsage project by imposing an abundance of *a priori* rules; if, after all, the community is to be relied upon for the creation of the project's communal intellectual property, then surely it is just as appropriate for it to take a leading role also in developing the support structures for that process. (This, of course, is a key lesson from open source, citizen journalism, and other successful produsage projects as well; the creators of *Slashdot*, for example, clearly worked with their community in developing the structures for its processes of self-moderation and self-meta-moderation.[17])

Wikipedia's Angela Beesley shows an understanding of this need to involve the community in the development of its own governance and facilitation structures that is significantly more in tune with the community's own views than is Sanger's, and it is perhaps not surprising in this context that Beesley as a leader of the *Wikipedia* process has emerged from within the community itself, while Sanger's involvement predated *Wikipedia*'s establishment:

> the biggest challenge is to maintain what made us who and what we are: the traditional wiki model of being openly editable. There are temptations to lock things down in order to placate the media who tend to focus on the inadequacies of the site.[18]

Wikipedia leaders must continue to resist such suggestions, then, as this would necessarily fundamentally undermine the site. Any changes to its *modus operandi* must be gradual, incremental, and implemented in consultation and collaboration with its wider community of contributors. Shirky thus describes this dilemma for *Wikipedia*, and its only workable solution, in these terms:

> at the extremes, co-creation, openness, and scale are incompatible. Wikipedia's princip[al] advantage over other methods of putting together a body of knowledge is openness, and from the outside, it looks like Wikipedia's guiding principle is "Be as open as you can be; close down only where there is evidence that openness causes more harm than good; when this happens, reduce openness in the smallest increment possible, and see if that fixes the problem."[19]

Any changes made in this process, and to the process, then, must remain in tune with the fundamental principles of produsage itself, with the prevailing community interpretation of *Wikipedia*'s own mission and founding principles, and with community sentiment more broadly. Changes which violate this approach will serve to undermine the *Wikipedia* model; changes which adhere to it will "not represent the death of Wikipedia but adaptation."

If Larry Sanger, as one of *Wikipedia*'s founders and early drivers, so fundamentally misunderstands the core principles of the project he helped to bring into being, then, this also highlights the problematic role possibly played by *Wikipedia*'s other core driver and undisputed leader, Jimmy Wales. Despite the recognition he deserves as project originator of both *Nupedia* and *Wikipedia*, Wales's role within the project, or more specifically his actions in discharging that role, may be seen to be increasingly at odds with the operation of the produsage project itself, if, like Sanger, he neither fully understands nor subscribes to the internal logic of the community he has helped create.

Indeed, already it has become evident that despite the generally permeable, fluid, heterarchical, and meritocratic structure of content development communities within the *Wikipedia*, its core administrative arrangements are "far from strictly bottom-up. In fact a close inspection of Wikipedia's process reveals that it has an elite at its center, (and that it does have a center is news to most), and that there is far more deliberate design management going on than first appears."[20] In part, this is perhaps an inevitable feature of centralized produsage projects overall: in *Wikipedia* as much as in *Slashdot*, *OhmyNews*, or the multi-user online gaming communities which we will encounter in later chapters, the owner and operator of the central servers on which the site exists, and the administrators of the Websites through which it facilitates its collaboration, will necessarily be placed in an especially privileged role. As the *Wikipedia* itself notes, "underlying all ... is a technocracy. Some people have power to develop and change code. Others have the power to change article histories and discover the IP addresses of logged-in users. And underlying all that, someone ... owns the hardware."[21]

However, the question then becomes how such individuals interpret and enact their own roles.

Shirky notes, for example, the important role that site operators and administrators play in continuing to develop the technological basis for collaborative produsage:

> our largest and most spontaneous sources of conversation and collaboration are busily being retrofit with filters and logins and distributed ID systems, in an attempt to save some of what is good about openness while defending against Wiki spam, email spam, comment spam, splogs, and other attempts at free-riding. Wikipedia falls into that category.[22]

We have seen similar processes also in the development of collaborative moderation and editing systems in many citizen journalism sites, as well as in the deployment of concurrent versioning systems for open source software development communities. In many such cases, the developers and administrators of these sites were smart enough to step back from overt control, trust their users and user communities, and implement the technological functionality to enable these communities themselves to take an ever greater role in facilitating and policing their processes of communication and collaboration. Administrators themselves intervene here openly only in extreme cases, or where legal frameworks require immediate action against content or contributors.

Such self-imposed limitation is a necessary aspect of fostering the open, equipotential, probabilistic, heterarchical approach to community involvement on which produsage projects crucially depend. It serves to maintain the overall meritocratic structure of the project, that is, the assumption that "those developers with the greatest ability (and motivation) should have the highest access level in the system,"[23] and that those who have practically unlimited access not by virtue of their role as content or technology developers, but through their involvement as founders and funders of a project, do not abuse such access in pursuit of their own ends. In the context of *Wikipedia*, of course,

> at the very top, with powers that range far beyond those of any mere Wikipedian mortal, is Wales, known to everyone in Wiki-world as Jimbo. He can do pretty much anything he wants—from locking pages to banning people to getting rid of developers. So vast are his powers that some began calling him "the benevolent dictator." But Wales bristled at that tag. So his minions assigned him a different, though no less imposing, label. "Jimbo," says Wikipedia administrator Mark Pellegrini, "is the God-King."[24]

Today, such titles, however humorous, do also point to the unresolved question of whether Wales's exercise of his powers is necessarily always benign and in keeping with overall community ethos. Several incidents in the recent past have highlighted potential conflicts between Wales's role as chief *Wikipedia* advocate and public face of the community, and his actions within the community itself. Among these is what many Wikipedians have regarded as a disproportionate response to the Seigenthaler controversy (without consultation with the wider community, Wales removed the fal-

sified information about Seigenthaler even from the edit history of the affected page), as well as his making a number of edits to his own biography on *Wikipedia*:

> Wales has been caught airbrushing his Wikipedia entry—eighteen times in the past year [2005]. He is particularly sensitive about references to the porn traffic on his Web portal. "Adult content" or "glamour photography" are the terms that he prefers, though, as one user pointed out on the site, they are perhaps not the most precise way to describe lesbian strip-poker threesomes. (In January, Wales agreed to a compromise: "erotic photography.") He is repentant about his meddling. "People shouldn't do it, including me," he said. "It's in poor taste."[25]

Although the impact of Wales's actions on the overall *Wikipedia* should not be overstated, they nonetheless serve to highlight the question of what role is available within produsage environments for a project's originator, and how sustainable the role of 'benevolent dictator' can be seen to be in the longer term. We have already observed similar questions in the context of open source, of course: here as well as there, even the originators of produsage projects cannot hope to remain leaders based simply on the status they derive from that initial role, but must also continue to maintain their merit and their resultant social status within the community through continued participation within the emerging adhocratic governance frameworks which the community continually adjusts in response to its current needs. Should a significant and strongly felt disconnect arise between Wales and the *Wikipedia* community, this may well undermine the *Wikipedia* project overall, or lead to phenomena similar to those we have already observed elsewhere: for example, to a forking of the *Wikipedia* project which splits the overall community into those who support, and those who reject Wales as leader.

At any rate, the processes of *Wikipedia* and other produsage projects must be seen therefore not as introducing some form of fundamental, all-encompassing direct democracy determining all aspects of the collaboration; instead, they do retain a non-flat, heterarchical structure of governance which is constantly at risk of reconfiguring itself into a more permanent, inflexible hierarchy of administrators. Thus, too,

> projects like Wikipedia do not overthrow any elite at all, but merely replace one elite—in this case an academic one—with another: the interactive media elite. Just because the latter might include a 14-year-old with an Internet connection in no way changes the fact that he's [sic] educated, techno-savvy, and enjoying enough free time to research and post to an encyclopedia for no pay. Although he is not on the editorial board of the *Encyclopedia Britannica*, he's certainly in as good a position as anyone to get there.[26]

The process of arriving at such positions of leadership, however, follows other pathways than those experienced in traditional production environments: absent overt disruptions by project originators, it proceeds along a path determined by the individual's continued, constructive, and collaborative involvement, and by the

evaluation of such involvement by the wider community. In essence, this translates Shirky's principle of 'publish, then filter' in online information communities (as opposed to 'filter, then publish' in conventional production) to the identification of community leaders: rather than operating on a 'select, then lead' logic by which staff are employed to act as project leaders, produsage communities operate on a 'lead, then select' model which observes and recognizes the informal leadership of contributors in the shared efforts of their communities, and on that basis facilitates their rise to higher roles. While project leaders acting as benevolent dictators and 'god-kings' have the power to unbalance this process of community-validated personal recognition by supporting specific individuals disproportionately, where they refrain from such favoritism, "in most cases, these reputations have been won through a process much closer to meritocracy, and through a fairer set of filters, than the ones through which we earn our graduate degrees," as Rushkoff puts it.[27]

Accrediting Wikipedians

This, then, points us towards the question of how *Wikipedia* evaluates and acknowledges the merit of its contributors, and how such internal meritocracy interconnects with the external accreditation of knowledge-holders through traditional educational and other systems. As *Wikipedia* use becomes more widespread, and as its own quality standards—as well as expectations of quality by outside users—increase, such questions have become ever more central for the project; they were further highlighted by the controversy surrounding one *Wikipedia* participant, known in the community as Essjay, in early 2007.

Essjay had been a frequent contributor to the *Wikipedia*, and through his participation had built a significant level of merit and status within the project. Ultimately, he had been made an administrator by the community, thus formally recognizing his contribution to and status within *Wikipedia*. Shortly after participating in a media interview about *Wikipedia*, however, it was revealed that the academic credentials claimed on Essjay's personal user page in the *Wikipedia* had been falsified; Essjay had never earned any academic degrees. Ultimately, this led to the user's retirement from the project, and also prevented him from taking up a position with Jimmy Wales's commercial wiki hosting company Wikia. Detractors of the *Wikipedia* model used the case as an opportunity to highlight the uncredentialed nature of participation in the collaborative content development efforts of the site, and pointed to apparent shortcomings inherent in *Wikipedia*'s equipotential model of produsage.

However, perhaps more importantly, such attacks, and the overall handling of the case, also reveal persistent misunderstandings of *Wikipedia* and its processes of communal content creation and evaluation. Although Essjay's falsification of personal credentials must necessarily be deplored, a more fundamental question is why he felt a

need to claim such credentials in the first place, and whether such claims had a substantial impact on the *Wikipedia* community's processes of evaluating his contributions. As Halavais points out,

> the truth is that Wikipedia shouldn't care whether someone has a Ph.D. or not—there are likely people claiming silly things about their own expertise every day on the talk pages of Wikipedia, but given that the resource is designed to draw its credibility from the sources, not the authors, this shouldn't be a big deal.[28]

This, of course, is an understanding which will perhaps need to be reinforced consistently within and beyond the *Wikipedia* community, and especially for newly arrived contributors: a key requirement of the produsage framework under which the site operates is that participants do not refrain from critiquing their peers' contributions in deference to the apparent or real credentials of others.

On this basis, then, the Essjay case may be less problematic than it first appears, and certainly does not undermine the *Wikipedia* model as such: to claim false credentials as Essjay did was clearly deceptive and unethical, and an offense against the collaborative spirit and mutual respect for fellow contributors which produsage projects crucially require, and Essjay's withdrawal from the project was certainly warranted for these reasons. His merits purely as a content contributor, and the merits of his contributed content as such, cannot and should not be affected by such evident personal shortcomings, however; here, status must be determined only by the communal evaluation of the content itself, regardless of the personal status of the originator of that content. (Where such status does interfere in the evaluation process, *Wikipedia* contributors acting as content evaluators must be better educated about and socialized into the process so that they do disregard the person and focus on the content.) This is an important distinction which has been lost in much of the discussion of this case, partly because Essjay's public visibility as an unofficial ambassador for *Wikipedia* through his media presence has skewed the perspective.

In addition, however, the Essjay case has also served to highlight the question of how *Wikipedia* identifies through its own processes the expertise of its authors in a specific field, and whether and how it enables those who are externally accredited experts in the field to translate part of that accreditation into merit within *Wikipedia* itself. Various solutions for such problems have been proposed in the recent past; in response to the Essjay controversy, for example, Jimmy Wales suggested that those claiming credentials in specific disciplines of knowledge should prove them to the *Wikipedia* community (for example by providing proof of their academic degrees to administrators), but such ideas have received little support from the wider community of participants. (A similar model has also been implemented by Larry Sanger in his project of developing *Citizendium*, an expert-led alternative to *Wikipedia*.)

At the same time, however, it is also important to keep in mind Shirky's caution that any changes to *Wikipedia*'s model of content creation must necessarily be incre-

mental and proceed in small adjustments to the overall process. The Essjay controversy and similar problems must be balanced against an understanding of how the underlying principles of *Wikipedia* otherwise enable the construction of a shared knowledge space through produsage and peer review: for example, *Wikipedia*'s lack of reliance on the overt display of personal credentials, and its highly informal meritocratic system (which notably does not use explicit karma scores as we have encountered them in *Slashdot* and other citizen journalism projects) has also meant that the site has not seen the emergence of tendencies towards participant hyperactivity as users attempt to rack up karma highscores through rapid-fire edits to existing content.

Overall, then, while *Wikipedia* may now need to move towards the development of more generally accessible tools to track participant activities and thereby identify them as more or less valuable community members, the development of merit recognition systems and community structures based on individual merit may also remain best orchestrated by individual topical communities, rather than organized by central decree and the deployment of unified systems; such systems may well contribute to the hardening of a site-wide contributor hierarchy rather than the maintenance of a fluid and diverse heterarchical structure spanning the diverse communities gathered in the *Wikipedia*. Designed and implemented intelligently under the leadership of the community of Wikipedians, on the other hand, a more formal system for the recognition of positive user contributions would significantly strengthen *Wikipedia*'s claim to being a meritocracy, in which

> those contributors who provide the best quality work are most likely to see their contributions come to influence specific articles. They are less likely to be edited and corrected by other users as they gather respect and influence within the community or sub-community of topic area.[29]

Some international *Wikipedias* may already be ahead of the English-language flagship, in fact. As administrator Elisabeth Bauer notes,

> in the German Wikipedia, there is increasingly a distinction between 'normal' authors and 'high-end' authors who are explicitly trying to get their articles 'featured'. To be featured means to get explicitly recognized for your work by the community. This may include being featured on the start page of the German Wikipedia. This is normally a three-stage process:
> - peer review;
> - candidature for 'lesenswerter Artikel' (= 'notable article');
> - candidature for 'exzellenter Artikel' ('excellent article').
> This process is addictive to some. Recently, a club of volunteer authors formed, whose members pledge to deliver a certain amount of featured articles over time.[30]

Indeed, this focus on evaluating (and even on implicitly or explicitly scoring) the merit of articles rather than of contributors may provide the most feasible pathway for *Wikipedia*'s development. (This is not unlike the rating of discussion contributions in

citizen journalism, in fact.) Such scores could come to affect the status of contributors more indirectly, then: if article scores improve in the short term following a user's edits, this might also increase the user's 'merit score'; correspondingly, if articles decrease in score, or if the user's changes are reverted immediately, this would negatively affect the user's karma. User edits could also be tracked more specifically; a contributor's personal score could be linked, for example, to the extent of time that their changes remain visible in an entry without further alteration by other community members (such scores would also need to be corrected to distinguish between higher- and lower-traffic articles, however). The point of such suggestions here is not to sketch out the ideal *Wikipedia* merit system *per se*, of course—but they do point to the potential for the development of more specific and explicit technological systems which add to existing informal processes for the recognition of the relative merits of users and content as they are already in use within the *Wikipedia* community at present. Such systems would go some way towards documenting the fact that *Wikipedia* is no unruly anarchy in which 'anyone can edit' without further evaluation of their work, but that it does in fact more closely resemble a community-driven heterarchy with increasingly sophisticated if informal systems of checks and balances.

However, one problem with any such systems is that they would also need to find a way to take into account the wide range of topical fields covered by the encyclopedia. A meritorious user in one field of knowledge may nonetheless be a complete novice in another; their status as a valued contributor in their core field of expertise should therefore not mislead the community to take a lax approach to evaluating their contributions to topics of which they have a far more limited knowledge. Again, this may simply point to the need for topical communities within specific areas (however loosely defined such areas may be in themselves) to develop their own modes of meritocratic governance, and their own approaches to using the centralized technologies of content evaluation which may become available to the community.

It also appears important to maintain *Wikipedia*'s collective intelligence not only with regard to its information commons, but also to its *innovation* commons, by encouraging those community members seen to emerge as leaders of their peer groups to take up greater involvement in the administration and guidance of the overall project. Such shifts have been observed by some long-time Wikipedians already: Angela Beesley notes, for example, that

> creating fewer articles as time goes on seems fairly common as people get caught up in the politics and discussion rather than the editing, which as a newcomer is mostly all you do. There is some divergence between those who spend all their time on one project, or even one topic within that, and those who work on Wikimedia as a whole, having some influence in multiple projects, and acting on an international level.[31]

However, the existence of such pathways may need to be made more obvious to all *Wikipedia* contributors, and the procedures of becoming more involved in administrative tasks more explicit.

Beyond *Wikipedia*

As early as 2001, then *Wikipedia* ambassador Larry Sanger suggested that "it seems very likely that, in coming months, Wikipedia will set up some sort of approval process, whereby certain versions of articles receive the stamp of approval of some body of Wikipedia reviewers."[32] Beyond the limited embrace of peer review processes to highlight excellent articles in the German *Wikipedia* (as well as in some other national versions, perhaps), clearly this has not happened in the *Wikipedia* on a broad scale in the intervening years, however. There are a number of possible avenues both from within and from outside the *Wikipedia* environment itself which could lead to the development of further peer- or expert-reviewed *Wikipedias* or *Wikipedia* competitors, and some such projects are now in the process of being established.

In the first place, *Wikipedia* leader Jimmy Wales himself has hinted at the potential of establishing a reviewed subset of the *Wikipedia*, based directly on the 'stable release' model common in open source software design: in 2004, he noted that

> I am currently working on a first draft proposal to the community for our "next phase" of review, which will involve getting serious about producing a "1.0 stable" release. The concept here is very analogous to that in the software world—the existing site is always the cutting edge nightly build, which rocks of course, but we also need a stable release that's been reviewed and tested and found good.[33]

Much as in the world of software, this 'stable build' would represent a channeling of part of the continuous and unfinished content creation processes, which in themselves necessarily result in temporary content artefacts rather than finished products, into more traditional production processes, by putting in place a set of conventional gatekeepers to put an official stamp of approval on the content available in *Wikipedia*.

There also remain some significant problems with this model, however, and the lack of obvious progress on this issue can itself be seen as an indication of the obstacles to producing a 'stable' *Wikipedia*. To date, some refereed subsets of *Wikipedia* have been issued on CD-ROM in static versions (aimed especially towards use in schools and in third world projects), but these versions have contained some 5,000 articles at most, thus constituting only a minute subset of the total content available on the site. Indeed, the pursuit of a stable version reintroduces the problems of content *production* which produsage is able to overcome: it is likely to rely on a limited team of reviewers or editors, and thus necessarily can deal only with a selection of what are seen to be the most 'important' topics in *Wikipedia*, from that team's perspective; by fixing its

contents in time, it creates a version of the available information in *Wikipedia* which is inherently immediately outdated (especially so for any topics relating to current events, of course); and it cuts off user access to those features which most distinguish *Wikipedia* from conventional encyclopedias—especially the ability to contribute one's own knowledge and perspectives and thereby to democratize the process of creating a shared knowledge resource. (That said, the intention of creating a free or low-cost version of *Wikipedia* for distribution to users who do not have Internet access or the resources to afford commercial encyclopedias remains laudable, of course.)

Community-driven approaches to awarding a 'seal of quality' to specific *Wikipedia* articles, as we have seen them for example in the German *Wikipedia*, or other means of communally rating the quality of individual revisions to *Wikipedia* entries, may prove a different, more workable approach to developing a stable version without introducing a special class of *Wikipedia* editors or reviewers. Such models would allow the task of content evaluation to remain in the hands of the community itself, and their resulting content ratings would therefore also represent a much wider perspective than that of a small, closed group of reviewers; a 'stable version' produced from such content would thus be likely to be more representative of *Wikipedia*'s overall range of content (but may in turn be skewed towards topics in popular culture). Under this model, the stable version could draw on those revisions in an article's edit history which had been rated most highly, rather than selecting the most recent version or an older and fixed version evaluated by the reviewers; indeed, the continuing process of user-led content evaluation may mean that content for 'stable' versions could be extracted from the overall *Wikipedia* database at any given moment and would nonetheless represent the community's current views on which of the available versions of its articles are regarded as the best in quality.

In addition, a number of alternatives to and variations on *Wikipedia* have now also been established, so far without being able to unseat the *Wikipedia* project itself as undisputed leader in the field of collaborative online encyclopedias. The emergence of such alternatives is significantly enabled by the content licenses applied to *Wikipedia* and its underlying wiki system itself, in fact: "not only the individual texts are available, the entire project—including its platform—can be downloaded as a single file for mirroring, viewing offline, or any other use. Effectively, not even the system administrator can control the project."[34] At the same time, however, access to the content and tools required to set up a rival *Wikipedia* does not guarantee the emergence of a similarly productive and enthusiastic community around the new site, of course, and it is here that *Wikipedia* continues to enjoy a substantial competitive advantage over any of the emerging alternatives.

Although it is possible to 'fork' *Wikipedia*, then (much in the same way that this can be achieved in open source software development), the motivations for doing so remain less clear. In the first place, of course, we have already seen *Wikipedia* itself as representing a still-emerging collaborative institution within which it remains possible

for individual contributors to effect change on the level of individual entries, larger topical fields, or in some cases even the overall project itself. *Wikipedia*'s NPOV policy, in particular, ensures that forking is unlikely to happen over simple differences of opinion on how to represent available knowledge on a specific topic; indeed, as we have seen, the site encourages the inclusion of a variety of representations of knowledge even where they are in conflict with one another, rather than working towards a synthesis of available evidence in a process of uncovering 'the truth'.

A number of alternatives to *Wikipedia*, therefore, are driven not by such content disputes in and of themselves, but by the desire to implement principles which fundamentally depart from the NPOV doctrine itself. Such sites include, for example, the *Conservapedia* and *DKosopedia*, which respectively aim to develop encyclopedias sympathetic to the perspectives of the right and the left of U.S. politics (the latter is orchestrated by the popular leftist blog *Daily Kos*). *Wikinfo* (also known somewhat misleadingly as *Internet-Encyclopedia*) focuses simply on embracing a 'Sympathetic Point of View' towards the topics it covers, and also explicitly invites the contribution of original research to its pages; *Debatepedia*, on the other hand, offers a space for direct debates between alternative positions on controversial topics, rather than merely implementing NPOV as a means of enabling their peaceful coexistence.

None of these alternatives (and other, additional sites which may exist to complement versions of *Wikipedia* in languages other than English) have been significantly successful to date—certainly not in the admittedly somewhat unfair comparison with *Wikipedia* itself. This does not mean that *Wikipedia* cannot learn from them, however; the stylistic, structural, procedural, social, and technological innovations attempted by such sites may also offer new ideas for *Wikipedia*'s own processes of continued innovation. *Wikipedia* also should not misunderstand itself as a somehow 'natural' leader of the online knowledge space; it, too, might be driven to casual collapse at a point when a still further improved model for collaborative content development emerges, much as *Wikipedia* itself may be seen as threatening the casual collapse of the conventional encyclopedic production model. As Sanger cautions,

> Wikipedia became what it is today because, having been seeded with great people with a fairly clear idea of what they wanted to achieve, we proceeded to make *a series of free decisions* that determined the policy of the project and culture of its supporting community. Wikipedia's system is neither the only way to run a wiki, nor the only way to run an open content encyclopedia. Its particular conjunction of policies is in no way natural, "organic," or necessary.[35]

Indeed, he notes, "if the project has problems (or features) which will keep it from being the maximally authoritative, broad, and deep reference that I believe could exist, I firmly believe that the world has the right to, and should, improve upon it."

Recently, Sanger himself has been highly vocal about what he perceives to be fundamental shortcomings in the *Wikipedia* content produsage model; these shortcomings

have led him to initiate a further alternative project to *Wikipedia*: the *Citizendium*. With this project, he returns to some of the principles of the earlier *Nupedia* project, in fact:

> Nupedia was to be a highly reliable, peer-reviewed resource that fully appreciated and employed the efforts of subject area experts, as well as the general public. When the more free-wheeling Wikipedia took off, Nupedia was left to wither. It might appear to have died of its own weight and complexity. But ... it could have been redesigned and adapted—it could have, as it were, "learned from its mistakes" and from Wikipedia's successes.[36]

Contrary to *Wikipedia*, then, *Citizendium* reintroduces a focus on experts as the final arbiters of an encyclopedia entry's quality, and limits open participation in the project to authenticated and credentialed users. Potential participants are (at the time of writing) required to email the project organizers, providing their real name, a brief biography outlining qualifications and interests, and their acceptance of the project charter, and (once accepted) operate "shoulder to shoulder" with content editors; only these editors are "empowered, singly or collectively, ... (1) to make decisions about specific questions, or disputes, concerning particular articles in an editor's area of expertise, and (2) to approve high-quality articles."[37]

Although inviting user contributions, therefore (at least from those users who pass the requirements for authentication), *Citizendium* clearly does not follow basic produsage principles on two important points: its participation is less than open, and content is evaluated by a specific group of administrators; and its structures are hierarchical and its governance guided by predetermined rules. This will not necessarily fundamentally undermine its ability to produce content, but it will undoubtedly substantially affect the range and style of content which is produced through this approach. In the first place, limitations imposed on the range of users able to participate, combined with the need for editorial review, will necessarily diminish the amount of content created through the process, and may redirect focus to those topical areas for which *Citizendium* has been able to attract the greatest number of accredited expert editors. In addition, the expert review process is also likely to reduce the number of alternative representations of knowledge presented through its entries, and may return its content coverage towards a focus on accepted, canonized knowledge much in line with the contents of conventional encyclopedias.

Citizendium thus represents an interesting attempt to harness some of the aspects of produsage in the pursuit of the aim of producing a relatively conventional encyclopedia; the limitations of this approach in comparison *both* to *Wikipedia*'s produsage-based approach *and* to the commercially powered processes of content production in established online and print encyclopedias raise significant doubts about its long-term sustainability, however. In addition, Sanger's *a priori* imposition of a detailed set of goals and principles for community participation and interaction on the site may have

a particularly obstructive impact on *Citizendium*'s development: "one of the most important things you can do to attract community is to give it a fertile environment in which to grow, and one of the most damaging things you can do is to try to force it to grow at a rapid pace or in a preset direction," as Shirky notes. [38]

Whatever the fate of any one encyclopedic online project, however, and whether employing produsage, production, or hybrid models of content creation, it does appear likely that *Wikipedia* will not remain the only challenger to the established conventional encyclopedias. The increase in the variety of options which this development represents for information seekers as well as for potential contributors to such content development projects must almost necessarily be seen as a positive development in its own right; at the same time, however, it also increases the burden on the user and contributor of making the effort to investigate in some detail the relative merits of each encyclopedic option. Indeed, it is likely that no 'one size fits all' encyclopedia will emerge, and that the combination and contrasting of relevant entries in *Wikipedia*, *Britannica*, and other alternative encyclopedias will provide the most complete overview of available knowledge and existing debates and disagreements on any one topic. This once again highlights the need to develop further research literacies and contribution capacities in the potential users and produsers of such sites, to combat a blind reliance on any one source; we will take up such questions in more detail in Chapter 13.

Non-Encyclopedic Knowledge Spaces

While at present it must certainly be seen as the most prominent, most important collaboratively created, produsage-based knowledge space, *Wikipedia* is far from being the only model for harnessing an open community of users as produsers in knowledge sharing and knowledge management. Indeed, for all its process innovation, and for all the crucial intellectual and social change and renaissance it may come to propel, *Wikipedia* may not even be considered to take the most radical approach to the collection and interconnection of human knowledge. Though doing so pluralistically, and respecting differences in the interpretation of available information, "*Wikipedia* (like encyclopedias in general) summarizes and reports the conventional and accepted wisdom on a topic but does not break new ground."[39]

A number of further alternative models have also emerged, some of which embrace more significantly different organizations of knowledge as compared to traditional knowledge repositories (but some of which, for that reason, have as yet also proven significantly less successful (in terms of attracting participants, and collecting knowledge) than *Wikipedia* and the flotilla of similar wiki-based encyclopedias following in its wake. Perhaps one of the longest-lived of these sites is *Everything2*, which emerged from within the *Slashdot* community. *Everything2*, like *Wikipedia*, allows its

users to create articles on any topic deemed to be relevant, but does not enforce a NPOV policy, nor limit its content to strictly encyclopedic material only. By contrast, much of the work presented through the site is significantly more personal in nature, ranging from write-ups by enthusiasts about their favorite (or least favorite) cultural icons through self-help advice to personal rants about the world in general. Such entries in themselves, and *Everything2* in general, have little ambition to be comprehensive or balanced in their coverage, but in the process display both a great deal of interest in and enthusiasm for their subjects, and often also significant insight into their topics.

Everything2 allows multiple users to add their definitions, opinions, or other contributions as a separate section under the same topic heading; it also offers a content rating system in analogy to similar systems existing in citizen journalism (and proposed for *Wikipedia*). In addition, much like *Slashdot* and other citizen journalism projects, the site also allows for user comments to be attached to the topics covered on its pages, as well as strongly encouraging the interlinkage of individual entries (called 'nodes') in the content base; overall, therefore, it appears to the user as something of a cross between a wiki-based, spatially networked encyclopedia and a blog-based, temporally ordered discussion about the topics covered. In essence, then, where *Wikipedia* can be described as a repository of (sometimes conflicting) knowledges about the topics it covers, *Everything2* is a repository of opinions instead. Compared to *Wikipedia*, its content necessarily takes a less overtly palimpsestic form, as there is no direct access to the page history for any of *Everything2*'s nodes, but the presence of multiple write-ups and additional comments for any one node nonetheless highlights the continuing discussions its users have about many of the topics contained within the site. Thus, its *modus operandi* can nonetheless continue to be described as produsage, as it embraces all four principles of produsage as we have encountered them.

In addition to sites such as *Everything2*, which like *Wikipedia* take an open-ended, quasi-comprehensive approach to covering the knowledge space of humanity, many other more specialist sites of knowledge produsage have also emerged in recent years. Today these span virtually all aspects of popular and expert knowledge, but it is useful to highlight three particularly active areas of produsage at present. Each of these is characterized by the free sharing of personal ideas and knowledge for communal use, evaluation, and improvement, and each provides further insight into the motivations of participants, as well as highlighting the importance for produsage projects of connecting into existing enthusiast communities in order to harness their energy: sites in each of these three areas have successfully identified participants who, in Raymond's words, have an itch to scratch, and provide the means for allowing the community to collectively address such needs.

One such area of strong development is found among do-it-yourself hobbyists. Here, a number of sites have appeared which allow their users to share personal knowledge about what to do and what to avoid in amateur projects ranging from the

everyday (painting a wall, cooking a roast) to the bizarre (embedding the electronics of a computer mouse in a taxidermically preserved, real mouse). Sites such as *Instructables* and *Videojug* specifically set out to harbor such communities by providing them with the tools for sharing their knowledge and step-by-step instructions in text, image, and—in the case of the latter site—short video form. In effect, such sites are of course very closely aligned to the open source model, which at least initially built similarly strongly on communities of DIY software programmers and enabled them to share quite literally the instructions for making their computers perform particular tasks; *Instructables* and similar sites simply broaden the definition and specificity of 'source code' to the point where what is shared is no longer machine-readable source only, but the source code to be executed by humans themselves in making, building, and creating particular things.

Additional developments have extended this hobbyist instructions model further. *Daytipper* introduces an editorial system, and pays its contributors US\$3 for each published tip; this represents a departure from produsage that (except for the question of payment, of course) is similar perhaps to the edited encyclopedic model of *Citizendium* in comparison to *Wikipedia*. The overt introduction of a need to create content which appeals to a set of editors may also serve to skew submitted DIY instructions towards the mundane or generally sought-after, however, which could ultimately prove to become a problem for the site's breadth of coverage much in the same way that prepublication editing is a problem for the traditional model of content production elsewhere—while, perhaps mercifully, ideas such as the mouse-in-mouse project may be filtered from *Daytipper*'s stream of incoming tips, for example, it is also likely that a limited staff of editors would filter obscure but useful tips which appeal only to a very small subset of users or which depart radically from the commonly accepted approach to solving given problems.

A further variation on the DIY instructions model extends the sharing of advice from specific DIY projects to life in general. Sites such as *43 Things* enable their users to share their 43 (or fewer) life goals, and to provide advice and encouragement for achieving them to their peers. Currently ranking 'stop procrastinating' and 'fall in love' as the two most commonly held life ambitions, in comparison with its more explicitly DIY-minded counterparts the site thus emphasizes community dimensions over practical advice, and provides the means for general social networking and personal engagement as much as those for more targeted knowledge sharing. In the process, it highlights the inherently social nature of produsage, which is, after all, based on the open and equipotential engagement between users interacting as peers, and therefore enables the emergence of heterarchical community structures.

Such social aspects are also in strong evidence in another key area of informational produsage, which is closely linked to the field of DIY advice: the sharing of travel stories and advice. A lucrative market of travel-related Websites (beyond the industry of online travel bookings itself) has emerged in recent years; sites such as *Igo-*

Ugo, *TripAdvisor*, *MyTripJournal*, and *TrekShare* all cater to seasoned as well as less experienced tourists wishing to share their adventures and thereby inform fellow travelers of where to go, what to do, and how to avoid trouble and disappointment. As is evident from their names, some such sites at least initially focused on simply providing a space for travelers to publish photos and journals from their trips, and as such can be seen perhaps as modern-day, specialist versions of earlier operators such as *Geocities*, which in the mid-1990s provided free space for their homepages to the masses of newly minted Web users turned content publishers; where the focus remains on this model of personal publishing, then, such sites cannot be described as communal produsage, of course.

However, many travel sites have now added functions for user commentary and broader engagement, and a number of sites have moved beyond the publishing of entire travel journals (which in that format are generally of interest only to a small group of visitors, perhaps) to a focus on sharing individual tips and advice on specific cities, attractions, hotels, travel operators, and other aspects of a trip. This is a move towards greater modularity of content, and towards an increased granularity of participation, as Benkler has outlined it, and significantly enhances the potential for produsage-based engagement to take place around the sharing of travel advice; it also better realizes the equipotentiality of participants as even those whose overall trips remained perhaps unremarkable in general may be able to contribute to the produsage process a small number of significant insights and knowledge gained during their travels.

Such travel sites further extend the model of communal evaluation as we have seen it in produsage more generally, in ways not unlike the gatewatching process we have encountered in citizen journalism: travel communities on these sites evaluate one another's advice and other contributions, and thereby highlight the most valuable travel tips and other suggestions made by their peers; in addition, however, they also collaboratively evaluate the quality of hotels, travel operators, and other aspects of tourism encountered on their trips. This is similar to citizen journalism in that there, too, outside content is introduced (through the practices of gatewatching) into the communal evaluation process; produsage-based travel advice communities play an analogous watchdog role for the industry to which they have attached themselves. Indeed, the benefits (but also the potential negative effects) of this process of communal evaluation are quickly beginning to be realized by the tourism and travel industry itself: a number of independent online travel booking agencies have begun to introduce their own systems for allowing users to rate and comment on hotels, flight operators, and other services on offer through these sites, thereby increasing customer satisfaction; flight and especially hotel operators themselves, on the other hand, are also increasingly active in monitoring and—where necessary—responding to user comments on their services.

In addition, however, such produsage-based travel communities also present an increasingly difficult challenge (as well as opportunity) to the traditional producers of

travel advice products: guidebook publishers such as *Lonely Planet* are likely to be forced to incorporate a growing amount of user-prodused content into their products if they hope to avoid the casual collapse of their traditional business models, especially as better Internet access to travelers and the improving storage and access capacities of handheld mobile devices enable tourists to switch from relying on printed guidebooks to using (and even contributing to) electronic, online resources even while on the road. The embrace of prodused content by commercial operators also raises questions around the economic and legal frameworks for harvesting such user content, of course; we have already encountered such questions about the legitimacy of commercially exploiting freely available commons content in the context of open source software development, and we will address them in some more detail in Chapter 10.

A third key area of informational and knowledge produsage beyond *Wikipedia* at present also relates closely to travel and geographic information more generally. This area is led by services such as *Google Earth*, *Google Maps*, *Frappr*, and their Yahoo!- and Microsoft-provided counterparts: here, representations of the surface of the Earth through maps and satellite images serve as the shared basis for a palimpsestic compilation and inscription of user knowledge. Indeed, where *Wikipedia* and wikis more generally can be seen as providing an abstractly spatial model for the organization of knowledge, such mapping services necessarily return to a more *literally* spatial, geographic structure for the knowledge they contain. In addition, increasingly connections between these two modes for the spatial or quasi-spatial representation of knowledge are also being made; so, for example, *Wikipedia* itself has begun to add specific geographical coordinates to much of its content where it relates to particular places in the world, enabling its users to navigate easily from entries in the encyclopedia to locations on the maps provided by any of the leading mapping services. Conversely, the *Semapedia* project aims to make the reverse connection by offering the tools to create printable barcodes which, when read by enabled mobile devices, convert to hyperlinks pointing to pages in the *Wikipedia*, and it encourages its users to attach such barcodes to objects and spaces in the physical world, in a process of what can be described as offline-to-online geotagging. Similar, online-to-offline geotagging tools have also been deployed for the photosharing service *Flickr*, for example, allowing its users to pinpoint the exact locations where their shots were taken.

Further extensions of this model have begun to emerge for almost any form of information which can be usefully linked to specific coordinates in the physical world; this has also been enabled by the opening of direct user access to the Application Programming Interfaces (APIs) of most of the leading mapping tools. This has led to the emergence of a very wide range of what has become known as service 'mash-ups,' mapping any variety of user-created or professionally, officially produced data on geographical maps. In essence, the leading geomapping services have thus become visualization tools for such data, and innovation in the further development of visualization ideas is now largely user-led[40]; such produsage of visualization models has re-

sulted in a variety of previously unavailable informational resources (including, for example, maps combining U.S. crime rates and housing prices to pinpoint the country's safest *and* most affordable residential communities).

Especially around tools such as *Google Earth*, strong produsage communities have also emerged: the *Google Earth* software, for example, connects its users directly to the *Google Earth* bulletin board system through which the community organizes shared projects of knowledge mapping and content creation, as well as engaging in the discussion of notable features as well as glitches in the satellite maps provided through the software. The community has collaboratively developed a growing set of additional informational layers for the software, enabling users to explore historical sites, natural landmarks, locations of current events, and places of more individual, personal significance; in addition, further functionality gradually made available has now also facilitated the user-led development of detailed geometric models of the cityscapes of many world metropoles, which can be superimposed onto *Google Earth*.

Overall, *Trendwatching* sees such developments as driven by a phenomenon it describes as 'infolust,' caused partly by the increasing levels of community involvement in content creation that have been enabled by the produsage model; it notes that "Google Maps has unleashed a whole new layer of detailed INFOLUST services, from Gawker Stalker to Proper Pint. And that's just celebs in Manhattan and bars in Dublin."[41] What the development of such geotagging service mash-ups points towards is the increased ability of enthusiastic users armed with appropriate tools to build on both produced and prodused content and services in order to develop further information and knowledge, and the tendency to make such knowledge freely available again to the wider community of users for their evaluation and further development. Produsage in specific environments, then, when taking place under appropriate preconditions, leads to the establishment of further produsage processes beyond these environments, in what may be seen as a virtuous cycle promoting the diffusion, distribution, and decentralization of knowledge produsage.

Beyond the Encyclopedia?

Ultimately, we may therefore approach a new version of Stallman's originally somewhat utopian vision for the Web itself, predicting in 1999 that

> the free encyclopedia will not be published in any one place. It will consist of all web pages that cover suitable topics, and have been made suitably available. These pages will be developed in a decentralized manner by thousands of contributors, each independently writing articles and posting them on various web servers. No one organization will be in charge, because such centralization would be incompatible with decentralized progress.[42]

Many Web users might be tempted to suggest that this state of total diffusion has long been achieved, and that centralized sites such as *Wikipedia* merely represent a convenient exception from the decentralized, disorganized jumble of information otherwise found on the Web. If so, is it appropriate to describe the Web itself as the ultimate open participation encyclopedia—or conversely, does it make any sense to continue to describe *Wikipedia* in particular, and much less the Web in general, as an encyclopedia? For boyd, for example, the answer is very clearly that *Wikipedia* "will never be an encyclopedia, but it will contain extensive knowledge that is quite valuable for different purposes."[43]

Such questions necessarily point to the problem of how we define the intent and purpose of encyclopedias themselves. Sanger reports that the inventor of the wiki system itself, Ward Cunningham, responded "when Jimmy [Wales] asked him whether wiki software 'could successfully generate a useful encyclopedia' ... : 'Yes, but in the end it wouldn't be an encyclopedia. It would be a wiki.'"[44] Indeed, it is possible to suggest that the specific features of *Wikipedia* as a wiki—or more to the point, its employment of wiki functionality as a means to the collaborative produsage of representations of knowledge—should be seen as a more significant advance for the project of developing a shared knowledge space for humanity than would be the universal acceptance of the resulting knowledge space as an encyclopedia on par with the conventional encyclopedias already in existence; from this perspective, "the goal should [not] be 'acceptance' so much as recognition of what Wikipedia is and what it is not."[45]

Indeed, rather than attempting to gain entry into the established cultural elite of encyclopedic production, *Wikipedia* might prefer to celebrate its difference; on closer examination, membership in the old boys' club (or indeed, in line with the common caricature of encyclopedic production, the dead white men's club) of the encyclopedic establishment may not be as desirable as it seems. Surprisingly, this view is supported even by former *Britannica* editor Charles Van Doren, who noted as early as 1962 that "in some sense the old idea of an encyclopedia, whatever it was, is now outmoded, and both the old aims and the old ability to serve them, whatever those aims and abilities were, are declining."[46]

If *Wikipedia* and *Britannica* are indeed "different animals,"[47] then, the key difference between the two must surely be found quite beyond their different models of participation, of evaluation, of governance, of ownership; it lies in their vastly different conceptions of the nature of the knowledge which is represented on their pages. As we have noted repeatedly, where *Britannica* assumes that its process of collating and synthesizing available information through the processes of encyclopedic production enables it to provide as complete and authoritative a sense of the 'truth' as is humanly possible, *Wikipedia* is instead satisfied with providing a variety of common *representations of knowledge* on any one topic; its content is therefore always necessarily unfinished, under development, and evolving, and its edit histories and discussion pages are

direct indicators of this ongoing process of exploration, negotiation, and communication. Thus, "Wikipedia isn't great because it's like the *Britannica*. The *Britannica* is great at being authoritative, edited, expensive, and monolithic. Wikipedia is great at being free, brawling, universal, and instantaneous."[48]

In the process, it comes closer to Van Doren's call for a reimagined encyclopedia which dares to explore the unexplored, unthought-of, *unknown* spaces of human knowledge than most of the conventional encyclopedias available even forty-five years after that call was first sounded:

> many academicians who fear the unknown most actively at the same time desire to conquer their fear and make knowledge once more one. Such a great and, at the beginning, perhaps Quixotic program might strike fear in the imaginations of many of those on whom an encyclopedia would depend for its reputation. Respectability seems safe. But what will be respectable in thirty years seems *avant-garde* now. If an encyclopedia hopes to be respectable in the year 2000 it must appear daring in the year 1963.[49]

By the same token, then, a project like the *Wikipedia*, still appearing daring today, may well feel staid and safe only a few years from now, and could face new competition from even more daring attempts at and innovations in the collaborative development of information commons and knowledge spaces.

Wikipedia's key advantage over encyclopedic tradition, then, unsurprisingly is not unlike the advances made over traditional software production by open source, or over industrial, mass media news by citizen journalism: it has provided the space for citizen participants in its produsage processes to voice their own views, and the means of channeling those views into the collaborative development of a shared knowledge space—a process enabled and facilitated, even kick-started in good part through the operation of its NPOV principle:

> the NPOV policy provides a shared basis of discourse among Wikipedians. On the "Discussion" pages that accompany every *Wikipedia* article, the number one topic of debate is whether the article adheres to the NPOV. Sometimes, those debates can go on at mind-numbing length, such as the literally hundreds of pages devoted to an entry on the Armenian genocide that still carries a warning that "the neutrality of this article is disputed."[50]

Contrary to "most encyclopedias," then, which "have little or no idea of themselves. They just grow; they are not created,"[51] Wikipedians have and express very clear (if often disputed) ideas of what they want to see in their project of continuing content creation; indeed, the communicative process of dispute, debate, and deliberation over the appropriate way to represent alternative opinions in a neutral, respectful, and generally acceptable manner must be seen as just as important as the resultant content as such. "Wikipedia is itself, really, a continuing discussion,"[52] and much as each individual entry must be seen as no more than a temporary artefact of the continuing, in-

cremental, palimpsestic process of content produsage which takes place among the millions of *Wikipedia* contributors, for Shirky the overall resource itself "is the most interesting conversational artifact I know of, where product is a result of process. Rather than 'We're specifically going to get together and create this presentation' it's just 'What's left is a record of what we said.'"[53]

In the process, *Wikipedia* and similar produsage projects alter their contributors' understanding of the world of knowledge by exposing the limitations of conventional content production processes:

> we begin to become aware of just how much of our reality is open source and up for discussion. So much of what seemed like impenetrable hardware is actually software and ripe for reprogramming. The stories we use to understand the world seem less like explanations and more like collaborations. They are rule sets, only as good as their ability to explain the patterns of history or predict those of the future.[54]

As our understandings of reality change, then, so necessarily must *Wikipedia* and similar spaces continue to move with the times; this, again, requires a reconceptualization of its contents not as fixed products attempting to asymptotically approximate an ultimate truth, as McHenry would have us believe, but as continuously and necessarily unfinished artefacts subject to constant review by users turned produsers.

This ongoing process of collaborative development of the shared knowledge space by a diverse community of self-selected participants, then, also has significant civic value: "those who create Wikipedia's articles and debate their contents are involved in an astonishingly intense and widespread process of democratic self-education"[55]; they are engaged not simply in a process of debate or discussion, but in fact are engaging in active, self-determined cultural citizenship, or what Hartley refers to as "DIY citizenship,"[56] and in the mutual education of their peers. This advances well beyond the conventional role of encyclopedias as Van Doren describes it: "the aim of the typical American encyclopedia is to inform ... ; it intends to make known, not to make comprehensible."[57] Wikipedians, by contrast, also inform, but more importantly, through the content they create, as well as through the discussions about such content creation and knowledge representation on *Wikipedia*'s 'talk' pages, each of them attempt to make their own views and perspectives comprehensible to those holding alternative views—not immediately to convince them to change their minds, but in the first place simply to ensure that all relevant views are neutrally and respectfully represented.

This necessarily involves processes of communal deliberation, and the effects of this open deliberation about how to interpret available information and represent commonly held perspectives on knowledge are among *Wikipedia*'s most important social contributions.

> Deliberation sets out to give a different answer to the question what is the meaning of public discussion. The meaning is not so much in the quest for truth, private pleasures of reception, or in dialogue as such. More than those, public discussion should

be about transformations of public definitions and opinions concerning common problems.[58]

Such transformations—aimed not towards the arrival at a unanimously homogenous perspective held by all of society, but at the development of a clearer understanding of what is the range of current views and opinions, and of how they interrelate—provide a crucial tool for the improvement of public discourse. If, as Van Doren suggests, "any encyclopedia is, more or less, an instrument of enlightenment,"[59] then surely *Wikipedia* makes a substantial contribution towards that goal.

Whether explicitly or implicitly, therefore, contrary to present-day encyclopedias which merely "satisfy the desire of a generation and of a culture which would rather look backward than forward,"[60] the *Wikipedia* is clearly directed at the future. This is at present perhaps simply a side effect of its (and its community's) youthful enthusiasm; as members of a still relatively recent project, it remains possible for Wikipedians not to become bogged down in questions over how to maintain the successes the project has already achieved, but rather to focus on developing the means to further their cause through the incremental improvement and extension of its operations. But an accidental benefit of the NPOV policy may indeed be that it forces contributors if not to resolve their intellectual and ideological differences, then at least to work towards the establishment of an equitable truce in hostilities; "they surprisingly often achieve 'a type of writing that is agreeable to essentially rational people who may differ on particular points.'"[61] This, then, does allow for a more forward-looking perspective, as it avoids an obsession with rehashing old conflicts and enables participants to move on to new fields—fields which may yet again serve as grounds for conflict, perhaps, but which also offer the hope that the pluralistic accommodation established elsewhere may well be extended to these new knowledge spaces as well.

Writing in the early 1960s, Van Doren suggested a reconceptualization of the aims to be pursued by the project of encyclopedia production:

1. The primary aim of an encyclopedia should be to teach. It should seek only secondarily to inform.
2. An encyclopedia should be primarily a work of art. It should be only secondarily a work of reference.
3. The point of view of an encyclopedia should be primarily human. It should be only secondarily historical and/or scientific and/or literary.
4. The ideal reader of an encyclopedia should be primarily the curious average man [sic]. He should only secondarily be the specialist and/or the high school student.
5. An encyclopedia should be primarily a document that hopes to change the world for the better. It should be only secondarily a document that accurately reflects the knowledge, opinions and prejudices of its time.[62]

Given our discussion over the past two chapters, it is not difficult to see *Wikipedia* as pursuing these aims, and to see its underlying processes of produsage as a key prerequisite for doing so. At its best, *Wikipedia* teaches its contributors how to represent

their knowledge, and how to respect and come to an arrangement with those who interpret reality differently; its information commons and knowledge space can very well be considered to be a collaborative created, continuously shifting work of art—an artefact in the true sense; through its involvement of the community of participants as active producers it necessarily adopts a human and humanistic rather than a strictly scientific, historical, literary, or otherwise abstractly theoretic stance; it is collaboratively developed by a wide range of participants ranging from the amateur to the pro-am to the professional; and it reflects not the knowledge, but the various competing and contradictory but nonetheless real and important *knowledges* of its time, and through their engagement with one another aims implicitly or explicitly to contribute to a greater engagement and deliberation between conflicting points of view.

Van Doren completes his sketch of the ideal encyclopedia by suggesting that

> finally, it is important that the work ... be thought of as a kind of message for the future. "This is the way it was," it would say. "We give you this world; now make it your own." It would speak to the next century rather than to this. It would attempt to interpret the twentieth century for the twenty-first. Such a document would provide an educative synthesis from which the "curious average man" [*sic*] could successfully encounter the novel complexities of the present, and build a future that is good for man [*sic*].[63]

Still in its first decade of existence, *Wikipedia* necessarily is too young to have already become such a generational document—but in the aftermath of the turn of the millennium, and in the context of an ever-increasing speed of life, this question of a trading-on of information and knowledge from generation to generation may itself also be considered as outdated today, itself a remnant of an industrial-age thought process that saw information as packaged in products rather than as transmitted through continuing, continuously unfinished processes. The *Wikipedia* is no such generational product, in the way that we might read an edition of *Britannica* from twenty, fifty, one hundred years ago as an encapsulation of the attitudes of its time, and cannot possibly be such a product; it is no product at all.

Instead, as we have seen, *Wikipedia* is a process generating only a steady, continuing stream of temporary artefacts, but encapsulated in this process is the very idea of passing on an interpretation, a representation of the knowledges of the day: not from century to century, not from generation to generation, but from day to day, from user to user, from produser to produser. It is a collaborative project for the continuing exploration, discussion, representation, extension, and preservation of humanity's understanding of the world, and of itself, conducted through the principles and processes of produsage. It is, as Pesce puts it,

> the first artifact of the age of hyperintelligence. It's not just a scan of the books from the world's biggest libraries. It's far more than that. It's the living embodiment of the

human world inside our own heads—something that could never fit into the pages of any book.[64]

If its aim to represent and preserve humanity's collected knowledges in this way requires unusual, untried, and themselves still developing approaches to the collaborative creation of content, such as the technological framework of the wiki and the organizational principles of produsage, so be it: as Van Doren suggested,

> because the world is radically new, the ideal encyclopedia should be radical, too. It should stop being safe—in politics, in philosophy, in science. It should create a synthesis where none is thought to be possible. It should carve a new order out of the chaos that has swept away the old. It should think of itself as an important—perhaps even the most important—tool for the reconstruction of a world that has meaning.[65]

Even, we might add, if that meaning is now inevitably multiple; even if knowledge has become irreversibly a plural.

NOTES

1. Daniel H. Pink, "The Book Stops Here," *Wired* 13.3 (Mar. 2005), http://www.wired.com/wired/archive/13.03/wiki.html (accessed 26 Feb. 2007), n.p.

2. Pink, n.p.

3. Clay Shirky, "Wikipedia: The Nature of Authority, and a LazyWeb Request..." *Many 2 Many: A Group Weblog on Social Software*, 6 Jan. 2005, http://many.corante.com/archives/2005/01/06/wikipedia_the_nature_of_authority_and_a_lazyweb_request.php (accessed 25 Feb. 2007), n.p.

4. Cory Doctorow, "On 'Digital Maoism: The Hazards of the New Online Collectivism' by Jaron Lanier," *Edge: The Reality Club*, 2006, http://www.edge.org/discourse/digital_maoism.html (accessed 28 Feb. 2007), n.p.

5. Pierre Lévy, *Collective Intelligence: Mankind's Emerging World in Cyberspace*, trans. Robert Bononno (Cambridge, Mass.: Perseus, 1997), p. 183.

6. Lévy, p. 207.

7. Stacy Schiff, "Know It All: Can Wikipedia Conquer Expertise?" *New Yorker*, 31 July 2006, http://www.newyorker.com/archive/2006/07/31/060731fa_fact (accessed 13 Mar. 2007), p. 6.

8. Wikimedia, "Power Structure," *Wikimedia: Meta-Wiki*, 11 Dec. 2006, http://meta.wikimedia.org/wiki/Power_structure (accessed 28 Feb. 2007), n.p.

9. Pink, n.p.

10. Pink, n.p.

11. Qtd. in Dirk Riehle, "How and Why Wikipedia Works: An Interview with Angela Beesley, Elisabeth Bauer, and Kizu Naoko," in *Proceedings of the International Symposium on Wikis (WikiSym)*, 21–23 Aug. 2006, Odense, Denmark, http://www.riehle.org/computer-science/research/2006/wikisym-2006-interview.pdf (accessed 12 July 2007), p. 5.

12. Lawrence M. Sanger, "The Early History of Nupedia and Wikipedia: A Memoir (Pt. 2)," *Slashdot: News for Nerds, Stuff That Matters*, 19 Apr. 2005, http://features.slashdot.org/ article.pl?sid=05/04/19/1746205 (accessed 27 Feb. 2007), n.p.

13. Clay Shirky, "News of Wikipedia's Death Greatly Exaggerated," *Many 2 Many: A Group Weblog on Social Software*, 25 May 2006, http://many.corante.com/archives/2006/05/25/ news_of_wikipedias_death_greatly_exaggerated.php (accessed 26 Feb. 2007), n.p.

14. Sanger, "The Early History of Nupedia and Wikipedia: A Memoir (Pt. 2)," n.p.

15. Lawrence M. Sanger, "The Early History of Nupedia and Wikipedia: A Memoir (Pt. 1)," *Slashdot: News for Nerds, Stuff That Matters*, 18 Apr. 2005, http://features.slashdot.org/ article.pl?sid=05/04/18/164213 (accessed 27 Feb. 2007), n.p.

16. Sanger, "The Early History of Nupedia and Wikipedia: A Memoir (Pt. 2)," n.p.

17. See Axel Bruns, *Gatewatching: Collaborative Online News Production* (New York: Peter Lang, 2005).

18. Qtd. in Riehle, p. 6.

19. Shirky, "News of Wikipedia's Death Greatly Exaggerated," n.p.

20. Kevin Kelly, "On 'Digital Maoism: The Hazards of the New Online Collectivism' by Jaron Lanier," *Edge: The Reality Club*, 2006, http://www.edge.org/discourse/digital_maoism.html (accessed 28 Feb. 2007), n.p.

21. Wikimedia, n.p.

22. Shirky, "News of Wikipedia's Death Greatly Exaggerated," n.p.

23. Wikimedia, n.p.

24. Pink, n.p.

25. Schiff, p. 5.

26. Douglas Rushkoff, "On 'Digital Maoism: The Hazards of the New Online Collectivism' by Jaron Lanier," *Edge: The Reality Club*, 2006, http://www.edge.org/discourse/digital_maoism.html (accessed 28 Feb. 2007), n.p.

27. Rushkoff, n.p.

28. Alex Halavais, "Wikipedia Editor Abased," *A Thaumaturgical Compendium*, 7 Mar. 2007, http://alex.halavais.net/wikipedia-editor-abased/ (accessed 13 Mar. 2007), n.p.

29. Wikimedia, n.p.

30. Qtd. in Riehle, p. 4.

31. Qtd. in Riehle, p. 5.

32. Lawrence M. Sanger. "Wikipedia Is Wide Open: Why Is It Growing So Fast? Why Isn't It Full of Nonsense?" *Kuro5hin: Technology and Culture, from the Trenches*, 24 Sep. 2001, http://www. kuro5hin.org/story/2001/9/24/43858/2479 (accessed 27 Feb. 2007), n.p.

33. Jimmy Wales in Robin Miller, "Wikipedia Founder Jimmy Wales Responds," *Slashdot: News for Nerds, Stuff That Matters*, 28 July 2004, http://interviews.slashdot.org/article.pl?sid=04/07/28/ 1351230 (accessed 27 Feb. 2007), n.p.

34. Felix Stalder and Jesse Hirsh, "Open Source Intelligence," *First Monday* 7.6 (June 2002), http://www.firstmonday.org/issues/issue7_6/stalder/ (accessed 22 Apr. 2004), n.p.

35. Sanger, "The Early History of Nupedia and Wikipedia: A Memoir (Pt. 1)," n.p.

36. Sanger, "The Early History of Nupedia and Wikipedia: A Memoir (Pt. 1)," n.p.

37. Citizendium, "The Citizendium's Statement of Fundamental Policies," Citizendium: The Citizen's Compendium, 22 Jan. 2007, http://www.citizendium.org/fundamentals.html (accessed 12 July 2007).

38. Clay Shirky, "Broadcast Institutions, Community Values," Clay Shirky's Writings about the Internet: Economics & Culture, Media & Community, Open Source, 9 Sep. 2002, http://shirky.com/writings/broadcast_and_community.html (accessed 24 Feb. 2007), n.p.

39. Roy Rosenzweig, "Can History Be Open Source? Wikipedia and the Future of the Past," Center for History and New Media: Essays, 2006, http://chnm.gmu.edu/resources/essays/d /42 (accessed 28 Feb. 2007), n.p.

40. See, e.g., the collection of Google Maps mash-ups at Google Maps Mania (http://googlemapsmania.blogspot.com/).

41. Trendwatching.com, "Infolust: Forget Information Overload, Consumers Are More Infolusty than Ever!" 2006, http://www.trendwatching.com/trends/infolust.htm (accessed 19 Feb. 2007), n.p.

42. Richard Stallman, "The Free Universal Encyclopedia and Learning Resource," GNU's Not Unix!: Free Software, Free Society, 2 May 2006 [1999], http://www.gnu.org/encyclopedia/free-encyclopedia.html (accessed 28 Feb. 2007).

43. danah boyd, "Academia and Wikipedia," Many 2 Many: A Group Weblog on Social Software, 4 Jan. 2005 http://many.corante.com/archives/2005/01/04/academia_and_wikipedia.php (accessed 25 Feb. 2007), n.p.

44. Sanger, "The Early History of Nupedia and Wikipedia: A Memoir (Pt. 1)," n.p.

45. boyd, n.p.

46. Charles Van Doren, "The Idea of an Encyclopedia," American Behavioral Scientist 6.1 (1962), p. 23.

47. Pink, n.p.

48. Doctorow, n.p.

49. Van Doren, p. 24.

50. Rosenzweig, n.p.

51. Van Doren, p. 23.

52. Joseph M. Reagle Jr., "A Case of Mutual Aid: Wikipedia, Politeness, and Perspective Taking," Reagle.org, 2004, http://reagle.org/joseph/2004/agree/wikip-agree.html (accessed 25 Feb. 2007), n.p.

53. Clay Shirky, "A Group Is Its Own Worst Enemy," Clay Shirky's Writings about the Internet: Economics & Culture, Media & Community, Open Source, 1 July 2003, http://shirky.com/writings/group_enemy.html (accessed 24 Feb. 2007), n.p.

54. Douglas Rushkoff, Open Source Democracy: How Online Communication Is Changing Offline Politics (London: Demos, 2003), http://www.demos.co.uk/publications/opensourcedemocracy2 (accessed 12 July 2007), p. 37.

55. Rosenzweig, n.p.

56. John Hartley, Uses of Television (London: Routledge, 1999).

57. Van Doren, pp. 23–24.

58. Heikki Heikkilä and Risto Kunelius, "Access, Dialogue, Deliberation: Experimenting with Three Concepts of Journalism Criticism," *The International Media and Democracy Project*, 17 July 2002, http://www.imdp.org/artman/publish/article_27.shtml (accessed 12 July 2007), n.p.

59. Van Doren, p. 26.

60. Van Doren, p. 26.

61. Rosenzweig, n.p.

62. Van Doren, p. 23.

63. Van Doren, p. 26.

64. Mark Pesce, "Hyperintelligence," *Hyperpeople: What Happens after We're All Connected?* 2 June 2006, http://blog.futurestreetconsulting.com/?p=17 (accessed 23 Feb. 2007), n.p.

65. Van Doren, p. 26.

Folksonomies: Produsage
and/of Knowledge Structures

Our investigation of the emerging new knowledge space of humanity so far suggests that we are in the process of entering a postindustrial, networked age where knowledge is irretrievably distributed, decentralized, and plural, where multiple alternative sources of information offer diverse and conflicting representations of knowledge, where user-led 'infolust' reigns and access to the means of individual and collaborative content creation and distribution leads to a "mass amateurization of the media," as Shirky puts it:

> the net has revolutionized media in the other direction, reducing the cost of being a media outlet to the point where many *many* more people can participate, and with peer-to-peer models offloading even more of the costs to the edges of the network ... , the lowering of the barriers still has a ways to go.[1]

As we have seen in our exploration of produsage so far, however, mass amateurization (which can also be understood simply as the avoidance of a return to traditional, professional models of content production) does not necessarily result in a reduction in content quality; under beneficial conditions and in the presence of widely shared understandings of what constitutes 'quality,' the 'amateur'-driven processes of communal content creation and evaluation are just as able to generate quality content.

If content creation and publication are widely decentralized, however, and if evaluation and quality control takes place through distributed communal processes after rather than before publication, it becomes all the more important to ask how we (especially if we are not already members of relevant interest communities) identify, collate, process, evaluate, combine, and synthesize the diverse range of content now available to us from a variety of sources, and whether the very processes and tools of produsage which have led to the creation and development of such content may also provide assistance in this task. In other words, our focus now shifts from an examination of the produsage of information and knowledge to the creation of information *about* information, knowledge *about* knowledge—or in short, to the creation of meta-

data and metadata structures. Is it possible to apply the fundamental principles which we have encountered not only to the produsage of information and knowledge, but also to the produsage of *knowledge structures*, and if so, what role remains for professional experts in a context of mass amateurization?

Tagging, Linking, Browsing

Metadata generation in a produsage context operates through the three core practices of tagging, linking, and browsing. The first of these often begins with the originator of the content itself: the blogger including descriptive keywords with their post, the uploader of photos to *Flickr* or videos to *YouTube* adding a few terms to outline in textual form what their material is about, and thereby enabling other users to find it more easily. Such tagging of content becomes all the more powerful, however, as other users join in adding tags not only to their own but especially also to other contributors' content, in a widely distributed process of annotation at a distance. It is here that produsage once again becomes possible, as the act of tagging meets all preconditions for produsage processes: adding tags to content is a shared practice which requires only a minute and therefore highly granular contribution from each individual user (at its simplest, the attachment of a single keyword to a piece of information, using appropriate and widely available tools); as a shared, distributed, and decentralized practice it upholds the equipotentiality of all participants; and (especially if large numbers of users participate as tag producers) it allows for the emergence of probabilistic effects through which frequently used tags can be highlighted for any one piece of content.

Tagging practices are exemplified especially by the tools for social bookmarking which have come to be seen as key examples for the social software of Web 2.0: such tools, including most prominently perhaps sites such as *del.icio.us*, *Digg*, and *Reddit*, no longer focus on the collaborative produsage of knowledge in pursuit of a better, shared understanding of how knowledge is represented, but instead in the first place simply enable their users to convert their long-established practices of *individually* bookmarking interesting Websites and Web pages, noting down URLs, and creating reminders-to-self about useful information available online, into a more or less collective practice conducted not through the functionality of their individual browser softwares, but through a centralized Web-based service. In the first place, then, such bookmarking need not necessarily be social in nature, as users are also able to use the information they store on *del.icio.us* and elsewhere simply as a direct replacement for their browser bookmarks, thereby adding the convenience of being able to access the same set of URLs from any networked computer.

However, even if users engage simply in personal bookmarking, if (as most do) they allow others to access their bookmarks this nonetheless enables the collation and comparison of tagging trends across the wider user community for such sites. This is

perhaps the key advance in the use of social bookmarking sites over traditional forms of (isolated) bookmarking: in the first place, such sites offer not only an indication of what individuals find interesting, but also clearly point to wider current interests of their communities. In addition, the more or less sophisticated tools for identifying clusters of users with similar interests, and for direct community communication which many such sites have also begun to offer enable the further exploration of the reasons for why participants have indicated their interest in specific online resources through bookmarking them; such discussion, then, can be seen as a (less clearly topically focused) form of the procedures of gatewatching and subsequent discussion of gatewatched content as we have encountered them in citizen journalism.

This shift from the creation of knowledge to the creation of information about knowledge in itself is a core aspect of Web 2.0 developments, as Pesce notes:

> metadata has become the defining feature of "Web2.0", most often implemented through "tagging." Tagging allows an individual—or, in rarer cases, an algorithm—to assign semantic keywords to any particular piece of information These tags do not reside in the data, but rather, sit in a "cloud" around the data, creating an envelope of context for data which, in isolation, has no specific meaning.[2]

Clearly, such practices become particularly interesting and more generally useful if the tags and metadata generated by individual users are collated and analyzed, and it is at this point that we begin to be able to describe such practices as produsage—not of shared knowledge, but of shared *knowledge structures*.

Beyond such centralized sites dedicated to social bookmarking and other forms of Web content tagging—that is, to the explicit creation of metadata by content originators as well as third-party users acting as produsers of knowledge structures—it has also become increasingly easily possible to extract further metadata from the content of the online knowledge space itself. Rather than relying on generic practices of tagging existing content using randomly, manually chosen keywords, the focus of such metadata extraction through automated analysis is usually the hyperlink and its context within the Web page in which it is found. In essence, of course, the link-in-context is simply a special form of tag: it both points to an online resource, and through its link text and the content which may immediately surround the link itself often provides some form of description or annotation for the resource thus highlighted. Contrary to explicit tagging through *del.icio.us* and similar sites, however, the metadata conferred through the practice of linking is implicit, and ubiquitous on the Web. Where tagging as produsage relies on the existence of a sizeable and diverse community of participants for its probabilistic processes of content annotation to work effectively, then, this precondition is already emphatically met for linking as a form of produsing metadata.

Building on the ubiquitous availability of such metadata, for blogs and other strongly temporally oriented forms of online publishing, for example, a variety of tools are now available which continually monitor their publishing activities, analyze their

content and the key terms and links contained within it, and from this extract a range of useful information. Sites such as the leading blog aggregator *Technorati*, and similar tools such as *TextMap*, *TechMeme*, and *Findory* differ in their analytic approaches to the content provided by bloggers and others, but from this wealth of material they are each able to extract a day-to-day, hour-to-hour indication of the prevailing memes within the wider community of Web content publishers; they point to the Websites most linked to at present, and the keywords most used by the population of the blogosphere overall, or by specific subsets of bloggers as defined in a variety of ways; and some tools now becoming available also enable the identification of interrelations between specific links and key words or (through advanced lexical analysis) the extent to which they are used with positive or negative connotations.

What happens on such sites (as well as through the tools on social bookmarking sites which create tag clouds and similar visualizations of the metadata generation patterns of the overall community or specific subsets of it) can be described as an automation and outsourcing of the communal evaluation processes of produsage; they constitute a process of produsage which takes place without the contributors to that process—those we may refer to as the actual produsers—even needing to be aware of their participation in this effort. In creating maps of metadata, structures of information and knowledge, indeed, such sites also facilitate the further emergence of site, user, and content heterarchies, then—they provide a clear indication of which participants in processes of content and metadata generation are the most active or consistent creators of content, and what content and what topics appear to be most frequently highlighted by content and metadata creators.[3]

Even further beyond this, "in the greatest leverage of the common user, Google turns traffic and link patterns generated by 2+billion searches a month into the organizing intelligence for a new economy. This bottom-up takeover was not in anyone's 10-year vision"[4] for how the Web would develop. The *Google* search engine and its core mechanism, the PageRank algorithm which determines the relative importance of a page from its embedding in overall patterns of interlinkage on the Web, are themselves examples of a form of (semi-automated) produsage which harnesses and harvests the actions of the millions of users publishing content and creating links on the Web.

> Google's strategy from the start has been to assume that what individuals are interested in is a reflection of what other individuals—who are interested in roughly the same area, but spend more time on it, that is, Web page authors—think is worthwhile. The company built its business model around rendering transparent what people and organizations that make their information available freely consider relevant.[5]

Google is also able to extract useful information from the third key source of user-generated metadata in the present environment: through a combination of client- and server-side tools which it offers to users and Web publishers (including the Google browser toolbar and the Google Analytics Website statistics package), and an examina-

tion of search practices on its own search engine, it is able to extract metadata information from the browsing practices of Web users. Essentially, thus, *Google* (and similar services such as the Amazon subsidiary *Alexa* which also aims to provide a ranking of Websites based on mining the traffic and linking patterns of the Web) turns *every user of the Web* into a potential produser of metadata making small incremental contributions to maintaining and improving the accuracy of *Google*'s search results.

Though not necessarily understood by its users as such, *Google*'s index is the result of an enormous, all-encompassing, yet implicit and invisible process of collaborative produsage which not only invites, but almost inevitably involves the entire population of the Web as participants, and harvests and makes visible the results of the massively distributed communal peer evaluation process constantly taking place on the Web (and expressed through the content and links published on Web pages and the search and browsing patterns of Web users); it results in the emergence of a detailed set of fluid heterarchical relationships between content providers in specific fields and on specific topics of interest; it is constantly under development and can never result in a final, fixed directory of online content as earlier Web indices may have hoped to provide it; and it is at least *treated* today much like a public service provided as common property to all who have contributed to its creation.

Much as this happens in, for, and through the Web as such with the help of such tools, however, it also takes place in more narrowly defined fields of content and metadata generation. For music fans, for example, services such as *Last.fm* and *iLike* survey the tracks stored and played on participating personal computers and mobile music players, and collate these metadata (which are therefore generated by music fans not through active content creation, but simply in the act of music listening) with the musical preferences of other users; this enables them to construct a wider overview of what tracks and what musical artists are frequently correlated with one another, and thus to provide further musical recommendations to their users; it also offers an opportunity to facilitate the development of listener communities based on shared tastes. (*Allconsuming* extends this model to cultural tastes more broadly, though relying on its users to directly submit information on their tastes rather than extracting such metadata through automatic means.)

This, then, also raises the question of the commercial harnessing and harvesting of such automated produsage models—a question which we will further investigate in Chapter 10. For the moment, it is useful first of all to note the significant role which commercial entities play as produsage aggregators of the form we have encountered here, and the important benefits they derive from such involvement—but also the useful services which they provide to their user communities. Perhaps the best-known such aggregator of consumption interests for immediate commercial purposes is the online retailer *Amazon*, of course: it mines both the search and the purchase patterns of the users of its various stores and from this generates listings and recommendations for other, related products which potential or existing customers may like to explore.

In a tangible way, *Amazon*'s catalog can therefore be described as having been produced by its customers; this is all the more true as *Amazon* has also increasingly allowed its users to add to these more or less covertly extracted metadata by explicitly creating their own product reviews, by collaborating in wiki environments attached to specific products, by posting recommendation lists related to specific genres or topics, and by tagging products with useful terms beyond the product metadata already provided by the *Amazon* catalog itself. This constitutes a significant embrace and harnessing of produsage activities in the pursuit of product sales and customer satisfaction.

Clearly, such sites display many of the aspects of produsage as we have outlined them: they are based on **open participation** and the (at least indirect, sometimes automatically aggregated) **communal evaluation** of content; a loose, **fluid heterarchy** can emerge on the basis of which members of the community are seen to contribute the most useful metadata, and on what information such metadata highlight as important and interesting; content on social bookmarking and similar sites necessarily resembles always **unfinished artefacts** and overall constitutes a growing, shifting directory of online material which can be explored through tag clouds, tag searches, and other means; and while the links and metadata compiled remain **common property**, **individual rewards** certainly are available for those who emerge as valuable contributors. However, the specific object of produsage in such environments remains somewhat elusive, and its definition is likely to differ significantly between individual participants; for some, the collaborative compilation of interesting links may be only a side effect of their personal uses, while others may work towards a more explicit purpose of imposing a collaboratively created structure on the Web by tagging its contents. In general, many participants may remain unaware of the fact that what they are ultimately contributing to is the collaborative creation of new, shared, perpetually shifting, and contested structures of knowledge.

Such processes come close to realizing Lévy's vision of an intricately connected, all-encompassing knowledge space for humanity, in which—not unlike the Heisenbergian uncertainty principle in which the observation of an action affects its outcome—the interaction of users with the space contributes to changes in and to the further produsage of the knowledge space itself. In this space, "the members of a thinking community search, inscribe, connect, consult, explore. Their collective knowledge is materialized in an immense multidimensional electronic image, perpetually metamorphosing, bustling with the rhythm of quasi-animate inventions and discoveries."[6]

Ultimately, what such sites, and other tools for the creation and publication of metadata on the Web, point towards may also be a wider phenomenon of disconnection between the processes of content creation and the processes of the produsage of further information and knowledge from such content. On the one hand, any process of content creation is necessarily also a process of metadata creation: any content, when analyzed, necessarily also yields *internal* metadata about itself (such as key words, date and time of publication, and other information about features of the text). On

the other hand, in an online context which allows third-party produsers to tag, publishers to link to, and users to browse that content, these three core practices also provide the basis for the generation of *external* metadata through annotation at a distance, thereby creating a wide range of further information and knowledge about the content well beyond what its original creators may have had in mind. Such internal and external metadata can be collated and analyzed in a variety of ways, and in the process contribute to the produsage of new, collaboratively and distributedly created, structures of information and knowledge available to participants in the network.

But the development of such tools has implications not only for information and knowledge itself, but also for the evolution of our knowledge *about* knowledge, and our understanding of how such meta-knowledge develops. As Johnson notes,

> hundreds of thousands—if not millions—of years ago, our brains developed a feedback mechanism that enabled them to construct theories of other minds. Today, we are beginning to create software applications that are capable of developing a theory of *our* minds. All those fluid, self-organizing programs tracking our tastes and interests, and measuring them against the behavior of larger populations—these programs are the beginning of a progression that will, in a matter of years, lead to a world where we regularly interact with media that seems [sic] to know us in some fundamental way.[7]

This should not be misunderstood as introducing a Tofflerian producer/consumer divide in which the consumer (as prosumer) is merely positioned as an expert in giving feedback for the further perfection of attractive consumption options, of course; the 'media which know us' that Johnson points to are also the media we have begun to create for ourselves, not least through the processes of produsage. Indeed, instead of a description of such materials simply as media, perhaps terms such as information and knowledge are increasingly more appropriate, as the introduction of ever more sophisticated forms of metadata—information about information, and knowledge about knowledge—can be seen to substantially change the use value of the media content thus described, and therefore the user's relationship to it. Beyond what in the past has been described as 'me media' or 'we media'—media forms personalized to best suit the individual user, or the emerging communities of like-minded users populating the network—, in other words, perhaps we return once more to the idea of the Web itself, the network itself, as a massively distributed, collaboratively created, internally contradictory but multiply structured encyclopedia, similar to Stallman's vision as we have encountered it at the end of the previous chapter. This characterization would be in line with Lévy's description of the knowledge space as a universal, pluralistic, collaboratively developed, and constantly renegotiated 'cosmopedia':

> not only does the cosmopedia make available to the collective intellect all of the pertinent knowledge available to it at a given moment, but it also serves as a site of collective discussion, negotiation, and development. A pluralistic image of knowledge, the cosmopedia is the mediating fabric between the collective intellect and its world,

between the collective intellect and itself. Knowledge is no longer separated from the concrete realizations that give it meaning, not from the activities and practices that engender knowledge and that knowledge modifies in turn. Depending on the zones of use and paths of exploration, hierarchies between users and designers, authors and readers, are inverted. ... In the cosmopedia, all reading is writing. The cosmopedia is a relativistic space, which curves when we read or write in it.[8]

Curating the Cosmopedia

If indeed, through *Wikipedia* but also through the wider environments of the World Wide Web, whose contents are increasingly created, evaluated, and interconnected through processes of produsage, we are approaching the establishment of a cosmopedia, this raises the crucial question of how the knowledge structures within that space are going to be determined and curated. It is impossible to overstate the importance of this question, and the impact of the answers we might find; in debates and deliberations about the future of humanity, in whatever context we may encounter them, knowledge is indeed to be equated with power, and the structures of knowledge that are prevalent in the cosmopedia will substantially affect the ability of participants in such discussions to arrive at a conclusion and consensus.

However, the divide between knowledge and meta-knowledge, and between their processes of produsage, is necessarily a soft and shifting one; if "the main problem in the knowledge space is to organize the organizing, objectivize the subjectivizing," and if "knowledge about knowledge is based on an essential circularity, one that is primordial, ineluctable"[9], a variety of technological and automated as well as social and manual means for finding at least partial solutions to this problem are now readily at hand. To say this is not to be misunderstood as falling into the trap of technological determinism; the analytical tools now available can be used to come to vastly different, even diametrically opposed interpretations and organizations of available knowledge which may be able to be used in support of highly divergent arguments; humanity now simply has the means of harnessing a significantly larger amount of available information and knowledge, but this does not mean that it will be any smarter or more homogenous at interpreting that material, and at extracting meaning from it.

The key means of generating such metadata, then, are the link and the tag, as Shirky points out. These enable

> much more organic ways of organizing information than our current categorization schemes allow, based on two units—the link, which can point to anything, and the tag, which is a way of attaching labels to links. The strategy of tagging—free-form labeling, without regard to categorical constraints—seems like a recipe for disaster, but as the Web has shown us, you can extract a surprising amount of value from big messy data sets.[10]

Indeed, the processes of linking and tagging are already well familiar to us from our examination of citizen journalism, of course, much of which is crucially based on the identification of useful and interesting material through the collation of links, and the annotation of that material at a distance, which is at the heart of the initial gatewatching process. More broadly, then, linking and tagging—or otherwise annotating—content is nothing more than an extension of gatewatching itself beyond the realm of citizen journalism (a practice of what Pesce describes as 'coolfinding'[11]); such extended gatewatching is a process leading to the collaborative generation of an initially unorganized, structureless, vast collection of metadata, then.

Such unstructured, even random metadata are necessarily different from the better-behaved, organized schemata of metadata which various groups have attempted to implement ever since the emergence of the World Wide Web itself (and before this also in other hypertext systems), and which constitute simply a translation of well-established taxonomic models to the online informational environment. In a process of metadata generation through linking and tagging, there are no fixed schemata for how specific aspects of a piece of content are to be described either by its originator or by others annotating it at a distance; multiple alternative forms and schemata of description may be applied by a variety of actors in this distributed, uncoordinated, and random process. However, the very randomness, the very failure to adhere to a predefined schema, also enables more participants to take part in this process more easily:

> this is something the 'well-designed metadata' crowd has never understood—just because it's better to have well-designed metadata along one axis does not mean that it is better along all axes, and the axis of cost, in particular, will trump *any other advantage* as it grows larger.[12]

Such metadata, in other words, are 'cheap' metadata, and as such have the following key characteristics:

1. It's made by someone else
2. Its creation requires very few learned rules
3. It's produced out of self-interest (Corollary: it is guilt-free)
4. Its value grows with aggregation
5. It does not break when there is incomplete or degenerate data[13]

If such metadata are different from traditional (taxonomic) systems of ordering information about information, then, this departure from taxonomy is indeed the key determinant of its usefulness: it breaks the bottleneck of metadata production according to preset schemes which had existed *a priori*, and instead puts both the creation of metadata itself, and the development of underlying metadata schemata as they emerge from these *ad hoc* metadata, in the hands of users acting as produsers. In the process, "sometimes a difference in degree becomes a difference in kind. The degree to which

these systems bind the assignment of tags to their use—in a tight feedback loop—is that kind of difference."[14]

In other words, through their instant visibility to other participants in their communities, the *ad hoc* creation of metadata tagging schemata especially by the users of social bookmarking systems and similar tools, but also the publication of gatewatcher contributions in other contexts, immediately provide a guide for other users to adopt similar tagging approaches in gatewatching 'their' content—but also an incentive to employ markedly different models of tagging if they happen to disagree with the initial metadata contribution. Further, as Udell describes it for *del.icio.us* and similar sites, for the *initial contributor* of metadata a similar mechanism also applies: "feedback is immediate. As soon as you assign a tag to an item, you see the cluster of items carrying the same tag. If that's not what you expected, you're given incentive to change the tag or add another."[15]

Through a combination of technological and social features, therefore, the creation of metadata in such environments, as well as the less explicit generation of metadata in other contexts in which this form of gatewatching occurs (even in fields where the metadata themselves are collated by automated services), involves a process of continuing, more or less explicit, negotiation and socialization between the different contributors. Users of *del.icio.us* may tag a URL, see how other contributors to the site have tagged the same resource, and revise their tags immediately—indeed, a recent study of popular bookmarks in *del.icio.us* found that even though new tags continued to be added to describe such resources,

> it turns out that the combined tags of many users' bookmarks give rise to a stable pattern in which the proportions of each tag are nearly fixed. ... Usually after the first 100 or so bookmarks [to the same resource], each tag's frequency is a nearly fixed proportion of the total frequency of all tags used.[16]

Participants in the gatewatching processes of citizen journalism, on the other hand, may submit a story collating and commenting on a number of news resources, follow the ensuing community discussion, and in the process change their interpretation of these resources; this, then, might result in a change of their gatewatching practices in subsequent content submissions, and similarly socialize them into the communal metadata creation process and shared metadata schemata as they exist on these sites.

At the same time, of course, the process will not result in the development of any uniformly accepted metadata schemata, structures, and interpretations; this process of generating 'cheap' metadata is necessarily conducted on a distributed, decentralized basis without the oversight of a central governing authority organized through hierarchical structures. Instead, it is thoroughly produsage-based, involving a broad range of more or less isolated contributors participating equipotentially on a highly fluid basis and forming only a loose heterarchy (whose most organized clusters are centered around the various social bookmarking and metadata tagging sites we have high-

lighted). Useful knowledge structures emerge from this approach by way of a probabilistic network effect, through a distributed and granular process of categorizing content by a diverse community of produsers, rather than through the directed application of external, predetermined taxonomic classification schemes by knowledge experts. Through such massively distributed produsage, Shirky suggests, "we're going to be able to build alternate organizational systems, systems that, like the Web itself, do a better job of letting individuals create value for one another, often without realizing it."[17]

Folksonomies

This is a decentralized process of produsage, then, but the object of this produsage are no longer information or knowledge themselves, but knowledge structures, structures of knowledge categorization—a new, fluid, dialogic, pluralistic form of user-driven, user-generated, produced content taxonomies which due to their broad participant base have been described as *folksonomies*. The idea of the 'folksonomy' also points towards the basis of such categorization systems in collaborative, communal action, or more precisely, in a form of *distributed* collaborative action which also does not necessarily involve one or a small number of (perhaps expert) communities only, but a much wider range of contributor groups and groupings which are themselves—in keeping with the idea of fluid heterarchies—constantly shifting and changing. As Benkler notes, thus,

> we are beginning to see the emergence of greater scope for limited-purpose, loose relationships. These may not fit the ideal model of "virtual communities." They certainly do not fit a deep conception of "community" as a person's primary source of emotional context and support. They are nonetheless effective and meaningful to their participants.[18]

Such loose groups of participants, as they exist for example on *del.icio.us* and similar social bookmarking sites, are therefore not necessarily communities defined by a shared sense of membership, a shared identity, or other 'communal' features; communal participation, and the grouping of participants, is *ad hoc* and even accidental, and results simply and immediately from the contributions made by the individual. This is in a sense a common feature of produsage itself, of course, whose open approach to participation and fluid model of involvement in the community have always made it possible for participants to make only random contributions without in a deeper sense becoming 'part of the community'; however, within such metadata produsage projects (and within metadata produsage more generally), the relative backgrounding of *any* sense of a shared object of produsage also serves to further background the sense of community which flows from such shared purpose.

Nonetheless, however, produsage in the collaborative development of metadata is as much a matter of communicative exchange as is participation in other, more strongly defined, projects of produsage: as we have already seen, it is especially the (however anonymous) experience of feedback and socialization which enables the emergence of useful folksonomies. As Mathes notes, the collaborative produsage of folksonomies is a form of (asymmetrical) communication between participants, through the metadata themselves: "the context of the use in these systems is not just one of personal organization, but of communication and sharing. The near instant feedback in these systems leads to a communicative nature of tag use."[19]

Participants in such communicative engagement may not be consciously aware of their participation in this way, however; they are not forced to engage with fellow metadata creators, nor are they required to accept others' interpretation and categorization of the content being tagged. Indeed, for the folksonomy to be generally useful,

> groups of users do not have to agree on a hierarchy of tags or detailed taxonomy, they only need to agree, in a general sense, on the "meaning" of a tag enough to label similar material with [similar] terms for there to be cooperation and shared value. Although this may require a change in vocabulary for some users, it is never forced.[20]

What coercion or pressure to perform in line with the apparently generally accepted patterns of tag use does exist, in fact, is driven more by other competitive and social features than by an inherent need to conform with community opinion, as Pesce notes. The principles encouraging 'good' contributions, and indeed encouraging contribution at all, are similar to the competitive principles behind gatewatching, then:

> that innate drive to be recognized for our tastes has been accelerated to the speed of light by the network. Now, even as we coolfind, we are constantly inundated and challenged by the coolfinding of our peers. It's produced a very healthy, if ultra-Darwinian, ecology of cool. Our peers are the selection pressure as we struggle to pass our memes on to the next generation.[21]

While such more or less overt competition between participants may continue to rely on the existence of one or a number of central arenas in which they can showcase their skills and attempt to out-do one another in the coolfinding competition, overall we can observe that the process of collaboratively creating metadata to describe and categorize the information and knowledge contained in the cosmopedia of the Web does not need to take place only through the operations of a few centralized spaces. By contrast, as we have already seen, much of the activity of Web users everywhere contributes to the produsage of knowledge about knowledge, and the Web itself as well as the various tools for its analysis now available provide the conditions for a thoroughly decentralized folksonomic *modus operandi*—a form of produsage significantly different from the community-driven produsage of many of the key sites of citizen journalism, and to the operations of the *Wikipedia*, but not unlike the massively distributed mean-

ing-making conversations taking place in the blogosphere, which similarly rely on conditions "under which the actions of many agents cohere and are effective despite the fact that they do not rely on reducing the number of people whose will counts to direct effective action."[22]

Such decentralized, distributed approaches to the generation of metadata are not necessarily an inevitable outcome of a reliance on links and tags, however: it is very much possible to imagine systems which allow only a small subset of participants to create the interconnections between pieces of content, or contribute annotations describing them. Indeed, even otherwise comparable open systems turn out to be used in different ways, as Mathes notes in his comparison of tagging practices on the social bookmarking site *del.icio.us* and the photosharing site *Flickr*:

> a primary difference between Delicious and Flickr is that while the tags on Delicious are primarily from the users of web documents that were written by another party, Flickr is primarily used by individuals to manage their own digital images, and the majority of the tags are users tagging photos they created themselves. This is not absolute; the system does have the option of allowing users designated as friends or family to tag a user's photos. Additionally, users can and do enter images others created into the system, often from web sites. This use of the system is much more like Delicious, but seems to be a small fraction of the use.[23]

Such differences may well be driven by a sense of content ownership that is greater for the artistic and personal work commonly displayed on *Flickr* than it is for the more impersonal information resources of the wider Web which are tagged through *del.icio.us*, and where such differences do exist to notable extent, they may well skew the quality of overall metadata structures. Indeed, the question of who does the tagging, and the extent to which the content originators are involved in tagging their own work, is an important one to consider as we begin to rely more heavily on the folksonomies created through such processes of metadata produsage. Overall, of course, an exploration of the interrelationships between the make-up of the tagging community (whether defined implicitly or explicitly) and the patterns of its tagging activities will always be instructive in determining patterns of knowledge interpretation, as Pesce notes:

> comparative analysis of folksonomies within any community will reveal the total knowledge encompassed by that community; this is the first step to establishing systems which allow individuals within that community to quickly and easily connect with others who possess some specific knowledge, or who have some specific need for knowledge. When an individual can immediately find the "go to" people with expertise in any specific area of interest, that individual's effectiveness is multiplied.[24]

Such analysis of tagging practices therefore will also enable the implementation of metadata filters based on shared or divergent approaches to the categorization of knowledge; it creates the possibility for clusters within the wider metadata produsage

heterarchy to focus in on themselves and explore their own categorization schemes to the exclusion of other schemes existing alongside theirs, and thereby provides the potential for a stronger sense of community within such clusters and a greater internal cohesion and even resilience against attempts to subvert their operations for commercial or other gain. Indeed, the development of smarter means of evaluating, and on the basis of that evaluation, of both collating and filtering the overall distributed processes and outcomes of folksonomic produsage is already under way, and likely to generate a number of further tools and methodologies for both social and automated approaches to these tasks.

Perhaps the most difficult aspect of such evaluation, however, is the filtering out or negation of metadata which is intended for purely personal uses; in the first place, after all, "the organizational scheme that emerges for each individual reflects their individual information needs. The popularity of the 'me' tag on Flickr perhaps best reflects this aspect of a folksonomy, as well as the 'toread' tag on Delicious."[25] Other idiosyncratic uses of tagging and annotation systems, and of the common terms used to describe the content so tagged and annotated, may similarly skew the folksonomic system which emerged from the overall process. Some such tags (such as "me") may be filtered out as anomalies already when large numbers of users are engaged in a decentralized effort to tag content; others (for example, "to read") will not disappear, but may rather be amplified if many other participants find a specific piece of content similarly worthy of further attention. In these cases in particular, it would be useful to harness rather than filter out this common sense that content is important, for example by providing additional means of metadata generation which enable users to note (and thereby enable the filtering of content for) importance without recourse to the tagging system proper—for example through rating or ranking. Some of the social bookmarking sites we have noted have begun to implement such systems; as Pesce notes, "sites like Digg, where users vote articles into front-page relevance, represent an attempt to automate filtering. But Digg displays no real expertise, and won't until it dissolves into an ever-increasing folksonomy of baby Diggs."[26]

This points us further in a direction back towards more strongly community-based approaches to content categorization, then—it opens a pathway for different content categorization communities to develop their own best model for undertaking a folksonomic produsage effort organized around what Pesce describes as "the 'Three Fs' of finding, filtering and forwarding"; such models would be determined by the specific social and intellectual conditions and requirements of each individual community.

> In this new social order, there is no mass market, no mass media, and no mass mind: instead, there are networks of experts, each feeding into collective networks of knowledge, social networks which both within themselves, and, pitted against each other, struggle to raise their standing in the world.[27]

The competitive aspects of this process of folksonomy construction, then, necessarily require systems for the qualitative or quantitative establishment, development, and tracking of the merit of content contributors within these communities. Some such reputation may continue to be determined through purely informal means (the gradual development of a general 'sense' of an individual's merit within the community of regular participants), but it is likely that more explicit systems of reputation will also emerge, also in order to mitigate attempts to subvert the system.

Put together, such systems provide the means for both horizontal and vertical filtering of content and contributors: they enable a vertical limitation of scope only to the most valued content, or to the content tagged only by the most valuable community members, and they allow for a horizontal restriction of scope only to the content tagging activities of a particular group, cluster, or community of users (as well as providing for combinations of horizontal *and* vertical filtering, of course). In essence, this is a matter of enabling the individual user as well as communities of participants to shift the 'zoom level' between a narrow focus on a small number of core contributions (defined horizontally or vertically) and a wide-angle perspective on the overall folksonomic structures emerging from the wider project of knowledge structure development, and the effects of these contrasting perspectives are likely to further influence the actions of individual and communal contributors:

> the real power emerges when you expand the scope to include all items, from all users, that match your tag. Again, that view might not be what you expected. In that case, you can adapt to the group norm, keep your tag in a bid to influence the group norm, or both.[28]

(The ability to operate such 'zooming' tools also requires a new set of information—or indeed, metadata—literacies on part of their user, of course.)

Where such tools enable the user to move fluidly into and out of community environments, then (thereby enabling the full experience of open participation and fluid membership in heterarchical systems as promised by the produsage model), users are also freed from the potential pressures of conformity that they may experience in ingroup environments. In contrast to more deeply rooted, traditional communities, new environments which build on open participation peer-to-peer dynamics to develop communal resources generate a different sense of collective action, as Bauwens points out:

> the collective hereby created, is not a 'collective individual', it cannot act with ambition apart from its members. The genius of the protocols devised in peer to peer initiatives, is that they avoid the creation of a collective individual with agency. Instead, it is the communion of the collective which filters value.[29]

Where they are building on produsage approaches, therefore, models of collective knowledge structure generation may be able to avoid an overt sense of 'groupthink,'

that is, of the gradual narrowing down and closing off of opportunities for interpretations of information and categorizations of knowledge alternative to the prevalent views of the community; "minority opinions can coexist alongside extremely popular ones without disrupting the nearly stable consensus choices made by many users,"[30] and the social bonds which exist in the loose communities of metadata produsage we have described here do not carry enough power to coerce individual participants to do away with oppositional readings. This, indeed, is already also visible in the patterns of traffic and interlinkage on the Web itself, which are themselves able to be understood as a form of metadata, of course:

> the clustering and actual degree distribution in the Web suggests ... that people do not simply follow the herd—they will not read whatever a majority reads. Rather, they will make additional rough judgments about which other people's preferences are most likely to predict their own, or which topics to look in.[31]

Again, this is not to claim that clustering tendencies do not occur, of course; but such tendencies emerge not predominantly out of a sense of obligation to the wider community, but in the main are indicative of the voluntary choices made by individual participants based on the information available to them: information which does often originate from peers and groups of peers, but through such origins holds only a certain degree of persuasion, without immediate powers of coercion. Thus, on sites such as the social bookmarking services we have discussed, "the behavior of the users can also be thought of as being influenced and related to their relationship to the other individuals using the service, and specific groups of users who they share tag use with,"[32] but not as being inherently driven by these other participants.

The very loose and voluntary nature of present-day environments of produsage-based metadata creation, therefore, may be an important benefit for their operations, as it avoids the establishment of strong tendencies of groupthink, and thus of an echo chamber amplifying specific approaches to the categorization of knowledge beyond proportion. As Jenkins points out, the

> emerging knowledge cultures [are] defined through voluntary, temporary, and tactical affiliations. Because they are voluntary, people do not remain in communities that no longer meet their emotional or intellectual needs. Because they are temporary, these communities form and disband with relative flexibility. Because they are tactical, they tend not to last beyond the tasks that set them in motion. Sometimes, such communities can redefine their purpose.[33]

Indeed, in the case of folksonomic categorization processes, they may yet be in the process of defining that purpose in the first place: they are to some extent only beginning to emerge from predominantly individually driven metatagging activities to a point of realizing the wider sense of utility and purpose which the resultant folksonomies may have, and it is only through the gradual establishment of aggregation and

filtering systems as automated additions to the produsage process itself that such value is being made visible. A broader understanding and realization of such value may be necessary to sustain the folksonomic produsage processes, however, and to provide incentives for its participants to engage constructively in this effort:

> whereas hierarchical systems are based on creating homogeneity amongst [their] 'dependent' members, distributed networks using the P2P dynamic regulate the 'interdependent' participants preserving heterogeneity. It is the 'object of cooperation' itself which creates the temporary unity.[34]

That object of produsage, a folksonomic system of knowledge categorization and structuration, may as yet appear too elusive to provide a strong sense of temporary unity for many participants.

Nonetheless, we can now clearly describe the folksonomic effort as a process leading to the produsage of shared knowledge structures. It is built on **open participation**, and involves the **communal evaluation** (by individuals, communities, and through automated tools) of the metadata which in combination provides structures for knowledge; it operates through highly **fluid heterarchical patterns** of organization and interrelation from which clusters of like-minded participants emerge only gradually and temporarily, and governance, where it exists at all, is therefore highly adhocratic (and largely exercised by individuals as they apply different filters to the metadata available to them); the process of generating metadata is necessarily as **unfinished and continuing** as are the processes of creating the knowledge to which such metadata is applied); and the metadata created in the process is treated as **common property** (although at closer inspection it is more appropriate to say that questions of ownership of the metadata generated by participants have simply not been identified, much less addressed, as yet), while individual creators are able to generate some degree of **individual rewards** and status from participating effectively in the process. At the same time, we might also want to point out that some of the key enabling tools for the development of strong produsage communities, as we have encountered them in other produsage environments, are as yet missing from folksonomic produsage efforts, and may well be required to ensure the sustainability of broad involvement in such efforts: further tools for the filtering of metadata, for the rating of metadata and its creators, and for communication about and discussion of the metadata creation process may well need to be developed (and are in fact gradually emerging around some of the key sites currently in existence).

Folksonomies and Taxonomies

The very idea of the folksonomy,[35] a system of categorization emerging from within the wider community of knowledge users, remains itself a relatively recent concept, of

course, and it is important to examine both its strengths and its weaknesses as we position it as a credible alternative to traditional taxonomies developed by experts in their fields. Perhaps the most crucial departure folksonomies make from the older model is that—in analogy to the heterarchical organization of their produser communities, as compared to the hierarchical structures of traditional expertise—the folksonomy represents what Mathes describes as a "flat namespace":

> that is, there is no hierarchy, and no directly specified parent-child or sibling relationships between ... terms. ... This is unlike formal taxonomies and classification schemes where there are multiple ... explicit relationships between terms. These relationships include things like broader, narrower, as well as related terms. ... Folksonomies are simply the set of terms that a group of users tagged content with, they are not a predetermined set of classification terms or labels.[36]

The correlation between the flat or at best heterarchical folksonomic knowledge structure and the heterarchical structure of the community which is responsible for its creation, and conversely between the largely hierarchical structure of traditional communities of experts and the taxonomic systems under which they operate, is not accidental, of course: traditional systems of knowledge classification are also systems for the establishment of disciplinary boundaries which both drive and are driven by the prevailing organization of scientific thought of their time. Indeed, while traditional taxonomies are systems of classification, for folksonomies the term categorization is more appropriate:

> categorization is generally less rigorous and boundaries are less clear. It is based more on a synthesis of similarity than a systematic arrangement of materials Most importantly, each document can have many terms associated with it. By contrast, classification schemes generally focus on providing a single classification to an item, and are very hierarchical and have clear relations.[37]

A common example for conventional systems of classification are traditional library catalogs, of course, in which each book must be allocated a unique call number which locates it in one specific field of knowledge, regardless of the fact that the content of most books is more or less strongly interdisciplinary in nature. Such systems also depend on an *a priori* classification of knowledge, which, while extensible within the overall framework at the lower levels of the hierarchy, remains largely immutable towards the top of its structures. (The classic case of many Western library systems, which award significant namespace for example to books on European and North American history, society, or religion, but amalgamate works on other regions of the world into an 'other' category, is a typical example for such tendencies.)

It is useful to remember that the application of models of hierarchical, taxonomic classification was also attempted for early Web content, through first-generation Web indices such as *Altavista* and *Yahoo!* Though still persisting in some contexts, however, it soon became obvious that a catalog-based approach could not possibly keep pace

with the development of the medium: "the primary problem ... is scalability and its impracticality for the vast amounts of content being produced and used, especially on the World Wide Web."[38]

Folksonomies, then, may be a necessary, and in fact perhaps the only feasible approach to dealing with the complexity of virtually infinite content as presented to us, and by us, in the form of the World Wide Web. Indeed, Shirky points out that in this context of a practically infinite supply of information which requires classification or categorization, economic factors also strongly tilt the balance in favor of the folksonomic approach:

> any comparison of the advantages of folksonomies vs. other, more rigorous forms of categorization that doesn't consider the cost to create, maintain, use and enforce the added rigor will miss the actual factors affecting the spread of folksonomies. Where the internet is concerned, betting against ease of use, conceptual simplicity, and maximal user participation, has always been a bad idea.[39]

This, of course, is the principle of the link and content analysis-driven, search-based paradigm best exemplified by *Google*, and points to the fact that fixed taxonomic systems are best suited to a finite knowledge space. By contrast, as Locke points out,

> digital networks have massively increased the scale of the intimate networks we can potentially create, and therefore have increased the number of participants that can create and share ad-hoc vocabularies. The internet has created tools that preserve the loosely-connected, the playful, the ad-hoc, vernacular, or amateur—the conditions of the infinite, rather than the finite game.[40]

This *ad hoc* nature of folksonomic categorization also makes it significantly more responsive to the substantial and rapid changes in the range, depth, and topical makeup of available knowledge which have characterized the late twentieth and early twenty-first centuries. Anyone browsing the catalogs of libraries utilizing traditional systems of classification, for example, will notice the difficulty such systems have in classifying works on new and emerging, and especially perhaps interdisciplinary, fields of knowledge, and may well come across works which, although appearing closely related to the average user, have been placed in entirely unrelated sections of the catalog. (Is research on Internet phenomena, for example, placed in sections relating to computer science, communication technology, sociology, economics, philosophy, psychology, culture? Have new classes and subclasses been added as branches of the hierarchical tree of knowledge classification, and at what branching points?) By contrast, "a folksonomy, with its uncontrolled nature and organic growth, has the capability to adapt very quickly to user vocabulary changes and needs. There is no significant cost for a user or for the system to add new terms to the folksonomy."[41]

Ultimately, in other words, classification systems built on taxonomic knowledge structures establish unified and fixed paradigms for the organization of knowledge—

folksonomic systems, on the other hand, are multiple and fluid: they make no lasting pronouncements about how knowledge should be structured, but establish only a temporary sense of order which changes as new folksonomy produsers add their own ideas on what individual pieces of content are similar or related, or even simply as users trace their paths through the existing folksonomic structures and thereby strengthen some of the 'desire lines' connecting items, and allow others to fall out of favor. Much in keeping with the core principles of produsage, then, the knowledge structures created through folksonomic systems remain themselves only temporary artefacts of an ongoing process, and do not solidify into permanent products.

> What makes the tagging phenomenon utterly fascinating is that there is a collective action component to it. We love to see how people will come to common consensus on relevant terms. But part of what makes it valuable is that, right now, most of the people tagging things have some form of shared cultural understandings. The "in the know" groups using these services are very homogeneous and often have shared values and thus offers valuable related links.[42]

An increasing diversity in the population of participants actively involved in metadata creation, whether through tagging or other means of folksonomic categorization, will impact negatively on the signal-to-noise ration in folksonomic systems, on the other hand. "While the disparate user vocabularies and terms enable some very interesting browsing and finding, the sheer multiplicity of terms and vocabularies may overwhelm the content with noisy metadata that is not useful or relevant to a user."[43] In addition, of course, as folksonomic categorization is an increasingly important tool in identifying useful information, and as the tagging of online resources as highly useful is likely to have direct impact on the visitor traffic to such sites (which in turn may generate commercial benefits for such sites), it is also likely that we will see an increased incidence of deliberate disruptions to the folksonomic system by spammers attempting to elevate their sites to a higher visibility; this is similar to disruptive 'gaming' behavior observed at various times in deliberate attempts to skew *Google*'s PageRank scores in favor of specific sites. This "issue of inevitable systematic disruptive behavior has been missing from a lot of these discussions" about folksonomies, however, as Lawley notes.[44] However, most commentators do not take such criticism to mean that folksonomic systems are inherently flawed; instead, in fact, they point to the need to further broaden out the range of participants actively engaged in the creation of metadata, to better educate them about the implications of their tagging and annotation practices, and to improve the tools available for the aggregation and analysis of such metadata.

Ultimately, in fact, while there are some significant and non-trivial problems with folksonomic metadata generated by a wide and diverse range of produsers acting in more or less pronounced isolation from one another, folksonomies may nonetheless represent the best available model for the comprehensive categorization of extant and available knowledge. In keeping with phenomena we have observed in other forms of

produsage, their communal approach offers a significant advance over models which involve only a limited number of contributors; the synergies which may be harnessed if a large enough group of like-minded participants is involved in metadata generation outweigh the potential disruptions caused by the presence of alternative views.

> The signal loss in traditional categorization schemes comes from compressing things into a restricted number of categories. With tagging, when there is signal loss, it comes from people not having any commonality in talking about things. The loss is from the multiplicity of points of view, rather than from compression around a single point of view. But in a world where enough points of view are likely to provide some commonality, the aggregate signal loss falls with scale in tagging systems, while it grows with scale in systems with single points of view.[45]

Indeed, then, this observation returns us once again to the call for the development of more effective technological as well as social systems for the filtering of all metadata according to specific criteria. "In tagging, quality is not just about 'accuracy', but about what cultural assumptions dominate"[46]; this highlights a need to be able to identify the various cultural assumptions (or more broadly, commonalities, that is, patterns of tagging behavior) held by the different communities and clusters of users who participate in the overall project of collaborative folksonomic development, and to be able to filter both for and against these clusters—in other words, to zoom in to the views dominant only in a specific cluster, or to filter out the impact of the cluster's tagging behavior on the wider metadata structures. Clearly, these are questions of design:

> how do we deal with conflicting cultural norms as more people are engaged in the act of tagging? How useful are tags across cultures? Do we only gain value from collective-action tagging amongst groups of shared values? If so, how do we implement that? And what are the social consequences for explicitly delimiting culture online?[47]

However, these are questions which will have no easy either/or answers: by contrast, they will require systems which enable their users to move fluidly between different cultural communities and interest groups, zoom out to the overall population of produsers or zoom in only to a limited network of recognized friends or colleagues. They will require systems, too which provide clearer rewards for those users who participate constructively in the metadata creation process, however constructive participation is defined by the individual content creation community the user may be aligned with.

A Casual Collapse of Taxonomies?

Whatever the exact fate of the folksonomic project, however, it has become increasingly clear that a return to knowledge structures dominated by taxonomic principles is highly unlikely—certainly for the unruly, changeable content of the Web itself, but also

for many other subsets of human knowledge. Clearly, "fantasies of using controlled metadata in environments like Flickr are really fantasies of users suddenly deciding to become disciples of information architecture"[48]; the same is true for other metadata repositories such as *del.icio.us* and similar social bookmarking sites. This is necessarily a threat to established hierarchies of knowledge; it threatens them in the first place with the disintermediation of knowledge management practices, and the subsequent replacement of the traditional controllers of knowledge structures with non-accredited, potentially untrained participants ranging from the communities of folksonomic metadata produsage to the new automatic knowledge 'librarians' including *Amazon* and *Google*.

As we have seen, however, the traditional expert-based paradigm of classification according to fixed schemata is unable to cope with the range of information and knowledge now available within the global knowledge space, for both practical and conceptual reasons. On the one hand, questions of scale mean that it cannot provide the army of experts which would be required to produce the consistent, well-behaved, uniformly structured metadata needed to describe and classify the entirety of that space. On the other hand, the very structuredness and uniformity of its classification systems is being severely undermined by the probabilistic, multiple, and pluralistic folksonomic model. Ultimately, this is therefore also more importantly "a question of philosophy. Does the world make sense or do we make sense of the world?"[49] Indeed, the choice to be made in this context is fundamentally one between a model of *a priori* classification, and *a posteriori* categorization (or, if possible, an *ad hoc* and *in situ* model which begins the user-led process of metadata generation as closely to the point of content creation as is possible); this is a choice, of course, which should also remind us strongly of the difference in philosophies between *Wikipedia* with its *ad hoc*, emergent content and community structures, and *Citizendium* with its *a priori*, fixed approaches— a point to which we return in the following chapter.

Experts can and do continue to play an important role in this process, though, much in the same way that they can continue to participate in open source software development, citizen journalism, or encyclopedic content creation: however, here as well as in those other fields their role has changed now from that of a producer of knowledge structures to one of a guide of that process, a co-curator of the coming cosmopedia which Lévy foresees. This curatorial role may be played through their direct involvement in the communities producing the new knowledge structures of folksonomy; perhaps even more importantly, however, experts may also be involved in the development of the more or less automated tools made available to these communities. Experts participating in this way are the experts creating the algorithms of Page-Rank, and the tag ranking and analysis tools of *del.icio.us*, *Digg*, and *Reddit*, as well as the many more metadata creation and analysis tools now gradually emerging into public view and use. More broadly, as Johnson notes, their role is therefore to continue to evolve the fundamental knowledge structures of the World Wide Web itself:

by tweaking some of the underlying assumptions behind today's Web, you could design an alternative version that could potentially mimic the self-organising neighborhoods of cities or the differentiated lobes of the human brain—and could definitely reproduce the simpler collective problem-solving of ant colonies. The Web's not inherently disorganized, it's just built that way.[50]

Any 'tweaks' to the Web, and indeed any changes to the knowledge structures represented on it, also make possible the rise of new information monopolists, however—just as the development of PageRank made possible the rise of *Google* as the undisputed new paradigm for search engines. Despite the declining hegemonic power of expert- and production-based models, and the overall decentralization of information, knowledge, and even knowledge structures which the move from production to produsage symbolizes, therefore, we also see the potential for "an important counter-trend, however, and it concerns the scarcity of attention. ... Yahoo, Google, Amazon, eBay ... exemplify the process of monopolization in the 'attention economy'."[51] However, such apparent monopolists harness and harvest the power of produsage itself, of course, and crucially rely on produsers for the generation of much of the content and content structures they provide; contrary to the producers of old, they exist no longer at arm's length from their customers, connected only through a highly imperfect and imbalanced feedback loop. For this reason, then,

the user community is not without power ... : collective reaction through opinion storms are activated by abusive monopolistic behavior, and can quickly damage the reputation of the perpetrator, thereby forcing a change in behavior in the monopolistic ambitions. Competing resources are almost always available, or can be built by the open source community.[52]

(This, of course, is true not only for the newly emerging corporate leaders of the online world, but also for produsage-based, collectively built leading institutions from *Slashdot* through *Wikipedia* to *del.icio.us*.)

More problematic than the potential monopolistic power itself of the new corporate and non-profit leaders of the knowledge space, then, is that such power to the extent that it exists has been built by harnessing an otherwise freely available resource; such leading institutions could therefore be regarded as the profiteers of the produsage movement. As Lanier points out, for example,

in the new environment, Google News is for the moment better funded and enjoys a more secure future than most of the rather small number of fine reporters around the world who ultimately create most of its content. The aggregator is richer than the aggregated.[53]

The same is true virtually across all areas of produsage; the sites harvesting and aggregating the efforts of distributed produsage communities, and the sites harboring produsage communities through centralized spaces, are able to generate significant

advertising incomes because of their popularity with the wider online population, for example (though not all of them do). We will examine the moral, ethical, and legal implications of such arrangements in Chapter 10; in balance to Lanier's view, however, it is already worth pointing out that many of the sites profiting from produsage effects also serve to drive traffic to the individual content originators whose work they aggregate, and thereby also increase both the visibility and status of such original contributors of content into the information commons.

As with other fields of produsage, at any rate, what the produsage of knowledge structures in the form of folksonomic systems of categorization contributes is an improved, public understanding of the processes of knowledge organization themselves—folksonomic produsage makes transparent the conventions, assumptions, and power dynamics inherent in taxonomic systems, and offers if not an alternative that is free of such factors, then at least an option which makes visible these influences and allows for the public negotiation of different approaches to mitigating their effects. Thus,

> the exponential network effects of the internet enable mass vernacular collaboration, and systems that can make visible the creation and revision of taxonomies that are simultaneously 'in play' as working infrastructures. Does this represent a revolution in classification processes? Does this visibility allow people to resolve the tensions inherent in any taxonomical structure, or make its implementation any more effective?[54]

Perhaps such hopes cannot be fulfilled even by the vernacular collaboration of a folksonomic produsage of knowledge structures; perhaps, indeed almost certainly, some of the tensions inherent in the categorization of knowledge are impossible to resolve to unanimous satisfaction. However, what folksonomic produsage does enable is the development of a number of alternative approaches to the categorization of knowledge which are able to exist in parallel and in dialog with one another, much as *Wikipedia* offers a model for the creation of a variety of representations of knowledge which may exist in parallel to one another even on the same page in the encyclopedia. In other words,

> the aggregate good of tags is *not* that they create consensus or accuracy; they observably don't, and this very observability is much of their value. ... There is both broad alignment around a few terms, but there is also a long tail of other views, which you don't get in formal systems.[55]

Much as the *Wikipedia*'s value is ultimately not only, and perhaps not even mainly, in the encyclopedic content which its contributors have created, but rather in the edit histories and discussion pages which trace and continue to facilitate the processes of negotiation and deliberation between diverging points of view, then, so the value of folksonomies may be seen to lie in the first place in enabling and encouraging the encounter of and engagement between differing views on how to structure the knowledge space. To fully realize this goal, however, we may well need to create and deploy

further tools and spaces to facilitate this process of engagement, discussion, and deliberation, in analogy to the tools available on *Wikipedia* and in many other produsage-based social environments.

Finally, then, not only should we see the development of folksonomies, and their potential gradual substitution for traditional taxonomic systems of classification as an appropriate, necessary, and generally positive step in the context of rapid changes and explosive increases in the availability of human knowledge through networked and participatory electronic media; ultimately, "it doesn't matter whether we 'accept' folksonomies, *because we're not going to be given that choice.* The mass amateurization of publishing means the mass amateurization of cataloging is a forced move."[56] Much as in many other areas affected by produsage, a turn away from traditional paradigms is virtually unavoidable, and the question is no longer whether that change will come, but how we will respond to it.

That response is in part a matter of further developing the technological tools to cope with and make sense of the multiple, pluralistic, flexible, and ever-changing knowledge structures created through folksonomic produsage; it will require the development of further filters that allow us to extract those patterns from the apparent chaos of user-generated metadata which are of direct relevance and use to us. To do this is not a matter of handing over the organization of our knowledge to machines, however, but instead simply of enhancing and extending the natural processes of knowledge organization which are common to our everyday lives.

Folksonomies themselves, though enhanced and—at least on a system-wide, cosmopedic scale—enabled by technology, are a fundamentally human construct, then. Much like other forms of produsage, they overcome the disruption caused by the domination of human interaction by industrial processes during the past century. Open source software development reacts against the corporately driven model of software innovation; citizen journalism corrects the biases built into the top-down, commercialized industrial news and media system; *Wikipedia* breaks the stranglehold of 'dead white men' on defining what is and is not deserving of inclusion and preservation in the knowledge spaces of humanity—folksonomies undermine models of top-down knowledge classification which emerged in their current form alongside the modern sciences and put in place a canonization of 'worthy' knowledge and intellectual pursuits which no longer represents the lived experience of humanity. By contrast, what folksonomies allow to emerge is a kind of 'folk intelligence,' a perpetually emergent, continuously changing collective intelligence that has been long in existence, but very recent in recognition.

NOTES

1. Clay Shirky, "Clay Shirky Explains Internet Evolution," *Slashdot*, 13 Mar. 2001, http://slashdot.org/article.pl?sid=01/03/13/1420210&mode=thread (accessed 20 Feb. 2002), n.p.

2. Mark Pesce, "The Tags Within," *Hyperpeople: What Happens after We're All Connected?* 7 Oct. 2006, http://blog.futurestreetconsulting.com/?p=18 (accessed 23 Feb. 2007), n.p.

3. For a fascinating statistical analysis of such patterns in *del.icio.us*, see Scott A. Golder and Bernardo A. Huberman, "The Structure of Collaborative Tagging Systems," Information Dynamics Lab, HP Labs, 2005, http://arxiv.org/ftp/cs/papers/0508/0508082.pdf (accessed 21 Sep. 2007).

4. Kevin Kelly, "We Are the Web," *Wired* 13.8 (Aug. 2005), http://www.wired.com/wired/archive/13.08/tech.html (accessed 24 Feb. 2007), p. 3.

5. Yochai Benkler, *The Wealth of Networks: How Social Production Transforms Markets and Freedom* (New Haven, Conn.: Yale University Press, 2006), p. 291.

6. Pierre Lévy, *Collective Intelligence: Mankind's Emerging World in Cyberspace*, trans. Robert Bononno (Cambridge, Mass.: Perseus, 1997), p. 217.

7. Stephen Johnson, *Emergence* (London: Penguin, 2001).

8. Lévy, pp. 217–218.

9. Lévy, p. 190.

10. Clay Shirky, "Ontology Is Overrated: Categories, Links, and Tags," *Clay Shirky's Writings about the Internet: Economics & Culture, Media & Community, Open Source*, 2005, http://shirky.com/writings/ontology_overrated.html (accessed 24 Feb. 2007), n.p.

11. Mark Pesce, "Hypercasting," *Hyperpeople: What Happens after We're All Connected?* 16 Oct. 2006, http://blog.futurestreetconsulting.com/?p=20 (accessed 23 Feb. 2007), n.p.

12. Clay Shirky, "Folksonomies + Controlled Vocabularies," *Many 2 Many: A Group Weblog on Social Software*, 7 Jan. 2005, http://many.corante.com/archives/2005/01/07/folksonomies_controlled_vocabularies.php (accessed 28 Feb. 2007), n.p.

13. Clay Shirky, "Folksonomy: The Soylent Green of the 21st Century," *Many 2 Many: A Group Weblog on Social Software*, 1 Feb. 2005, http://many.corante.com/archives/2005/02/01/folksonomy_the_soylent_green_of_the_21st_century.php (accessed 25 Feb. 2007), n.p.

14. Jon Udell, "Collaborative Knowledge Gardening," *InfoWorld*, 20 Aug. 2004, http://www.infoworld.com/article/04/08/20/34OPstrategic_1.html (accessed 1 Mar. 2007), n.p.

15. Udell, n.p.

16. Golder & Huberman, p. 6.

17. Shirky, "Ontology Is Overrated," n.p.

18. Benkler, p. 357.

19. Adam Mathes, "Folksonomies: Cooperative Classification and Communication through Shared Metadata," *Adammathes.com*, Dec. 2004, http://www.adammathes.com/academic/computer-mediated-communication/folksonomies.html (accessed 28 Feb. 2007), n.p.

20. Mathes, n.p.

21. Pesce, "Hypercasting," n.p.

22. Benkler, p. 62.

23. Mathes, n.p.

24. Pesce, "The Tags Within," n.p.

25. Mathes, n.p.

26. Mark Pesce, "The Three Fs," *Hyperpeople: What Happens after We're All Connected?* 28 Jan. 2006, http://blog.futurestreetconsulting.com/?p=6 (accessed 23 Feb. 2007), n.p.

27. Pesce, "The Three Fs," n.p.

28. Udell, n.p.

29. Michel Bauwens, "Peer to Peer and Human Evolution," *Integral Visioning*, 15 June 2005, http://integralvisioning.org/article.php?story=p2ptheory1 (accessed 1 Mar. 2007), p. 3.

30. Golder & Huberman, p. 7.

31. Benkler, p. 173.

32. Mathes, n.p.

33. Henry Jenkins, *Convergence Culture: Where Old and New Media Collide* (New York: NYU Press, 2006), p. 57.

34. Bauwens, p. 1.

35. A term attributed to Thomas Vander Wal—see Gene Smith, "Folksonomy: Social Classification," *Atomiq*, 3 Aug. 2004, http://atomiq.org/archives/2004/08/folksonomy_social_classification.html (accessed 12 July 2007).

36. Mathes, n.p.

37. Mathes, n.p.

38. Mathes, n.p.

39. Shirky, "Folksonomies + Controlled Vocabularies," n.p.

40. Matt Locke, "A Taxonomy of Humour: What Nurses Can Teach Us about Classification," *Test*, 25 Feb. 2005, http://www.test.org.uk/archives/002370.html (accessed 27 Feb. 2007), n.p.

41. Mathes, n.p.

42. danah boyd, "Issues of Culture in Ethnoclassification/Folksonomy," *Many 2 Many: A Group Weblog on Social Software*, 28 Jan. 2005, http://many.corante.com/archives/2005/01/28/issues_of_culture_in_ethnoclassificationfolksonomy.php (accessed 25 Feb. 2007), n.p.

43. Mathes, n.p.

44. Liz Lawley, "Social Consequences of Social Tagging," *Many 2 Many: A Group Weblog on Social Software*, 20 Jan. 2005, http://many.corante.com/archives/2005/01/20/social_consequences_of_social_tagging.php (accessed 25 Feb. 2007).

45. Shirky, "Ontology Is Overrated," n.p.

46. boyd, n.p.

47. boyd, n.p.

48. Shirky, "Folksonomies + Controlled Vocabularies," n.p.

49. Shirky, "Ontology Is Overrated," n.p.

50. Johnson, p. 120.

51. Bauwens, p. 3.

52. Benkler, p. 3.

53. Jaron Lanier, "Digital Maoism: The Hazards of the New Online Collectivism," *Edge: The Third Culture* 183, 30 May 2006, http://www.edge.org/documents/archive/edge183.html (accessed 27 Feb. 2007), n.p.

54. Locke, n.p.

55. Clay Shirky, "Folksonomy Is Better for Cultural Values: A Response to danah," *Many 2 Many: A Group Weblog on Social Software*, 29 Jan. 2005, http://many.corante.com/archives/2005/01/29/folksonomy_is_better_for_cultural_values_a_response_to_danah.php (accessed 25 Feb. 2007), n.p.

56. Clay Shirky, "Folksonomies Are a Forced Move: A Response to Liz," *Many 2 Many: A Group Weblog on Social Software*, 22 Jan. 2005, http://many.corante.com/archives/2005/01/22/folksonomies_are_a_forced_move_a_response_to_liz.php (accessed 28 Feb. 2007), n.p.

Folks and Experts:
Beyond the Pro/Am Divide

At the end of the previous chapter, we described the emerging folksonomies which structure the new knowledge space, the emerging cosmopedia, which is constructed by the contributors to *Wikipedia*, the co-produsers of knowledge sharing Websites, and the participants in social bookmarking systems, as being indicative of a kind of folk intelligence: a manifestation of the Web population's collective intelligence which, though not new, is now becoming increasingly visible and accessible.

Such descriptions necessarily raise the question of what role remains in a folksonomically organized knowledge space for the incumbents of information and knowledge organization: the experts in specific topical fields and the expert librarians and other information gatekeepers who have traditionally evaluated and organized knowledge within such subjects. Such questions have emerged already in the context of a number of the produsage environments we have encountered in this book, and no more so perhaps than in the *Wikipedia*, where especially its co-founder and erstwhile chief promoter Larry Sanger has been vocal in highlighting what he sees as a culture of rejecting expert knowledge. In *Wikipedia*, it appears that "someone whose expertise rests on having done extensive original research on a topic gets no particular respect. That denigration of expertise contributed to Larry Sanger's split from the project."[1]

Such denigration or denial of a previously established and externally accredited status of expertise in a given field of knowledge is directly related to the existence of alternative *internal* processes for the acknowledgment of contributor merit and the development of largely meritocratic heterarchies within produsage, of course. The question thus becomes one of whether even *bona fide* experts in a field will need to once again earn their status in the internal heterarchy of contributors, like all other members of the produsage site, or whether their existing status in the external hierarchy of traditional knowledge systems and disciplines should be translated into and respected by participants in the produsage project—as well as, of course, how this translation process may be orchestrated in practice.

Sanger is not alone in his criticism of *Wikipedia*. Lanier similarly sees a kind of blind trust in the collective of produsers, both by that collective itself, and by users of information available from the site:

> the problem is in the way the Wikipedia has come to be regarded and used; how it's been elevated to such importance so quickly. And that is part of the larger pattern of the appeal of a new online collectivism that is nothing less than a resurgence of the idea that the collective is all-wise, that it is desirable to have influence concentrated in a bottleneck that can channel the collective with the most verity and force.[2]

In engaging with such arguments it is important to note that neither Sanger nor Lanier claim that *Wikipedia* simply is an 'anything goes' environment: an anarchic space in which all users have an equal opportunity to have their thoughts and views on a topic aired, regardless of the quality of their contribution; this both supports a view of *Wikipedia* and other produsage projects as *equipotential* rather than simply equal environments, much as Bauwens describes them, and highlights the fact that even in the open participation environments of produsage, structures of community which police and channel contributions into more or less consistent outcomes do exist. Thus, Sanger writes, "is Wikipedia an experiment in anarchy? I don't think so. Is anarchy of such extreme, perhaps intrinsic, value that we ought to try to preserve it at the cost of other values? Absolutely not."[3]

Instead, *Wikipedia*'s model of community-led content creation, maintenance, and further development clearly builds on processes of constant and often highly involved and detailed discussion, debate, deliberation, and negotiation between differing points of view, as we have seen; "Wikipedians edit *each other's* stuff, so they feel a sense of collective purpose, responsibility, and camaraderie, which is yet another motivation to participate."[4] If there is a conflict between 'experts' and 'folks' on the pages of the *Wikipedia*, then, it is not one which can be described simply as pitting hierarchy against anarchy, control of knowledge systems against freedom of speech (however far off the mark that speech may be in terms of representing existing knowledge); rather, it is a struggle between two different systems of representing knowledge: one, the expert paradigm, which ultimately and ideally aims to develop well-behaved, universally accepted, and internally consistent understandings of the world, and one, the folksonomic paradigm, which allows for multiplicity, conflicts of interpretation, and the existence of a number of alternative representations of extant knowledge which are accepted only by a subset of the entire community (but which nonetheless are based on an interpretation of available evidence).

It is worth engaging in some detail with these problems of reconciling experts and folks, as they reappear in virtually all fields of produsage and are likely to constitute one of the key questions as produsage establishes itself increasingly as a credible model for content creation alongside production and, more importantly, in various forms of collaboration with the traditional, professional models. We will begin here by examin-

ing more closely Larry Sanger's own discussion of this matter, especially also in the context of his recent establishment of *Citizendium* as an alternative model to *Wikipedia* that is more respectful of expertise. Indeed, looking back on his role in developing *Wikipedia* (and before this, *Nupedia*), Sanger claims that he

> maintained from the start that something really could not be a credible *encyclopedia* without oversight by experts. I reasoned that, if the project is open to all, it would require *both* management by experts *and* an unusually rigorous process. I now think I was right about the former requirement, but wrong about the latter, which was redundant; I think that the subsequent development of Wikipedia has borne out this assessment.[5]

As we have already seen in previous chapters, in fact, he has argued strongly for the *a priori* enshrinement of a special role for subject experts in the charter or basic rules of the encyclopedic project: "there are *special* requirements of nearly every serious community [which are] best served by relevant experts; and so I think a prominent role for the relevant experts should be written into the charter."[6]

However, perhaps the core problem with such suggestions in our present context is not that the *a priori* establishment of charters and rules, and an overly zealous enforcement of such rules, is likely to prevent the community from developing organically and establishing its own procedures of governance: even *Wikipedia* itself, after all, proceeds from the three core principles of Neutral Point of View, Verifiability, and No Original Research—it *is* important to note, however, that these principles themselves have remained open for further development by the community (quite literally so as the *Wikipedia* pages defining the principles are themselves open for editing by contributors), and that they have evolved considerably over time.[7] As we have noted in previous chapters, it may well be most conducive to the development of produsage projects if those projects do have at least an *a priori* mission statement which galvanizes community involvement around a common aim; as far as Sanger's proposed charter goes, what is problematic is perhaps only that he seems to be disinclined to provide for community agency in further evolving and clarifying the mission and charter of the encyclopedic project he envisions.

The more fundamental problem, however, is that for all the argument in favor of respecting preexisting expertise, Sanger and others offer few ideas on how to define and recognize such existing expertise: what, in other words, constitutes 'expertise' in a field, and how can the holders of such expertise be distinguished from ordinary 'folks' engaging in the produsage project? Such problems emerge clearly from Sanger's statement of "several excellent and obvious reasons why expertise *does* need special consideration in an encyclopedia project, and in other collaborative projects":

> first, there are many subjects that dilettantes cannot write about credibly.... . Second, there are very many specialized subjects about which no one but experts has any significant knowledge at all. Third, it is only the opinions of experts that will be trusted

by *most* of the public as authoritative in determining whether an article is generally reliable or not. Moreover, the standards of public credibility are not likely to be changed by the widespread use of Wikipedia or by online debate about the reliability of Wikipedia.[8]

On closer examination, such arguments from common sense are less convincing than they may seem to the casual observer. For the almost overwhelmingly broad spectrum of knowledge represented in the *Wikipedia*, for example, we might question the number of subjects to which non-experts (or knowledgeable amateurs and Pro-Ams rather than accredited experts) are truly *entirely* unable to make any contributions of value—including both functional contributions such as improvements to the style and quality of writing, other forms of quality oversight such as contributions to the discussion pages attached to *Wikipedia* entries which may indicate shortcomings of the encyclopedic entry or request further clarification of the content provided, and direct contributions of knowledge.

Indeed, Sanger appears to assume that there are only two categories of contributors available to the *Wikipedia*: 'experts' and 'dilettantes,' but offers no indication of how these may be distinguished from one another. Is an undergraduate or postgraduate student in a specific discipline of knowledge to be considered a dilettante or an expert? Is an uncredentialed enthusiast, from amateur astronomers to local historians, from committed fans of *Battlestar Galactica* to the volunteer developers of open source software, to be considered as inherently less knowledgeable than 'experts' in these fields? As Leadbeater and Miller have argued persuasively, and as we have seen in our discussion of produsage as an alternative to production, the lines between amateurs and professionals, between enthusiasts and experts, are nowhere near as clearly defined as Sanger would have us believe; 'Pro-Ams' and committed produsers have blurred them considerably. Strong distinctions *may* exist in a small number of 'hard science' disciplines, but for the vast majority of topics covered by *Wikipedia* they are likely to appear rather less clear-cut.

It is important to note, too, that at least some of Sanger's argument seems to focus not on the quality of the content collaboratively produced by both experts and amateurs, and the many holders of expertise which exist between these points, on the *Wikipedia*, but rather to concern itself with the *appearance* of quality which such processes of produsage may or may not serve to generate if they show no inherent deference to the views of 'experts'. Indeed, as Sanger puts it, "*regardless* of whether Wikipedia *actually* is more or less reliable than the average encyclopedia, it is not *perceived* as adequately reliable by many librarians, teachers, and academics."[9]

While public acceptance as a quality resource *is* a worthy goal for *Wikipedia*, however, surely it cannot and must not be seen as any more than a secondary consideration in determining the internal processes of content produsage on the site. In the first place, what matters must always be the question of whether Wikipedians themselves are confident that what they have created collaboratively is of sound and im-

proving quality, and whether under impartial scrutiny *the content itself* holds its own against more conventional competitors; outsiders with limited knowledge of the internal processes of the site—and especially outsiders in academia and media whose established systems of knowledge organization and accreditation may be directly under threat from produsage models and environments such as *Wikipedia*—are unlikely to be better judges of quality than are those involved in the processes of knowledge creation themselves (Robert McHenry's prejudiced diatribe against *Wikipedia* may serve as a particularly extreme case in point here). In the first place, *Wikipedia* should be neither concerned with public assessments of its credibility, nor aim to change 'the standards of public credibility' overall—instead, proof for the success of its model of content produsage lies simply in its continued ability to attract significant numbers of contributors to sustain and extend the project.

Beyond such irrelevant questions of how *Wikipedia* is perceived by external observers, then, the more pressing issue of how to accommodate experts in the produsage process is not dealt with as simply as Sanger appears to indicate: questions of who is an expert, and on what topics, and what defines and documents such expertise, have no easy answers. Sanger recalls the early stages of developing *Wikipedia*:

> in those first months, deference to expertise was a policy that at least *I* usually insisted upon, but not strongly or clearly enough. ... Indeed, most users *did* make a practice of deferring to experts up to that time. ... In the long run, it was *not* adopted as official project policy, as it could have been.[10]

Based on our discussion so far, it is now clear that this failure to adopt deference to expertise as an official policy of the project is neither surprising nor ill-advised: any policy enshrining a special role for experts would have had to have been based on a number of oversimplifications about how expertise is defined and documented, and over time would likely have turned into a legalistic nightmare of clauses and procedures outlining exactly how and to what extent different levels of expertise from undergraduate to professor, from industry worker to industry leader, should be respected by one another and by the wider community; the terms of this policy, in other words, would have had to have defined the shape and structure of a new hierarchy of experts to replicate and amalgamate the external hierarchies of experts already in existence in various domains of knowledge and industry.

In addition, a policy even of such complexity would not even have begun to consider the question of how to recognize experts internal to *Wikipedia* itself, especially also in fields where there exist no inherent external hierarchies of knowledge. Clearly, for example, gradations of expertise also exist in the many fields of popular and enthusiast culture covered by *Wikipedia*; here, too, a logic of deference to expertise should surely be applied. In addition, if the project of collaboratively developing an encyclopedia through produsage is considered at least in part an educational one as well, then it must entertain the possibility of experts arising from within its communi-

ties, informed by the knowledge available within the site, and avoid an inherent fet-ishization of external experts only. Such possibilities are not provided for in a model which favors the *a priori* both in a recognition of *a priori* structures of expertise, and an *a priori* definition of community principles for deferring to that expertise.

Ultimately, then, Sanger's suggested approach to engaging with experts seems unworkable, and possibly damaging to the project of harnessing community involve-ment in the *Wikipedia*. Instead of the development of strict and detailed rules for re-specting experts, perhaps it is instead more appropriate to retain a degree of trust in the common sense of the community and its efforts at self-policing and contributor socialization, which Sanger himself, in fact, advocated in his earlier role of chief *Wikipedia* enthusiast:

> contributing articles to Wikipedia is *easy*, as is editing other people's articles. There is naturally little motivation to make substantive edits to articles on subjects about which one knows nothing, and mistakes are often caught and made a public specta-cle. So experts are respected and deferred to, which encourages and motivates the ex-perts—thus the increasing level of expertise on the website.[11]

At the same time, of course, such trust that under the right circumstances the community will be self-correcting in its balance of 'expert' and 'amateur' knowledge does not mean the embrace of *blind* trust in such phenomena. Principles such as Veri-fiability and No Original Research already go some way towards avoiding the intrusion of self-proclaimed 'experts' and unsubstantiated 'theories' into the legitimate and nec-essary debates about representations of knowledge which are carried out through the entry and discussion pages of the *Wikipedia*, and the enforcement of such principles must be further strengthened by all members of the community. Indeed, in any such debates, it is important that participants remain open to the arguments and, more im-portantly, the evidence for such arguments, provided by the proponents of all points of view, and that well-established (in the sense of comprehensively verified, not simply commonly or traditionally held) views are accorded particular respect. In this context, Sanger is certainly right to "disagree with the notion that that Wikipedia-fertilizing openness requires disrespect toward expertise. The project can *both* prize and praise its most knowledgeable contributors, *and* permit contribution by persons with no creden-tials whatsoever."[12] However, the prominence accorded to specific interpretations and representations of knowledge must always be based in the evidence supporting it, not simply in the status of its proponents (whether within *Wikipedia* or external to it).

Restoring the Expert? *Citizendium* and Beyond

Sanger's own response to his growing disenchantment with *Wikipedia*, of course, has been the establishment of *Citizendium*, a model of collaborative encyclopedic content

production which enshrines a greater respect for experts in a quasi-hierarchical structure of administration, and can therefore no longer be considered to be a form of user-led produsage in its own right. Where the participation of variously 'expert' users as contributors to open systems of knowledge creation and representation represents "an assault upon editorial control, because these works have been created outside of the systems of creative production which ensure a consistent, branded product"[13], then, *Citizendium* restores such editorial control at least in part. While wiki-based, as we have noted, it enables editing only for registered users, and institutes a process of registration which requires users to show their scholarly credentials and disciplinary expertise to be accepted as full contributors; as such, it can be seen as an attempt to resurrect the *Nupedia* model, and as Sanger believes,

> the projects, Wikipedia and Nupedia, were naturally complementary parts of a single, symbiotic whole. ... From the founding of Wikipedia, I always thought Wikipedia without Nupedia would have been unreliable, and that Nupedia without Wikipedia would have been unproductive.[14]

The *Citizendium* approach has been criticized from a number of perspectives, however—most importantly for our present discussion, of course, in the context of its renewed focus on expert knowledge. For some, such emphasis on expertise is seen as a form of elitism: indeed, "Sanger goes as far as suggesting Wikipedia needs to be more *elitist* (note how he doesn't say more *meritorious*), which would explicitly undermine the value of the project."[15]

Following our earlier discussion, however, perhaps a more appropriate description would mean translating this charge of elitism into an observation that *Citizendium* is built on the assumption that an *a priori* hierarchy of expertise exists and can be quantified and operationalized in determining editorial decisions on the site. In this approach, Pesce suggests, *Citizendium* is as vulnerable to systemic shortcomings inherent in its hierarchical model as *Wikipedia* is at times open to abuse due to its *ad hoc* or *a posteriori* processes of governance:

> Citizendium is proactive and presumes too much; Wikipedia is reactive (and for this reason will occasionally suffer malicious damage) but only modifies its access policies when a clear threat to the stability of the community has been demonstrated. Wikipedia is an anarchic horde, moving by consensus, unlike Citizendium, which is a recapitulation of the top-down hierarchy of the academy.[16]

(Again, however, we might like to substitute observations of heterarchical community structures for claims of outright anarchy in *Wikipedia*.)

If Sanger is right in his belief that elements of *Nupedia* or *Citizendium*, and of *Wikipedia*, may only in combination give rise to a collaboratively produced, user-led encyclopedia which is comparable in quality with the best products of traditional encyclopedic models and avoids both an over-deference to expertise and the deleterious

effects of anti-elitism, then we might well ask how best to systemically reintroduce some greater degree of respect for established expertise (if not for experts in and of themselves) into the produsage process. As *Wikipedia* has risen to greater public recognition, and as the question of expertise within the site has been problematized by Sanger and other commentators, some such suggestions have already been made: boyd, for example, suggests the introduction of new article features into *Wikipedia*. This could mean the combination of "an open entry that is universally writable with a section that has been vetted and whose authors, affiliations and motivations are listed alongside that vetted component," for example:

> I would like the combination of vetted and open portions of an entry. I would love if Wikipedia would allow scholars to write static components to entries with a publicly identified author. Let the Asian Tsunami Disaster be written at first by anyone, but let the scientists have a vetted section that explains how the quake created a tsunami.[17]

The implementation of such suggestions is unlikely to proceed by introducing overt editorial restrictions for users, however; rather, it would most probably rely on individual *Wikipedia* users choosing for themselves to restrict their participation only to those areas where they are best able and best equipped to contribute. Such tendencies do already exist within the community, of course; they are driven not through overt editorial policing by *Wikipedia* administrators, or by technological features restricting access to specific sections of the site for any but the accredited knowledge-holders in a field, but by internal peer pressures and social dynamics. These factors do not protect the present-day *Wikipedia* from individual disruptive users, nor are they likely to do so for a future version of the site which more overtly distinguishes high-quality components from other content, but there is great potential for these factors to be harnessed, enhanced, and multiplied to further discourage users from acting disruptively.

Citizendium, by contrast, operates not by harnessing the social dynamics inherent within the community of its users and contributors itself, but attempts to create incentives and disincentives for specific forms of participation through a combination of regulatory *fiat* and the technological separation of contributors and users which ultimately undermines the potential for users to become produsers without significant administrative oversight; it is the ease of moving from passive consumer to interactive user to intercreative produser, however, which most crucially enables the success of produsage projects in harnessing a large, active, and productive community of contributors. In the process, *Citizendium* undermines some of the core principles for "why Wikipedia started working" which Sanger himself had identified:

1. Open content license.
2. Focus on the encyclopedia.

3. Openness.
4. Ease of editing.
5. Collaborate radically; don't sign articles.
6. Offer unedited, unapproved content for further development.
7. Neutrality.
8. Start with a core of good people.
9. Enjoy the Google effect.[18]

The comparative reduction in open participation, in access to contributory possibilities, and in the fluidity and heterarchy of collaboration which the *Citizendium* model necessarily introduces, also changes the nature of its outcomes; the artefacts of the *Citizendium* model are no longer rapidly evolving and inherently unfinished, but will appear more and more similar to the products of the traditional encyclopedic content creation process, in turn thus also offering a far less open invitation to participate in their further development. Where the open, participatory, community-driven, and meritocratic approach of *Wikipedia* can be seen as enabling the possibility of a self-reinforcing virtuous cycle of content development, *Citizendium* breaks that cycle by strengthening artificial barriers to involvement in pursuit of its goal of higher quality. Most crucially, perhaps, it returns to a focus on *a priori* systems of reputation, which offer little incentive for new and uncredentialed participants to become deeply involved in the process; this disables any opportunity to harness the wider community of potential contributors:

> letting reputation of contributors emerge in a transparent manner will reward higher-quality contributions, and may provide a partial answer to coordination problems if those who make good contributions receive some proportionate ability to decide conflicts.[19]

By contrast, coordination problems within *Citizendium* are likely to return in force as (and if) its community of contributors grows and becomes more diverse; its internal processes of decision making and quality assurance will come to resemble a microcosm of the disciplinary divisions and arguments of the wider academic and intellectual environments whose knowledge it aims to present. Inevitably, its administrative overhead will grow markedly.

Such problems of coordination may be manageable in fields where knowledge is relatively stable and knowledge systems have solidified into generally accepted taxonomies; they will be highlighted, on the other hand, for areas characterized by the rapid development of new knowledge and the absence of strong taxonomies. *Citizendium* will be poorly placed to engage with such fields of 'live' knowledge, and may indeed come to focus mainly on presenting the 'dead' knowledge of traditional disciplines; in this it would come to replicate the shortcomings of many traditional encyclopedias which have frequently been slow to embrace new fields of knowledge

(from advanced science to popular culture) and to develop encyclopedic entries for current events. (And while random comparisons and examinations of resources under development are perhaps necessarily unfair, it is instructive to observe that at the time of writing, *Citizendium*'s entry for Aristotle was nearly six times the size of that for George W. Bush, the latter devoting only one paragraph to Bush's response to the events of 11 September 2001.) By contrast, as Pink notes, the open participation *Wikipedia* approach

> creates something alive. When the Indian Ocean tsunami erupted ... , Wikipedians produced several entries on the topic within hours. By contrast, World Book, whose CD-ROM allows owners to download regular updates, hadn't updated its tsunami or Indian Ocean entries a full month after the devastation occurred. ... Fixing ... contents in a book or on a CD or DVD is tantamount to embalming a living thing. The body may look great, but it's no longer breathing.[20]

The same, we might suggest, is a possible fate for content in *Citizendium*, which, while presented online, shares many of the characteristics common to the production models of *World Book* or *Encyclopædia Britannica*.

Ultimately, this tendency to embalm living knowledge is perhaps a fundamental feature of hierarchical structures for knowledge (and for experts as the holders of knowledge)—the taxonomic system is in a very real sense a system of embalming, of taxidermy, of transferring knowledge from the live processes of collective intelligence to the static repositories of collected intelligence. Indeed, as Jenkins suggests, "what holds a collective intelligence together is not the possession of knowledge—which is relatively static, but the social process of acquiring knowledge—which is dynamic and participatory, continually testing and reaffirming the group's social ties"[21]; this process of acquiring and sharing knowledge through the social processes of community interaction necessarily requires the testing of claims to knowledge against one another without undue deference to established expertise.

Wikipedia, in this sense, is closely aligned with the live processes of academic exchanges of knowledge in the development and testing of scientific hypotheses—processes which at least in their ideal and idealized forms operate unencumbered by preexisting, *a priori* claims to scientific expertise and allow newcomers to the scientific establishment to acquire community merit just as much as this is open to long-established participants (even if in practice the effects of an embedding of such processes in wider academic, scientific, educational, and other knowledge industries substantially reduce the degree to which open participation is possible). *Citizendium*, on the other hand, is concerned more with the ordering and structuring of knowledge which emerges from such live processes; its model does not encourage these processes to occur on the site itself, but contends itself with the gathering and presenting of the knowledge emerging from the contest between alternative perspectives and theories as it is carried out elsewhere. *Citizendium*, in other words, constitutes the mere, dead,

data shadow of the live interactions between representations of knowledge and their proponents which take place both within the traditional society of experts and within the new communities of professionals, Pro-Ams, and amateurs gathered on *Wikipedia* and elsewhere. Thus, Pesce states unequivocally, "Citizendium, as an attempt to make perfect what is already good enough, must be doomed to failure, out of tune with the times, fighting the trend toward the era of the amateur."[22]

The trend towards the amateur, indeed (much as we might want to move away from simple pro/am dichotomies and instead point out the many gradations which exist between the two), is necessarily also a trend towards the unfinished. As *Wikipedia* leader Jimmy Wales puts it, "Wikipedia will never be finished"[23]; *Wikipedia* is the process of gathering in ever greater detail the collective knowledge of its community of contributors, and of pitting the different interpretations and representations of knowledge which they hold against one another in a continuous (but ideally, fair, open, and equipotential) contest of ideas, and much like the process of scientific exploration it can therefore never arrive at a final conclusion. *Citizendium*, on the other hand, provides a process for determining, through the development of a hierarchy of expertise and experts, the apparently most core, most central, most 'truthful' version of reality, (re)establishing a canon of knowledge. It installs a set of hierarchs whose position cannot be questioned while at the same time obstructing the emergence of heterarchs from within the community itself.

A Continuum from 'Pros' to 'Ams'

What emerges from the discussion so far, then, is the need for a more balanced, nuanced, detailed approach than is provided by Sanger's inherent trust in (ultimately relatively ill-defined, and possibly indefinable) expertise; the opposition between *Wikipedia*'s and *Citizendium*'s models serves here only as one particularly salient example for a wider conflict between production and produsage, between taxonomic and folksonomic paradigms, of course. In reality, 'expertise' exists on a sliding vertical scale stretching from recognized leaders in their fields and disciplines through a variety of lesser 'professional' and 'Pro-Am' possessors of knowledge to enthusiasts and rank amateurs themselves; in addition, it also spans an even less immediately quantifiable or accreditable continuum of fields, disciplines, and subsets of knowledge which—in spite or even because of the efforts of centuries of scientific thought—have no clearly and reliably identifiable boundaries.

Although it is perhaps necessary to develop and deploy the means to filter the effects of participation by less knowledgeable contributors in any one field and community of knowledge, then, to do so cannot be attempted on the basis of existing forms of 'expert' accreditation, which have always been inadequate and are now found to be entirely unsuited to controlling participation in collaborative content creation. As

Shirky notes, most likely "you need barriers to participation. ... You have to have some cost to either join or participate, if not at the lowest level, then at higher levels. There needs to be some kind of segmentation of capabilities."[24] However, such barriers cannot come in the form of simple membership-style in-group/out-group boundaries, but must arise organically from participation within the community itself. They must, in other words, be systems determining access to higher forms of contribution which are based on the already existing track record of participants in the community; they must activate, harness, quantify, make visible, and operationalize existing if informal systems of reputation and merit within the community.

Again, too, it is important to point out that the aim of such systems is not (or at least, not predominantly) to raise the reputation of the produsage project in the wider, outside community; instead, these systems serve to protect the community from threats arising from within itself; "it has to be hard to do at least some things on the system for some users, or the core group will not have the tools that they need to defend themselves"[25] from more marginal members poorly socialized into the community's ethos and mode of operations. Systems of reputation and merit within the community are thus necessarily themselves in constant flux as the community continues to change and evolve:

> in an intelligent community the specific objective is to permanently negotiate the order of things, language, the role of the individual, the identification and definition of objects, the reinterpretation of memory. Nothing is fixed. Yet, this does not result in a state of disorder or absolute relativism, for individual acts are coordinated and evaluated in real time, according to a large number of criteria that are themselves constantly reevaluated in context.[26]

In *Wikipedia* as well as elsewhere in produsage communities, examples for the failure of such processes exist, of course. Schiff, for example, recounts a 2005 case in which

> William Connolley, a climate modeller at the British Antarctic Survey, in Cambridge, was briefly a victim of an edit war over the entry on global warming, to which he had contributed. After a particularly nasty confrontation with a skeptic, who had repeatedly watered down language pertaining to the greenhouse effect, the case went into arbitration. ... It can still seem as though the user who spends the most time on the site—or who yells the loudest—wins.[27]

Where such cases continue, clearly the community has not yet established structures of reputation and merit, and barriers to participation by (or at least means of filtering out the contributions of) those identified as less knowledgeable, sufficient to avoid appeals to external systems of arbitration.

However, the common focus on scientific topics which many such examples for the apparent failure of *Wikipedia* communities' self-policing approaches have in common should also alert us to a need not to see such cases as symptomatic for the wider

whole of *Wikipedia* as such. Scientific facts (or more properly, scientific theories which, like climate change, have been independently verified beyond reasonable doubt) constitute only a minute component of the wider range of knowledges represented in *Wikipedia*, and of the human knowledge overall; most other fields of human knowledge are significantly more open to interpretation, discussion, and debate. While, for example, the fundamental facts of economic science may be similarly indisputable, their interpretation, and even more so the question of implementing economic policy, is a choice involving a variety of social, cultural, ethical, moral, ideological, and personal factors, not only scientific ones; the presence in *Wikipedia* of controversial debates over, say, the correct depiction of economic rationalism is therefore not only unavoidable, but even beneficial to the creation of a comprehensive entry for that topic, as long as the debate is conducted on the basis of available evidence rather than out of a communal common sense. 'Experts' as such have no privileged role in that debate (but expertise to understand and accurately evaluate available evidence does, as does the ability to look to those who have that expertise where participants do not possess it themselves). Thus,

> in the age of hyperintelligence, expertise has become a broadly accessible quality; it is not located in any particular community, but rather in individuals who may not be associated with any official institution. Noise is not the enemy; it is a sign of vitality, and something that we must come to accept as part of the price we pay for our newly-expanded capabilities.[28]

Far from being able to be dismissed as noise to be stamped out and avoided, the presence of such debates indicates the conduct of active processes of knowledge organization; where "a passive approach assumes that knowledge ... has inherent in it the principle of its own ordering"[29], this active approach realizes that representations and structures of knowledge are worth arguing over, that the place and representation of each topic in the encyclopedia, or in the wider knowledge space of humanity, are not inherent in the topic itself, only waiting to be uncovered, but a matter for interpretation and debate—a matter of creativity in structuring knowledge, as Van Doren puts it:

> to discover its proper place by thought and discussion would be to use what we term the active, or creative, approach to the making of an encyclopedia. ... The creation of this structure is the most important task that faces the editors of an encyclopedia.[30]

A focus on experts as not even actively determining such knowledge structures, but as themselves products of the preexisting structures of knowledge represented by academic disciplinarity, which is common to traditional encyclopedic production as well as to the expert-driven model of *Citizendium*, necessarily cuts off much of the creative potential of the more active model of knowledge structuration. This is a common trait of the production model more generally, as compared to the more open produc-

sage model which is not chained to preexisting knowledge structures; so, for example, Heikkilä and Kunelius similarly point out that

> the predominant ideas about expertise incorporated in journalistic practices can often be seen as obstacles for deliberation. The routinely accessed and privileged experts are not assumed to derive their knowledge and opinions from social experience, but rather independently from it. Experts frame problems differently from citizens. Therefore, experts—be they philosophers, sociologists, engineers etc.—almost by definition alienate themselves from the practices of everyday life.[31]

Fundamental characteristics of the academic environment, as the basis for the establishment of knowledge structures, also work against an open societal (or even only academy-wide) deliberation about the structures appropriate to the representation of knowledge, as Van Doren noted already in the 1960s:

> the fragmentation which is so marked a characteristic of American encyclopedias is a function of the fragmentation of the American university. Interdepartmental squabbling would be amusing if it did not imply the breakdown in conversation between scholars of what were, only a few years ago, closely allied "fields." Perhaps the game should not yet be given up. ... It may be that the world cries out for an encyclopedia to do the job.[32]

Wikipedia, and the environments of produsage more generally, can serve as vehicles for moves beyond established and increasingly ossified structures of knowledge and expertise, then; they pay respect not to abstract certificates of expert accreditation, but to the active display and embodiment of expertise through constructive participation in their communities of content and knowledge creation. At their best, therefore, they are by no means anti-elitist, but instead openly invite elites and experts to share their knowledge with the wider community so that the community overall is able to gain knowledge; they are opposed, however, to any tendency to take established expertise for granted and to use one's status as an accredited expert to refrain from answering legitimate questions and challenges, wherever they may originate. Thus, for example, in journalistic produsage the lack of special prestige accorded to experts "does not mean, however, that deliberative journalism should reduce all discussion to common sense. Rather, the perspectives of 'ordinary people' should be allowed to transform the analytical distinctions of established experts as well as define new questions."[33]

Such engagement between 'experts' and 'non-experts,' or indeed between the varying levels of expertise existing throughout the continuum, does not operate best through the facilitation of journalists, editors, or other intermediaries, but must be managed by the communities themselves; "in general, the most net-like solution ... is going to be to bypass the notion of third parties and instead to find ways of putting the users' hands directly on the dial."[34] What emerges from this community-based model may well be what Van Doren described as "an entirely new organization of

scholars"[35]: a community of knowledge creators and curators which involves those in the higher reaches of the continuum of expertise just as much as those further down the scale, and enables all to make contributions to the communal process as is appropriate to their skills and abilities—much in line with Bauwens's principle of equipotentiality which, as we have seen, assumes "that there is no prior formal filtering for participation, but rather that it is the immediate practice of cooperation which determines the expertise and level of participation."[36]

The other side of the equipotential coin, however, is also the realization by individuals that with the right to participate openly, that is, with the acceptance of a communal stance that all participants have a useful contribution to make, regardless of their level of accreditation as experts, comes also a responsibility: the responsibility to ensure that contributions *are* made only where individuals have a reasonable indication that their contribution will be constructive and useful to the common aim. In other words, "equipotentiality is the assumption that the individual can self-select his [sic] contributions, which are then communally validated."[37] This, then, is perhaps the full implication of the fundamental produsage principle of open participation and communal evaluation: an individual right, but also an obligation to the community, and a question of what we may describe as the individual's participatory capacity.

Such principles are clearly at work in many forms of collaborative content creation through produsage processes; in open source software development, for example,

> the contributors for any given project are self-selected. ... Contributions are received not from a random sample, but from people who are interested enough to use the software, learn about how it works, attempt to find solutions to problems they encounter, and actually produce an apparently reasonable fix. Anyone who passes all these filters is highly likely to have something useful to contribute.[38]

Indeed, such filters are necessarily more appropriate than any filters based on expert accreditation as "nobody but the individual concerned knows better the precise nature of the skills he [sic] can contribute"[39], but the precision of such self-selection processes also depends crucially on individuals choosing to assess their own skills and abilities honestly. This question of self-awareness of one's own abilities and limitations provides perhaps the greatest hurdle to constructive community participation in produsage, as many disruptive contributions are nonetheless made in good faith and from a sense of having something useful to contribute;

> the prevalence of misperceptions that individual contributors have about their own ability and the cost of eliminating such errors will be part of the transaction costs associated with this form of organization. They parallel quality control problems faced by firms and markets.[40]

Here, of course, communal evaluation and filtering comes to play an important role both in policing participant contribution and neutralizing any potentially deleterious

effects, and (through this process) in socializing participants to community values and needs in order to ensure that future contributions are more closely and directly aligned with the community's interests and goals. What is necessary, then, is a recognition and strengthening of community procedures by the communities themselves, and a sharing of knowledge about such processes throughout the entire project.

A stronger recognition and quantification of individual reputation and merit may help in this process; as Raymond notes for open source, "the ... community's internal market in reputation exerts subtle pressure on people not to launch development efforts they're not competent to follow through on"[41], and the strengthening of similar 'markets' in reputation in *Wikipedia* and elsewhere is likely to provide further support for these other projects. Especially as such markets develop and are better recognized, then, it is also necessary to ensure that new community members are being made aware of the environment they are entering as they begin to participate; indeed, as Japanese *Wikipedia* administrator Kizu Naoko points out, already "on several wikis we have a 'welcoming committee', a group of users who inform newcomers of a principal set of policies and guidelines."[42] Ultimately, indeed, in keeping with the 'reputation market' metaphor Jenkins argues that what emerges from such community self-policing tendencies "might be called a moral economy of information: that is, a sense of mutual obligations and shared expectations about what constitutes good citizenship within a knowledge community."[43]

The Long Tail of Expertise

Evidently, then, questions of reconciling traditional expertise and emergent community knowledge structures appear throughout the various environments of produsage. Neither a return to traditional, hierarchical models of expertise and expert accreditation nor a full embrace of internal community mechanisms for contribution and reputation management are likely to be completely successful in isolation, indeed; experts turn out to be especially useful in the establishment of core and fundamental knowledge, especially perhaps in the sciences, and have an important role to play also as curators of knowledge by pointing out the interrelations between different fields of knowledge, but their ability to lead knowledge creation and organization for areas further away from these core environments is more limited. Partly, in fact, this limitation is simply a manifestation of long tail effects: inherently limited in numbers by the very processes of accreditation which highlight their expertise, experts are necessarily unable to explore and map the available knowledge space right into its furthest reaches; they cannot have comprehensive expertise on areas of knowledge remote from their core field. So, for example, "collaborative tagging is most useful when there is nobody in the 'librarian' role or there is simply too much content for a single authority to classify; both of these traits are true of the web."[44]

Produsage, on the other hand, is able to harness the long tail of theoretical and practical knowledge which extends beyond the conventional disciplinary boundaries of expert communities; as we saw in Chapter 2, this removal of hard boundaries separating producers from consumers is a core affordance of the shift from production to produsage, of course, and in the context of knowledge and knowledge structures translates to the transformation of an expert/non-expert or professional/amateur dichotomy into a smooth continuum connecting both ends. In the new model, therefore, hierarchies of expertise are revealed to be themselves no more than the peaks of the wider heterarchical structures of the knowledge space; experts and their expertise cover no more than the tips of the iceberg of human knowledge. The waterline in this image, indeed, is drawn by the extent of their individual capabilities, as Jenkins points out; necessarily,

> the expert paradigm requires a bounded body of knowledge, which an individual can master. The types of questions that thrive in a collective intelligence, however, are open ended and profoundly interdisciplinary; they slip and slide across borders and draw on the combined knowledge of a more diverse community.[45]

Broad, community-based approaches to the mapping of knowledge, in other words, are by necessity the only available tools for dealing with the vast bulk of the knowledge iceberg.

Such approaches crucially rely on the produsage-based tools for knowledge creation, mapping, and organization which we have already encountered in previous chapters—open environments for the contribution and development of content, communal systems for its evaluation, the folksonomic means of categorization, and a set of automated or manual tools for the collation, filtering, browsing, and searching of the content and metadata thus compiled. For dealing with the vast amount of content, information, and knowledge existing below the 'waterline' of traditional expertise, indeed, such tools provide the only feasible option:

> the advantage of folksonomies isn't that they're better than controlled vocabularies, it's that they're better than nothing, because controlled vocabularies are not extensible to the majority of cases where tagging is needed. Building, maintaining, and enforcing a controlled vocabulary is, relative to folksonomies, enormously expensive, both in the development time, and in the cost to the user, especially the amateur user, in using the system.[46]

By embracing a community-based approach, such folksonomic (and, more broadly, folk or collective intelligence) models harness the synergies made available through breaking down the overall task of taxonomic classification into a series of vanishingly small, highly granular actions of categorization; they enable individual contributors to act as what Pesce refers to as 'nanoexperts'[47], and thus rely on the

workings of collective intelligence. This necessarily results in a democratization of categories as the system shifts from taxonomy to folksonomy, and indeed,

> perhaps the most important strength of a folksonomy is that it directly reflects the vocabulary of users. ... A folksonomy represents a fundamental shift in that it is derived not from professionals or content creators, but from the users of information and documents. In this way, it directly reflects their choices in diction, terminology, and precision.[48]

At the same time, however, through the processes of tracking individual merit and reputation as a contributor which the folksonomic system also enables, folksonomic nanoexperts *are* able to rise to greater recognition among their peers, and therefore to emerge above the waterline into the traditional expert model (though not necessarily becoming formally accredited by it); overall, this gives rise to "communities of collective *hyperintelligence*, where the collective value of the community's knowledge is greater than the sum of its individual parts."[49]

The quality of the information and knowledge present in such communities, however, is then also directly related to their degree of diversity; noting Raymond's observation of the power of eyeballs in ensuring the quality of open source processes, therefore, we might extend this to highlight the particular power inherent in a large set of *diverse* eyeballs. In Lévy's terms, for the collective intellect

> each increase in qualitative diversity strengthens the interest of everyone in its continued existence. And the more its members are involved in its permanent re-creation, the more the immanent dynamic of expression will favor the proliferation of ways of being. Each mode of freedom will be reflected upon the others in a positive spiral. In this way collective intellect creates a new space.[50]

In the context of the collective intellect as spanning a continuum of expertise from 'pros' to 'ams,' then, while community-based collaborative content creation and folksonomic modes of structuring the content thus created are highly productive, effective, and useful, they remain only one part of the wider picture. Traditional experts do have a role to play in addition to and in combination with the wider communities of contributors which have sprung up to complement them, as do social processes and technological aids designed to support processes of content, information, and knowledge creation. "The bottom-up hive mind will never take us to our end goal. We are too impatient. So we add design and top down control to get where we want to go."[51]

What is necessary is in the first place to identify the areas where each of the components of the overall system—'experts' and 'amateurs,' producers and produsers, hierarchies and heterarchies, taxonomies and folksonomies—has the most to contribute. Some, like Locke, suggest that folksonomies and the multiplicitous, pluralistic, indeterminate systems of content and metadata creation which they exemplify are useful only where nothing significant is at stake:

folksonomies are, in essence, just vernacular vocabularies; the ad-hoc languages of in-timate networks. They have existed as long as language itself, but have been limited to the intimate networks that created them. At the point in which *something is at stake*, either within that network or due to its engagement with other networks (legal, finan-cial, political, etc) vernacular communication will harden into formal taxonomy, and in this process some of its slipperiness and playfulness will be lost.[52]

As a necessarily imprecise tool, in other words, folksonomies have limited use where precision is required; the same may be said also of other outcomes of produsage proc-esses which remain ever-unfinished and in a process of constant evolution. On the face of it, this claim appears to be true, but it fails to explain why the outcomes of pro-dusage projects are nonetheless increasingly able to challenge traditional products also (and perhaps especially) where *quality* is a determining factor (as for example in the context of software development); here, clearly, the use of probabilistic, community-based models of quality assurance has not led to a degradation of quality.

The answer to this question is likely to be found in the fact that such successful communities (if we measure success in this context by the ability of the produsage con-tent to compare favorably to traditional products) have been able to develop the com-munal, social protocols for a collaborative process of quality assurance. For Bauwens, this points to the crucial importance of what he describes as protocollary power in community collaboration:

> protocols ... imply a vision: should everyone be able to judge, and in that case, would that not lead to a lowest common denominator, or should equipotency be defined in such a way that a certain level of expertise is required, to allow higher quality entries to be filtered upwards?[53]

Community protocols, in other words, provide the means for a community to po-lice itself, its members, and its activities; they provide a replacement for the traditional structures of power inscribed in professional hierarchies. Indeed, they describe a new set of (heterarchical) structures to replace hierarchies, and through those structures enable the successful, constructive, and productive functioning of the community it-self. Such protocols, then, must necessarily be made transparent to the community, by the community; they operate just as much by enforcing the community rules as they do simply by spelling them out and thus providing a means for each member of the community to be part of the overall communal process of policing their peers. This is what Bauwens describes as holoptism, as we have already seen: "whereas participants in hierarchical systems are subject to the panoptism of the select few who control the vast majority, in P2P systems, participants have access to holoptism, the ability for any participant to see the whole."[54]

Any attempts to develop better quality assurance mechanisms for the content cre-ated through produsage, then, and to involve a greater range of established experts in that process, must make sure to retain such holoptic protocols; this means that an in-

volvement of experts *as* experts, as participants in a category separate from the 'regular' community, is doomed to fail. Instead, what is necessary is to involve experts as the leaders of produsage communities, deriving their claim to be recognized as leaders not from their preexisting external accreditation as experts, but from their value to the community (for which their expertise should be an important determinant, of course). Embedded into the community on such terms, then, experts would be 'organic' members of the community rather than artificially introduced foreign bodies; they would derive their influence on the community just as much from the merits of this organic status of leadership as they would from any externally recognized expertise which they have to contribute.

As Rosenzweig notes for the case of his field of expertise and the *Wikipedia*, indeed, the more that produsage-driven projects become important components in the knowledge space of humanity, the more does an inherent need for experts to involve themselves in such projects arise:

> if *Wikipedia* is becoming the family encyclopedia for the twenty-first century, historians probably have a professional obligation to make it as good as possible. And if every member of the Organization of American Historians devoted just one day to improving the entries in her or his areas of expertise, it would not only significantly raise the quality of *Wikipedia*, it would also enhance popular historical literacy.[55]

Experts who refrain from participation in the key produsage projects in their fields, by contrast, in essence may be in a process of self-censoring themselves out of existence, leaving the field instead wide open for the rise of an alternative heterarchy of expertise and folksonomy of knowledge which may ultimately come to replace them altogether.

Indeed, for the case of *Wikipedia* and other produsage projects which are at this point predominantly led by amateurs and Pro-Ams without a strong direct involvement of the recognized, traditional knowledge institutions in their fields, this development would be only in keeping with developments in open source (and today to some extent also in citizen journalism), where experts of various backgrounds have already begun a much stronger involvement: "the free software movement is led and dominated by highly-qualified programmers, and ... the 'free encyclopedia movement' ... needs to move in that direction."[56] Here as well as there, however, they must continue to rule not by *fiat*, not by *a priori* rules, and not by reference to their status as experts outside of the produsage environment, but instead through the protocollary powers which the accepted heterarchical and meritocratic processes of the community itself have bestowed on them (and which they are able also to withdraw once again if the expert produsage leader violates the terms of that protocol).

Even if experts constitute a highly important resource in the further improvement of the processes and outcomes of produsage projects, then, it does not follow that they can be accorded special roles within the community other than by approval of the community itself, without breaking the processes of produsage itself. What is necessary

is for communities themselves to realize the need to respect expertise and devise the appropriate community protocols—and indeed, the debates within the *Wikipedia* and other spaces about the role of certified experts in a field are a sign of this process of protocol development in progress. Therefore, Kelly is right to note that

> a massive bottom-up effort will only take us part way—at least in human time. That's why it should be no surprise to anyone that over time more and more design, more and more control, more and more structure will be layered into the Wikipedia.[57]

However, this is right only if we also understand that the only group able to effect such layering of additional structure and protocols into the *Wikipedia* process are Wikipedians themselves; this cannot be done from the outside or through top-down decrees, by *Wikipedia* administrators acting without due consultation with the wider community, or by *Wikipedia* leader Jimmy Wales himself. *Mutatis mutandis*, the same applies just as well for other produsage projects.

The primary principle of such collaborative engagement between traditional experts and community produsers must be one of mutual respect, therefore, much as this is the core principle for engagement within the community itself, too. Further, then, the community may need to ensure that it privileges the input of experts into the core fields of knowledge, and that it encourages the contributions of experts further afield from such centers of the structures of knowledge, but also ensures that the contributions of community produsers are similarly recognized here. Beyond the development of content, information, and knowledge itself, too, the management of communities must involve both traditional experts and community produsers, and must not allow either group to have an inherent advantage over the other: "make the volunteer project *management* a meritocracy, and not based on longevity but based on the ability to lead and contribute to the project; that is the only condition under which very many of the best qualified people will want to participate."[58] However, such meritocracy must necessary always remain in flux, and cannot be allowed to ossify into a hierarchy determined by past glories, as the guidelines of the *Wikipedia* itself have already recognized: "if meritocracy is understood as a community where merits can be *accumulated* in a power status that afterwards is rendered *untouchable* whatever the quality of further contributions (or deletions), then Wikipedia is not a meritocracy."[59]

Layers of Knowledge, Lines of Desire

In combination, the structure of such a system is no longer simply a hierarchy or a heterarchy, no longer strictly organized along taxonomic or folksonomic lines; instead, it layers both the traditional expert accreditation system and the new model of community-based produsage on top of one another, and in the process harnesses the benefits of both. It provides a model which enables the creation, development,

maintenance, and extension of information, knowledge, and knowledge structures which extend from the central cores of established scientific disciplines to the far reaches of emerging informational fields and niche cultures, and connects these to one another to create a common but pluralistic, multiperspectival, and thus necessarily conflicted knowledge space. This model is by no means perfect, but may be the only solution to the pro/am problem available in the context of an explosion in information and knowledge; it is "a revolution of scale, not the erasure of tension between formality and informality. That boundary still exists, and will be just as sharp, if not sharper, as it will be negotiated between thousands, rather than a handful, of participants."[60]

Both the informal and formal camps have the potential to profit from their contribution to this shared project, too: while the proponents of community-based, folksonomic produsage approaches are able to thereby highlight the quality of their own efforts and to destabilize and deterritorialize some of the ossified knowledge structures of the establishment, the defenders of traditional systems of disciplinary knowledge and expert accreditation can utilize the efforts of produsage as a form of research aimed towards the development of more permanent disciplinary and taxonomic structures once again: representing the knowledge equivalent of 'desire lines,' "the footworn paths that appear in a landscape over time" which "demonstrate how a landscape's users choose to move, which is often not on the paved paths"[61], folksonomies help identify potential avenues for the further improvement, reconfiguration, and evolution of the taxonomies we still continue to live by.

The systems to effect this combination of hierarchical and heterarchical approaches, of taxonomic classification and folksonomic categorization, do not necessarily exist in any one single space in the network, of course. Instead, in keeping with the underlying principles of social software and Web 2.0, which have already served to significantly decentralize the human knowledge space, the overall project of layering diverse knowledges may require the combination of a range of tools. However, just as important as this compound technological basis is the harnessing of a wide range of contributing communities to ensure a wide and diverse representation of viewpoints.

This also points to the fact that for all the tendency to develop better aggregators of content, information, knowledge, and knowledge structures, no final unified system combining everything into one handy package will emerge—even in the age of *Google*. The idea of a collective intelligence emerging from the collection of human thought and knowledge now available through the electronic networks does not equate to what Lanier decries as "foolish collectivism"[62]; such a view would mistake the network itself for the communities which exists within and around its nodes and interconnections. "The beauty of the Internet is that it connects people. The value is in the other people. If we start to believe the Internet itself is an entity that has something to say, we're devaluing those people and making ourselves into idiots."[63] Indeed, as Jenkins notes,

the strength and weakness of a collective intelligence is that it is disorderly, undisciplined, and unruly. Just as knowledge gets called upon on an ad hoc basis, there are no fixed procedures for what you do with knowledge. Each participant applies their own rules, works the data through their own processes, some of which will be more convincing than others, but none of which are wrong at face value. Debates about the rules are part of the process.[64]

This, indeed, is much in keeping with Lévy's idea of the cosmopedia, which we have already encountered. The cosmopedia does not determine and prescribe the relationships between the knowledges it contains, nor the individuals who contribute to its development, maintenance, and evolution. Indeed, the cosmopedia is changed in the very process of using it;

> if we were to ask *who* implies the relations among utterances within the space of the cosmopedia, the answer would be the collective intellect itself, its navigations, the trail of its inscriptions, the footprints left on the plane of immanence of its knowledge. ... Once they plunge into the cosmopedia, space reorganizes around them, depending on their history, their interests, their questions, their previous utterances. They are surrounded by everything that concerns them, which arranges itself within their reach.[65]

There is no permanent structure, no fixed taxonomic arrangement in the cosmopedia, therefore; its structure is brought into being in the very act of using it, and structure as well as content of the cosmopedia remain themselves temporary artefacts of the ongoing global processes of produsage which take place in the many individual produsage environments contained within it. (For the moment, however, such processes remain strongly skewed towards those who have already begun to access and participate in the cosmopedia—and have the skills and capabilities to do so successfully; this will remain one of the core underlying problems in the further realization of the cosmopedic dream, and we will return to highlighting these issues of inequitable access to the tools and literacies of participation in later chapters.)

Further, each individual site of produsage, each element and tool in the produsage process, remains only part of the wider environment—or ecosystem—of the cosmopedia. As Johnson notes,

> interacting with emergent software is already more like growing a garden than driving a car or reading a book. In the near future, though, you'll be working alongside a million other gardeners. We will have more powerful personalisation tools than we ever thought possible—but those tools will be created by massive groups scattered all across the world.[66]

Such distributed, multifaceted efforts will necessarily create a more subjective, pluralistic, internally contradictory collection of information and knowledge than traditional models of knowledge production, but this is not in itself a negative of the produsage model. Indeed, the existence of a multitude of subjective, context-dependent, infinitely interpretable, unfinished, evolving representations of knowledge

may well offer the most appropriate approach to describing our complex world which we are able to imagine. As Lévy asks, "why would we want to adapt (adapt to what exactly?) once we realize that this reality is not present before us, outside us, pre-existent, but rather the transitory consequence of something we have constructed together?"[67] Ultimately, Kelly suggests, there is little that is truly new in this. Indeed, knowledge was never any *more* stable and taxonomically definable than it is today, but we were able to avoid confronting this fact as we had a less complete—or in fact, holoptic—view of it. Today,

> what's new is only this: never before have we been able to make systems with as much 'hive' in it [sic] as we have recently made with the Web. Until this era, technology was primarily all control, all design. Now it can be design and hive. In fact, this Web 2.0 business is chiefly the first step in exploring all the ways in which we can combine design and the hive in innumerable permutations.[68]

This, then, must necessarily impact on both our own representations of knowledge, and thus on our understanding of the world, as well as on the structures of community which help such new structures of knowledge come into existence.

This network-centric, 'hive' mindset, then, provides the basis for the emergence of collective intelligence, or what Pesce describes as 'hyperintelligence':

> each of us knows something that others do not: specific, peculiar and unquestionably important—to someone. One man's trivia is another's vital fact. Only now can we see the truth of this, now that when we can ... build up our own little cells of knowledge, individually, yet in unconscious concert with millions of others who have the same desire to share what they know. Individually the actions are innocent, and without direction; collectively they result in the biggest transformation in human knowledge since the birth of language a hundred thousand years ago. This is the emergence of "hyperintelligence," the collective creation of a billion individuals, amplifying the intelligence of each one of us.[69]

Like any process of emergence, of birth, we should not imagine that process to take place without its own complications, however; we are moving from the established, taxonomic, expert-driven paradigm into a new and uncharted territory.

> If it were simply a matter of crossing from one culture to another, we would have numerous examples to follow, historical landmarks. Rather, we are moving from one humanity to another, a humanity that not only remains obscure and indeterminate, but that we refuse to interrogate, that we are still unwilling to acknowledge.[70]

NOTES

1. Roy Rosenzweig, "Can History Be Open Source? Wikipedia and the Future of the Past," *Center for History and New Media: Essays*, 2006, http://chnm.gmu.edu/resources/essays/d/42 (accessed 28 Feb. 2007), n.p.

2. Jaron Lanier, "Digital Maoism: The Hazards of the New Online Collectivism," *Edge: The Third Culture* 183, 30 May 2006, http://www.edge.org/documents/archive/edge183.html (accessed 27 Feb. 2007), n.p.

3. Lawrence M. Sanger, "Is Wikipedia an Experiment in Anarchy?" *Wikimedia: Meta-Wiki*, 1 Nov. 2001, http://meta.wikimedia.org/wiki/Is_Wikipedia_an_experiment_in_anarchy (accessed 27 Feb. 2007), n.p. Note that in this section it is at times unavoidable to juxtapose earlier statements by Sanger acting as Wikipedia chief enthusiast with later statements from Sanger as Wikipedia critic and Citizendium founder. Both the date of publication and the tone of the statement will usually make it easy to distinguish one persona from the other.

4. Lawrence M. Sanger, "Britannica or Nupedia? The Future of Free Encyclopedias," *Kuro5hin: Technology and Culture, from the Trenches*, 25 July 2001, http://www.kuro5hin.org/ story/2001/7/25/103136/121 (accessed 28 Feb. 2007), n.p.

5. Lawrence M. Sanger, "The Early History of Nupedia and Wikipedia: A Memoir (Pt. 1)," *Slashdot: News for Nerds, Stuff That Matters*, 18 Apr. 2005, http://features.slashdot.org/article.pl?sid=05/04/18/164213 (accessed 27 Feb. 2007), n.p.

6. Lawrence M. Sanger, "The Early History of Nupedia and Wikipedia: A Memoir (Pt. 2)," *Slashdot: News for Nerds, Stuff That Matters*, 19 Apr. 2005, http://features.slashdot.org/article.pl?sid=05/04/19/1746205 (accessed 27 Feb. 2007), n.p.

7. Verifiability and No Original Research have evolved from an earlier, simpler rule of Attribution, indeed; see http://en.wikipedia.org/wiki/Wikipedia:Attribution.

8. Sanger, "The Early History of Nupedia and Wikipedia: A Memoir (Pt. 2)," n.p.

9. Lawrence M. Sanger, "Why Wikipedia Must Jettison Its Anti-Elitism," *Kuro5hin: Technology and Culture, from the Trenches*, 31 Dec. 2004, http://www.kuro5hin.org/story/2004/12/30/142458/25 (accessed 25 Feb. 2007), n.p.

10. Sanger, "The Early History of Nupedia and Wikipedia: A Memoir (Pt. 1)," n.p.

11. Sanger, "Britannica or Nupedia? The Future of Free Encyclopedias," n.p.

12. Sanger, "Why Wikipedia Must Jettison Its Anti-Elitism," n.p.

13. Mark Pesce, "Going into Syndication," *Hyperpeople: What Happens after We're All Connected?* 9 Feb. 2006, http://blog.futurestreetconsulting.com/?p=7 (accessed 23 Feb. 2007), n.p.

14. Sanger, "The Early History of Nupedia and Wikipedia: A Memoir (Pt. 2)," n.p.

15. Aaron Krowne, "The FUD-based Encyclopedia: Dismantling Fear, Uncertainty, and Doubt, Aimed at Wikipedia and Other Free Knowledge Resources," *Free Software Magazine* 2, 28 Mar. 2005, http://www.freesoftwaremagazine.com/articles/fud_based_encyclopedia/ (accessed 2 Mar. 2007), p. 1.

16. Mark Pesce, "Herding Cats," *Hyperpeople: What Happens after We're All Connected?* 20 Oct. 2006, http://blog.futurestreetconsulting.com/?p=21 (accessed 20 Feb. 2007), n.p.

17. danah boyd, "On a Vetted Wikipedia, Reflexivity and Investment in Quality (a.k.a. More Responses to Clay)," *Many 2 Many: A Group Weblog on Social Software*, 8 Jan. 2005,

http://many.corante.com/archives/2005/01/08/on_a_vetted_wikipedia_reflexivity_and_investment_in_quality_aka_more_responses_to_clay.php (accessed 25 Feb. 2007), n.p.

18. Sanger, "The Early History of Nupedia and Wikipedia: A Memoir (Pt. 2)," n.p.

19. Hassan Masum and Yi-Cheng Zhang, "Manifesto for the Reputation Society," *First Monday* 9.7 (July 2004), http://firstmonday.org/issues/issue9_7/masum/ (accessed 27 Feb. 2007), n.p.

20. Daniel H. Pink, "The Book Stops Here," *Wired* 13.3 (Mar. 2005), http://www.wired.com/wired/archive/13.03/wiki.html (accessed 26 Feb. 2007), n.p.

21. Henry Jenkins, *Convergence Culture: Where Old and New Media Collide* (New York: NYU Press, 2006), p. 54.

22. Pesce, "Herding Cats," n.p.

23. Pink, n.p.

24. Clay Shirky, "A Group Is Its Own Worst Enemy," *Clay Shirky's Writings about the Internet: Economics & Culture, Media & Community, Open Source*, 1 July 2003, http://shirky.com/writings/group_enemy.html (accessed 24 Feb. 2007), n.p.

25. Shirky, "A Group Is Its Own Worst Enemy," n.p.

26. Pierre Lévy, *Collective Intelligence: Mankind's Emerging World in Cyberspace*, trans. Robert Bononno (Cambridge, Mass.: Perseus, 1997), p. 17.

27. Stacy Schiff, "Know It All: Can Wikipedia Conquer Expertise?" *New Yorker*, 31 July 2006, http://www.newyorker.com/archive/2006/07/31/060731fa_fact (accessed 13 Mar. 2007), p. 4.

28. Pesce, "Herding Cats," n.p.

29. Charles Van Doren, "The Idea·of an Encyclopedia," *American Behavioral Scientist* 6.1 (1962), p. 24.

30. Van Doren, p. 25.

31. Heikki Heikkilä and Risto Kunelius, "Access, Dialogue, Deliberation: Experimenting with Three Concepts of Journalism Criticism," *The International Media and Democracy Project*, 17 July 2002, http://www.imdp.org/artman/publish/article_27.shtml (accessed 12 July 2007), n.p.

32. Van Doren, p. 24.

33. Heikkilä & Kunelius, n.p.

34. Clay Shirky, "Clay Shirky Explains Internet Evolution," *Slashdot*, 13 Mar. 2001, http://slashdot.org/article.pl?sid=01/03/13/1420210 (accessed 20 Feb. 2002), n.p.

35. Van Doren, p. 26.

36. Michel Bauwens, "Peer to Peer and Human Evolution," *Integral Visioning*, 15 June 2005, http://integralvisioning.org/article.php?story=p2ptheory1 (accessed 1 Mar. 2007), p. 1.

37. Bauwens in Richard Poynder, "P2P: A Blueprint for the Future?" *Open and Shut?* 3 Sep. 2006, http://poynder.blogspot.com/2006/09/p2p-blueprint-for-future.html (accessed 1 Mar. 2007), pt. 1.

38. Eric S. Raymond, "The Cathedral and the Bazaar," 2000, http://www.catb.org/~esr/writings/cathedral-bazaar/cathedral-bazaar/index.html (accessed 16 Mar. 2007), n.p.

39. Bauwens in Poynder, pt. 1.

40. Yochai Benkler, *The Wealth of Networks: How Social Production Transforms Markets and Freedom* (New Haven, Conn.: Yale University Press, 2006), p. 112.

41. Raymond, n.p.

42. Qtd. in Dirk Riehle, "How and Why Wikipedia Works: An Interview with Angela Beesley, Elisabeth Bauer, and Kizu Naoko," in *Proceedings of the International Symposium on Wikis (WikiSym)*, 21–23 Aug. 2006, Odense, Denmark, http://www.riehle.org/computer-science/research/2006/wikisym-2006-interview.pdf (accessed 12 July 2007), p. 7.

43. Jenkins, p. 255.

44. Scott A. Golder and Bernardo A. Huberman, "The Structure of Collaborative Tagging Systems," Information Dynamics Lab, HP Labs, 2005, http://arxiv.org/ftp/cs/papers/0508/0508082.pdf (accessed 21 Sep. 2007), p. 1.

45. Jenkins, p. 52.

46. Clay Shirky, "Folksonomies + Controlled Vocabularies," *Many 2 Many: A Group Weblog on Social Software*, 7 Jan. 2005, http://many.corante.com/archives/2005/01/07/folksonomies_controlled_vocabularies.php (accessed 28 Feb. 2007), n.p.

47. Pesce, "Going into Syndication," n.p.

48. Adam Mathes, "Folksonomies: Cooperative Classification and Communication through Shared Metadata," *Adammathes.com*, Dec. 2004, http://www.adammathes.com/academic/computer-mediated-communication/folksonomies.html (accessed 28 Feb. 2007), n.p.

49. Mark Pesce, "The Tags Within," *Hyperpeople: What Happens after We're All Connected?* 7 Oct. 2006, http://blog.futurestreetconsulting.com/?p=18 (accessed 23 Feb. 2007), n.p.

50. Lévy, pp. 114–115.

51. Kevin Kelly, "On 'Digital Maoism: The Hazards of the New Online Collectivism' by Jaron Lanier," *Edge: The Reality Club*, 2006, http://www.edge.org/discourse/digital_maoism.html (accessed 28 Feb. 2007), n.p.

52. Matt Locke, "A Taxonomy of Humour: What Nurses Can Teach Us about Classification," *Test*, 25 Feb. 2005, http://www.test.org.uk/archives/002370.html (accessed 27 Feb. 2007), n.p.

53. Bauwens, p. 3.

54. Bauwens, p. 1.

55. Rosenzweig, n.p.

56. Sanger, "The Early History of Nupedia and Wikipedia: A Memoir (Pt. 2)," n.p.

57. Kelly, n.p.

58. Sanger, "The Early History of Nupedia and Wikipedia: A Memoir (Pt. 2)," n.p.

59. Wikimedia, "Power Structure," *Wikimedia: Meta-Wiki*, 11 Dec. 2006, http://meta.wikimedia.org/wiki/Power_structure (accessed 28 Feb. 2007), n.p.

60. Locke, n.p.

61. Peter Merholz, "Metadata for the Masses," *Adaptive Path*, 19 Oct. 2004, http://www.adaptivepath.com/publications/essays/archives/000361.php (accessed 1 Mar. 2007), n.p.

62. Lanier, n.p.

63. Lanier, n.p.

64. Jenkins, p. 53.

65. Lévy, p. 219.

66. Stephen Johnson, *Emergence* (London: Penguin, 2001), p. 207.

67. Lévy, p. xxiii.

68. Kelly, n.p.

69. Mark Pesce, "Hyperintelligence," *Hyperpeople: What Happens after We're All Connected?* 2 June 2006, http://blog.futurestreetconsulting.com/?p=17 (accessed 23 Feb. 2007), n.p.

70. Lévy, p. xxiii.

The Art of Produsage:
Distributed Creativity

So far in this book, we have focused on the produsage of information and knowledge in its various forms: the produsage of information (informed by its produsers' knowledge) which can be operationalized in the form of open source software; the produsage of information about news and current events in citizen journalism, which leads to the emergence of new understandings and knowledge among its participant communities; the produsage of representations of knowledge in the spaces of the *Wikipedia*, engaged in the project of developing humanity's emerging cosmopedia; and the produsage of metadata, knowledge *about* knowledge, of knowledge structures for the cosmopedia, through distributed folksonomic efforts.

Throughout the following chapters, we examine the produsage of other forms of content. These are necessarily also informational; as we have seen, produsage provides a new paradigm emerging from the networked information economy in contrast to the production models of the industrial age, which have until now also been applied to the production of informational goods along industrial lines. These other forms of content are also necessarily representing knowledge, of course—the knowledge of their produsers and produsage communities. Nonetheless, what moves to the foreground in these cases of produsage is information and knowledge not for their own sake, but in the pursuit of other aims: of art and entertainment, of social interaction and engagement, of education, and of political participation.

We begin with what is perhaps only a small step beyond the realm of knowledge itself, beyond the produsage of knowledge representations in the *Wikipedia* and elsewhere, and the folksonomic ordering of such knowledge through the tools provided by sites such as *del.icio.us*, *Digg*, and *Reddit*—the collaborative produsage and distribution of creative work. The environments within which such creative produsage takes place will be familiar to many readers, as they have received a great deal of publicity and public participation in recent years; such environments include well-known sites such as the photosharing site *Flickr*, videosharing sites such as *YouTube* and its many imitators, music sharing sites such as *ccMixter*, and a wide network of creative writing

Websites which includes creative fiction blogs[1] as well as the many fan fiction communities. Beyond such stand-alone sites, the produsage and sharing of creative works also takes place within social networking sites such as *MySpace* and *Facebook*, which we examine with a view to their social uses separately in a later chapter.

Before we make any overly general pronouncements to claim that all that happens within these sites and other multi-user environments is necessarily produsage, however, it is important to point out a number of crucial distinctions. Many of the Websites mentioned here, and many others which have inspired or were inspired by them, are not necessarily inherently concerned with produsage; many of them are used for a variety of other purposes outside of practices which we have described here as produsage (and such practices are marked by the fact that the four key principles of produsage which we have encountered are not, or not all, observable in such cases). Much of what takes place on many of the sites which allow for the uploading, publication, and exchange of media content (text, images, music, video) and original creative work can be described simply as what *Trendwatching* has called 'life caching': these sites provide a convenient space for individuals to store their family photos and home videos, and to share them with friends and relatives. Such life caching describes activities of

> collecting, storing and displaying one's entire life, for private use, or for friends, family, even the entire world to peruse. The LIFE CACHING trend owes much to bloggers: ever since writing and publishing one's diary has become as easy as typing in *www.blogger.com*, millions of people have taken to digitally indexing their thoughts, rants and God knows what else; all online, disclosing the virtual caches of their daily lives, exciting or boring. Next came moblogging, connecting camera phones to online diaries, allowing not only for more visuals to be added to blogs, but also for real-time, on the go postings of experiences and events. And that's still just the beginning.[2]

However, blogs themselves, while still being able to be used as simple online versions of traditional personal diaries, have also moved considerably beyond any simple practice of life caching, of course; today, the various genres of blogging which have been established are indeed so diverse that the term 'blogging' itself has lost all meaning beyond describing a basic form of ordering the online publishing of information in reverse chronological order, and must for clarity necessarily be used in conjunction with modifiers which specify the particular *genre* of blogging that is of interest (personal blogging, news blogging, moblogging, fictional blogging, etc.).[3]

Beyond their use as a form of life caching, blogs also point us to the fact that they, as well as a number of environments for the online publication and sharing of creative work, are of course also fundamentally communicative tools—regardless of whether such communication follows a largely broadcast model (as, for example, practiced by bloggers using their sites as online soapboxes promoting their own political, social, or other ideas and ideologies), or whether it takes a largely conversational turn (in blogs, for example, the conduct of distributed discussions through interlinking between blog

sites and intensive commentary attached to blog posts). Outside of the largely textual media form of blogs, in which such communicative uses are perhaps most obvious to the casual observer, we can see such communication also for non-textual media: on sites such as *Flickr* and *YouTube*, for example, a great deal of broadcast and interpersonal communication is similarly conducted both through commentary and interaction attached to the photos and videos uploaded to such sites, as well as through uploading the media content itself.

In addition, the life caching of personal content and the communication through and around that content is itself an important development; as *Trendwatching* reminds us, it also holds significant business opportunities:

> consumers will come to expect that they can relive and share every experience they've ever had, and have instant access to any life collection they've ever built, giving them a bit of grip on lives that are filled with more content, experiences and data than ever before. And that spells Big Bucks for any marketer or company smart enough to provide consumers with the means to CACHE, if not resell THEIR LIVES.[4]

In themselves, such practices cannot necessarily be considered to be produsage *per se*, however—they lack the collaborative, communal aspects of content creation, exchange, and development which we have come to expect of produsage by now. Much as individual bookmarking on sites such as *del.icio.us* also contributes to the development of a shared resource which is of use to more than the contributor themselves, however, in being able to be collated under different criteria than intended by the original contributor, the personal memories cached on *Flickr* and elsewhere also inherently contribute to the development—the produsage—of a shared spatial memory, a collective repository of our visual knowledge of the world.[5] Partly in recognition of such potential uses beyond personal storage, then, *within* the wider communities of life caching and content exchange which can readily be found on these sites it is now also possible to identify the emergence of specific groups of users which do engage in the produsage proper of creative content.

Within such produser groups, content is exchanged not merely for its inherent personal or communicative value, but overtly as creative work to be showcased to and exchanged with other members of the community. Participants both comment on and critique one another's works; they collaborate on creative projects both by pooling together their individual contributions to form a composite whole, and by directly editing, rearranging, and remixing the material already provided by others; and in the process they in effect collaboratively curate an ever-expanding, constantly changing exhibition of the community's creative works. From such practices also emerge heterarchical structures of recognition and merit within the community, and while initially perhaps thought of as life caching sites, the environments for such creative produsage are therefore "enabling GENERATION C to become a generation of true storytellers,

helping them to visually and compellingly share their experiences ... , which makes them stand out and feel special."[6]

Trendwatching identifies two main drivers for such trends:

> (1) The creative urges each consumer undeniably possesses. We're all artists, but until now we neither had the guts nor the means to go all out. (2) The manufacturers of content-creating tools, who relentlessly push us to unleash that creativity, using—of course—their ever cheaper, ever more powerful gadgets and gizmos. Instead of asking consumers to watch, to listen, to play, to passively consume, the race is on to get them to create, to produce, and to participate.[7]

Indeed, creative produsage practices are intimately connected (but in reality both inspire *and* are inspired by) recent industry campaigns exhorting the buyers of consumer electronics products and software to 'rip, mix, burn' or to 'create something' (a modern echo of earlier campaigns encouraging hi-fi enthusiasts to become audiophile 'prosumers'); while some forms of creative produsage significantly predate such industry efforts to harness them, these campaigns nonetheless have contributed substantially to the mainstreaming of creative produsage practices.

Whether users are directly collaborating in the creation of collective works of art, or collaborating somewhat more distantly in the sharing and mutual critiquing of individual work and its collection and exhibition in creative communities, we can generally describe such practices as forms of distributed creative work. The shift to the broader recognition and exercise of individual and collective creativity has the potential to have significant effects on our overall understanding of creativity; as Jenkins notes for practices of collaborative writing and textual exchange, for example, it may "result in a demystification of the creative process, a growing recognition of the communal dimensions of expression, as writing takes on more aspects of traditional folk practice."[8]

This, then, is a wider effect well beyond the question of whether all such work is necessarily creatively 'valuable' according to conventional critical views. As *Trendwatching* puts it unequivocally, "GENERATION C ... will continue to create heaps and heaps of crap which, at best, will be appreciated only by inner-circle friends and family"[9], but that is not the point; all creative artists, indeed, will be able to point to substandard works in their *oeuvre*. We have seen much the same in other forms of produsage as well, of course: not all the contributions made by all produsers in the community are likely to be of uniform, high value to the shared underlying project. Much like such forms of produsage, however, creative produsage, too, enables the embrace of a probabilistic approach: the larger the numbers of contributors involved in the collaborative creation of art and creative work, the higher the likelihood that from it will emerge works of genuine artistic value (however such value may be defined by the individual observer); what is significant about creative produsage as much as about

other forms of produsage, in other words, is that it embraces the equipotentiality of each participant to become an artist in their own right.

The term of the artist, especially in the romantic idea of the 'great artist,' however, also points us to the wider effect of the collaborative aspects of produsage in this and other cases: artistry and creative work, and the idea of *the* creative work, are substantially affected by community-based produsage efforts, as these undermine the idea of the work itself as a complete, finished, and defined entity just as they undermine the idea of the industrial product as a complete, finished, and defined package. Produsage, as we have seen, has no fixed products, but only temporary artefacts of the ongoing process; creative produsage, then, does not generate artworks, not even artworks 'in progress,' but instead offers a creative process which may generate temporary artefacts along the way (in this case embodying the literal meaning of 'artefact' as *arte factum*, 'made by art,' that is, generated through artistic processes). Lévy describes this move from work to artefact—to what he describes as 'the art of implication'—as a natural next step beyond the 'open work,' the work remaining open to interpretation, which has been a common feature of contemporary, postmodern art, but which has generally remained very clearly associated with its creator (as indicated by the artist's signature):

> clearly the 'open work' prefigures such an arrangement. But it remains trapped in the hermeneutic paradigm. ... The art of implication doesn't constitute a work of art at all, even one that is open or indefinite. It brings forth a process, attempts to open a career to autonomous lives, provides an introduction to the growth and habitation of a world. It places us within a creative cycle, a living environment of which we are always already the coauthors. Work in progress? The accent has now shifted from work to progress. Its embodiment is manifested in moments, places, collective dynamics, but no longer in individuals. It is an art without a signature.[10]

At the same time, this does not imply or suggest that all art of the future will consist of such artefacts, that the artwork in a traditional sense will somehow vanish altogether—such claims would be no more true here than they are in other areas of collaborative content creation in which the rise of produsage has significantly affected, but has not entirely destroyed traditional forms of production. There *will* be a redistribution of effort, no doubt, and artworks and artefacts will increasingly come to coexist beside one another, but the artistic 'product' is not going to disappear any more than it has disappeared elsewhere. Indeed, contrary to other fields, where traditional production processes are often seen as providing only a limited feedback loop between producers and customers, in art the traditional paradigm of individual artistic creation (or, put more prosaically, production) with its limited opportunity for 'user' involvement is not necessarily to be seen as a shortcoming: the ability for individual artists to operate without a constant monitoring of and pandering to their 'market' provides the freedom necessary for individual artistic exploration, of course. As Rushkoff points out,

not all creative work can be collectivized through produsage: "the collective is nowhere near being able to compose a symphony or write a novel—media whose very purpose is to explode the boundaries between the individual creator and his [sic] audience."[11]

Sites of Creative Produsage

Such potential tensions between individual artistic vision and collective content creation, and approaches to their resolution, are evident from a number of key examples for collaborative creative work which we may explore. These operate across a number of media forms from text through sound to still and motion images, and each highlight different aspects of and models for collaborative creativity. Many more central sites and distributed networks of creative activity exist, of course, and together form the wider network of distributed creative produsage engaged together in a kind of 'vernacular creativity,' as Burgess has described it[12]; the examples cited here, then, serve only as useful pointers for a wider exploration of such creative practices as they emerge to greater public recognition.

Text: Universes of Fan Fiction

We begin our overview with the field of textual creativity—a form of collaborative creativity which (partly because of the comparative ease of sharing texts even through earlier electronic communication networks, as well as through the exchange of printed materials, as compared to more resource-heavy sound and image files) can already look back on a long history, and has been comparatively well-researched. Among the key examples commonly cited in this context are fan fiction communities in general, and the writers of what has become as 'slash fiction' in particular: communities which add to the existing textual universes of popular print, television, and movie culture by adding their own stories that are internally consistent with the fictional universe within which they operate (and which, in the case of slash fiction, focus particularly on the romantic and sexual encounters between established characters).[13]

The communities sustaining such fan fiction provide in the first place simply the sense of community itself: an environment in which the individual writers of fan fiction can share their own works and receive feedback from fellow enthusiasts. Translated to fiction, this is not unlike the community engagement we have encountered in the context of citizen journalism, perhaps, where individual discussion contributions attempting to interpret news and current events are similarly based within the established universe of facts pertaining to the specific news story, and from this basis offer a more or less novel contribution to interpreting the wider causes, implications or repercussions of the event. Similar to citizen journalism, too, the communities of fan fiction will provide direct feedback to their contributors, thereby communally evaluat-

ing both the inherent qualities of a story itself (from expression and style to characterization and plot), as well as its plausibility within the overall fictional universe.

In addition to providing such environments for the exchange, collection, and communal evaluation of individually produced content, however, a number of fan fiction sites and communities have also begun to move further beyond individual authorship: they offer the means, for example, of presenting fictional works-in-progress for communal evaluation, and even for directly collaborative authoring projects. Jenkins, for example, points to the 'beta-reading' model of *Sugar Quill*, a major *Harry Potter* fan fiction Website, as a form of collaborative story development which is directly modeled on the beta-testing practices common especially in open source software development; here, authors are able to upload their story drafts so that other members of the community are able to provide direct and detailed critical feedback about the achievements and shortcomings of their work.[14] In other cases, authors may directly seek out collaborators, and thus collaborate not only indirectly by improving their work based on feedback received but also by sharing the work of writing the story itself.

Fan fiction is not an entirely unproblematic field, however, as by definition the initial fictional environment for fan fiction (in open source terms, the 'itch' which the writers of fan fiction scratch through their practice) is provided usually by traditional copyright industries rather than by the communities—or individuals within the community—themselves. Although it would certainly be possible for a community of authors to develop a new and consistent fictional universe from nothing, and to invite fan fiction authors to help populate that universe, few examples for such activities exist at present; this is hardly surprising, perhaps, if we keep in mind that the very motivation for becoming involved in fan fiction activities is usually the participant's established role as a *fan* of the original story, which in turn is driven substantially by the story's presence in the mainstream media.

Fan fiction activities usually provide a collaborative and collective extension of existing copyright properties, and in doing so have repeatedly come into conflict with the commercial holders of such properties; perhaps unsurprisingly, this has been a particular problem especially for slash fiction communities, whose frequently strongly erotic (and in many cases, homoerotic) stories are seen by some corporations as having the potential to negatively affect the status of the original copyright property as 'family entertainment'. At the same time, however, a heavy-handed and generic enforcement of existing copyright to the detriment of fan fiction communities has also proven to generate strong negative effects for the commercial copyright holders themselves; fan fiction communities, after all, are above all also strong *fan* communities, and it is generally counterproductive for the fiction franchise to alienate such key audiences.

Jenkins points out that what emerges from cases of copyright enforcement against fan fiction communities, which pose no immediate commercial threat to the copyright holders themselves and in fact help promote fan involvement in the fictional universe,

is perhaps a need for better protection of such amateur activities; indeed, he notes, under U.S. law parodies and satires of the fictional universe (which may be more inherently detrimental to the copyright franchise) are better protected than generally benign fan activities.

> Current copyright law simply doesn't have a category for dealing with amateur creative expression. ... Our current notion of fair use is an artifact of an era when few people had access to the marketplace of ideas, and those who did fell into certain professional classes. It surely demands close reconsideration as we develop technologies that broaden who may produce and circulate cultural materials.[15]

However, at the same time, it is also worth remembering that (as we have seen throughout this book) the line between amateur and professional work is an increasingly less obviously visible one; the development of copyright protections for 'amateur' activities could therefore be seen as reintroducing a strict pro/am division and may indeed be a backward step. What emerges from our discussion of produsage is instead the observation of a need for both 'professionals' and 'amateurs' to provide the means for an easier movement between both positions; copyright industries, thus, would be well-advised to harness fan fiction communities as a form of collaborative research into potential storylines and character developments. On the other hand, of course, this, too, raises further questions, especially relating to the morality and legality of commercially exploiting communities of open, collaborative, voluntary, and noncommercial produsage.

Images: *Flickr* and Collaborative Curation

The collaborative aspects of fan fiction produsage have also been translated into a number of non-textual environments. Perhaps the most prominent such environment at the present moment is the photosharing Website *Flickr*, now operated under the auspices of Yahoo! Beyond the forms of life caching and other photo storage activities which we have already discussed, *Flickr* is also home to an increasingly active range of communities engaging in produsage proper, and indeed showcases through its tools and services especially the communal and collaborative aspects of produsage. *Flickr* provides a range of means for setting up groups and communities of users, and collecting images on the site into photographic 'pools'; this has given rise in the first place to groups which collect and comment on photos defined by certain common characteristics (ranging from specific subject matter to geographic commonalities shared by photos or photographers, as well as to particular photographic and other techniques employed in creating the works).

Beyond such sharing and commenting, which can already be described as a form of produsage similar to the textual produsage in the *Harry Potter* fan fiction community and elsewhere, *Flickr*—in concert with now standard image editing tools and soft-

ware—also provides a space for communities engaged in the active co-creation of content, however: groups such as the aptly named 'remix' community on *Flickr*, for example, engage in the mutual reediting and remixing of one another's content, as contributed by members of the group. (Especially in such practices, of course, it also becomes evident that *Flickr* is in reality a space for sharing any form of still image, not only of conventional photography.) What is created in the process (and in similar processes in music- and video-related sites and communities we will encounter later) are what are now commonly known as 'mashups': composite, multiply layered, and repeatedly reedited artworks which in themselves remain also temporary artefacts of an ongoing creative process as they serve themselves again as input into further creative activity within the group. This represents an artistic approximation of the palimpsestic content creation models which we have already identified as common to produsage projects: here, again, content turns away from fixed, finished products, and instead comes to be seen as always unfinished, continuously evolving.

That observation, however, applies not only for individual pieces of content: it applies also for the collaboratively compiled 'photostreams' emerging from such groups. In such streams, we can see collaborative community efforts to curate its content; they represent, therefore, the produsage-based creation not only of content, but also of the metadata structuring such content. At the same time, of course, that same content also remains open for integration into other groups and contexts on the same site (and elsewhere); here as well as in other environments of produsage, therefore, the structuration of information remains incomplete and open to contestation, and the specific features of the site (which indicate, for example, the various groups and communities in which both individuals and their content participate) make such multiple interpretations and contextualizations transparent to all users. Overall, this marks *Flickr* as a large-scale, pluralistic, stigmergic environment as defined by Elliott:

> the interdependence of collaborative loci, drafted by a large number of people and mediated by the encoding of a local environment, is what gives stigmergic collaboration one of its most distinguishing features and sets it apart from traditional co-authorship: a coherent collaborative domain emerging from the interrelated, implicitly coordinated efforts of many individuals and groups of contributors.[16]

In addition to such multiple produsage-based uses for the material gathered on *Flickr* itself, we can also identify the emergence of further collaboratively produced environments for creative content on this site and in other photosharing environments: indeed, a very large number of '*Flickr* mashups' have now emerged which either build on manual curation work or on the technological interfaces to *Flickr* content as made publicly available through the site's Application Programming Interface (API). Such automated *Flickr* mashups place its images on the mapping services provided by Google and Yahoo!, for example, shrink and tile a large number of images according to their average color value to create from this a further, pixelated image, or otherwise

remix and composite available *Flickr* content according to a range of criteria and approaches.

A further example for the manual collaborative curation of shared photos (though not conducted through *Flickr* itself), can be found in the collaboratively developed *JPG Magazine*. This photographic site operates its own (significantly smaller-scale) photosharing site aimed specifically at the community of experienced photo artists: it provides them with the space to upload their work and collaboratively evaluate and curate each other's contributions. This results in the publication of a quality bimonthly magazine in both online and print versions which contains both the best photos as determined and arranged by the community itself, as well as self-help information and other inspirational ideas gathered by the community. (In the process, *JPG Magazine* also demonstrates that it *is* possible for produsage artefacts to be harvested to generate traditional-style products, of course—but it might be argued that what is prodused here in the first place is in fact the community of creators and curators of photographic art itself, a process from which the magazine itself emerges only as a secondary outcome.)

Music: Asynchronous Collaboration on *ccMixter*

In contrast to the well-known *Flickr* site and the flotilla of smaller projects (in part building on the *Flickr* API) which have emerged around it, collaborative produsage in the area of music and sound remains somewhat less well recognized. This is due in good part to the continuing disputes surrounding digital and online music and the heavy-handed efforts of the commercial music industry in pursuing what it regards as copyright 'piracy'. The most prominent legal music sharing sites, therefore, exist explicitly outside of the commercial realm; chief among these in the context of our discussion of produsage, perhaps, is *ccMixter*, a site developed and operated by the Creative Commons organization: here, all material uploaded and shared to the site is governed by Creative Commons licenses, an alternative to traditional copyright licenses which specifically allows the sharing, reuse, and remixing of content. On that basis, *ccMixter* encourages its participants to upload their own musical works, and music so uploaded is then made freely available to other members of the site to download, use, and further mash up and remix.

This has led to the emergence of a large number of distributed, asynchronous, artistic collaborations, for example involving individual artists uploading solo performances on their instrument of choice which are then gradually layered with other instrumental and vocal performances, sound effects, and other editing and remixing interventions by other contributors to the site. Such composite tracks therefore once again resemble palimpsestic texts, and often approach professional production and performance quality; in being available from the site they also remain permanently open to further remixing, of course, so that any one version of a track in reality consti-

tutes only a temporary artefact of a continuing process of artistic development involving a community of participants which is distributed in both space and time. This mode of creation and development can be seen as a direct equivalent to the creation of encyclopedic entries in the *Wikipedia*, or of software through open source processes, therefore; like the edit history functionality of *Wikipedia* or the concurrent versioning systems of open source, too, *ccMixter* provides the means of tracking the development history of each musical work, and the availability of each intermediary revision even offers the opportunity of a forking of creative developments into a variety of artistic directions.

ccMixter's direct relation with the Creative Commons organization and its licensing frameworks is as necessary in the field of musical produsage as the embrace of GNU, open source, or Creative Commons licenses is for open source software development and *Wikipedia* editing, of course; the traditional copyright system is poorly compatible with massively distributed, collaborative, and open-ended approaches to content creation (and we further explore this problem in Chapter 10). However, in the field of music, the question of copyright becomes particularly crucial, not only because it has been so heavily highlighted by the incumbent industry itself: in addition to such influences, it is also important to note that the remixing of existing musical themes and recordings has been a mainstay of music at least since the arrival of hip hop and other sampling-based creative forms some twenty years ago; beyond this, however, many music and music industry scholars have also pointed out that the remixing of existing cultural forms in the process of exploring new artistic possibilities has been a fundamental practice of musicians in commercial and non-commercial environments at least for the past century. The development of the blues, for example, was based in part on the harnessing of African and English folk song, and this musical form itself became the basis for genres such as jazz and rock'n'roll; rock'n'roll, in turn, split into a variety of further forms as diverse as beat music, country and western, funk, punk, and rap. Music, and the artistic process more generally, is based on a continuing process of building on—sometimes very explicitly, through direct citation—and expanding on existing cultural texts, therefore, and any attempt to lock down this process through the enforcement of copyright must necessarily produce significant chilling effects on cultural developments. In the context of music, in particular, *ccMixter* remains one of a very small number of environments which allow for a legally sanctioned open experimentation with and extension of other musicians' work in the way that open source or *Wikipedia* allow for the open experimentation with and extension of other contributors' program code or representations of knowledge; for musical development, therefore, it plays a crucial role that should not be underestimated. (Other alternatives to *ccMixter* do exist, but have been forced underground where they operate entirely outside of current copyright frameworks.)

Video: Mashups on *YouTube*

Copyright is also a persistent complication in the context of the final example for media sharing and produsage which we examine here: videosharing, as conducted through the current market leader *YouTube* and a variety of alternative options including *Revver*, *JumpCut*, and *Blip.tv*. As with the photosharing site *Flickr*, it is important to point out again that not all uses of such sites fall under our definition of produsage; they are also used simply for a form of life caching (such as the sharing of family videos with distant relatives) or the more or less illegal distribution of video clips captured from television and other video sources. However, in addition to such uses, here, too, we can observe the emergence of produsage communities which—much in keeping with similar communities on *Flickr* and elsewhere—share, comment on, communally evaluate, mash up, and remix one another's content; indeed, at least *JumpCut* explicitly provides a variety of means for its participants to do so on-site, on the fly, as well as offering the tools to identify and incorporate additional content from sites such as *Flickr*.

Similar in some ways to a combination of fan fiction communities and sample-based musical genres, some of the groups existing on such sites also specifically set out to remix existing mainstream media content; prominent recent examples for such activities include a variety of satirical videos setting footage of U.S. President George W. Bush and former U.K. Prime Minister Tony Blair to the music of saccharine love songs to critique their close political collaboration in the military 'Coalition of the Willing,' or the editing of footage from television drama and motion pictures for comical effect. (Indeed, comedian Stephen Colbert has directly played into such phenomena by providing instantly remixable footage of himself to such communities through segments on his *Colbert Report* television show, issuing a 'remix challenge'.)

Increasingly, such remixing activities may be seen as fulfilling an important cultural and political role; the political aspects of such activities especially may be seen as compatible with the political role also played by citizen journalism, as the satirical mashup of news media content similarly serves to expose and correct what participants perceive as shortcomings and bias in the commercial media. In addition, the less inherently political activities of mashup artists also provide an opportunity for the experimentation with new artistic forms, much as the emergence of sampling technology provided an opportunity for new musical genres to be explored and developed.

Such cultural and political intentions are also at the core of the development of a further videosharing site, *Current.tv*, a project chaired by former U.S. Vice President Al Gore that aims to 'democratize the media'. Contrary to videosharing sites which focus on the sharing and remixing of existing content, however, *Current.tv* is built around the sharing of original video content created by its participants, and for such contributors provides a space to exhibit their work to and receive feedback from the wider community. Much like a variety of other produsage environments, especially in citizen

journalism, *Current.tv* also provides tools for the explicit communal evaluation and rating of content, including a system of 'greenlighting' videos—its particular innovation in this context is that the most frequently greenlighted videos are ultimately selected for broadcast through the U.S. and U.K. cable television channels operated by *Current.tv*. This constitutes a form of harnessing and harvesting produser creativity for further exhibition, similar to the *JPG Magazine* model; though by definition time-based and ephemeral, these external outcomes from the produsage process could therefore be likened to the 'stable' versions of open source software.

Again, of course, such models crucially depend on the existence of communities which rate and thereby curate the selection of artistic works presented through such channels; this is in line with our overall observation of communal evaluation systems in produsage, and the potential for merit-based heterarchies of participants to emerge from such community activity. While the *Current.tv* television channels themselves necessarily represent a singular compilation of available content, it is also important to point out that on the Website itself, a variety of further options for the exploration of *Current.tv* content exist; the metadata created by the community of produser-curators on the site is therefore by no means expressed as—pressed into—a unified hierarchical structure, but remains pluralistic and multiperspectival.

Distributed Multimedia Creativity: *OurMedia* and Beyond

Finally, beyond the collaborative content sharing, evaluation, and remixing sites existing within any one media form which we have explored here, it is also worth pointing out that a growing trend towards the interconnection and intermingling of multiple such media forms can also be observed. An interesting development in this field is *OurMedia*, a site which provides the tools for its users to share texts, photos, music, *and* videos, or for what the site summarizes as 'grassroots creativity'; the site is unlikely to remain the only project to attempt the integration of such multiple media forms, but places a special emphasis on the harnessing of such produser creativity in pursuit of greater citizen involvement in all aspects of media and communication (indeed, the project is led by prominent citizen journalism advocate J.D. Lasica). *OurMedia* thus provides a further indication of the gradual recognition of remix and mashup practices as an important cultural trend of the early twenty-first century—a trend which points to the important observation that culture consists of more than simply 'original' texts created by individual authors, and that in fact even such texts are always already based on the totality of cultural forms and works within whose context they have emerged.

Indeed, what sites such as *OurMedia* (as well as the many single-medium creative produsage environments we have explored here) point towards is the fact that cultural artefacts *are* indeed simply artefacts of the continuing processes of culture from which they have emerged; that culture (or perhaps more appropriately, cultures and subcul-

tures) is itself a collaborative process that is not at all unlike the process of produsage as we have encountered it in our journey so far. What produsage-based approaches to collaborative creativity contribute, therefore, is not a fundamental change to cultural processes themselves, but simply a return to a greater citizen involvement in the continuing processes of culture—an involvement deterred and disrupted by the increasing industrialization, corporatization, and (through copyright) enclosure of culture as conducted in and through the media industries. A greater focus on produsage rather than production of culture and its artefacts, then, offers the potential for a further re-democratization of culture, or the re-culturization of media industry content production processes through greater citizen involvement. This necessarily also involves a further move not to collective (in the sense of unified and globally orchestrated), but to collaborative processes of creativity (involving a vast range of diverse communities acting for themselves or in coordinated or competitive engagement with one another). As Benkler points out, already

> one of the phenomena we are beginning to observe on the Internet is an emerging culture of conversation about culture, which is both self-conscious and informed by linking or quoting from specific reference points. ... The basic tools enabled by the Internet—cutting, pasting, rendering, annotating, and commenting—make active utilization and conscious discussion of cultural symbols and artifacts easier to create, sustain, and read more generally.[17]

Such developments are only set to increase and intensify in the current context.

Overall, the various forms of collaborative creative action which we have observed in the examples discussed here clearly point to the operation of the key produsage principles in these creative domains. Each of the sites we have encountered is based on the **open participation** of a diverse range of contributors, and provides the means for the **communal evaluation** of contributed content according to a variety of criteria; in the process, these communities also generate metadata which can be used for a folksonomic ordering of the content, and even for the channeling of such content into conventional, 'stable' products. In addition, the communal evaluation allows for the emergence of community leaders and valued contributors, and therefore for a **fluid heterarchy** of content and participants; governance remains generally *ad hoc,* **based on contributor merit,** and determined by the community itself (for example in the development of beta-reading processes within the fan fiction community), but is affected also to some extent by the fundamental technological features of the sites themselves, or the legal frameworks under which they operate (requiring communities to police against breaches of applicable copyright laws, for example). The outcomes of the produsage process in these environments may be able to be used as conventional cultural products, but in most cases remain temporary, **unfinished artefacts** open for further remix and mashup; this is the case both for individual pieces of creative content as well as for the communally curated collections of material in which they are

included—content as well as content structures **continue to evolve** on a perpetual basis. Finally, the collaborative work taking place in such sites must necessarily rely on licenses which designate all content as **communal property** (and indeed, where such licenses are not utilized, the sites leave themselves open for attacks from the copyright industries); on sites which are also able to be used for life caching and other non-produsage purposes, the participant's act of applying a creative commons or other open content license to the content they have uploaded can in fact be seen as a conscious step towards joining the community of producers which exists on the site: it is a statement that the content is both ready and intended to be remixed by the wider community. From such active declarations of participation, and from the quality of content they have provided to the overall creative produsage process, participants are also able to generate **individual rewards** and social standing within the produser community; as *Trendwatching* observes, therefore,

> especially for younger consumers, participation is the new consumption. For these creatives, status comes from finding an appreciative audience (in much the same way as brands operate). No wonder that it's becoming increasingly important to hone one's creative skills. Status symbols, make way for STATUS SKILLS?[18]

Ultimately, we may see the emergence or re-emergence of such produsage-based approaches to creativity simply as returning the process of creative work to what it used to be before the establishment of powerful creative and media industries. This does not mean that such industries will disappear, of course; however, it does mean that their *modus operandi* is no longer the only option for creative practitioners, and that more distributed forms of creative engagement and collaboration are open especially also for those participants who by themselves may not (or not yet) have the skills and confidence to attempt larger-scale creative works. Creative produsage, as examples ranging from collaborative fan fiction development through collective curation of *Flickr* content and multilayered musical works on *ccMixter* to the creative mashup of video content on *YouTube* and *OurMedia* demonstrate, has reintroduced a greater level of equipotentiality and granularity into the creative process, and therefore enables even those whose ability or commitment allows for no *greater* levels of involvement to *be* involved in the creative process in the first place.

Needless to say, such involvement is not guaranteed to generate quality outcomes, any more than the traditional creative production process guarantees quality content; creative produsage like other forms of produsage takes a probabilistic approach to produsage which assumes that the greater the public involvement in creative work, the more likely the emergence of quality outcomes will be. In addition, it is also interesting to observe that the introduction of incentives for creative participation in a number of current sites for the collaborative sharing and evaluation of content has had a direct and not necessarily positive effect on their contents. A number of videosharing sites, for example, have introduced revenue models generally based on the popularity

of the materials uploaded by contributors: some such sites automatically embed commercial advertising directly into the videos they host, or place advertising content on their pages immediately alongside the video content; this allows them to attract contributors with a promise that users whose content turns out to be highly popular will be able to receive a proportion of the advertising revenues generated by such schemes.

On a number of sites, however, this model has had a directly and markedly negative impact on the quality of content, as the creators of video content now begin to operate under much the same assumptions as do mainstream television channels and begin to cater to the lowest common denominator in order to attract the largest possible audience. Sites such as *Revver* and *MetaCafe*, both of which have implemented revenue sharing models, can be seen to suffer from such mass media effects; another video- and photosharing site, *Break.com*, was indeed created specifically to harness them, and markets itself as offering 'free pictures, video, and comedy for guys' (at the time of writing, popular video uploads included footage of a Molotov cocktail attack on an armored vehicle in Iraq, a 'hot' Norwegian ice skater's fall during a live TV broadcast, and various student pranks). At the same time, however, incentives such as the possibility of seeing one's content featured on the *Current.tv* cable television channel, published in *JPG Magazine*, or otherwise featured on and beyond a site itself may also significantly encourage constructive participation—what such observations point towards is that quality and style of content on any one such site is likely to be dependent on a combination of incentive models and community ethos; monetary incentives on media democracy sites such as *Current.tv* or *OurMedia* would be likely to have vastly different effects than they do on *MetaCafe* or *Break.com*, for example.

In this context, the level of balance between community and monetary (or other) incentives is perhaps also significant, as is the order in which such incentives are introduced. *Current.tv*, for example, by now has developed a highly active and engaged community that by and large is likely to share the common goal of developing a grassroots alternative to the content of conventional television channels (regardless of whether its content is made available through the *Current.tv* channel itself, or over the Website); the introduction of monetary rewards for high-quality content may shift, but would be unlikely to undermine this overall ethos of the community. *ccMixter*'s community is similarly united in its embrace of sharing, reusing, and remixing musical content in the exploration of new creative opportunities; any harnessing of its content for example by offering recording contracts to the best-respected community members would not necessarily substantially affect community interaction as such (unless such contracts had the effect of excluding such contributors and their content from the continuing processes of creative collaboration on the site). For sites such as *MetaCafe* and *Break.com*, however, their offer of revenue sharing provides the core distinguishing feature from market leader *YouTube*, and most likely predates the development of a significant on-site community; indeed, the shape of the community which has formed around such sites by now is significantly affected by this factor—the financial aspect of

participation balances and most likely outweighs any more inherently communal aspects. Where the *YouTube* community has formed around its members' common interest in videosharing, the *Break.com* community has formed around an interest in videosharing *for potential profit*—this is a subtle but important difference.

Whether for financial or communal reasons, at any rate, and whether for the inherent artistic qualities of their content or for the cultural affinity of such content with the target audience gathered at specific sites, such creative produsage environments do allow for the emergence of new creative leaders from within the community, at least for the short term; as *Trendwatching* puts it,

> not much has changed since Warhol's 15 minutes of fame. Most people still entertain the thought of being a celebrity, even a minor one. What has changed though, is that the implied waiting-time to get one's precious (and short lived) celebrity moment is over: members of GENERATION C can produce, display and then distribute to millions their own images, their creations, their 'content'.[19]

Indeed, for some of them an opportunity to enter the media industry may also present itself; increasingly, the activities of the grassroots of creativity are being watched closely by an industry constantly on the lookout for new talent and new ideas. For some of the leading lights of creative produsage, then, "their stories, their observations, their articles, their pictures, their songs, and their books are noticed and bought by niche audiences, as well as (increasingly) by mass-media moguls eager for real-time, original content."[20] Such potential for the development of more traditional careers from involvement in emerging creative produsage communities may itself also act as a further incentive to participation, of course; in this, creative produsage is no different from other fields of produsage, as we have seen for example in the case of open source software developers moving from voluntary involvement in development communities to paid employment in open *or* closed source software and service companies.

The Produsage of Creative Distribution Systems

Beyond the models for produsage-based distributed creativity which we have encountered so far, and which rely largely on centralized spaces for the distribution of their outcomes to users, it is important also to look at another meaning of 'distributed creativity': the distribution of creative works through what we may similarly identify as produsage-based processes. This form of distributed creativity, in other words, is concerned less with the creation of works themselves, but with the creation, operation, and maintenance of the means for distributing creative works regardless of how, under what models, and by whom such works themselves were created. What we focus on here, then, are the communicative aspects of cultural participation—the perhaps fun-

damental, innate human tendency to share what interests, excites, and entertains us. As Litman puts it for the networks of modern communication overall, indeed,

> the most powerful engine driving this information space turns out not to be money—at least if we're focusing on generating and disseminating the content rather than constructing the hardware that it moves through. What seems to be driving the explosive growth in this information space is that people like to look things up, and they want to share.[21]

It is today virtually impossible to escape this conclusion that sharing is a fundamental trait of humanity, indeed; the Web itself and its overwhelming array of freely available informational sources, many provided voluntarily by enthusiasts across virtually all fields of human knowledge, speak powerfully in its support, and the practices and processes of produsage only serve to provide particularly fertile grounds and effective means for such sharing. More specifically, however, the past decade has also seen the development of ever more effective means of distributing audio and video content at a time when the offering and download of such content through Websites was both technically impracticable and legally prohibited (as it continues to be for much copyrighted content, of course). In direct response to such limitations, enthusiast communities have developed the technological, social, and cultural conventions of filesharing—to the point that today, "do-it-yourself file sharing, through Napster and its offspring, Kazaa and others, has created a peer-to-peer Pro-Am distribution system."[22]

The development of filesharing can be described as the produsage of distribution systems. It should be pointed out in this context that such descriptions are not intended to whitewash filesharing practices of their association with copyright violations—it remains true that much of the content available from popular filesharing networks is protected by copyright and is shared there without permission from its owners, who therefore are fully within their rights to prosecute such violations. At the same time, however, it is also important to note that to date, such prosecutions have failed to stamp out or significantly reduce filesharing practices; indeed, seen by filesharers themselves as a form of *persecution*, they may be said to have succeeded only in creating an even stronger sense of resistance within the filesharing community, and have certainly had the tangible effect of driving further technological developments by the community. Well beyond the functionality offered by Napster and other first-generation tools which relied on central servers and highly visible nodes within the network to maintain network efficiency, today's filesharing technologies are highly decentralized and diffused, and impossible to shut down through legal action against individual participants; in addition, leading software tools for filesharing, such as the BitTorrent software, have been developed in a wide range of generally interoperable variations by open source communities, making even legal action against the providers of such software impossible, impractical, or at least highly ineffective.

BitTorrent and other current-generation filesharing tools, then, operate by harnessing the distributive capabilities of each node in the network, regardless of whether it has actively engaged in sharing its own content or is simply acting as a 'leecher,' downloading a file from elsewhere on the net. As Bauwens points out, this means that "even passive use becomes useful participation for the system as a whole. ... BitTorrent makes any user who downloads a resource, in his/her turn a resource for others to use, unbeknownst and independent of any conscious action of the user." He describes this as "Participation Capture"[23]—an activation even of passive participation in pursuit of communal goals which is not unlike the mining of user traffic and search behaviors in produsing the product catalog of *Amazon* or the PageRank ratings of *Google*. Once made available to the network by any one participant, and begun to be downloaded by others, files in the filesharing network therefore transform into a kind of diffused and growing 'data fog' pervading the filesharing network, able to be pieced together again by interested participants residing at other locations in the network, and persisting in the network even after the original 'seed' contribution has been removed through deliberate or accidental disconnection for as long as at least one copy of each 'fog' particle remains present in the network. This model of distribution directly harnesses the benefits of granularization, therefore; it makes granular the very act of distribution itself, as well as the products being distributed (both of which were previously significantly more unitary, if we compare such granular distribution with the act of purchasing a media item—for example, a CD or DVD—from a physical store, or even of receiving media content through broadcast on radio or TV or direct download from an online store).

While prosecuted, or indeed persecuted, fiercely by certain sectors of the media industries, and chiefly by music industry associations in North America and Europe, the real impact of filesharing on the consumption of music and other media forms remains disputed. Early industry claims of significant losses have been roundly discredited; any apparent downturn in CD sales during the late 1990s, for example, must also be seen in the context of wider market trends (the mid- to late 1990s mark the end of the first decade after the introduction of CDs, for example—a time at which the first wave of purchases replacing vinyl records with CDs was gradually coming to a close).[24] It is also notable that with the exception of a small number of high-profile artists, complaints about filesharing from artists themselves (rather than from industry executives) have remained rather muted; some artists, indeed, have openly supported filesharing as a new opportunity for the buying public to discover and try out their music.[25] Such artist approaches to filesharing are similar to long-established practices by some artists to openly allow the (non-commercial) bootlegging of their concerts as a means of generating listener excitement and familiarity—as Benkler puts it, thus, "peer-to-peer networks are a genuine threat to displacing the entire recording industry, while leaving musicians, if not entirely unaffected, relatively insulated from the change and perhaps mildly better off."[26]

On present evidence, it is very much possible to suggest that the overall impact of filesharing on the music industry—and perhaps also on other media industries—has been revenue-neutral; it *may*, however, have shifted listener allegiance from mainstream acts likely to be discovered through radio and television further out to artists less commonly played on the conventional media and more commonly promoted through social networks of recommendation (this would be in tune with effects also observed through the impact of *Amazon* and similar online stores which allow for a more effective marketing of products down the long tail of media content).

Whatever the exact impact of filesharing on the industry, however, it is evident that the relentless industry attacks on filesharing through legal prosecution have had the effect of both driving filesharing further underground, and increasing the resilience and determination of networks and community against such intrusions. Such attacks are ultimately counterproductive, therefore, and their effects should serve as an important lesson for the media industries as they engage with produsage-based distribution networks, as Pesce points out in the context of recent attempts to stop the sharing of commercial television content through filesharing as well as *YouTube*:

> television producers are about to learn the same lessons that film studios and the recording industry learned before them: *what the audience wants, it gets*. Take your clips off of YouTube, and watch as someone else—quite illegally—creates another hyperdistribution system for them. Attack that system, and watch as it fades into invisibility. Those attacks will force it to evolve into ever-more-undetectable forms. When you attack the hyperdistribution system, you always make the problem worse.[27]

Viewed from the perspective of technological innovation, this is particularly unfortunate, as—while promoting further technological development—it has also tainted the technology through association with illegal practices of copyright 'piracy'. After all, even despite the prevalence of more or less inherently illegal uses of filesharing, many legitimate uses of the technology also remain possible and practicable even through the same networks already in place. Much like the carrier technologies underlying the overall Internet as well as older communications networks such as television, radio, telephone, and even postal mail, the specific technologies of filesharing in its BitTorrent and other varieties are content-neutral: they support the exchange of permitted, free content in much the same way that they support the exchange of prohibited, copyrighted material—indeed, for a variety of providers they offer a substantially cheaper and faster alternative to content distribution than do traditional physical or electronic means of distribution. Instead of demonization, Litman suggests that the development of filesharing technology—perhaps leading to the emergence of genuine systems of 'hyperdistribution' as Pesce describes them—should be supported, therefore:

> anecdotal evidence indicates that at least for some material, untamed digital sharing turns out to be a more efficient method of distribution than either paid subscription or the sale of conventional copies. If untamed anarchic digital sharing is a superior

distribution mechanism, or even a useful adjunct to conventional distribution, we ought to encourage it rather than make it more difficult.[28]

Litman's description of filesharing as a form of anarchic distribution may be slightly inaccurate, however—once again, we would be best advised to substitute the term 'heterarchical' here, as even the widely distributed, diffuse network of peer-to-peer filesharing builds on a variety of major and minor nodes as determined *ad hoc* by prevailing network conditions and content availability. That aside, it is becoming perfectly clear that filesharing can be described as a form of communally driven many-to-many distribution in significant contrast to the broadcast-style one-to-many distribution models of conventional media. Legally or illegally, filesharers distribute content "collaboratively, by sharing the capacity of their computers, hard drives, and network connections"[29]; this communal nature of the technology and of the networks which it creates is also evident in the social and cultural contexts within which such networks exist, indeed, and is visible particularly through the support sites of the BitTorrent community.

The Culture of Sharing Culture

BitTorrent is particularly interesting in this context, in fact: contrary to older filesharing technologies, which provided content search capabilities built into the sharing software itself, BitTorrent generally separates such search functionality from the sharing process. BitTorrent sharing is instead initiated by participants making the pointer to a shared piece or collection of content (a piece of software, a collection of documents, images, audio recordings, videos, even the digital representation of an entire CD or DVD) available on the network, in the form of a torrent file. That file contains no potentially copyrighted content in itself—it is simply a pointer to content—, and under many legal jurisdictions, providing it therefore constitutes no more of a violation of copyright than providing the television guide which may enable users to set their video recorders to record copyrighted content from television broadcasts.

To facilitate the announcement and sharing of such torrent files, therefore, a wide variety of Web-based communities have now emerged, and it is useful to examine their operations in some more detail. One particularly active community within the field of music filesharing, for example, is *Dime a Dozen*; this community focuses especially on the sharing of music bootlegs (or of what some music communities euphemistically refer to as RoIOs: 'Recordings of Indeterminate Origin'). What is remarkable about sites such as this is not simply the high throughput of (pointers to) bootleg material, or the availability of new live recordings often only days after a concert, however: instead, what becomes immediately apparent here is the high level of

commitment of the community to the site's shared ethos, and the strong communal enforcement of the rules of participation.

Partly also for their own protection, *Dime a Dozen* and many other such filesharing communities enforce a strict rule that no officially released material may be traded through their spaces; any legitimately commercially released live tracks must be removed from bootlegs before they can be announced through the site, for example. The site and its community take great pains, in other words, to avoid being implicated in 'music piracy' in a narrow definition of the term—the unsanctioned sharing of commercially released recordings—even while they are engaged in high-volume practices of distributing unreleased (mainly live) recordings in audio and video formats. (Indeed, if a commercial release of one of 'their' torrents becomes available, that torrent is usually removed from the site immediately.) Similar tendencies can also be observed in some BitTorrent communities dedicated to the sharing of television shows, which make available recordings of episodes almost immediately after their first broadcast on the show's home network, but remove such torrents if and when official DVD and other commercial releases are published.

By contrast, the site community takes great pride in undermining the remaining commercial bootleg business: many contributors point out whether shared content has been 'liberated' from commercially sold bootlegs, and exhort their peers not to engage in for-pay trading activities using the content whose sharing is facilitated through the site. In addition, there are strictly policed community rules that material must be as clearly documented as is possible, in particular also pointing out the lineage of trade, copying, and editing from original recording to shared content, where known (in part so that different versions or generations of bootlegs of the same show can be distinguished from one another), and that contributors must submit proof that audio tracks were never encoded using 'lossy' compression technologies such as MP3 (re-encoding of the lossless shared audio files is also strongly frowned upon).

Perhaps most remarkably, however, this audiophile attitude is also manifested in the effort which many contributors place in the content they share with the help of the site. Torrent files announced through the site are frequently accompanied by detailed descriptions of the various splicing, dehissing, declicking, equalizing, speed correction, and other editing steps undertaken in compiling the music shared, and in some cases rival the energy invested into commercial live recordings; in addition, it is also common practice for editing experts in the community to download some of the less polished recordings and invest further hours and days in improving their audio quality, before making available an updated version. (To a somewhat lesser extent, such tendencies can also be observed in the contribution of cover art for the CDs and DVDs whose trading is facilitated through the site.) Similar, but even substantially more intensive work is also done on DVD bootlegs released to the community: frequently, such releases involve community members mixing together the recordings from a number of independent audio and video sources, producing multi-angle, multi-

audio concert DVDs which sometimes approach professional recording quality. Especially in such cases, then, *Dime a Dozen* and similar BitTorrent sharing communities can be seen as being engaged in both the produsage of content (though of course on the basis of sources of dubious legitimacy), and in the produsage of the means, mechanisms, and networks of its distribution.

It is very much possible, then, to consider such distribution networks (thought of here as comprised of both the communities, and the technologies used by the communities) to be engaged in a form of produsage. The object of such produsage is the development of the cultural, social, and technological conventions, means and mechanisms for content distribution, and therefore also the creation of distribution networks themselves; as we have seen, such networks allow for the **open participation** of all users as both providers and sharers of content, and frequently inherently involve participants in helping to further distribute content even when in the first place they are only using the networks to access the material as 'leechers'. In addition, **communal means of evaluating** the performance of contributors to the distribution systems, and the quality of the content shared, are partially built directly into the technologies themselves (in the processes through which filesharing technologies automatically spread the load of sharing content throughout as much of the network as is possible), as well as being provided through ancillary Websites and other tools (for example the *Dime a Dozen* support fora in which quality of content and distribution network performance are being discussed). What emerges from this is a highly **fluid heterarchy** of nodes in the distribution network, again both from the point of view of the technological layer of the network itself (where nodes equate to the connected computers themselves), and that of the community layer (from which key contributors acting as nodes in the social network emerge as distribution leaders). Sites such as *Dime a Dozen* also provide a glimpse of *ad hoc* **community self-governance processes**, there enforcing adherence to the ethos of bootleg trading, for example. The distribution system itself remains a highly **unfinished artefact**, of course, and is undergoing **constant processes of evolution**, much in the same way that the content shared through such networks for the distribution of creative work is itself open to further alteration and development; finally, content sharing and distribution using the means we have encountered here is built on an understanding (whether based in legal fact or not), or more precisely, an appropriation of the content shared and the means of distribution themselves as **common property**–and yet, **individual rewards** for distributors can emerge from this sharing process as they are recognized variously as the originators of interesting new content, as the creators of quality remixes and remasters of shared material, or as key facilitators of the sharing process.

Industry Impacts

We have already highlighted the fact that at least for the music industry, claims about a significant impact of filesharing on the business bottom line must be regarded with a great deal of skepticism. Of course this does not mean, however, that the development of produsage-based approaches to the distribution of media content does not have a substantial impact on the media industries more generally. Indeed, especially the widespread disregard for current configurations of the copyright system which pervades much of the sharing community can be seen as a key challenge for the future of the media industries overall.

It is also evident that the highly confrontational approach to policing copyright violations which the music and movie industries have so far pursued has shown little signs of widespread success to date. Attempts to undermine the filesharing of copyrighted content and other related illegal practices have not only failed to significantly dent the popularity of the practice, but they have even contributed to the further improvement of filesharing technologies (making such technologies less susceptible to disruption, and harder to trace to any one central node), as well as increasing the stance of explicit opposition to the conventional copyright industries already adopted by many filesharers. What is required, then, is perhaps the development of entirely new responses to the question of produsage-based content distribution, and a reassessment of the threats and opportunities inherent in such distribution models. Absent such a re-evaluation, the casual collapse of significant sectors of the traditional media industries may loom as a realistic possibility.

In the process, it is also important to point to notable distinctions in the models for embracing filesharing-based distribution which are available to various sectors in the media and entertainment industries. Benkler notes, for example, that "for now, although the sound recording and movie industries stand shoulder to shoulder in the lobbying efforts, their circumstances and likely trajectory in relation to file sharing are likely quite different"[30], and such differences become even more pronounced if we also add the television industry into the mix.

Pesce goes as far as to say that as a medium, television is already dead, and even points to the date of its demise: "October 18th, 2004 is the day TV died. That evening, British satellite broadcaster SkyOne—part of NEWS Corp's BSkyB satellite broadcasting service—ran the premiere episode of the re-visioned 70s camp classic *Battlestar Galactica*."[31] Though perhaps an overly dramatic statement, it is nonetheless true that *BSG* serves as a particularly convincing example for the casual collapse of the traditional distribution model in the televisual industry. As Pesce notes,

> the production costs for *Battlestar Galactica* were underwritten by two broadcast partners: SkyOne in the UK, and the SciFi Channel in the USA. SciFi Channel programmers had decided to wait until January 2005 (a slow month for American

television) to begin airing the series, so three months would elapse between the airing of "33" in the UK, and its airing in the US. Or so it was thought.[32]

What happened instead was that science fiction fans in the United Kingdom immediately recorded, packaged, and distributed the premiere *BSG* episode via BitTorrent, thus making it available to their U.S. counterparts and to fans around the world within minutes. The 'controlled geographic release' approach common to television series as well as to the release of DVDs and other media content had been fatally undermined. It is perhaps no surprise that a science fiction series should be among the first to be distributed effectively in this way, as science fiction fans have traditionally formed very strong online communities (due perhaps to the overrepresentation of 'geeks' and 'nerds' in the early cyberspace), but Pesce could have pointed just as well to the widespread filesharing distribution of other popular current series such as *Desperate Housewives* or *Lost* around the world, particularly in cases where a similarly staggered release into different television territories has been attempted. What made *BSG* a special case for the television industry was perhaps simply that here, for the first time, filesharing distribution was used in a substantial way to *import* TV content into the world's dominant television market, rather than to *export* what had already shown on U.S. television to other, secondary markets around the world.

Just as significant, however, was the fact that even despite this unintended 'prerelease' of the *Battlestar Galactica* premiere and subsequent episodes into the United States, the show nonetheless attracted substantial ratings when it did eventually appear 'officially' on U.S. screens. Far from destroying the show's domestic television market, BitTorrenting had served as an effective means of viral marketing to the hard core of science fiction fans enthusiastic enough to download and watch the video files shared from the United Kingdom, and word had spread from this in-group to more casual viewers. What Pesce terms 'hyperdistribution' through filesharing had boosted conventional distribution through television. In addition, of course, the BitTorrented episodes of the show also managed to reach viewers well beyond the United States and the United Kingdom, whose domestic television networks had not yet shown *Battlestar Galactica*, and perhaps had no plans to do so in the future. Though not inherently a market for the show's content itself, this distribution of the show well beyond its initial core markets could nonetheless serve to increase the size of secondary markets for further *BSG* merchandise.

Indeed, it is important to consider the underlying business models of television in this context. Free-to-air television—traditional *broadcast* in the core meaning of the term—operates not by selling content to audiences, of course, but by selling attractive audiences to advertisers; its production and distribution costs are substantial, and financed entirely from advertising revenue. Cable television operates somewhat differently (charging customers for access in some, though not all countries where cable has been introduced), but—except for the special case of pay-TV in which users pay a pre-

mium for the absence of commercial advertising—nonetheless derives a significant proportion of its revenues from advertising income. In addition, the overall model of television broadcasting as a continuing, 24-hour service means that stations must use their prime time advertising income to subsidize the content of less lucrative program slots, and the limits to the geographic reach of conventional television broadcasts also lead to a further concentration of programming on the interests of key target audiences in the local area.

In combination, such underlying financial considerations lead to the concentration of television production on large and lucrative markets, and to a relative failure to address niche audiences especially where such audiences are geographically dispersed; in terms of industry structure, they privilege amalgamation and centralization both horizontally (combining as many stations and geographic markets as possible under the same corporate roof to share the costs and risks inherent in production and distribution) and vertically (combining production and broadcasting within the same operation). However, the *Battlestar Galactica* case points to the fact that such centralizing tendencies no longer need to apply in the context of the availability of online, produsage-based modes of content distribution:

> the Internet presents the possibility of a radical reversal of this long trend [towards centralization]. It is the first modern communications medium that expands its reach by decentralizing the capital structure of production and distribution of information, culture, and knowledge. Much of the physical capital that embeds most of the intelligence in the network is widely diffused and owned by end users.[33]

Indeed, perhaps most notably, the Internet makes it possible for the first time to imagine television *without broadcasting*. BSG and other examples point to the feasibility of relying on fans themselves (and evidently, even on fans who have only just encountered a show for the first time) to orchestrate the distribution of the episodes of a series; the eventual screening of the show on domestic U.S. television in essence became an optional network rerun of the content which had already been seen on many fans' computer screens, and the number of potential new audience members such reruns are able to attract is decreasing with the continuing growth of participation in BitTorrent and other filesharing networks. In addition, the global nature of this filesharing network creates an amalgamated audience that is, potentially, substantially larger than the audience any one conventional television network would have been able to attract; overall, then, the filesharing network becomes "a distribution channel which is even more efficient than broadcasting."[34]

There is no reason to believe that a direct-to-filesharing television content production model should not be possible under such conditions. Much like television itself, it could continue to be supported by advertising—either on the *Dime a Dozen*-style BitTorrent site of the originating television 'broadcaster' where fans must go to download the initial torrent file pointing to each new episode, or in the form of conventional

advertising embedded into the video content itself. Much like cable television or pay-TV, the filesharing 'broadcaster' might also be able to charge users a small fee for each episode (even offering a commercial-free premium version, for example) as they access the torrent file. At the same time, the new 'broadcasters' of this environment may also be able to make substantial savings compared to the traditional broadcasting model, as there is now no longer a need for them to operate or negotiate for time on a chain of costly, high-energy local broadcast transmitters or proprietary cable networks; instead, their mode of distribution consists of comparatively low-cost, conventional Internet servers whose main purpose is to seed the initial content and provide the means for audiences to access and/or purchase the torrent files; beyond this, the in-built load-sharing mechanisms of the filesharing technology itself spread the duty of content distribution across the fan community. Illegitimate redistribution of downloaded content directly between peers does remain a problem, perhaps, but only to the extent that a significant proportion of revenue is generated from direct user fees; the more costs can be carried by contextual or (especially) embedded advertising, the more does redistribution increase the potential audience for advertisers, in fact.

What the rise of produsage distribution models points towards is that the industrial models of television production and distribution, the variety of content it had to offer, the approaches to programming it took, were always driven mainly by the inherent features of broadcasting technology and its regulatory environments;

> TV's worst characteristics—its blandness, its cultural homogeneity, its appeal to the lowest common denominator—weren't an inevitable part of the medium, they were simply byproducts of a restricted number of channels, leaving every channel to fight for the average viewer with their average tastes.[35]

Today, as is shown by both the environments for the collaborative produsage of creative works which we encountered at the beginning of this chapter, and the models for a produsage-based distribution of content which we have examined more recently, alternative models of creating and distributing creative media forms *are* readily available, and no longer need to be pressed into the straitjackets of broadcast;

> now we get to see the great, unspoken truth of television broadcasting—it's nothing special. Buy a chunk of radio spectrum, or a satellite transponder, or a cable provider: none of it gives you any inherent advantage in reaching the audience. Ten years ago, they were a lock; today, they're only an opportunity. There are too many alternate paths to the audience—and the audience has too many paths to one another.[36]

Television, of course, is only one of the media industries challenged by new models of content creation and distribution (though perhaps the one most likely to see significant industrial restructure in the near future); other industries from music to movies are likely to be forced to address such changes for themselves, too.

The Audience Is Dead

Each of these industries will need to determine for itself where its core business will lie in the future, and how it intends to engage with its customers; what is already evident, at any rate, is that old approaches on the basis of mere improvements to producer/consumer relations will no longer be sufficient: the solution to working with customers who have become users and even produsers of media content and of the means of media distribution can never be to reduce them again to being mere audience members.

Indeed, it is now possible to observe the emergence of a number of new models and new operators harnessing the online medium, both in television and in the media industries beyond:

- *Joost* has partnered with a number of established television providers to create a kind of online on-demand television broadcast service;
- as part of a wider 'BBC 2.0' strategy, the BBC has begun to post some of its content in a special channel on *YouTube*, and is planning to revamp its own Website to offer similar functionality to produsage-based content sharing sites such as *Flickr*, *YouTube*, and music sharing services;
- after a variety of failures of other music download services, *iTunes* was able to utilize its tie-in to the popular iPod portable media player to develop a successful commercial service for the sale of content ranging from individual tracks to whole albums, and more recently also including video content;
- more specialized commercial music download sites such as *DGMLive* connect to specific fan communities, and here cater especially also to the audiophile market by making available music in lossless compression formats;
- DVD rental company Netflix has begun to offer a streaming media service making available a selection of its most popular videos.

Even such developments, significant though they may be for each of the media industries concerned, hardly begin to fully embrace produsage; mostly, they continue simply to deploy enhanced distribution mechanisms for commercial content which merely use the Net as a distribution medium, but without harnessing produsage communities. For the most part, they continue to perpetuate what Pesce refers to as "the Big Lie of Big Media: if it isn't professionally produced, the audience won't watch it. No statement could be more mendacious, no assertion could be further from the truth."[37]

By contrast, over time we might expect the development of media industry approaches which better engage with "an information environment that both technically and as a matter of social practice enables user-centric, group-based active cooperation platforms of the kind that typify the networked information economy."[38] Such approaches put the identification of quality content into the hands of 'audiences'—that

is, of produsers in their role as metadata generators and curators—themselves; produsers, in other words, channel content into curated collections which improve that content's 'findability' for further users. Where such channeling is effective, it fundamentally undermines any opportunity for traditional media producers to retain their hold over an audience simply by virtue of the production values embedded in their products: instead,

> salience determines whether an audience will gather around and share media, not production values. In the time before hyperdistribution, audiences had a severely limited pool of choices, all of them professionally produced; now the gates have come down, and audiences are free to make their own choices. When placed head-to-head, can a professional production of modest salience stand up against an amateur production of great salience? Absolutely not. The audience will always select the production which speaks to them most directly. Media is [sic] a form of language, and we always favor our mother tongue.[39]

Ultimately, this can be described as the triumph of 'produsage values' over 'production values,' and it is played out every day in the spaces of *YouTube* and other produsage-based environments of distributed creativity and creative distribution.

As the traditional modes of media production and distribution employed by the industry fade into the background, then, the loss of such controlled and controllable mechanisms for the distribution of industry content will come to have a lasting and substantial impact on its further fortunes. "Technological change has rendered obsolete a particular mode of distributing information and culture"[40]; it has opened up the possibility for the rise of a new participatory media culture which *may* set in motion a more gradual, overall shift away from commercially driven media culture, and towards the rediscovery of a more vernacular culture of folk creativity. The net effect is likely not to be necessarily greater overall quality, but certainly greater diversity of content:

> the basic filter of marketability has been removed, allowing anything that emerges out of the great diversity of human experience, interest, taste, and expressive motivation to flow to and from everyone connected to everyone else. Given that all diversity within the industrial information economy needed to flow through the marketability filter, the removal of that filter marks a qualitative increase in the range and diversity of life options, opinions, tastes, and possible life plans available to users of the networked information economy.[41]

This does not mean the demise of our entire system of media and creative industries, of course. The new produsage-based approach to creative development and distribution offers an opportunity for the rise of new business models and new industry leaders in this field just as much as it has done so in other areas where produsage has come to play an ever more important role. Such operators are likely to engage directly with produsers as partners, however, rather than pressing them into a role as mere audiences; their models of operation are likely to be based on the harnessing and har-

vesting of produsage content for specific interest communities rather than the production of material designed to appeal to the largest possible audience (and thus almost necessarily also to the lowest common denominator).

Such trends, then, pose a notable threat to the established media industries, especially where they understand themselves principally as copyright industries, that is, industries based on the principle of protecting and enforcing their intellectual property rights; that narrow definition of media industries has no more place in a collaborative, produsage-based environment. Beyond that threat, however, the new environment offers something far more important: the hope for a greater democratization of cultural participation, for a broadly based, produsage-based, participatory culture.

NOTES

1. See, e.g., Angela Thomas, "Fictional Blogs," in Axel Bruns and Joanne Jacobs (eds.), *Uses of Blogs* (New York: Peter Lang, 2006), pp. 199–210.

2. *Trendwatching.com*, "Life Caching: An Emerging Consumer Trend and Related New Business Ideas," 2007, http://www.trendwatching.com/trends/LIFE_CACHING.htm (accessed 20 Feb. 2007), n.p.

3. See Axel Bruns and Joanne Jacobs, eds., *Uses of Blogs* (New York: Peter Lang, 2006).

4. *Trendwatching.com*, "Life Caching," n.p.

5. Dong Hoo Lee, "Re-imagining Urban Space: Mobility, Connectivity, and a Sense of Place," keynote speech at *Mobile Media 2007*, Sydney, 2–4 July 2007.

6. *Trendwatching.com*, "Life Caching," n.p.

7. *Trendwatching.com*, "Generation C," 2005, http://www.trendwatching.com/trends/GENERATION_C.htm (accessed 18 Feb. 2007), n.p.

8. Henry Jenkins, *Convergence Culture: Where Old and New Media Collide* (New York: NYU Press, 2006), p. 179.

9. *Trendwatching.com*, "Generation C," n.p.

10. Pierre Lévy, *Collective Intelligence: Mankind's Emerging World in Cyberspace*, trans. Robert Bononno (Cambridge, Mass.: Perseus, 1997), p. 123.

11. Douglas Rushkoff, "On 'Digital Maoism: The Hazards of the New Online Collectivism' by Jaron Lanier," *Edge: The Reality Club*, 2006, http://www.edge.org/discourse/digital_maoism.html (accessed 28 Feb. 2007), n.p.

12. Jean Burgess, "Vernacular Creativity and New Media," PhD Thesis, Queensland University of Technology, 2007.

13. See, for example, Henry Jenkins's extensive work on fan fiction in the Harry Potter universe, in *Convergence Culture*, and on slash fiction in a number of the essays in *Fans, Bloggers, and Gamers: Exploring Participatory Culture* (New York: NYU Press, 2006).

14. See Jenkins, *Convergence Culture*.

15. Jenkins, *Convergence Culture*, p. 189.

16. Mark Elliott, "Stigmergic Collaboration: The Evolution of Group Work," *M/C Journal* 9.2 (May 2006), http://journal.media-culture.org.au/0605/03-elliott.php (accessed 27 Feb. 2007), b. 15.

17. Yochai Benkler, *The Wealth of Networks: How Social Production Transforms Markets and Freedom* (New Haven, Conn.: Yale University Press, 2006), pp. 293–294.

18. *Trendwatching.com*, "Top 5 Consumer Trends for 2007," 2007, http://www.trendwatching.com/trends/2007top5.htm (accessed 17 Feb. 2007), n.p.

19. *Trendwatching.com*, "Generation C," n.p.

20. *Trendwatching.com*, "Generation C," n.p.

21. Jessica Litman, "Sharing and Stealing," *Social Science Research Network*, 23 Nov. 2003, http://ssrn.com/abstract=472141 (accessed 14 Mar. 2007), p. 8.

22. Charles Leadbeater and Paul Miller, "The Pro-Am Revolution: How Enthusiasts Are Changing Our Economy and Society," *Demos* 2004, http://www.demos.co.uk/publications/proameconomy/ (accessed 25 Jan. 2007), p. 10.

23. Michel Bauwens, "Peer to Peer and Human Evolution," *Integral Visioning*, 15 June 2005, http://integralvisioning.org/article.php?story=p2ptheory1 (accessed 1 Mar. 2007), p. 2.

24. See, e.g., Suw Charman, "Listen to the Flip Side," *Guardian Unlimited Online*, 22 July 2004, http://www.guardian.co.uk/online/story/0,3605,1265840,00.html/ (accessed 20 Nov. 2004); Danny Butt and Axel Bruns, "Digital Rights Management and Music in Australasia," *Media & Arts Law Review* 10.4 (2005), pp. 265–278.

25. See, e.g., Courtney Love, "Courtney Love Does the Math," *Salon Magazine*, 14 June 2000, http://dir.salon.com/tech/feature/2000/06/14/love/index.html (accessed 20 Nov. 2004).

26. Benkler, p. 425.

27. Mark Pesce, "Nothing Special," *Hyperpeople: What Happens after We're All Connected?* 3 Nov. 2006, http://blog.futurestreetconsulting.com/?p=23 (accessed 20 Feb. 2007), n.p.

28. Mark Pesce, "Hypercasting," *Hyperpeople: What Happens after We're All Connected?* 16 Oct. 2006, http://blog.futurestreetconsulting.com/?p=20 (accessed 23 Feb. 2007), n.p.

29. Benkler, p. 425.

30. Benkler, p. 428.

31. Mark Pesce, "Piracy Is Good? How *Battlestar Galactica* Killed Broadcast TV," *Mindjack*, 13 May 2005, http://www.mindjack.com/feature/piracy051305.html (accessed 24 Feb. 2007), n.p.

32. Pesce, "Piracy Is Good?" n.p.

33. Benkler, p. 30.

34. Pesce, "Piracy Is Good?" n.p.

35. Clay Shirky, "RIP the Consumer, 1900–1999," *Clay Shirky's Writings about the Internet: Economics & Culture, Media & Community, Open Source*, 1999, http://www.shirky.com/writings/consumer.html (accessed 24 Feb. 2007), n.p.

36. Pesce, "Nothing Special," n.p.

37. Pesce, "Hypercasting," n.p.

38. Benkler, p. 357.

39. Pesce, "Hypercasting," n.p.

40. Benkler, p. 426.
41. Benkler, pp. 166–167.

Media and Creative Industries: New Opportunities or Casual Collapse?

T hroughout this book, we have encountered produsage in the first place as a mode of content creation taking place outside of the established industry of whichever field such content creation is attempted in, and the same is true also for the creative field as we have examined it in the previous chapter. Here, produsage-based approaches to creative collaboration and the collaborative distribution of creative work have combined to enable a great variety of users to become creative practitioners, and have allowed their individually and collaboratively authored works to be made available to the wider public; they have also enabled others to join them directly in expanding, developing, and remixing such work in the pursuit of further creative expression, and even to produse the networks of distribution for their own work and that of others. Such phenomena are set to have a profound effect on the various media and creative industries traditionally engaged in the production and distribution of creative work, and it is possible to identify these effects in a number of cases already.

In the first place, however, much as in other industries, what we find in the creative field is the emergence to widespread public visibility of an entire sector of grassroots creativity which may have existed before, but was facilitated in the main only on a much smaller scale through local and fan group-specific networks of exchange. Today, instead, it is possible for the creative work of individuals participating in the blogosphere, on photo-, music-, and videosharing sites, and in other related environments to be seen by millions, and it is possible for individuals therefore to emerge as the new stars of these grassroots communities at least for a short moment.

This expression of grassroots, vernacular creativity outside of the confines of the media industry proper is part of the wider phenomenon of the "long tail," as Anderson has described it:

an entirely new economic model for the media and entertainment industries, one that is just beginning to show its power. Unlimited selection is revealing truths about what consumers want and how they want to get it People are going deep into the catalog, down the long, long list of available titles, far past what's available at Block-buster Video, Tower Records, and Barnes & Noble. And the more they find, the more they like. As they wander further from the beaten path, they discover their taste is not as mainstream as they thought (or as they had been led to believe by marketing, a lack of alternatives, and a hit-driven culture).[1]

Online retailers such as Amazon, for example, have traditionally found that they make the majority of their sales in areas outside of the commercial mainstream, areas which have been neglected for practical and commercial reasons by offline stores that are forced for practical reasons to limit their stocks only to those titles that can be guaranteed to sell the most. Where high street shops sell the top 20 percent of available merchandise, as measured by sales volume, and stock little else, Amazon and others have built a business model based on catering to those customers whose specific interests are not sufficiently met by the conventional bestsellers. Similarly, on a global level encompassing all information available on the Web, *Google* provides a ranking of online resources for any one search term which indicates the relative importance of such resources as measured by Web user behavior patterns (including interlinkages between Websites); this ranking includes the small number of key sites on the search topic as well as a long tail of progressively less mainstream, more specialist resources.

The increased degree of visibility for minor resources that such long tail phenomena make possible shifts the balance between the core and the periphery. Much in the same way that produsage comes to rely on a wider, potentially unlimited continuum of contributors extending from core, expert team members to a long tail of highly peripheral, even random participants, rather than working with a closed group of staff only, in the context of media and cultural options and opportunities the long tail similarly breaks the boundaries and constraints imposed by conventional industrial necessities and thereby increases choice, diversity, and access. As we have seen, well beyond the product catalog of Amazon and other online stores lies an even vaster universe of content created and distributed by users-as-produsers themselves, from fan fiction to the collected creative works and knowledge of enthusiast and specialized communities, in the first place satisfying the outer reaches of the long tail where industrially organized cultural, media, and informational production has (or wants) no purchase.

Here, cultural participation is no longer limited to exchanges between producers and audiences: because all participants are at least equipotential nodes in the network, produsers themselves are able to form interest, enthusiast, and creative communities among themselves with far greater efficiency than in the pre-network age, and to communicate among themselves and with conventional media producers from this position of collective strength. Thus, Jenkins suggests, for the media industries "the greatest changes are occurring within consumption communities. The biggest change

may be the shift from individualized and personalized media consumption toward consumption as a networked practice,"[2] as well as beyond this towards active individual and collaborative participation in the creation and distribution of cultural artefacts.

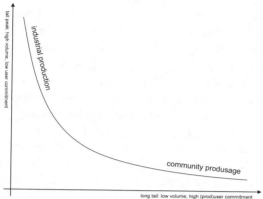

Figure 10.1: The Tall Peak and Long Tail of Media Content

It is especially within this long tail that the produsage of creative content has built its strongest support bases; within this long tail exist for example enthusiast communities for 'niche' tastes, fan communities creating their own fan fiction content, and experimental artists exploring the possibilities of their chosen media forms and genres. Through produsage-based means of collaboration, distribution, and sharing, these groups are now able to come together and work together (even collaborating across taste boundaries at least in the development of the networks and sites for sharing content), and thereby to present their works to a wider audience of potential users and participants; in addition, through the processes of communal evaluation and the emergence of heterarchical contributor merit structures within the community which flows from these processes, the leaders of these communities (both in terms of the quality of their artistic work and the quality of their contribution to the taste community) are now beginning to be identified. Such produsage is to some extent itself a consequence of the increased visibility of the long tail of interests, knowledge, and expertise which the move of consumer and user communities to the network has enabled, and increasingly, in a variety of media forms, its artefacts have now begun to hold their own against and influence the production processes of the conventional media industries—the long tail of networked, grassroots, vernacular culture and creativity has begun to wag the dog that is the star system of traditional media industries.

What content and contributors are ultimately identified through such processes is necessarily also dependent on each community's own sense of its interests and values, as well as on the structural features of their sites; we have already encountered, for example, the effect of overt monetary incentive structures on the range of content made

available through sites such as *Revver*, *MetaCafe*, or *Break.com*. However, where such effects are recognized and taken into account, the sites of creative content sharing and evaluation communities are nonetheless able to serve as highly instructive research and development spaces for the creative industries more broadly: fan fiction Websites, for example, provide an important source of ideas for the further development of existing fictional universes; music sharing sites offer a clear indication of what musical styles are growing in popularity, and what artists are likely to be *en vogue*; and some videosharing sites are beginning to help identify a new generation of filmmakers whose artistic vision is powerful enough to attract sizeable audiences even when they are forced to work with low-end equipment and untrained actors—in addition to having single-handedly revived the genre of the short video exposé.

The development of hybrid produsage/production models such as *Current.tv* with its transition of content from online video to cable television, and the occasional invitation to cross over from produsage to production which the established industry extends to artists identified as highly popular within their own communities, may already be seen as the first steps beyond a parallel development of produsage and production practices, beyond the non-market/ market dichotomy which Benkler has described,[3] and towards a more active embrace of the former by the latter. At the same time, the dabbling of traditional producers in produsage-based models of content distribution, evaluation, and sharing can be seen as a move in the opposite direction: an attempt by the existing media production industry to divest itself of outdated components and practices of the industry and to engage more directly with 'the people formerly known as the audience.'[4] Both moves hold considerable risks and challenges for both produsers (who stand to lose their independence and become simply unpaid labor for the industry) and producers (who are at risk of losing further control of their content, and of undermining even the last remnants of their traditional business models). Both moves, however, may also generate substantial opportunities for new, mutually acceptable models of cultural engagement which are both creatively productive and financially sustainable.

Copyright, Users' Rights?

The rise of produsage-based models of content distribution, from distributed filesharing to centralized content sharing sites, has long been seen as a key challenge to the established media industries, and industries from music to television to movies have fought hard (and, some would suggest, dirty) to protect their copyright properties. In addition to pursuing and suing those identified as 'copyright pirates' with the full force of applicable laws, they have also introduced increasingly sophisticated technological measures to prevent unauthorized copying and redistribution, as well as campaigning successfully for the creation of new laws in the United States and many other

countries to make not only copyright breaches themselves illegal, but also the provision of the tools for breaking the technological prevention measures (TPMs) used to protect against copying (even where such copying itself is specifically permitted by law, for example as fair use for academic, satirical, or critical purposes).

At the same time, however, it has also become increasingly obvious that even the most sophisticated systems for copy prevention and digital rights management (DRM) *are* ultimately breached, and often within a very short time of their deployment, and that the increasingly elaborate systems used to implement DRM and related measures are now often significantly disruptive to the user experience (recent anti-copying measures prevented, for example, the playback of some CDs on personal computers, and consumer protection groups successfully argued that such products should be considered to be defective and ought to be replaced with less stringently protected versions). In addition to their inability to protect the content, then, such systems have also contributed substantially to further alienating users, thereby making systemic copyright breaches even more likely.

Further, the success of for-pay content distribution models such as *iTunes* also clearly demonstrates that commercial models for the distribution of digital content are possible and economically viable under favorable conditions, even if DRM is not used or copyright is not enforced strongly through technical and legal means. Gradually, therefore, some industry players have begun to explore alternative models for the distribution of their content, and they are increasingly beginning to harness the distribution tools provided by produsage communities. Such models almost uniformly appeal to their customers not as mere members of a passive and anonymous audience, but instead as active users and community members, and perhaps even as produsers of both content and the means of distribution for content. From a commercial point of view, in this context, the appeal to be and remain *customers* purchasing content is now no longer a purely legal one (pointing out simply that any breach of copyright is illegal and may be pursued through the courts), but instead operates on moral and communal levels: it highlights the fact that the creators of content *should* be rewarded for their work, and that the community of fans overall will suffer if the creation of further content is undermined by falling revenues.

Such arguments are substantially easier to maintain for industry participants who have not been strongly implicated as key drivers in previous punitive approaches to dealing with the peer-to-peer content sharing phenomenon, of course; indeed, as many users now understand the major media industries to be highly exploitative businesses operating according simply to the financial bottom line, and not necessarily in the best interests of artists and other creative practitioners, such arguments for users to act morally in their engagement with commercial media content can be successful only where they are made by individuals and institutions understood to have themselves acted morally and ethically in the past, or where the costs of acting morally are not significantly higher than those of engaging in copyright 'piracy'.

To fully understand the cost-benefit calculations made by users as they choose whether to pay for access to online content, therefore, it is not sufficient to examine simply whether they would be able to gain access to the same content for free elsewhere: judged on that basis alone, most commercial models for distributing digital content for pay online *are* doomed to fail, as any protected content of any interest is virtually assured to become available for free through legal or illegal means soon after its release. But beyond this, other factors do come into play:

- the ease and safety of accessing the content from a reputable source, in a convenient package (which must therefore not prevent common practices such as transfer between devices or re-encoding to other digital or physical formats);
- the relative cost to the user (in terms of time, effort, and broadband service fees, as well as personal self-perception) of accessing the content not from its original source, but from a filesharing network or other unauthorized redistributor;
- the user's loyalty to the content creator(s), and extent to which they believe that only direct financial support will ensure the continued creation of further content.

The success of *iTunes* where other music download services such as the music industry-operated 'zombie' version of Napster have failed, then, is easily explained by the fact that contrary to the music industry coalition which took over Napster, *iTunes* operator Apple had an untarnished reputation among music fans (or indeed, had gained a significant positive reputation through the popularity of its iPod portable music player), and that it managed to find the right price point for the music downloads it offers; to the average participant, the financial cost of using *iTunes* is not substantially higher than would be the cost in terms of time and effort of joining a filesharing network to search for specific music tracks, added to the cost in terms of moral self-worth resulting from such actions. This does not mean that all potential filesharers will use *iTunes* instead, or that music bought from *iTunes* will not be shared through the networks subsequently, but it clearly has provided an alternative model of accessing digital music that has become at least competitive with the 'free' content available (largely illegally) through filesharing.

In addition, where *iTunes* offers relatively low prices and high convenience, the success of commercial models for content distribution using the BitTorrent filesharing network in cases such as the online music label *DGMLive* (which distributes the music of veteran guitarist Robert Fripp, progressive rock band King Crimson, and other related artists) is explained less through its pricing strategy, and more through its direct tie-in to existing enthusiast communities. In the case of this and other artist-driven music sales sites, the visible commercial transaction is no longer simply between audi-

ence and musical distributor (or the industry more generally) as intermediary, but directly between fan and musician; this enables the musician to appeal directly to the ethics of their fans, pointing out that insufficient financial returns will directly and immediately impact on the artist's ability to create further work.

Indeed, where this moral appeal is dominant, it is even possible for artists and labels to explore the possibility of an honors-based voluntary pay system, in which content is freely available, but users are strongly encouraged to show their appreciation by contributing financially *a posteriori* if they like what they see, hear, or read. (Such a model essentially translates Shirky's 'publish, then filter' approach to professional artistry: in music, it could be described as 'listen, then pay,' for example.) That model, however, also crucially depends on the artists' trust in the continued quality of their own work; further, it may make them subject to their fans' established preferences and reduce their ability to explore new styles—but such tendencies are no different from commercial artistic practice under established industry models, of course. A 'watch/listen/read, then pay' model would have the advantage of being highly accessible also to potential new fans, enabling them to sample an artist's *oeuvre* before committing to a purchase, and in this is simply an extension of the existing *de facto* model of curious users borrowing from friends or downloading from the networks before making a purchase decision; however, it does afford the artist themselves better control over the content so sampled than is possible under the rather more random traditional model of borrowing or downloading.

To some extent, such models can also be seen as a further move beyond a conception of the artistic work as a product, of course: payment here is no longer for the content itself, but for the service thereby rendered by the artist (to the individual fan, but in a wider sense also to the community overall, or—in the eyes of committed fans—even to humanity as such). This, then, is a postmodern, postindustrial reinvention of the medieval concept of royal patronage, democratizing the concept by basing it not on the support of a single wealthy patron, but on the support of the fan community as a whole. It points to significant changes in the relationship between artists and audiences, and (in keeping with the creative produsage models we encountered in the previous chapter) may also provide a pathway towards a greater involvement of fans in direct collaboration with their favorite artists; it would help embed the artist as leader of a produsage community formed around their works, rather than maintaining a creative distance between practitioner and audience (this may have both positive and negative effects, however, as artists could feed off the creativity of their audiences, but may also be compromised in their ability to work independently). Artists who have issued 'remix challenges' to their fans (for example through the music site *ccMixter*) may be seen as early adopters in this context.

It is crucial to note that such models which depend on the ethical behavior of users are not only more likely to succeed if the appeal to act ethically comes from a source which is itself seen as an ethical actor (thereby in the eyes of many users ruling

out much of the established structure of the media industries), they are also feasible only where users *are* seeking or at least leaving open the possibility of a longer-term involvement with the artist or genre; such models are possible mainly, in other words, where users are already enthusiasts, or are willing to become fans. Ethical appeals are unlikely to succeed in cases where access to content is expected to be a one-off event only (where for one reason or another a user is purely sampling, without any intent to return), or where there is only highly limited buy-in to the artist or genre—it is not surprising, therefore, if *DGMLive* with its connection to the tight-knit and highly specialized community of progressive rock fans is successful in generating sales among its users; it would be substantially more surprising if a site providing the music of more generic, mainstream acts from Britney Spears to Robbie Williams were to be able to generate a comparable level of customer commitment, on the other hand. (That said, even harnessing only the most committed core of the listener community for such artists may still be able to generate substantial revenue in its own right.) The same is likely to be true in other fields of culture, too—the *Battlestar Galactica* experience may not be repeatable by shows like, say, the *CSI* family, whose audience *may* constitute a less unified and committed community.

Thus, it is likely that for industry attempts to employ ethical rather than legal appeals to persuade users to become customers, success will lie outside the mainstream; "the new riches will come from servicing the new niches,"[5] not from embracing the traditional centers of cultural content creation. On the other hand, the *iTunes* model of charging a relatively modest fee for the convenience of accessing such content without having to resort to unregulated filesharing networks may still be feasible here, and is now being explored by shows such as *Desperate Housewives*, for example. (Beyond charging *a priori* or *a posteriori* for access to specific content, of course, a further possibility would also be the inclusion of a generic content access fee in the overall costs of broadband, in exchange for an end to the legal prosecution of filesharers; such models usually find it difficult to answer the question of how the money thus raised would be distributed through the industry and to specific artists, however.)

From Produser to Producer?

Most of the commercial approaches to produsage which we have discussed so far deal mainly with the embrace of produsage communities by traditional producers in an effort to harness the distribution, evaluation, and sharing practices common in such communities. Although this is necessarily an important step especially in the context of electronic networks which make obsolete many of the traditional models for content distribution and product marketing, it provides only one opportunity for the commercial embrace of produsage. Just as important is the opposite move of attempting to incorporate noteworthy producers themselves into the production industry.

Such tendencies are now also in progress, though slowly and still hampered by industry obstacles.

Indeed, it appears that new rather than traditional players in the media industries are most likely to be able to harness the creativity of produsage communities and individual produsers; *Current.tv* provides one example for this trend. Any attempt by conventional television broadcasters to establish a project such as *Current.tv* would be likely to be regarded by potential contributors as a blatant attempt to cash in on the produsage and videosharing trend; in addition, content submitted for the channel would be required to be consistent with the established corporate identity of the parent organization. *Current.tv*, on the other hand, provides a clean slate, and comes certainly not without its own 'corporate identity' (through the role of Al Gore in the organization, it may well attract a range of submissions that is skewed substantially towards the progressive side of U.S. and international politics, for example), but at the very least presents an identity that is significantly at variance from the mainstream of commercial television.

Similar tendencies apply in the realm of music. Here, a number of independent music sharing sites have emerged that are explicitly focused on providing a space for unsigned, semi-professional artists to make a name for themselves; on Websites such as *Garageband* (not to be confused with the Apple Macintosh music software of the same name) and *Purevolume*, bands and solo musicians can upload recordings of their music and create mini-Websites providing information about themselves. Further, such sites allow for the download, communal evaluation, and rating of this music, resulting in on-site charts and in-depth engagement among fans and between fans and artists; they also offer the means for artists to sell self-produced CDs, DVDs, and other merchandise directly to their fans. Such sites engage not in the produsage of music as such, therefore, but could be described as promoting the produsage of fan communities; several successful artists emerging from such environments have now been signed by major music labels.

At the same time, however, the ability for artists to find at least off-mainstream artistic and commercial success through such sites may also increase their reluctance to enter the industry proper, where they might reasonably expect to be provided with a more limited sense of artistic freedom (in pursuit of greater popular success), and to be confronted with the exploitative corporate practices which have come to characterize the mainstream music business. For a band or musician able to operate successfully (both from an artistic and a financial perspective) by themselves, and without the trappings of the wider music business, within the community-driven environment of a *Garageband*, perhaps to remain in that environment constitutes ultimately a more sustainable option than to enter the industry star system; in addition, as they develop a loyal following of their own, the artist-run direct-to-enthusiasts marketing system exemplified by *DGMLive* and similar sites also becomes an ever more feasible option.

Such tendencies to become one's own producer—particularly pronounced of course in fields in which quality production technologies are now readily available to the 'end user,' such as text, image, and music, but less so in television production, and much less so in motion picture production—may come to substantially undermine the range of inputs available to the traditional industries in these fields. Already, for example, music self-publication could be seen to be responsible for the continuing contraction of focus by the major music industry players on a small number of headline artists; the industry's traditional star system model no longer copes well with the emergence of a vast range of alternative, enthusiast-supported, and self-distributed 'niche' artists and styles over the past decades. Similarly, the growing ability for television producers to bypass broadcasters altogether and market their shows directly to audiences for download is set to affect significantly the range of television formats we will see on our screens in the future; phenomena such as the BitTorrenting of *Battlestar Galactica* or the vocal fan campaign opposing the cancellation of *Farscape* would indicate that at least within the science fiction fan community, critical mass for direct-to-online 'television' models may now be available.

What such emerging alternatives to traditional production and distribution have in common is that they are strongly driven by fan power: they are most likely to succeed in areas where the existence of a strong and loyal enthusiast community provides both a ready-made market for quality new content, and the likelihood that loyalty to genre and artists will lead at least a substantial section of the community to agree to contribute financially to fund further production at least in part (another contribution to funding may well be provided by embedded or contextual advertising, especially if products prove to be successful). Some of the synergistic effects of the traditional studio production system may continue even here, of course; studios may choose to be involved in developing a number of series across different fan communities at the same time, to cross-subsidize struggling product through the proceeds of more successful series. However, instead of appealing to the greatest possible audience across the entirety of the viewing public, as they would do in a traditional television context, they would now directly aim to achieve only the greatest possible audience share within a specific niche, enthusiast, fan community; where successful, this is likely to further increase the loyalty of fans who from past experience are accustomed to having 'their' plots watered down through the incorporation of extra-generic elements designed to appeal to non-core audiences.

Where they find success, such niche-driven production models are likely over time to substantially alter the operations of traditional media, the available overall media mix, as well as our cultural frameworks themselves. To begin with, the more the operation of niche production and distribution approaches is finding success, the less 'niche' do such approaches become; the success of niche programming will contribute to a swelling of the enthusiast communities themselves, and thereby shift the balance between mainstream and off-mainstream further in favor of the many communities

existing in the long tail of cultural diversity outside of the tall peak of popular, mass culture.

> With consumers not only being comfortable wandering further from the beaten path, but the beaten path also being much easier to leave … , they discover their taste is not as mainstream as they thought. Mass popularity was based more on what was available (think mass marketing budgets, limited physical shelf space, limited broadcasting channels, and a nearly complete lack of transparency), than on absolute laws of nature that dictated 'good' or 'bad'.[6]

The net result is not a simple replacement of mainstream and non-mainstream tastes, however—this is no simple reversal of the peaks and troughs on the long tail graph. Indeed, that graph itself is somewhat misleading, as it condenses the many and varied cultural options existing outside of the mainstream of mass culture into a single, one-dimensional continuum from 'popular' to 'unpopular'. In reality, it would perhaps be more appropriate to speak of a gentle slope falling away in all directions from the tall peak of common-denominator mass culture, surrounding that peak in a 360 degree circle. Different sections of that slope represent different taste cultures which have found their home there, and these cultures and communities sometimes overlap considerably, and sometimes police their boundaries with a quasi-religious zeal; some communities will allow their members to have many other citizenships, some will require commitment only to the one true culture. At any rate, there is no longer any one publisher, broadcaster, or other media producer whose message reaches and unites all the inhabitants of that slope extending to the horizon—some continue to broadcast from the highest peak in hopes of reaching the largest possible audience, but many have chosen instead to set up community stations in various locations further down the foothills.

Figure 10.2: The Tall Peak and Gentle Slope of Mediated Cultural Communities[7]

Those still attempting to reach the largest audience will increasingly come to focus on the core advantages of their media form. Television, for example, already shows signs of contracting in the direction of live broadcasts—from 24-hour news channels to sports, from reality TV to late-night call-in gameshows. Other programming, by virtue of being prepackaged *programming*, is just as easily, and from the user's perspective significantly more conveniently, made available through online, on-demand services; in the age of TiVo and portable media players, for any non-live content, broadcast has become only an imperfect delivery mechanism for shows to be viewed in time- and space-shifted form at the viewer's discretion. Indeed, as *Battlestar Galactica* demonstrates, and as is further reinforced by Jenkins's description of the spoiler community which has emerged around the *Survivor* reality TV series (aiming to uncover the mysteries and likely plot developments of the series even before it goes to air, even if that means sending community members to the exotic shooting locations themselves),[8] even quasi-live events such as the premieres of new series and new seasons of popular shows are no longer 'live' enough for many viewers: if events on television are not taking place the very moment they are recorded, chances are that someone has already posted clips on *YouTube* or distributed them through BitTorrent.

> Word of mouth now travels the world instantly, making every new product launch globally in a flash, and turning every new brand into a potential global player. ... The information gap has already closed, and it won't be much longer before the distribution gap is history too. Sony still (but only just) gets away with a phased introduction of its PSP. There is no such escape for anything that can be digitized: it needs to be rolled out around the world in one go, as consumers anywhere may hear about it within hours, then want to watch it, listen to it, read it, and [they] won't hesitate to download pirated versions if you make them wait too long.[9]

Similar problems also exist for the movie industry, of course; here, the solution has been to focus increasingly on staging cinematic events which cannot possibly be replicated even with the growing availability of high-end home theater entertainment packages to the 'average' user. Such approaches are feasible only for a sub-section of all cinematic entertainment, of course, and threaten the survival of other movie genres in the cinema. Cinema also suffers markedly from its necessary reliance on geographically unified audiences, and the use of physical carriers for films themselves (which limits their distribution); the need for patrons to seek out what is playing where, and to literally go to the movies—that is, the inability for cinema to offer any potential of time- and space-shifting the viewing experience—is increasingly emerging as a severe inconvenience in a media world which otherwise offers such affordances almost everywhere. A move further towards digital projection may be beneficial insofar as it would allow a broader distribution even of minor films (since, as with all digital products, the creation and distribution of additional copies is essentially cost-free), and ultimately even the on-the-fly reorganization of screening schedules in immediate response to cus-

tomer demand, but the changeover costs remain substantial at present. Although improvements in home entertainment and the strong market for DVDs do not attempt to have hurt cinema patronage all too badly to date, therefore, it is nonetheless possible that we may see a further move of cinematically non-lucrative projects towards a direct-to-DVD, or increasingly, a direct-to-download model. This could lead to a gradual amalgamation of the direct-to-download production industries in television and cinema, of course.

The music industry, finally, faces perhaps the most significant challenge, as its incumbent peak organizations also remain most staunchly opposed to change. Here, a casual collapse of the traditional industry is perhaps most likely; indeed, those industry players associated in the peak bodies of music and movie industries (in the American context, RIAA and MPAA) have already increasingly adopted a highly literal understanding of the description of their industries as 'copyright industries,' and appear to focus largely on sustaining their operations through the enforcement and exploitation of existing copyright properties rather than the development of new products and genres. Most stylistic research and development in music now takes place outside of the mainstream industry, and increasingly it is likely to remain there as produsage-driven and enthusiast-supported community markets provide a viable alternative for artists reluctant to enter the cut and thrust of the core industry.

From this perspective, then, "the emerging digital entertainment economy is going to be radically different from today's mass market. If the 20th-century entertainment industry was about hits, the 21st will be equally about misses"[10]—that is to say, much more of the commercial and semi-commercial activities of the wider industry are likely to take place outside of the tall peak of mass culture, where even what are considered in conventional terms to be misses rather than hits can still attract a significant audience. This, then, could be regarded as a sign of cultural fragmentation: the taste communities arranged on the slopes around the tall peak of mass culture are now no longer in sight of each other, and may indeed take positions which are inherently incompatible with one another, threatening cultural and social cohesion. However, such threats have been thematized ever since taste subcultures first came to be studied, and have as yet failed to materialize as dramatically as may have been expected; a reason for this is that no one taste culture ever operates on its own, and that no one community member ever serves as part of only one taste culture. In reality, our tastes and interests are always multiple, and more or less diverse and contradictory, our personas never unified or uniform; through our everyday interactions with others, and with culture itself, we sustain the continued engagement between the different cultural and social perspectives and communities in our society.

Clearly, such engagement is not perfectly distributed, of course; indeed, we might suggest that the quality of social and cultural exchange in society is directly related to the diversity of interests and tastes held by any one of its members. A further move towards niche cultures, far from fragmenting society, could therefore also be seen to

increase our mutual understanding for each other's perspectives by highlighting the very diversity of views and interests now held by different groups. This, Jenkins suggests, is a side effect of convergence: "convergence represents a cultural shift as consumers are encouraged to seek out new information and make connections among dispersed media content."[11] Manifestations of such shifts can be seen throughout the developed and developing world, as cultural tastes have become more diverse and previously 'niche' cultures become ever more popular—examples in the West include a new-found fascination with the martial arts of Asia as interpreted through *Matrix*, *Kill Bill*, and other movies, or with the colorful action of Bollywood cinema as represented and reinterpreted in an increasing number of East-West crossovers. Such developments cannot help but promote a greater cultural exchange.

It is perhaps most appropriate, then, to understand today's society and culture not simply as unified or fragmented, internally coherent or inherently contradictory, but instead as *networked*: cultural influences in this networked social structure travel by word of mouth, traverse the realms of diverse communities and are reinterpreted and changed in the process, disintegrate and recombine in new combinations on an ongoing basis. Making sense of this are no longer the mainstream media as the giant filter of cultural options according to what is popular, but the network itself, in which hubs rise and fall, nodes shift and clusters form; the determinants of social and cultural change are the people formerly known as the audience themselves, having turned users and produsers, creators of culture and of knowledge about culture, influencing one another's decisions about cultural participation on a peer-to-peer basis by recommending what to seek out, what to avoid.

Mass markets, of course, will not disappear altogether; the gentle slope of community-based taste cultures most likely cannot exist without the tall peak of mass culture in its center. Indeed, for the foreseeable future, a strong industry trend towards a re-amalgamation of popular tastes into mainstream culture will continue, even if it is becoming increasingly evident to the producers of mainstream culture that production models built on the embrace of individual enthusiast communities can be just as successful as those built on the largest common denominator. Generally,

> we'll still need mass, whether it's for low cost goods or to satisfy sudden cravings to belong to a larger group. And something that is really, really good or desirable will still be able to reach mass status. But it will be mass by choice, not mass by scarcity.[12]

It will be mass culture, in other words, not due to the efficiencies of an outdated industrial production system, but because a large enough number of users as produsers of culture and cultural knowledge agree on its value.

As Johnson describes it through a metaphor from human history,

> the overall media system will end up reaching a different equilibrium point, somewhere between Roman ultracentralization and the scattered chaos of the Dark Ages.

Out of the turbulence of media convergence, the hill towns will appear. They'll be built out of patterns of local behaviour, and they'll be in continuous flux. But they will give shape to what would otherwise be an epic expanse of shapelessness. The entertainment world will self-organise into clusters of shared interest, created by software that tracks usage patterns and collates consumer ratings. These clusters will be the television networks and the record labels of the twenty-first century.[13]

The New Creative Industries

These *new* creative industries, then, will have little similarity with the existing industries of publishing, music, television, and film. Though not necessarily engaging in produsage itself, they will be substantially more engaged *with* produsage communities (both communities producing media content themselves, as well as communities producing information, knowledge, and recommendations about the media relevant to their specific enthusiast interests). At first, we are likely to see such industries continue to operate as cottage industries in the hill towns located on the gentle slopes of culture, alongside the established leaders and their media factories on the tall peak, but over time, that balance is likely to shift; in the media environments of the mid- or even the short-term future, the balance between cottages and smokestacks is likely to be redressed in favor of the cottages. This is part of an overall shift from a focus on producing media commodities, with a focus largely on their exchange in the market or "commodity space," to creating knowledge to be shared in the knowledge space, as Lévy suggests:

> the commodity space is incapable of apprehending the knowledge space as such. We can't buy or distribute the thought of a collective intellect. We can only commercialize its projection on the commodity space, propagate unattached signs in the media market. But in doing so the reciprocal interaction of the collective intellect and its world is dissolved. Thought is no longer involved.[14]

Only where commercial aspects of the exploitation of media properties dominate, then, do traditional media industry models prevail; elsewhere, the smarter, more mobile, more community-connected new players of the creative industries will exercise their competitive advantage over the majors of old:

> the knowledge space will nourish the commodity space to the extent that it can free itself of it. The sooner intelligent collectives escape the territory, the better off governments and institutions will be, once freed of their stifling castes, bureaucracies, and history.[15]

The new players, then, are embedded into the networks of community and cultural exchange, and *participate* in such networks where traditional industry only utilized them to capture new product for the media industries once it had become

sufficiently visible; the new operators instead connect directly into the grassroots of fandom and creative practices to cultivate new ideas and new participants, they work with, for, and as part of communities, and share in their tacit knowledge and informal practices. Indeed, as Bauwens notes, it is true in many industries that

> most value is not created in the formal procedures of the enterprise, but despite it, because, despite impediments, we remain creative and cooperative, against all odds. We come to the job, no longer as workers just renting our bodies, but as total subjectivities, with all we have learned in our lives, through our myriad social interactions, and solve present problems through our personal social networks.[16]

The emerging model of creative industries as it has been formulated over the past decade recognizes such effects, and encourages media, information, and cultural industries to revise their practices to better address the fundamental principles of creative work.[17] In particular, it points to the fact that in creative as well as many other enterprises, a networked heterarchy of participants produces greater potential for development and innovation than a hierarchical bureaucracy; as Miller and Stuart explain,

> in a cellular world, power is transactional, not institutional. Network-centric organizations measure their effectiveness not by how much money they raise or how much press they get, but by how well they are able to make fruitful connections between their constituents. Interactions are more important than broadcasts.[18]

This, of course, is all the more pertinent in the context of an increasingly networked culture—'networked' to be understood here as both referring to the decentralized, fragmented, multiply interconnected structure of culture and society itself, as well as its underlying and enabling technological systems of peer-to-peer communication.

Such networked structures necessarily shift power away from the core, the tall peak, and towards the periphery, the gentle slopes; the top end of overall industry structures still remains important, of course, but no longer acts as the sole (or even a key) determinant of cultural developments or 'mass' culture; indeed, mass culture itself gradually dissolves and is reconstituted only occasionally. In addition, there is a potential that "consumers will be more powerful within convergence culture—but only if they recognize and use that power as both consumers and citizens, as full participants in our culture."[19] Grassroots or vernacular creativity, in particular, comes to play an ever more important role as the research and development engine of our many interwoven cultures; as Quiggin suggests, the new-found openness of media

> allows for innovation in the content and style of the text and other material presented. This in turn produces new genres of writing, as models based on pre-existing media turn out to be inadequate. Finally, the desire to extend the medium, and to respond to problems that emerge, produces a steady demand for, and supply of, technical innovations of various kinds.[20]

Grassroots creative produsers themselves therefore gain the chance to become not only artistically, but also commercially successful; not necessarily in the manner of the stars of the traditional media system (though this remains a possibility as well), but at least as respected content creators and community leaders within their own enthusiast communities. Generation C may thus turn at least in part into Generation Cash, as its members turn into 'minipreneurs' or join with others in entering the community's local cottage industries.[21]

In addition, as Quiggin points out, a strong market in the tools to enable grassroots creativity, and the distribution, evaluation, and sharing of such produser content also emerges; this is already plainly visible not only in the development of many of the produsage environments which we have encountered in this and earlier chapters, but also in the Web 2.0 movement's strong focus on providing APIs and other means of accessing, combining, remixing, and mashing up the content available from various sources around the Web in pursuit of new recombined forms of creative and communicative expression.

At present, it is notable in this context that for copyright reasons such remix facilities necessarily favor materials which are already freely available online; the established copyright industries' continuing defense of their properties from repurposing through remixing must therefore ultimately have the negative result of effectively excluding such materials from wider cultural circulation unless that industry stance is reversed (or at least no longer enforced, as may to some extent already be the case). For as long as remix artists working in audio and video formats are still prosecuted for their work, these creators as well as their creative work are driven underground, on the one hand significantly stifling the ability of such genres to flourish, yet on the other hand also creating an ever more loyal group of fans and supporters; overall, however, cultural diversity and the right to free cultural expression suffer. Although copyrighted inputs to such art forms remain important, the copyright industries should consider whether they stand to gain or lose from such action: while protecting their right to generate further returns from the commercial exploitation of their property, they also limit that very exploitation both by rejecting the possibility of such new art to become commercially successful, and by negatively affecting their own brand image. As non-copyrighted inputs are used effectively in the place of copyrighted content, too, the industry loses further hold on its cultural position of centrality, and ultimately diminishes in stature; it begins to deny its own continued existence by preventing the cultural circulation of its content.

Detaching Authorship from Ownership

Observers have increasingly pointed out that current intellectual property (IP) models, especially as they continue to extend the terms of copyright protection, narrow avail-

able exceptions from protection, and criminalize additional forms of potential uses for copyrighted material, are not only imperfect, but indeed directly opposed to the processes of innovation and intellectual development which they were originally meant to encourage (by providing the holders of IP with an assurance that they are able to generate income from their work). As Benkler notes, for example,

> prohibiting technologies that allow individuals to make flexible and creative uses of digital cultural materials burdens the development of the networked information economy and society. It burdens individual autonomy, the emergence of the networked public sphere and critical culture, and some of the paths available for global human development that the networked information economy makes possible. All these losses will be incurred in expectation of improvements in creativity, even though it is not at all clear that doing so would actually improve, even on a simple utilitarian calculus, the creative production of any given country or region.[22]

Indeed, von Hippel goes so far as to describe the ultimate effects of the increasingly stringent and extensive protection of IP rights through the extension and aggressive enforcement of applicable laws as contributing to "a tragedy of the anticommons," leading to a situation in which "multiple owners each have a right to exclude others and no one has an effective privilege of use."[23] Part of what emerges through the extension of copyright and patent terms, and the application of such protections to an ever widening range of IP use practices, is what he describes as a patent thicket: a dense network of usage restrictions which have mutually deleterious effects not even because of their actual enclosure of information and knowledge for exclusive use by IP holders, but simply because of the potential that such IP may be claimed to be enclosed:

> patent thickets create plausible grounds for patent infringement suits across a wide field. Owners of patent thickets can use the threat of such suits to discourage others from investing research dollars in areas of technical advance relevant to their products. Note that this use of patents is precisely opposite to policy makers' intentions to stimulate innovation by providing ways for innovators to assert intellectual property rights.[24]

Although von Hippel focuses here largely on patents and industrial processes of innovation, much the same tragedy of the anticommons applies also in areas of information and knowledge innovation commonly governed more by copyright than patent law—just as in industrial innovation, "corporations that can use a patent thicket to deter others' research in a field might well decide that there is less need to do research of their own,"[25] so does the ability to deter potential genre innovators in the media through copyright enforcement limit the need for IP holders to create innovative new content in their fields, for example. Much of the artistic practice of remixing and mashup, for instance, is constantly under threat of legal action by copyright holders, and is therefore largely prevented from developing a commercially viable industry

model of its own; artists engaged in audio or video mashup are unable to derive direct financial benefits from their artistry because what we may describe as copyright thickets governing their source materials prevent them from anything but the free sharing of their work (and may make even such practices potentially illegal and prosecutable).

Indeed, we can also see the deleterious effects of such IP anticommons by observing the comparatively explosive growth in innovation and development once conditions shift so that such copyright and patent thickets no longer hold sway over potential competitors. Open source itself, for example, by consistently basing all of its work on a commons model and studiously avoiding any inputs copyrighted or patented by the conventional software industry, has been able to bring its core projects to a 'commercial' grade of quality often more quickly and successfully than the commercial model itself has been able to; similarly, the explicit opening of application programming interfaces (APIs) to external participants in the context of Web 2.0 has generated a substantial amount of new content and information services more quickly and more successfully than a previous decade of conventional Internet services development had been able to. Produsage itself is built on such approaches, of course: by avoiding the engagement with and development of copyright and patent thickets, its communities are able to explore more rapidly and more widely the options available to them for the further development of their projects than would have been possible in an environment governed by more traditional principles of IP protection.

Produsage transforms conventional understandings of intellectual property rights by detaching authorship from ownership, and this is enshrined in the produsage principle of **communal ownership, but individual rewards**, as we have discussed it: while individual *ownership* in IP (a construct developed to enable authors to extract direct financial benefit from their work) is largely dissolved and converted to communal ownership, individual *authorship* (a concept enabling authors to claim personal merit for the quality of their work) remains respected, and is in some cases even highlighted more prominently than under a hierarchical production model in which financial and not reputational and social benefits provide the central motivation and reward for participation.

The produsage concept of asserting individual authorship in contributions to produsage projects should not be misunderstood to be broadly analogous to individual authorship in the traditional model of production, however: as is clearly evident from most produsage environments, it does not mean that the individual artefacts collected in such environments are each the work of an individual author, in the same way that this may be true (to some extent) for industrially produced collections such as newspapers or encyclopedias, or for creative products. The granularity of contribution on which produsage is built means that even the individual artefacts within the produsage space are themselves often created from a large number of individual contributions which may range from a minor bug fix to an entirely new component for the overall project; at the same time, however, in most cases the technological supports or

social conventions of produsage also do make it possible for individual participants to point directly to the contributions they have made, even down to an individual comma in the *Wikipedia* or to a single utterance in citizen journalism debates.

This constitutes a markedly different sense of authorship than is the case for traditional production, and from a conventional perspective, therefore, Quiggin is right to describe the content of *Wikipedia* and other wikis co-authored on a massively distributed basis as appearing to be 'authorless':

> the authorless nature of wikis creates obvious problems for theories of intellectual property based on the assumption that creative work is, in its origins, the product of individual effort, and that large-scale collaboration will normally take place under conditions of 'work for hire'. ... The growing significance of wikis is highly problematic for policy frameworks organized around notions of 'strong intellectual property'.[26]

Instead of regarding *Wikipedia* and other prodused resources as inherently and irretrievably authorless, however, it may be more accurate to describe them as lacking *individual* authors and owners, and as being authored and owned instead by the overall *community* of contributors.

Bauwens notes that peer-to-peer content creation has led to the emergence of "a new public domain—an information commons—which people are expected to protect and extend, especially in the domain of common knowledge creation."[27] That said, however, the commons does not equate simply to 'public domain'—a model in which all content is simply available to all users, without restriction. The information or knowledge commons models employed by produsage projects are substantially more sophisticated; here, individual users specifically give up a limited set of ownership rights in order to enable their peers to engage in the further development of such resources, and they do so in a manner that is defined very clearly and with legally binding effects. Specific rights given up in the process generally include for example the right to determine any further use of one's IP (at least as far as non-commercial use is concerned), and especially the right to allow or prevent others from using the content; rights retained, on the other hand, frequently include the right to be acknowledged as a co-creator of the content and of any further resources which incorporate it, and the right to be involved in and benefit from any decisions over the *commercial* exploitation of the content.

(It is important to note here that not all of the produsage models we have encountered in this book do apply appropriate commons licenses, of course: some—like filesharing and other forms of reworking and remixing creative content—largely ignore the legal ramifications of their practices altogether; some—like *YouTube* or *Second Life*—exist within a corporate enclosure governed by end-user licenses that may require users to assign commercial rights to their IP to the proprietor of the produsage environment. Such unclear or corporate licensing frameworks for content produsage are prob-

lematic, and may well threaten the long-term sustainability of a produsage project itself as they remain open to legal action against or commercial exploitation of participants.)

The information and knowledge commons structures developed through such legal mechanisms usually establish a form of regulated, yet (under the conditions of these regulations) open-access commons[28]—or more specifically, a commons which is open to use by all, but open to participation in further *development* only for those who are prepared to accept the license conditions already imposed, and to release their own contributions to the common project into the commons under equivalent license conditions as well. Overall, then, "the salient characteristic of commons, as opposed to property, is that no single person has exclusive control over the use and disposition of any particular resource in the commons"[29]; the commons is governed in the first place by the licenses which producers have put in place to manage their content, and by the community itself as it enforces those licenses both through social means (such as peer pressure to comply with the licensing requirements) and, sometimes, directly through legal means (open source and Creative Commons licenses have now been tested successfully in a number of national jurisdictions).

Communities as Copyright Holders

This further points to the crucial importance of the role played by the *community* of produsers as the collaborative manager and controller of produsage processes, and to the question of how that role can be recognized more effectively given that the community itself is constantly in flux and organized only through heterarchical, *ad hoc* structures of governance. The appearance of produsage leaders such as Linus Torvalds or Jimmy Wales in discussions of produsage projects is misleading in this regard; although both played crucial individual roles in kickstarting and guiding their projects, especially as those projects generated broader levels of involvement by vast communities of produsers, Torvalds and Wales (and many lesser-known leaders of produsage projects) moved further into roles as figureheads and public representatives of their communities rather than conventional, hierarchical leaders; their ability to *lead* in a conventional sense is today highly limited. Even if Wales holds *Wikipedia*'s equivalent of nuclear launch codes in his ability to ban users from the community at will, to exercise such powers without due consultation would likely result in similar mutually assured destruction, as the community would protest *en masse* against such interventions.

Traditional intellectual property frameworks provide no clear place for communities as entities able to protect their own interests and their own property, and able to drive the processes of innovation in information and knowledge which IP protection is meant to ensure, however; as Quiggin notes, "in most discussion of innovation policy, markets and bureaucracies are assumed to exhaust the set of institutions to pro-

duce innovation: individuals will produce new ideas, it is implied, only if they are either directed to do so by a manager or rewarded for doing so by the market."[30] Clearly, produsage highlights the myopia of such views, and it may be necessary, therefore, to move beyond current frameworks for IP as held only by individuals (or by corporations acting as legal persons), and to develop models which allow for a truly communal ownership of IP.

Even produsage itself is far from free from a focus on the individual as the beneficiary of IP ownership, of course. Questions around ownership remain centered especially around the recognized leaders of produsage projects at present: do the originators of such projects—a Linus Torvalds or a Jimmy Wales—remain the main beneficiaries of their own magnanimity in providing the initial motivation and seed content for the project? If so, should their ability to benefit be considered in the first place as their just reward, or does it turn into an exploitation of community labor at a certain point? This is also a question relating to community structures and the fluidity of the project heterarchy, of course: if the project originator remains the undisputed leader and public face of the project, to the exclusion of all others, then this is likely ultimately to alienate the wider community; "any desire to contribute to a community or to an organization developing radically new ways of conceiving cultural transmission will be squashed."[31]

What is necessary instead is perhaps to provide the opportunity for other valuable contributors also to begin to benefit from their sustained commitment to a project. While such opportunities are provided for example in open source as software development companies offer paid employment to individual well-credentialed open source developers, they are more difficult to envisage in cases where the project as a whole generates a commercial profit, which could be distributed back to participants. As Pesce notes, for example,

> it is possible to know who created any article in Wikipedia, but it is also pointless. Wikipedia is contribution atomized, reduced down to words and phrases which, out of context, bear no value. Only in its collective whole does it have value; that value can not be licensed or sold without being viewed as the most obvious sort of theft. Projects which rely on peer-production inevitably come to resemble Wikipedia's atomization of contribution.[32]

The downside of atomization (another metaphor for what Benkler describes as granularity, which as we have seen is a necessary precondition of produsage processes), then, is that it makes it virtually impossible to accurately distribute back to the community the proceeds potentially generated from produsage outcomes—quite apart from the logistical problems such attempts would face. What is the value of a single grammatical correction, or of a contribution to an entry discussion page that helped solve a conflict between opposing views on how best to represent available knowledge on a specific topic?

Such questions highlight the fact that conventional models of IP, even where they are modified through the development and implementation of open source, commons licenses, still fail to fully address the problem of large-scale collaboratively prodused resources. What open source and Creative Commons licenses enable is the streamlining of negotiations between individual contributors to a common project: by applying a blanket license accepted by all contributors to the project, produsers can ensure that current as well as future generations of participants have a guaranteed and unified set of rights in and obligations towards the resources developed by the community.

However, contributions to such shared resources ultimately remain individually owned: IP holders merely waive some of their rights to enforce such ownership. In their interaction, the individual license agreements for their own contributions which each participant accepts as they contribute to the produsage project act as a kind of 'license thicket,' a mirror image of the patent and copyright thicket of the conventional IP industries: rather than progressively diminishing the possibility of innovation with each new copyright and patent, as the copyright thicket does, this license thicket positively reinforces the innovative potential of the community as each contribution to the commons further broadens the basis of material guaranteed to be available for further development.

But perhaps it is now time to escape the thickets altogether. As Lévy notes, the recognition of *individual* rights to ownership of IP, as a means of encouraging innovation by providing an opportunity to profit from it, was itself a key development; today, the experience of produsage strongly points us to the further realization that

> we are now faced with the necessity of making a similar transition with respect to the skills and intelligence of collectivities, for which no system of measurement currently exists, no method of accounting, representation, or legal regulation worthy of the name, although they are the source of all contemporary forms of power.[33]

Such a shift, then, would enable produser communities *as communities* to gain and hold control of their communal resources, rather than operate through the imperfect legal kludge of collating their individual rights in such a way as to protect the shared resource. Indeed, rather than waiving some rights to enable the sharability, usability, and extensibility—in short, the produsability—of their information and knowledge commons, a move towards true collective ownership of prodused resources would mean that communities would be better able to enforce their full set of IP rights.

In practice, such moves towards communal ownership could already proceed on the basis of assigning all IP rights in the common resource to a single representative of the community (for example, to community leaders like Linus Torvalds or Jimmy Wales where they are clearly visible). However, this would necessarily place a significant amount of trust in the actions of a single person, and would be likely to be perceived as a highly problematic move even where such leaders already have a strong track record of acting in the best interests of their communities. An alternative option

could therefore be the recognition of produsage communities as legal persons able to act for and represent themselves, much in the way that companies are able to do so in certain jurisdictions. (The question of how such legal entities would be governed then also emerges, however, much as it does in the context of corporate governance.)

Wikipedia co-founder Larry Sanger has proposed an alternative model for recognizing communal work, a concept which he describes as 'shopwork':

> *Shopwork*, briefly, stands for any strongly collaborative, open source/open content work. The name is a portmanteau constructed from "*shared open work*"; the name arguably has the advantages of suggesting collaboration in both the original meaning of "shopwork" (which implies something constructed or fixed in a shop, perhaps by several workers together) and, with its parts reversed, "workshop" (which implies participatory learning).[34]

In his proposal, Sanger focuses not on the legal status of the community as the collective owner of shared resources, but on the resources themselves, therefore—his "shopworks are, in a certain sense, *legally* autonomous: versions of them exist, or *may* (legally) exist, independently of any entities that initially develop them. (That, anyway, is the ideal behind their licenses.)" Shopworks, in other words, are not constituted by any one current, past, or future revision of the *Wikipedia* or any other collaboratively created common resource, but incorporate *any* such revisions *simultaneously*: they include the entire range of existing and imaginable combinations of all elements of the shared resource, and exist as entities separate from their creators. Thus,

> one will be able to speak of ... the shopworks themselves, as institutions as well. A shopwork that develops in enough depth to inspire many forks, or versions, is probably going to stick around for a while; lacking any essential ties to any particular organization, its autonomy ensures that it can last as long as we want it to last, and the fact that it is developed by a strong collaboration ensures that it can outlast any particular person or set of people.[35]

Ultimately, however, Sanger's concept of shopwork and the idea of communities as separate legal persons in their own right are nonetheless highly compatible; they constitute two approaches to the same problem which are distinguished only by which aspects of the produsage process they highlight: the common resource or the community of producers. Similar to shopwork as a concept that transcends any current, momentary configuration of available revisions of elements of the common resource, the legal person of the community similarly transcends whatever collective of individual contributors is at work on the produsage project at any given time, and instead includes the full community of committed past, present, and perhaps even future contributors to the project—both shopwork and community-as-person necessarily *must* do so, in fact, due to both the open and fluid nature of the community and the constantly and inherently unfinished nature of the content it has prodused. A shopwork which refers to only one combination of available content elements would become

outdated as soon as any change or addition to that content is made; a community-as-person which has a defined membership must renegotiate its goals and protocols each time that membership changes. In addition, shopwork and community-as-person cannot exist independently of one another; shopworks without contributors are merely dead resources, while communities without shopworks of some kind are merely aimless groups of users. (This does not contradict Sanger's description of shopworks as being independent entities, incidentally: shopworks *as* shopworks may exist independently of "any particular person or set of people," but not independently of the collective community-as-person which transcends such particularity.)

Pesce provides a useful overview of the key issues which result from the potential commercial exploitation of common resources:

> when the wealth of a community leaves that community—when it is committed to print, or licensed out [to] a commercial organization—problems immediately arise. The first of these is the question of authorship: is the creator of the information being recognized as the author the work? If so, the social calculus of expertise expands into a new sphere. If not, it will feel like theft. Next comes the question of money: who profits from the work of another? [Cui] bono? If the host of the community takes the content generated by that community and realizes profit from that content, the creators of that content will immediately be afflicted with a number of conflicting feelings.[36]

The establishment of a legal community-as-person construct would go some way towards addressing such problems—however, to some extent it would also serve simply to shift problems from the leader or host of the community to the community-as-person itself; in the process, it raises crucial questions about the governance of that legal person, of course. Such problems necessarily exist in produsage communities, whether recognized as legal entities in their own right or not: if *Wikipedia*'s Jimmy Wales notes, for example, that "advertising ... would be very lucrative for the Wikimedia Foundation if the community decided to do it, because our cost structure is extremely low compared to any traditional website,"[37] then the operative words to be highlighted here are 'if the community decided to do it'—they point to the question of what consensus-finding processes would be employed in such a decision. What a community-as-person model may provide is an ability to build on existing other 'legal person' constructs, and to modify these as is appropriate for the recognition of open and heterarchical produsage communities as legal persons.

In this context, the question of financial rewards is necessarily always raised as a key concern. It is important also to notice in this context that direct financial rewards have not traditionally provided a significant motivation for participation in produsage, however; produsage communities able to generate revenue from their activities may be better placed to distribute any such monies not to their own members, therefore, but to direct them towards the maintenance of the community and its enabling technologies overall, as well as to further opportunities for outreach and development:

> this problem will not be solved simply by offering content creators a license fee for their content. *They're not in it for the money.* They are **not** professionals. Their motivations have everything to do with the sharing of expertise in a context that is all about social standing and not about commerce. Mixing these diametrically opposed influences will quickly result in a spiraling series of crises, leading inevitably to the collapse of the community, once its members realize that they're being "ripped off."[38]

Whatever the fate of specific concepts such as shopwork and the communities-as-persons which are involved in its creation, at any rate, it appears highly necessary to confront the fundamental problems of intellectual property management to which they point. The development of the concept of IP itself provided a major boost to the practice and processes of innovation, even if today the concept is systematically abused, and utilized effectively to prevent rather than promote innovation; the addition of open source and Creative Commons licensing schemes to address such widespread corruption of IP principles was itself a significant development towards the re-establishment of popular participation in creative and innovative activities. Today, however, it is possible to identify a need to advance further still:

> we have an opportunity to change the way we create and exchange information, knowledge, and culture. By doing so, we can make the twenty-first century one that offers individuals greater autonomy, political communities greater democracy, and societies greater opportunities for cultural self-reflection and human connection.[39]

A further and thoroughgoing modification of IP frameworks to better address and encourage the massively distributed, collective and collaborative practices of produsage as we have encountered them in this book is therefore vital. As Sanger puts it, "what I want to urge is that society respect and, through its laws, support the existence of the presently-nascent general institution of shopwork."[40]

Given the significant hold of present-day copyright industries over policy-making processes in relation to IP, it is unlikely that such changes are going to proceed without challenge; at the same time, the community of produsers (and users) of the information and knowledge commons created through produsage is also developing an increasingly strong and audible voice, and is beginning to make its influence felt in such debates. A global struggle between producers and produsers over the shape of future IP frameworks is possible; at the same time, however, the emergence of corporate players engaging with produsage in a way that is mutually beneficial for both interests also provides opportunities to avoid outright conflict—a redefinition of IP that protects the rights of all participants where appropriate, while allowing sharing, reuse, and further innovative development wherever feasible, certainly remains a possibility. At the very least, of course, the fact that such questions over the relevance and appropriateness of IP regimes are now being voiced and debated in itself demonstrates the substantial impact of produsage-based processes of collaborative content creation on traditional, industrial models.

Shifting the Balance

The conventional media industries' copyright hangovers may significantly dampen produsage- and remix-based developments, then, but they cannot stop them;

> there are people in the commodity or territorial spaces who fear the establishment of a space of collective invention. They are unaware that competition is impossible among the spaces. By preventing the knowledge space from becoming autonomous, they deprive the circuits of commodity space ... of an extraordinary source of energy.[41]

Indeed, the copyright industry's rear-guard battles may be described as battles over the very shape of the creative ecology encompassing knowledge and commodity spaces themselves; they are designed to delay the inevitable shifting of the balance between the two for as long as possible. Such delays are motivated by deep-seated fears about the future, of course; the copyright industries rightly see a dim future for their traditional ways of operation, and at least in part are highly resistant to any change which would undermine their twentieth-century position of dominance over culture itself. That dominance itself, however, was only ever temporary and is ultimately unsustainable; it was a by-product of the temporary dominance of the industrial production model and its application to the production of information, knowledge, and creative work which is coming to an end with the establishment of produsage as a credible alternative. As Jenkins describes it,

> if, as some have argued, the emergence of modern mass media spelled the doom for the vital folk culture traditions that thrived in nineteenth-century America, the current moment of media change is reaffirming the right of everyday people to actively contribute to their culture. ... This new vernacular culture encourages broad participation, grassroots creativity, and a bartering or gift economy.[42]

As much as there remains a reluctance to shift to this model among many in the traditional media industries, for some in the newly reconceived creative industries there also is a race to open engagement—to be the first among the early adopters can itself also generate significant advantages for participants in the industry, of course: *iTunes*, *YouTube*, *Second Life*, and *Current.tv* all benefit from such status.

In the end, of course, a mere embrace of produsage culture by an otherwise unchanged industry is not enough; "ultimately," as Bauwens points out, produsage represents "a new form of social organization,"[43] and old or new industry players must recognize and address this fact in their approaches. "The promises of this new media environment raise expectations of a freer flow of ideas and content. Inspired by those ideals, consumers are fighting for the right to participate more fully in their culture."[44] Any attempts by industry to prevent that free flow are likely to backfire, and backfire immediately. As Jenkins continues, "having felt ... power, fans and other subcultural groups are not going to return to docility and invisibility. They will go farther under-

ground *if they have to*—they've been there before—but they aren't going to stop creating."[45]

Ultimately, fans and enthusiasts also have the advantage over traditional media industries by the very virtue of *being* fans, of *being* enthusiastically rather than merely professionally involved, of course; this observation is true across many of the spaces of produsage, indeed. Lévy points out that

> given equal material resources and similar economic restraints, victory will be claimed by those groups whose members work for their enjoyment, learn quickly, live up to their commitments, respect themselves and others, and move freely throughout a territory rather than trying to control it. Those who are the most just, the most capable of fashioning a collective intelligence together will succeed.[46]

It should be self-evident by now that a heterarchical, adhocratic, merit-based organization is necessarily more likely to provide the foundation for the development of collective, collectively intelligent, tendencies than a bureaucratic industrial hierarchy.

In addition, of course, any continued refusal by the industry to engage with the community may also serve to speed its collapse, as users-turned-produsers will simply turn to operating under their own steam, in their own communities; rather than being shut out from cultural participation by the industry, it is the industry which is shut out from access to their potential consumers. Von Hippel notes such tendencies elsewhere in produsage as well:

> users are not required to incorporate manufacturers in their product-development and product-diffusion activities. Indeed, as open source software projects clearly show, horizontal innovation communities consisting entirely of users can develop, diffuse, maintain, and consume software and other *information* products by and for themselves—no manufacturer is required. Freedom from manufacturer involvement is possible because information products can be "produced" and distributed by users essentially for free on the web.[47]

Indeed, observations of the re-emergence of folk or vernacular culture and creativity strongly point us to the realization that the media and entertainment industry was never the most suited guardian for our cultural ecology; the impact of commercial considerations has always served to curtail the range of cultural expressions and cultural exchange possible through the media. Commercial culture is necessarily a heavily mediated culture, a less direct cultural experience than that offered by direct involvement of users as produsers in cultural activity and engagement. Although full disintermediation is necessarily impossible for as long as content is transmitted through the communications environments of the electronic network, produsage-based, grassroots, vernacular cultural participation offers at least the chance for a process of reintermediation which features more prominently the cultural choices of the individual produser and participant without further filtering through an industrial production process. Information, knowledge, and culture cannot be detached from those *holding*

information, *using* knowledge, and *engaging* in culture, and produsage offers an opportunity for them—for all of us—to participate more directly in an equipotential, peer-to-peer, open and unpredetermined exchange of culture, knowledge, and information: the more diverse and broadly based, the more exciting and productive this exchange is going to be.

NOTES

1. Chris Anderson, "The Long Tail," *Wired* 12.10 (Oct. 2004), http://www.wired.com/wired/archive/12.10/tail.html (accessed 20 Feb. 2007), p. 1.

2. Henry Jenkins, *Convergence Culture: Where Old and New Media Collide* (New York: NYU Press, 2006), p. 244.

3. Yochai Benkler, *The Wealth of Networks: How Social Production Transforms Markets and Freedom* (New Haven, Conn.: Yale University Press, 2006).

4. Jay Rosen, "The People Formerly Known as the Audience," *PressThink: Ghost of Democracy in the Media Machine*, 27 June 2006, http://journalism.nyu.edu/pubzone/weblogs/pressthink/2006/06/27/ppl_frmr.html (accessed 12 July 2007).

5. *Trendwatching.com*, "Nouveau Niche," 2006, http://www.trendwatching.com/trends/NOUVEAU_NICHE.htm (accessed 18 Feb. 2007), n.p.

6. *Trendwatching.com*, "Nouveau Niche," n.p.

7. The Gentle Slope image was created and contributed by Julien Beauséjour, following a call for graphics artists on my blog at http://snurb.info/. My sincere thanks to Julien for his excellent work. His interactive works as a media artist and art teacher are inspired by virtuality and collaborativity—see http://www. julienbeausejour.net/.

8. Jenkins, ch. 1.

9. *Trendwatching.com*, "Hygienia," 2006, http://www.trendwatching.com/trends/HYGIENIA.htm (accessed 20 Feb. 2007), n.p.

10. Anderson, p. 1.

11. Jenkins, p. 3.

12. *Trendwatching.com*, "Nouveau Niche," n.p.

13. Stephen Johnson, *Emergence* (London: Penguin, 2001), pp. 218–219.

14. Pierre Lévy, *Collective Intelligence: Mankind's Emerging World in Cyberspace*, trans. Robert Bononno (Cambridge, Mass.: Perseus, 1997), p. 234.

15. Lévy, pp. 236–237.

16. Michel Bauwens, "Peer to Peer and Human Evolution," *Integral Visioning*, 15 June 2005, http://integralvisioning.org/article.php?story=p2ptheory1 (accessed 1 Mar. 2007), p. 3.

17. See, e.g., John Hartley, ed., *Creative Industries* (Malden, Mass.: Blackwell, 2005).

18. Jed Miller and Rob Stuart, "Network-Centric Thinking: The Internet's Challenge to Ego-Centric Institutions," *PlaNetwork Journal: Source Code for Global Citizenship*, n.d., http://journal.planetwork.net/article.php?lab=miller0704 (accessed 14 Mar. 2007), p. 2.

19. Jenkins, p. 260.

20. John Quiggin, "Blogs, Wikis, and Creative Innovation," *International Journal of Cultural Studies* 9.4 (2006), p. 485.

21. See *Trendwatching.com*, http://www.trendwatching.com/trends/gen-cash.htm and http://www.trendwatching.com/trends/MINIPRENEURS.htm (accessed 19 Feb. 2007).

22. Benkler, p. 418.

23. Eric von Hippel, *Democratizing Innovation* (Cambridge, Mass.: MIT Press, 2005), p. 113.

24. Von Hippel, p. 114

25. Von Hippel, p. 114.

26. Quiggin, p. 485.

27. Michel Bauwens interviewed in Richard Poynder, "P2P: A Blueprint for the Future?" *Open and Shut?* 3 Sep. 2006, http://poynder.blogspot.com/2006/09/p2p-blueprint-for-future.html (accessed 1 Mar. 2007), pt. 1.

28. Also see Benkler, p. 61.

29. Benkler, p. 61.

30. Quiggin, p. 492.

31. William Thake, "Editing and the Crisis of Open Source," *M/C Journal*, 7.3 (2004), http://journal.media-culture.org.au/0406/04_Thake.php (accessed 1 Oct. 2004), b. 15.

32. Mark Pesce, "Qui Bono? [sic]". *Hyperpeople: What Happens after We're All Connected?* 11 Nov. 2006, http://blog.futurestreetconsulting.com/?p=24 (accessed 20 Feb. 2007), n.p.

33. Lévy, p. 16.

34. Lawrence M. Sanger, "Why Collaborative Free Works Should Be Protected by the Law," 2005, http://www.geocities.com/blarneypilgrim/shopworks_and_law.html (accessed 24 Feb. 2007), n.p.

35. Sanger, n.p.

36. Pesce, n.p.

37. Jimmy Wales qtd. in Robin Miller, "Wikipedia Founder Jimmy Wales Responds," *Slashdot: News for Nerds, Stuff That Matters*, 28 July 2004, http://interviews.slashdot.org/article.pl?sid=04/07/28/1351230 (accessed 27 Feb. 2007), n.p.

38. Pesce, n.p.

39. Benkler, p. 473.

40. Sanger, n.p.

41. Lévy, p. 236.

42. Jenkins, p. 132.

43. Michel Bauwens interviewed in Richard Poynder, "P2P: A Blueprint for the Future?" *Open and Shut?* 3 Sep. 2006, http://poynder.blogspot.com/2006/09/p2p-blueprint-for-future.html (accessed 1 Mar. 2007), pt. 2.

44. Jenkins, p. 18.

45. Jenkins, p. 158.

46. Lévy, p. 32.

47. Von Hippel, p. 126.

The Produsage Game: Harboring the Hive of Produsers

In spite of the sometimes very real threat of a casual or not-so-casual collapse of their traditional operational models, most of the media and creative industries remain at present still very much at the beginning of their transformation towards a fuller embrace of produsage and produsers. Other industries are substantially further ahead—these include sectors of the software industries, as we have already seen, as well as the new leaders of the information industries from Google to Amazon. It is perhaps not surprising that such industry players should have an advantage over some of the older media organizations: as natives of the knowledge space, they were founded and are staffed in good part by Generation C itself.

Perhaps the outright trailblazer for this process, however, is the computer games industry, and here especially the developers and publishers of games which create a sense of community among their players through more or less direct interaction and exchange. Operators in this field have managed to harness their community hives as drivers of success, to harvest their work as co-developers; frequently they harbor the spaces of player-led produsage themselves, thereby helping the produser community to interact among itself—but at times, this can also turn into a hijacking of the hive as players are locked in to spaces whose underlying principles and dynamics they do not fully understand and have no power to adjust.

In many cases, such environments have become much more than 'mere' games, of course: they are spaces for communal and social interaction, give rise to community leaders and minipreneurs, lead to the establishment of in-game ethical frameworks and social, economic, and governmental organization by players for players. Where such tendencies are present, indeed, they can be understood as providing training grounds for the wider information or knowledge game which results from the decline of fixed authorities and ultimate truths that is facilitated in good part by produsage tendencies. This new playful approach to knowledge offers "less of the dogmatic and more of the ludic, less of the canonical and more of the festive. Fewer arguments from authority, through more juxtaposition *of* authorities"[1]—while we have already seen how

other fields of produsage from open source to *Garageband* incorporate such ludic aspects into their own operations (for example through the considered harnessing of competitive effects among their contributors), and how they derive great benefits in terms of user involvement and enthusiasm from such productive play, there are few spaces better exemplifying such changes than the virtual worlds of online gaming.

At the same time, it is also important to note the significant differences in approach between the various spaces for playful produsage in the gaming world. The objectives and fictional game worlds of these games necessarily differ, and such differences influence the forms of community interaction which are possible within them, but beyond this, too, their operators build a sometimes vastly differing relationship with their customers, the citizens of their online social spaces. All such spaces are subject to the five core principles for online communities which Shirky has identified:

1. Audiences are built. Communities grow.
2. Communities face a tradeoff between size and focus.
3. Participation matters more than quality.
4. You may own the software, but the community owns itself.
5. The community will want to build. Help it, or at least let it.[2]

How, and how successfully, such principles are transformed into online game environments is notably different from site to site, however, and we therefore begin our examination of games by examining four key online spaces of playful produsage to identify such differences.

Produsing the Space

We begin with what is perhaps one of the best-recognized online games of the past decade: *The Sims*. More an artificial life simulation than a conventional computer game, *The Sims* allows its users to control realistically simulated in-game characters, steering them through all aspects of their daily lives and facilitating their interactions with other characters in the game. Working within a set budget, players are able to provide their characters with furniture and other objects of daily consumption, to refurbish and rebuild their houses, and to change their clothing and other physical attributes. However, as important as the actual gameplay is the fact that players are also enabled to develop new objects to be embedded into the game itself—from household objects and designer furniture to hairstyles and clothes.

This, indeed, is just as significant an innovation in *The Sims* as is the highly advanced in-game artificial intelligence, and (at least until the launch of the multiplayer *The Sims Online*) it has done more to facilitate the development of a gamer community than any other aspect of the game. Players-turned-produsers of the game contribute furniture modeled after the latest releases from leading retailers, copying antiques, or

designing their own pieces, they create clothing which resembles prêt-a-porter designs or the latest dresses worn by celebrities on the red carpets of Hollywood and Cannes, they design hairstyles to imitate the looks of models, actors, and sports stars. Indeed, as Herz reported as early as 2002, a staggering ninety percent or more of in-game objects in *The Sims* had been created by users rather than by the game's producer Maxis or its distributor Electronic Arts[3]; some seven additional expansion packs for *The Sims* have now also been released, "developed in response to the creations of its own R&D estuary of fans."[4]

Herz describes this as a new form of vernacular culture; "for the casual gamers who furnish *The Sims'* virtual dollhouse, ... the practice of creating levels and skins and custom objects is a kind of 21st century folk art—a form of self-expression for the benefit of themselves and their immediate community."[5] We might prefer the term produsage here, but the idea is much the same: on the basis of the shared text of *The Sims*, which acts as the foundation for this user engagement both in the way that the initial kernel of *Linux* acts as kickstarting and in the way that the technological support system of *Wikipedia* acts as harboring their communities of participants, users are able to transcend their status as 'mere' players, and become creators of content in their own right: they become produsers of the game, in collaboration with one another and with the game's original producers.

Around *The Sims*, a network of user-driven content sharing and swapping sites have now sprung up to further facilitate the development, maintenance, interaction, and growth of this produsage community: contributors discuss and share the tools and techniques for creating new objects for the game; they upload their latest creations, and download, test, evaluate, rate, and provide feedback on those of others; they identify and coordinate the development of in-demand objects with such enthusiasm and efficiency that simulated approximations of the clothes of actors and actresses at the Academy Awards are often online already on the very same night, and that in-game versions of 'hot' consumer goods from sneakers to iPods are sometimes available before the physical products themselves have even been launched to the wider public. Leadbeater and Miller describe this as a community of Pro-Ams, then:

> the *Sims* community is a distributed, bottom-up, self-organising body of Pro-Am knowledge, in which players are constantly training one another and innovating. This is just one among many examples of how communities of Pro-Am gamers are helping to co-create the games they play.[6]

However, such co-creation of games can also be regarded as problematic: where in the development of Linux or the *Wikipedia*, the initial seed content for community development and the underlying technology for its existence and operations are made freely available to the community, after all, *The Sims* remains first and foremost a commercial product; any community enthusiasm for creating and sharing in-game objects, in the process building a vast library of resources to be used in the game, ulti-

mately benefits (in real economic terms) first and foremost Maxis and Electronic Arts as the producers and publishers of the game. The community may be invited to contribute its own content, and the success of the game may depend on its doing so, but having to purchase the game, the community also pays for entry to the process in the first place; it pays for the privilege of being able to contribute its own creativity and innovation to the commercial product.

At the same time, from a legal point of view the actions of the game's producer and publisher are entirely legitimate, of course; in essence, they extract from the community simply a fee for providing the tools with whose help, or a rent for harboring the space within which the core community activities take place. Maxis and Electronic Arts clearly harness community enthusiasm for their games in promoting the *Sims* brand, but in itself this is no different from the harnessing of community participation in other contexts of produsage; they have no need even to harvest the prodused materials for incorporation into the game package itself, as such materials remain freely available from the multitude of *Sims* support sites throughout the Web. Therefore, the question of whether and how to recognize community contributions to *The Sims*' success becomes a moral and ethical one.

Similar questions are also faced by other games harnessing enthusiast produsage communities. One key example here is *Trainz*, a game developed by Brisbane-based software company Auran (not to be confused with the model railroad retailer *Trainz.com*). *Trainz* is a train simulator which could be regarded as a ground-bound offshoot from the long family tree of highly realistic flight simulators: the game provides a variety of gameplay experiences, ranging from a physically accurate, driver's-perspective simulation of the processes involved in operating both historical and current trains through the simulation of railroad traffic management considerations to the bird's eye simulation of model train sets, and the game also enables the fluid movement of the player between these options.[7]

Much as *The Sims*'s producers could not by themselves have created the wealth of content now available for the game, however, Auran would have been unable to generate a comprehensive collection of visually and physically realistic models for the wide range of locomotives, rolling stock, trackside and landscape objects which could be expected to be found in a railway simulation; this problem, indeed, is made all the more acute by the existence of highly knowledgeable communities of train enthusiasts around the world who would want to have 'their' trains represented in the game. Where *The Sims* clearly provides a fictional world operating by its own principles, and needing (if at all) to be only vaguely representative of reality, *Trainz* must very directly and accurately model real-life trains and related elements, in much the same way that quality model railway sets are intricately designed to approximate original specifications.

Much like Maxis with *The Sims*, therefore, Auran harnessed the enthusiasm of its player community; railroad fans from around the world were encouraged to develop

their own 3D models of trains and other elements, and modeling software and tutorials were made available by the company. Today, hundreds of thousands of in-game assets are available for the game, and many incorporate textures and other graphical elements generated directly from real-life objects. Auran, however, took a somewhat different approach to engaging with its community than did Maxis: it created the 'Download Station,' a space on its own Website to facilitate community interaction and the sharing of in-game assets within the produsage community.

On the one hand, the Download Station enables Auran to police simply against the use of pirated copies of the *Trainz* game: only registered users are able to access the content available here. On the other hand, however, it also provides the means for Auran to become actively involved in the community's procedures of quality control, and to assist with communal processes of produsage; it can help with difficult content design problems by providing information on how to achieve certain effects (realistic steam rising from steam locomotives, or complex motions of gears and levers), but it is also able to identify need for further improvement of the *Trainz* game engine itself. Thus, the community is not only harbored in the Download Station, and harnessed as creators of content for the game; they also become co-innovators of the game itself, in concert with Auran's own designers. Such processes correctly identify active produsers in the *Trainz* community as what von Hippel describes as 'lead users,' both able to provide direct and highly valuable contributions for innovative processes, and highly motivated to participate in such constructive ways: "they are ahead of the majority of users in their populations with respect to an important market trend, and they expect to gain relatively high benefits from a solution to the needs they have encountered there."[8]

For Auran's lead users, indeed, an additional motivation to participate is also the potential of seeing their own work embedded in the game itself: the company has actively sought out and approached those users making the most interesting contributions to the asset Download Station, and negotiated arrangements for their work to be packaged into new releases of the game. This is significantly different from the practices of many other games developers, including Maxis, as we have seen: here, the content prodused by the community often remains at arm's length from the canonical text of the game package itself, and is utilized only implicitly as a selling point for the game, but not included explicitly in the sold package itself. Through *Trainz*, on the other hand, Auran offers its gamers the opportunity to move from produser to co-producer of the games package, adding a further incentive to engage in the produsage community. This can be seen as a softening of the producer/produser divide much in line with the models we have encountered in the previous chapter, of course: here, the traditional, hierarchical model of software production builds on and feeds from the heterarchical structures of the produsage community which allow the most valued, most knowledgeable, and most productive community members to rise to public recognition.[9]

In addition, however, and even despite the clear placement of the Download Station as the central hub of the community, a variety of *Trainz* enthusiasts developing ingame representations of their favorite train models and of other simulation elements have also set up shop independently of Auran; a veritable *Trainz* cottage industry has now emerged. Groups of *Trainz* content producers around the world are engaged in this practice; beyond train and asset models, a company in Germany called Trainz-Land has even built its commercial operations largely on simply selling packages of highly realistic sky textures for use in the game. What is remarkable in this context is the wide variety of participants who have begun to operate in such ways. Traditionally, railroad enthusiasm is a relatively male-dominated domain, and this is borne out also in the *Trainz* community; however, more importantly model railroading is also frequently seen as an activity drawing in good part on middle-aged and post-middle-aged participants. This group is notably well-represented within the *Trainz* community; for these participants, then, who must be considered to be anything but 'natural' digital natives, engagement in *Trainz* fandom and produsage has also had a tangible educational effect: such leaders of the *Trainz* content creation and innovation community have become experts in 3D modeling and graphic design, as well as in programming the in-game physics and interaction simulators. Produsage across its many domains, indeed, can be said to have such educational effects, as it harnesses participants' enthusiasm for the task at hand and utilizes that enthusiasm to encourage them to build the skills, literacies, and capacities required for becoming expert users of the technology that is used to support the produsage process itself.

Produsing in the Space

Games such as *The Sims* or *Trainz*, companies such as Maxis and Auran, harness their communities of fans largely in support of making the gamespace itself better (by adding more content to be used within it, or helping to innovate the games engine itself). The games themselves, however, remain largely stand-alone, single-user experiences; the community of users exists outside and around the game itself. (Both *The Sims* and *Trainz* have more recently also introduced multiplayer online options, however.) Beyond such models, of course, past years have also seen the emergence of a range of highly successful massively multiplayer online games (MMOGs) which provide immersive, 3D environments for their large communities of simultaneously co-present players. Such games are themselves based on a long history reaching back to the first text-based online multi-user dungeons (MUDs), of course, and those games could already be described as produsage environments; the current generation of MMOGs, however, has further multiplied the opportunities for players to act as producers in the shared online space.

What players produse in such environments are not only in-game assets and elements, but more importantly also underlying individual and shared narratives; increasingly, indeed, such narratives are perhaps better described as a shared history, sociality, or society much in analogy to the way that national narratives in the physical world have provided the imagined community of the nation-state[10] with a shared identity. Much as such narratives and identities may be disputed in the physical world, however, so are they also under constant negotiation in the online space; much as opinion leaders, political actors, governments, and other societal institutions seek to guide that debate in the directions they favor, so do the proprietors of MMOGs, as well as the lead users and other emerging institutions of the produsage community, engage in a struggle over the perceived and stated values of the in-game society.

Perhaps the most useful example for such processes at present is the online world of *EverQuest*, a Sony online game. Simulating the fictional world of Norrath, *EverQuest* transcends the conventional fantasy games genre by providing a highly open-ended gameplay model; while more traditional games are based on an internal logic which necessarily requires players to strive constantly to advance to higher levels, *EverQuest* offers a greater chance for users themselves to develop their own in-game narratives and approaches to playing the game. As the game's title suggests, *EverQuest* still offers quests to be completed by the user in pursuit of greater in-game riches and character development, but the social aspects of participation in such quests have become just as important as the direct benefits obtainable from questing. *EverQuest* and similar games therefore clearly exemplify the role of the game producer as first and foremost harboring the produsage community—as providing not so much the narratives they may live by within the space, but the means for developing their own narratives in a collaborative, communal, social way. Here, in other words, "the role of the commercial provider is not to tell a finished, highly polished story to be consumed start to finish by passive consumers. Rather, the role of the game provider is to build tools with which users collaborate to tell a story."[11]

Much as in other community-based games environments (whether massively multi-user, or relying on the existence of a community outside and around the game product itself), this increased role for the users as co-produsers of gameplay also raises significant moral and ethical challenges, of course. Narrative development of this kind, which significantly contributes to the game's success, is not only an unpaid activity for users; indeed, they themselves are paying monthly access fees for the privilege of participation in the community (such models therefore move even beyond cases from *The Sims* to *Trainz*, in which users make only a one-off game purchase payment; *EverQuest* and many other MMOGs operate on a subscription basis which guarantees significant continuing cashflow for the game operator). At the same time, of course, it must also be noted that the game provider has to contend with potentially significantly larger costs for the continued harboring of the player community, as the power-

ful live servers required to facilitate seamless multi-user engagement must be serviced and maintained on an ongoing basis.

In addition, the economic frameworks within such immersive worlds are substantially different from those of the single-user environments we have encountered so far. By simulating an in-game community and society which includes a variety of status systems (ranging from implicit social status within the community to the explicit professional status skills held by player characters, and further to the financial capital indicated by their possessions in the game), MMOGs also enable their players to accumulate various forms of wealth within the game, which can be quantified as outcomes beneficial to the individual players from their gameplay activities. On this basis, therefore, the game subscription becomes a simple financial transaction enabling player access to wealth creation activities within the game; and indeed, a 2001 study of player activities in the *EverQuest* game world concluded that "for the average Norrath resident, an hour in Norrath produces utility worth $14.15. This figure is more than the fee of $10 per month that users pay to access Norrath. Norrathians gain a substantial consumer surplus from the world's existence."[12]

Although not all residents of the *EverQuest* world of Norrath will approach their game participation from such an explicitly economic perspective, such productive uses of the game clearly highlight the significant level of participant engagement in the world of *EverQuest*, then—and we would do well to keep in mind also that such figures are averaged across all Norrath residents; it is likely that a smaller sub-group of quasi-professional—Pro-Am—participants in the game will be responsible for a majority of wealth creation in this world. This, of course, is a common feature of many produsage spaces; as Leadbeater and Miller put it,

> Pro-Am leisure is a very serious activity involving training, rehearsal, competition and grading, and so also frustration, sacrifice, anxiety and tenacity. Pro-Ams report being absorbed in their activities, which yield intense experiences of creativity and self-expression. Pro-Am activities seem to provide people with psychic recuperation from—and an alternative to—work that is often seen as drudgery. Leisure is often regarded as a zone of freedom and spontaneity, which contrasts with the necessity of work. Yet much Pro-Am activity is also characterised by a sense of obligation and necessity. Pro-Ams talk of their activities as compulsions.[13]

The seriousness of *EverQuest* as an in-game economy is further documented in the fact that for that world and a number of other leading MMOGs, it has become increasingly possible to apply standard economic measurements to the wealth creation activities within the game. Castronova, for example, calculated the gross national product of the Norrath 'nation,' coming to the conclusion that in comparison with 'real-life' nations, during 2001

> Norrath is the 77th richest country in the world, roughly equal to Russia. ... The result[s] of two other methods [of calculation] give a lower GNP per capita, the lowest

making Norrath equivalent to Bulgaria. By all measures, Norrath is richer than many important countries, including China and India.[14]

However, the more similar to real-world countries such online worlds come to be, the more we must also begin to question elements of their society other than economic aspects. Although residents within such spaces may generate in-game personal wealth, for example, such wealth remains protected in the first place not by an accountable system of governance balancing executive, legislative, and judicial powers, but is subject simply to the game's end-user license agreement (EULA), commonly concerned mainly with spelling out the extent and limits of the game provider's responsibilities. By setting themselves up as entities which harbor communities and societies of users, however, games providers (and other providers of communal produsage spaces) become something more: whether they intend to or not, they assume a role as *de facto* government, police, and courts of the in-game community.

For game providers poorly prepared for (or slow to understand) this role, it holds significant challenges. The *EverQuest* community, for example, has repeatedly found itself subject to EULA-supported rules which appeared to explicitly counteract community practice and sentiment; such disputes have arisen especially around questions of user ownership of the wealth created within the game. Sony's *EverQuest* EULA explicitly stated that the company retained ownership of in-game assets and characters, for example, and prohibited their sale through off-world, real-life markets; nonetheless, users gradually began to trade in-game goods and even their own experienced *EverQuest* characters directly or through online auctioning services such as *eBay*. (Indeed, from such activities Castronova was even able to calculate an unofficial exchange rate between the *EverQuest* currency and the U.S. dollar—exceeding "that of the Japanese Yen and the Italian Lira" during 2001.[15])

Attempts by Sony to shut down such sales created an instant and vocal community reaction. They highlighted the strongly divergent understandings of the community as held by the community itself, and by its corporate landlord; ultimately, no full resolution of this conflict was ever achieved, and Sony now generally simply tolerates off-world auctions of goods and characters—in addition, some such sales and auctions have also moved further underground, beyond *eBay*, to a set of more directly community-driven environments. Indeed, even despite Sony's efforts, more recent reports suggest the emergence of 'sweat shops' in Mexico and Hong Kong which pay local gamers to play the game in order to gather in-game items and develop player characters which can be sold to other community members at an overall profit.[16] Castronova compares the emergence of such cross-border markets to similar processes in tourism: "in the tourism industry, members of country X use X's currency to obtain goods and services that are created in and remain in country Y. In Norrath's foreign trade markets, Earthlings use US dollars to obtain goods that are created in and remain in Norrath."[17]

But beyond the economic descriptions of such exchanges, what should interest us here is the economic policy that has enabled them, and beyond this the question of what overall policies exist in any one produsage space. In the case of online communities gathered in a central, harboring space, the EULA document becomes substantially more powerful than it is for stand-alone games: although there, too, it fulfills the legal role of defining legitimate uses to be made of a specific software, at least in practice it remains relatively difficult to enforce as for the most part producers have no direct indication of end users' actual activities. Where users are gathered as communities *within* a gamespace governed by the EULA, the situation changes, and the EULA becomes a document not only defining the actions of the individual, but also serving as the founding charter of the community itself. As such, however, it can no longer stop at outlining commercial rights and responsibilities; it must also begin to define the core values and ethics of the community, or provide the community with the rights to do so itself. Failure to do so, and the presence of conventional license provisions which limit the provider's liability while maximizing its rights over the community space, leaves the community vulnerable to subsequent hijack: a community without explicit rights is a community whose fundamental structures may be changed by the provider at a moment's notice, and without recourse to further arbitration; this, however, is all the more problematic given the often significant financial, social, and personal investment already made by members of the community. Users have turned, if not into a captive audience, then at least into a captive community.

In contrast to *EverQuest* and similar earlier online worlds, a potentially more advanced understanding of this new role of software providers as harborers of community may be evident in the relatively recent development of *Second Life*. Launched in 2003 and made popular through media reports during 2006 and 2007, *Second Life* moves even further beyond the online gaming model embraced by *EverQuest* and others; it operates without reference to in-game character attributes, quests, or other explicit gameplay goals. Instead, *Second Life* essentially provides its players with a blank geographic canvas to be populated with their own interests and ideas; players may use their in-game Linden dollars (L$) to purchase land and other objects and thereby develop their own personalized spaces in a variety of game neighborhoods. *Second Life* players are engaged, therefore, in nothing less than the collaborative produsage of the online world itself; "virtually every object, terrain and animation is the creative work of its membership. They use the built-in scripting tools to construct objects or actions from their imagination."[18]

Ultimately, therefore, to speak of *Second Life* as a 'game' is no longer fully appropriate. Although some users may regard their engagement with this world as a playful activity, it comes to resemble a simulated world more than a conventional game:

> there is no top down game plan or overarching narrative. Users determine their activities, ways of grouping and social codes. Second Life 'residents' therefore eschew

the notion that they are playing a 'game' (although games may be created and played within the construct), and prefer to identify themselves as citizens of a synthetic world, a 'metaverse'.[19]

A further description now being applied to *Second Life*, therefore, is that as a multi-user virtual environment, or MUVE.

Nonetheless, user activities operate under the core principles of produsage much as we have seen them in other examples: *Second Life* is **open to user participation** (and notably does not charge an outright access fee), it allows for the gradual formation of social structures through player engagement—a form of **communal evaluation** between peers—as well as the more explicit communal policing of content created within the game, ensuring for example that content created by players in the game does not negatively affect others' participation in the world. From such communal engagement, social structures are gradually beginning to form, and are leading to the development of **fluid heterarchies** of participants residing at specific locales in the gamespace, and even to the development of local government organizations covering specific, limited spaces in the online world. In addition, of course, the world itself remains **permanently unfinished** as participants move through it, create content, and place it in various locations (from which it may be removed again by other residents or the *Second Life* system itself)—much like that of our 'First Life,' the world of *Second Life* remains a process, not a product. Finally, though, ownership of the space is more conflicted: although the underlying technological framework of *Second Life* is of course owned and operated by its creator Linden Labs, the in-game world overall is seen very much as communal property of all residents, but individual property in real estate and objects also exists; it therefore combines aspects of gated community, open commons, and individualist society within the same space.

In this context, a key development by Linden Labs is the explicit acceptance that users participating in *Second Life* retain property rights in the content they contribute to the game. This is a step beyond traditional EULAs as we have seen them for example in the case of *EverQuest*, which tend to allow the game producer to claim and retain all property in content developed through user participation in the gamespace; by contrast, it serves to introduce aspects of both commons-based *and* individual ownership into the *Second Life* environment, as it provides an opportunity for users to embrace both approaches to sharing their individual work. Most crucially, however, individual ownership provides the basis for the development of in-game trade: through Linden Labs' denial of ownership rights for itself, "users retain the intellectual property of their creations and are free to trade, copy or exploit it in the virtual or real world environment, resulting in a robust virtual economy with real world consequences."[20]

New Internal and External Economies?

Indeed, then, the *Second Life* community has spawned a number of internal and external economic markets as well as developed an exchange rate system between Linden dollars and real-world currencies. Trade encompasses all aspects of the in-world environment, ranging from land and real estate sales to the sale of in-world objects, and the in-world sale of digital or other objects which are also of use in first life; such objects include downloadable books and music as well as clothing and apparel. In addition, significant markets offering in-world services from building and maintenance to streaming media access and, more controversially, gambling and pornography have also emerged.

Like other game-based multi-user produsage environments, *Second Life* has recently seen the emergence of a variety of minipreneurs generating sometimes substantial profits from such work; for some, profits are largely in L$ themselves and serve mainly to subsidize their other in-game activities, but for other participants, their *Second Life* work also generates significant off-world income measured in real-life currencies. In addition, of course, Linden Labs itself also acts as an important provider of goods and services in the virtual world, as well as constituting its central bank: Linden, which provides each participant with a certain amount of start-up funding as they enter the space, thereby effectively controls the amount of currency in circulation; in addition, it is also able to generate new monetary value by creating new land to be sold off to would-be residents. This dual role as quasi-government and central bank of *Second Life* is problematic, of course, and certainly uncommon in stable first-life nations; it raises the possibility for Linden Labs to be able to alter fundamental economic principles within the space at a moment's notice, and without the community's recourse to arbitration procedures. This creates growing concern especially as the *Second Life* economy itself grows; as of early 2007, that economy is now reported to produce a GDP of US$500–600 million.[21]

Overall, however, the first life-inspired model for *Second Life*'s in-world economic frameworks has led its economy and society to develop in close parallel with comparable first-life spaces—especially the capitalist societies of Western nations. However, the specific affordances of the online environment also introduce their own effects, of course: Linden Labs' power over the environment is substantially larger than that of first-life governments, and the citizenship rights of residents are correspondingly more limited; at the same time, however, citizen buy-in to the space, while highly intense for some residents, is far more casual and uncommitted for many others (confirming again Castronova's tourism comparison, perhaps), and Linden's ability to create more territory in its world also helps it to avoid any social unrest resulting from a scarcity of resources.

Paradoxically, therefore, in spite of its billing as a *second* life, and thus an opportunity to explore alternative models for commercial, communal, and social interac-

tion, many of the economic processes taking place in the space are remarkable mainly for their unremarkability; the names of commercial leaders and entities in this space may have changed, and produsers participating in the communal development of the *Second Life* world are now able to act as producers of content to be sold to their peers, but *Second Life* resembles in parts simply a consumerist paradise and an extrapolation from first-life capitalism which entirely removes any physical limitations. Gradually, even the special role for produser communities as content creators in this space is beginning to come under threat: recent months have seen the growing influx of first-life commercial entities into the world of *Second Life*, developing their own commercial operations in competition with *Second Life*'s native minipreneurs and entrepreneurs. Among such brands, Salomon names companies such as "IBM, Dell, ING, Philips Electronics, Telstra, and the Australian Broadcasting Corporation,"[22] and describes some of the activities conducted in-world:

> *Starwood Hotels* for example, launched 3D designs of its new boutique hotel series 'Aloft' and monitored the response and comment from the SL community whom it believed was representative of the new product's target market. Similarly, Philips Electronics has set up in Second Life with a view to scouting the innovation niches. It believes that harvesting data may lead to a rethink or even an entirely new approach in their modes of practice and product development and that the future of design is in the co-creation of products.[23]

Other commercial operators are more directly engaged in providing products and services; Reuters, for example, has opened a virtual news bureau, and various music retailers allow residents to browse and shop for CDs and DVDs.

In addition, various educational, non-profit, and governmental organizations have also opened *Second Life* sites; these range from the online campuses of a number of leading U.S. and international universities to the Creative Commons island, and even to the opening of an official Swedish embassy to *Second Life*, the 'Second House of Sweden,' by the country's Foreign Minister Carl Bildt on 30 May 2007. (The event involved a traditional ribbon-cutting ceremony, acted out by Bildt's in-game avatar.) Such developments point to the success of the *Second Life* model even well beyond the commercial strategy outlined by Castronova:

> start a virtual world in a game of truly massive scale, so that millions can use it at any time. Make the game free. Allow people to use their credit cards to make transactions. Then wait for the society and markets to develop, and invite Earth retailers to open 3D stores in the virtual space.[24]

Although we may lament the ultimately perhaps rather unimaginative uses made of *Second Life*'s virtual world at least as far as its in-game economic structures are concerned, then, it is nonetheless obvious that the site is rife with user-led innovation in content development; as Salomon reports, "many residents are classified as user-producers, which is why the lead innovation models come not from real world com-

panies hoping to import their services but from the in-world eco-system where virtual start-ups have sprung up to support residents."[25] Indeed, by contrast, as the Starwood and Philips examples indicate, first-life organizations are now harnessing the innovative abilities of this produser community to further improve their real-world products:

> Second Life is emerging as test bed for new ideas, where real world prototypes can be released at low cost, with direct feedback from users significantly enriching the design process and leading to innovative or unexpected results. The process is enhanced by the nature of its residents who, typically, are techno-savvy, playful and demonstrate a high receptivity to new ideas.[26]

In the process, Second Life may thus come to be a tool for the facilitation of producer-produser interaction as we have outlined it in the previous chapter; in a very immediate way, it provides a common, neutral ground for a potentially mutually beneficial engagement between the organizations of the traditional production industries and the lead users emerging from the new processes of produsage. Participating in this way outside of their zone of comfort, convention, and traditional commonsense, producer organizations may be better able to understand the underlying drivers of the produsage phenomenon than by attempting to replicate such principles within the confines of their own corporate environments.

More immediately, it will be important for researchers to study in some detail the motivations of Second Life participants themselves. To some extent, such motivations are likely to be driven by the ability for a further 'leap to authorship' as Rushkoff has described it:

> what of the gamer who then learns to programme new games for himself [sic]? ... He has moved from a position of a receiving player to that of a deconstructing user. He has assumed the position of author, himself. This leap to authorship is precisely the character and quality of the dimensional leap associated with today's renaissance.[27]

Even in comparison with EverQuest and other online worlds, Second Life has taken this leap another step further, by putting (almost) the entire world of the MUVE into the players' hands (in this, in fact, it is more similar to some extent to Trainz, but adds massive multi-user capabilities as well as moving away from an inherent focus only on activities related to railway transport, of course).

This leap to authorship on the one hand offers in-world as well as off-world economic possibilities, of course, and may therefore be attractive particularly to participants for whose in-world skills and abilities, acquired through experience in playing games and operating computers, there is a greater demand than for additional first-life skills they may possess; this could be described as a form of 'economic escapism' in which active and intense participation in the online world (for example in designing in-world structures and objects) serves to generate an economic environment in which the relevant design skills are in strong demand. To some extent, in addition, a differ-

ent sense of escapism may also drive the take-up of Second Life, especially in the current context; while geopolitical conflict dominates the headlines of first-life news, Second Life offers an opportunity to return to the inherent capitalist optimism of the American dream, and Second Life with its focus on real estate ownership, self-employed commercial activity, and the experience economy could therefore be read as an idealized version of the United States. This reading, however, is complicated at least to some extent by an examination of Second Life demographics; as of March 2007, U.S. users appear to account for only some 16 percent of the entire Second Life population, with Europeans making up a majority 61 percent group.[28] Such figures must be approached with some caution, however, as due to Linden Labs' privacy policies no detailed analysis of user nationality is possible; in addition, of course, we should also keep in mind that in contrast to such recent observations, early Second Life users were overwhelmingly American, and would have played a crucial role in determining at least the initial conventions of communal and social interaction within the space. An escapist reading of the Second Life phenomenon, for American, European, and other international users, does remain possible, therefore.

Imagining a Produsage-Based World

Ultimately, perhaps the most convincing explanation for the rapid rise to popularity of the Second Life MUVE is its flexibility and adaptability as an online world, however. Free of narrative rules, constrained only by a small subset of conventional physical-space limitations, open to new participants at least initially without cost, and equipped with powerful toolkits for the modification of existing environments and the creation of new objects, Second Life harnesses the key principles of produsage much like the produsage environments we have examined in other chapters; in addition, and this, perhaps, is its key selling point, it translates the produsage phenomenon to the creation at least of *simulated* physical objects. While the application of produsage approaches and processes to *real* physical production models at present still remains largely impossible, Second Life allows its participants at least to explore a simulation of physical produsage; this makes it highly attractive both to the new class of quasi-physical produsers which has emerged within the online world of Second Life (the developers of structures and objects to be inhabited and used within the game), and to the many commercial and non-commercial organizations now establishing a presence in the space which seek to learn from such quasi-physical processes what improvements to *actual* physical products and services may be possible and in demand by users.

In addition, of course, Second Life offers an opportunity to apply user-led, produsage principles also to other aspects of the simulation of conventional, 'first life' which takes place in its environment. Most importantly, this occurs in the context of in-

world governance, and it is worth examining phenomena in this context in some more detail. We have already highlighted Linden Labs' somewhat conflicted role as the quasi-government for the MUVE: as primary landowner and central bank of *Second Life*, as its citizenship authority and primary provider of essential services, it cannot escape at least some aspects of this governmental position. At the same time, however,

> Linden wants its users to set their own values, rules and goals. A growing number are deeply engaged in the wider debate as to how this virtual world runs Whilst users must agree to Linden Labs' terms of service there are no prescriptions. Technical limitations and hitches aside, Second Life is a place for doing stuff; as the Second Life's mantra goes, 'your world, your imagination'.[29]

Like the decision to allow users to retain their ownership of content contributed to the shared environment, this devolution of powers to users is a conscious choice on behalf of Linden Labs, and should be considered an improvement over the traditional producer-takes-all model of conventional EULAs; however, in itself it cannot hope to solve entirely the fundamental conflict between Linden's ownership and operation of much of the global *Second Life* environment, and the internal dynamics of the local communities which have come to call that environment their (second) home. Linden Labs itself states that it

> cannot play the role of arbitrating personal grievances or defining behavioral standards. This is particularly important as Linden Lab becomes more international. We don't want to force a California-centric set of rules on the virtual world. Rather, we want to facilitate Residents banding together and creating their own civic centers around their unique ideals and ambitions.[30]

Recent strategies embraced by Linden Labs therefore strongly favor the development of a variety of local self-government approaches for in-game neighborhoods, and (in keeping with the multinational, multifaceted make-up of *Second Life*'s citizenry) allow and expect these approaches to be highly divergent in nature. Perhaps somewhat surprisingly, such approaches have been both applauded and criticized by the in-world community, however; some residents have welcomed the relative freedom which the approach provides, while other community members have expressed fears that the approach invites the establishment of a variety of totalitarian, anarchic, or other communities which are regarded as undesirable. Overall, indeed, Linden Labs' approach could be seen as a significant and large-scale experiment in social innovation—or indeed, in the produsage of social and societal structures—, and (given the locally based approach which the 3D environment of *Second Life* necessitates) may ultimately lead to the emergence of a patchwork of communities resembling the city states of ancient Greece or medieval Northern Italy. Indeed, the different buy-in of participants in the online world (for some constituting a more strongly active citizenship than in their first lives, for some enabling a more fluid and flexible approach to civic participation

than is possible offline) may well lead to greater experimentation and a more explicit expression and exploration of diverse governmental models than would be likely in the offline world. In the process, Jenkins notes, Second Life's "virtual world allows us not only to propose models" for the structuring and operation of culture and society, "but to test them by inviting others inside and letting them consider what it might feel like to live in this other kind of social institutions. I think of what goes on there as a kind of embodied theory."[31]

This also raises questions over how such models may be implemented and enforced, however. The overall open participation approach of the Second Life environment could well come to stand in direct conflict with the governmental enclosure of civic communities within the space, especially also as government rights as they are now envisaged by Linden Labs itself are closely connected to land ownership in the Second Life world: following recent technology changes,

> groups have new features that allow them to fine tune the rights and responsibilities of their members. Individuals are better able to manage their personal experience of Second Life … . Parcel [land] owners have a no-push setting and a larger ban list. Estate owners can assign a Covenant to their land that explains the rules they wish visitors and Residents to abide by, rules that reflect their values and goals. That's just the beginning. … You'll see many more tools and features rolled out that will allow Second Life users to define their own rules and enforce them.[32]

This, then, "offers us a way to construct alternative models of the world and then step inside them and experience what it might feel like," as Jenkins describes it[33], but it could also spell the emergence of a new kind of landed gentry within the Second Life space, able to move on transients and itinerants to places beyond their borders. The fact that just about anyone can potentially *become* a land owner in Second Life does not change the fact that such approaches, taken to their extreme, would serve to cover the space with a string of gated communities accessible to no-one but members of their ingroup, thereby destroying any sense of an overarching community or society within Second Life.

Such tendencies may fail to carry through to their very extremes, of course; in the first place, the emergence of individual civic communities within the overall MUVE would be likely simply to lead to a further development of multiple centers, clusters, and key hubs within the overall heterarchical structure of the Second Life community. It is possible that some such centers would convert into more traditional social hierarchies, however (whether governed by democratically elected leaders, or ruled by self-styled autocrats), and that such tendencies may ultimately come to undermine the open experimentation with possibilities which characterizes Second Life and produsage overall.

In addition, the interrelations between individual civic entities will also become an increasingly interesting problem. Overall, Linden Labs envisages what it describes

as a 'federated model,' with civic communities perhaps acting in the role of federal states to whom certain rights and responsibilities are devolved, and an overall government focusing only on the tasks which necessarily must be undertaken by a central authority:

> Linden Lab will continue to police the world for problems that threaten the stability of our technical, economic and social structures. But when it comes to deciding what behavior should be allowed in a particular place or social group, those rules and their enforcement will be decided by the people involved—those who understand the context of the situation and have a stake in its outcome. Linden Lab is carefully planning the move to this federated model, and during the transition we'll continue to enforce the [global] Community Standards. Note that after the transition, all of Second Life will still be required to abide by the Terms of Service, even though local community standards may vary.[34]

At the time of writing, the exact nature of this federated model remains unclear, however, as do eventual processes for negotiation between local and federal authorities. Indeed, in embracing this federated model, Linden may place *Second Life* and itself on the fast track towards replicating the questions faced by multilevel governmental structures in our first lives: big government or small government? Which level should be responsible for what? Who arbitrates conflicts between local and federal governments? Who elects the government? What civic rights and duties does the individual have?

At the same time, this cannot be an argument for the establishment of unified, unitary rule under Linden Labs' sole leadership, of course, any more than for anything-goes anarchy. Indeed, participation in the development of multi-level civic structures within *Second Life* may well be a highly educational experience for many participants, and open their eyes to the implications of civic participation in the offline world. Where "often, real world institutions and practices constrain our ability to act upon the world by impoverishing our ability to imagine viable alternatives,"[35] civic engagement in the federated communities of *Second Life* very clearly points users to the wide range of alternative social structures available and imaginable in this online world.

Perhaps we would also do well to remember that *Second Life* is 'only' an online, virtual world, however; personal, property, and civic rights and regulations need not apply here in the same way and to the same extent as they must do offline, and not all the social structures possible in the MUVE can be translated and made to work on a sustainable basis in 'First Life'. On the other hand, the digital environment allows for a more flexible testing of possible models; it would be entirely possible, for example, to operate two alternative *Second Lives*, containing identical content and a self-chosen subset of the overall community—one operating as a federation of diverse civic communities controlled according to a variety of models by the landed gentry, and perhaps restricting participants' free movement across and participation in the immersive environment, one open to all and ruled in accordance with a global charter of rights by a

central authority. This would constitute a fork of *Second Life* into two parallel universes, of course—and although such forking is impossible in the offline world, it should be embraced by the *Second Life* community if differences of opinion over the future of in-world governance become too pronounced to be dissolved. (Indeed, one such fork may have happened already, if for different reasons, with the development of *Teen Second Life*, a space restricted to underage users only, and banning certain content and interactions as inappropriate.)

Producing Sociality

Beyond *Second Life* itself, each of the games and gaming worlds we have encountered here provide an opportunity for the development of a gamer community engaged in the produsage of both game assets and a wider social structure around and within the game; for each of them, governance emerges as a central question: how are the assets created by the produser communities governed (well beyond whatever the EULA stipulates), how do the communities themselves envisage their governing beliefs, values, and rules, and how do such ideas relate to the game producers' vision for the governance of internal and external communities of players and content produsers? Indeed, what is the self-understanding of the games company in relation to the gamespace they have created—does it regard itself simply as a producer, selling product and experience to otherwise silent consumers; does it operate as a landlord, imposing and altering rules and regulations according to commercial considerations without consultation with the community; does it (as Linden Labs is attempting to do) explore opportunities for the involvement of users in the governance process, and the devolution of some of the powers of governance to user-led entities within the overall community?

Such questions return us to Shirky's five principles for online communities as we noted them at the start of this chapter; in answering them, operators must necessarily balance a number of social, ethical, moral, legal, and commercial considerations. In the first place, of course, the operator of the gamespace, the producer of the game software, has a legitimate interest in keeping the game platform financially sustainable (and that interest is shared by the users who depend on it at least to some extent for the continued existence of their community); the company has a right to see substantial financial returns on the significant capital investments it has made to develop and host the community space, and to attract users to it. Beyond this, however, users themselves have also made significant investments of time and resources into the game and gamespace, well beyond the purchase or access fees they may have paid or continue to pay; while made 'for fun,' in the pursuit of leisure, MMOG players for example "are spending real economic goods ... on a form of entertainment that uses a platform for active coproduction of a story line to displace what was once passive reception of a finished, commercially and professionally manufactured good."[36]

Though leisurely labor, therefore, the activities of users in such spaces must be considered to be labor nonetheless, and indeed a form of labor that is a crucial input for the continued existence of the games we have encountered here, and many more beyond. This alone is reason enough to continue to investigate such environments, as Castronova points out:

> one does not study the labor market because work is holy and ethical; one does it be-cause the conditions of work mean a great deal to a large number of ordinary people. By the same reasoning, economists and other social scientists will become more inter-ested in Norrath and similar virtual worlds as they realize that such places have begun to mean a great deal to large numbers of ordinary people.[37]

The question of labor itself also leads us further to consider labor rights and civic rights for the workers and citizens living (at least part-time, and in some cases for a considerable portion of their daily lives) within these environments, of course. The producers and providers of produsage-based games and game environments cannot escape a comparison of their role to that of the managers of a gated community, or that of a government more generally; this necessarily requires a substantial transforma-tion of traditional producer-consumer, producer-user relationships—as Shirky suggests, indeed, "to create an environment conducive to real community, you will have to op-erate more like a gardener than an architect."[38]

Even this may be a somewhat misleading image, however, as communities cannot be planted, and as users and producers have an agency of their own: as we have already noted, indeed, produsage communities with their gradually emerging, ever-fluid heter-archical structures leave traces *within* the landscape itself, well-trodden paths or 'desire lines' indicating their most prevalent patterns of interaction. Where the producers and providers of games and gamespaces can be likened to landscape architects, then, the users and producers constitute the individuals, groups, and communities roaming that landscape, altering it according to their own needs and wants, and adding their own features; the landscape designers must be prepared to allow for and respond to this.

In this image, then, what are the spaces of productive gaming as we have encoun-tered them here? They are not simple civic commons, communally managed property, as games commons have (sometimes very elaborate) internal economies of their own, and are themselves owned by the games provider—they could be said to constitute a kind of private, pay-for-access commons, therefore, but even this does not come to fully approximate their real nature, and certainly does not apply in the case of the open-access space of *Second Life*. They are, ultimately, privately owned spaces which give the *appearance* of being a quasi-commons which nonetheless allows for the parcel-ing-off of specific corners of the world for private use, often without detriment to the overall community; they are economies built on the exchange of artificially rarified but inherently non-rival resources. This conflicting nature is made possible only within a

digital environment which allows for the infinite multiplication of space and assets, and no analogy from the physical world is likely to fully and accurately describe them in their totality.

For this reason, then, it is also crucially important not to attempt wholesale to apply traditional governmental approaches of any kind to these spaces; governance structures for such hybrid, conflicting environments are themselves likely to be multi-faceted and multilayered.

> The relationship between the owner of community software and the community itself is like the relationship between a landlord and his or her tenants. The landlord owns the building, and the tenants take on certain responsibilities by living there. However, the landlord does not own the tenants themselves, nor their relations to one another. If you told tenants of yours that you expected to sit in on their dinner table conversation, they would revolt, and, as many organizations have found, the same reaction occurs in online communities.[39]

What is necessary, then, is to encourage the further exploration of potential structures of governance by producers and produsers alike, much as this is now beginning to take place in *Second Life*. The solutions to any problem of governance are likely to be highly locally specific, of course, but over time it will nonetheless be possible to identify the emergence of a variety of common approaches, and future community developers (from industry as well as from the community itself) would be well-advised to examine such emerging models, much as they would be well-advised to work to understand the internal dynamics of produsage overall.

However, the governance problematics we have encountered here apply to many produsage communities, spaces, projects, and environments outside of the gaming world just as much as they do within it. "The act of writing social software is more like the work of an economist or a political scientist. And the act of hosting social software, the relationship of someone who hosts it is more like a relationship of landlords to tenants than owners to boxes in a warehouse."[40] Wherever produsage communities and their activities are centralized and harbored in a space or environment provided by a commercial or non-commercial entity, therefore, questions over the terms of that tenancy will arise.

We can point to such questions in some of the sites we have already encountered in our travels so far, of course:

- in *Wikipedia*, we have seen questions over policy, and concerns over the role of *Wikipedia* administrators and Jimmy Wales himself in determining policy on the fly, without wider community consultation; questions about the procedures of vetting *Wikipedia* articles for a stable version, and the harvesting of content for stand-alone products, have also begun to emerge;

- in *YouTube* and other spaces, controversies about their own EULAs have begun to be voiced—here, too, it is unclear whether and how the community would be rewarded for the content it has contributed to the site if such content is used for commercial gain;

- in environments such as *Flickr*, the risk of community hijacking has been highlighted: given the significant user buy-in indicated by the life caching phenomenon, the commercial exploitation of such user commitment is as tempting as it would be lucrative.

A very different kind of threat, on the other hand, comes from the user community itself, and specifically from its most recent members: even where mutually satisfactory arrangements between communities and operators, between produsers and producers have been established, they are under constant danger of disruption from new users insufficiently socialized into established community rules and values. Rapid demographic change may be as destructive in this context as the arrival of a few highly vocal individuals, and community members are likely to

> treat growth as a perturbation as well, and they will spontaneously erect barriers to that growth if they feel threatened by it. They will flame and troll and otherwise make it difficult for potential new members to join, and they will invent in-jokes and jargon that makes the conversation unintelligible to outsiders, as a way of raising the bar for membership.[41]

We should also keep in mind the fact that such risks are not limited to *online* worlds and communities, however; any community must necessarily be in constant flux as established members leave and are replaced by newcomers. What is important in this context is most of all the development of effective means of handing down social and communal traditions from one generation to the next, while also allowing for change and adjustment as required to address present circumstances, or even for overall community division or forking.

Such questions, then, must lead us to consider the wider social aspects of produsage communities—within the spaces and environments of productive gaming as well as beyond them. What takes place here can be described also as another form of produsage, well beyond the produsage of sites and assets in the environment itself: communities of producers, acting according to the principles of produsage and therefore communally engaging in a shared project, evaluating one another's work, forming fluid heterarchical structures and accumulating personal merit and reputation, are necessarily always also involved in the produsage of social networks, of social structures, of sociality itself. Indeed, massively multi-player online games have shown that increasingly, the social aspects of the games rather than the in-game narratives have become a key factor of attraction; *Second Life* reflects this clearly in its move away from the MMOG model, and towards a MUVE, or multi-user virtual environment. Not all

such environments must necessarily take the form of 3D immersive spaces, however—in the next chapter, therefore, we examine the produsage of sociality in comparatively more conventional, Web-based, social networking sites, and the questions of reputation and trust which emerge from it.

NOTES

1. Debray, Régis, "The Book as Symbolic Object," *The Future of the Book*, ed. Geoffrey Nunberg (Berkeley: University of California Press, 1996), p. 146.

2. Clay Shirky, "Broadcast Institutions, Community Values," *Clay Shirky's Writings about the Internet: Economics & Culture, Media & Community, Open Source*, 9 Sep. 2002, http://shirky.com/writings/broadcast_and_community.html (accessed 24 Feb. 2007), n.p.

3. JC Herz, "Harnessing the Hive: How Online Games Drive Networked Innovation," *Release 1.0: Esther Dyson's Monthly Report* 20.9 (18 Oct. 2002).

4. Herz, p. 12.

5. Herz, p. 12.

6. Charles Leadbeater and Paul Miller, "The Pro-Am Revolution: How Enthusiasts Are Changing Our Economy and Society," *Demos* 2004, http://www.demos.co.uk/publications /proameconomy/ (accessed 25 Jan. 2007), p. 11.

7. Also see John A. L. Banks, "Negotiating Participatory Culture in the New Media Environment: Auran and the *Trainz* Online Community—An (Im)possible Relation," *Melbourne DAC 2003 Proceedings*, http://hypertext.rmit.edu.au/dac/papers/Banks.pdf (accessed 12 July 2007).

8. Eric von Hippel, *Democratizing Innovation* (Cambridge, Mass.: MIT Press, 2005), p. 4.

9. Also see John A.L. Banks, "Opening the Production Pipeline: Unruly Creators," *Proceedings of DiGRA 2005 Conference: Changing Views—Worlds in Play*, http://www.digra.org/dl/db /06276.19386.pdf (accessed 12 July 2007).

10. Benedict Anderson, *Imagined Communities*, rev. ed. (London: Verso, 1991).

11. Yochai Benkler, *The Wealth of Networks: How Social Production Transforms Markets and Freedom* (New Haven, Conn.: Yale University Press, 2006), p. 74.

12. Edward Castronova, "Virtual Worlds: A First-Hand Account of Market and Society on the Cyberian Frontier," *The Gruter Institute Working Papers on Law, Economics, and Evolutionary Biology* 2.1 (2001), p. 30.

13. Leadbeater & Miller, p. 21.

14. Castronova, p. 28.

15. Castronova, p. 3.

16. Celeste Biever, "Sales in Virtual Goods Top $100 Million," *NewScientist* 29 Oct. 2004, http://www.newscientist.com/article.ns?id=dn6601 (accessed 12 July 2007), n.p.

17. Castronova, p. 26.

18. Mandy Salomon, "Business in Second Life: An Introduction" (Eveleigh, NSW: Smart Internet Technology CRC, May 2007), http://smartinternet.com.au/ArticleDocuments /121/Business-in-Second-Life-May-2007.pdf.aspx (accessed 12 July 2007), p. 5.

19. Salomon, p. 5.

20. Salomon, p. 5.

21. *Wikipedia*, "Economy of Second Life," *Wikipedia: The Free Encyclopedia*, 11 July 2007, http://en.wikipedia.org/wiki/Economy_of_Second_Life (accessed 12 July 2007), n.p.

22. Salomon, p. 3.

23. Salomon, p. 7.

24. Castronova, p. 4.

25. Castronova, p. 3.

26. Salomon, p. 3.

27. Douglas Rushkoff, *Open Source Democracy: How Online Communication Is Changing Offline Politics* (London: Demos, 2003), http://www.demos.co.uk/publications/opensourcedemocracy2 (accessed 12 July 2007), p. 35.

28. Enid Burns, "Second Life Users Top 1.3 Million in March," *ClickZ*, 4 May 2007, http://www.clickz.com/showPage.html?page=3625769 (accessed 12 July 2007), n.p.

29. Salomon, p. 5.

30. "Civic Center," *Second Opinion: A Newsletter for the Friends and Residents of Second Life*, 2 Dec. 2006, http://secondlife.com/newsletter/2006_12/html/civiccenter.html (accessed 22 May 2007), n.p.

31. Henry Jenkins, "How Second Life Impacts Our First Life..." *Confessions of an Aca/Fan: The Official Weblog of Henry Jenkins*, 13 March 2007, http://www.henryjenkins.org/2007/03/ my_main_ question_to_jenkins.html (accessed 13 Mar. 2007), n.p.

32. "Civic Center," n.p.

33. Jenkins, n.p.

34. "Civic Center," n.p.

35. Jenkins, n.p.

36. Benkler, p. 74.

37. Castronova, p. 2.

38. Clay Shirky, "Broadcast Institutions, Community Values," *Clay Shirky's Writings about the Internet: Economics & Culture, Media & Community, Open Source*, 9 Sep. 2002, http://shirky.com/writings/broadcast_and_community.html (accessed 24 Feb. 2007), n.p.

39. Clay Shirky, "Broadcast Institutions, Community Values," n.p.

40. Clay Shirky, "A Group Is Its Own Worst Enemy," *Clay Shirky's Writings about the Internet: Economics & Culture, Media & Community, Open Source*, 1 July 2003, http://shirky.com/ writings/group_enemy.html (accessed 24 Feb. 2007), n.p.

41. Clay Shirky, "Broadcast Institutions, Community Values," n.p.

Social Produsage:
Questions of Reputation and Trust

T he previous chapter clearly pointed to the fact that as a community-driven practice, produsage almost always also has strong social aspects; indeed, throughout this book we have highlighted the communities of produsers with their heterarchic, meritocratic structures of organisation and their *ad hoc* principles of governance. As Bauwens describes this,

> the more one shares, the more this material is used by others, the higher one's reputation, the bigger one's influence. This process is true for individuals within groups, and for the process among groups, thus creating a hierarchy of influence amongst networks. But ... in a true P2P environment, this process is flexible and permanently reversible.[1]

Questions of how to assess personal merit, how to award, maintain, and withdraw indicators of communal reputation, and how to ensure that such indicators can be trusted by others inside and beyond the community, therefore become paramount, and we examine them here in more detail.

Such questions become especially pronounced the more we enter the realm of produsage in areas where it has become the dominant force, or where it operates at a remove from the traditional sources of 'trusted' information—

> when thrust into the hyper-connected realm of the Web, our natural first reaction is to seek signposts, handholds against the onrush of so much that clamors about its own significance. In cyberspace you can implicitly trust the BBC, but when it comes to The Smoking Gun or Disinformation, that trust must be earned.[2]

This applies to the inner realms of *Second Life* as much as to the distributed networks of the blogosphere, but here, even reliance on the familiar, the apparently trustworthy operators of 'first life' can mislead; the *Second Life* or *YouTube* presences of the BBC, for example, are by no means central or normative for those spaces, but instead represent merely an attempt of old media to become a participant in new media,

without any special privileges or the benefits of inherent trust earned through long-time constructive engagement with the community. In the native spaces of produsage, even the familiar sources must earn their trust like everyone else.

This, of course, applies to organizations developing their bases of operations in such environments just as much as it applies to individual produsers; they, too, must carefully build and maintain their reputations in the community. In addition, of course, they may—from what we have seen, they are indeed likely to—participate in a variety of such communities at once, each with its own social conventions and rules, each with its own systems to reputation and trust. For the most part, such systems are independent of one another, however, and thus,

> one problem with online reputation is the lack of portability of virtual identities (and reputations) between systems. For example, if you build a positive seller or buyer reputation on eBay or Slashdot, it cannot be transferred to other virtual environments. (eBay has sued some who have tried to do so.) It's great for the host of the community, such as eBay—some speculate that this aggregation of social capital is the key to their success—but for the individual and for social networks, it's a serious problem. It creates islands of reputation, which are time-consuming to earn.[3]

In addition, reputation systems may not even be unified within and across specific spaces as a whole, but may exist as islands within an overall project; we have already seen the *Wikipedia* as an example for a community of communities, each loosely focused around particular topics and interests within the *Wikipedia*, each with its own (informal) systems of community reputation and trust, which do not translate across its boundaries—and perhaps should not: reputation earned as a valuable contributor to one realm of the encyclopedia does not necessarily indicate that the same produser will be able to be as useful a community member on another topic. This is further complicated also by the fact that the nature of individual contributions must be recognized: a valuable content contributor to entries on the history of ancient Greek settlement in western India cannot necessarily be trusted to contribute useful material on wireless networking technology; however, an expert *editor* of content in the former area may also be able to be relied upon to polish up entries in the latter. Spaces such as *Wikipedia* would therefore likely need to combine localized systems of reputation and trust (which also raises the question of how to define such localities within the *Wikipedia*) with distinctions between informational, functional, and administrative contributions made to the communal project, as well as developing the means of making visible contributors' rankings in such reputation systems to the wider community.

Further, reputation systems must also ensure that reputation rankings do not give rise to the re-emergence of more traditional hierarchical structures of power, in which the most highly ranked contributors are automatically also positioned as the undisputed and indisputable leaders of a project. That approach would violate the overall assumption of equipotentiality of contributors on which produsage is based, and

would come to undermine the community itself. "The open process of participation (equipotentiality) precludes a systematic strengthening of reputation so that it could become a factor of conservatism (as it is in science and its dependence on dominant paradigms) and power."[4]

An overreliance on established reputation, especially where standing in the community is expressed explicitly in numerical or other scores, would serve to discourage and alienate newcomers starting (literally) at zero, as well as give rise to processes of reputation score building and hoarding—known in the Slashdot community with its karma points reputation system as 'karma whoring'—which are likely to lead to the deterioration of community collaboration by introducing overly competitive aspects into social engagement. Although mild competition to be seen as a highly constructive contributor can have strong positive effects on the community overall, such effects are negated where competition itself becomes the central purpose of participation, and comes to be conducted to the detriment or exclusion of other community members.

By contrast, then, it is important to develop systems in which reputation remains temporary, thereby both preventing the emergence of more fixed hierarchies and encouraging contributors not to rest on their achievements, but to continue to participate constructively. Thus, "in the better P2P systems, reputation is time-sensitive on the degree of recent participation," and in such systems of produsage "the possibility of forking and of downgrading reputation grades, introduce[s] an aspect of community control, flexibility and dynamism."[5] To some extent such systems of reputation assessment and tracking are perhaps not so unlike models for staff performance management as they exist in many corporations and other organizations; to some extent they do indeed serve the same purpose of identifying and rewarding those contributors who are most actively furthering the shared project, and who can therefore be seen to be most directly aligned to the overall vision of the organization. At the same time, of course, the ultimate purpose of tracking performance and reputation in the community is vastly different: where traditional, hierarchical organizations are utilizing such data to facilitate the movement of valuable employees to higher levels of the corporate pyramid, heterarchical communities use reputation information to build networks of collaboration and trust which are of use to the shared mission and in the shared tasks of community itself. Community reputation systems may certainly facilitate the emergence of leaders for the project's heterarchy, but such leadership always remains task-specific and temporary, and depends crucially on continued performance as assessed by the community itself—a process vastly different from the top-down performance assessment in the conventional corporate world.

At any rate, then, it is self-evident that the community-based models of collaboration which exist in produsage environments crucially rely on systems of evaluating merit, establishing reputation, and building trust. This is all the more pronounced in large and distributed projects relying on a diverse community whose members are largely unknown to one another—regardless of whether the entire community facili-

tates its collaborative engagement through one central site (as in the case of *Wikipedia*, or in *Second Life*) or whether it operates across a vast, loosely connected and constantly changing network (as it exists in the blogosphere and in social bookmarking). Reputation and trust is necessarily central for projects in which quality concerns are paramount—in the development of open source software, in the collaborative creation of the *Wikipedia*—and less so perhaps in areas where probabilistic models of contribution aggregation can be employed to generate an overall picture of the contributions made or where diversity itself is encouraged—for example, in the collaborative creation of folksonomic knowledge structures or in creative produsage models. Even in the latter cases, however, systems of reputation and trust (whatever the factors which determine contributors' merit in each individual case) remain important means for identifying and filtering out the contributions of consistently anomalous participants, or for highlighting those community members commonly seen as most creative, inventive, or exciting in their work.

Indeed, merit, reputation, and trust have become especially important also in produsage environments where the object of produsage itself remains relatively undefined, and where social interaction itself becomes the central purpose of community participation—or where, as we might say more appropriately, *the produsage of sociality* itself turns out to be the underlying mission of the produsage environment. Here, the more or less overt evaluation of peers by peers in the community becomes a core practice, as does the evaluation of peer-contributed content as an indirect means of evaluating peers themselves. A number of key spaces for this produsage of sociality have emerged to public attention in the past years, ranging from *Friendster* through *MySpace* to *Facebook*, from *Cyworld*[6] to *Orkut*,[7] as well as to more professionally focused social networking sites such as *LinkedIn* or *Ecademy*. In addition, of course, we have already highlighted the strong social aspects of sites such as *Flickr* or *YouTube* and of spaces such as *EverQuest* and *Second Life*, and there are significant groups of participants on such sites which use them not predominantly for the purposes of sharing content or playing games, but mainly for building and maintaining social relationships and networks. Further, the decentralized network of the wider blogosphere also enables a form of distributed social networking which is maintained through interlinkage and cross-commenting between individual bloggers, highlighting the conversational rather than publicational aspects of blogging.

Indeed, blogs themselves, and early and centralized hosts for blogging such as *Blogger* and *LiveJournal*, but also early personal homepage providers such as *Geocities*, should be considered to be the forerunners for the current generation of social networking Websites; they have set in motion an important and momentous trend. As Rushkoff suggested in 2004,

> in the short time Blogger has been available, it has fostered an interconnected community of tens of thousands of users. These people don't simply surf the Web. They

are now empowered to create it. Rising from the graveyard of failed business plans, these collaborative communities of authors and creators are the true harbingers of cultural and perhaps political renaissance.[8]

Many such first-generation homepage and blog hosts, as well as the second-generation social networking sites which have emerged since, have added further functionality to the blog-like posting of news, views, and commentary by their members: in addition to textual content, users can now frequently also upload images, sound, and video; they can create personal profiles and highlight their current interests in popular culture; but most importantly, they can also identify their social networks of fellow users on the site and award these peers varying levels of status as family, friends, associates, colleagues, and acquaintances (the exact nature of such networking terms varies from site to site, of course). In addition, the sites themselves may also highlight further existing or potential linkages between peers on the basis of common patterns of browsing or interaction, or on shared nodes in their individual social networks; from this, then, a wider picture of social relations within the overall community gradually emerges.

Overall, then, Pesce suggests that

> the lesson we can draw from this is simple: social networks emerge from interactions; they are not created in a one-off process, but rather, grow and change over time. The success of any digital social network relies on its ability to be able to (relatively) invisibly monitor the activities of the actors within that digital social network, and seamlessly weave these activities into a social network model.[9]

Indeed, such sites provide very useful insights into the processes of social network formation, and are studied with increasing interest by social scientists; in many cases they also serve as important educational tools for their participants themselves, as they attempt to transfer to the online environment and make explicit their existing, offline social networks, and thereby expose the assumptions underlying such existing networks. Many users have found themselves confronted with difficult decisions on whom (and how many peers) to award the much-coveted 'friend' status, and how to rank their various peers on a sliding scale of close association. Vastly different approaches to such questions are in evidence, from MySpace users with thousands of 'friends' to others whose core network remains a highly exclusive group. Benkler describes the decisions made in the process as a form of liberation from traditional and obligatory social bonds, made possible by the clean slate provided by the new environment:

> the interpolation of new networked connections, and the individual's role in weaving those for him- or herself, allows individuals to reorganize their social relations in ways that fit them better. They can use their network connections to loosen social bonds that are too hierarchical and stifling, while filling in the gaps where their real-world relations seem lacking.[10]

Overall, then, we can clearly describe such processes as a form of produsage—as the produsage of social networks and sociality itself:

- it is based on the **open participation** of users in the wider social network, and on the **continuous evaluation of peers by peers** (and of the strength of the network ties connecting them);
- through this process, each participant specifies their own network of connections, and in combination the overlapping networks of each peer allow for the emergence of **heterarchical network** structures showing nodes, hubs, and clusters; such networks are governed by individuals (and sometimes, groups) through *ad hoc* **decisions based on participant merit**, deciding what existing connections to sever, and what further connections to make;
- the resultant network, or network of networks, necessarily remains inherently **unfinished** as existing and new participants continue to adjust their personal networks in an **ongoing process** of evaluation;
- the overall network itself, the overlapping networks themselves, made up of individual users, constitute a **common property** and describe a communal social structure, but each user in the networks is able to derive **individual rewards** (in the first place, visibility beyond their local cluster) from participating actively in the shared process of network building and maintenance.

Such produsage processes can also be used in pursuit of more specific outcomes, of course, and are being employed for example in the case of sites such as *LinkedIn* or *Ecademy* to produse not simply generic *social* networks, but more specific *professional* social networks (thus creating the potential for more tangible rewards—professional status, new job opportunities—for key participants in network produsage). Such sites nonetheless operate in much the same way as do standard social networking sites; they simply add more standardized functionality to allow their members to identify exactly their professional specializations, expertise, qualifications, employment history, and other information of professional interest. In this context, too, a careful consideration of 'friending' processes is of particular importance, and highlights the overall recognition of informal networks of professional peers in recent management and economic theory; *LinkedIn* and its competitors can therefore be seen as the immediate and necessary consequences of a move from industrial to networked economy. At the same time, of course, the utilization of produsage-based social networking environments in pursuit of tangible professional outcomes also highlights the particular importance of developing systems of reputation and trust which will evaluate the veracity of the professional information supplied by individual participants; especially as the network of users grows and becomes more diverse and complex, it is unlikely that such verification can be provided by any one central governing authority charged with sighting all information provided by users, however—instead, it is likely that in such spaces just as

elsewhere in produsage, communities of participants engaging in in-depth processes of peer assessment are going to undertake much of the work of reputation evaluation and quality control themselves.

From Social Networks to the Internet of Things

It is important to note that the produsage of social networks, in particular, also extrudes further from the Internet proper into spaces of everyday life than most other forms of produsage activity we have encountered so far. Although all forms of produsage are likely to have 'real-world' implications, social network produsage now does so often quite immediately, as the tools for social networking come to reside no longer only in the conventional online environment, but also in mobile networked devices—such social networking functionality is being built into mobile phones, PDAs, laptops, and other devices, and enables its users to identify shared contacts and form new network ties *ad hoc*, on the fly. Indeed, extending even further beyond online *and* offline social networks, such networks may come to include not only the individual participants who form them, not only human resources, but also other informational and physical resources which form the basis upon, or the material with which such networks of users collaborate. In the process, produsage comes full circle: where we have seen social networking sites emerge by increasingly abstracting the social aspects of produsage from any one specific and stated object of collaborative produsage (the development of software, the creation of an encyclopedia), coming to focus instead on the produsage of sociality itself, here we see that the generic or professional networks of participants and resources which emerge from such abstract produsage of sociality are able to be re-employed in the pursuit of specific objects of produsage once again, by introducing into the network a variety of resources with which it can work.

Again, the mobile aspects of such tendencies should not be underestimated in this context; the connection of social networks with networks of resources is supported in important ways by developments such as Semacode which extend the informational network of the Web even beyond the social exchange layer introduced through Web 2.0 technologies, and towards what has come to be called an 'Internet of things': a network combining informational, human, and physical resources through a variety of permanent and *ad hoc* technological structures ranging from Internet Protocol (IP)-layer Internet infrastructure to Web-based content and participant interlinkage to the tagging of physical objects and resources through machine-readable barcodes which act as quasi-hyperlinks. *Trendwatching* sees such developments as driven by a fundamental 'infolust' characterizing the present moment, and notes three key developments in this context:

1. Even more transparency in the online world

2. Search and answers go mobile
3. Real world objects join the game[11]

Jenkins describes such developments as driven by a similar 'transmedia impulse,' seeking to extend the forms of informational engagement now prevalent on the Web, and on the Internet more generally, to an ever wider range of contexts, and thereby furthering the shift towards convergence culture[12]; already, he notes, we now exist in an always-on, multiply connected state.

> Media convergence impacts the way we consume media. A teenager doing homework may juggle four or five windows, scan the Web, listen to and download MP3 files, chat with friends, word-process a paper, and respond to e-mail, shifting rapidly among tasks. And fans of a popular television series may sample dialogue, summarize episodes, debate subtexts, create original fan fiction, record their own soundtracks, make their own movies—and distribute all of this worldwide via the Internet.[13]

Social networking, then, provides the glue between all of these activities, and between the participants engaged in them; the merit, reputation, and trust structures which emerge from it assist the participants themselves, and any users of the resultant information accessing it from outside of the core social network, in evaluating the quality and reliability of the information they encounter.

However, to utilize social networking and its structures in this way also requires an important set of additional skills and capacities on behalf of the user, and in particular points to a need to query and investigate any assumptions and systemic biases built into the social network and its technological supports.

> Thinking of the platform as social software entails designing it with characteristics that have a certain social-science or psychological model of the interactions of a group, and building the platform's affordances in order to enhance the survivability and efficacy of the group, even if it sometimes comes at the expense of the individual user's ease of use or comfort.[14]

Where a social software, social network platform privileges certain forms of interaction over others (in the way that, for example, *LinkedIn* or other professional social networking sites may privilege certain explicit indicators of professional status over other, more implicit or unquantifiable aspects of professional practice), therefore, such systemic emphasis on specific qualities is likely also to be reflected in the evaluations of individuals through rankings of reputation and trust that it produces. In itself, this is not a problem as long as all participants of the site are aware and mindful of such inherent biases; this, then, points us to a need to clearly articulate the underlying social models of any one social networking site.

Such models may be substantially easier to articulate, however, if there is a shared common purpose to which all members of the community subscribe; reputation of and trust in specific participants is likely to be much easier to evaluate, for example, if

they can be evaluated against a shared goal through such participants' performance as contributors to the collaborative project of developing software or compiling an encyclopedia, for example, than against the less well-defined project of produsing sociality. Indeed, as Pesce suggests,

> the most impressive example of a working social network isn't known as a social network—and this may be why it works so well. For a decade eBay has carefully built up a social network with commerce as its organizing principle. Every buyer and every seller exist in a network of relationships, which is constantly reinforced by the only requirement eBay makes on its user base: that they rate the transactions conducted through eBay.™[15]

Similar examples include the citizen journalism Websites discussed in Chapter 4: here, too, the shared project provides a clear organizing principle for the social networks which exist around it. Where the produsage of social networks themselves provides the core organizing principle, on the other hand, a failure of the model to achieve and maintain sustainability may be more likely in the long term: on *eBay*, in citizen journalism, and elsewhere, social networks based on merit, reputation, and trust emerge from participants rating and commenting on one another's actions in common processes, against a communal standard; such ratings can be accumulated automatically as well as evaluated communally. By contrast, in sites which harbor social networks simply *as* social networks, without such further organizing principles, rating and commenting itself becomes the core content generation activity, but often provides significantly more limited incentives for sustainedly engaged participation:

> social networks, in the human sphere, are dynamic and constantly evolving; we maintain some relationships throughout our lives, but others come and go, as we change jobs, cities, and partners. A web page can't even attempt to encapsulate that sort of complexity, and this highlights the basic problem: you can spend a week building up your Friendster contacts, but will you spend the hours-per-week keeping that list fresh?[16]

Producing Society?

Even if the produsage of sociality in 'pure,' goalless social networking sites may therefore be less successful than its current popularity may indicate—"even NEWS Corporation is wondering how to monetize MySpace," Pesce notes[17]—seen more broadly as a common feature of produsage projects and environments in general, it may nonetheless come to be a core feature of the emerging knowledge space of humanity which produsage is helping to develop. Such peer-to-peer community interaction, then, could become "a template of human relationships, a 'relational dynamic' which is springing up throughout the social fields."[18] Beyond the knowledge space, beyond the cosmope-

dia, which is necessarily also a social project in itself, of course, produsage could be very directly engaged in the produsage of society as such: "collective intelligence is not a purely cognitive object. Intelligence must be understood here ... as uniting not only ideas but people, 'constructing society.'"[19]

Indeed, the emergence of produsage itself can be seen simply as a symptom of a wider informationalization of all aspects of our everyday lives, our economy, our society. With the help of technological advances, information is being embedded ever more deeply into all aspects of life, but this is not a process driven by technology as such; indeed, perhaps it would be more correct to say that our networked information and communication technologies have helped merely to make more notable, more visible, more explicitly extractable and usable, the information and knowledge which was already always, inherently, necessarily embedded in all aspects of human existence, action, and interaction. Technology, in this view, is merely a support mechanism serving to connect and amplify processes of information use and knowledge generation which have always been a fundamental aspect of human life; it helps address what Lévy describes as a central problem for collective intelligence,

> that of discovering or inventing something beyond writing, beyond language, so that the processing of information can be universally distributed and coordinated, no longer the privilege of separate social organisms but naturally integrated into all human activities, our common property.[20]

Produsage adds to this by providing a system which enables this broad-scale participation in collective intelligence without channeling it necessarily through the processes of conventional production; removing commercial and other filters which operate through an imposition of hierarchical structures determining a priori what knowledge and what participants are to be seen as most valuable, or most likely to be valuable—by contrast, it allows such structures to emerge from within the process, from within the community, and from within the commons itself. "Building the commons has a crucial ingredient: the building of a dense alternative media network, for permanent and collective self-education in human culture, away from the mass-consumption model promoted by the corporate media."[21] This, too, may be understood not so much as a new development, but merely as the rediscovery of older patterns of human interaction and collective intelligence extant in a preindustrial age, of course. Ultimately, then,

> this new human dimension of communication should obviously enable us to share our knowledge and acknowledge it to others, which is the fundamental condition for collective intelligence. Beyond this are two major possibilities, which could radically transform the fundamental data of social life. First, we will have at our disposal simple and practical means for knowing what we are doing as a group. Second, we will be able to manipulate, much more easily than we are able to write, the instruments for collective utterance. This will ... take place ... in keeping with the size and speed of the

enormous turbulence, deterritorialized processes, and anthropological nomadism that we are now subject to.[22]

But we should not simply assume that such shifts to collaborative processes of produsage will continue unhindered, or that they are not themselves open to diversion through commercial or other interests. Although it remains as yet unclear exactly what direct benefits, if any, News Corporation will derive from its acquisition of *MySpace*, and what effects the clash of its conventional, top-down, corporate culture with the bottom-up social network of *MySpace* will generate, this corporate embrace (and perhaps enclosure) of social networking environments and produsage sites more generally—as we have also already seen it in our examination of corporately owned online gaming environments, for example—raises serious questions for a future in which more and more of our activities of social interaction and social networking may take place in such online environments. Benkler suggests, for example, that the winners from a shift to what he describes as 'commons-based peer production' "would be a combination of the widely diffuse population of individuals around the globe and the firms or other toolmakers and platform providers who supply these newly capable individuals with the context for participating in the networked information economy"[23]; what remains unclear from this description, however, is the exact manner in which the corporate players in this process would be likely to extract their winnings from the social commons.

Again, here, we can envision a variety of more or less benign possibilities; it is certainly conceivable that significant corporate earnings can be generated simply from advertising and other ancillary practices which harness the level of interaction in produsage communities without directly or substantially affecting that interaction itself. In addition, and more problematically, the content generated by produsers may also be harvested and on-sold for commercial gain; this would be acceptable as long as it respects the community's own intentions for how its work would be used, and does not operate simply under cover of legal but essentially unethical end-user license agreements. Harboring the community itself may also be able to generate substantial income flow, where the harboring services themselves are such that community members will happily pay one-off or continuous service fees, but at the same time it also raises the specter of community hijack: fee structures may be altered, and corporate governance rules changed, without consultation with a community whose strong buy-in to an existing site might make it prohibitively difficult for it to take its contents and social networks and move on to a different, more benevolently governed environment.

More fundamentally, however, if the majority of produsage-based processes of information, knowledge, creative, and network generation in a society take place in corporately governed environments, we might also ask whether even societies whose processes involve significant degrees of such produsage are ultimately substantially dif-

ferent from more conventional consumer societies. If produsage is commercially har-
nessed, this is likely to affect the processes of produsage themselves—sometimes lightly,
as in the case of open source projects which involve commercial contributors or redis-
tributors, sometimes more strongly, as in the case of examples such as *Break.com* or
EverQuest, as we have seen. If the majority of produsage operates under such models,
how different from the more banal harnessing of consumers as prosumers does it re-
main? (At the same time, however, we should also note that commercial support for
produsage may help to move past some of the copyright-based roadblocks for some
produsage activities: corporately endorsed produsage or the commercial harboring of
produsage communities may enable a wider variety of remixing and mashup activities
to take place at least within such commercially operated spaces—but also raises ques-
tions about the extent to which such mashup artefacts are permitted to be used and
further prodused beyond that produsage space itself.)

Concerns over the commercial enclosure of produsage are significantly reduced,
however, if we realize that the networked information technologies which have helped
us to rediscover vernacular creativity and cultural engagement, and to channel such
activities into produsage proper, also enable us to develop many forms of produsage
which no longer require the existence of a central, unified space or environment; in-
creasingly, as the blogosphere, filesharing networks, and folksonomic content tagging
activities all demonstrate at present, produsage can also take place as a massively dis-
tributed, decentralized activity. Today, such spaces can no longer be enclosed through
commercial, legislative, or other top-down processes: their contributors form loose and
non-committal networks only, and may not even be fully aware of the networks to
which they belong; they are connected through the use of shared technological frame-
works either intentionally (through their own efforts to engage with one another) or
through automatic means. Such interconnections are increasingly enabled through the
further development of technologies which facilitate them, including Application Pro-
gramming Interfaces (APIs) and the AJAX frameworks which form the basis for Web
2.0; they enable the further disconnection of content from the spaces in which it
originates. To the extent that they are effectively policed, these environments are po-
liced by the community itself as it develops social and technological norms which fa-
cilitate the effective exchange and engagement between nodes within the overall
distributed network.

What will become more important to examine in the future, then, is how such
norms themselves develop; here, it will be interesting to investigate especially also the
extent to which any such patterns may be said to be culturally specific and related ei-
ther to established geographical cultures or to the emerging cultural communities of
the wider network of humanity itself. Broadly speaking, for example, can we discern
clear trends for users originating in individualist Western cultures to embrace espe-
cially those communities of produsage which operate under more explicitly competi-
tive structures of merit and reputation (as exemplified perhaps by *Slashdot*'s karma

model); do participants from collectivist Asian cultures instead embrace more inherently communal and collaborative environments which do not allow for the emergence of strong individual leaders? Alternatively, do continuing trends towards a broad international collaboration between contributors from a wide variety of social, cultural, and geographic backgrounds begin to close the gap between different attitudinal preferences? (Cross-cultural comparisons of the emerging administrative models in the various language-specific version of *Wikipedia* will be highly instructive in this regard.)

Indeed, the engagement between groups and communities of differing cultural origins both in centralized sites and in decentralized networks of produsage is likely to create a number of conflicts as well, which may lead to the forking of communities, but could also encourage further tendencies towards cross-cultural engagement. *Wikipedia*, for example, has been described by some observers as serving to provide a crucial common and neutral ground for groups known for otherwise frequently heated clashes; through their discussion pages, participants on entries on controversial topics from abortion to Israel have often managed to establish a workable truce and even a mutual understanding that is some way ahead of the state of debates in the wider international dialog. On the other hand, some social networking spaces have been affected potentially more negatively by the consequences of a profound cultural disconnect between different groups of participants; Fragoso, for example, vividly describes the impact of a large influx of Brazilian participants into the previously American-dominated social networking Website *Orkut*, whose very character was altered substantially as a result.[24] Whether considered to be undermining a traditional U.S. dominance over the spaces of online engagement, and thus perhaps a positive development, or to constitute a fundamental challenge to the continued existence of an online community dependent on a shared understanding of and adherence to common social values and rules, such cases clearly point to the always inherently precarious nature of produsage processes and environments as reliant on the continued goodwill of a substantial majority of their participants.

A Networked Society of Produsers

Again, however, such observations point to clear parallels between the produsage of sociality as it takes place in such environments themselves, and the fundamental processes of establishing, maintaining, and altering shared societal and communal beliefs, values, norms, and rules as they take place within society itself. Society, indeed, may be considered to be the greatest produsage project of all, and the rise of produsage as a distinct model which we have documented here may therefore also offer new impulses for the continuing project of creating a society (or a variety of overlapping global societies, based on geographical, socioeconomic, and other factors) which appropriately reflects the current condition and future aspirations of humanity. In this project and

process, the modern-day produsage movement itself follows at least implicitly a specific set of objectives and interests, of course: as Bauwens articulates it, "if there is an 'offensive' strategy it would look like this: to build the commons, day after day, the process of creating of a society within society. In this context, the emergence of the internet and the web is a tremendous step forward."[25]

Indeed, Rushkoff suggests that such produsage of society holds the potential for a new renaissance:

> a moment when we have the ability to step out of the story altogether. Renaissances are historical instances of widespread recontextualisation. People in a variety of different arts, philosophies and sciences have the ability to reframe their reality. Renaissance literally means 'rebirth'. It is the rebirth of old ideas in a new context. A renaissance is a dimensional leap, when our perspective shifts so dramatically that our understanding of the oldest, most fundamental elements of existence changes. The stories we have been using no longer work.[26]

As society changes—whether through renaissance or more dramatically through a series of technological, economic, social, or societal revolutions—then, this must necessarily also affect the specific communities and individuals extant within the overall society; indeed, as Lévy suggests, "the individuals who animate the knowledge space are, far from being interchangeable members of immutable castes, singular, multiple, nomadic individuals undergoing a process of permanent metamorphosis (or apprenticeship)."[27]

Much like produsage itself as it takes place in specific produsage environments and networks, and much like the communities which drive such produsage projects, then, the produsage of sociality and society is necessarily a collective, communal, collaborative project, and relies on and harnesses network effects perhaps more strongly than has been the case for the conventional mass-mediated societies of the twentieth century; to some extent, perhaps, it returns to the social processes of preindustrial communities, but connects and amplifies them to enable a wider, more truly global form of collaborative engagement, realizing more fully the potential of collective intelligence.

> This project implies a new humanism that incorporates and enlarges the scope of self knowledge into a form of group knowledge and collective thought. The old adage 'I think, therefore I am' is generalized as a process of collective intelligence leading to the creation of a distinct sense of community. We pass from the Cartesian *cogito* to *cogitamus*. Far from merging individual intelligence into some indistinguishable magma, collective intelligence is a process of growth, differentiation, and the mutual revival of singularities. The shifting image that emerges from such skills and projects, and from the relations among members in the knowledge space, constitutes, for a community, a new mode of identification, one that is open, dynamic, and positive.[28]

The *cogitamus, ergo sumus* of the collective intellect should not be misunderstood as pointing to some kind of collectivist thought process, then; *cogitamus* does not describe a *cogito* occurring in parallel, in sync, and in unison in a larger number of minds, but the interconnection of a large number of independent thought processes combining together to form collective intelligence. In this, it resembles very closely the collective processes of produsage, of course, in which different nodes in the overall network alternate in productivity, contribution, centrality, and importance, and only together drive forward the shared project of creating information and knowledge. A society based on such ever-shifting *ad hoc* interconnections between individual participants in the network is therefore substantially different from the society of the mass media age with its few dominant channels of transmission and interaction, and its inherently subordinate networks of 'average,' private individuals gazing in on that public sphere.

> It is precisely the varied modes of participation in small-, medium-, and large-scale conversations, with varied but sustained degrees of efficacy, that make the public sphere of the networked environment different, and more attractive, than was the mass-media-based public sphere.[29]

Indeed, in Chapter 10 we have already introduced the image of a gentle slope of interest communities, engaged in their own conversations, surrounding the remaining tall peak of the mass media; if, and as, the balance between tall peak and gentle slope continues to shift, then, this may come to fundamentally undermine the traditional model of the mediated public sphere. In an environment driven by niche cultures, "where the demise of institutions and their stifling conventions has unlocked latent hyper individualization, where it is all about 'me' (for better or worse), where being special will lend consumers status, to be mass is now every consumer's nightmare."[30] Rather than promising the produsage of sociality, and of society itself, then, such predictions could be read to suggest the potential of a debilitating fragmentation of society into disconnected interest groups speaking only to themselves.

Such fears are hardly new, however; they have been voiced at least since the first modern projects of research into subcultural communities in the 1960s. What such dystopian visions ignore is the fact that very few cultural participants have only one identity, only one interest, only one cultural home; any one of us combines instead a variety of diverse cultural influences into our personality and is a member implicitly or explicitly of a range of cultural groups. Indeed, far from retreating into predetermined niches and refusing any further engagement with the outside, we are increasingly actively seeking out new ideas and new cultural influences to incorporate into our mix: "consumer societies are now about standing out, not conformity, which in turn means an encouragement to explore one's often broader-than-assumed taste."[31]

Nonetheless, rather than a unified culture, a coherent society, such overlapping communities of interest resemble a patchwork; they are indeed a *network* of communi-

ties with key hubs and nodes as well as less accessible, less well charted areas of limited connectivity. This raises the question of what becomes of the traditional, mass-mediated public sphere whose function as "an intermediary system between state and society"[32] is regarded as a crucial element of modern democracies. Are we witnessing simply the demise of the traditional public sphere, or are we also seeing the simultaneous emergence of a new, non-mass-mediated, networked public sphere to replace it—a sphere which is perhaps no longer a simple sphere, but instead a 'sphere of spheres,' a network of networks: a space containing many overlapping individual communities engaging directly with one another without mediation by the orchestrators of the traditional public sphere—the mass media?

If so, then far from leading to the fragmentation and disintegration of society, it may enable the development, the produsage of a higher quality of sociality:

> instead of the lowest-common-denominator focus typical of commercial mass media, each individual and group can—and, indeed, most likely will—focus precisely on what is most intensely interesting to its participants. Instead of iconic representation built on the scarcity of time slots and space on the air or on the page, we see the emergence of a "see for yourself" culture.[33]

Further, of course, such 'do it yourself,' 'see for yourself,' participatory culture and society, based on the open access and open participation principles of produsage, would also enable individuals more directly to seek out and more immediately to see the perspectives of communities other than their own. Bypassing the mass media as the traditional moderators of such engagement, then, also reduces the potential for such media to skew processes of interaction and evaluation for commercial or political reasons. In the process, communities become more 'molecular' in nature, as Lévy describes it, a development also supported by the emergence of similarly molecular technologies:

> the multiplication of molecular communities assumes the relative decline of [mass] media-based communication for the benefit of a cyberspace that is receptive to collective intelligence, a space that becomes increasingly navigable and accessible as molecular technologies become operational and available at low cost. Real-time, large-scale collective intelligence thus requires a sufficient technical infrastructure.[34]

Where such infrastructure is available—and today, that is increasingly the case at least for the citizens of developed nations—, "the communities of intelligence flee the territory, escape the networks of commodity for a knowledge space that they produce by thinking, dreaming, and wandering."[35] If such a decentralized, networked, community-mediated re-imagining of the traditional public sphere is possible, then, what it requires is not the operation of a centralist mass media to amalgamate, normalize, and unify popular opinion and thereby to represent the public to itself, but instead the means to manually and automatically collate, contrast, and compare the multiple views held by individuals within different communities, and to facilitate their cross-

and interconnection. We have already identified the role of many of the environments of information and knowledge produsage as contributors to that task, from the collaborative evaluation of available information in citizen journalism to the development of a shared set of representations of knowledge in *Wikipedia* to the communal gathering and structuring of knowledge about knowledge through folksonomic processes.

Such processes also necessarily hold within them the potential for a further re-centralization of the decentralized knowledge space; this tension is a productive one, however, and indeed turns out to be one of the inherent contradictions which animate the produsage-based society itself—like produsage overall, perhaps, the produsage of sociality continually oscillates between the amalgamation of available information and knowledge in search of a universally shared, generally accepted understanding of the world, and the introduction of new and contradictory views and ideas which must again be addressed and incorporated into the wider knowledge space. Such constant oscillation drives processes of emergence and decline of the *ad hoc* hubs and clusters in the network, and in combination these cluster structures existing across the network form an effective and resilient system for the processing of information and knowledge:

> the result is an ordered system of intake, filtering, and synthesis It does not depend on single points of control. It avoids the generation of a din through which no voice can be heard, as the fears of fragmentation predicted. And, while money may be useful in achieving visibility, the structure of the Web means that money is neither necessary nor sufficient to grab attention—because the networked information economy, unlike its industrial predecessor, does not offer simple points of dissemination and control for purchasing assured attention.[36]

Merit, Reputation, and Trust

Indeed, instead of such single points of control, the collaborative knowledge space of the networked information economy, or—more broadly—of the network society, is structured, organized, and policed through decentralized processes of merit, reputation, and trust which incorporate both specific localized systems operating within individual sites of social produsage, and diffused, implicit and explicit schemes of folksonomic evaluation that can be collated into indications of what participants and what sites are likely to emerge as temporary lead hubs in the network.

Such schemes may exist in the form of direct personal ratings bestowed by participants on the members of their personal, professional, or collaborative network, ranging from the friends lists of *MySpace* to the seller ratings on *eBay*; they may take the form of the communal content ratings system on *Slashdot*, which through such rat-

ings more indirectly generates a karma score for each contributor. They may indicate a participant's personal standing yet more indirectly by tracking each individual's record of contributions to the shared project, or by evaluating their interconnection with peers for example through the amount of inlinks received by their blog or personal profile. Each such scheme is useful in its own right, and more so in combination, but at the same time may also be open to misinterpretation, misapplication, or misuse: apparently high standing as shown by one indicator may not necessarily correspond to strong performance in a different context (a frequent contributor to *Slashdot* may simply frequently make unconstructive contributions); a track record of constructive contribution cannot mean that further contributions should go unchallenged (established community leaders in open source must nonetheless continue to adhere to the community's values); a status of leadership cannot transcend its immediate domain of knowledge (an expert in one topic on *Wikipedia* may nonetheless be a novice in another).

Overall, then, it must be recognized clearly that 'karma' is not perfectly portable, and that the level of reputation developed by a user in one context may indeed be inherently incompatible with the level of reputation held by the same user in another context. A further complication, of course, is that the very openness of participation in produsage environments also means that the same user could be contributing to the same project under a number of different guises, or may make contributions anonymously, for a variety of legitimate or questionable reasons. This necessarily means that it is not, it cannot be possible to fully amalgamate or aggregate the different systems of merit, reputation, and trust existing across the networks of produsage, even where such systems in themselves produce quantitative and apparently authoritative reputation scores, in order to create a universal 'produser score' for each individual contributor; the best which may be able to be achieved is the collation and comparison of a user's track record across a variety of individual spaces and environments for produsage. Nonetheless, for the very reason that karma scores *are* imperfectly portable, the development of produsage infrastructure which does perform such collation may be all the more pressing a need at the present moment.

Only with the help of such systems, indeed, can the network society, the knowledge society, the produsage society also become a reputation society, Masum and Zhang suggest:

> reputation systems systematically combine many reputations, providing a point of access and enforcing "rules of the game." The information institutions that make these services available—formal and informal, for-profit and non-profit, private and public—will become pillars of the Reputation Society. The challenge is to first understand and then design, build and foster healthy reputation systems—to systematically benefit from the experience of others, and avoid stumbling through endless trial-and-error cycles. In a world where information institutions are often global (and can underpin critical infrastructure) the cost of avoidable failure is unacceptably high.[37]

Indeed, some such organizations have already emerged, and come to join some of the existing reputation systems of the declining age of industrial production and consumption, such as credit ratings authorities and other services; the popularity of peer-to-peer auction site *eBay*, for example, has led to the emergence of seller authentication services like *SquareTrade*, which offer seals of distinction for traders adhering to specific ethical principles, while various guild-like communities of users committed to specific rules of participation also populate produsage spaces ranging from *Wikipedia* through *Second Life* to the wider blogosphere. While some such reputation accreditation systems rely on central evaluating processes or the formalized communal evaluation of a user's reputation, however, other projects attempt to put as much agency into the user's own hands: the *Social Physics* project, for example, is engaged in developing a 'trust framework' code-named Higgins which allows for the client-side tracking of user identity and relationships in a standardized form which can then be evaluated more accurately and without misrepresentation by server-side technologies.

Indeed, as we further examine questions of reputation and trust, we come to a question of weighing up the benefits of extracting information about the individual contributor to produsage projects from their actions against the intrusions into that user's privacy which such mining of data could also represent. Participation in produsage environments, even anonymously or under assumed usernames, constitutes a significant source of information about individual and community interests and patterns of behavior, and could be exploited for commercial or other gain; indeed, even actions appearing to be benign as they are first carried out may come to be seen in a different light at a later point as their consequences become known, or as the personal attitudes of the individual produser shift. (All-too-brash statements made on a personal blog, *Facebook* or *MySpace* page, or candid camera shots uploaded to *Flickr* or *YouTube*, could well influence the future employment opportunities of the contributor, for example.) For such reasons,

> often privacy is desired out of fear that information about oneself might be used against one by others. We usually prefer to know more about others while hiding our own shortcomings and embarrassments—living life with social sunglasses. The natural dynamic of effective reputation systems is to increase transparency, so there is an open question as to what the desirable countervailing privacy–preserving forces should be.[38]

In the first place, the decentralized and mainly community-based interplay of merit, reputation, and trust across the networks of produsage necessarily increases such transparency, of course, and applies a peer-to-peer, many-to-many, back-and-forth dynamic also to the establishment of reputation; reputation itself becomes a networked commodity, and divides into "inbound reputation—reputation that others have about you" and "outbound reputation—reputation that you have about others."[39]

The maintenance of reputation and trust through collaborative processes, then, may also be able to be understood as a form of collaborative surveillance, but (as tak-

ing place within the communal network it can no longer be performed from a panoptic top-down position, but relies instead on the holopticism of peer-to-peer environments) is perhaps better described as a kind of surveillance from below, or sousveillance.[40] In the environments and networks of produsage, everyone watches—potentially—everyone else, and from such observation builds their individual perceptions of fellow peers' merit and trustworthiness as produsers and members of the community. Such processes are further applied also to those remaining external to the practice of produsage itself, in fact, where the actions or products of such external organizations are incorporated into the produsage environment in one form or another; so, for example, citizen journalism continuously tracks and observes the actions of relevant members of society (politicians, journalists, civic leaders) regardless of whether they are formally members of the produsage community.

However, it is also possible for such sousveillance processes to become overly intrusive, and here, again, privacy concerns must be considered; the *Spymedia* model of photosharing which allows members to place bounties on in-demand content, or even *The Guardian*'s 'Blair Watch Project' inviting citizen snapshots of then-British Prime Minister Tony Blair on the re-election campaign trail, could easily turn into nothing more than the open-sourcing of paparazzi activity, for example. At the same time, more civically valuable models built on similar strategies can also be imagined: *Trendwatching* reports, for example, that

> in Lewisham, UK, residents are helping to keep the southeast borough of London clean …: after installing special software on their cameraphone, observant townspeople can snap a picture of graffiti or overflowing litter bins, enter location details, and send it to the local council. The picture is then posted on the council's website, and cleaning crews are sent to resolve the issue.[41]

Whatever the specific forms of such sousveillance, at any rate, and whatever the ends to which they are deployed, it does become clear that new social structures built through produsage will almost inevitably be organized through holoptic, peer-to-peer principles of mutual observation, and policing—this is in keeping, of course, with the underlying produsage principle of communal evaluation of content and contributors. What remains crucial here, therefore, is that participants in such processes are aware of their limitations, and alert to any systemic biases which the underlying structures of reputation may have introduced into the system. Indeed, Masum and Zhang warn that the easy availability of too much reputation information could well lead to a "sort of 'satisficing' where decision-makers become overly reliant on the measures they can easily measure, becoming passive users of reputations without adequately considering their limitations."[42] In the context of the open source, for example, recruitment of administrators simply from those contributors most active in editing the shared resource, without consideration of the quality of their contributions, would be an unsatisfactory, inappropriate model; in the context of *Wikipedia*, a blind reliance on expert

accreditation without further consideration of the specific nature of participant exper-
tise and its application to topical questions at hand would constitute a similar form of
satisficing.

Further, a constant and explicit focus on highlighting the processes of sousveil-
lance within the communities of a produsage-based society may also produce negative,
deleterious effects for the practices of produsage themselves: users' obsession with
maintaining positive reputation ratings is likely to lead to risk-averse behavior.

> If everyone lives "under the microscope" in their dealings with others, the scope for
> innovation and risk–taking may be unduly constricted. Since everyone makes mis-
> takes, a certain level of forgetfulness in maintaining reputations seems necessary, to
> encourage redemption and forgiveness; perhaps this will emerge naturally, since repu-
> tations of people are often relative to norms.[43]

Indeed, this further highlights the need for the degradation of karma scores and other
reputational assessments over time, so that the consequences of the actions of indi-
vidual users do not remain with them indefinitely into the future.

The very absence of universal reputation systems at present must therefore also be
seen as a key enabling factor for the rise of produsage in recent years, therefore; it has
allowed for the open experimentation with different approaches to the produsage of
information, knowledge, creative works, social networks, and thus in the end of soci-
ety itself, without a threat that participation in such environments, and especially in
failed or failing attempts at harnessing produsage towards certain ends, would come to
have lasting negative effects on participants' overall reputation as members of society.
As it matures, however, the produsage model will increasingly be in need of stronger
systems of reputation tracking, collation, and management, to cope with the growing
number of participants collaborating with one another across an increasingly diverse
range of produsage environments. The development of such systems will make a sub-
stantial contribution to ensuring the long-term sustainability of individual produsage
communities as well as of the produsage-based societal structures which may emerge
from them.

At the same time, and in keeping with the constant struggle between deterritori-
alization and reterritorialization, between devolution to fluid heterarchies and rede-
ployment of fixed hierarchies, which we have already found to be at the heart of
produsage environments, the development of such reputation systems also holds the
potential for the emergence of new powerbrokers, however: established under the
wrong principles, reputation systems hold the potential to do more harm than good
for produsage communities and the knowledge space of society overall. It is likely that
such inappropriate reputation systems will be rejected by the communities of produ-
sage themselves, though, much as the participants in *Slashdot*, *Wikipedia*, or *Second Life*
have already played a crucial part in helping to shape their own (or to prevent the
shaping of inappropriate other) reputation systems for those specific contexts. Reputa-

tion systems to be utilized in the specific collaborative projects of produsage, or the collaborative project of produsing society overall, are likely to be developed only in close cooperation with and by participant communities themselves.

Ultimately, then, a shift to the produsage of sociality, through participation in produsage-based, communal, collaborative environments, and a subsequent shift towards the produsage of society itself, necessarily constitutes also a shift in the power structures operating within that society. A shift to produsage is a shift from organized hierarchy to networked heterarchy, from centralized mass culture to decentralized cultural communities; it transfers the locus of power from the tall peak to the gentle slope. Already,

> collective intelligence can be seen as an alternative source of media power. We are learning how to use that power through our day-to-day interactions within convergence culture. Right now, we are mostly using this collective power through our recreational life, but soon we will be deploying those skills for more "serious" purposes.[44]

As the produsage of sociality, and the produsage of society, build in pace and impact, then, along with the technologies which support such practices they offer the opportunity for a substantial reorientation of our communal and social processes, enabling us to re-connect with one another and our communities, and containing the potential for a social renaissance.

> Thus, in an era when crass perversions of populism, and exaggerated calls for national security, threaten the very premises of representational democracy and free discourse, interactive technologies offer us a ray of hope for a renewed spirit of genuine civic engagement.[45]

NOTES

1. Michel Bauwens, "Peer to Peer and Human Evolution," *Integral Visioning*, 15 June 2005, http://integralvisioning.org/article.php?story=p2ptheory1 (accessed 1 Mar. 2007), p. 3.

2. Mark Pesce, "Going into Syndication," *Hyperpeople: What Happens after We're All Connected?* 9 Feb. 2006, http://blog.futurestreetconsulting.com/?p=7 (accessed 23 Feb. 2007), n.p.

3. Shane Bowman and Chris Willis, *We Media: How Audiences Are Shaping the Future of News and Information* (Reston, Va.: The Media Center at the American Press Institute, 2003), http://www.hypergene.net/wemedia/download/we_media.pdf (accessed 21 May 2004), pp. 44–45.

4. Bauwens, p. 2.

5. Bauwens, p. 2.

6. Jaz Hee-jeong Choi, "Living in Cyworld: Contextualizing Cy-Ties in South Korea," in Axel Bruns and Joanne Jacobs (eds.), *Uses of Blogs* (New York: Peter Lang, 2006), pp. 173–186.

7. Suely Fragoso, "WTF a Crazy Brazilian Invasion," in Fay Sudweeks, Herbert Hrachovec, and Charles Ess (eds.), *Proceedings: Cultural Attitudes towards Communication and Technology 2006* (Perth, WA: Murdoch University, 2006), pp. 255–275.

8. Douglas Rushkoff, *Open Source Democracy: How Online Communication Is Changing Offline Politics* (London: Demos, 2003), http://www.demos.co.uk/publications/opensourcedemocracy2 (accessed 12 July 2007), p. 31.

9. Mark Pesce, "EBay as Emergent Digital Social Network," *Hyperpeople: What Happens after We're All Connected?* 16 Jan. 2006, http://blog.futurestreetconsulting.com/?p=5 (accessed 23 Feb. 2007), n.p.

10. Yochai Benkler, *The Wealth of Networks: How Social Production Transforms Markets and Freedom* (New Haven, Conn.: Yale University Press, 2006), pp. 366–367.

11. *Trendwatching.com*, "Infolust: Forget Information Overload, Consumers Are More Infolusty than Ever!" 2006, http://www.trendwatching.com/trends/infolust.htm (accessed 19 Feb. 2007), n.p.

12. Henry Jenkins, *Convergence Culture: Where Old and New Media Collide* (New York: NYU Press, 2006), pp. 129–130.

13. Jenkins, p. 16.

14. Benkler, pp. 373–374.

15. Pesce, "EBay as Emergent Digital Social Network," n.p.

16. Pesce, "EBay as Emergent Digital Social Network," n.p.

17. Pesce, "EBay as Emergent Digital Social Network," n.p.

18. Bauwens, p. 1.

19. Pierre Lévy, *Collective Intelligence: Mankind's Emerging World in Cyberspace*, trans. Robert Bononno (Cambridge, Mass.: Perseus, 1997), p. 10.

20. Lévy, p. xxviii.

21. Bauwens, p. 3.

22. Lévy, p. xxviii.

23. Benkler, p. 380.

24. Fragoso, "WTF a Crazy Brazilian Invasion."

25. Bauwens, p. 3.

26. Rushkoff, pp. 32–33.

27. Lévy, p. 17.

28. Lévy, pp. 17–18.

29. Benkler, p. 259.

30. *Trendwatching.com*, "Nouveau Niche: An Emerging Consumer Trend and Related New Business Ideas," 2006, http://www.trendwatching.com/trends/NOUVEAU_NICHE.htm (accessed 18 Feb. 2007), n.p.

31. *Trendwatching.com*, "Top 5 Consumer Trends for 2007," 2007, http://www.trendwatching.com/trends/2007top5.htm (accessed 17 Feb. 2007), n.p.

32. Jürgen Habermas, "Political Communication in Media Society: Does Democracy Still Enjoy an Epistemic Dimension? The Impact of Normative Theory on Empirical Research," *Communication Theory* 16.4 (2006), p. 412.

33. Benkler, p. 232.

34. Lévy, p. 54.

35. Lévy, p. 183.

36. Benkler, p. 254.

37. Hassan Masum and Yi-Cheng Zhang, "Manifesto for the Reputation Society," *First Monday* 9.7 (July 2004), http://firstmonday.org/issues/issue9_7/masum/ (accessed 27 Feb. 2007), n.p.

38. Masum & Zhang, n.p.

39. Masum & Zhang, n.p.

40. See, e.g., Steve Mann, Jason Nolan, and Barry Wellman, "Sousveillance: Inventing and Using Wearable Computing Devices for Data Collection in Surveillance Environments," *Surveillance & Society* 1.3 (2003), http://www.surveillance-and-society.org/articles1(3)/sousveillance.pdf (accessed 12 July 2007), pp. 331–355.

41. *Trendwatching.com*, "Customer-Made: Co-Creation, User-Generated Content, DIY Advertising and More!" 2006, http://www.trendwatching.com/trends/CUSTOMER-MADE.htm (accessed 18 Feb. 2007), n.p.

42. Masum & Zhang, n.p.

43. Masum & Zhang, n.p.

44. Jenkins, p. 4.

45. Rushkoff, p. 16.

Educating Produsers, Produsing Education: Produsage and the Academy[1]

O ur examination of produsage across a variety of diverse domains of information, knowledge, and creative work has clearly demonstrated the substantial potential for change inherent in this model of user-led, collaborative content creation. We have also seen that much of the activity in the produsage sector is so far driven largely by enthusiasts, contributing *ad hoc* when motivated enough to do so; although this is one of produsage's greatest strengths, as it creates a base of engaged and committed participants unrivaled by more traditional workforces organized through conventional systems of command and control, it could also be seen as one of its persistent weaknesses, however. Rosenzweig observes, for example, that

> overall, writing is the Achilles' heel of *Wikipedia*. ... Some Wikipedians contribute their services as editors and polish the prose of different articles. But they seem less numerous than other types of volunteers. Few truly gifted writers volunteer for *Wikipedia*.[2]

Indeed, it may well be that the uneven quality of writing in this collaborative encyclopedia, and other shortcomings not necessarily in the substance, but in the style of collaboratively produced online resources, point to more than simply a shortage of skilled writers: they indicate that participation in volunteering projects more generally is often uneven, and that the skills brought by volunteers to such projects are not necessarily uniformly appropriate. The equipotential and probabilistic approach of produsage projects can be successful overall, as long as a sufficient number of participants can be attracted and engaged for the project, but this does not result in a level averaging-out of contributions across all aspects of the project. Some aspects—those most exciting or immediately likely to lead to significant advances in development—are likely to attract a greater number of contributors more quickly than others—for example those concerned with more mundane tasks of maintenance or coordination.

In addition, what emerges here is also an indication of a new form of digital divide: a divide between those already tuned in to the produsage process (for example, software designers, niche knowledge enthusiasts, and others with an itch to scratch) and those not yet motivated to participate, as well as a divide between those who already have the skills and capacities to contribute to large-scale, heterarchically organized, meritocratic collaborative content creation communities, and those for whom participation in such environments remains an apparently insurmountable challenge. Such divides could come to crucially undermine the development and growth of produsage as a credible, sustainable challenge to conventional industrial production models, and beyond this for the development of a new knowledge space supporting the emergence of a produsage-based society; they limit the population of users from which produsage may draw as it continues its expansion.

What is likely to be needed, then, is the greater involvement of educational organizations at all levels in teaching the skills and capacities required for participation in produsage. Such educational activities would both improve the quality of produced resources themselves, by ensuring that their creators are contributing the necessary and relevant skills to the collective enterprise, and help to guarantee that a principle of equipotentiality does indeed remain at the foundation of produsage processes: they would ensure that potential contributors are indeed equipotential (though not equal) in the skills and capacities they bring to the project of produsage.

In addition to providing the education required for users to be able to become produsers, however, there is also a lesser and more immediate goal for education: in the first place, it is necessary for educational organizations also to teach the skills to *use* the outcomes of produsage more effectively. Concerns by teachers and others about student use of the *Wikipedia*, for example, clearly indicate that even among teachers themselves, understanding of produced resources and their processes of development remains somewhat limited; such teachers are unlikely to provide their students with a strong and nuanced appreciation of the benefits and shortcomings of this collaborative resource. Therefore, it is crucial to improve both teachers' and students' literacy of such outcomes of collective intelligence, so that they may better judge for themselves the value of any material they may encounter, and fruitfully juxtapose it with the products of the conventional model. As Doctorow puts it, for example, "reading Wikipedia is a media literacy exercise. You need to acquire new skill-sets to parse out the palimpsest. That's what makes it genuinely novel. Reading Wikipedia like *Britannica* stinks. Reading Wikipedia like Wikipedia is mind-opening."[3]

From Literacies to Capacities

Ultimately, thus, the challenge for education is two-fold. On the one hand, it must provide its students (and teachers) with the ability to use the outcomes of produsage.

"As more and more information comes online, it's imperative that we give our students the skills to analyze and manage it."[4] This is fundamentally a question of *literacy*: much as in traditional domains and under conventional models of knowledge creation, it requires users of information to be able to *read* resources as well as to understand their origins and modes of production—just as in encountering a traditional newspaper article, a conventional encyclopedia entry, readers should keep in mind the industry practices which led to this final product, so in engaging with citizen journalism or the *Wikipedia*, users must be aware of the collaborative model of content creation which prodused this artefact—and whether dealing with industrial products or produsage artefacts, they are able only on the basis of that knowledge to fully assess the quality of the material they encounter. Understood in this way, then, the need for new literacies to enable users to work effectively and assuredly with the artefacts of produsage requires simply the extension of traditional literacies to these new modes of collaborative content creation: the ability to read critically, the ability to understand that specific models of production as well as produsage will introduce their own systemic biases into the outcomes of their processes, and the ability to assess and compare the quality of different information and knowledge resources on that basis.

In the first place, then, as Benkler points out, this raises the question of ensuring at a very fundamental level users' "human communicative capacity—the creativity, experience, and cultural awareness necessary to take from the universe of existing information and cultural resources and turn them into new insights, symbols, or representations meaningful to others with whom we converse."[5] But that description simultaneously also moves beyond the simple ability to *use* information and knowledge, and turns such use into a more productive form of engagement which comes to resemble produsage itself; Jenkins adds that literacy should be

> understood to include not simply what we can do with printed matter but also what we can do with media. Just as we would not traditionally assume that someone is literate if they can read but not write, we should not assume that someone possesses media literacy if they can consume but not express themselves.[6]

A second challenge for education in a produsage context, then, is not only to teach the literacies required to engage with the outcomes of produsage, but also to develop the *capacities* to harness such literacies in order to participate actively in produsage itself. Especially as produsage becomes more prevalent, such capacity becomes paramount: only where it is developed will students retain the ability to make their own voices heard, to represent their own views and ideas, within the wider community of produsers. The capacity to be an active produser, especially as produsage affects wider elements of everyday life and even turns towards the produsage of sociality itself, equates increasingly with the capacity for active, participatory citizenship (and we further examine such developments in the following chapter); education which enables students to become produsers is therefore crucial and indispensable. Such forms of

education must not only encourage and guide processes of active participation in produsage, of course: they must also highlight the threats and dangers inherent in a widely distributed collaborative project. Produsage education must also build the capacity for individuals to protect their own work where necessary, and to identify whether and where engagement in conventional models of production or innovative models of produsage is more suited to their specific interests and needs. Indeed, such assessments must necessarily take into account both individual benefits *and* wider social gains which may result from this or that model—this, then, requires the form of active literacy outlined by Jenkins, and must extend users' understanding of the implications of their participation well beyond individual acts of content creation.

Both basic produsage literacies and active produsage capacities are necessarily closely interrelated, of course; "the practice of producing culture makes us all more sophisticated readers, viewers, and listeners, as well as more engaged makers."[7] Therefore, both are likely to be taught in close connection with one another. To teach them requires a substantial shift of many underlying principles of education as it is practiced today; indeed, it may ultimately require a shift from an understanding of education as based on the principles of production to an educational model embracing produsage for its own operations. To develop produsage literacies and capacities in an organic fashion, it is necessary that universities themselves explore ways to model and deploy the processes of produsage in their learning and teaching environments (and beyond).

This means especially a rethinking of the roles of teachers and learners, much as the roles of experts and amateurs are being rethought in other contexts of produsage. Traditional and rigid teacher/learner, staff/student, institution/client dichotomies are counterproductive in the co-creative, collaborative context of produsage, which—as we have noted—thrives on a fluid and heterarchical (rather than hierarchical) organization of participants. Indeed, to the extent that a teacher/learner dichotomy still exists, it can be seen as a further example of the outdated scarcity-based production model as we have encountered it: the dichotomy stems from a time when the information and knowledge available from teachers did indeed constitute a scarce resource, but (due in no small part to the emergence of the Internet as a major information source) that time has passed.

Today, the question in education is no longer how to provide students with the information and knowledge they will require in their future professions, and which has been available in the main only from the experts gathered in the academy; it is no longer how to structure the process of learning as a form of apprenticeship in which information flows from teachers to learners. Instead, it is necessary to reinvent learning as a process of collaboration between learners and teachers, as Jenkins points out:

> so far, our schools are still focused on generating autonomous learners; to seek information from others is still classified as cheating. Yet, in our adult lives, we are depending more and more on others to provide information we cannot process ourselves. Our workplaces have become more collaborative; our political process has

become more decentered; we are living more and more within knowledge cultures based on collective intelligence. Our schools are not teaching what it means to live and work in such knowledge communities.[8]

To address this problem, then, requires not only the teaching of new ideas; it requires teachers themselves to fundamentally reposition themselves as teachers, and it requires educational institutions to reconsider their core purposes.

Based on our description of produsage processes themselves, and the understanding of the literacies and capacities required of learners and teachers which follows from it, then, it is possible here to outline five pillars on which the pedagogy of produsage must be founded. The aim of this pedagogical approach can be understood as enabling learners to take part in produsage, and thereby become members of Generation C; it therefore pursues the development of five core capacities in learners: the capacities to be creative, collaborative, critical, combinatory, and communicative—or in short, the C5C.[9]

- **Creative:** not to be misunderstood as pertaining purely to artistic creation in a narrow sense, creative capacities are crucial to Generation C. Produsage itself is fundamentally concerned with content (information, knowledge, art) creation; although the development of creative capacities in this broad sense has of course been an aim of education virtually throughout the ages, what is important for our present context is a focus especially on the development of creative capacities which can be exercised successfully in the collaborative environments of produsage (as exemplified *inter alia* in the technological environments gathered under the Web 2.0 banner). Crucial to *this* form of creative capacity is particularly the ability to act as collaborative co-creator in flexible roles, or in short, as one among a number of creative *produsers* rather than as a self-sufficient creative *producer*. To the extent that the reasons for this are not yet already self-evident to contemporary learners, it may also be necessary to provide the motivations for engaging as active content creators in produsage environments. Such motivations are economic (given the significant shifts brought about by the rise of produsage, the ability to participate in such environments is increasingly sought after by employers and governments), social (open collaborative content development in areas such as knowledge management, journalism, software development, research, and creative work can create high-quality but freely accessible resources which are of benefit to overall society), and individual (in the online environment, non-participation increasingly equates to invisibility, while sustained and constructive participation enables the accumulation of positive social capital).
- **Collaborative:** as noted earlier, collaborative engagement under variable, fluid, and heterarchical rather than hierarchical organizational structures and

in shifting roles is fundamental to produsage processes. As communal, societal, as well as workplace processes move towards a greater embrace of produsage principles, collaborative capacities therefore become all the more crucial. In this context, it is as important to be able to know how to collaborate effectively as it is to know when, where, and with whom to choose to collaborate, and under what circumstances not to do so. Further, collaborative capacities also require an advanced understanding of the consequences of collaboration—that is, of questions pertaining to intellectual property and other legal rights in a collaborative environment. (In addition, of course, it is also important to develop the specific skills to collaborate within the major technological environments of produsage—such as blogs, wikis, or immersive 3D environments—, but such skills are subject to rapid change as the technologies themselves continue to change. It is by now well recognized that rather than to focus on building expert skills in using specific systems, teachers should ensure that students develop a life-long personal interest in updating their technological skills.)

- **Critical:** as a corollary to collaborative capacities, critical capacities are exercised in establishing the appropriate context for engagement in collaborative produsage processes. This requires a critical stance both towards potential collaborators and their work (in order to identify the most beneficial of all possible collaborations) and towards one's own creative and collaborative abilities and existing work portfolio (to gauge whether a potential collaboration would constitute a good fit of styles, abilities, and experience). In addition, a critical eye is also needed in identifying the appropriate venues and conditions for effective collaboration—and further, during the collaborative process itself, critical capacities are indispensable in the giving and receiving of constructive feedback on the ongoing collaborative process and the artefacts it produces. Finally, and just as importantly, critical capacities are also crucial to an engagement with the outcomes of produsage processes at times when one acts mainly as user rather than active contributor—only well-developed critical capacities enable users to discern whether a particular piece of information is to be trusted, to look beyond the surface to examine the sources for that information, and the process of its produsage (such as, for example, the edit history of a *Wikipedia* entry), and to compare the relative merit of multiple perspectives on the same issue as they may be expressed in one or a number of related produsage artefacts. Such capacities were already highly important during the mass media age (but were frequently underexercised as a result of a sometimes misplaced trust in the quality of established media brands); however, the recent proliferation of media alternatives, to which produsage processes have contributed significantly, has further in-

creased the central importance of a healthily critical stance towards all available information, whatever the source.

- **Combinatory:** produsage is fundamentally based on an approach which deconstructs overall tasks into a more granular set of distributed problems, and therefore in the first place generates a series of individual, incomplete artefacts which require further assembly before becoming usable and useful as a whole. As a result, information and knowledge as generated through produsage processes is itself distributed and inherently incomplete; as Pesce puts it, "knowledge is everywhere, freely available, but hyperintelligence doesn't confer any great wisdom."[10] To effectively participate in and benefit from the knowledge space of hyper- or collective intelligence, therefore, those engaging in and with produsage and its artefacts require enhanced capacities to combine and recombine these specific artefacts in their pursuit of personal understanding. But beyond the pursuit of knowledge itself, combinatory capacities are also required for active participation in produsage processes: as we have seen, produsage in many contexts also proceeds from the reappropriation, reuse, and remixing of existing content in new combinations which themselves create new meaning and new understandings of knowledge. Learners must therefore develop the capacities to identify and harness individual chunks of existing information which may be constructively employed in this fashion, as well as the capacities to undertake such recombination and redistribution of information and knowledge through the shared collaborative environments of produsage projects.

- **Communicative:** inasmuch as communication underpins every human endeavor, it is necessarily already implicitly embedded in the other capacities outlined here. However, in addition to overall, generic communicative capacities it is particularly important to develop an explicit focus on effective and successful communication between participants within the collaborative environments of produsage—this addresses for example the communication of ideas generated in exercising one's own combinatory and critical capacities (here focusing especially on the ability to be *constructively* critical), as well as communication between participants *about* collaborative and creative processes (what could be described in other words as metacollaboration). Such communicative capacities are not necessarily a natural outcome of general communicative development, but may need to be fostered specifically to enable graduates to act effectively and successfully as members of Generation C. (Once again, though this might also require the development of a more in-depth understanding of communicative processes within particular produsage environments, it is important not to focus all too specifically on current communications technologies employed by produsage communities, as these are subject to change.)

A Casual Collapse of Conventional Education?

For many teachers, it will be self-evident that to embrace a pedagogy of produsage based on these principles is not a revolutionary act; indeed, these principles merely extend the learner-centered models of constructivist learning philosophy by highlighting especially the specific requirements of participation in produsage environments: they outline the key capacities required of effective contributors to produsage projects. However, inherent in these principles, and in the wider shift towards produsage which they promote, is a deeper challenge to the traditional educational model, and even the threat of its casual collapse. A casual collapse of established hierarchies and institutions is the typical outcome of a paradigm shift—and produsage-driven casual collapses can already be observed in *Encyclopædia Britannica*'s rear-guard battle with *Wikipedia*, the news industry's struggle with citizen journalism, and the software industry's gradual transition towards open source-based business models. As we have seen, journalism, for example, for the most part still refuses to come to terms with a changed mediasphere in which information is already available to audiences, and in which the role of the journalist shifts from that of a gatekeeper of information to one of gatewatcher, guiding users through the available wealth of information to the most important and insightful sources; in doing so, it has left open a wide space rapidly being populated by alternative news and discussion sources from *OhmyNews* to *Instapundit* to *The Daily Show*, which are gradually drawing audiences away from the incumbent industry.

Educational systems, too, are under increasing threat from a Generation C whose produsage activities can no longer be contained through the artificial scarcity imposed by traditional production and accreditation processes. On the one hand, access to scholarly sources and academic debate is now available at the touch of a button, from outside the system; on the other hand, participants on the outside of traditional institutions (some of them academics frustrated by the internal machinations of the ivory towers and their commercial associates) are increasingly seen to collaborate to produse and publish quality information and knowledge resources of their own. Traditional teacher/learner apprenticeship-style education may no longer have a future here: tertiary education's competitive advantages now lie squarely in its ability to provide a strong combination of systematic overviews and deep knowledge of specific disciplines, and in its ability to provide a targeted course of study aimed at developing those C5C capacities which are crucial to successful participation in produsage environments. Thus,

> the educational system itself will be under pressure to respond to the ability of students to learn 24/7 from a variety of sources. ... The vertical model of a teacher disseminating information and knowledge to students may not be very effective in an environment in which learning is a much more horizontal or collaborative undertaking.[11]

Similar to the situation in journalism, educators must learn to become guides through a wealth of always already available information, rather than hanging on in any way to long-outdated notions of the teacher as controlling what information and knowledge students do or do not encounter.

A traditional model of education would position its staff as experts, literally *professing* their knowledge and thereby imparting it to students. Such experts are engaged in a process of collecting, synthesizing, and predigesting available knowledge into lectures, textbooks, and other resources much as do their counterparts in the journalistic of encyclopedic industries, for example; students are positioned as receivers of that knowledge and are required to work through a number of predetermined sample cases which are designed to confront them with typical problems in which their information recall and ability to use discipline knowledge can be tested. This conventional, conservative model of education has been subject to a variety of challenges for some time already, of course, and in its full orthodoxy hopefully is no longer practiced anywhere; in the present context, it has now become necessary to finally move well beyond the many remnants of that model which still do remain.

Today, the walls of the ivory tower of academia and other educational institutions have been thoroughly breached; rather than taking place within the dedicated environments of the institutions themselves, education has shifted well beyond their confines. Today's classroom is the Web itself, as Richardson notes, and it is a classroom "of seamless transfer of information; of collaborative, individualized learning; and of active participation by all members of class. It is marked by the continuous process of creating and sharing content with wide audiences."[12] Much as the role of journalists has shifted from watchdog to guidedog, much as experts in other environments of produsage are no longer experts *qua* external accreditation, but expert produsers and accepted as community leaders for that reason, therefore, teachers may also need to reconsider their role in the classroom and their relationship with learners:

> one of the consequences of moving to e-learning and pedagogies based heavily on collaborative learning is that the whole role of the instructor is changing from one of the 'sage on the stage' to the 'guide on the side.' In addition, organized approaches to the development of e-learning programs requires [sic] a team-based approach where the faculty member is a subject matter expert, but works in collaboration with other instructors and educational technology professionals. Quite apart from the implications of these changes for the role and self-image of the instructor they have wide implications for the evaluation of performance and for the kind of employment contracts envisaged.[13]

Such shifts to a guiding rather than leading role for teachers are themselves a result of what Pesce describes as the hyperconnectivity of the modern communications environment—they require teachers not to synthesize, extract meaning from, and present all relevant information for students to consume, but instead to point to that information, wherever it may exist, and to guide learners through a process of working

through that information (perhaps even engaging directly with the communities which created it) and extracting meaning for themselves. In the process, they may also point out and enable the emergence of guides other than themselves within the knowledge spaces of collective or hyperintelligence;

> in an age of hyperconnectivity we can reach out to someone who has understanding, who can guide us into understanding. ... Hyperintelligence and hyperconnectivity are the twin forces which are shaping the world of the 21st century; hyperintelligence creates opportunity, while hyperconnectivity transforms opportunity into reality.[14]

If teachers are not prepared to re-imagine their role in this way (and perhaps *particularly* if they are not), then other guides to the information available 'out there' will inevitably emerge from the wider knowledge space itself; this, then, would give teachers even less of an opportunity to influence the learning processes of their students. (In a concrete example, therefore, rather than outlawing the use of *Wikipedia* altogether, ignoring that project as a knowledge resource, teachers would be much better placed to work with their students to develop the capacities required to use it effectively; failure to do so means that students will of course still use *Wikipedia* as a resource, covertly and under guidance by *Wikipedia*'s own community of contributors, but without the benefit of a thorough understanding of its advantages and disadvantages as produsage education would be able to provide it.)

What teachers need to do, then, is to explore the resources of the knowledge space for themselves, and to engage with its leaders;

> teachers will have to start to see themselves as *connectors*, not only of content, but of people. ... The access to much greater amounts and more timely information means that it will be imperative for educators to model strategies to not only find worthwhile and relevant content, but to use primary sources in the classroom. ... Teachers must be willing and able to find and use these sources effectively.[15]

Student knowledge itself also becomes paramount in this context; the very vastness of the knowledge space means that no one teacher can hope to gain a thorough overview of its diverse environments, and the teacher therefore becomes a learner alongside the other learners in their class. This, then, also presents an opportunity for such learners to act as subject guides alongside their teachers; such an approach would also model standard produsage practices: where the teacher is likely to be an expert holding the core knowledge in their field, and would therefore act as subject guide to students as they explore that tall peak of required knowledge in their field of knowledge, other learners would be able to add to such endeavors by exploring the gentle slopes of knowledge beyond the center, and reporting back to the wider community of learners about what they have found. Many learners will already bring some form of specific expertise which may well complement the core knowledge held by the teacher; such collaborative approaches would therefore enable a combination of core and

complementary knowledges to the mutual benefit of all members of the learning community.

A learning approach structured in this way would no longer follow a sender-receiver transmission paradigm (which is itself a special form of the producer/consumer dichotomy we have encountered before, of course), but would instead turn education into a more communal, networked process; such learning would constitute "a continuous conversation among many participants."[16] Some such models have existed in education for some time now, and are present for example in activities which use learner workshops or establish other processes for collaborative knowledge exchange between learners (and involve teachers as guides and moderators rather than conventional lecturers). Often, however, they falter as focus moves towards the question of assessment: here, students continue to be asked predominantly to produce individual assignment works intended for an audience of one—their teacher. As Richardson notes, however, such forms of assessment are inherently counterproductive and inauthentic:

> when today's students enter their post-education professional lives, odds are pretty good that they will be asked to work with others collaboratively to create content for diverse and wide-ranging audiences. Compare that to an educational system that, by and large, asks those same students to work independently for a very narrow audience … and the disconnect becomes painfully clear.[17]

It becomes necessary, then, to move beyond the solo assignment model and develop more effective means of groupwork which not only enable students to work together in producing an assignment, but also to experience the specific processes of collaborative *produsage*: as we have seen, this would involve not only collaborative content creation itself, but also extensive deliberation and negotiation about the processes employed and the artefacts created, the development of heterarchical structures of facilitation and governance for the process, and the recognition of individual merit even in the context of a communal process.[18] Overall, in other words, it would mean advancing beyond the assessment only of the final outcomes of an assignment production process (individual or collaborative), and towards the guidance and assessment also of the process itself.

In addition, educators should also seriously consider the potential of such processes taking place in plain sight of, or even with direct involvement from outside contributors. Where the work students are required to do would constitute a recreation of what has already been done through the collaborative processes of knowledge produsage in the *Wikipedia*, for example, it is possible to argue that students' energy may be better directed towards further improving the *Wikipedia* content rather than to repeat that community's efforts individually and for a strictly limited audience[19]; the learner's ability to thereby also contribute to the common good, rather than only to generate an individual assignment grade could also serve as a significant incentive for personal en-

gagement. Thus, "the idea that the relevance of student work no longer ends at the classroom door can not only be a powerful motivator but can also create a significant shift in the way we think about the assignments and work we ask of our students in the first place."[20]

What such suggestions point to is the need for an overall shift in educators' understanding of their role in the world, and of the connection of their pedagogic work with the wider knowledge space; rather than simply preparing students to engage with and participate in that knowledge space at a later date, beyond the conclusion of their formal education, it is now necessary to enable learners to contribute to humanity's collective intelligence already while still engaged in formal education. Education overall must work to understand this shift in order to avoid entering into a process of casual collapse; it must engage in produsage itself rather than subscribing to ever more outdated models of knowledge production. Happily (encouraged by drives towards constructionist learning and authentic assessment), some such changes have been in train for some time (and to some extent predate and prefigure the rise of produsage as a major trend), but a complete adoption of this mindset throughout educational institutions has yet to be achieved.

Many learners themselves, of course, already do engage in knowledge creation well beyond the environments of formal education, but they do so often largely in spaces of fandom and Pro-Am activity left ignored by professional educators; educators and their institutions would do well to explore and harness such activity as models and examples for produsage-based pedagogical approaches within formal education as well. There is no reason why students already engaged in the collaborative creation and evaluation of fan fiction could not also participate in the peer-assessment of one another's academic work, for example; there is no reason why students collaborating on the development of articles on citizen journalism sites or entries in the *Wikipedia* which cover their personal interests could not also do the same for topics with which they are confronted in their learning, and for which they are developing a growing expertise through their educational activities.

Teachers, as facilitators of such engagement, would then become little more than heterarchical lead produsers, working with their students as the wider community of produsers; as a result, what is produced here is both knowledge, and education itself. Where individual students are particularly knowledgeable about specific topics, indeed, they could assume the mantle of community leader at least for a specific instance or limited timeframe, allowing the teacher to step back and guide the communal and collaborative process with a light touch rather than drive it along; In addition, indeed, produsers from the wider community of content creators beyond the confines of the academic environment could also be involved in such processes. Such approaches would further serve to boost learners' C5C capacities, of course: they would learn to collaborate more widely, critically assess and combine a more diverse

range of inputs, communicate with a wider community of partners, and thereby create a more multifaceted resource.

Where they act simply as facilitators of a fruitful connection between learners and outside collaborators, then,

> teachers need to think of themselves more as *coaches* who model the skills that students need to be successful and motivate them to strive for excellence. ... We teach students the skills of the Read/Write Web and motivate them to seek their own truths and their own learning.[21]

Such a role of coaching learners in the development of skills and capacities may be seen by some teachers as a step backwards from an involvement in imparting information and knowledge, but it is important to note here that the two are not mutually exclusive. In the first place, in this model, teachers would strive to build learner literacies and capacities to enable them to engage in produsage processes both as modeled in the classroom environment and directly in the wider knowledge space beyond; where learners have acquired a sufficient level and range of such capacities, then, they are able to engage directly with the wider communities of produsage and gain information and knowledge from them, with the teacher shifting into the role of a leading member of such communities, facilitating and guiding learner engagement in the wider knowledge space.

This argument essentially mirrors the debate over the role of experts as we have encountered it for *Wikipedia* and other collaborative projects for the creation and representation of knowledge and knowledge structures: here, too, teachers are now no longer positioned as experts simply by virtue of their accreditation as experts, outside of the produsage process itself; instead, they come to be seen as experts because of their role as leaders of the produsage community. In other words, the argument that they should be respected by their students is made no longer on the basis of their role in the academic hierarchy, their positions and titles, but by their established track record as produsers themselves. To make that argument, then, "teachers must become *content creators* as well. To teach these technologies effectively, educators must learn to use them effectively."[22] In essence, this extends Bauwens's principle of equipotentiality to education itself: it accepts that learners as well as teachers already have the potential to be valuable contributors to the collaborative processes of knowledge creation through education, allows for the fact that (at least at the start of a learner's educational journey) teachers are likely to be clear leaders of such processes, *and* maintains the possibility that as learners' literacies and capacities to engage in produsage improve, the balance between teachers and learners may well shift significantly towards the latter.

The Tip of the Iceberg

An explicit embrace of produsage principles by educators is likely to increase the permeability of educational institutions, as teachers and learners will come to work more closely with produser communities in the wider knowledge space beyond academia. Even where such shifts in pedagogical approaches within educational institutions are slow to proceed, however, outside of the industry they are already in progress, and new models for self-education by produsers for produsers are rapidly emerging. Produsers are rarely content with working as contributors of content, information, and knowledge into conventionally structured knowledge industries; rather, as we have seen, their collaborative efforts often lead to the development of structures which are parallel to and in competition with the traditional leaders of these industry sectors. It is likely that in the education sector, too, growing trends towards produsage will lead to experimentation with the establishment of entirely produsage-based educational institutions. While for now, absent official accreditation, such projects may still appear esoteric and fanciful, the establishment of the 'Wikiversity' as an official project of the Wikimedia Foundation (also in association with the Wikibooks project for the collaborative authoring of textbooks) could be seen as a portent of future developments.[23]

Sanger suggests, for example, that

> a need and motivation similar to what led to the creation of Wikipedia is bound to lead to many free textbooks. ... There are enough scholars and teachers in the world, motivated not by money but simply by a desire to teach, who will probably together create, co-edit, and maintain up-to-date textbooks in most fields. It seems to be merely a matter of time before this happens on a large scale.[24]

The need for a granularity of tasks as Benkler has pointed it out, however, may make such projects more difficult to realize; where Wikipedia benefits from the highly granular structure of knowledge as presented in individual entries in the overall resource, textbooks require a more consistent approach which not only presents knowledge, but orders it into structures that assist learning.[25] Here, then, the role of knowledgeable communities of produsers, and of expert leaders of produsage projects, becomes particularly crucial; while the produsage of textbooks is by no means impossible, it will require the development of effective social and technological systems of facilitation which are perhaps not entirely different from the systems employed in the development of open source software—another project which, while highly granularizable, also requires a significant degree of effective integration and coordination between its constituent parts.

Indeed, the need for a substantial degree of oversight to ensure the consistency of such projects may well also point to a role for conventional educational institutions as collaborators with the wider produsage community; in this way, the educational establishment would serve as the hierarchical tip of the heterarchical iceberg of educational

knowledge produsage much in the same way as we have discussed that pro/am relationship more generally in Chapter 8. Several current projects could be seen as approaching this hybrid model, from a variety of angles: MIT's OpenCourseWare (OCW), for example, makes a wealth of educational resources from the Massachusetts Institute of Technology available for free use under a Creative Commons license. Although not itself providing the means for an incorporation of user-developed alterations and extensions, thereby turning such course resources into a truly *prodused* collection of educational materials, the Creative Commons framework under which OCW is released does allow for such modification and extension to take place; OCW therefore provides an initial seed from which an educational knowledge space could grow through produsage.

The nascent *TeacherTube* project (a *YouTube*-style videosharing site for educational resources) has the potential to move some way further towards that idea—as, indeed, have general knowledge-sharing projects such as *Instructables*, as we have already encountered them: they enable any educator (professionally accredited or not) to share their educational and instructional resources with the wider community, to comment, tag, rank, and rate them, and (if appropriate open content licenses are used) to modify and redistribute updated versions of such content. Such projects should not be misunderstood as simple extensions of online learning resources provided in aid of distance education or flexible learning, for which Apple's recently launched iTunes University provides a typical example: where such services offer simply another avenue for distributing prepared educational resources, what is significant about *TeacherTube* and other projects is that they widen the range of those participants who are able to engage in the development and provision of teaching resources, and offer an opportunity for distributed collaboration on developing such resources. This, then, can be understood as a further step in the open-sourcing of education: "more and more, the 'code' to teaching and learning that schools once held dear is disappearing, creating open-source-type classrooms in which everyone contributes to the curriculum."[26]

What such projects enable, then, is similar to what projects such as citizen journalism and *Wikipedia* provide for: they offer a more diverse, multiperspectival range of educational resources which present not only more than the commonly accepted understandings of knowledge, but also cover a broader range of fields. In the process, they give rise to similar objections—the disappearance of apparent certainties of what is true (and should therefore be taught)—as well as provide similar answers to counter such laments (by noting that many questions about truth and the canonical status of knowledge are better left to be decided by individual knowledge seekers and through processes of public deliberation than by a small group of apparent experts). Once again, they also highlight the need for expert contributors to become involved directly in the collaborative processes of produsage themselves, to ensure that the materials they consider to be quality and the knowledge resources they regard as canonical *are* sufficiently represented within the overall educational knowledge space (and indeed,

MIT's release of OCW can very well be regarded as a preemptive strike in this fight for legitimacy).

In addition, of course, educational institutions also retain a special role as the only bodies sanctioned by law to provide an official accreditation for knowledge holders. It is possible to envisage a model by which such institutions would increasingly allow the processes of education themselves to take place in collaboration between entities within and beyond the academy itself, in line with the collaborative approaches between learners, teachers, and produsage communities which we have already identified, and would retain only that right to assess and accredit learner achievement as their core privilege; indeed, such developments could be regarded to be in line with an overall trend for educational institutions to position themselves as service providers to their learner clients. Under this model, however learners arrive at their level of knowledge (that is, whether through the formal courses offered by the institution itself, or through engaging with the learning resources available beyond the formal academic environment), the institution would evaluate and rate such achievements; indeed, teachers freed from a need to work with students who are already able to act as independent learners would thereby be able to focus especially on those learners still requiring more assistance in developing their key literacies and capacities, and they might also find more time to participate in the community as content and knowledge produsers themselves.

Such a model could be seen as pursuing an overly simplistic model of academia: it may be understood to position educational institutions as merely rubberstamping knowledge, providing certificates to learners who have achieved a certain understanding in their field. However, this would misrepresent the idea, and assume that even advanced levels of knowledge are easy to attain and demonstrate: instead, what the model for educational institutions that is suggested here would require is not simply the documentation of knowledge, but the demonstration of the literacies, capacities, and engagement in processes of knowledge creation. In other words, in recognition of the fact that education no longer takes place only within the spaces provided by educational institutions themselves, educational evaluation and accreditation in a specific discipline would require educators to observe the practices of information use and knowledge creation as exhibited by their students in whatever environments such practices may take place; they would assess the quality of such knowledge work against the state of the art in both the orthodox knowledge communities of academia and the new knowledge communities of produsage. In the process, they would introduce benchmarks for knowledge practices which transcend the boundaries of either community. Such models are not unlike professional doctorates and other degrees assessing sustained practice by experts in the industry, *within* the environment of the industry; what they would do is to extend this model for the assessment and accreditation of practice from expertly participation in industry production practices to expertly participation in communal produsage environments.

Reopening Academia

Such processes of assessment and accreditation are perhaps not at all unlike conventional models in academic publishing as they have existed for centuries—and indeed, academic publishing and the processes of peer review upon which it is founded can be understood as a key precursor to the development of produsage proper. In principle, academic publications are **open to the participation** of anyone able to submit an article; such articles are then **communally evaluated** through processes of peer review which assess the contents of a submission independently of the status of its author. What emerges from such processes, then, is a **fluid heterarchy** of scientific theories and theorists, on the basis of their evaluation against available evidence; the engagement between theoretical models and their proponents remains driven by *ad hoc,* **meritocratic models** involving a continuous process of testing and review. Therefore, theories also remain **permanently unfinished** and open to further development; our current understanding of the state of the art in any one discipline is necessarily always only an artefact of such **ongoing processes**. Ultimately, the theories must remain **common property** (as any enclosure would hinder further exploration), although their major proponents can nonetheless develop **individual rewards** from developing them.

The model of academic evaluation and educational accreditation of produsers as holders of knowledge which we have outlined above simply extends this system of academic publishing to the wider field of produsage; it takes seriously academic publications' open invitation to contribute content regardless of personal circumstances or established credentials, and extends it to the overall knowledge space established and extended by produsage practices. It respects the equipotentiality of all contributors, while not claiming an inherent equality of all participants: a contributor to the *Wikipedia* is no more likely to be accredited as an expert on a specific field of knowledge by this system of accreditation than an uncredentialed author is to be published in a major scientific journal, *unless* the content they have contributed holds up in peer review against the standard required by the system; where it does, though, such contributors have the right to be recognized for their work, and their academic peers indeed could be said to have the duty to recognize them. Educators, therefore, would reposition themselves as peer reviewers for their learners, regardless of the contexts in which learners demonstrate their knowledge; educational institutions would embrace produsage as an alternative space for their students to exercise and prove their capacities as knowledge workers, rather than as a challenge to their own existence.

Ultimately, then, educational institutions may be as ill-advised to rely on their official status and brand recognition as *Encyclopædia Britannica* was in its dismissal of *Wikipedia* as a temporary fad unable to compete with its centuries-old brand. Further, experience from other sectors appears to indicate that a defensive campaign aimed at undermining the new model's credibility is likely to backfire; instead, institutions would be better advised to develop proactive strategies aimed at embracing the creative

potential inherent in produser communities. Although it is far too early to do anything more than to sketch out the shape that such an embrace could take, as we have done here, it is possible to imagine a more permeable, flexible academic environment which builds the capacities of learners entering produsage communities and provides authentication and accreditation for the content and participants emerging from produsage environments. Academic institutions must lead change, not respond to it; teachers, too,

> need to be *change agents*. The ideas will not be easily embraced or readily supported at first because of the transparency that they create. So teachers need to find ways to use these tools to move away from the more traditional paradigms of instruction on their own terms in their own ways and recruit others to follow suit.[27]

Although the suggestion here cannot be to leave behind traditional scholarly and educational practices in academia altogether, in pursuit of new models which have not yet been proven to provide a qualitative improvement of outputs for the academic system, there is strong potential for a combination of traditional and new approaches which would place less emphasis on the in-house development of skills, capacities, and knowledges, or the in-house production of new research outcomes (kept increasingly out of public circulation as institutions pursue opportunities to commercialize their intellectual property), and which would instead shift its attention more to providing the service of quality assurance for both internal *and* external content creation activities, in the process profiting from the growth of publicly available knowledge and communally held intellectual property which such activities generate.

That shift from production to service, in fact, is entirely consistent with similar transitions occurring in many other industry sectors affected by the rise of produsage. It is a change from which academia might gain a great deal of new insights, and would constitute a reopening of the academy to all comers. Such openness in pursuit of the goal of sharing knowledge as widely as possible throughout society, and of enabling as large a number of citizens as possible to develop the literacies and capacities required for effective participation in the new knowledge spaces of humanity, has always been an underlying mission for academic and educational institutions, of course, but can be said to have been corrupted and undermined in recent times by the increasing industrialization and commercialization of teaching, research, and publishing; it is now possible to identify many deleterious effects from the dismantling of an academic and educational commons.

Counter-trends to such obstructions of the pursuit of knowledge and enlightenment have also emerged in recent years, however. The development of a scientific and academic commons in line with the creative commons has become a declared goal of the Creative Commons organization, and a variety of (often online) open access journals have emerged outside of the highly commercialized market for academic print journals; indeed, some, such as the *Economics* e-journal, have even adopted an open

source approach to their peer review processes and now conduct them in plain sight of their readers. A variety of research projects, especially those requiring large-scale collaboration between individual scientists, have similarly opened out their processes to open participation, freely sharing their datasets and communally evaluating their results.

Overall, many researchers have shown a strong interest in returning to open access principles, leaving behind the corporate enclosure of their work and the patent thickets surrounding their innovations, for as long as the financial sustainability of their work can also be assured. Answers to such questions can be identified in analogy to similar models in open source software development and elsewhere, which enable experts not to profit directly from their innovations as products, but to derive indirect income from offering their services as holders of expert knowledge, and they have been in place in the academic environment in the form of consultancies and other advisory roles since well before the emergence of produsage as a model in its own right.

However, what remains necessary is to translate such already existing and successful models, based in communal, collaborative knowledge development and peer evaluation, from the realm of academic research to the wider environment of education. Academics should be well placed to understand the processes and requirements of engaging in produsage, as they already have a deep familiarity with the proto-produsage models in their own practices of research and publication; with that experience in mind, the C5C model for the literacies and capacities required by students as they train to become produsers should already begin to make sense intuitively.

Educators need to help their students understand that in produsage environments, "even though the writing is not their own, they must take it as their own because they have the ability to edit and make it better." As Richardson notes, for teachers as well as students, "this is a huge shift"[28] from present practice, but it should not appear as such either to academics who in their own work stand on the shoulders of giants, build on the existing wealth of knowledge, or to learners who in their practices outside of the educational environment are increasingly familiar with practices of reappropriation, reuse, and remixing of existing materials, to the point of being native members of Generation C themselves. In preventing such participation in produsage in an educational context, it is educational organizations which are out of step with the rest of the world; for institutions which should lead and guide their clients in the acquisition of new knowledge and the development of new understandings, this is an untenable position.

Thus, Richardson is only partially right to note that "by inviting students to become active participants in the design of their own learning, we teach them how to be active participants in their lives and future careers"[29]: today, many learners are already actively involved in determining the course of their own lives through collaborative participation in communal knowledge spaces, and through the produsage of sociality

itself which can flow from such engagement. What educational institutions must now do is on the one hand to ensure that their own pedagogical approaches are not so out of step with the realities of produsage that they hinder rather than help such processes of self-determination, and on the other hand to engage especially in enabling those learners who have yet to join their more advanced peers to develop their own literacies and capacities to participate effectively in collaborative produsage projects as well as the collaborative project of social and societal produsage overall.

NOTES

1. Versions of this chapter (development forks from a first draft) have been presented at *ICE 3* and *Mobile Media 2007*: see Axel Bruns, "Beyond Difference: Reconfiguring Education for the User-Led Age," paper presented at *ICE 3 (Ideas, Cyberspace, Education)* conference at Ross Priory, Loch Lomond, Scotland, 21-23 Mar. 2007, http://snurb.info/files/Beyond%20Difference%20(ICE %203%202007).pdf (accessed 12 July 2007); Axel Bruns, Rachel Cobcroft, Jude Smith, and Stephen Towers, "Mobile Learning Technologies and the Move towards 'User-Led Education,'" paper presented at *Mobile Media 2007* conference, Sydney, Australia, 2-4 July 2007, http://snurb.info/files/Mobile%20Learning%20Technologies.pdf (accessed 12 July 2007).

2. Roy Rosenzweig, "Can History Be Open Source? Wikipedia and the Future of the Past," *Center for History and New Media: Essays*, 2006, http://chnm.gmu.edu/resources/essays/d/42 (accessed 28 Feb. 2007), n.p.

3. Cory Doctorow, "On 'Digital Maoism: The Hazards of the New Online Collectivism' by Jaron Lanier," *Edge: The Reality Club*, 2006, http://www.edge.org/discourse/digital_maoism.html (accessed 28 Feb. 2007), n.p.

4. Will Richardson, *Blogs, Wikis, Podcasts, and Other Powerful Web Tools for Classrooms* (Thousand Oaks, Calif.: Corwin Press, 2006), n.p.

5. Yochai Benkler, *The Wealth of Networks: How Social Production Transforms Markets and Freedom* (New Haven, Conn.: Yale University Press, 2006), p. 52.

6. Henry Jenkins, *Convergence Culture: Where Old and New Media Collide* (New York: NYU Press, 2006), p. 170.

7. Benkler, p. 275.

8. Jenkins, p. 129.

9. The C5C model further extends a C4C model developed at Queensland University of Technology in collaboration with Jude Smith, Stephen Towers, and Rachel Cobcroft; also see Axel Bruns, Rachel Cobcroft, Jude Smith, and Stephen Towers, "Mobile Learning Technologies"; Axel Bruns, "Beyond Difference." C5C adds a further capacity to engage with content in a combinatory fashion, which we failed to fully articulate in that earlier model.

10. Mark Pesce, "Hyperintelligence," *Hyperpeople: What Happens after We're All Connected?* 2 June 2006, http://blog.futurestreetconsulting.com/?p=17 (accessed 23 Feb. 2007), n.p.

11. Richardson, p. 132.

12. Richardson, p. 127.

13. Tom Calvert and Paul Stacey, "Learning for an e-Connected World," in Stephen Coleman (ed.), *The e-Connected World: Risks and Opportunities* (Montreal: McGill-Queen's University Press, 2003), pp. 66–67.

14. Pesce, n.p.

15. Richardson, p. 132.

16. Richardson, p. 90.

17. Richardson, p. 126.

18. For a concrete example for the establishment of such approaches, see, e.g., Axel Bruns and Sal Humphreys, "Wikis in Teaching and Assessment: The M/Cyclopedia Project," *Proceedings of the 2005 International Symposium on Wikis*, San Diego, 17–18 Oct. 2005, http://www.wikisym.org/ws2005/proceedings/paper-03.pdf (accessed 12 July 2007).

19. Also see Richardson, p. 64.

20. Richardson, p. 28.

21. Richardson, p. 133.

22. Richardson, p. 132.

23. *Wikiversity*, 2007, http://en.wikiversity .org/ (accessed 6 March 2007).

24. Lawrence M. Sanger, "Why Collaborative Free Works Should Be Protected by the Law," 2005, http://www.geocities.com/blarneypilgrim/shopworks_and_ law.html (accessed 24 Feb. 2007), n.p.

25. That said, there is now a project on the Wikimedia Foundation's *Wikibooks* site to collaboratively develop the South African national high school curriculum and its textbooks. See http://en.wikibooks.org/wiki/South_African_Curriculum.

26. Richardson, p. 128.

27. Richardson, p. 133.

28. Richardson, p. 67.

29. Richardson, p. 129.

Produsing Democracy[1]

W e have already highlighted the potential for participation in produsage to also lead to the produsage of sociality, and indeed to the produsage of social structures themselves. Finally, then, it is necessary also to examine the extent to which produsage may drive changes to the democratic system itself—not so much perhaps leading to its casual collapse *per se*, but to a significant reinvigoration of citizen participation in democratic processes which during the mass media age generally took place as acted out in front of, rather than as enacted by, citizens.

Some commentators are already foreshadowing the potential of such wider social and societal change. For Benkler, the newly emerging practices of commons-based peer production or produsage

> hint at the emergence of a new information environment, one in which individuals are free to take a more active role than was possible in the industrial information economy of the twentieth century. This new freedom holds great practical promise: as a dimension of individual freedom; as a platform for better democratic participation; as a medium to foster a more critical and self-reflective culture; and, in an increasingly information-dependent global economy, as a mechanism to achieve improvements in human development everywhere.[2]

Although it is important to remain skeptical of the transformative potential of produsage if it is presented as an inevitable outcome of current trends (history shows a number of similarly promising developments which faltered due to political or commercial intervention, or because they exhausted their participants' enthusiasm), it is nonetheless important to investigate the potential shape of a more strongly produsage-based society and democracy; for those so inclined, this investigation may also provide a blueprint for changes which can be pursued through political activism and the development of produsage spaces and projects which are constructive of such changed social and societal relations.

As Rosenzweig notes, "those who create Wikipedia's articles and debate their contents are involved in an astonishingly intense and widespread process of democratic self-education,"[3] and similar observations have also been made for other fields of pro-

dusage—Douglas Rushkoff, for example, has highlighted the potential for participation in open source projects to affect users' perception of their ability to effect change in the world around them, leading to a new period of societal renaissance and heralding the emergence of what he calls "open source democracy." He believes that

> we are heading not towards a toppling of the democratic, parliamentary or legislative processes, but towards their reinvention in a new, participatory context. In a sense, the people are becoming a new breed of wonk, capable of engaging with government and power structures in an entirely new fashion.[4]

We have also observed the gradual development of increasingly sophisticated community self-governance structures in *Second Life* and other multi-user virtual environments.

What, then, does happen if the principles of produsage are applied to the political and democratic process at least in theory? Perhaps it is useful to start by describing the current *status quo*: indeed, mass-mediated politics as it exists in most developed nations bears some strong similarities to the observations made about traditional production industries earlier in this book. Despite the lip-service paid to the principle of democratic consultation of the people in the political process, politics is today based largely on an industrial value-chain model which features clear distinctions between the producers of politics (politicians, lobbyists, commentators, and media advisors); the distributors of politics (journalists, editors, and media organizations); and the consumers of politics (the wider populace). Much as in other industries, too, producers and distributors undertake regular market research of "end user" preferences through polling and focus groups, as well as through elections themselves, and subsequently revise their product accordingly; much as in other industries, such products are mainly targeted either at achieving the largest available market share, or at servicing small but loyal or lucrative minority groups.[5]

Indeed, the global trend towards person- rather than issues-based political campaigning, and the increasing reliance on spin doctoring rather than clear statements of policy differences between political opponents, could be regarded as the logical outcome of a large-scale industrialization of politics—fierce competition between opponents in a mature industry tends to erode and ultimately eliminate most of the obvious differences between the major competing brands, and therefore necessarily shifts marketing strategy towards advertising based not on such objective differences but based on the appeal of celebrities associated with the product. In politics, party leaders have become such celebrities, and much as a choice between two brands of cola is often simply a choice between the celebrity cachets attached to them, so has the choice between two mainstream parties in many countries become one between the public personas of their leaders more than between clearly distinct policy proposals. At the same time, in commercial industries as well as in politics, minor competitors are driven by their inability to engage with market leaders on equal footing to an embrace

of smaller, more clearly identifiable niche interest communities; in politics this is a driver for the development of issue politics.

From Industrial to Produsage Politics

Late-industrial politics can be criticized in ways similar to late-industrial production; its main proponents necessarily must embrace middle-of-the-road, lowest-common-denominator political positions in order to attract the largest number of voters. (This tendency may be particularly pronounced in first-past-the-post voting systems like those of the United States and the United Kingdom, which inherently favor a two-party structure, and less so in proportional representation systems such as those of Germany and a number of other European countries.) Political deliberation and policy-making takes place in such environments not in the open engagement between different political points of view as espoused by major parties, but behind the closed doors of the party room, and is driven perhaps just as much by the aim to maintain a majority as it is by questions of what policy is best for the long-term future of the electorate. Much as the shortcomings of mass industrial production have led over past decades first to a strong counter-trend towards customization and individualization, and (at least in the informational industries) to the emergence of produsage-based models as an alternative to industrial production altogether, though, it is now possible to outline a potential shift away from industrialized, mass-produced politics and towards a produsage model of political information and policy-making. Similar again to other industries, here, too, this would effect a change from politics-as-product (to be "purchased" at elections) to politics-as-process (to be participated in throughout the legislative period). It would turn the object of politics—public policy as expressed through and enshrined in legislation—into a continuously revised and revisable artefact rather than a finished product to be updated only irregularly.

On present evidence, that shift may be highly necessary at the present moment. As Coleman notes,

> it is undoubtedly the case that most developed democracies are experiencing a collapse of confidence in traditional models of democratic governance. While there is no discernible popular disaffection from the idea of representative democracy as such, traditional structures and cultures of policy formation and decision-making are perceived as being remote from ordinary citizens.[6]

Although there is no collapse of democracy as such, in other words, the party-political model for organizing democratic deliberation and policy-making may well be undergoing a process of casual collapse after all, even if it remains as yet unclear what may succeed that model. Rushkoff adds to this that the age of the party as a broad-based political movement may well be over:

movements, as such, are obsolete. They are incompatible with a renaissance sensibility because of the narrative style of their intended unfolding. They yearn forward towards salvation in the manner of utopians or fundamentalists: an increasing number of people are becoming aware of how movements of all stripes justify tremendous injustice in the name of that deferred future moment. People are actually taken out of their immediate experience and their connection to the political process as they put their heads down and do battle. It becomes not worth believing in anything.[7]

Such observations provide a clear and credible explanation for the recent emergence of a number of global and local 'action coalitions' and other formations of campaigners which do not resemble formal movements in the traditional sense of that term: groups proposing alternative models for addressing pressing issues such as globalization, global warming, or world poverty do not resemble the nascent labor movement of the early twentieth century, or the emergent green parties of the 1960s and 1970s; instead, they are formed by a broad and sometimes internally conflicted coalition of participants who are nonetheless able to look past their political differences with one another to act as powerful advocates for their causes. "Pro-Am political campaigners are driving single issue, pressure group politics. The massive growth in nongovernmental organisations around the world in the last decade is largely due to Pro-Am political campaigners. Pro-Ams are reshaping the way democracy works."[8]

The success of such groups in mobilizing their participants to action is even more remarkable as it has taken place against a backdrop of overall citizen apathy:

> there is a pervasive contemporary estrangement between representatives and those they represent, manifested in almost every western country by falling voter turnout; lower levels of public participation in civic life; popular cynicism toward political institutions and parties; and a collapse in once-strong political loyalties and attachments.[9]

The new action coalitions do not operate like political parties or other established movements, requiring their participants to become members and thereby swear allegiance to the aims of the organization; they do not amalgamate their members into a movement unified through a common vision for society. They are instead able to rely on a loose, open community of contributors much as produsage projects elsewhere are able to. Such groups operate under principles best described as swarming behavior, triggered by outside influences and coordinated only lightly and without a central point of control; they build on "extensive communications leading to concordant and cooperative patterns of behavior without the introduction of hierarchy or the interposition of payment."[10]

In part, much like produsage in general, such movements also build on the availability of new technologies for networked communication and coordination, of course; in the process, they demonstrate how "new technology may fundamentally and irrevocably change the nature of the very processes of political and social interac-

tion."[11] This should not be understood as a form of technological determinism, of course; the same technologies are also available to the traditional leaders of the democratic system, and it is therefore the specific social and political uses made of such communication tools which determine change, not some inherent properties of the technologies themselves. At the same time, as Lévy notes, technology does have a crucial role to play:

> the only way we can improve democracy is by fully exploiting contemporary communications tools. Conversely, a deepening sense of democracy as a form of collective intelligence could become a goal that is both socially useful and gratifying for the builders of cyberspace. The most socially useful benefit of computer-mediated communication will be to combine their mental forces in constructing intelligent communities and real-time democracies.[12]

Such developments would constitute a direct translation of current practices in other fields of collective engagement and knowledge development to the political arena; it is therefore highly appropriate to seek answers in the realm of produsage which has already proven to provide an effective challenge to the *status quo* in other social and cultural environments:

> how do we generate the same level of emotional energy challenging the current Powers That Be in Washington that fans routinely direct against the Powers That Be in Hollywood? When will we be able to participate within the democratic process with the same ease that we have come to participate in the imaginary realms constructed through popular culture?[13]

Similarly, participation in open source and *Wikipedia* development also provides contributors with an enhanced understanding both of the diversity of opinions existing in any community of collaborators, and of the social and technological mechanisms for consensus building and policy development which may be available to solve community disputes and disagreements.

> The experience of open source development, or even just the acceptance of its value as a model for others, provides real-life practice for the deeper change in perspective required of us if we are to move into a more networked and emergent understanding of our world. The local community must be experienced as a place to implement policies, incrementally, that will eventually have an effect on the whole.[14]

Participants in fan communities, open source developers, Wikipedians, Second Lifers, and other produsers may therefore be able to use their engagement in such collaborative environments as a training process for political produsage, for active citizenship. Perhaps the most obvious example for such educational effects of participation in produsage is provided by citizen journalism projects from centralized open news sites to the decentralized spaces of the blogosphere, however—where such environments are concerned with the coverage of news and current events, they already fre-

quently play into the political realm, of course. This is "a shift in the public's role in the political process, bringing the realm of political discourse closer to the everyday life experiences of citizens"; participation here constitutes "a shift from the individualized conception of the informed citizen toward the collaborative concept of a monitorial citizen."[15]

A crucial step in this advance towards a more participatory, active, monitorial form of citizenship is the embedding of such practices into everyday life, and again blogging and other forms of participation in continuing, produsage-based, deliberative models for discussing and debating the news provide a useful model. As Jenkins points out, this is a question of moving beyond participation in political processes only in the lead-up to elections and in the context of major political issues; "the next step is to think of democratic citizenship as a lifestyle."[16] This does not necessarily provide an argument against the necessarily limited issue-based action coalitions we have discussed already, however; instead, it encourages citizens to participate in a variety of such coalitions, to join a number of the communities of political produsers whose interests and concerns match their own. Much as elsewhere in produsage, to do so will give rise to loose and fluid heterarchies of participation, and *ad hoc* alliances organizing specific actions and coordinating the development and evaluation of new policy initiatives.

If the core characteristics of produsage are translated to the political process, then, this would lead us to the following principles:

- **Open participation, communal evaluation:** political produsage proceeds from the assumption that the community of informed citizens as a whole, if sufficiently large and varied, can contribute more than a closed team of politicians and policy-makers, however qualified they may be, and thereby affirms the probabilistic principle. Policies and political ideas proposed by participants and developed by the community are also evaluated collaboratively by the community.

- **Fluid heterarchy, *ad hoc* meritocracy:** citizens participate in political deliberations and policy-making processes as is appropriate to their personal skills, interests, and knowledges (their equipotentiality to do so is affirmed), and may form loose subgroups to focus on specific issues, topics, or problems; this changes as the produsage project proceeds, and is governed *ad hoc*, based on merit, by the community itself.

- **Unfinished artefacts, continuing process:** political positions and policies as artefacts of the political produsage project are continually under development, and therefore always unfinished; their development follows evolutionary, iterative, palimpsestic paths. No one political actor, no one ideology, holds all answers and is set in stone: instead, politics and policy are reconstituted as granular in structure.

■ **Common property, individual rewards:** contributors permit community sharing, adaptation, and further development of their political and policy ideas, rather than defending them strongly as *their* ideas and thereby preventing participants from different political backgrounds to contribute to and collaborate in the policy development process; nonetheless, the developers and implementers of political ideas are recognized and rewarded by the status capital they gain through this process.

Perhaps these principles appear relatively modest at first glance, and perhaps they appear not to extend much beyond the bounds of citizen consultation in the political process as it has been practiced more or less effectively (and honestly) for some time already. However, on closer inspection they signal a major departure from the late-industrial model of politics.

In the first place, the shift to a community-based model of political produsage would mean that policy no longer emerges from the think-tanks and party rooms associated with political parties, but may originate just as well from citizen communities themselves. Further, the fluidity of roles in this process indicates that in order to see policy adopted by governments it would be no longer necessary for such citizen communities to align themselves with political parties, or seek election to office in their own right; instead, they would work with and alongside governments in order to gain broad acceptance of their policy suggestions. In effect, this changes both the procedures for policy generation and the ownership of political and policy ideas: where in the present late-industrial system, political positions are generated and "owned" by specific parties, and adoption of the opposition's policy suggestions is decried and eschewed as a sign of weakness, a produsage-based system of politics would be more permeable to new ideas once they have been sufficiently vetted, debated, and deliberated on by the community of informed citizens. Put another way, where presently, political parties have a tendency to pass off new policy ideas as their own once they have incorporated them into their political agendas, in an open system based on produsage political capital is generated not mainly from being the originator of new ideas, but from the ability to identify, flesh out, and implement them.

This is analogous to the shift of parts of the software industry from closed to open source production models: for companies which have embraced open source, the business model is based not on developing new technologies exclusively in-house for later commercialization as products (whose inner workings are highly guarded trade secrets), but on allowing staff programmers to freely contribute to collaborative open source projects, thereby both building a better understanding of what users want and need, relying on a much larger community of developers, software testers, and users than is available in-house, and identifying further potential for offering commercial products and services around the free resources created in the produsage process. Produsage politics would similarly shift from the in-house production of policy, which suf-

fers from a limited understanding of citizens' lived experience, hopes, and expectations of government, to an open and collaborative engagement with informed citizens in developing policy, and from a "business model" based on outdoing the opposition through surprise policy announcements and government spending in swing electorates to one where approval is gained and maintained by providing the best "products and service" around the collaboratively prodused policy initiatives—that is, approval is gained from demonstrating faithful and efficient development, implementation and management of prodused policy initiatives (thus translating the "common property, individual rewards" principle to the political realm).

Finally, produsage politics like all artefacts of produsage projects must also be seen as inherently unfinished and ready for further improvement; this means that a politics based on produsage is, although not opposed to participants with strongly held ideological positions, then certainly inaccessible to those who are unwilling to engage in open and meaningful political deliberation which may ultimately change their minds. Produsage-based politics would open the pathway to a political structure in which there are constant small, granular, incremental, evolutionary changes to policies and political positions rather than lengthy periods of limited change punctuated by (apparent) political paradigm shifts when government and opposition exchange place. This constantly adjusting model of politics may also be what Lévy has in mind when he writes that

> we can't reinvent the instruments of communication and collective thought without reinventing democracy, a distributed, active, molecular democracy. Faced with the choice of turning back or moving forward, ... humanity has a chance to reclaim its future ... by systematically producing the tools that will enable it to shape itself into intelligent communities, capable of negotiating the stormy seas of change.[17]

Such politics, and such democracy, is molecular, then, because it no longer relies on the large and (without lengthy periods of socialization and apprenticeship) relatively closed bodies of political parties to contain the majority of the political and policy-making process, in much the same way that software and encyclopedia users now no longer need to rely on the large and closed enterprises of Microsoft and *Britannica* and their various commercial competitors to produce the products they require. Instead, the molecular approach decentralizes and distributes the process of development into a wider, broader, and deeper network of contributors to the overall project (respectively, groups of informed citizens, open source software development communities, and the interest groups attached to any page or collection of pages in the *Wikipedia*), and from out of this network emerge the evolving and gradually improving artefacts of the process which can be used in place of traditional industrial products.

Such a produsage-based model of policy generation therefore necessarily requires a new approach to engagement between the governing and the governed. This is a common development in the context of produsage, of course, as it mirrors the re-

moval of producer/consumer dichotomies elsewhere; here, too, "the notion of citizens as members of an inert audience is no longer tenable, even if it ever was in the past."[18] Instead, engagement between citizens themselves as well as between citizens and other actors in political processes proceeds much more in line with the equipotential, fluid, open model of produsage itself, which allows each participant to take the lead if their ideas are good enough and persuasive enough to be accepted by the wider community.

However, even if they were technically feasible, such models clearly cannot proceed simply by enabling a form of direct representation which places all citizens within the same communicative environment; instead, they are likely to operate much more in tune with the *Wikipedia* or other produsage models which rely on the granularity of tasks and are able to distribute the available community effectively across the specific problems which need to be solved in order to arrive at larger solutions. "A strengthened model of representation depends upon informed public deliberation within a framework of interactive communication in which citizens can share their experience and expertise with those entrusted to represent them."[19] Most importantly, in contrast to the present industrial system of communication which strongly privileges one class of political actors as senders and turns all others mainly into receivers of their political messages, such systems must be highly equitable in their communicatory structures; they cannot be built on conventional hierarchical models: "just as political journalists and party spin doctors are expert in disseminating information and publicizing their agendas, strong representation calls for the refinement of equivalent skills in the art of listening, learning, responding, and absorbing public knowledge and experience into the policy cycle."[20]

Moving towards Molecular Democracy?

The application of produsage principles to the overall political process remains a largely utopian project at present, particularly in the face of throwbacks to highly autocratic leadership regimes especially in countries such as Australia, the United Kingdom, and the United States during the first decade of the new millennium. Nonetheless, and to some extent perhaps prompted especially by such setbacks for deliberative democracy, it is possible to identify some tendencies towards a more "molecular" style of political engagement. "We see collective action emerging from the convergence of independent individual actions, with no hierarchical control like that of a political party or an organized campaign."[21] Such tendencies remain limited at present still to particular geographic regions, political topics, or communities in the public sphere, but they may point to the slow emergence of a wider trend in which political audiences who are now becoming used to acting as produsers in other domains of their lives are beginning to ask the question of why such active and productive engagement should not also be possible in the field of politics.

As we have noted, one such development exists in the field of journalism, which is closely related to politics, of course. Here, the emergence of political and news bloggers and citizen journalism Websites already provides key spaces for the community-based, distributed debate and deliberation on the political dimension of news reports; through their engagement, such communities have significantly weakened the mass media's existing dominance over the mediated discussion of political issues in the public sphere, and in effect "molecularized" political deliberation to the point where there are a number of overlapping realms for political debate. Such realms include the remaining mainstream media environments where political debate is staged for and in front of viewers and readers by documenting the encounters between a selected handful of politicians, journalists, and pundits who are claimed to represent wider public opinion, but importantly also the produsage-based, open environments of blogs, discussion sites, and collaborative citizen journalism publications which directly involve informed citizens in the political debate itself.[22]

Beyond (citizen) journalism, another example which is more immediately located in the political realm itself is *MoveOn*, a U.S.-based community for the produsage-based development and facilitation of political campaigns. Although involving some 3.3 million signed-up members (*MoveOn* 2007, n.p.), *MoveOn* campaigns are neither closed to those who are non-members, nor necessarily binding for those who are members; instead, *MoveOn*'s membership is in the first place the foundation for the produsage of political action ideas which are relevant and feasible in the current political climate of the United States. Contrary to political parties, in other words, *MoveOn* does not work from a stock of approved core policies which it uses to distinguish itself from political rivals, but instead actively works to have its political views adopted by as many major players in U.S. politics as possible; its members need not sign up to a party ideology, but select from the campaigns on offer those which they feel most deeply about. Miller and Stuart describe this as a network approach to political action, and suggest that

> if civil society institutions can invest their activities with more network-centric thinking, they can attract a huge pool of untapped supporters into their campaigns. Of the ... people who joined MoveOn.org, most had not previously thought of themselves as activists.[23]

Again, this is a molecularization of political participation, then, but at the same time also counteracts a fragmentation of citizens into hermetically separate issue politics groups. In *MoveOn*, as elsewhere in produsage environments, participation is fluid and changes with the object of the produsage project.

A variety of other organizations similar to *MoveOn* have now also emerged, including for example the Australian *GetUp*. In addition, the *Care2* project combines citizen journalism and political activism: it not only enables its members to engage in the gatewatching and communal evaluation of news stories which are of interest to

them, but also links this directly with an opportunity to develop action campaigns which further explore and advocate the issues identified through such processes. Such molecular, produsage-based politics, then, clearly shifts the pressure points of the political process in much the same way that citizen journalism has undermined the gatekeeping role of the traditional journalistic industry. In essence, in this model the intelligence in the system shifts from the core to the periphery—as it does in many other produsage environments. Rather than relying on the intelligence of a select few central controllers of the system, the system is collaboratively managed, watched over, and filtered for quality ideas and content from the periphery, by participants acting as produsers. This proceeds along the same logic as that which Shirky identifies when he writes that "the internet is strongly edited, but the editorial judgment is applied at the edges, not the center, and it is applied after the fact, not in advance."[24] For Lévy, the shift implied in this is one towards collective intelligence, and is crucial: "if our societies are content merely to be intelligently governed, it is almost certain that they will fail to meet their objectives. To have a chance for a better life, we must become collectively intelligent."[25]

Such collective intelligence does much to undermine the traditional party-political model as it continues to dominate political processes in a large number of countries. In a molecular model of politics, parties become just one community of political produsers among many others, and must interact and interface with those others to compare their suggestions for political action and develop a shared approach through further, constructive collaboration. In the process, they are likely to lose membership as participating citizens can now avail themselves of a much wider range of (non-exclusive, membership-based as well as open to all) options for and communities of political action. Ultimately, political participation is carried back out of the party rooms and once again permeates society. Thus,

> in a system organized around molecular politics, groups are no longer considered as sources of energy to be exploited for their labor but as collective intelligences that develop and redevelop their projects and resources, continuously redefine their skills, and attempt to enhance their individual qualities indefinitely. ... Molecular politics, or nanopolitics, enhances the very substance of social relations at the finest level of detail and on a just-in-time basis. ... It engineers a social bond that integrates and creates synergy between creativity, the capacities for initiative, and the diversity of skills and individual qualities, without circumscribing or limiting them through the use of categories or a priori molar structures. The goal of such a micropolitics is not to model the community according to a preestablished plan. ... Rather, it brings into being an immanent social bond, one that emerges through one-to-many relations.[26]

Much as in other areas of produsage, however, the internal structures of the individual groups, communities, and projects which take place in this network of political produsage remain as yet unclear. Not unlike political parties, many produsage projects from Linux to the *Wikipedia* continue to emerge and galvanize around charismatic

leaders acting as catalysts for community formation and holding a significant degree of more or less explicit influence over the future direction of the project: Linus Torvalds, for example, continues to have final say over what changes make it into the Linux kernel, while Jimmy Wales still holds ultimate power over the *Wikipedia*. At the same time, community members *are* free to ignore their judgment and pursue other goals than those espoused by the community leaders, either by forming alternative structures within the community itself to the extent that this is possible, or by forking, that is, the creation of an alternative evolutionary line of development from a common foundation—"individuals can always leave, fork to a new project, create their own. The challenge is to find affinities, to create a common sphere with at least a few others and to create effective use value. Unlike in representative democracy, it is not a model based on a majority imposing its will on a minority."[27] If leaders in produsage projects are unelected, then this does not only mean that they serve as a kind of "benevolent dictator" chosen by popular acclaim; it also means that they are unelected also in the sense that—different from mainstream democracy—they do not have the ability to point to a popular mandate which even opponents are forced to respect.

As we have seen, the main factor preventing frequent forking even in controversial produsage projects such as *Wikipedia* is that to fork means to leave behind the community buy-in and social capital which one may have accumulated within the existing community—and it is worth noting that for the same reasons, it is also rare to see political parties split in two. Even where, as for example in the UK's New Labour, there exist significant internal differences over the political orientation of the party on key issues, there has not been a major rift permanently cleaving the party into an 'old' and a 'new' left, because to do so would likely be more damaging to the political fortunes of all involved even than to maintain the *status quo* of internal division but joint participation in elections. Such tendencies to stick together for better or for worse are necessarily more pronounced the larger the party, and thus the more valuable the political capital that would be likely to be destroyed in a public rift; they are also further strengthened in political systems which by design provide better electoral opportunities for a small number of major political parties than they do for a larger number of smaller groupings.

With a move to a produsage-based political system, such hindrances to forking over political differences do no longer exist to the same extent. Here, political allegiances are by definition more fluid, and participants may indeed be encouraged to move through various political communities to encounter a wide variety of perspectives on specific problems. Such communities are smaller and both more permeable and less permanent than traditional late-industrial political parties; they demand less buy-in by erecting smaller barriers to entry, and require less allegiance to the common goal by highlighting the need for members to remain active produsers rather than merely "end users" of party policy. Much like other produsage environments, their processes for arriving at community consensus are deliberation-based, and the influ-

ence of individual contributors on the produsage process is determined not by the predetermined and fixed roles they hold within a party-style hierarchy, but depends on the reputation they have developed through their prior actions within the community.

Intriguingly, Bauwens describes this model as a form of "non-representational democracy": "non-hierarchical governance represents a third mode of governance, one based on civil society rather than on representational democracy; in other words, non-representational democracy."[28] This also raises questions about its democratic legitimation, however—if such governance is non-representational, how can it accurately execute the will of the people? How can it serve as an improvement over the current late-industrial model of politics which—though flawed, open to manipulation, and frequently privileging lowest-common-denominator policies over more sophisticated, but less electorally "saleable" approaches—nonetheless provides citizens with the opportunity to record their vote on their political leaders at least every few years?

However, it is possible to offer strong arguments in favor of such new, non-representational models in which, as Lévy writes,

> everyone would have a completely unique political identity and role, distinct from any other individual, coupled with the possibility of working with others having similar or complementary positions on any given subject, at any given moment. ... We would no longer participate in political life as a 'mass,' by adding our weight to that of the party or by conferring increased legitimacy on a spokesperson, but by creating diversity, animating collective thought, and contributing to the elaboration and resolution of shared problems.[29]

One answer to the problem of non-representation, then, is that a produsage-based approach to politics and policy-making would provide an opt-in model by which policy outcomes represent those who chose to participate in the political deliberative process, while those who were unwilling to make a contribution are considered to have signaled in this way that they trust in the collective intelligence of those who did participate. This necessarily relies on a conceptualization of citizens as knowledgeable and active on political matters, and by contrast moves away from a citizens-as-audience model, in much the same way that citizen journalism has turned readers into participants in the journalistic reporting and commentary process. Indeed, the shift from representational to non-representational democracy could be seen as directly aligned with the shift from informed citizens (relying on general mass media coverage of news and politics to make their electoral choices) to monitorial citizens (participating actively in following and debating the political process on topics which are of direct interest to them) which Jenkins has identified.[30] A non-representational democracy, in other words, is nonetheless a deliberative democracy, with deliberation taking place between self-selecting, fluid groups of citizens-as-produsers, rather than either necessarily involving the participation of all citizens in the deliberative process at all times or alternatively having political deliberation acted out on the political stage of the mass

media by a small number of more or less representative politicians, lobbyists, pundits, and journalists. Although not involving all the people, all the time, then, nonetheless

> new forms of online deliberation will increasingly involve select groups who can bring their particular experience and expertise to the policy-making process. These groups will be made up of the politically organized and the politically alienated, policy experts and service users, the articulate and the less articulate—in short, a representative sample of the real world.[31]

This sample is representative not in a purely statistical sense, however; it represents not simply all walks of life, all strata of society, regardless of the issue at hand, but represents a self-selected group of interests which are most closely related to that issue—it represents the key stakeholders in those areas of public policy which are currently under consideration. Again, this is very similar to the overall model of *ad hoc* participation by produsers in the produsage process as it is appropriate for the current issues to be addressed; much as in open source or the *Wikipedia* those with the most to offer and the most at stake will nominate themselves for involvement, and those whose skills are unsuited to the question at hand are knowledgeable enough about the produsage process to step back and let others drive the project forward, so here, too, it is necessary for participants to be sufficiently self-critical and self-aware to remove themselves from the process when their presence is not required or would serve as a hindrance. In other words,

> one is not here envisaging a citizenry that is constantly engaged in decision-making, as would be required by a direct, plebiscitary democracy, but citizens who have learned to use the democratic muscles that have atrophied during long years of exclusion from the deliberative process.[32]

Again, then, this reveals produsage-based democracy to be highly distinct from a direct and constant polling of all citizens on all questions to determine public opinion.

Ultimately, the development of a produsage-based democratic model which follows such principles "is in reality a debate about the reinvention of representative democracy for an age in which the cultural norms of deference, distance and distrust are in decline."[33] In no small part, this is necessarily also a question of developing the technological supports for such a form of non-representative democratic participation, of course; some such tools are now already available in the shape of citizen journalism sites, blogs, and wikis, but what is necessary beyond this is the development of systems which extract from this multitude of views and ideas a more general picture of the overall state of deliberation on specific issues, of key views in the produsage community, of a collective voice representing groups of contributors in the discussion.

> This collective voice could, for example, take the form of a complex image or dynamic space, a changing map of group practices and ideas. ... Collectivity is not necessarily synonymous with solidity and uniformity. The development of cyberspace provides us

with the opportunity to experiment with collective methods of organization and regulation that dignify multiplicity and variety.[34]

The availability of such overviews of the current state of deliberation would further strengthen public debate and deliberation itself, as it enables those who have as yet failed to contribute to identify the views of others, and thereby to determine whether their own individual voice should be added into the mix or whether their views have already been expressed sufficiently well; it would also enable them simply to add their support to one or the other of the currently represented groups within the debate. This would further help strengthen the process of widespread public deliberation without requiring a fully representational approach.

Such a move to a non-representational, self-selecting model for a produsage-based democracy (or indeed for a produsage of democracy, by citizens) may contribute to what Lévy describes as

> a shift ... from democracy (from the Greek *démos*, people, and *cratein*, to command) to a state of *demodynamics* (Greek *dunamis*, force, strength). Demodynamics is based on molecular politics. It comes into being from the cycle of listening, expression, evaluation, organization, lateral connection, and emerging vision. It encourages real-time regulation, continuous cooperative apprenticeship, optimal enhancement of human qualities, and the exaltation of singularity. Demodynamics does not imply a sovereign people, one that is reified, fetishized, attached to a territory, identified by soil or blood, but a strong people, one perpetually engaged in the process of self-knowing and self-creation, a people in labor, a people yet to come.[35]

Demodynamics vs. Democracy

Any shift from democracy to demodynamics, or even any accommodation of demodynamic forces within traditional democratic structures, is necessarily going to be an uneasy, halting process. The institutions of power in the democratic system are no more likely to give up or reduce their influence than are the traditional industrial leaders of the software, media, or knowledge industries. Even where hybrid and crossover models building on both forms are theoretically possible, they are as yet untried and open to attack, especially while those experimenting with such models do not yet understand the full implications of their work.

The instability which is likely to characterize this transitional moment is perhaps already visible in a number of as yet isolated examples. Foremost among them is the ultimately unsuccessful primary campaign of Democrat contender Howard Dean in the lead-up to the 2004 U.S. presidential elections. Dean's campaign was fought on two levels—on the one hand, by using the standard media tools of mainstream U.S. politicians, but on the other also by encouraging a groundswell of loosely coordinated

grassroots support especially through what at the time was a relatively sophisticated use of blogs and other online communications and media forms. However,

> like the dot-com boom that pre-figured it, the Howard Dean craze made exaggerated claims that were undeliverable. This movement, fueled by unsupervised local initiatives and virally-activated small donors, could not reach far enough beyond its loyal, wired base. Politics as we know it did not change overnight, as John Kerry's presidential campaign proved in Iowa, and as the Republican spin machine and the complicit media proved again in the subsequent demolition of the Dean candidacy.[36]

Dean's downfall, then—although commonly attributed simply to the effects of the mass media's relentless coverage of the "Iowa Scream"[37]—, can be traced back just as much to his inability to reconcile the industrial mode of production of politics as it was practiced by his and all other mainstream campaigns with the produsage approach which emerged among his grassroots supporters beyond the control of his campaign. As far as the grassroots campaign went, Jenkins notes, "Dean didn't so much create the movement; his staff simply was willing to listen and learn."[38] Excepting the Iowa Scream, Dean himself publicly portrayed the role of the charismatic leader as prescribed by the standard operating procedures of late-industrial politics; however, this persona is significantly different from and ultimately incompatible with the charismatic leader of produsage projects. Where the traditional political leader must show control and command of the political issues of the day, with any need to defer to outside opinion (especially when coming from non-aligned positions) ultimately seen as a weakness, the leader of a produsage community is in a vastly different position of gaining reputation from listening to alternative views and facilitating the development of a consensus across different political camps. "Like the dot-com executives before him, [campaign manager] Trippi (and Dean) mistook their own sales pitch for a realistic model of how media change takes place,"[39] and they failed to take into account the realities of either traditional or new media environments.

Indeed, as we have seen in the context of other produsage environments, where the traditional leader (political or otherwise) stands atop a hierarchy of contributors by virtue of having been elected or employed *a priori* to deal with problems perhaps yet unknown, the leader of a produsage community rises to the top *a posteriori* as a result of the reputation gained by their contribution to the handling of the pressing issues of the moment. A role of leadership in produsage is conferred on the basis of the individual's established and *proven* merit as a contributor, and withdrawn immediately where such merit declines due to poor performance; a role of leadership in conventional politics is conferred on the *appearance* of existing merit, and on the electorate's hope that politicians, once elected, may continue to act in citizens' best interests, and it is withdrawn other than in extreme cases only after the completion of the present term of office. If we were to translate the produsage model fully to the political arena, then, we might paraphrase Clay Shirky's famous statement that "the order of things in

broadcast is 'filter, then publish.' The order in communities is 'publish, then filter'"[40] for the political context by saying that the order of things in traditional, industrial politics is "elect, then lead," while in political produsage that order would have to be reversed to "lead, then elect": leaders arise from within the community based on their contribution to the collaborative building of consensus on current issues, to the collaborative creation of policy, to the collaborative governance of the *res publica*, the 'public matter,' *by* the public—a formal recognition as a leader in governance, in other words, requires a long track record of constructive participation in the everyday acts of governance undertaken by all citizens.

From this it becomes clear that for Dean to have fulfilled the role of leader in both models would have been a very difficult and perhaps impossible task. Dean would have had to unilaterally set policy in the manner of traditional political leaders, thereby showing his capabilities as a contender for President, while at the same time working in an open-ended manner with his grassroots supporters to facilitate the emergence of policy out of that community. Tending towards the latter strategy would have left him open to attacks from his political opponents working under a traditional political model, who could have accused him (and indeed, did) of having no strong policies of his own and running a purely populist campaign which shifted its political agendas simply according to what appeared to be the majority opinion among his constituency (a misrepresentation of the processes of political produsage, yet one which would have been difficult to fight effectively within the news cycle of Primaries coverage). Tending towards a more traditional, hierarchical style of political leadership, on the other hand, would (and did) alienate the community of grassroots Dean supporters, whose enthusiasm for direct and open participation in shaping the policies of the Dean campaign through produsage would have necessarily been undermined by the very obvious presence of a final closed filtering stage of Dean and his staffers selecting only those of the emerging policies which appeared to them to be suitable to their wider political campaign.

Similar problems are faced also by any other leader experimenting with the open consultation of informed citizens as produsers of policy. Where (online or offline) consultative fora are made available to citizens, there tend to be two main reactions: political opponents will accuse the leader of having run out of ideas and playing the populist game of latching on to whatever seems to exercise the minds of voters at present, especially if the mode of citizen consultation is open and does actually lead to the adoption of policy ideas which emerge from it; on the other hand, participating citizens themselves will accuse their leaders of populism for the diametrically opposed reason of not opening up the policy process enough and conducting mere feel-good exercises which *appear* to consult citizens but ultimately do little to implement their ideas. It seems as difficult to overcome this problem as it is for traditional, industrial journalism to both embrace the produsage efforts of citizen journalists *and* maintain the editorial processes of the journalistic industry, or as it is for software producers to

harness open source software produsage while retaining a business model built around the sale of copyrighted products.

Nonetheless, some commentators suggest that a gradual transition towards more peer engagement- and produsage-based modes of politics and democracy (or demodynamics) is as unstoppable in that field as it has proven in software, journalism, and many other industries, and that this may occur through a process of osmosis, as it were, by which participants accustomed to produsage in those areas will also increasingly expect to see politics operate according to the same principles. Bauwens, for example, expects that

> peer governance within peer communities will co-exist with our current political democracies, and these in turn will be influenced by the P2P ethos, and so begin to adopt more and more multi-stakeholder forms of governance themselves. ... It is no longer realistic for any political group to claim that it has easy solutions to complex problems.[41]

Given the preceding discussion, it is unlikely that such gradual adoption of produsage models will proceed without controversy; at the same time, perhaps it is also likely that it will succeed more easily in some areas of politics and policy where the fact that no easy, populist solutions are available is most strongly felt. Such areas might include the development of political responses to the realities of global warming, and the international fight against poverty, for example: although in both cases there remain some powerful lobby groups with very strongly partisan political positions, recent years have seen an acceptance by the political mainstream in most countries that solutions to these problems must be found irrespective of one's own political persuasion, and that such solutions are likely to be feasible only if a non-partisan approach is adopted. Thus, although the *means* of reducing CO_2 emissions or the mechanisms for reducing or canceling third world debt may continue to be hotly debated, few serious political actors would still argue that there is no need to pursue these actions. At the same time, both fields have also seen the emergence of a diverse range of non-government organizations (some operating already on open models similar to *MoveOn*) which are increasingly accepted as participants in political deliberations, and have formed a loose network of communities which, while differing on individual points, still cooperate in furthering public discussion, debate, and deliberation—*Make Poverty History* is one such coalition.

Towards Renaissance?

The relatively open debate and deliberation which takes place on a global scale on such issues may point the way towards a produsage-led transformation of political processes. It is perhaps problematic that the hegemony of the industrial model of po-

litical production can be overcome at present only in the case of such global issues which clearly overwhelm the individual abilities even of the world's most powerful governments, but it is possible to see these developments as the first cracks in the armor of industrial politics, and the start of a broader trend towards political produsage which will reach further down into the national and local level. (At the same time, it is also likely that there exists a similar but less visible trend upwards from the micro-local and local to the national level.) Again, parallels can be drawn here to other industries which have already faced peer-to-peer- and produsage-based opposition.

Attacks by the political establishment on the new grassroots movements which have begun to challenge it, indeed, may serve only to strengthen these movements by showing that their work is having a tangible effect. If such trends do continue, we are likely to see the relative weakening of traditional political institutions, and their complementation (and occasional supplementation) by new, produsage-based organizations, much as this has occurred already in other fields and industries. Traditional models of controlling such fields from a position of hegemony over existing hierarchies will struggle amid an offensive of community- and reputation-based produsage-style alternatives; as Lévy points out, "power in general has no affinity for real-time operations, permanent reorganization, or transparent evaluation" as they are prevalent in such produsage models. "In general it strives to maintain its advantages and preserve its acquisitions, maintain situations, and block circuits, all extremely dangerous attitudes in a period of rapid and large-scale deterritorialization."[42]

There can be little doubt that attempts at reterritorialization will also occur: leaders of political produsage communities may well be tempted to convert the changeable reputation-based social capital which has propelled them for the moment to the center of their community into a more constant, permanent, position of power; once-permeable produsage communities themselves may solidify (indeed, ossify) into more traditionally structured political organizations and parties by establishing stronger barriers to and statutes of membership, and by developing rules of 'due process' for their internal workings. Such changes would return from the community-based, flat or at most heterarchical structures of produsage to a hierarchical model of production; however, for reasons outlined earlier, it is unlikely that a complete return to this model will be possible for all of politics: once participation and power has been networked and dispersed through the adoption of produsage-based models, there is no longer any one point of control or leverage for those attempting to again rein in this community- or peer-based mode of interaction. Reterritorializing tendencies are possible for individual groups, or in specific fields, but the vacuum created by the departure of such groups from the produsage model is likely to be filled quickly by those who oppose this reterritorialization.

More pressing problems for produsage politics, then, are the question of how to ensure that produsage models do provide an opportunity to participate in political deliberation to all those who do want to take part, and the associated question of how to

coordinate the consensus-finding processes taking place simultaneously within a large number of parallel political produsage communities. As much of produsage currently takes place in online informational environments, the first question also particularly relates to the persistence of digital divides at local, national, and international levels along various geographical, economic, and social lines. A produsage politics which involves only the affluent, the educated, the well-connected, or those with sufficient time for meaningful engagement is necessarily fundamentally flawed, and would therefore be ever more problematic if more of politics were to move towards a basis in produsage principles; there is, therefore, a need to provide the access and skills necessary for participation to as large a section of global civil society as is possible, both by enabling them to take part in or develop new online political produsage communities and by pursuing the possibility of translating produsage models to offline environments. Part of this work must also be done by educators, building the capacities for effective participation in produsage environments in all fields of endeavor in their students (this lends additional urgency to the educational transformations we have discussed in the previous chapter).

If broad-based political produsage can be achieved by overcoming such digital divides, then, it is further necessary to aim for an interconnection of individual produsage communities and thereby work towards the development of a widely accepted consensus on the issues under discussion. Community-based produsage may be seen at first glance as embodying a tendency towards the increasing fragmentation of the public sphere into separate and unconnected "issue publics," debating specific topics among themselves but acting as little more than a continuous echo chamber for the perpetuation of "groupthink"; however, while this may be true of some such communities it does ignore the fact that for most members of any community, their personal experience is not limited strictly only to that community. Instead, we are almost always already members of a variety of overlapping groups based on shared origins, location, socioeconomic status, education, interest, taste, values, or beliefs, and through this overlapping of individual groups their boundaries are made permeable at least to a certain extent; we have already examined such tendencies for overlapping and clustering to occur in introducing the image of the gentle slope of cultural participation in Chapter 10, and in our examination of the produsage of sociality in Chapter 12.

Indeed, while pointing out that "the shift toward 'issue voting' reveals the growing impact of public discourse on voting patterns and, more generally, of public discourse on the formation of 'issue publics,'" even Habermas, who has adopted a characteristically skeptical position towards modern many-to-many communications media such as the Internet and the World Wide Web, notes that "although a larger number of people tend to take an interest in a larger number of issues, the overlap of issue publics may even serve to counter trends of fragmentation."[43] However, it may be insufficient to rely on the "natural" overlap between issue publics to ensure that produsage-based political deliberation both takes place, and covers and connects the full

range of opinions and ideas on any given issue. Instead, in addition to such existing tendencies to overlap, it may also be necessary to deliberately enable, encourage, and facilitate the encounter and debate between different positions, and to guide such debate towards the formation of consensus and the adoption of collaboratively created policies.

This process may involve a number of different stages, as well as the participation of different entities. In the first place, to enable participants to encounter multiple perspectives on any given issue may require a solution partly based on technology, and partly based on the work of individuals and groups providing a handmade alternative to such technology—already, for example, sites such as *Technorati*, *del.icio.us*, and *Textmap* enable interested users to identify the key or most recent blog posts, Websites, and other online resources on specific topics (as identified through keywords and other means); in turn, such sites crucially rely on the distributed work of millions of bloggers, Web users, and Web publishers which is aggregated, evaluated, and digested by their various automatic algorithms. The availability of such sites (and of many others like them, as well as similar issue digests which are not created by automatic aggregation but through a gatewatching process conducted by a large community of human contributors) is only a necessary precondition, however, but not sufficient to ensure that actual Web users will indeed encounter the variety of views and opinions available in such online produsage communities. Beyond enabling Web users, therefore, it is necessary also to *encourage* them to seek out and engage with other participants debating the issue at hand. This is a task both for society at large, as well as for education and other specific social institutions, and again relates to the task of capacity building outlined earlier—in addition to the mere building of produsage capacities, then, it is also necessary to provide users with the motivation to exercise their capacities for produsage.

In addition to employing the existing spaces of produsage themselves for the produsage of democracy, it is important to keep in mind also the continued role of the remaining mainstream media. As we have already seen, produsage-based media forms and deliberative spaces act as a complement to such media, and (in part) also as a corrective; this boosts the vitality of the overall public sphere. At the same time,

> the new political culture—just like the new popular culture—reflects the pull and tug of these two media systems: one broadcast and commercial, the other narrowcast and grassroots. New ideas and alternative perspectives are more likely to emerge in the digital environment, but the mainstream media will be monitoring those channels, looking for content to co-opt and circulate. Grassroots media channels depend on the shared frame of reference created by the traditional intermediaries Broadcasting provides the common culture, and the Web offers more localized channels for responding to that culture.[44]

As models for produsage-based democracy emerge further, it will be important to en-sure that they do not lead to the development of (or the increasingly pronounced separation of society into) a two-track democratic system. A model in which socially progressive, innovative policy ideas are developed and expressed mainly in and through the online environments of produsage, and in which mainstream media con-tinue to provide platforms for conventional politicians concerned as much with the preservation of their power as the legitimate 'representatives' of the people as they are with the selling of their parties' policy ideas would be likely to be highly damaging to social cohesion overall; at the same time, however, for all the complicity of much of present-day commercial media with specific political actors, media organizations will also be acutely aware that they can only ignore strong public sentiment in favor of greater democratic participation for a limited duration of time without losing the sup-port of their remaining audiences.

As Coleman points out,

> in the century since the rise of the mass franchise, democratic societies have operated with weak models of representation, based upon unbridgeable barriers of distance and cognition between representatives and electors. Democratic representation exists to reflect the will of the people. But this will is not always clearly formed or efficiently communicated to the political elite.[45]

Finally, then, there remains the question of how to facilitate the encounter and en-gagement with the views and opinions of other participants, and of how to move be-yond 'mere debate' towards the facilitation of a consensus-oriented deliberation and towards the development and adoption of feasible government policy. Here, perhaps, we see the potential for suggesting a new role for journalists and politicians, whom a move to produsage-based approaches dispossesses of their previous positions as gate-keepers and policy-makers, respectively. Much as the rise of produsage-based citizen journalism necessitates "a shift from the watchdog to the 'guidedog'" for journalists,[46] for politicians it may similarly mean a move from policy-maker to policy facilitator and implementer: their role would now be to identify the key policy ideas on any one spe-cific issue as they emerge from a variety of political produsage communities, to facili-tate further (broad as well as deep) deliberation of these suggestions, and to guide participants towards the development of a consensus which incorporates elements from many such suggestions and thereby is acceptable to most, though perhaps a per-fect solution for none.

In other words, much as produsage-based citizen journalism breaks with the stan-dard journalistic pattern of pitting against one another the opinions of diametrically opposed parties and reporting on the clash between them, and instead covers the many nuances of opinion which exists in between the central rallying points of oppos-ing ideologies, so would a produsage politics move away from an oversimplified choice between the rigid political solutions to an issue which are offered by the left and the

right, and instead reopen debate and deliberation on these ideas as well as many others which may exist in between them, with the aim of finding a middle ground that is acceptable if not to all, then at least to as wide a range of citizen participants as possible. Politicians facilitating this consensus-building process would no longer be in a position to claim that the solution eventually adopted was their (or their party's) idea, with an aim to generate political capital from being seen as 'strong' on the issue at hand; instead, they would now gain in political reputation and may be accepted as leaders by openly acknowledging the contributions made by all, and on the basis of the expertise they have shown in guiding all parties to reaching such widely acceptable consensus. Their role would be one of peacemaker rather than of partisan.

Whatever the exact shape of this emerging model of produsage democracy, the path towards such changes will not be easy or straightforward, and it is likely to see many missteps as well as rear-guard actions from those established institutions that stand to lose authority and power from a move to produsage. Such disruptions to the *status quo*, and the as yet only sketchy nature of what form a more strongly produsage-based society and democracy might take, may be seen as reasons not to begin the journey in the first place; however, it is important to keep in mind that the present model of democracy, as well as—more to the point—the present actual practices of democracy in many nations, are by no means ideal in their own right, and are perhaps increasingly out of step with the wants and needs of the *démos* which they govern.

It is interesting to note in this context that von Hippel's description of the inefficiencies of traditional, industrial innovation systems can be used almost verbatim also to describe the inefficiencies of the political system, which after all is similarly concerned with the development of innovative approaches to addressing existing social problems. As he notes,

> the traditional pattern of concentrating innovation-support resources on just a few pre-selected potential innovators is hugely inefficient. High-cost resources for innovation support cannot be allocated to "the right people," because one does not know who they are until they develop an important innovation. When the cost of high-quality resources for design and prototyping becomes very low ... these resources can be diffused widely, and the allocation problem then diminishes in significance. The net result is and will be to democratize the opportunity to create.[47]

In a political context, it is perhaps just as difficult to identify *a priori* which political leaders will be the most innovative in finding social solutions, and history is littered with cases of politicians who failed to deliver on their promise as innovators after they were elected to office. At a time when access to the resources for policymaking (that is, to information, research, and reports on issues to be addressed by government policy) was limited and costly, the conventional model of democracy may indeed have been the best among a number of suboptimal solutions for selecting policymakers; today, however, in the context of a vastly improved access to informational

resources and in the face of a large number of issues which are better dealt with at a global or local than at a national level, this may no longer be the case. It is interesting, then, that the diffusion of resources and the distributed approaches to innovation, which von Hippel outlines, are described by him as democratizing the opportunity to create (or to innovate)—by extension, distributed approaches to political deliberation as we have described them here should be considered to present a potential of democratizing the opportunity to create policy, and thus perhaps even as democratizing democracy itself.

Although such produsage-based democracy may take the shape of a non-representational democracy, as Bauwens describes it, "where an increasing number of people will be able to manage their social and productive life through the use of a variety of networks and peer circles,"[48] this is nonetheless a highly participative model of democracy. Among its main departures from late-industrial democratic practices is the fact that such produsage-based democracy relies less on the regular but highly limited participation of citizens in their democracy through the act of casting a vote (a practice which must necessarily condense a universe of small and nuanced policy options on a vast variety of political issues into a simple choice between a handful of candidates); instead, it relies more on the continuous engagement, between elections, of informed citizens in the deliberation on policy decisions which interest and affect them.

For Rushkoff, this signals a return to active citizenship and democratic participation, then: "these three stages of development: deconstruction of content, demystification of technology and finally do-it-yourself or participatory authorship are the three steps through which a programmed populace returns to autonomous thinking, action and collective self-determination."[49] It does not represent a return of democracy to an older style of direct plebiscitary participation along the lines of the small-scale Athenian model, however, but instead represents a step forward towards the large-scale deployment of democratic, demodynamic, molecular systems which are uniquely suited to the present social, cultural, and technological environment.

That process of change is necessarily likely to proceed slowly and unevenly, but is nonetheless likely to show strong effects even in the short term; indeed, through projects such as *MoveOn*, *GetUp*, and *Care2*, it is perhaps already engaged in fundamentally changing citizens' involvement in their national and international democratic environments. In fact, it is especially the significant international political problems that many such campaigns are attempting to address which will bring about the rise of produsage democracy:

> when something breaks in a knowledge culture, the impulse is to figure out how to fix it, because a knowledge culture empowers its members to identify problems and pose solutions. If we learn to do this through our play, perhaps we can learn to extend those experiences into actual political culture.[50]

Much as the number of diverse eyeballs looking at a problem in open source development increases the community's chances of finding a solution, then, produsage democracy may similarly be able to rely on the probabilistic effects of its broad-based participatory model: here, too, the larger the community of informed citizens involved in public deliberation, the better its chances of coming up with innovative and effective social solutions. Such solutions are not necessarily those supported simply by the majority of citizens, but those determined, through open and intelligent deliberative processes, to be the most likely to lead to real and positive change. As Leadbeater and Miller put it, "the more Pro-Ams there are in a society the healthier its democracy is likely to be"[51]; we might broaden out that statement to suggest that the greater the number of citizens participating in processes of political produsage along the lines which we have discussed here, the better the chances of their society to weather the challenges of rapidly changing local, national, and international environments, and to maintain social cohesion and cooperation even in the face of a highly decentralized and diversified framework of produced sociality.

NOTES

1. A draft version of this chapter was presented at the MiT5 conference. See Axel Bruns, "Produsage, Generation C, and Their Effects on the Democratic Process," paper presented at *MiT 5 (Media in Transition)* conference, MIT, Boston, USA, 27–29 Apr. 2007, http://snurb.info/files/Produsage,%20Generation%20C,%20and%20Their%20Effects%20on%20the%20Democratic%20Process.pdf (accessed 12 July 2007).

2. Yochai Benkler, *The Wealth of Networks: How Social Production Transforms Markets and Freedom* (New Haven, Conn.: Yale University Press, 2006), p. 2.

3. Roy Rosenzweig, "Can History Be Open Source? Wikipedia and the Future of the Past," *Center for History and New Media: Essays*, 2006, http://chnm.gmu.edu/resources/essays/d/42 (accessed 28 Feb. 2007), n.p.

4. Douglas Rushkoff, *Open Source Democracy: How Online Communication Is Changing Offline Politics* (London: Demos, 2003), http://www.demos.co.uk/publications/opensourcedemocracy2 (accessed 12 July 2007), pp. 63–64.

5. The latter especially in systems which—unlike the United States or United Kingdom—rely on proportional representation.

6. Stephen Coleman, "Democracy in an e-Connected World," in Stephen Coleman (ed.), *The e-Connected World: Risks and Opportunities* (Montreal: McGill-Queen's University Press, 2003), p. 124.

7. Rushkoff, p. 64.

8. Charles Leadbeater and Paul Miller, "The Pro-Am Revolution: How Enthusiasts Are Changing Our Economy and Society," *Demos* 2004, http://www.demos.co.uk/publications/proameconomy/ (accessed 25 Jan. 2007), p. 11.

9. Coleman, p. 124.

10. Benkler, pp. 265–266.

11. Richard Allan, "Foreword: Dancing to a New Tune," in Stephen Coleman (ed.), *The e-Connected World: Risks and Opportunities* (Montreal: McGill-Queen's University Press, 2003), p. xi.

12. Pierre Lévy, *Collective Intelligence: Mankind's Emerging World in Cyberspace*, trans. Robert Bononno (Cambridge, Mass.: Perseus, 1997), p. 61.

13. Henry Jenkins, *Convergence Culture: Where Old and New Media Collide* (New York: NYU Press, 2006), p. 234.

14. Rushkoff, p. 61.

15. Jenkins, p. 208.

16. Jenkins, p. 234.

17. Lévy, pp. xxiv–xxv.

18. Coleman, p. 127.

19. Coleman, p. 124.

20. Coleman, p. 125.

21. Benkler, p. 265.

22. See Axel Bruns, *Gatewatching: Collaborative Online News Production* (New York: Peter Lang, 2005); Axel Bruns, "The Practice of News Blogging," in Axel Bruns and Joanne Jacobs (eds.), *Uses of Blogs* (New York: Peter Lang, 2006).

23. Jed Miller and Rob Stuart, "Network-Centric Thinking: The Internet's Challenge to Ego-Centric Institutions," *PlaNetwork Journal: Source Code for Global Citizenship*, n.d., http://journal.planetwork.net/article.php?lab=miller0704 (accessed 14 Mar. 2007), p. 1.

24. Clay Shirky, "Broadcast Institutions, Community Values," *Clay Shirky's Writings about the Internet: Economics & Culture, Media & Community, Open Source*, 9 Sep. 2002, http://shirky.com/writings/broadcast_and_community.html (accessed 24 Feb. 2007), n.p.

25. Lévy, p. xxviii.

26. Lévy, pp. 53–54.

27. Michel Bauwens, "Peer to Peer and Human Evolution," *Integral Visioning*, 15 June 2005, http://integralvisioning.org/article.php?story=p2ptheory1 (accessed 1 Mar. 2007), p. 3.

28. Michel Bauwens interviewed in Richard Poynder, "P2P: A Blueprint for the Future?" *Open and Shut?* 3 Sep. 2006, http://poynder.blogspot.com/2006/09/p2p-blueprint-for-future.html (accessed 1 Mar. 2007), pt. 1.

29. Lévy, p. 65.

30. Jenkins, p. 208.

31. Coleman, pp. 128–129.

32. Coleman, p. 129.

33. Coleman, p. 137.

34. Lévy, p. 66.

35. Lévy, p. 88.

36. Miller & Stuart, p. 1.

37. See *Wikipedia*, "Howard Dean," *Wikipedia: The Free Encyclopedia*, 29 Mar. 2007, http://en.wikipedia.org/wiki/Howard_Dean (accessed 29 Mar. 2007).

38. Jenkins, p. 210.

39. Jenkins, p. 210.

40. Shirky, n.p.

41. Michel Bauwens interviewed in Poynder, pt. 1.

42. Lévy, p. 87.

43. Jürgen Habermas, "Political Communication in Media Society: Does Democracy Still Enjoy an Epistemic Dimension? The Impact of Normative Theory on Empirical Research," *Communication Theory* 16.4 (2006), p. 422.

44. Jenkins, p. 211.

45. Coleman, p. 124.

46. Jo Bardoel and Mark Deuze, "'Network Journalism': Converging Competencies of Old and New Media Professionals," *Australian Journalism Review* 23.3 (Dec. 2001), p. 94.

47. Eric von Hippel, *Democratizing Innovation* (Cambridge, Mass.: MIT Press, 2005), p. 123.

48. Michel Bauwens interviewed in Poynder, pt. 1.

49. Rushkoff, p. 24.

50. Jenkins, p. 232.

51. Leadbeater & Miller, p. 53.

Conclusion:
Production, Produsage,
and the Future of Humanity

Throughout the course of this book, we have seen the principles of produsage applied to a variety of vastly different domains which have shared only the one common characteristic that they all dealt with information in one of its forms—information as code, information as news, information as knowledge, information as metadata, information as creative work, even information as the glue that binds together our communities and societies and enables democracy to function. This documents the versatility of produsage itself, and the breadth and depth of the impact on human knowledge and interaction it may come to have; it also points to the observation that produsage crucially relies on those technologies which can be said to have hypercharged information in recent decades, by making it accessible, shareable, networkable, remixable, and extensible: interactive, intercreative, participatory digital networking systems. As Rushkoff puts it, "the rise of interactive media does provide us with the beginnings of new metaphors for cooperation, new faith in the power of networked activity and new evidence of our ability to participate actively in the authorship of our collective destiny."[1]

At the same time, it is important not to fall into the trap of technological determinism in this context. The new informational networks which support produsage are crucial in achieving a wide-scale, equipotential access to the environments and projects of produsage, of course, but they only serve to extend their reach and speed up their processes; slower, offline, geographically more limited precursors to produsage may be found just as well in the processes of academic peer review or the exchange of folk culture and vernacular knowledge in pre-mass media environments, for example. Perhaps most importantly in the present environment, the technologies of produsage also serve to bypass the stranglehold of the industrial model on our mechanisms for creating content and exchanging information; they highlight the fact that the industrial process is neither the natural nor necessarily the most productive or socially beneficial ap-

proach imaginable. In doing so, as Jenkins points out, produsage and its technologies advance processes of convergence, and are involved in a range of crucial conflicts over the shape and balance of our future technological, industrial, economic, cultural, and social environments—these are conflicts which will ultimately determine the character of our emerging human knowledge space itself: "the key battles" in the emerging convergence culture "are being fought now. If we focus on the technology, the battle will be lost before we even begin to fight. We need to confront the social, cultural, and political protocols that surround the technology and define how it will get used."[2]

Some key observations we have made about produsage in past chapters bear repeating here, especially as we consider its role as a key overall model for alternatives to the corporate, industrial enclosure of the human knowledge space. In the examples for produsage which we have encountered, it has become very clear that produsage does not emerge out of thin air: it develops not 'from scratch,' but indeed from 'scratching that itch' felt by an individual participant or group of participants who begin to develop a first, basic, and incomplete solution to their problem. As Raymond puts it for open source, "one cannot code from the ground up in bazaar style"[3]; produsage projects must be seeded with a small kernel of ideas which are sufficiently interesting to attract a larger community of participants and kickstart their wider processes of innovation. In addition, they also rely on the granularity (or granularizability) of their problems, and the feasibility of a modular approach to developing the overall solution; we have seen these in action in open source as well as in *Wikipedia* and many other produsage contexts. Such granularity and modularity also enables the equipotentiality of produsage, as it makes it more likely that any one contributor will be able to find at least one specific aspect of the project to which they can make however small a contribution; thereby granularity also sets in train the probabilistic approach to problem-solving which relies on the diversity of a multitude of eyeballs developing and considering potential solutions to the granular problems presented by the project. If Raymond says that "the cutting edge of open-source software will belong to people who start from individual vision and brilliance, then amplify it through the effective construction of voluntary communities of interest"[4], we may state more generally that the success of produsage itself will be determined by those who can provide interesting and inspiring seed problems, break these down into specific granular tasks, and attract and motivate a wide range of contributors to engage in developing solutions which can then be collated and aggregated into an active and dynamic project and community.

It is certainly possible for conventional industry players to participate in and drive produsage projects as well—the open source cottage industry provides ample demonstration of this fact—, but only if they understand, accept, and embrace the principles of produsage itself. To operate by defending their traditional possessions and advantages will be counterproductive; "in fact, traditional power centers are exposed for what they really are: entities that survived because of an unequal distribution of in-

formation, not because of their brilliance or skill or because they did something unique with this possession."[5] Instead, commercial operators engaging in produsage will need to move beyond the producer/consumer distinction, and to learn to share their own innovations with the wider community; they will need to reconceptualize products as always incomplete, constantly evolving artefacts of the continuing produsage process, and come to focus not on a business model formulated around the sale of products, but around the provision of services both to the produsage community itself, helping it produse more efficiently, and to the wider community of the users of produsage artefacts, helping them to understand how to approach those artefacts and encouraging them to engage in produsage if and when they have ideas of their own to contribute to the community.

Turning Artefacts into Products

We may raise the question, then, to what extent produsage by communities themselves, or in collaboration with commercial entities, may be able to be applied even beyond the realms which we have encountered so far. Are there natural limits to the applicability of the produsage approach; in particular, perhaps, is it necessarily confined to the informational, intangible, digital realm, or can it be translated also to the produsage of physical products? As von Hippel points out, clearly "production and diffusion of physical products involves activities with significant economies of scale,"[6] and a direct translation of produsage to the physical realm is therefore unlikely; at the same time, however, physical products also contain an important informational layer, and Bauwens therefore suggests that

> in industrial processes, ... we could see the design phase being separated from the material production phase. I see no objection in theory or practice, for instance, why cars cannot be designed by Open Source communities, and then produced by a third party who has access to the necessary capital.[7]

Indeed, in his own work von Hippel points to a number of "user innovation communities" operating along what we could describe as produsage principles to develop a collection of information and knowledge sufficient to allow for the industrial production of physical goods. As he reminds us,

> note that physical products are information products during the design stage. In earlier days, information about an evolving design was encoded on large sheets of paper, called blueprints, that could be copied and shared. The information on blueprints could be understood and assessed by fellow designers, and could also be used by machinists to create the actual physical products represented. Today, designs for new products are commonly encoded in computer-aided design (CAD) files. These files can be created and seen as two-dimensional and three-dimensional renderings by designers.[8]

He cites the case, for example, of online kitesurfing communities sharing and collaboratively improving the designs for the aerodynamic kites they use to propel themselves through the surf; such designs are then turned into physical objects by sailmaking shops located in the vicinity of major kitesurfing beaches, and enthusiasts acting as betatesters for the kite 'blueprints' report their experiences back to the community to feed into the next round of innovative improvements. The resultant designs, having been extensively tested and developed by users acting as produsers themselves, frequently possess better aerodynamic properties than the products of the kitesurfing industry itself. In the process, too, sailmaking shops turn from a business based on product development and production to a service industry creating physical goods on demand.

Similar phenomena can be observed elsewhere, and especially in areas commonly associated with enthusiast communities and DIY practices; that early developments in the physical realm fall into such categories should not surprise us, given the emergence of informational produsage from similarly enthusiast-driven domains. Ultimately, then, even "in physical product fields, product development by users can evolve to the point of largely or totally supplanting product development—but not product manufacturing—by manufacturers."[9] This is all the more true the more service providers are emerging to take advantage of such innovative design communities; as one recent case, *Trendwatching* highlights for example the

> US-based eMachineshop.com, which lets ordinary consumers download free, easy-to-use software which they can use to design objects like car parts, door knobs, in metal or plastic. They can then get a quote, order the product online and eMachineshop will forward the design to a 'real world' machine shop for manufacturing.[10]

In the presence of such services, even Bauwens's vision of an 'open source car,' designed from the ground up by a community of knowledgeable enthusiasts, no longer appears utopian—even if the necessary 'beta-testing,' quality control, obtaining of road safety approvals, and other aspects beyond the design and manufacturing process may still constitute significant obstacles.

Similar approaches may also be feasible for scientific projects, Benkler suggests:

> the wet lab seems to present an insurmountable obstacle for a serious role for peer production in biomedical science. Nevertheless, it is not clear that it is actually any more so than it might have seemed for the development of an operating system, or a supercomputer, before these were achieved. ... Those machines that are redundantly provisioned in laboratories have downtime. That downtime coupled with a postdoctoral fellow in the lab is an experiment waiting to happen.[11]

We could even imagine the development of a scientific service industry around such processes, in analogy to the emerging engineering services industry in kitesurfing and elsewhere; here, enthusiasts would be able to rent lab time or telescope time to con-

duct their experiments and observations, and could contribute the results of such work back to the wider community of researchers. To some extent this simply replicates the way that, say, telescope time in astronomy is already distributed among a number of research teams, but it would further open out the community and its resources to a wider range of participants (and may thereby also generate the funds for the further development and maintenance of scientific research facilities).

Overall, then, because they are infused with information, even in such non-intangible, physical realms of collaborative and innovative research, design, and development, produsage may have its place. In many of its native environments, the community of produsers is already working more speedily and more effectively on the creation, sharing, and development of new information and knowledge resources than conventional producers are able to, and for such producers, their business is rapidly converting from one based on content production to one which provides services to aid the community in its produsage efforts. In physical production, the emergence of produsage models may similarly contribute to a wider shift from an industrial focus on production *per se* to one on production service provision. Certainly there *are* limits to the expansion of produsage; certain non-granular physical goods from raw materials to foodstuffs are unlikely to come under the purview of produsage itself, but as soon as significant layers of information are added to the mix, produsage becomes feasible— while foodstuffs remain produced, for example, it has always been common practice for food recipes to be shared, beta-tested, and further developed by what we can now describe as produser communities, and for respected leaders of such communities to emerge even in spite (or indeed because) of the free sharing of their knowledge with the wider community.

While in the online context, substantial shifts from informational production to informational produsage have already occurred, and have led to concomitant shifts of industry models form production to service, then, offline they will continue to be slower to materialize. As yet,

> the vast majority of manufacturers still think that product development and service development are always done by manufacturers, and that their job is always to find a need and fill it rather than to sometimes find and commercialize an innovation that lead users have already developed.[12]

Where such new opportunities are realized, however, they lead not to the disappearance of products altogether, as we have observed it in the informational realm, but to a similar, related trend: here, the core business of the new production service industries will be to convert the intangible artefacts of the ongoing produsage-based design processes taking place in the informational realm into tangible products—that is, to *produce* the artefacts of produsage.

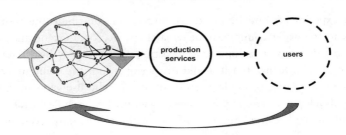

Figure 15.1: A New Produsage Services Value Chain

Turning Products into Artefacts

Beyond this application of produsage models to the development of new 'products,' giving the temporary artefacts of informational produsage a permanent physical manifestation, it is also important to explore whether a converse process of turning permanent products into a more temporary form of artefact is also possible. To some extent, this requires in the first place the addition of an informational layer of prodused product reviews, recommendations, and other related knowledge to existing products, and we can identify such processes in a growing range of what can be described as social shopping communities operating in much the same way as the communities of knowledge sharing which we have encountered in the form of *Instructables* or *Videojug*; here, however, what is shared is not information on how to complete DIY projects, but on how to assess and make the most use of commercial products. Such communities *are* produsage communities; in the first place, they are engaged in the produsage of knowledge about commercial products, but in addition to this core function, they also produse advertising and marketing for many of the products they discuss. Today, such communities exist for example in the form of *Epinions*, *Crowdstorm*, *AllConsuming*, *Stylehive*, the British site *Ciao*, or the Indian community *MouthShut*; the effect of such sites is to make potential buyers more aware of the positive as well as negative features of specific products, as well as informing those who have already purchased such products about potential other uses, about means of modifying or extending their capabilities, and about the resale potential of their possessions.

It is this latter aspect which has come to be most prominently highlighted by resale and auctioning sites such as *eBay*. As Nissanoff points out, the auctioning culture which *eBay* has helped create is

> as significant for the retail community and for the brand consumer products community as the Internet was ten years ago. The ability to control the flow of your goods and the consistency of experience attached to your brand went out the window when

people became able to buy or sell on a platform like eBay, and reach so many others. You can't ignore that.[13]

What *eBay* and other sites for the rapid sale and resale of goods of virtually any form have done is to create the potential for physical possessions to become more fluid; they "have begun to create levels of liquidity in our everyday goods." The products we own, far from fixed and permanent possessions, are now themselves turned into temporary artefacts of a continuous process of material sharing that is governed by the reciprocal exchange of goods and currency, and it is possible that "we will begin to evolve as a society of consumers and recognize that being temporary owners of the things we buy, of our possessions, becomes the more efficient way of living."[14]

We may not be produsing the goods we own *per se*, but there certainly are strong elements of produsage about this continuous sharing of (informationally enhanced) products across a community of participants in our auction culture. Perhaps what we are produsing in the process is a new decentralized and networked market, a new economic framework based on temporary ownership—what is prodused here, then, could be described as a form of networked sociality that is strongly infused with economic aspects, resulting in a probabilistic, trial-and-error economy in which we are less averse to taking risks in our purchases because we have become more aware of the opportunities available for our possessions to re-enter the market once we no longer need them. Nissanoff, for example, notes the phenomenon that,

> as eBay began to grow, people began to buy musical instruments, especially guitars, much more frequently, because they weren't as worried about taking up the wrong instrument or buying the wrong instrument and getting stuck with it.
> It's beginning to empower the consumer to reach because they can afford better items since they're not paying the whole ticket for them. They know there's going to be residual value at the end of the day and they're willing to take more chances because they know there's an exit if they made a mistake.[15]

This trial-and-error approach to market participation can also be described as a playful, gamelike approach to the economy, then: "games are nothing but invitations to be daring, and try, try, try until you find a solution and succeed."[16] It is perhaps not surprising that *eBay* and similar services have emerged as the computer game generation has grown up, then, nor that other gamelike economic activities (we also speak of playing the stockmarket, for example) have grown in popularity in recent times.

Again, the role of increased access to information about goods plays a highly important role in this context; it is only the addition of this additional layer of information to products which provides potential users with the confidence to try out new options and thereby become what *Trendwatching* describes as 'trysumers.' "Reviews on anything, anytime remove the risk of buying a lemon, and will entice TRYSUMERS to explore the Long Tail with confidence,"[17] and of course such enticement is particularly likely to succeed if it comes from sources other than the traditional channels of adver-

tising and marketing—widely seen as untrustworthy—and instead is based on recommendations and reviews provided by users for users, through the environments of social shopping and other produsage-based models. Ultimately, what is prodused here is the market itself, and as in other forms of produsage, this system is based on the **open participation** of a wide range of contributors, and the **communal evaluation** of goods for sale as well as the sellers offering them, leading to the emergence of **fluid heterarchical structures** within the market exchange community itself; market exchanges are **constantly in progress** and therefore create a complex and always evolving networked structure, which nonetheless allows trusted and meritorious participants to emerge as leaders of the community.

However, such monetized sharing models may not be the only model for a produsage-based exchange of physical goods. Bauwens suggests the potential for the creation of a new kind of 'physical commons' combining aspects of the *eBay*-driven auction or trysumer culture with the commons of informational produsage:

> we could start to make physical items freely available under Open Source licences—artworks say, or bicycles The licensed item could then be linked to a digital address so that it can be monitored, and protected from private appropriation or theft. This strategy offers a tremendous opportunity for creating a wide variety of different physical commons.[18]

This, too, would turn products, possessions, into temporary artefacts; possession would be shared, distributed, diffused across a larger number of participants rather than centralized in any one owner, and sharing of resources would be organized along equipotential lines. Indeed, as one example, the commercial Zipcar system for sharing car ownership and use which has been introduced to a number of cities in the United States, the United Kingdom, and Canada can be seen as a first step towards such a model.

Finally, in the context of economic extensions of the produsage model, we must also highlight the emergence of 'open capital' models which essentially establish a system of what we might describe as produsage-based moneylending or social banking. Services such as *Zopa* in the United Kingdom and *Prosper* in the United States have developed communities around moneylending which enable their members to pledge variable amounts of money to a communal pool from which accredited borrowers are able to receive loans, or to specific borrowers outlining their need for funds. In the process, the community itself determines its interest rates and lending conditions, and the service acts as the intermediary handling the transfer of funds and sharing the lending risk.

A similar model is in place in the microcredit system as established by Grameen Bank, the communal development bank originated in Bangladesh by 2006 Nobel Peace Prize winner Mohammad Yunus, and here focuses especially on supporting the poor:

traditional banks, reliant on professional expertise, regarded poor people seeking small loans as unprofitable. Grameen built a different model, based on Pro-Am expertise. It employs a small body of professionals who train an army of barefoot bankers. Village committees administer most of Grameen's loans. This Pro-Am workforce makes it possible to administer millions of tiny loans cost-effectively.[19]

Again, we can see elements of produsage in such models: participation is open to lenders and borrowers, and (in addition to standard credit checks) the suitability of specific borrowers is communally evaluated; all lenders gain a sense of communal ownership in their shared 'bank,' and derive individual rewards (as well as tangible interest) from their participation. Especially among Grameen's barefoot bankers and their clients, a sense of heterarchical community structures may also emerge, and the community of participants and their ownership structures remain constantly in flux.

Grameen in particular is a clear example of produsage's overall heterarchical, bottom-up approach in response to the shortcomings of the hierarchical, top-down model. Indeed, whether in reaction to the giants of the software industry, the oligarchs of the mass media, the hegemons of knowledge, the captains of the world of finance, or the local, national, and global institutions of governance from G8 to World Bank, produsage almost always highlights the existence of open, participatory, collaborative, communally driven and determined, consensus-based models of development and decision making. At the same time, it does not necessarily take an inherently oppositional stance seeking to replace existing organizations, but instead focuses in the first place on developing alternative approaches operating outside of their sphere of influence; thus,

> unlike in the 1960s, when people questioned their authorities in the hope of replacing them (revolution), today's activists are forcing us to re-evaluate the premise underlying top-down authority as an organising principle (renaissance). Bottom-up organisational models ... seem better able to address today's participatory sensibility.[20]

Produsage Futures

It becomes necessary, then, to move beyond the struggle between production and produsage, and towards the development of approaches which harness the best elements of both models. If, as von Hippel notes, "a growing body of empirical work shows that users are the first to develop many and perhaps most new industrial and consumer products,"[21] then this spells out a significant role for produsage-based approaches in this emerging new environment, and that role should also be reflected in the frameworks and incentives for innovation and development which are provided in our societies. "Standard assumptions about the competitive nature of innovation are ... undersupported in the new environment. If governments want to encourage the

maximum amount of innovation in social production, they need to de-emphasize competition and emphasize creativity and cooperation."[22] In the process, as we have already heard von Hippel put it, they would "democratize the opportunity to create."[23]

At the very least, however, it is important that government policies and legal regulations no longer work *against* the models of informational and other produsage which we have encountered in this book. Current systems of copyright and patent law, which strongly privilege existing holders of intellectual property and actually provide disincentives against the open sharing of knowledge, are no longer appropriate in an environment where innovation thrives on available knowledge; current economic models built to accommodate the processes of industrial, physical production are increasingly out of step with the informational, networked, knowledge economy. In the first place, then, Leadbeater and Miller suggest that "the main goal of public policy should be relatively modest: to avoid policy interventions that might stifle the growth in Pro-Am activity. Powerful social and economic trends are likely to promote Pro-Am culture, without government intervention."[24] This requires as much trust in the self-righting, evolutionary processes of produsage among governments and other administrators as it does among the contributors to produsage projects themselves—but as produsage successes accumulate, such trust may be increasingly easier to develop and maintain.

Perhaps the most crucial realization for governments and policymakers will be that administrative interventions will be significantly more difficult in the heterarchical community spaces of produsage than they have been in the hierarchical organizations of production. Supported by their communities of peers, informed by the spaces of citizen journalism and collaborative knowledge sharing, the population of produsers is no longer highly susceptible to media spin or other forms of the engineering of public opinion; instead, these new

> hyperpeople are compelled toward authenticity, because the authentic is the only ground for understanding. Any deceit, any guile will only fetter the progress of this new human endeavor. We will lose our ignorance—that will come as a shock to some, and as a welcome release to others.[25]

As it spreads further throughout society, then, produsage will fundamentally affect our structures of social organization, as we have already seen in the previous chapters. Society will reduce its reliance on hierarchical, top-down forms of social organization, and come to rely on more *ad hoc*, heterarchical, networked, and decentralized structures. "The twentieth century was shaped by large hierarchical organisations with professionals at the top. Pro-Ams are creating new, distributed organisational models that will be innovative, adaptive and low-cost."[26]

Is it possible, then, to identify an endpoint for the developments set in train by the shift from production to produsage? If produsage constitutes "nothing else than a premise of a new type of civilization that is not exclusively geared towards the profit motive,"[27] what will be the shape of that new civilization; what will define the new

state of equilibrium which we will reach once the current process of rebalancing is complete? Will there *be* a new equilibrium, indeed, or are we likely to experience significant swings between top-down political, legal, and commercial control and bottom-up reorganization and redistribution?

Today, through the workings of produsage across a number of previously well-controlled domains,

> we have witnessed together the wizard behind the curtain. We can all see, for this moment anyway, how so very much of what we have perceived of as reality is, in fact, merely social construction. More importantly, we have gained the ability to enact such wizardry ourselves.[28]

However, our ability to act is under challenge from the incumbents in the areas now most affected by produsage, who are either attempting to regain their power bases or at least hope to prevent further slippage towards the community-driven alternative model. Any missteps by proponents of this model (which are likely to occur given its probabilistic, trial-and-error approaches), from errors in open source code through misinformation and misadministration in the *Wikipedia* to the systematic infringements against existing copyright regulations in filesharing, are likely to be utilized by the defenders of conventional orthodoxies as arguments in favor of abandoning and undermining produsage models altogether, even despite their demonstrated benefits to the individual and to society overall. As Toffler notes, then, to protect the still-fragile spaces of experimentation with new models, "the application of the imagination to the future ... requires an environment in which it is safe to err, in which novel juxtapositions of ideas can be freely expressed before being critically sifted. We need sanctuaries for social imagination."[29] If such sanctuaries can be established and protected, it is unlikely and unnecessary that innovation in such spaces will reach a stable endpoint, just as much as it is unlikely for any one specific produsage project to end up with a 'final product.'

Instead, a feasible model for the wider structure of the emerging knowledge environment could be constituted by a flexible, continually shifting constellation of commercially provided spaces and platforms for produsage (ranging from generic communication platforms such as the Internet itself to specific technological spaces such as the wiki environments offered by for-profit *Wikipedia* offshoot *Wikia*) and community-run and communally owned projects for the produsage of information, knowledge, and creative content. Such a model would break through the dichotomy pitting proprietary, market-based industrial production against non-proprietary, non-market community produsage, and instead of envisioning two parallel economies allow for a recombination and interweaving of the two; it would place production and produsage at the opposite ends of a common continuum of content development models which would also include the 'Pro-Am,' producer/produser hybrid approach near the center of that sliding scale. Indeed, of course, even within the produsage

realm itself we can identify a range of subtly different approaches which are distinguished for example by their degree of openness, their degree of centralization, and their balance between heterarchical fluidity and hierarchical fixity; the same is true also for models on the production side.[30] Therefore, a producer-produser continuum would reconnect the two internal continua by introducing various additional hybrid models combining aspects from either camp.

In connecting to the produser continuum, then, producers must be prepared for the produsage model to have the potential to unsettle their conventional practices. Leadbeater and Miller describe this as a form of disruptive innovation, and such "disruptive innovation changes the way an industry operates by creating new ways of doing business, often by making products and services much cheaper or by creating entirely new products. Disruptive innovation often starts in marginal, experimental markets rather than mainstream mass markets,"[31] but it may extend significantly beyond the marginal and provide new mainstream content, ideas, and innovations as well as lead to the discovery of new leaders for the industry. Again, in harnessing produsage in this way, producers connect to the heterarchies of produsage and position themselves as mere tips of the produsage iceberg; in doing so, they are able to offer pathways to more permanent leadership roles for the most meritorious participants in the community of produsers.

As we have seen, this profoundly shifts the balance between experts and non-experts, between professionals and amateurs. Far from serving merely as a disruption, however, such shifting can also lead to the identification of new ideas and solutions; a hybrid approach combining expert knowledge within the professional community with practitioner experience among produsers may therefore be more successful than either approach in isolation. "Professionals create a distribution bottleneck. That is why many of the most imaginative social innovations in the developing world employ Pro-Am forms of organisation."[32]

Any move beyond the professional enclosure of information and knowledge practices is also likely to have profound impact beyond the narrow field of economic practices itself; the rise of produsage also heralds the potential for a new participatory culture, for new structures of social interaction and organization. Participation in produsage environments, whichever form they may take, therefore can be seen to help build the capacities for active forms of cultural and democratic citizenship; we can see examples in the way that citizen journalism increases the active deliberation of political topics, in how *Wikipedia* encourages us to question our representations of knowledge and to engage with alternative points of view, even in how the residents of *Second Life* are beginning to shape their own structures of local government under a federalist model. Through such actions, individuals are "making the culture they occupy more their own than was possible with mass-media culture. ... We can say that culture is becoming more democratic: self-reflective and participatory."[33] Indeed, we can see this as a gradual process that involves citizens realizing that the equipotentiality they have

been awarded in specific environments of produsage also applies (or should apply) more widely across society; this change

> is represented in the experience of being a potential speaker, as opposed to simply a listener and voter. It relates to the self-perception of individuals in society and the culture of participation they can adopt. The easy possibility of communicating effectively into the public sphere allows individuals to reorient themselves from passive readers and listeners to potential speakers and participants in a conversation.[34]

What is able to emerge in place and in the midst of conventional, commercial, mediated culture instead is a new form of folk or vernacular culture driven by produsers for produsers: "a practice that has been largely suppressed in the industrial era of cultural production ... where many more of us participate actively in making cultural moves and finding meaning in the world around us."[35] Such folk cultural practices are different from those of the preindustrial past, however, as they operate within communities defined predominantly by shared tastes and interests, not by the accidents of shared geography or ethnicity; it is a folk culture which is globally distributed but 'locally' specific in the sense of being based in very strong communities of participants congregating and collaborating in shared online spaces regardless of where in the world their physical bodies may reside. "The new knowledge culture has arisen as our ties to older forms of social community are breaking down, our rooting in physical geography is diminished, our bonds to the extended and even the nuclear family are disintegrating, and our allegiances to nation-states are being redefined,"[36] but its own bonds may be all the stronger for its basis in shared tastes, interests, values, and beliefs. In addition, of course, it also does interact with existing folk and commercial cultures in the physical world, often providing them with new impulses for their own practices; it acts as a force of innovation and inspiration for such cultures just as much as produsage-based practices may act as an inspiration for conventional commercial production models.

Together, groups of produsers animate a new form of collective intelligence, as we have seen, but they are in themselves not collectivist; they are driven not by groupthink or even majority rule, but by continuous processes of internal, communal deliberation, and evaluation which allow the best ideas and the most valued community members to emerge. "The new commons is not a unified and transcendent collective individual, but a collection of large number of singular projects, constituting a multitude."[37] This multitude of opt-in commonses, each with their own fiercely loyal and committed communities, yet always open to new participants if these newcomers are prepared to accept the social norms of the community and contribute to the common project, together recreate society as a patchwork of overlapping interest groups and issue publics, as we have seen; they operate by building social capital,

> networks of relationships that allow people to collaborate, share ideas and take risks together. Social capital can help glue a society together and allow people to trust one

another more easily, thus helping them to adjust to change collaboratively and share risks.[38]

Produsing the Global Renaissance

The arrival and gradual embrace of produsage clearly has the potential to significantly reshape our existing cultural, commercial, social, and political institutions. Such changes are unlikely to proceed without conflict, however, as they subvert and in doing so reconfigure existing power relations within society, and as the new power structures, although based in a networked heterarchy which will be more difficult to subjugate, are not entirely safe from being misused, either. To prepare for such possible conflict, we must continue to "furiously build the commons," as Bauwens has put it[39]; in particular, perhaps, it is important to extend the commons to those who have as yet struggled to access it. At present, access to produsage remains available mainly to the affluent and well-educated—to those who have the resources, the time, and the inclination to participate. What is necessary now is to ensure that a wider section of society begins to participate; this is clearly important for fields such as citizen journalism and encyclopedic practice, which share information and represent knowledge of direct use and importance for citizens, but just as much for fields of creative work and productive play which engage in the creation of a shared culture and sociality, and prepare citizens to be better and more active participants in and critics of cultural and social forms of engagement. "The practices of nonmarket information production, individually free creation, and cooperative peer production must become more than fringe practices. They must become a part of life for substantial portions of the networked population,"[40] and of society as such.

A common knowledge space which can grow its base in this way is likely to be increasingly robust and resilient against outside attempts to undermine it, indeed, and it is likely that it will begin to exhibit self-reinforcing tendencies once broad critical mass is reached; this may already have happened in specific areas of the wider knowledge space (for example in some open source communities, several citizen journalism sites, and the *Wikipedia*). Indeed, the share-alike content license clauses themselves also help the knowledge space to become more resilient and self-perpetuating, as we have seen: because they stipulate that derivations of the open content available in the commons must be shared again under similar open licenses, "peer property spreads in a viral fashion, in a process that we call the 'circulation of the common.' This is a new phenomenon, and it operates in parallel with the 'circulation of commodities' process of the traditional market system."[41] Similarly, some sectors of the knowledge space have made it increasingly easy, even inevitable, for users to become co-produsers of the space, even without their knowledge or intent; here, "even passive use becomes useful

participation for the system as a whole. ... One of the key elements in the success of P2P projects, and the key to overcoming any 'free rider' problem, is therefore to develop technologies of 'Participation Capture.'"[42] Although it is necessary from an ethical point of view to better inform participants that they do become participants in produsage through their use, and to retain their ability to opt out from such automatic commons, such systems nonetheless vastly multiply the potential of the produsage model by aggregating usage and produsage and thereby increasing their ability to reach critical mass quickly and reliably.

If, as Benkler suggests, the current "heightened activity is, in fact, a battle, in the domain of law and policy, over the shape of the social settlement that will emerge around the digital computation and communications revolution,"[43] then there is good reason to hope that produsage can establish the critical mass in both enthusiasts and enthusiasm to prevail against incumbent political and commercial forces seeking to stifle and contain its development. Produsage, as a diffuse, decentralized, networked, and fundamentally demotic movement may be delayed in its development and its shifting of the balance between the industrial and the postindustrial model of content creation, but it is unlikely to be derailed altogether; indeed, its development so far has shown that the stronger the resistance from incumbents, the stronger the desire by produsers to establish their model as a clear and credible alternative. The growing range of hybrid models moving beyond a dichotomic adversarial stance also serves to soften the resistance of adherents of the old model, of course, as some of their own begin to experiment with embracing the produsage approach at least in part. As always, the software industry may already provide the best indication of further developments across all fields of produsage:

> free software is responsible for some of the most basic and widely used innovations and utilities on the Internet today. Software more generally is heavily populated by service firms that do not functionally rely on exclusive rights, copyrights, or patents. Neither free software nor service-based software development need patents, and both, particularly free and open-source software, stand to be stifled significantly by widespread software patenting.[44]

On the one hand, then, produsage can be understood as a model whose time has come; this equipotential, collaborative, networked approach to content creation "is as rational and efficient given the objectives and material conditions of information production at the turn of the twenty-first century as the assembly line was for the conditions at the turn of the twentieth."[45]

At the same time, produsage in general and Pro-Am activity in particular also reconnect with older models of folk culture and DIY production which had been in place well before the industrial revolution, and had been sidelined by the rise of mass media and mass culture which the industrial model also promoted; in this sense, then, produsage is also a model whose time has come *again*—it contributes in a very direct

way to the rebirth, the renaissance, of older practices in a new, networked context. Thus, "with more Pro-Ams in a society there will be more innovation, deeper social capital and healthier democracy,"[46] but any uneven distribution of participation in produsage then becomes an even more significant problem; "the digital divide is giving way to concern about the participation gap,"[47] and this applies both within any one society itself, as well as on a global level. This, then, lends even more urgency to calls to focus more strongly in formal and informal education on building student literacies in new technologies, and on developing their C5C capacities as we have described them in Chapter 13. Any society which fails to do so is likely to experience an ever deeper rift between produsers and consumers, between those who participate actively in the creation of their own culture, and those who are able only to passively consume it; thus, "we may also see the current struggle over literacy as having the effect of determining who has the right to participate in our culture and on what terms."[48]

But beyond any one society, too, participation in produsage must be further fostered. In the process, on the one hand it is important to explore different approaches to participation in produsage as they may be necessary to address different cultural sensibilities; on the other hand, however, it is also necessary to encourage greater collaboration across national and cultural boundaries to facilitate a greater cross-cultural understanding and cooperation—the cross-cultural exchanges that can now be observed in many produsage environments from citizen journalism to *Wikipedia* to *Second Life* already point to the great potential for engagement in produsage to foster better international understanding without leading to a homogenization of cultural specificities. Again, questions of access and participation emerge here, too: entire nations and cultures in the developing world still remain left out of produsage environments at present (or indeed, remain poorly connected to the overall global information network), and in the process continue to be confined to industrially, proprietarily controlled forms of culture, information, and knowledge only.

This is all the more problematic as it is especially these developing nations which have the most to gain from participating in produsage processes; by doing so, they are able to ward off at least in part the corporate enclosure and exploitation which today threatens them. If "the manner in which we produce new information—and equally important, the institutional framework we use to manage the stock of existing information and knowledge around the world—can have significant impact on human development,"[49] it does so in the first place by determining the rights and cost of access to such information; a creative commons, an information commons, a knowledge commons, an innovation commons significantly lower the costs of access and participation for the citizens of developing nations, and thereby enable them to assume their rightful place in the shared knowledge space of humanity, while at the same time also allowing them to retain the potential to derive substantial cultural, economic, and social gains from their participation.

In the present industrially driven environment, "intellectual property is particularly harmful to net information importers. In our present world trade system, these are the poor and middle-income nations,"[50] whose development is stifled by the prevailing copyright and patent thickets and the prohibitive tariffs for participation which such thickets enable their owners to impose. Produsage on a global scale, on the other hand, not only proceeds from the assumption of individual equipotentiality, but thereby also supports the equipotentiality of nations as participants in global information, knowledge, and economic exchange; it allows all citizens, all communities, and all nations to share and participate equally in the development and exchange of culture, information, and knowledge, and thereby builds a common knowledge space upon whose content economic activity within and across nations can also be founded, without a need for continued payments to the holders of conventional intellectual property. (The enthusiastic embrace of open source software by many developing nations is not surprising, therefore.)

For the same reasons, then, those governments and nations which choose to disconnect themselves and their citizens from the global knowledge space are ill-advised to do so, and must in the longer term learn to develop approaches other than simplistic forms of information censorship. The Chinese government's ambivalent stance towards *Wikipedia* serves as a useful example in this context; as *Wikipedia* founder Jimmy Wales states,

> it's a huge embarrassment for the censors if they block Wikipedia, because we are none of the things that they claim to want to censor. Censoring Wikipedia is an admission that it is unbiased factual information itself that frightens you. We are not political propaganda, we are not online gambling, we are not pr0n. We are an encyclopedia.[51]

Indeed, to restrict users' access to *Wikipedia* is also counterproductive for another reason: not only does it disable domestic Chinese users from accessing the encyclopedia, but it also prevents them from actively participating in the resource; both in the English and Chinese versions of *Wikipedia*, topics deemed to be sensitive to Chinese government interests (from Tibet to Falun Gong, from Tian'anmen Square to democratic reform) are therefore likely to be portrayed largely from the perspective of Chinese and international participants residing outside of the country, thereby further working against government interests. This further documents a phenomenon which we have observed in a variety of contexts already: once the produsage-based knowledge space reaches a substantial size, to withdraw one's content or participation from it has strongly negative effects for the currency of that content, and the status of the participant.

Overall, then, the environments of produsage individually and in concert provide an open access commons and build a knowledge space which may offer greater opportunities for economic and social development to developing nations than do the cir-

cuits of the conventional, industrial model of knowledge exchange. In doing so, they remove barriers to access and level the playing field for participation, and enable the emergence of such developing nations as equal or at least equipotential participants in the shared environments of produsage; they remove the tendency for such less privileged participants to be marginalized or sidelined from the overall process through explicit interventions or implicit bias.

Indeed, produsage-based approaches which do not inherently privilege specific points of view or traditional approaches to problem-solving may also provide new impulses to dealing with the fundamental issues now facing the world; the collective intelligence on which produsage is based and for whose operations it serves as a key example is better able through its broad-based, probabilistic, and heterarchical processes to allow innovative ideas to emerge from its community of participants. By contrast,

> bureaucratic hierarchies ... , media monarchies ... , and international economic networks ... can only partially mobilize and coordinate the intelligence, experience, skills, wisdom, and imagination of humanity. For this reason the development of new ways of thinking and negotiating engendered by the growth of genuine forms of *collective intelligence* becomes particularly urgent.[52]

Commentators such as Lévy, Pesce, and Rushkoff, indeed, see the development of such broad-based, collective, networked, and participatory approaches to developing solutions as heralding our entry into a new era of humanity; as Pesce points out, for example,

> the individual can do much; the individual in an organization or institution can do even more, but the individuals in a hyperconnected community, those individuals can change the world. When you multiply hyperintelligence with the understanding gathered in a hyperconnected community, you have the real force of the 21st century; not bombs, not ideology, but hyperpeople.[53]

The development of such a hyperpeople is anything but ensured at present, however, even if produsage processes contribute significantly to their emergence; the incumbent institutions of the industrial age still hold considerable power and are likely to continue to hold on to that power for as long as they can. Thus, Lévy notes the alternative now faced by humanity:

> either we cross a new threshold, enter a new stage of hominization, by inventing some human attribute that is as essential as language but operates at a much higher level, or we continue to 'communicate' through the media and think within the context of separate institutions, which contribute to the suffocation and division of intelligence. In the latter case we will no longer be confronted only by problems of power and survival. But if we are committed to the process of collective intelligence, we will gradually create the technologies, sign systems, forms of social organization and regulation that enable us to think as a group, concentrate our intellectual and spiritual forces,

and negotiate practical real-time solutions to the complex problems we must inevitably confront.[54]

The move towards a hyperpeople, towards a collective intelligence, also depends crucially on the wide deployment of the technologies, tools, literacies, and capacities for produsage which enable as large a section of humanity to participate in the networked and distributed processes of collective intelligence as is possible; such developments contribute to the further building of cyberspace, to the building of the information commons, the innovation commons, the cosmopedic human knowledge space itself. "The development of cyberspace, the quintessential medium of communication and thought, is one of the principal aesthetic and political challenges of the coming century,"[55] and it must proceed along the lines spelt out by the fundamental principles of produsage as we have outlined and explored them in this book.

Such developments will necessarily create significant upheaval and uncertainty, not only among the incumbents of the traditional proprietary informational spaces of the industrial economy, but also among the builders of this new knowledge space as they explore and experiment with its structures, its processes, and its protocols, and as they pass on their understandings to the newcomers who are continuously joining this global effort. Even if "we are already well on the way to becoming hyperpeople,"[56] we are likely to live in a continuing state of future shock for some time to come, "the dizzying disorientation brought on by the premature arrival of the future" that Toffler foresaw[57]—but these are the necessary birthing pains of the renaissance of folk culture and folk tradition, of human knowledge and human cooperation, of a global system for the produsage, sharing, exchange, and evolution of culture, information, and knowledge.

As *Wikipedia* founder Jimmy Wales puts it, "imagine a world in which every single person on the planet is given free access to the sum of all human knowledge. That's what we're doing."[58] The individual inhabitants of the spaces of produsage from open source to the blogosphere to *Second Life* may not be fully aware of their engagement in this process, but their participation in the development of this global knowledge space of humanity, this vehicle for the collation, circulation, and communication of collective intelligence, may be the most important contribution to global development and international welfare—to the human commons of culture, information, and knowledge—which they are ever likely to make.

However, realizing such ambitions requires a level of participation in produsage well beyond even what *Wikipedia* has been able to generate thus far. So—*let's get started*.

NOTES

1. Douglas Rushkoff, *Open Source Democracy: How Online Communication Is Changing Offline Politics* (London: Demos, 2003), http://www.demos.co.uk/publications/opensourcedemocracy2 (accessed 12 July 2007), p. 18.

2. Henry Jenkins, *Convergence Culture: Where Old and New Media Collide* (New York: NYU Press, 2006), p. 212.

3. Eric S. Raymond, "The Cathedral and the Bazaar," 2000, http://www.catb.org/~esr/writings/cathedral-bazaar/cathedral-bazaar/index.html (accessed 16 Mar. 2007), n.p.

4. Raymond, n.p.

5. *Trendwatching.com*, "Infolust: Forget Information Overload, Consumers Are More Infolusty than Ever!" 2006, http://www.trendwatching.com/trends/infolust.htm (accessed 19 Feb. 2007), n.p.

6. Eric von Hippel, *Democratizing Innovation* (Cambridge, Mass.: MIT Press, 2005), p. 126.

7. Michel Bauwens interviewed in Richard Poynder, "P2P: A Blueprint for the Future?" *Open and Shut?* 3 Sep. 2006, http://poynder.blogspot.com/2006/09/p2p-blueprint-for-future.html (accessed 1 Mar. 2007), pt. 2.

8. Von Hippel, p. 104.

9. Von Hippel, p. 14.

10. *Trendwatching.com*, "Minipreneurs," 2006, http://www.trendwatching.com/trends/MINIPRENEURS.htm (accessed 19 Feb. 2007), n.p.

11. Yochai Benkler, *The Wealth of Networks: How Social Production Transforms Markets and Freedom* (New Haven, Conn.: Yale University Press, 2006), p. 352.

12. Von Hippel, p. 15.

13. Daniel Nissanoff interviewed in Tom Peters, "Daniel Nissanoff," *TomPeters.com*, 2007, http://www.tompeters.com/cool_friends/content.php?note=008780.php (accessed 17 Feb 2007), n.p.

14. Daniel Nissanoff interviewed in Tom Peters, n.p.

15. Daniel Nissanoff interviewed in Tom Peters, n.p.

16. *Trendwatching.com*, "Top 5 Consumer Trends for 2007," 2007, http://www.trendwatching.com/trends/2007top5.htm (accessed 17 Feb. 2007), n.p.

17. *Trendwatching.com*, "Top 5 Consumer Trends for 2007," n.p.

18. Michel Bauwens interviewed in Poynder, pt. 2.

19. Leadbeater & Miller, p. 12.

20. Rushkoff, p. 58.

21. Von Hippel, p. 2.

22. John Quiggin, "Blogs, Wikis, and Creative Innovation," *International Journal of Cultural Studies* 9.4 (2006), p. 494.

23. Von Hippel, p. 123.

24. Leadbeater & Miller, p. 57.

25. Mark Pesce, "Hyperintelligence," *Hyperpeople: What Happens after We're All Connected?* 2 June 2006, http://blog.futurestreetconsulting.com/?p=17 (accessed 23 Feb. 2007), n.p.

26. Leadbeater & Miller, p. 12.

27. Michel Bauwens, "Peer to Peer and Human Evolution," *Integral Visioning*, 15 June 2005, http://integralvisioning.org/article.php?story=p2ptheory1 (accessed 1 Mar. 2007), p. 1.

28. Rushkoff, p. 39.

29. Alvin Toffler, *Future Shock* (New York: Random House, 1970), p. 411.

30. See, e.g., Axel Bruns, *Gatewatching: Collaborative Online News Production* (New York: Peter Lang, 2005).

31. Leadbeater & Miller, p. 52.

32. Leadbeater & Miller, p. 11.

33. Benkler, p. 15.

34. Benkler, p. 213.

35. Jenkins, p. 15.

36. Jenkins, p. 27.

37. Bauwens, p. 3.

38. Leadbeater & Miller, p. 49.

39. Bauwens, p. 3.

40. Benkler, p. 385.

41. Michel Bauwens interviewed in Poynder, pt. 1.

42. Bauwens, p. 2.

43. Benkler, p. 386.

44. Benkler, p. 438.

45. Benkler, p. 463.

46. Leadbeater & Miller, p. 49.

47. Jenkins, p. 23.

48. Jenkins, p. 171.

49. Benkler, p. 310.

50. Benkler, p. 318.

51. Qtd. in Robin Miller, "Wikipedia Founder Jimmy Wales Responds," *Slashdot: News for Nerds, Stuff That Matters*, 28 July 2004, http://interviews.slashdot.org/article.pl?sid=04/07/28/1351230 (accessed 27 Feb. 2007), n.p.

52. Lévy, p. xxiv.

53. Pesce, n.p.

54. Lévy, p. xxvii.

55. Lévy, p. 119.

56. Pesce, n.p.

57. Toffler, *Future Shock*, p. 13.

58. Qtd. in Robin Miller, "Wikipedia Founder Jimmy Wales Responds," *Slashdot: News for Nerds, Stuff That Matters*, 28 July 2004, http://interviews.slashdot.org/article.pl?sid=04/07/28/1351230 (accessed 27 Feb. 2007), n.p.

Bibliography

Anderson, Benedict, *Imagined Communities*, rev. ed. (London: Verso, 1991).

Anderson, Chris, "The Long Tail," *Wired* 12.10 (Oct. 2004), http://www.wired.com/wired/archive/12.10/tail.html (accessed 20 Feb. 2007).

——, *The Long Tail: Why the Future of Business Is Selling Less of More* (New York: Hyperion, 2006).

Anderson, Rob, Robert Dardenne, and George M. Killenberg, "The American Newspaper as the Public Conversational Commons." In Jay Black (ed.), *Mixed News: The Public/Civic/Communitarian Journalism Debate* (Mahwah, N.J.: Lawrence Erlbaum, 1997), pp. 96–115.

Banks, John A. L., "Negotiating Participatory Culture in the New Media Environment: Auran and the Trainz Online Community—An (Im)possible Relation," *MelbourneDAC 2003 Proceedings*, http://hypertext.rmit.edu.au/dac/papers/Banks.pdf (accessed 12 July 2007), 8–17.

——, "Opening the Production Pipeline: Unruly Creators," *Proceedings of DiGRA 2005 Conference: Changing Views—Worlds in Play*, http://www.digra.org/dl/db/06276.19386.pdf (accessed 12 July 2007).

Bardoel, Jo, and Mark Deuze, "'Network Journalism': Converging Competencies of Old and New Media Professionals," *Australian Journalism Review* 23.3 (Dec. 2001), 91–103.

Bauwens, Michel, "Peer to Peer and Human Evolution," *Integral Visioning*, 15 June 2005, http://integralvisioning.org/article.php?story=p2ptheory1 (accessed 1 Mar. 2007).

Benkler, Yochai, *The Wealth of Networks: How Social Production Transforms Markets and Freedom* (New Haven, Conn.: Yale University Press, 2006).

Tim Berners-Lee, *Weaving the Web* (London: Orion Business Books, 1999).

Biever, Celeste, "Sales in Virtual Goods Top $100 Million," *NewScientist*, 29 Oct. 2004, http://www.newscientist.com/article.ns?id=dn6601 (accessed 12 July 2007).

Bruce Bimber, Andrew J. Flanagin, and Cynthia Stohl, "Reconceptualizing Collective Action in the Contemporary Media Environment," *Communication Theory* 15.4 (2005).

Boczkowski, Pablo J., "Redefining the News Online," *Online Journalism Review*, http://ojr.org/ojr/workplace/1075928349.php (accessed 24 Feb. 2004).

Bowman, Shane, and Chris Willis, *We Media: How Audiences Are Shaping the Future of News and Information* (Reston, Va.: The Media Center at the American Press Institute, 2003), http://www.hypergene.net/wemedia/download/we_media.pdf (accessed 21 May 2004).

boyd, danah, "Academia and Wikipedia," *Many 2 Many: A Group Weblog on Social Software*, 4 Jan. 2005, http://many.corante.com/archives/2005/01/04/academia_and_wikipedia.php (accessed 25 Feb. 2007).

——, "Issues of Culture in Ethnoclassification/Folksonomy," *Many 2 Many: A Group Weblog on Social Software*, 28 Jan. 2005, http://many.corante.com/archives/2005/01/28/issues_of_culture_in_ethnoclassificationfolksonomy.php (accessed 25 Feb. 2007).

——, "On a Vetted Wikipedia, Reflexivity and Investment in Quality (a.k.a. More Responses to Clay)," *Many 2 Many: A Group Weblog on Social Software*, 8 Jan. 2005, http://many.corante.com/archives/2005/01/08/on_a_vetted_wikipedia_reflexivity_and_investment_in_quality_aka_more_responses_to_clay.php (accessed 25 Feb. 2007).

Bruns, Axel, "Beyond Difference: Reconfiguring Education for the User-Led Age," paper presented at *ICE 3 (Ideas, Cyberspace, Education)* conference at Ross Priory, Loch Lomond, Scotland, 21–23 Mar. 2007, http://snurb.info/files/Beyond%20Difference%20(ICE%203%202007).pdf (accessed 12 July 2007).

——, *Gatewatching: Collaborative Online News Production* (New York: Peter Lang, 2005).

——, "The Practice of News Blogging." In Axel Bruns and Joanne Jacobs (eds.), *Uses of Blogs* (New York: Peter Lang, 2006).

——, "Produsage, Generation C, and Their Effects on the Democratic Process," paper presented at *MiT 5 (Media in Transition)* conference, MIT, Boston, USA, 27–29 Apr. 2007, http://snurb.info/files/Produsage,%20Generation%20C,%20and%20Their%20Effects%20on%20the%20Democratic%20Process.pdf (accessed 12 July 2007).

——, "Produsage: Towards a Broader Framework for User-Led Content Creation," paper presented at *Creativity & Cognition* conference, Washington D.C., USA, 13–15 June 2007, http://snurb.info/files/Produsage%20(Creativity%20and%20Cognition%202007).pdf (accessed 12 July 2007).

Bruns, Axel, and Joanne Jacobs, eds., *Uses of Blogs* (New York: Peter Lang, 2006).

Bruns, Axel, and Sal Humphreys, "Wikis in Teaching and Assessment: The M/Cyclopedia Project," *Proceedings of the 2005 International Symposium on Wikis*, San Diego, 17–18 Oct. 2005, http://www.wikisym.org/ws2005/proceedings/paper-03.pdf (accessed 12 July 2007).

Bruns, Axel, Rachel Cobcroft, Jude Smith, and Stephen Towers, "Mobile Learning Technologies and the Move towards 'User-Led Education'," paper presented at *Mobile Media 2007* conference, Sydney, Australia, 2–4 July 2007, http://snurb.info/files/Mobile%20Learning%20Technologies.pdf (accessed 12 July 2007).

Burgess, Jean, "Vernacular Creativity and New Media," PhD Thesis, Queensland University of Technology, 2007.

Butt, Danny, and Axel Bruns, "Digital Rights Management and Music in Australasia," *Media & Arts Law Review* 10.4 (2005), 265–278.

Calvert, Tom, and Paul Stacey, "Learning for an e-Connected World." In Stephen Coleman (ed.), *The e-Connected World: Risks and Opportunities.* (Montreal: McGill-Queen's University Press, 2003).

Castronova, Edward, "Virtual Worlds: A First-Hand Account of Market and Society on the Cyberian Frontier," *The Gruter Institute Working Papers on Law, Economics, and Evolutionary Biology* 2.1 (2001).

Chan, Anita J., "Collaborative News Networks: Distributed Editing, Collective Action, and the Construction of Online News on Slashdot.org," MSc thesis, MIT, 2002, http://web.mit.edu/anita1/www/thesis/Index.html (accessed 12 July 2003).

Charman, Suw, "Listen to the Flip Side," *Guardian Unlimited Online*, 22 July 2004, http://www.guardian.co.uk/online/story/0,3605,1265840,00.html/ (accessed 20 Nov. 2004).

Choi, Jaz Hee-jeong, "Living in Cyworld: Contextualizing Cy-Ties in South Korea." In Axel Bruns and Joanne Jacobs (eds.), Uses of Blogs (New York: Peter Lang, 2006), pp. 173–186.

"Civic Center," Second Opinion: A Newsletter for the Friends and Residents of Second Life, 2 Dec. 2006, http://secondlife.com/newsletter/2006_12/html/civiccenter.html (accessed 22 May 2007).

Coar, Ken, "The Open Source Definition," Open Source Initiative, 7 July 2006, http://opensource.org/docs/osd (accessed 12 July 2007).

Coates, Tom, "My Working Definition of Social Software…," Plasticbag.org, 8 May 2003, http://www.plasticbag.org/archives/2003/05/my_working_definition_of_social_software (accessed 25 Feb. 2007).

Coleman, Stephen, "Democracy in an e-Connected World." In Stephen Coleman (ed.), The e-Connected World: Risks and Opportunities (Montreal: McGill-Queen's University Press, 2003), pp. 123–138.

——, "Introduction." In Stephen Coleman (ed.), The e-Connected World: Risks and Opportunities (Montreal: McGill-Queen's University Press, 2003), pp. 1–8.

Debray, Régis, "The Book as Symbolic Object." In Geoffrey Nunberg (ed.), The Future of the Book (Berkeley: University of California Press, 1996), pp. 139–151.

Deuze, Mark, Axel Bruns, and Christoph Neuberger, "Preparing for an Age of Participatory News," Journalism Practice 1.3 (2007), 322–338.

Doctorow, Cory, "On 'Digital Maoism: The Hazards of the New Online Collectivism' by Jaron Lanier," Edge: The Reality Club, 2006, http://www.edge.org/discourse/digital_maoism.html (accessed 28 Feb. 2007).

Elliott, Mark, "Stigmergic Collaboration: The Evolution of Group Work," M/C Journal 9.2 (May 2006), http://journal.media-culture.org.au/0605/03-elliott.php (accessed 27 Feb. 2007).

Fragoso, Suely, "WTF a Crazy Brazilian Invasion." In Fay Sudweeks, Herbert Hrachovec, and Charles Ess (eds.), Proceedings: Cultural Attitudes towards Communication and Technology 2006 (Perth, WA: Murdoch University, 2006), pp. 255–275.

Gans, Herbert J., Deciding What's News: A Study of CBS Evening News, NBC Nightly News, Newsweek, and Time (New York: Vintage, 1980).

Giles, Jim, "Internet Encyclopaedias Go Head to Head," Nature 438.900-901 (15 Dec. 2005), http://www.nature.com/nature/journal/v438/n7070/full/438900a.html (accessed 25 Jan. 2007).

Gillmor, Dan, "Moving toward Participatory Journalism," Nieman Reports (fall 2003), 79–80.

Goetz, Thomas, "Open Source Everywhere," Wired 11.11 (Nov. 2003), http://www.wired.com/wired/archive/11.11/opensource_pr.html (accessed 1 Oct. 2004).

Golder Scott A., and Bernardo A. Huberman, "The Structure of Collaborative Tagging Systems," Information Dynamics Lab, HP Labs, 2005, http://arxiv.org/ftp/cs/papers/0508/0508082.pdf (accessed 21 Sep. 2007).

Grudin, Jonathan, "Computer-Supported Cooperative Work: History and Focus," Computer 27.5 (May 1994), pp. 19–26, http://research.microsoft.com/research/coet/grudin/papers/ieeecomputer1994.pdf (accessed 21 Sep. 2007).

Habermas, Jürgen, "Political Communication in Media Society: Does Democracy Still Enjoy an Epistemic Dimension? The Impact of Normative Theory on Empirical Research," *Communication Theory* 16.4 (2006), 411–426.

Hartley, John, ed., *Creative Industries* (Malden, Mass.: Blackwell, 2005).

Heikkilä Heikki, and Risto Kunelius, "Access, Dialogue, Deliberation: Experimenting with Three Concepts of Journalism Criticism," *The International Media and Democracy Project*, 17 July 2002, http://www.imdp.org/artman/publish/article_27.shtml (accessed 12 July 2007).

Herz, JC, "Harnessing the Hive." In John Hartley (ed.), *Creative Industries* (Malden, Mass.: Blackwell, 2005), pp. 327–341.

Hyde, Gene, "Independent Media Centers: Cyber-Subversion and the Alternative Press," *First Monday* 7.4 (April 2002), http://firstmonday.org/issues/issue7_4/hyde/index.html (accessed 12 July 2007).

Jenkins, Henry, *Convergence Culture: Where Old and New Media Collide* (New York: NYU Press, 2006), p. 133.

——, *Fans, Bloggers, and Gamers: Exploring Participatory Culture* (New York: NYU Press, 2006).

Johnson, Stephen, *Emergence* (London: Penguin, 2001).

Kahney, Leander, "Citizen Reporters Make the News," *Wired News*, 17 May 2003, http://www.wired.com/news/culture/0,1284,58856,00.html (accessed 12 July 2007).

Kelly, Kevin, "Gossip Is Philosophy," interview with Brian Eno, *Wired* 3.05 (May 1995), http://www.wired.com/wired/archive/3.05/eno.html (accessed 12 July 2007).

——, "On 'Digital Maoism: The Hazards of the New Online Collectivism' by Jaron Lanier," *Edge: The Reality Club*, 2006, http://www.edge.org/discourse/digital_maoism.html (accessed 28 Feb. 2007).

——, "We Are the Web," *Wired* 13.8 (Aug. 2005), http://www.wired.com/wired/archive/13.08/tech.html (accessed 24 Feb. 2007).

Kovach, Bill, and Tom Rosenstiel, *The Elements of Journalism: What Newspeople Should Know and the Public Should Expect* (New York: Crown, 2001).

Krowne, Aaron, "The FUD-based Encyclopedia: Dismantling Fear, Uncertainty, and Doubt, Aimed at Wikipedia and Other Free Knowledge Resources," *Free Software Magazine* 2, 28 Mar. 2005, http://www.freesoftwaremagazine.com/articles/fud_based_encyclopedia/ (accessed 2 Mar. 2007).

Lanier, Jaron, "Digital Maoism: The Hazards of the New Online Collectivism," *Edge: The Third Culture* 183, 30 May 2006, http://www.edge.org/documents/archive/edge183.html (accessed 27 Feb. 2007).

Lasica, J.D., "Blogs and Journalism Need Each Other," *Nieman Reports* (fall 2003), http://www.nieman.harvard.edu/reports/03-3NRfall/V57N3.pdf (accessed 4 June 2004).

Lawley, Liz, "Social Consequences of Social Tagging," *Many 2 Many: A Group Weblog on Social Software*, 20 Jan. 2005, http://many.corante.com/archives/2005/01/20/social_consequences_of_social_tagging.php (accessed 25 Feb. 2007).

Leadbeater, Charles, and Paul Miller, "The Pro-Am Revolution: How Enthusiasts Are Changing Our Economy and Society," *Demos* 2004, http://www.demos.co.uk/publications/proameconomy/ (accessed 25 Jan. 2007).

Lessig, Lawrence, *The Future of Ideas: The Fate of the Commons in a Connected World* (New York: Vintage, 2002).

Lévy, Pierre, *Collective Intelligence: Mankind's Emerging World in Cyberspace*, trans. Robert Bononno (Cambridge, Mass.: Perseus, 1997).

Litman, Jessica, "Sharing and Stealing," *Social Science Research Network*, 23 Nov. 2003, http://ssrn.com/abstract=472141 (accessed 14 Mar. 2007).

Locke, Matt, "A Taxonomy of Humour: What Nurses Can Teach Us about Classification," *Test*, 25 Feb. 2005, http://www.test.org.uk/archives/002370.html (accessed 27 Feb. 2007).

Love, Courtney, "Courtney Love Does the Math," *Salon Magazine*, 14 June 2000, http://dir.salon.com/tech/feature/2000/06/14/love/index.html (accessed 20 Nov. 2004).

Mann, Steve, Jason Nolan, and Barry Wellman, "Sousveillance: Inventing and Using Wearable Computing Devices for Data Collection in Surveillance Environments," *Surveillance & Society* 1.3 (2003), http://www.surveillance-and-society.org/articles1(3)/sousveillance.pdf (accessed 12 July 2007), 331–355.

Masum, Hassan, and Yi-Cheng Zhang, "Manifesto for the Reputation Society," *First Monday* 9.7 (July 2004), http://firstmonday.org/issues/issue9_7/masum/ (accessed 27 Feb. 2007).

Mathes, Adam, "Folksonomies: Cooperative Classification and Communication through Shared Metadata," *Adammathes.com*, Dec. 2004, http://www.adammathes.com/academic/computer-mediated-communication/folksonomies.html (accessed 28 Feb. 2007).

McHenry, Robert, "The Faith-Based Encyclopedia," *TCSDaily: Technology, Commerce, Society*, 15 Nov. 2004, http://www.tcsdaily.com/article.aspx?id=111504A (24 Feb. 2007).

Meikle, Graham, *Future Active: Media Activism and the Internet* (New York: Routledge, 2002).

Merholz, Peter, "Metadata for the Masses," *Adaptive Path*, 19 Oct. 2004, http://www.adaptivepath.com/publications/essays/archives/000361.php (accessed 1 Mar. 2007).

Miller, Jed, and Rob Stuart, "Network-Centric Thinking: The Internet's Challenge to Ego-Centric Institutions," *PlaNetwork Journal: Source Code for Global Citizenship*, n.d., http://journal.planetwork.net/article.php?lab=miller0704 (accessed 14 Mar. 2007).

Miller, Robin, "Wikipedia Founder Jimmy Wales Responds," *Slashdot: News for Nerds, Stuff That Matters*, 28 July 2004, http://interviews.slashdot.org/article.pl?sid=04/07/28/1351230 (accessed 27 Feb. 2007).

"New Forms of Journalism: Weblogs, Community News, Self-Publishing and More," Panel on 'Journalism's New Life Forms,' *Second Annual Conference of the Online News Association*, University of California, Berkeley, 27 Oct. 2001, http://www.jdlasica.com/articles/ONA-panel.html (accessed 31 May 2004).

O'Reilly, Tim, "Web 2.0 Compact Definition: Trying Again," *O'Reilly Radar*, 10 Dec. 2006, http://radar.oreilly.com/archives/2006/12/web_20_compact.html (accessed 12 July 2007).

Pesce, Mark, "EBay as Emergent Digital Social Network," *Hyperpeople: What Happens after We're All Connected?* 16 Jan. 2006, http://blog.futurestreetconsulting.com/?p=5 (accessed 23 Feb. 2007).

——, "Going into Syndication," *Hyperpeople: What Happens after We're All Connected?* 9 Feb. 2006, http://blog.futurestreetconsulting.com/?p=7 (accessed 23 Feb. 2007).

——, "Herding Cats," *Hyperpeople: What Happens after We're All Connected?* 20 Oct. 2006, http://blog.futurestreetconsulting.com/?p=21 (accessed 20 Feb. 2007).

——, "Hypercasting," *Hyperpeople: What Happens after We're All Connected?* 16 Oct. 2006, http://blog.futurestreetconsulting.com/?p=20 (accessed 23 Feb. 2007).

——, "Hyperintelligence," *Hyperpeople: What Happens after We're All Connected?* 2 June 2006, http://blog.futurestreetconsulting.com/?p=17 (accessed 23 Feb. 2007).

——, "Nothing Special," *Hyperpeople: What Happens after We're All Connected?* 3 Nov. 2006, http://blog.futurestreetconsulting.com/?p=23 (accessed 20 Feb. 2007).

——, "Piracy Is Good? How *Battlestar Galactica* Killed Broadcast TV," *Mindjack*, 13 May 2005, http://www.mindjack.com/feature/piracy051305.html (accessed 24 Feb. 2007).

——, "Qui Bono? [sic]". *Hyperpeople: What Happens after We're All Connected?* 11 Nov. 2006, http://blog.futurestreetconsulting.com/?p=24 (accessed 20 Feb. 2007).

——, "The Tags Within," *Hyperpeople: What Happens after We're All Connected?* 7 Oct. 2006, http://blog.futurestreetconsulting.com/?p=18 (accessed 23 Feb. 2007).

——, "The Three Fs," *Hyperpeople: What Happens after We're All Connected?* 28 Jan. 2006, http://blog.futurestreetconsulting.com/?p=6 (accessed 23 Feb. 2007).

Peters, Tom, "Daniel Nissanoff," *TomPeters.com*, 2007, http://www.tompeters.com/cool_friends/content.php?note=008780.php (accessed 17 Feb. 2007).

Pink, Daniel H., "The Book Stops Here," *Wired* 13.3 (Mar. 2005), http://www.wired.com/wired/archive/13.03/wiki.html (accessed 26 Feb. 2007).

Poynder, Richard, "P2P: A Blueprint for the Future?" *Open and Shut?* 3 Sep. 2006, http://poynder.blogspot.com/2006/09/p2p-blueprint-for-future.html (accessed 1 Mar. 2007).

Quiggin, John, "Blogs, Wikis, and Creative Innovation," *International Journal of Cultural Studies* 9.4 (2006), 481–496.

Raymond, Eric S., "The Cathedral and the Bazaar," 2000, http://www.catb.org/~esr/writings/cathedral-bazaar/cathedral-bazaar/index.html (accessed 16 Mar. 2007).

Reagle Jr., Joseph M., "A Case of Mutual Aid: Wikipedia, Politeness, and Perspective Taking," *Reagle.org*, 2004, http://reagle.org/joseph/2004/agree/wikip-agree.html (accessed 25 Feb. 2007).

Reynolds, Glenn Harlan, "Weblogs and Journalism: Back to the Future?" *Nieman Reports* (fall 2003), 81–82.

Richardson, Will, *Blogs, Wikis, Podcasts, and Other Powerful Web Tools for Classrooms* (Thousand Oaks, Calif.: Corwin Press, 2006).

Riehle, Dirk, "How and Why Wikipedia Works: An Interview with Angela Beesley, Elisabeth Bauer, and Kizu Naoko," in *Proceedings of the International Symposium on Wikis* (WikiSym), 21–23 Aug. 2006, Odense, Denmark, http://www.riehle.org/computer-science/research/2006/wikisym-2006-interview.pdf (accessed 12 July 2007).

Rosen, Jay, "The People Formerly Known as the Audience," *PressThink: Ghost of Democracy in the Media Machine*, 27 June 2006, http://journalism.nyu.edu/pubzone/weblogs/pressthink/2006/06/27/ppl_frmr.html (accessed 12 July 2007).

Rosenzweig, Roy, "Can History Be Open Source? Wikipedia and the Future of the Past," *Center for History and New Media: Essays*, 2006, http://chnm.gmu.edu/resources/essays/d/42 (accessed 28 Feb. 2007).

Roush, Wade, "Wikipedia: Teapot Tempest," *Technology Review*, 7 Dec. 2005, http://www.technologyreview.com/blog/editors/15974/ (accessed 28 Feb. 2007).

Rushkoff, Douglas, "On 'Digital Maoism: The Hazards of the New Online Collectivism' by Jaron Lanier," *Edge: The Reality Club*, 2006, http://www.edge.org/discourse/digital_maoism.html (accessed 28 Feb. 2007).

——, *Open Source Democracy: How Online Communication Is Changing Offline Politics* (London: Demos, 2003), http://www.demos.co.uk/publications/opensourcedemocracy2 (accessed 12 July 2007).

Salomon, Mandy, "Business in *Second Life*: An Introduction" (Eveleigh, NSW: Smart Internet Technology CRC, May 2007), http://smartinternet.com.au/ArticleDocuments/121/Business-in-Second-Life-May-2007.pdf.aspx (accessed 12 July 2007).

Sandoval, Greg, "Sony to Ban Sale of Online Characters from Its Popular Gaming Sites," *CNet News*, 10 Apr. 2000, http://news.com.com/2100-1017_3-239052.html (accessed 12 July 2007).

Sanger, Lawrence M., "Britannica or Nupedia? The Future of Free Encyclopedias," *Kuro5hin: Technology and Culture, from the Trenches*, 25 July 2001, http://www.kuro5hin.org/story/2001/7/25/103136/121 (accessed 28 Feb. 2007).

——, "The Early History of Nupedia and Wikipedia: A Memoir (Pt. 1)," *Slashdot: News for Nerds, Stuff That Matters*, 18 Apr. 2005, http://features.slashdot.org/article.pl?sid=05/04/18/164213 (accessed 27 Feb. 2007).

——, "The Early History of Nupedia and Wikipedia: A Memoir (Pt. 2)," *Slashdot: News for Nerds, Stuff That Matters*, 19 Apr. 2005, http://features.slashdot.org/article.pl?sid=05/04/19/1746205 (accessed 27 Feb. 2007).

——, "Is Wikipedia an Experiment in Anarchy?" *Wikimedia: Meta-Wiki*, 1 Nov. 2001, http://meta.wikimedia.org/wiki/Is_Wikipedia_an_experiment_in_anarchy (accessed 27 Feb. 2007).

——, "Why Collaborative Free Works Should Be Protected by the Law," 2005, http://www.geocities.com/blarneypilgrim/shopworks_and_law.html (accessed 24 Feb. 2007).

——, "Why Wikipedia Must Jettison Its Anti-Elitism," *Kuro5hin: Technology and Culture, from the Trenches*, 31 Dec. 2004, http://www.kuro5hin.org/story/2004/12/30/142458/25 (accessed 25 Feb. 2007).

——, "Wikipedia and Why It Matters," *Wikimedia: Meta-Wiki*, 16 Jan. 2002, http://meta.wikimedia.org/wiki/Wikipedia_and_why_it_matters (accessed 27 Feb. 2007).

——, "Wikipedia Is Wide Open: Why Is It Growing So Fast? Why Isn't It Full of Nonsense?" *Kuro5hin: Technology and Culture, from the Trenches*, 24 Sep. 2001, http://www.kuro5hin.org/story/2001/9/24/43858/2479 (accessed 27 Feb. 2007).

Schiff, Stacy, "Know It All: Can Wikipedia Conquer Expertise?" *New Yorker*, 31 July 2006, http://www.newyorker.com/archive/2006/07/31/060731fa_fact (accessed 13 Mar. 2007).

Seigenthaler, John, "A False Wikipedia 'Biography'," *USA Today*, 29 Nov. 2005, http://www.usatoday.com/news/opinion/editorials/2005-11-29-wikipedia-edit_x.htm (accessed 28 Feb. 2007).

Shirky, Clay, "Broadcast Institutions, Community Values," *Clay Shirky's Writings about the Internet: Economics & Culture, Media & Community, Open Source*, 9 Sep. 2002, http://shirky.com/writings/broadcast_and_community.html (accessed 24 Feb. 2007).

——, "Clay Shirky Explains Internet Evolution," *Slashdot*, 13 Mar. 2001, http://slashdot.org/article.pl?sid=01/03/13/1420210&mode=thread (accessed 20 Feb. 2002).

——, "Communities, Audiences, and Scale," *Clay Shirky's Writings about the Internet: Economics & Culture, Media & Community, Open Source*, 6 Apr. 2002, http://shirky.com/writings/community_scale.html (accessed 24 Feb. 2007).

——, "Folksonomies Are a Forced Move: A Response to Liz," *Many 2 Many: A Group Weblog on Social Software*, 22 Jan. 2005, http://many.corante.com/archives/2005/01/22/folksonomies_are_a_forced_move_a_response_to_liz.php (accessed 28 Feb. 2007).

——, "Folksonomies + Controlled Vocabularies," *Many 2 Many: A Group Weblog on Social Software*, 7 Jan. 2005, http://many.corante.com/archives/2005/01/07/folksonomies_controlled_vocabularies.php (accessed 28 Feb. 2007).

——, "Folksonomy Is Better for Cultural Values: A Response to danah," *Many 2 Many: A Group Weblog on Social Software*, 29 Jan. 2005, http://many.corante.com/archives/2005/01/29/folksonomy_is_better_for_cultural_values_a_response_to_danah.php (accessed 25 Feb. 2007).

——, "Folksonomy: The Soylent Green of the 21st Century," *Many 2 Many: A Group Weblog on Social Software*, 1 Feb. 2005, http://many.corante.com/archives/2005/02/01/folksonomy_the_soylent_green_of_the_21st_century.php (accessed 25 Feb. 2007).

——, "A Group Is Its Own Worst Enemy," *Clay Shirky's Writings about the Internet: Economics & Culture, Media & Community, Open Source*, 1 July 2003, http://shirky.com/writings/group_enemy.html (accessed 24 Feb. 2007).

——, "The Interest Horizons and the Limits of Software Love," *Clay Shirky's Writings about the Internet: Economics & Culture, Media & Community, Open Source*, Feb. 1999, http://shirky.com/writings/interest.html (accessed 24 Feb. 2007).

——, "News of Wikipedia's Death Greatly Exaggerated," *Many 2 Many: A Group Weblog on Social Software*, 25 May 2006, http://many.corante.com/archives/2006/05/25/news_of_wikipedias_death_greatly_exaggerated.php (accessed 26 Feb. 2007).

——, "Ontology Is Overrated: Categories, Links, and Tags," *Clay Shirky's Writings about the Internet: Economics & Culture, Media & Community, Open Source*, 2005, http://www.shirky.com/writings/ontology_overrated.html (accessed 24 Feb. 2007).

——, "RIP the Consumer, 1900–1999," *Clay Shirky's Writings about the Internet: Economics & Culture, Media & Community, Open Source*, 1999, http://www.shirky.com/writings/consumer.html (accessed 24 Feb. 2007).

——, "Wikipedia: The Nature of Authority, and a LazyWeb Request..." *Many 2 Many: A Group Weblog on Social Software*, 6 Jan. 2005, http://many.corante.com/archives/2005/01/06/wikipedia_the_nature_of_authority_and_a_lazyweb_request.php (accessed 25 Feb. 2007).

Stalder, Felix, and Jesse Hirsh, "Open Source Intelligence," *First Monday*, 7.6 (June 2002), http://www.firstmonday.org/issues/issue7_6/stalder/ (accessed 22 Apr. 2004).

Thake, William, "Editing and the Crisis of Open Source," *M/C Journal*, 7.3 (2004), http://journal.media-culture.org.au/0406/04_Thake.php (accessed 1 Oct. 2004).

Thomas, Angela, "Fictional Blogs." In Axel Bruns and Joanne Jacobs (eds.), *Uses of Blogs* (New York: Peter Lang, 2006), pp. 199–210.

Toffler, Alvin, *Future Shock* (New York: Random House, 1970).

——, *Powershift: Knowledge, Wealth, and Violence at the Edge of the 21st Century* (New York: Bantam, 1990).

——, *Previews & Premises: An Interview with the Author of* Future Shock *and* The Third Wave (New York: William Morrow, 1983).

——, *The Third Wave* (New York: Bantam, 1980).

Trendwatching.com, "Curated Consumption: An Emerging Consumer Trend and Related New Business Ideas," 2006, http://www.trendwatching.com/trends/CURATED_CONSUMPTION.htm (accessed 19 Feb. 2007).

——, "Customer-Made: Co-Creation, User-Generated Content, DIY Advertising and More!" 2006, http://www.trendwatching.com/trends/CUSTOMER-MADE.htm (accessed 18 Feb. 2007).

——, "Feeder Businesses: An Emerging Consumer Trend and Related New Business Ideas," 2006, http://www.trendwatching.com/trends/FEEDER_BUSINESSES.htm (accessed 20 Feb. 2007).

——, "Generation C," 2005, http://www.trendwatching.com/trends/GENERATION_C.htm (accessed 18 Feb. 2007).

——, "Generation C(ash)," 2007, http://www.trendwatching.com/trends/gen-cash.htm (accessed 18 Feb. 2007).

——, "Hygienia: An Emerging Consumer Trend and Related New Business Ideas," 2006, http://www.trendwatching.com/trends/HYGIENIA.htm (accessed 20 Feb. 2007).

——, "Infolust: Forget Information Overload, Consumers Are More Infolusty than Ever!" 2006, http://www.trendwatching.com/trends/infolust.htm (accessed 19 Feb. 2007).

——, "Life Caching: An Emerging Consumer Trend and Related New Business Ideas," 2007, http://www.trendwatching.com/trends/LIFE_CACHING.htm (accessed 20 Feb. 2007).

——, "Minipreneurs: An Emerging Consumer Trend and Related New Business Ideas," 2006, http://www.trendwatching.com/trends/MINIPRENEURS.htm (accessed 19 Feb. 2007).

——, "Nouveau Niche: An Emerging Consumer Trend and Related New Business Ideas," 2006, http://www.trendwatching.com/trends/NOUVEAU_NICHE.htm (accessed 18 Feb. 2007).

——, "Ready-to-Know: An Emerging Consumer Trend and Related New Business Ideas," 2006, http://www.trendwatching.com/trends/READY-TO-KNOW.htm (accessed 18 Feb. 2007).

——, "Status Skills: A Value Shift in Status: From Passive Consumption to Mastering Skills," 2006, http://www.trendwatching.com/trends/status-skills.htm (accessed 18 Feb. 2007).

——, "Top 5 Consumer Trends for 2007," 2007, http://www.trendwatching.com/trends/2007top5.htm (accessed 17 Feb. 2007).

——, "Twinsumer: An Emerging Consumer Trend and Related New Business Ideas," 2006, http://www.trendwatching.com/trends/TWINSUMER.htm (accessed 20 Feb. 2007).

Udell, Jon, "Collaborative Knowledge Gardening," *InfoWorld*, 20 Aug. 2004, http://www.infoworld.com/article/04/08/20/34OPstrategic_1.html (accessed 1 Mar. 2007).

Van Doren, Charles, "The Idea of an Encyclopedia," *American Behavioral Scientist*, 6.1 (1962), 23–26.

Von Hippel, Eric, *Democratizing Innovation* (Cambridge, Mass.: MIT Press, 2005).

Wikimedia, "Power Structure," *Wikimedia: Meta-Wiki*, 11 Dec. 2006, http://meta.wikimedia.org /wiki/Power_structure (accessed 28 Feb. 2007).

Wikipedia, "Wikipedia: Neutral Point of View," *Wikipedia: The Free Encyclopedia*, 11 July 2007, http://en.wikipedia.org/wiki/Wikipedia:Neutral_point_of_view (accessed 12 July 2007).

——, "Wikipedia: No Original Research," *Wikipedia: The Free Encyclopedia*, 11 July 2007, http://en.wikipedia.org/wiki/Wikipedia: No_original_research (accessed 12 July 2007).

——, "Wikipedia: Verifiability," *Wikipedia: The Free Encyclopedia*, 9 July 2007, http://en.wikipedia.org/wiki/Wikipedia:Verifiability (accessed 12 July 2007).

——, "WikiLove," *Wikipedia: The Free Encyclopedia*, 18 Feb. 2007, http://en.wikipedia.org /wiki/Wikipedia:WikiLove (accessed 27 Feb. 2007).